AN EY

COU

a collector's exploration of 20

PRESTEL
Munich • London • New York

E FOR

TURE

th century fashion

conten

CRISTÓBAL BALENCIAGA

CALLOT SŒURS

PACO RABANNE

GRÈS

RUDI GERNREICH

ANDRÉ COURRÈGES

GEORGES LEPAPE

ELSA SCHIAPARELLI

PIERRE CARDIN

ROGER VIVIER

MAGGY ROUFF

MADELEINE VIONNET

MADELEINE PANIZON

JEANNE LANVIN

YOHJI YAMAMOTO

HUSSEIN CHALAYAN

LUIGI ZANOTTI

SALVATORE FERRAGAMO

GABRIELLE CHANEL

CHRISTIAN DIOR

HUBERT DE GIVENCHY

PAUL POIRET

JEAN PATOU

YVES SAINT LAURENT

SONIA DELAUNAY

HERMÈS

BRUYÈRE

CHARLES JAMES

ALIX

CLAIRE MCCARDELL

MADELEINE & MADELEINE

LANVIN-CASTILLO

FORTUNY

JACQUES FATH

EISA

INTRODUCTION AND ACKNOWLEDGEMENTS

An Eye for Couture presents and explores Francesca Galloway's collection of 20th-century haute couture and fashion, built over a period of thirty-five years. As with any collection, this one started small and grew into something more tangible and serious with every new acquisition, the passing of time, and of course the all-important editing. Led by her eye, and free from narrow collecting constraints, Galloway was attracted to fashion as an art form. She sought out couturiers and designers who were visionaries and trend-makers, many of whom were also supreme in their craft.

Galloway has been informed by her profession as an art dealer in Indian painting and Asian textiles; therefore her eye has subconsciously been caught by couture that is in dialogue with, or references, motifs, techniques and cuts from Asia. This theme is explored in Mei Mei Rado's essay, while the process of collecting is discussed, along with related matters, in Judith Clark's interview. Reflecting an attraction to tastemakers and innovators, the collection includes a group of Paul Poiret dresses and accessories that come from Denise Poiret's wardrobe. Caroline Evans examines the nature of this group in her text. The name of the original owner of couture garments is often lost, but not always; in her essay, Betül Başaran revisits the life and times of Princess Niloufer of Hyderabad, who was a client of the Parisian couture houses. Alexis Romano describes how societal changes in the 1960s led to a fundamental change in fashion.

This book, which illustrates over 100 pieces, is organised in a chronological order, but should not be interpreted as a chronology of 20th-century fashion. It is a portrait of a collection, and as such it expresses the personality of the collector, with naturally occurring areas of high concentration balanced by inevitable 'gaps'. Indeed, the beauty of exploring a private collection is that we have been able to focus on compelling facets without the pressure to be comprehensive. This book should not least be understood as a celebration of the assembled couturiers and designers, whose work visually shaped our reading of the 20th century. The aim is to enchant through the pieces and further our understanding of the subject.

We are grateful to the many people whose contribution made this publication possible. We are indebted to fashion historian Rebecca Arnold, who provided early advice, input and invaluable suggestions; Antoine Bucher and Nicolas Montagne (Diktats bookstore), with regard to their help and magnanimity in a myriad of ways; and Caroline Evans, who not only wrote a perceptive and captivating essay, but has been incredibly generous too.

We are appreciative to the authors for their inspiring texts: Judith Clark, Mei Mei Rado, Betül Başaran, Alexis Romano and Waleria Dorogova. Their work forms an essential part of this publication. We would like to express our gratitude to William DeGregorio, for researching each of the pieces and leaving no stone unturned; to

Katrina Lawson Johnston for her nuanced and beautiful photography; to Sarah Glenn for her expertise in dressing and styling the garments; and Mary Galloway for infusing life into the mannequins by bringing her thespian knowledge to the photoshoot.

We are hugely grateful to the following for their expertise, sharing of knowledge, and support: Valerie Steele (director and chief curator, The Museum at the Fashion Institute of Technology); Anna Jackson (Keeper of the Asian department, Victoria and Albert Museum); Philip Garner; Laure Harivel (Patrimoine Lanvin); Adelheid Rasche (chief curator for dress, textiles and jewellery, Germanisches Nationalmuseum, Nuremberg); and Givenchy specialist Henry Wilkinson.

Our thanks also go to Marie-Sophie Carron de la Carrière, Marie-Pierre Ribère, Éric Pujalet-Plàa and Ève Briend (Musée des Arts Décoratifs, Paris); Sophie Grossiord and Laurent Cotta (Palais Galliera, Musée de la Mode de la Ville de Paris); Rosemary Harden (Fashion Museum Bath); Dilys Blum (Philadelphia Museum of Art); Sonia Dingilian, Zainab Floyd, Eileen Costa and Melissa Marra-Alvarez (The Museum at the Fashion Institute of Technology); Mary Redfern and Masami Yamada (Victoria and Albert Museum); Helen Persson; Kohka Yoshimura; Clément Migeon (Patrimoine Paco Rabanne); Lesley Ellis Miller; Joana Tosta (Dior Héritage); Hélène Starkman (Christian Dior Couture); Igor Uria Zubizarreta (Cristóbal Balenciaga Museoa); Francesco Pastore (Maison Schiaparelli); Alexandra Palmer (Royal Ontario Museum); Gaspard de Massé (Balenciaga Heritage); Leslie Veyrat (Fondation Pierre Bergé–Yves Saint Laurent); and Dominique Juigné and Jean-Charles Virmaux (Archives de Paris).

For their kind contributions, we would also like to thank Anne-Françoise Bédhet (CMI France); Danielle Beilby; Hannah Brown (reconstruction of headdress No. 81); Susanna Brown; Jessica Burgess; Sylvie Daniel; Patrice Dutartre; Austen Eadie-Friedmann; Séverine Experton-Dard; Cynthia Meera Frederick; Patricia Frost; Hubert Felbacq; Amin Jaffer; Nobuko Kajitani; Charlotte Knapp (Peter Knapp); Naomi Laan; Janie Lightfoot; Harriet MacSween; Michele Majer; Andreas Marks (Minneapolis Institute of Art); Katie Mooney; Pamela Parmal; Jeevak Parpia and Banoo Parpia; Glenn Petersen; Nicolas Poiret; Matthew Reeves; Piotr Szostak; Kerry Taylor; Morgane Weitz; and Michael Zimmermann (Fotostiftung Schweiz).

Our further gratitude goes to Françoise Auguet, Titi Halle and Martina D'Amato for their support with this project, and for their friendship.

This book would not have been possible without Ben Evans, Malin Lonnberg and Kanittha Mairaing of Hali Publications, and above all our designer and friend Misha Anikst. We dedicate this book to Pip.

Francesca Galloway Christine Ramphal

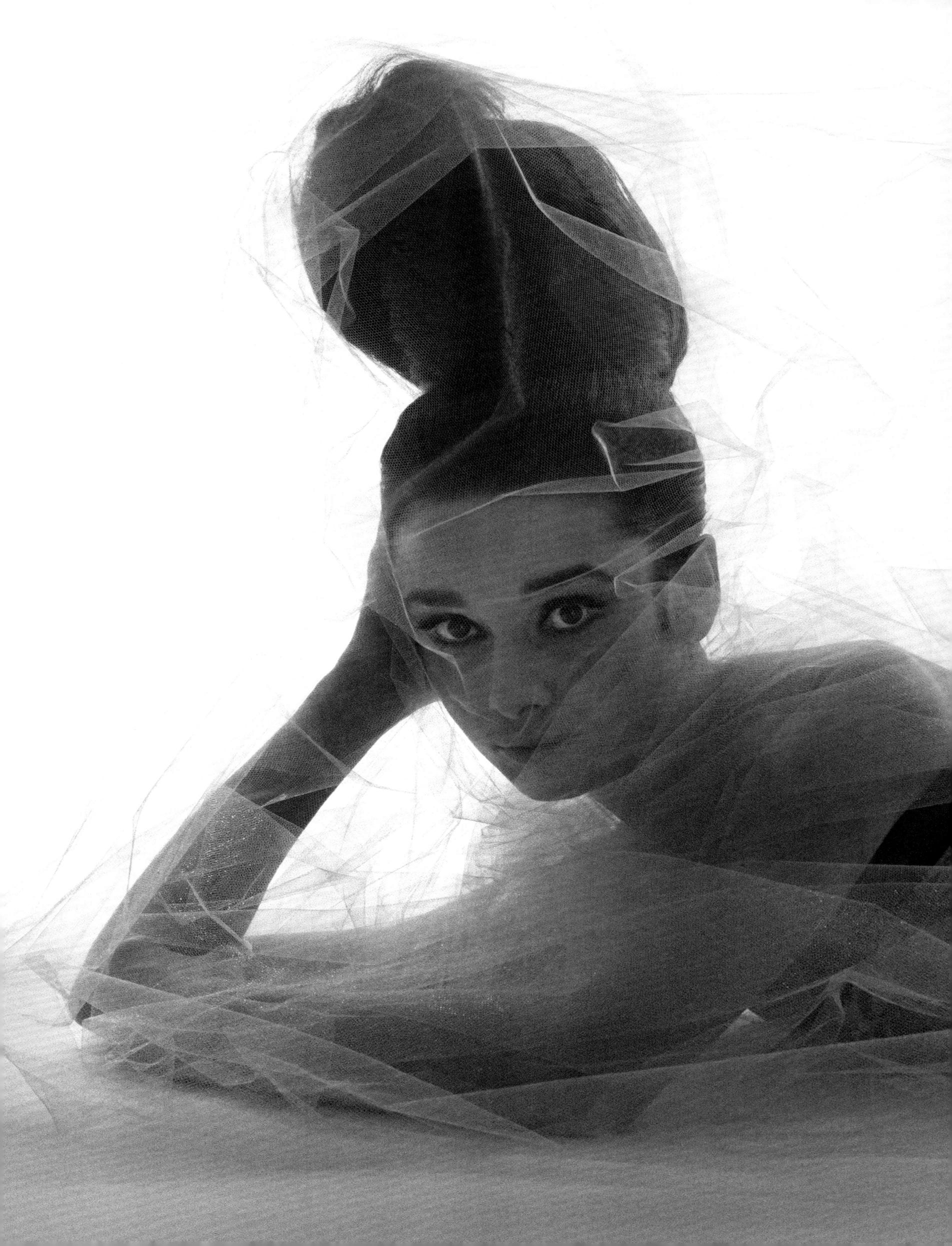

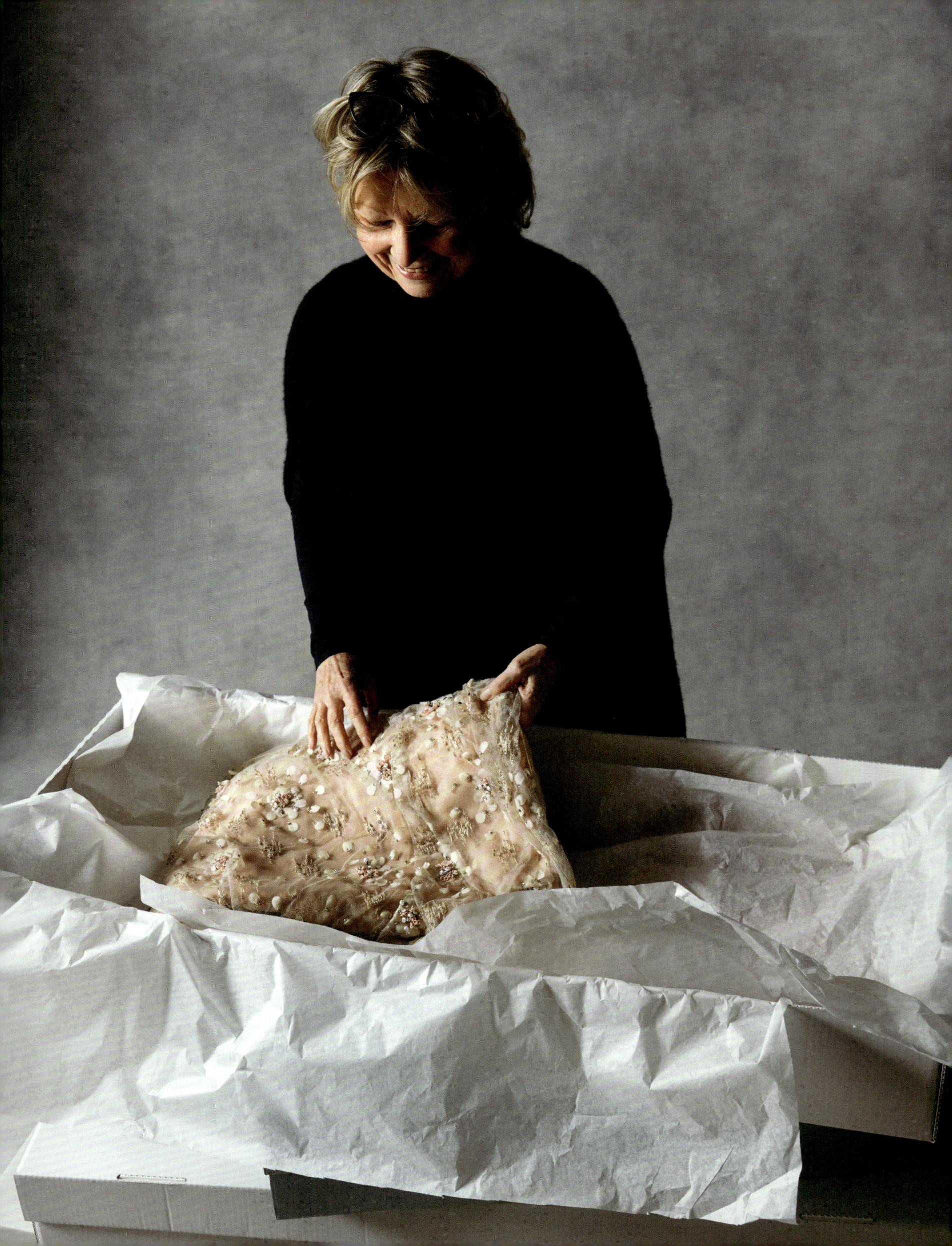

BALENCIAGA
FIRST, SECOND AND THIRD...

An interview with Francesca Galloway

Judith Clark

Francesca Galloway and I met as this book was going to print, so that this interview might act as an introductory text and, as all introductory texts, be written last. We sat close together at her desk in her home in west London, scrolling through the provisionally laid-out pages, stopping and starting when a detail illustrated an idea or an essential memory.

I had received a selection of mood boards that had been used for the book in the days leading up to the interview: photographs of quietly posed mannequins clothed in the exquisite couture that constituted a selection from Galloway's extraordinary collection, next to zoomed-in details that created a kind of visual guide, an invitation from her to look carefully and closely. It was like a guide also to Galloway's preoccupations, clues to the reasons why these and not others had been selected. These were the details that had made their purchase irresistible. 'They jump at you. They don't let you go past...' she would later tell me of a beaded evening gown, but also of the ingenuity of Chalayan's Tyvek Airmail dress, of a boned corset, of the drama of a gathered sleeve. Trying to theme the collection would be like attempting to understand the idiosyncrasies of desire or curiosity.

While I tried to pin down the moment that Francesca Galloway started collecting dress, like the founding date of a museum, she reminded me it is and was not like that; it was instead a fine line that started with buying for herself, and which became more and more ambitious, or perhaps a little more self-conscious. We did however discuss the origins of her fascination with dress – she remembered being 'mesmerised', while she was still at school, by the costume for a 1920s matron in a play, adorned with multiple, tiny, fabric-covered buttons. But it was the purchase of a 1950s Balenciaga black silk gazar cocktail dress that she cited as the beginning of what we agreed constituted collecting. 'It was masterly in its construction – its internal horsehair structure supported a dress that was as light as air. I bought it for what it was, and not for what I was going to look like in it,' she said.

The collection's highlights presented here include some of the most iconic designs of the 20th century such as one might find in collections such as the Costume Institute at the Metropolitan Museum of Art in New York, the Palais Galliera in Paris or Kyoto's Costume Institute; key examples by Paul Poiret, Jeanne Lanvin, Gabrielle Chanel, Madame Grès, Cristóbal Balenciaga, Paco Rabanne... and it goes on. Yet the collection has the freedom to include anomalies that museums might edit out in favour of illustrating a linear chronology of 20th-century couture, for

previous pages

Audrey Hepburn wearing Givenchy gown (no. 73), photographed by Bert Stern. April 1963

opposite

Francesca Galloway with Givenchy gown (no. 73)

example, or the idea of a progressive narrative. This collection doesn't have gaps because it is not like that. While phenomenally knowledgeable about fashion history, Galloway does not make such a claim for herself, and instead underplays the idea of pursuit in favour of the idea of exciting opportunity.

Galloway has always been interested in clothes, she told me, and often only to admire and not to imagine necessarily wearing herself. 'I remember Biba, going into Biba, and it wasn't how I lived. But I was very curious and attracted to it, though it isn't what I bought,' she recalled of shopping for clothes in the 1960s. It feels as if there is something about the daring that she stayed shy of. Her collection does include the fabulous, revolutionary Monokini designed by Rudi Gernreich in 1964 (no. 72), something that Galloway hastens to add she would not wear nor would have worn, although that didn't stop her utter delight in its design, its audacity, its innovation and its humour – the modesty of the bottom half and the total exposure of the top. The collection provides a totally different kind of pleasure, of ownership distinct from imagining it on her own body, and not necessarily consistent with her own lifestyle.

One of Galloway's first jobs was indeed in fashion, for Valentino in Rome in 1972. Her mother was Italian and, through her determination for financial (and geographic) independence, Galloway left London to seek employment in Italy while still only nineteen years old. Galloway described to me the comic circumstances of her very short employment due to the fact she did not speak Italian, but she did watch Sophia Loren, Audrey Hepburn, Elizabeth Taylor and even Italian President Leone's wife come in for fittings. She was sacked, but she found a job at Christie's auction house in Rome, having pretended to be a collector – and indeed she did become one very quickly, she quips, collecting shoes with her pay cheques. To those are now added designs by Salvatore Ferragamo, Roger Vivier and the legendary Perugia, who collaborated with the likes of Paul Poiret and Elsa Schiaparelli.

In 1975, Francesca Galloway, still only twenty-three, returned from Italy to take up her position within the South Asian Department at Spink & Son, the legendary antique emporium which, at the time, was the world leader in Indian and Southeast Asian art. It was here that her interest in textiles and couture was fostered. Her boss, Anthony Gardner, collected textiles and so a world of dealers and experts opened up to her. Couture was still cheap at auction at the time, so she was able to buy for herself as well as, with her department's permission, to collect for major

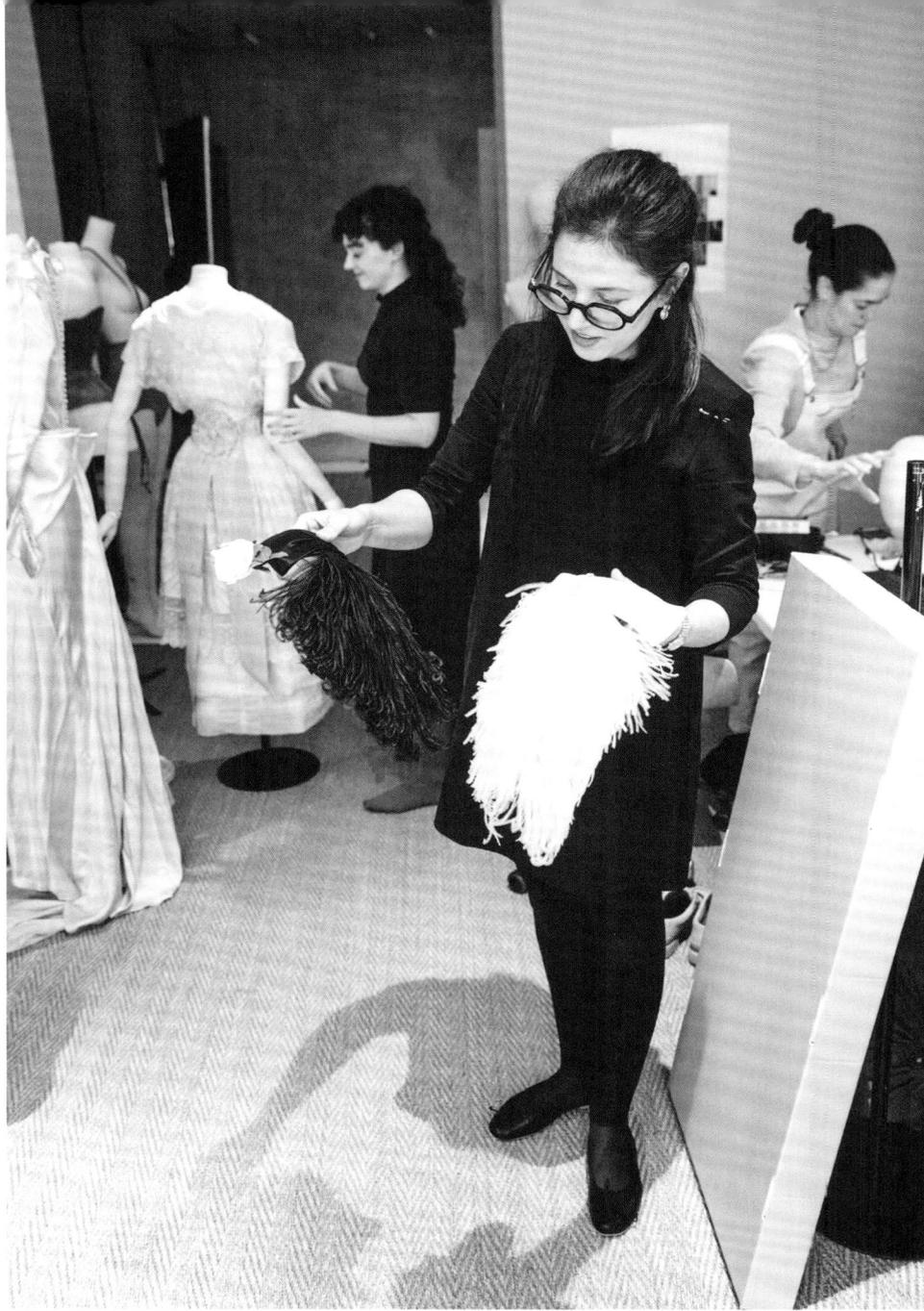

international clients: Museum director James Mollison, for example, was a client, who was building the collection at the National Gallery in Canberra, with the help of Robyn Healy who was then curator of fashion, famously ambitious and uncompromising in his attitude to his purchasing programme. She published *Haute Couture at Spink* in 1989 and *Costume & Textiles at Spink* in 1990.

The people whom Galloway cites as teaching her to look 'forensically' at textiles and dress were Christa Mayer Thurman, Betty Kirke and Marie-Andrée Jouve – the latter being the Balenciaga specialist *par excellence*. Thurman, like Galloway, was born in Germany, and had migrated to the US, working first at the Cooper Hewitt and then, by the time she and Galloway met, as curator of textiles at the Art Institute of Chicago. Thurman is now acknowledged as one of the great protagonists of textile museology, having expanded the Institute's collection to 15,000 textiles by the time she retired in 2009. Galloway was witnessing a seismic shift in attitudes to collecting, examining, conserving, documenting and – importantly to Galloway as a dealer at that time – valuing dress. Prices were being driven up as dress was being re-assessed within histories of the decorative arts.

Christine Ramphal during the photoshoot at 31 Dover Street

The dissolution of the haute couture department at Spink in 1992 meant that she had the opportunity to purchase the 'old stock'. She therefore inherited a group that included examples of Givenchy and Callot Sœurs and Fortuny. A collection of important 1930s Vionnets also came her way. The collection was unlabelled so, ever-meticulous, she commissioned Vionnet expert and biographer Betty Kirke to document the gowns and verify their authenticity. Kirke had worked in the conservation departments at the Metropolitan Museum and at the Fashion Institute of Technology before devoting the last decades of her life to Madeleine Vionnet.

Despite her immersion in the world of couture Galloway decided that she needed to clarify her own direction. 'It was a practical thing. I can't show a dress and then the next minute an Indian miniature. I started on my own in 1992, and decided fairly early on, say within two years, that I would collect couture, but not deal in it. Business – I think business sharpens your mind, you can't just do what you want, you have to do what's going to work, otherwise you go bankrupt. I was being offered such fantastic things in the Indian painting world. A collection, in fact, two collections came my way, and that's where I had to concentrate.

'You have to buy what you can't live without.'

Galloway continued to put the exceptional collection of couture together privately, at the beginning often being outbid by museums and established collectors, but it gained momentum, and the privacy was key. It meant she could wait for auctions, for private collections to become available after decades of having been unobtainable, and use her expertise, enthusiasm and her own taste carefully. She dealt in Indian miniature paintings, documenting the complexity of their provenance to ensure she was presenting the best ('to be sure that is not me who thinks it is the best, but that it is the best'). It feels as though this provided the discipline that was applied to her own collection as well: going to the ends of the earth to secure authentication when sometimes the records were scarce. The images that accompany the collection in this book are part of that scrupulousness, of connecting the garments to very precise moments in time, both in terms of design, but also to the women whose wardrobes they were part of. What were the occasions on which they were worn, and why?

Fashion's value for Galloway is complicated by her intense desire in relation to it. And then there is her curiosity around its social context and the lives of those who might have worn the clothes. Her love for writers such as Rosamond Lehmann

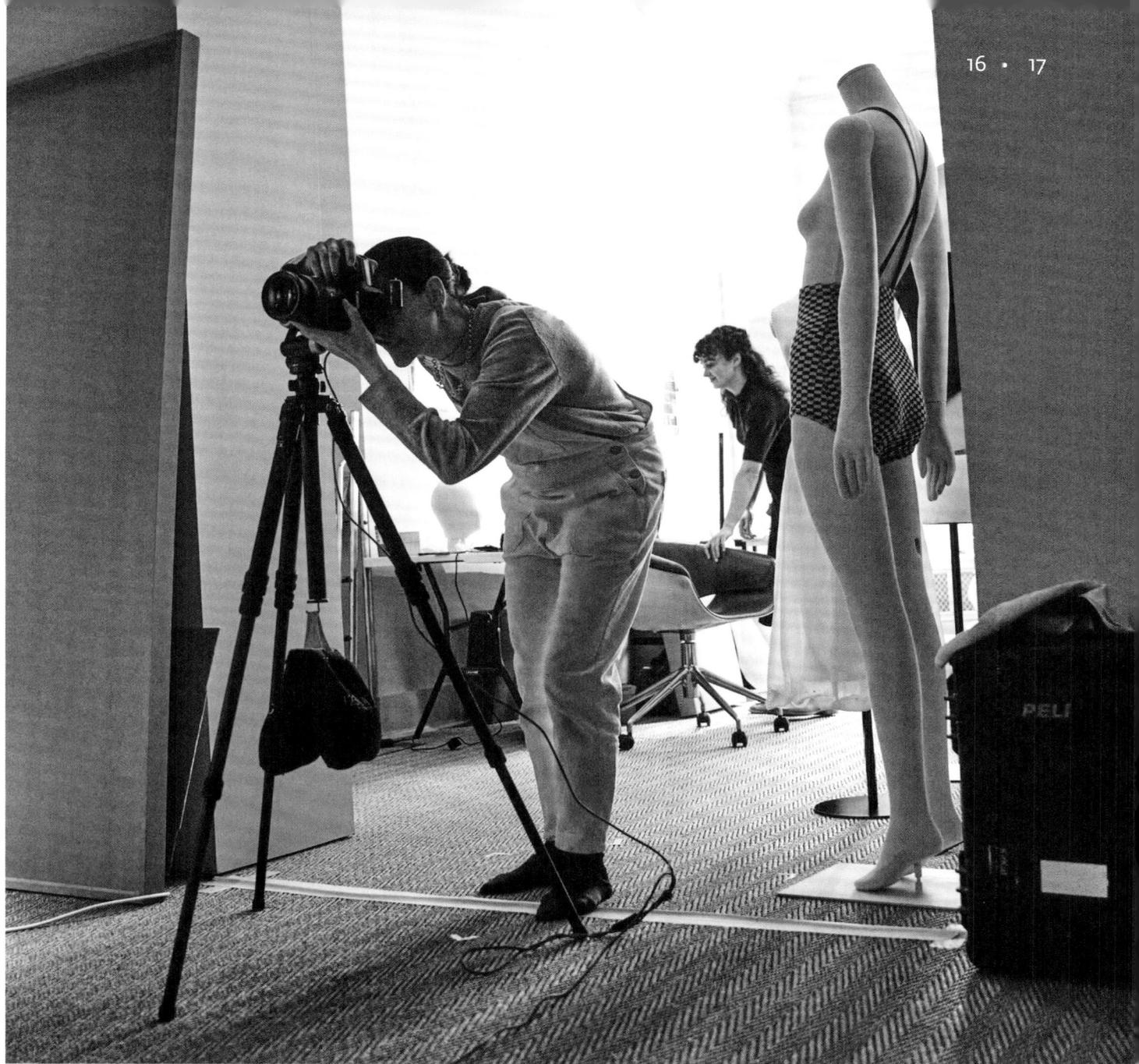

– whose father was the cult editor of *Punch* magazine, the social chronicler par excellence – is about reading about fashion's details observed and translated into language. Forays into research for her have often been about just that, establishing whether the Givenchy gown (no. 73) was in fact the one worn by Audrey Hepburn. Galloway is not happy with just speculating, but making sure that what she might say about it is backed up.

There is a huge project underway of documenting the collection, with her long-term collaborator Christine Ramphal; however, the aspects that most interest Galloway, and that are reflected in the essays in this volume, are about her own curiosity. There is something about the physicality of worn garments and their enigmatic effect and allure that she is attuned to and that extend out into alternative histories. The photographs reveal the confidence of the wearer, their own seductive power, over and above perhaps the fact of fetish boots and corsets that are also found in the collection. Her interests leave this extraordinary project open-ended, and remind us of the idiosyncrasies of public collections and the people who formed them.

Katrina Lawson Johnston behind the camera during the photoshoot

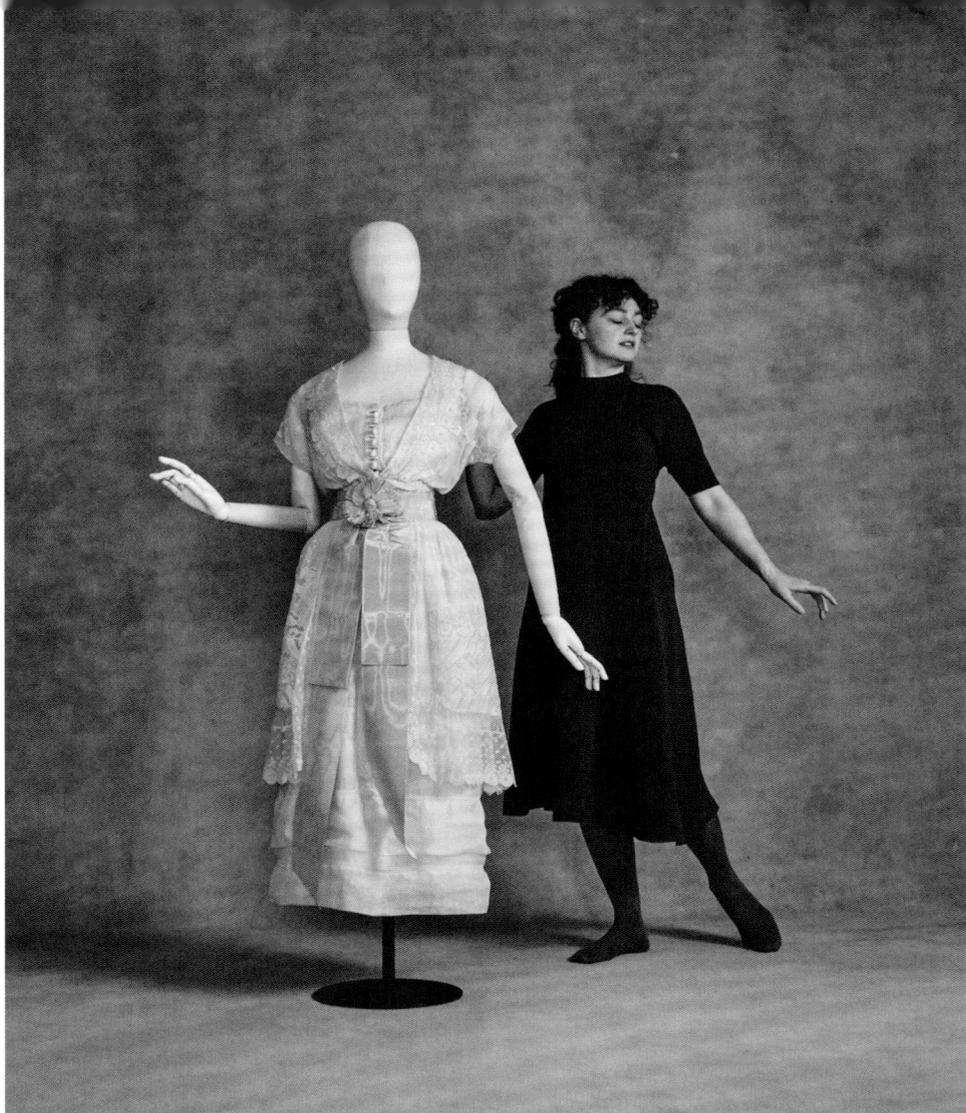

Asked to describe the purchase of one garment, she told me about a late 1960s Paco Rabanne: 'a long, knitted cotton mesh dress (no. 82), looped with metal washers, worn by the singer Béatrice Arnac'. She liked it because it had ingenuity (who would think of making a dress from industrially produced tap washers?), 'and moulds the body like fish-scale, in a sexy, really heavy way. It has strong style and gives the wearer animal magnetism – I can imagine a performer making an entrance with this. The dress weighs at least five kilograms.' Another reason she was drawn to this particular dress was 'because, although I've never heard Béatrice Arnac sing, I imagine her like Juliette Gréco, singing and slinking around in a small, smoke-filled basement nightclub'.

It is however Balenciaga that still moves Galloway most. She describes visiting the seminal retrospective of his work, *Hommage à Balenciaga*, staged at the Musée Historique des Tissus, Lyon in 1985, as 'a wake-up call in that I saw his pieces in terms of sculpture for the body. I had not expected this reaction.' And it is still about the reaction.

Galloway was extremely reticent about speaking about herself, and making herself known, preferring to speak about the power of the work. Sitting next to each other at the screen, looking forward, allowed for distraction and delegation – but also allowed me to witness her physical delight at the objects as they appeared, the pull that had prevented her from 'passing by'.

Mary Galloway adds gesture to a mannequin

1 – 16

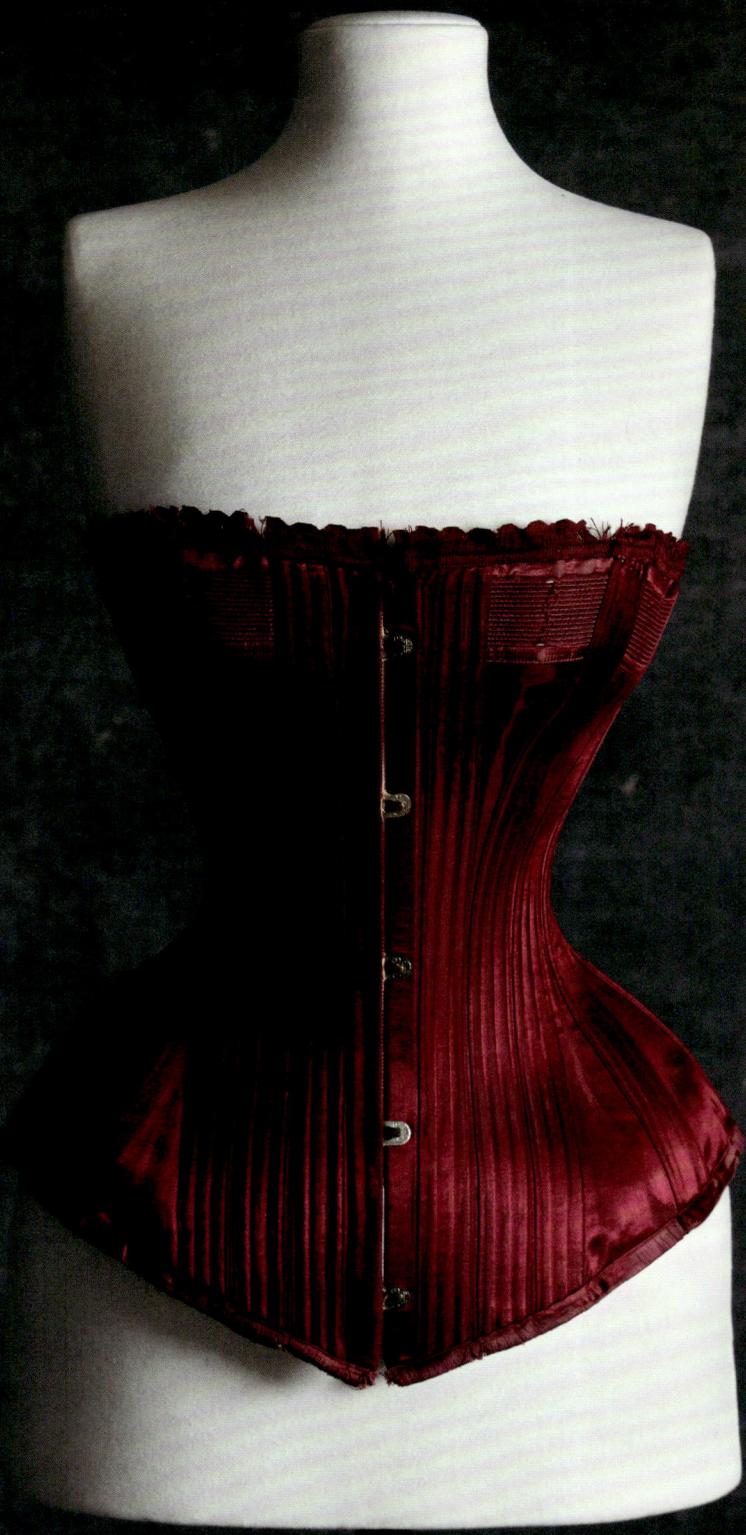

1. **À La Spirite**, Nineteen-inch corset, American, c. 1893

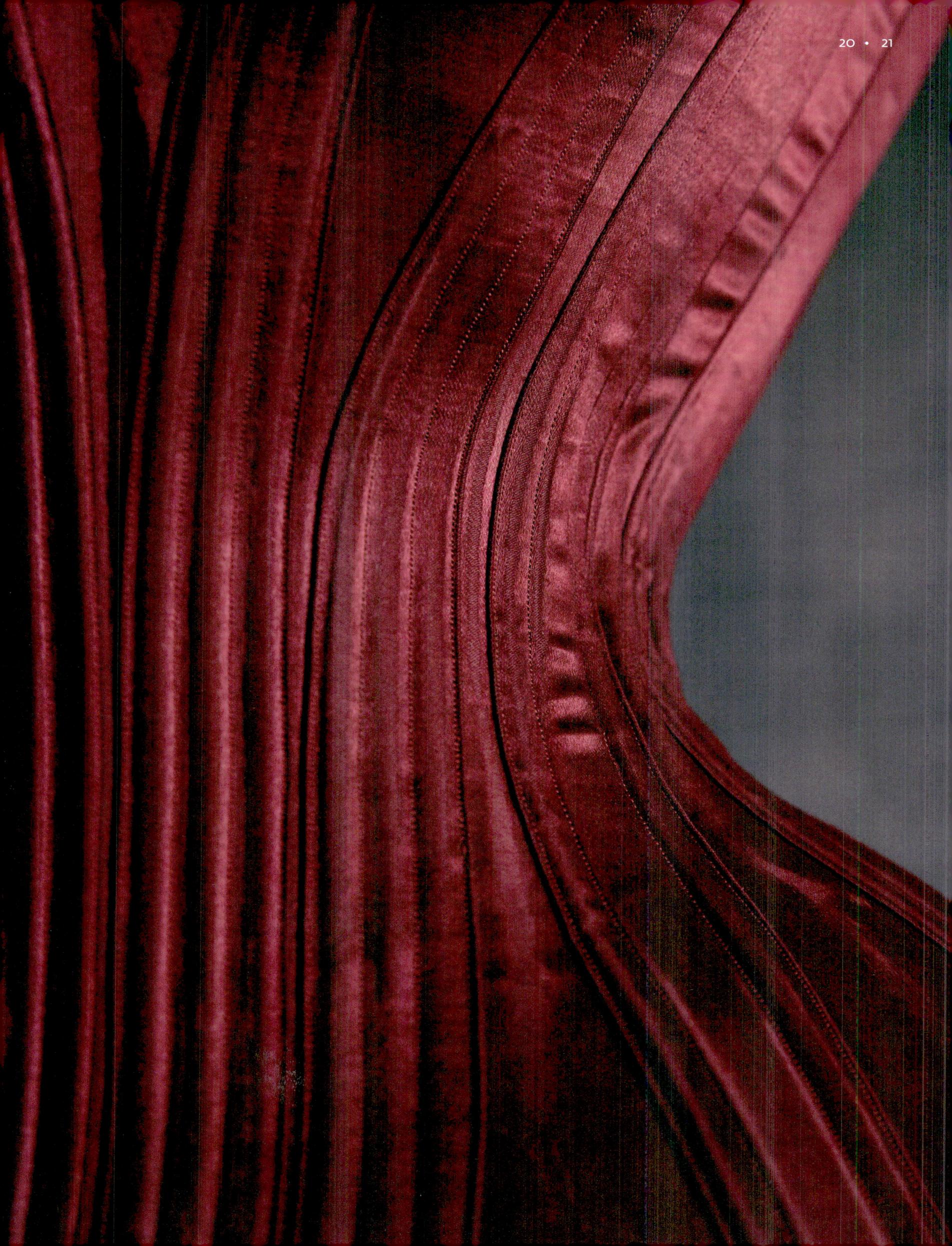

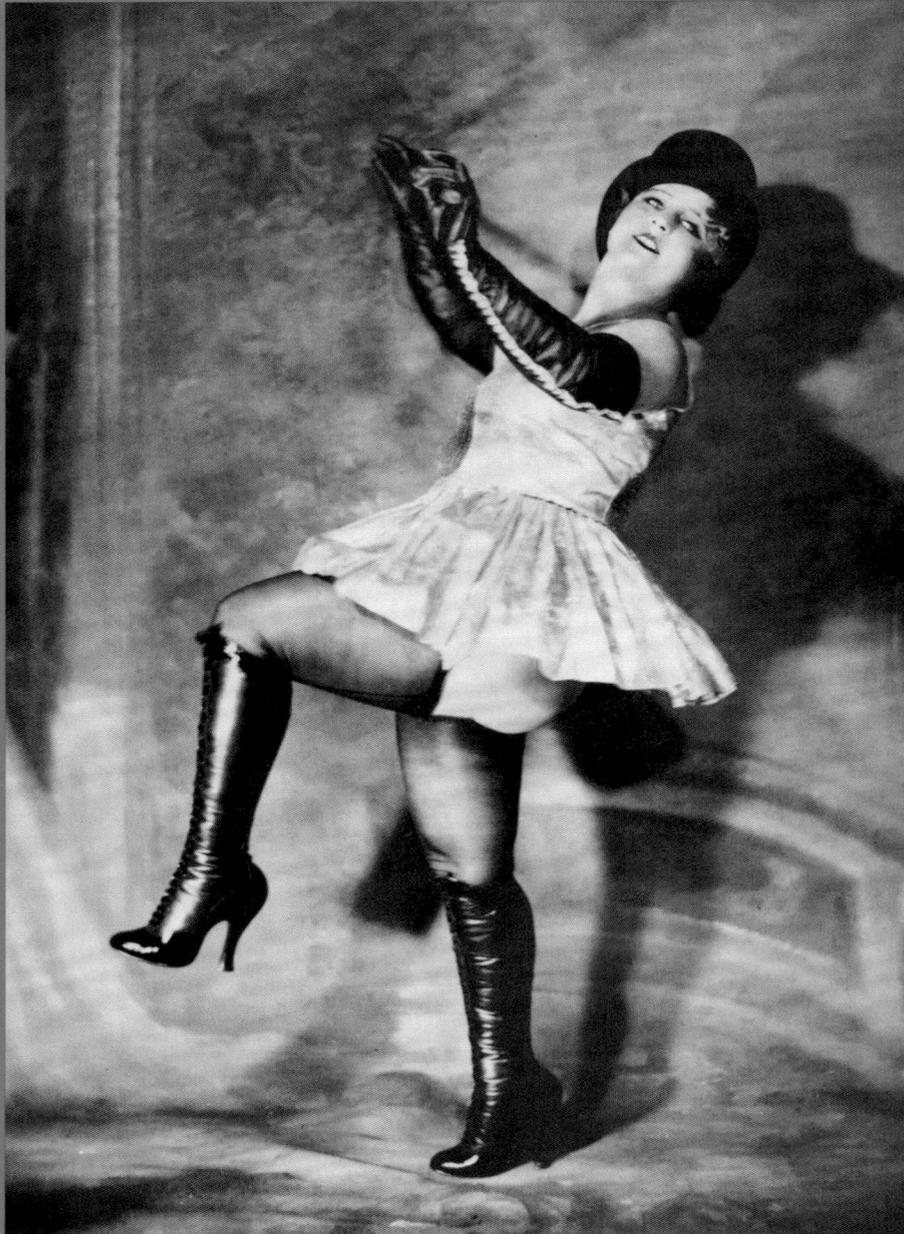

fig. 1 Dancing girl, Yva Richard, c. 1895

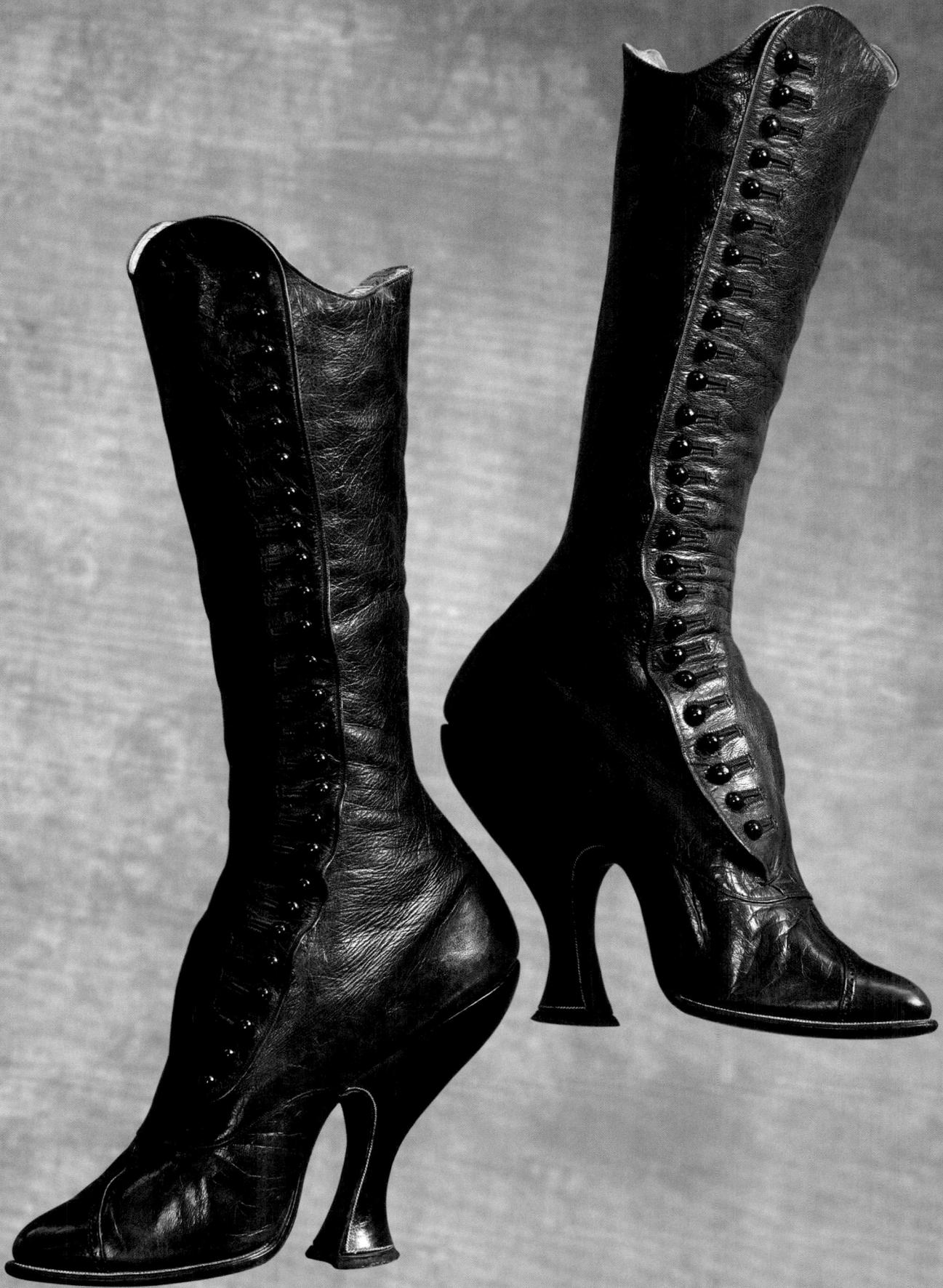

2. Pair of fetish buttoned boots European, c. 1895

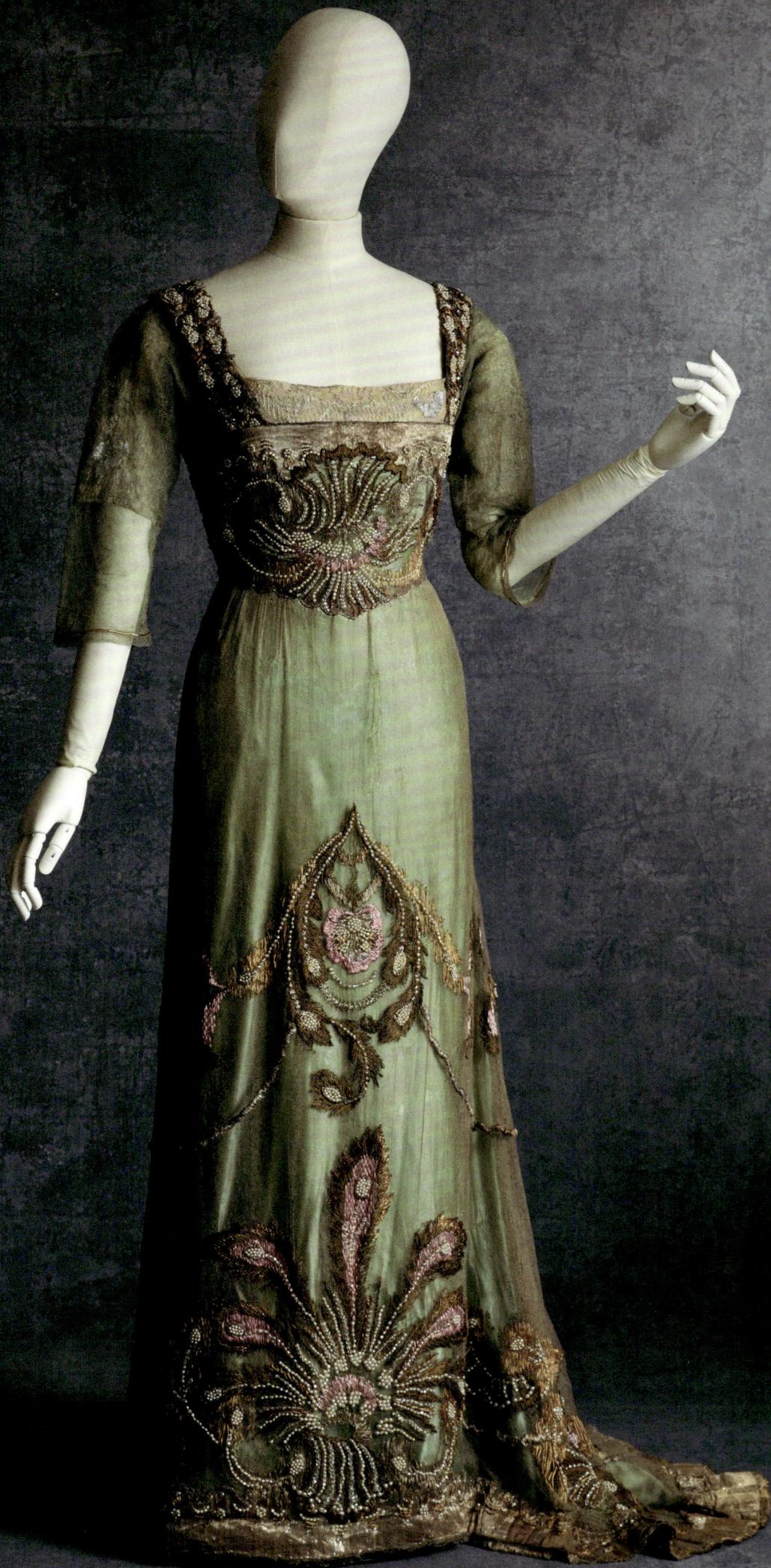

3. Callot Sœurs Evening dress, c. 1913

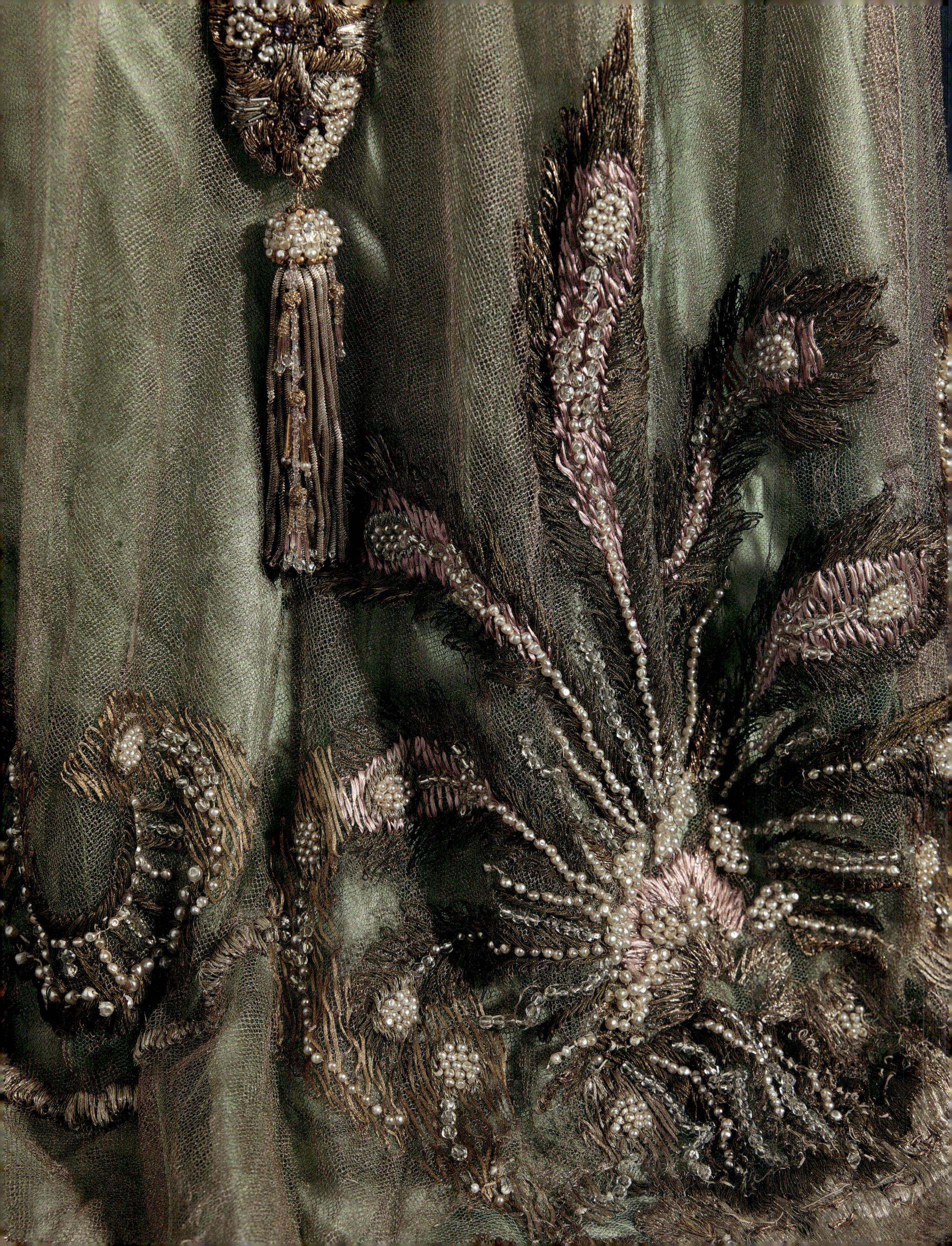

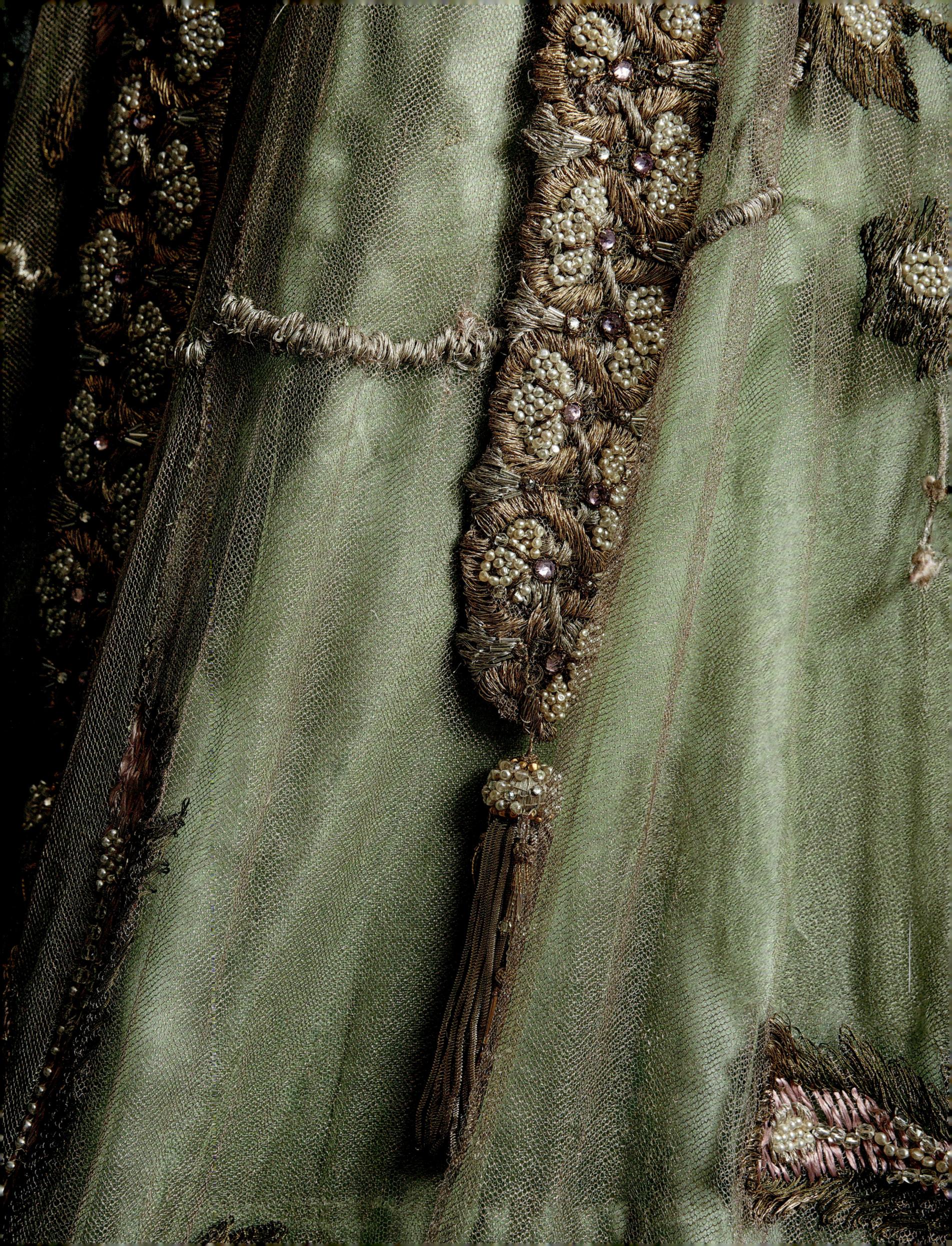

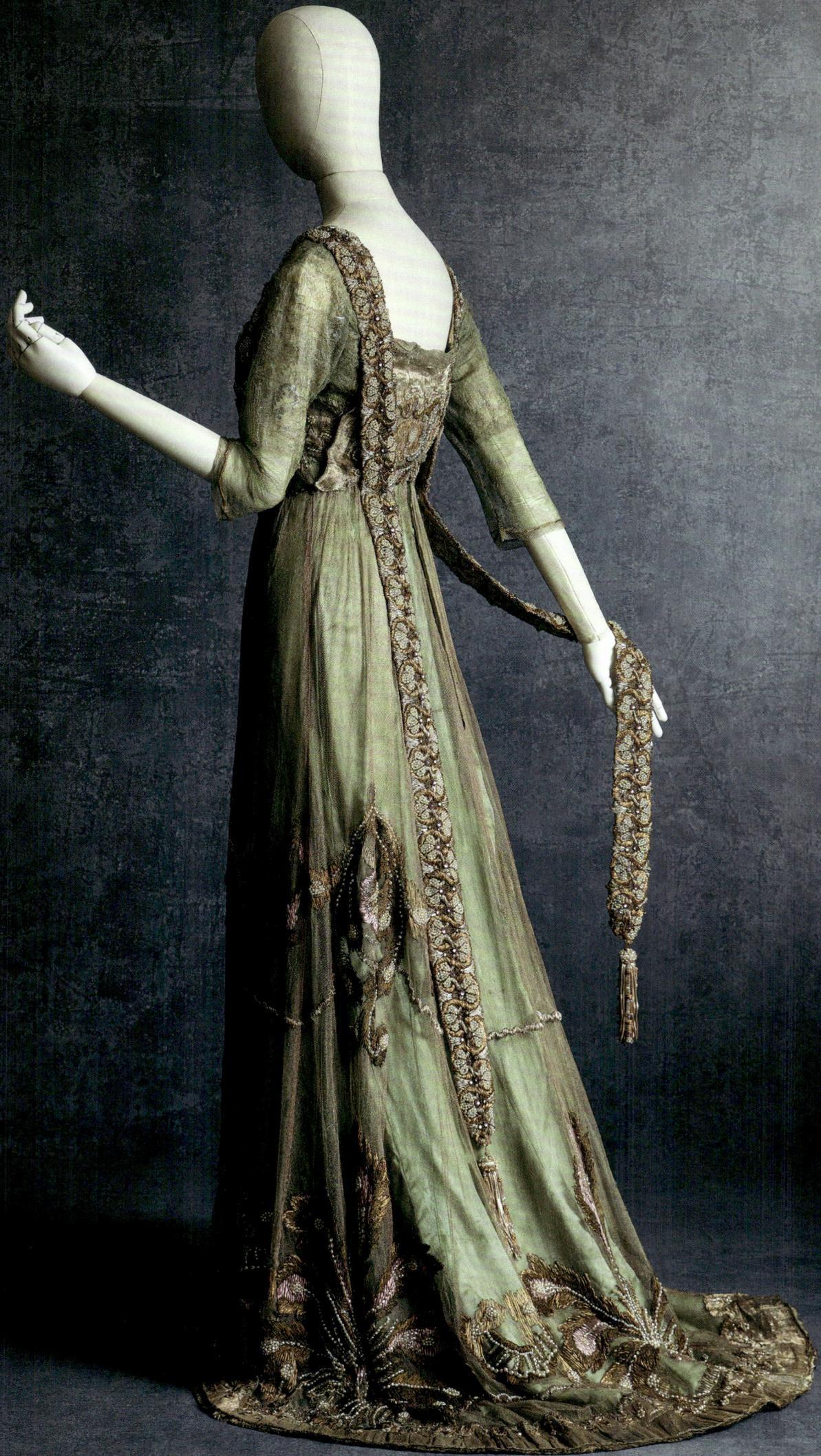

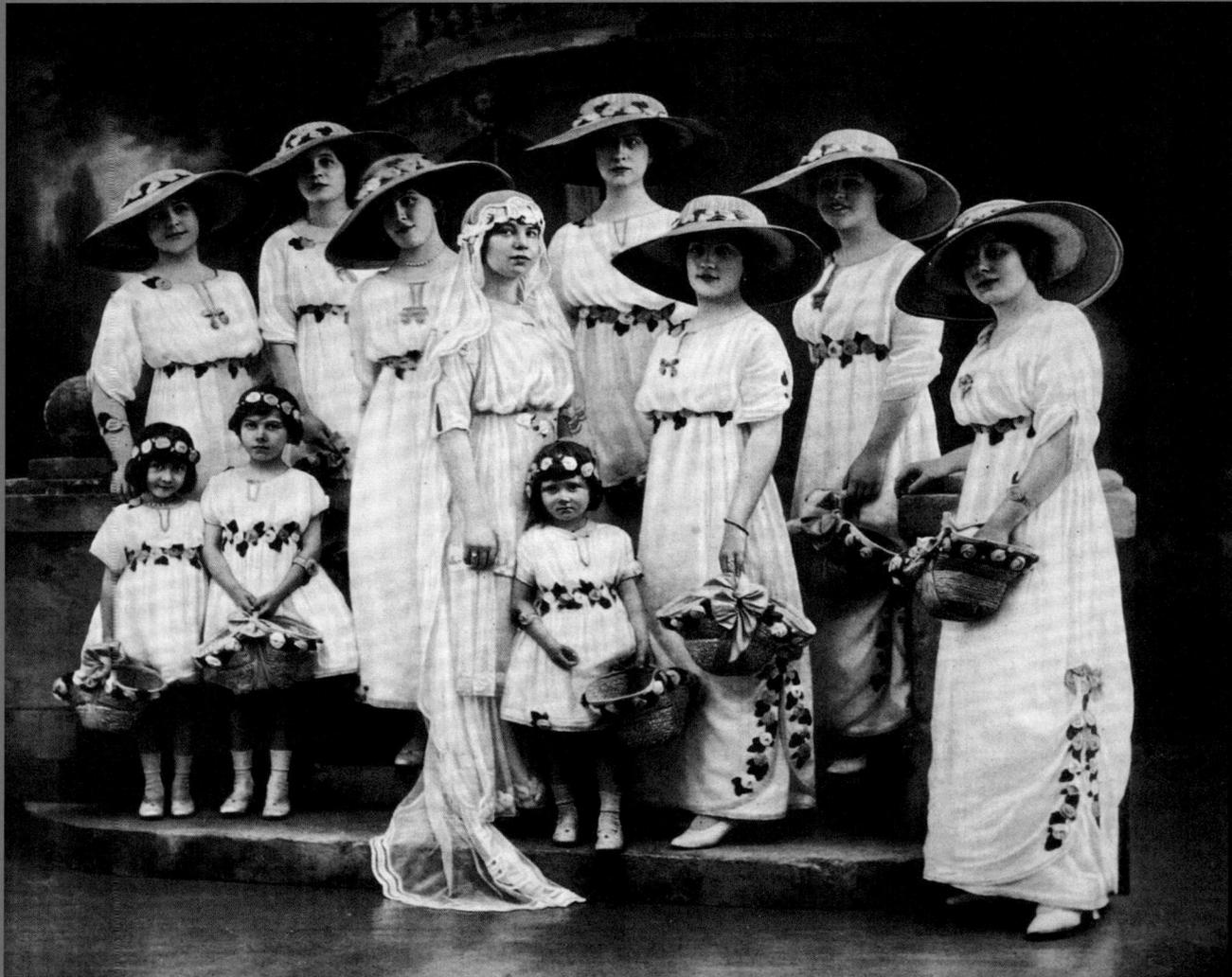

fig. 2 'Un Mariage chez Jeanne Lanvin', *Les Modes*, July 1912

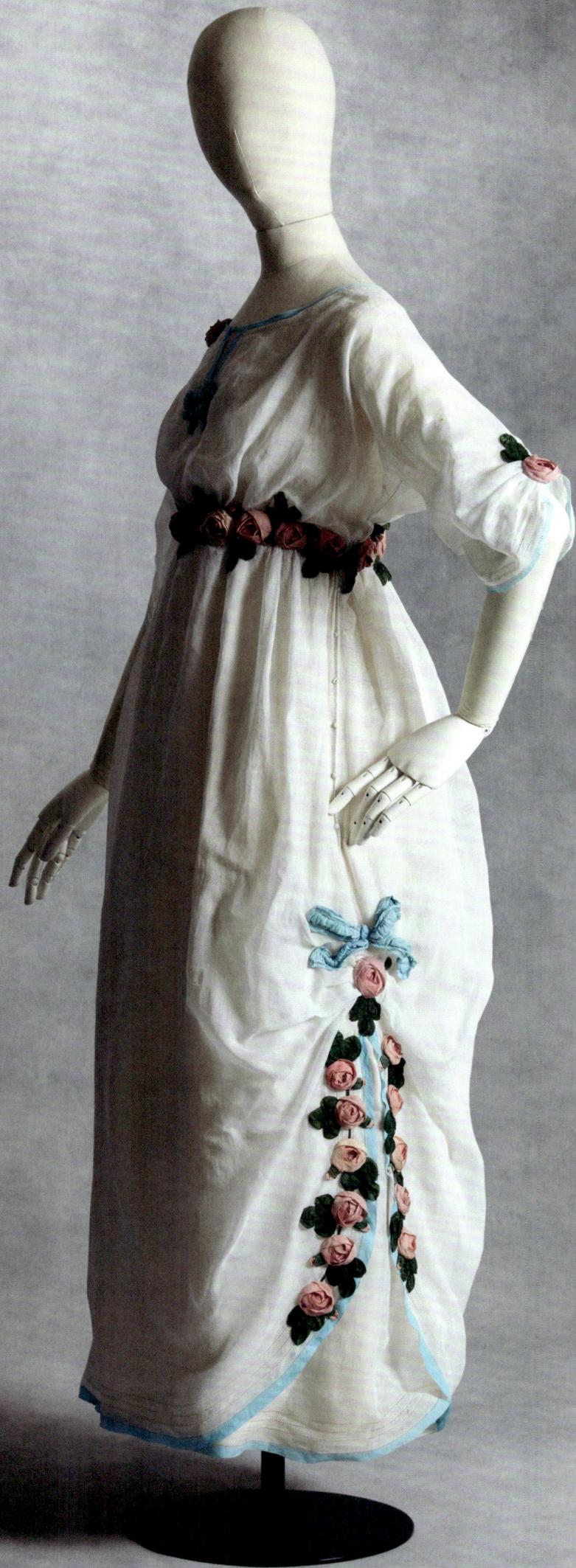

4. Jeanne Lanvin Bridesmaid dress, 1912

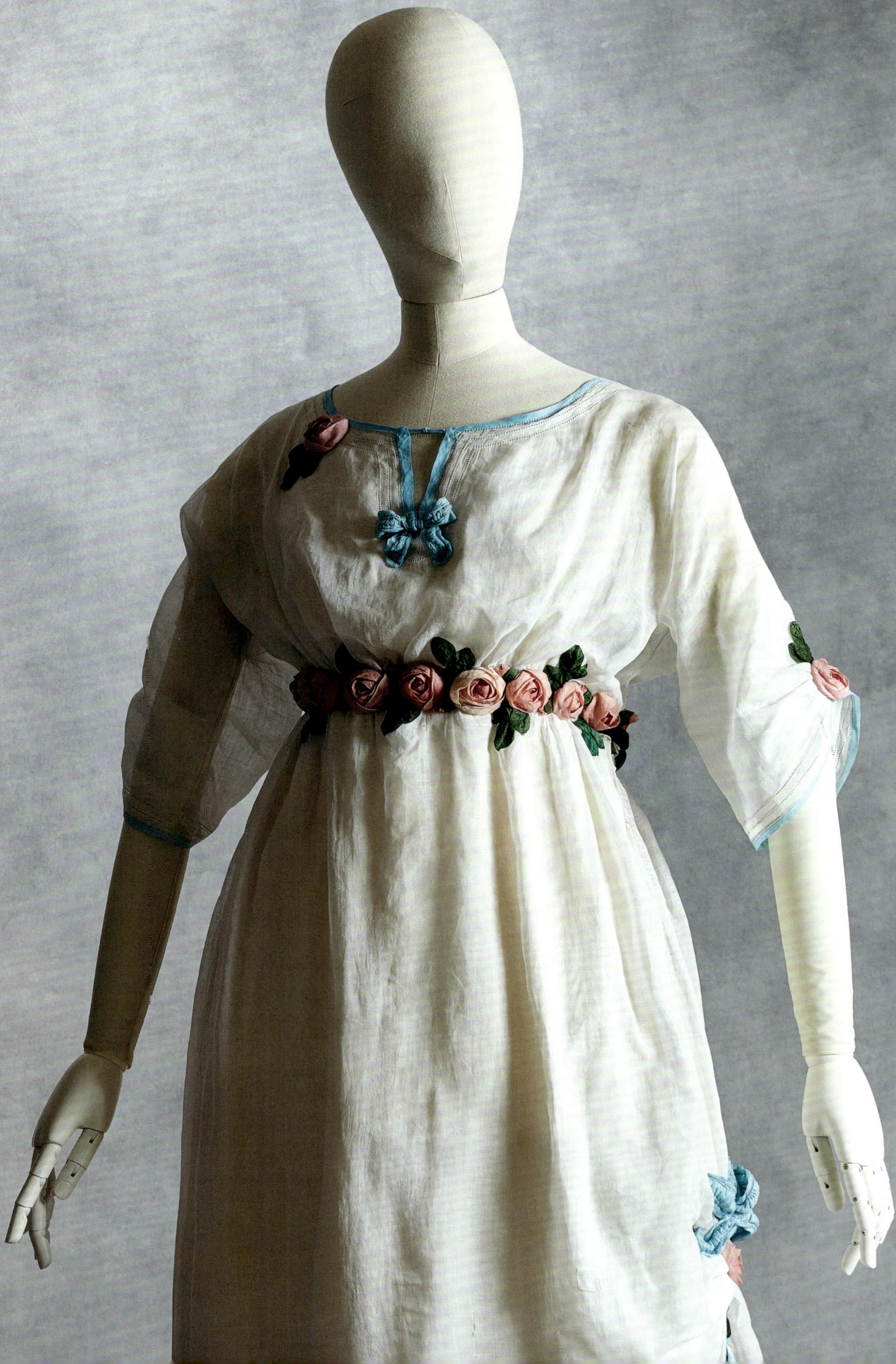

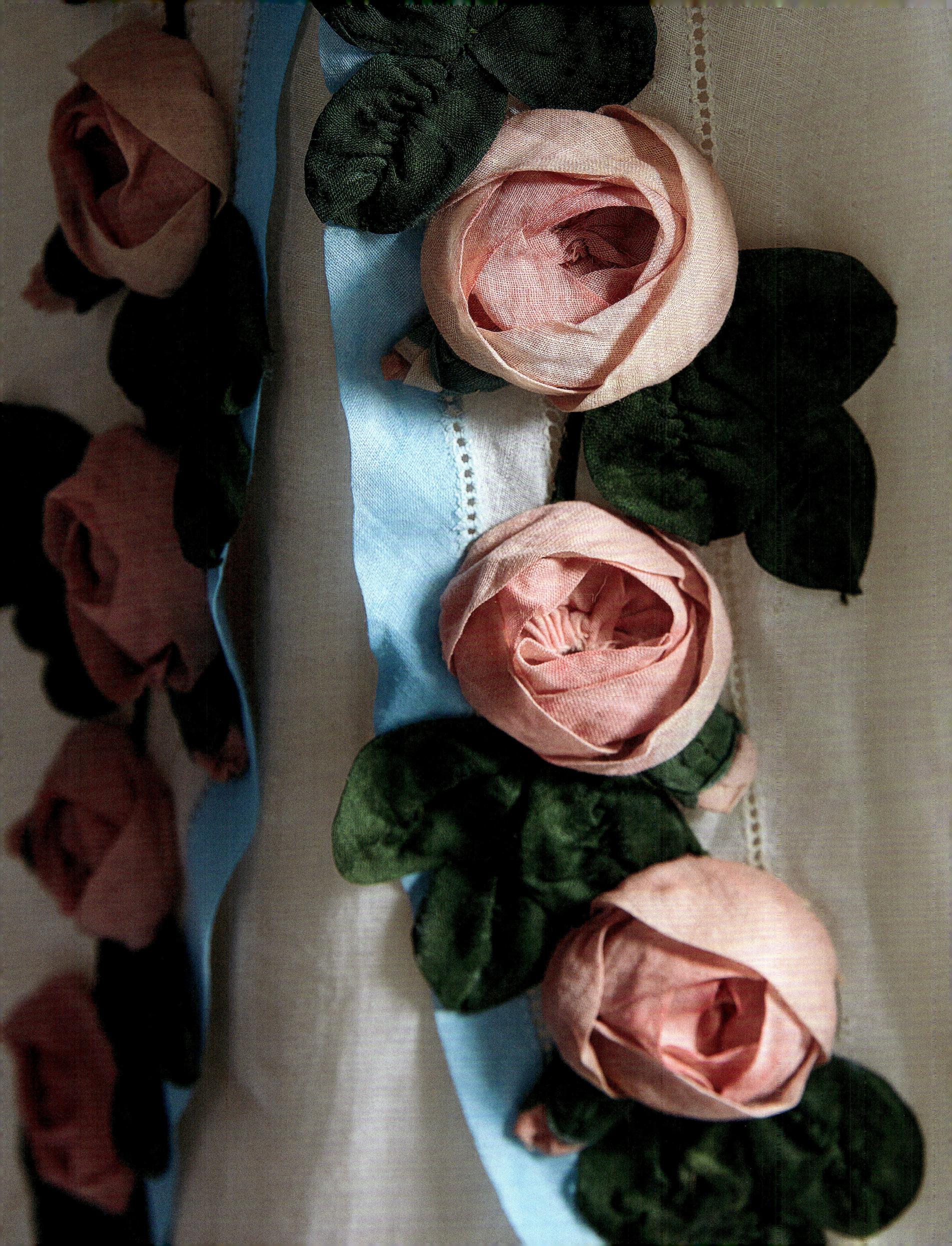

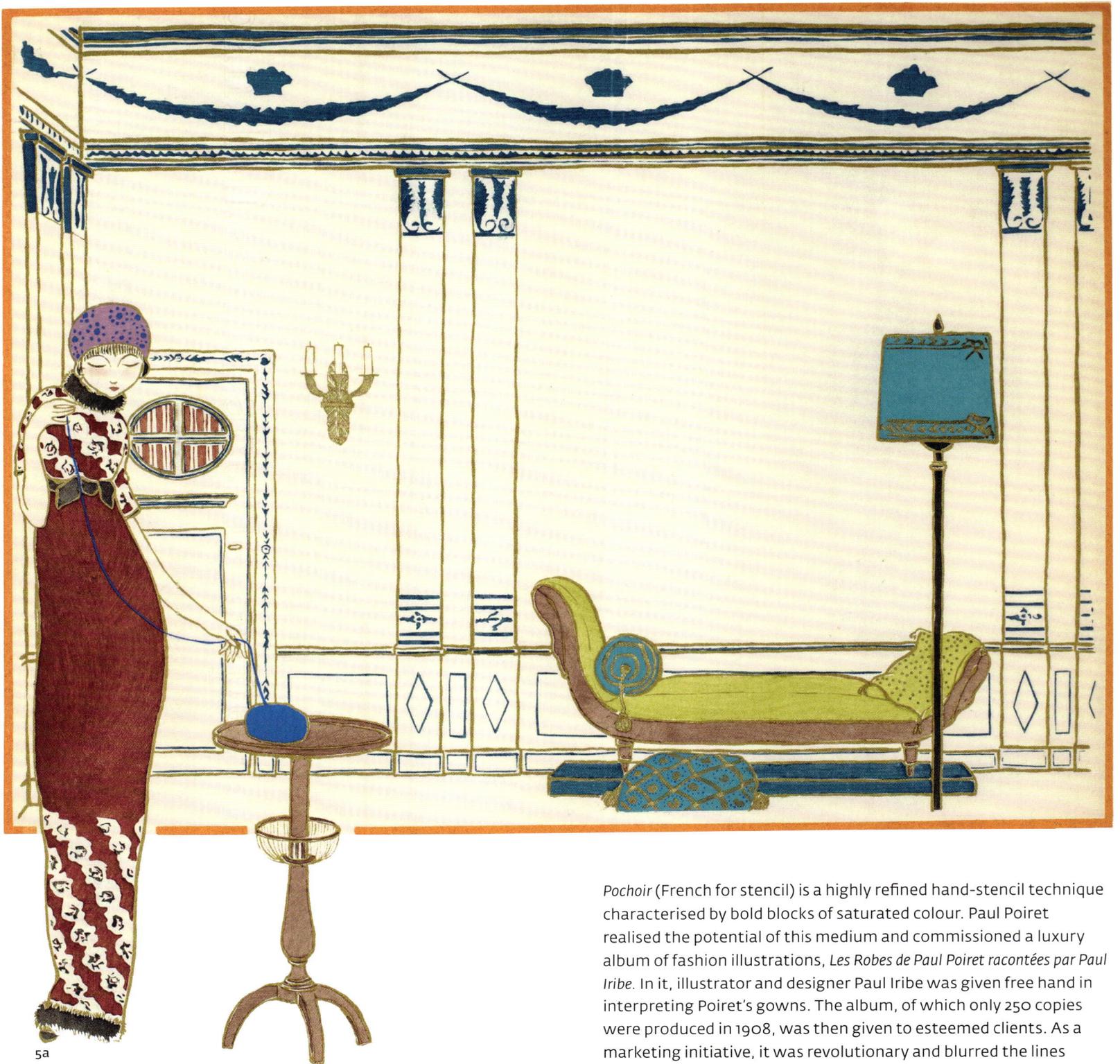

5a

Pochoir (French for stencil) is a highly refined hand-stencil technique characterised by bold blocks of saturated colour. Paul Poiret realised the potential of this medium and commissioned a luxury album of fashion illustrations, *Les Robes de Paul Poiret racontées par Paul Iribe*. In it, illustrator and designer Paul Iribe was given free hand in interpreting Poiret's gowns. The album, of which only 250 copies were produced in 1908, was then given to esteemed clients. As a marketing initiative, it was revolutionary and blurred the lines between art and advertising.[1]

Three years later, in 1911, Poiret commissioned the illustrator Georges Lepape to create a *pochoir* album titled *Les Choses de Paul Poiret vues par Georges Lepape*. This time an edition of 1,000 copies was published. Approximately 700 copies were made available for sale, and 300 special editions were numbered and divided between Poiret and Lepape to be given as gifts. The album, thanks to its wider reach, introduced Poiret and Lepape to an audience beyond Poiret's exclusive clientele.[2]

LES CHOSES DE PAVL POIRET VVES PAR GEORGES LEPAPE

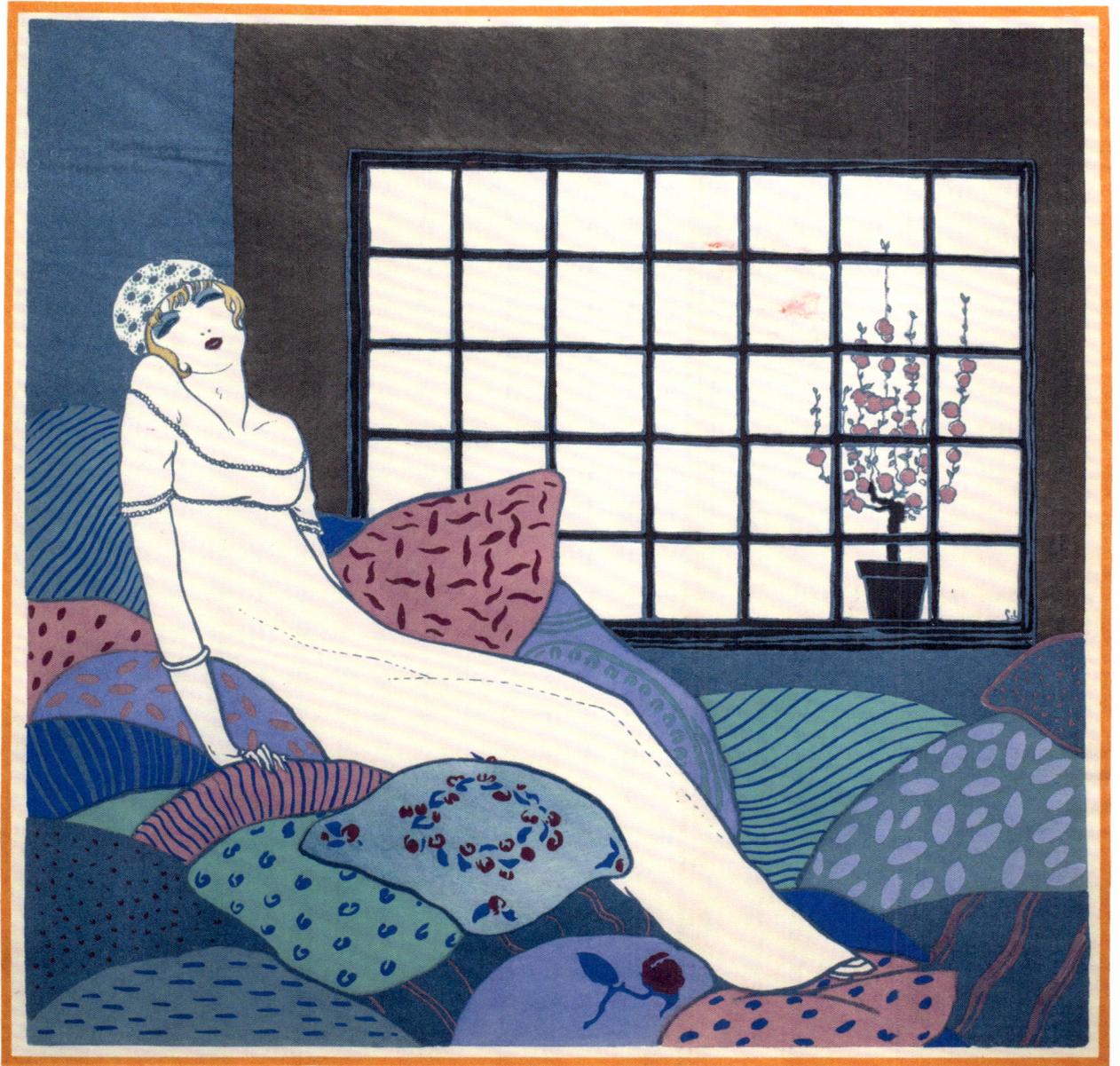

5b

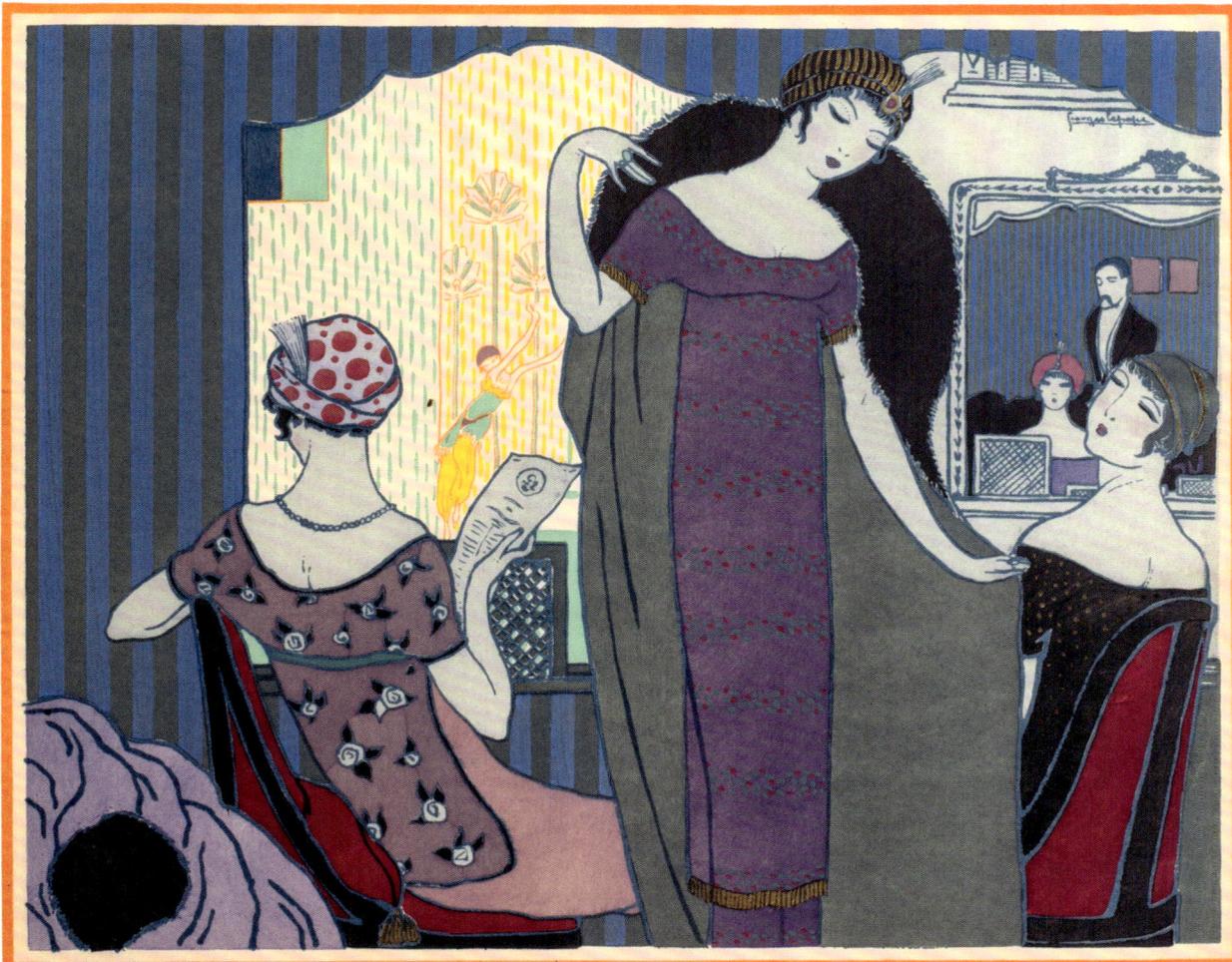

5c

5a–c Georges Lepape
Pochoir 'Les Choses de Paul Poiret vues par Georges Lepape' (The Things of Paul Poiret as seen by Georges Lepape)
Album with 12 illustrations
1911

PAUL &
POIRET

DENISE

the afterlife of a collection

CAROLINE EVANS

RESEARCH BY CHRISTINE RAMPHAL

The Poiret dresses, hats, stockings and shoes in the collection were once owned by Denise Poiret, née Boulet (1886–1982), wife of the couturier Paul Poiret (1879–1944). Despite the revolutionary significance of Poiret's creations, his work might well have been lost to posterity after his death but for the careful stewardship of his ex-wife, Denise. Her lifelong dedication and enthusiasm for his legacy ensured that these, and many other important Poiret designs, ended up in the archives of international museums and collections.

Paul Poiret opened his couture house in Paris in 1903, and in 1906 he designed a corsetless dress for Denise, for the christening of their first child.[1] Despite his claims, he was not the earliest designer to reject the corset, but there is no doubt that his fluidly draped designs that hung from the shoulders changed both the silhouette and the fashionable pose and walk in the pre-war years.[2] He inaugurated the hobble skirt, the split skirt (*jupe-culotte*), and harem trousers. He raised the waistline to below the bust, first in Directoire designs and later in a series of orientalist looks which pictured the wearer as an odalisque, lounging luxuriantly in turbans and kaftans, against exotic gold cloth and lavish embroidery (figs. 3 and 5). Some of these background textiles were produced in Poiret's workshops, but many were bought on his extensive foreign travels. His influences were nearly always non-European: Middle Eastern, Japanese and, in the 1920s, Indian and north African.[3]

In addition to his design innovations, Poiret pioneered what today is called 'lifestyle marketing', in a series of firsts. He was at the forefront of new and emerging publicity formats, particularly fashion shows and early fashion film. He commissioned innovative fashion photographers including Edward Steichen in 1908 and Man Ray in 1922, and illustrators Paul Iribe and Georges Lepape, who created de luxe, *pochoir* albums of his designs in, respectively, 1908 and 1911 (no. 5).

In 1911 he instigated mannequin tours of Europe, and in 1913 he toured the US. Capitalising on the enormous press coverage he received enabled him to build his business internationally. He was the first designer to create his own perfume, in 1911, and that year he also set up a training school producing decorative arts for sale, the École Martine. His fancy-dress parties were legendary, especially the three-day One Thousand and Second Night Party in 1911, where Paul appeared as the Sultan and Denise as his favourite.[4] After the war, he opened a nightclub, L'Oasis (fig. 4), and he designed costumes for several films.

fig. 3 Denise Poiret, 1906–07

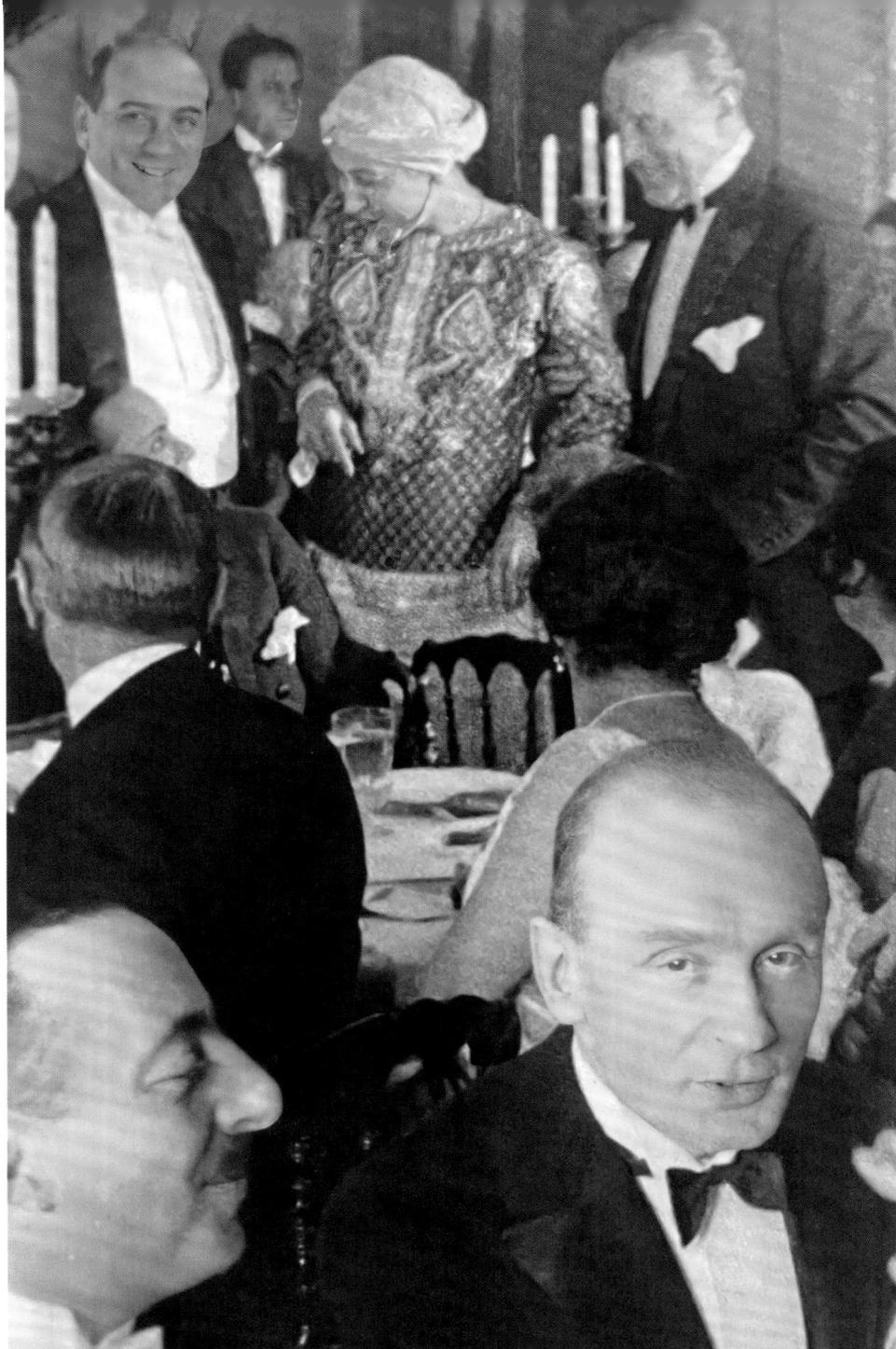

fig. 4

While Poiret continued to design and travel in the 1920s, the new business practices of post-war Paris fashion did not suit him. His relationship with his backers soured, and in 1929 he closed the firm, thereafter leading a hand-to-mouth existence until his death in 1944 aged sixty-five. Luckily, however, the story does not end there, owing in large part to the efforts of his former wife, who lived to the age of ninety-six.

The daughter of a provincial textile retailer, Denise had married Paul as a nineteen-year-old, in 1905. Together they had five children, three of whom survived into adulthood. Their marriage lasted twenty-three years, and during that period the elegant Denise epitomised the new Poiret style. After their separation in 1928, Denise moved 40 kilometres outside Paris, to the village of Évecquemont, taking with her almost all the Poiret oeuvre, with her husband's blessing: her own wardrobe, Paul's coloured waistcoats, the children's outgrown clothing, fancy-dress costumes, homeware, photographs and news cuttings.

fig. 4 Denise Poiret wearing the 'Persane' evening dress and turban at L'Oasis, 1925

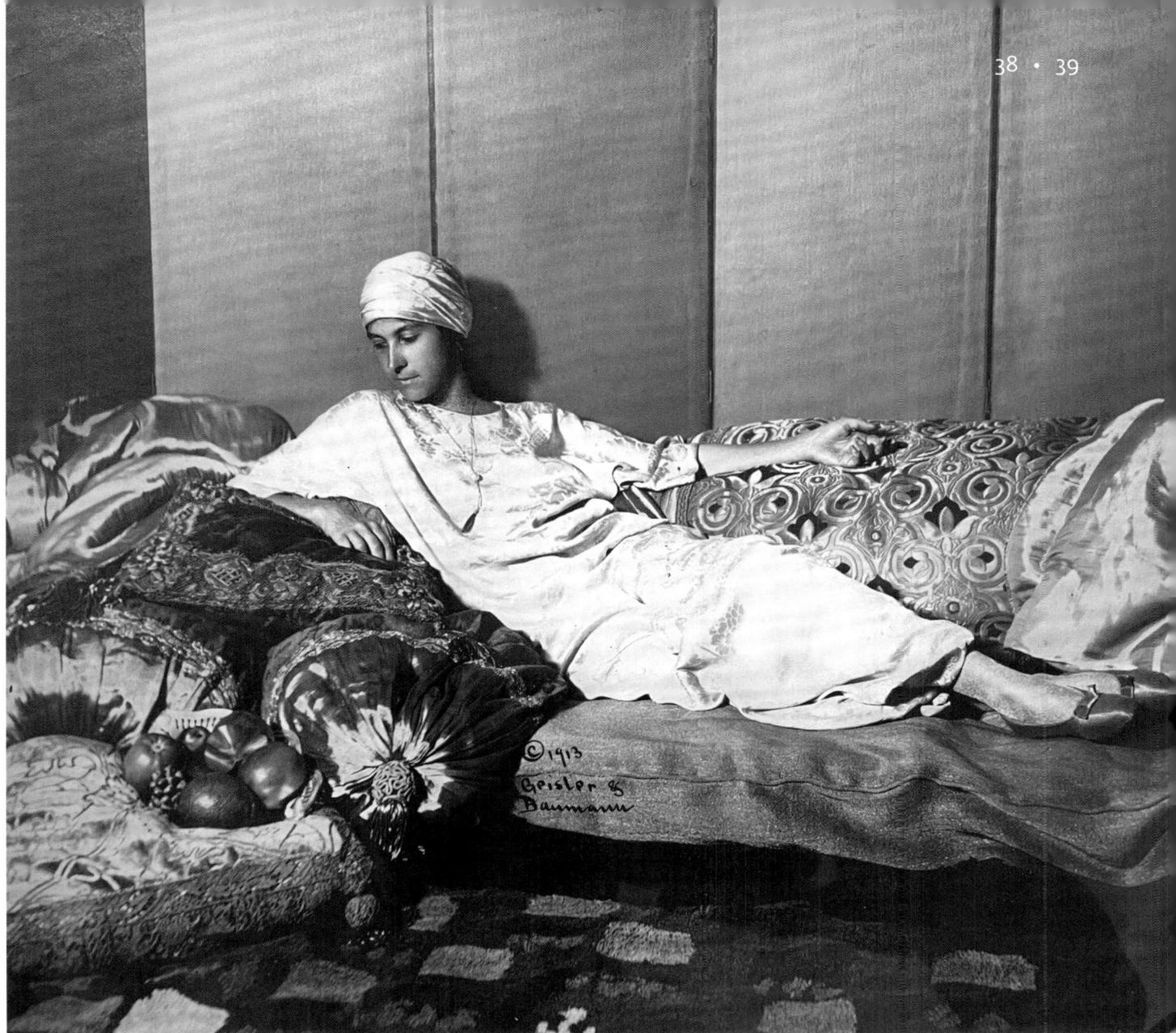

fig. 5

As her granddaughter Charlotte Poiret recalled, 'After the divorce, she left with trunks and trunks and trunks of dresses.'[5] This was fortunate, because in 1932 the firm went into liquidation; the few remaining assets were seized, and the clothing and textiles were sold by the kilo to a ragman. Denise thus became the 'curator' and custodian of the Poiret legacy in later years, and it is thanks to her that it survives today in such quantity and quality.

Throughout her marriage, Denise had played an important role in the business. A photograph of 1906–07 shows her aged twenty-one, two years married to the rising young designer (fig. 3). The unattributed photographer was almost certainly her husband. Her pose is the odalisque of 19th-century French orientalist painting, one arm crooked to her head, her body lounging on a cushioned dais. In the same year, Henri Matisse painted his 'Blue Nude' in a similar pose.[6] For all its avant-garde elements, Matisse's naked odalisque is dated compared with Denise's pose. The epitome of modernity, her slim body uncorseted, she wears a body-hugging dress embellished with black pearls (which look like mesh), its long, fitted sleeves ending at her knuckles. Her alert yet calm gaze ranges beyond the picture frame. Indifferent to the spectator, she seems to look forward to the new century, rather than backwards to the orientalist tropes of a 19th-century colonial vision.

fig. 5 Denise Poiret at the Plaza Hotel, New York, 1913

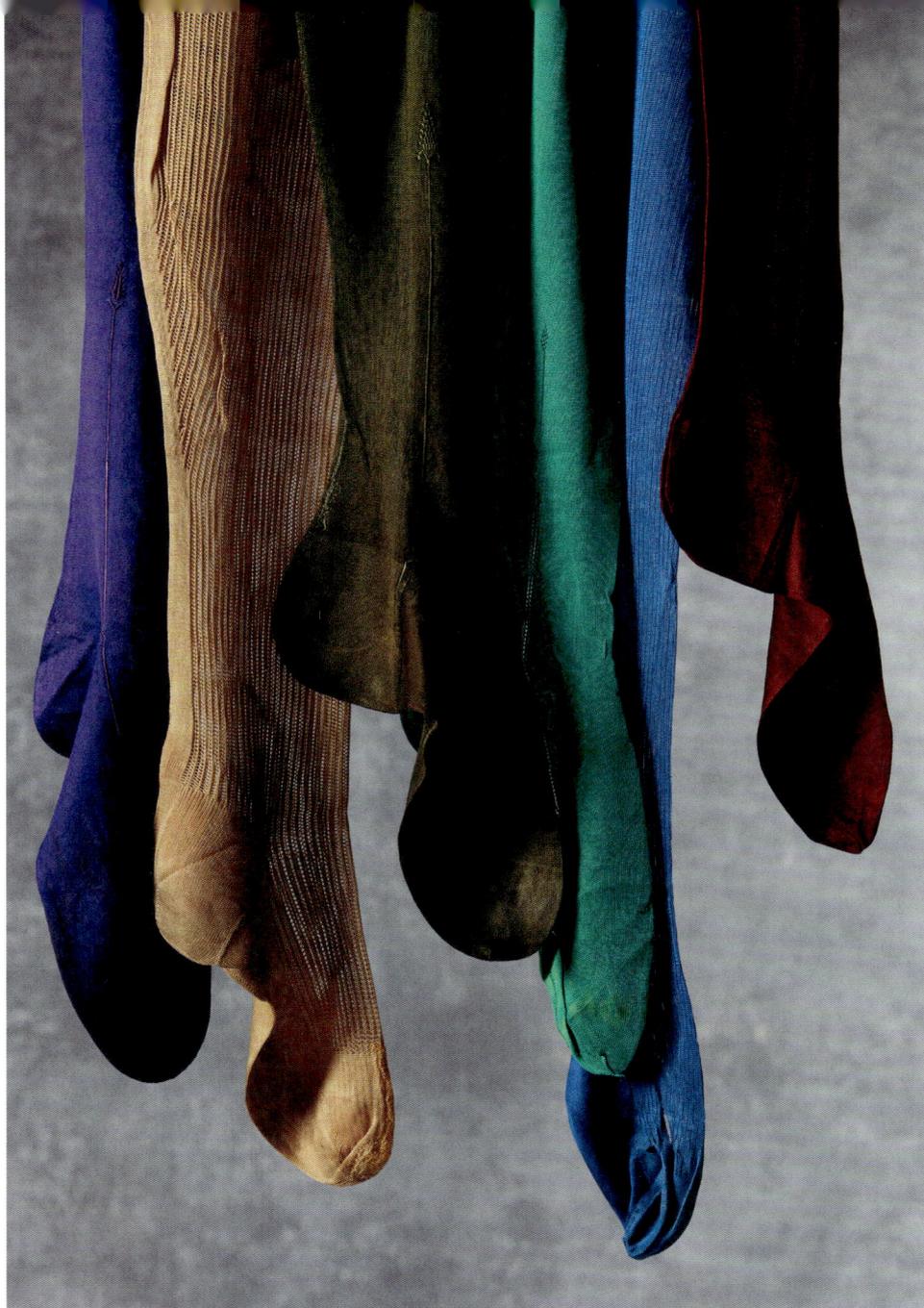

6

Within a couple of years, the orientalist style came to dominate her husband's designs, and Denise became its physical incarnation. This is the earliest photograph of Denise in this pose (fig. 3), but she was to adopt it throughout her life, even (perhaps especially) after she contracted tuberculosis and was left with one lung, when she often needed to rest for lengthy periods, according to her grandson Antoine Poiret.[7] Turning her disability into an aesthetic and a style, in later life she received guests while reclining on a sofa scattered with embroidered gold cloth and cushions by the artist Raoul Dufy, who had designed textiles for her husband in his heyday.

Charlotte Poiret remembered her in the 1960s and 1970s: 'In her house, she spent her days on a kind of sofa, full, full, full of cushions covered in fabrics made by Dufy and others... She received people lying down, in a very charming, simple way. She kept it to the end of her life. Certain body positions, including certain arm movements ... always with elegance. She ... behaved and held herself proudly. She held herself beautifully.'[8]

In 1913, Denise and Paul toured the major US cities. Everywhere, she was lauded by the American press for her elegance and originality. At the Plaza Hotel in New

6. **Denise Poiret's stockings** 1910–1925

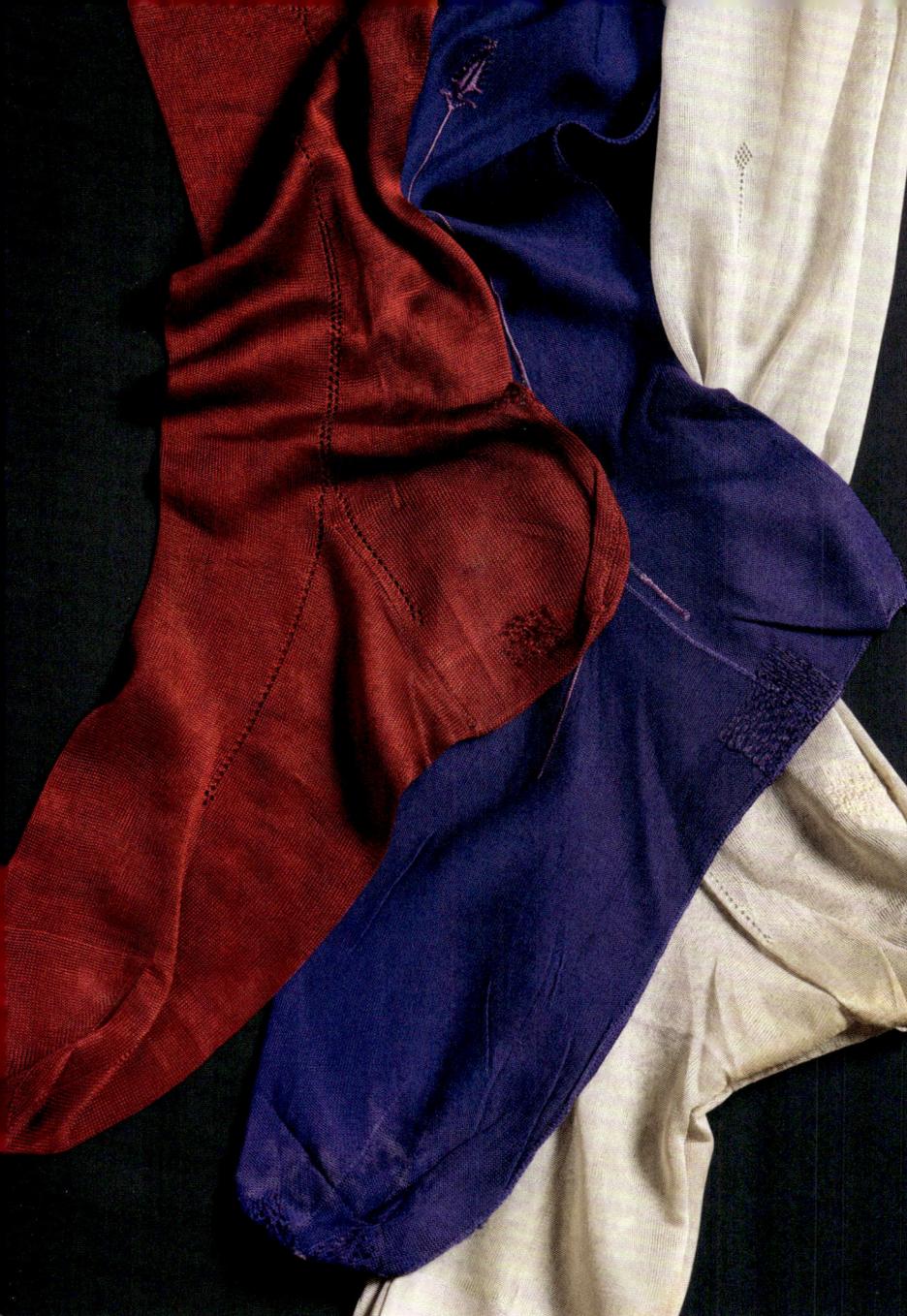

6a

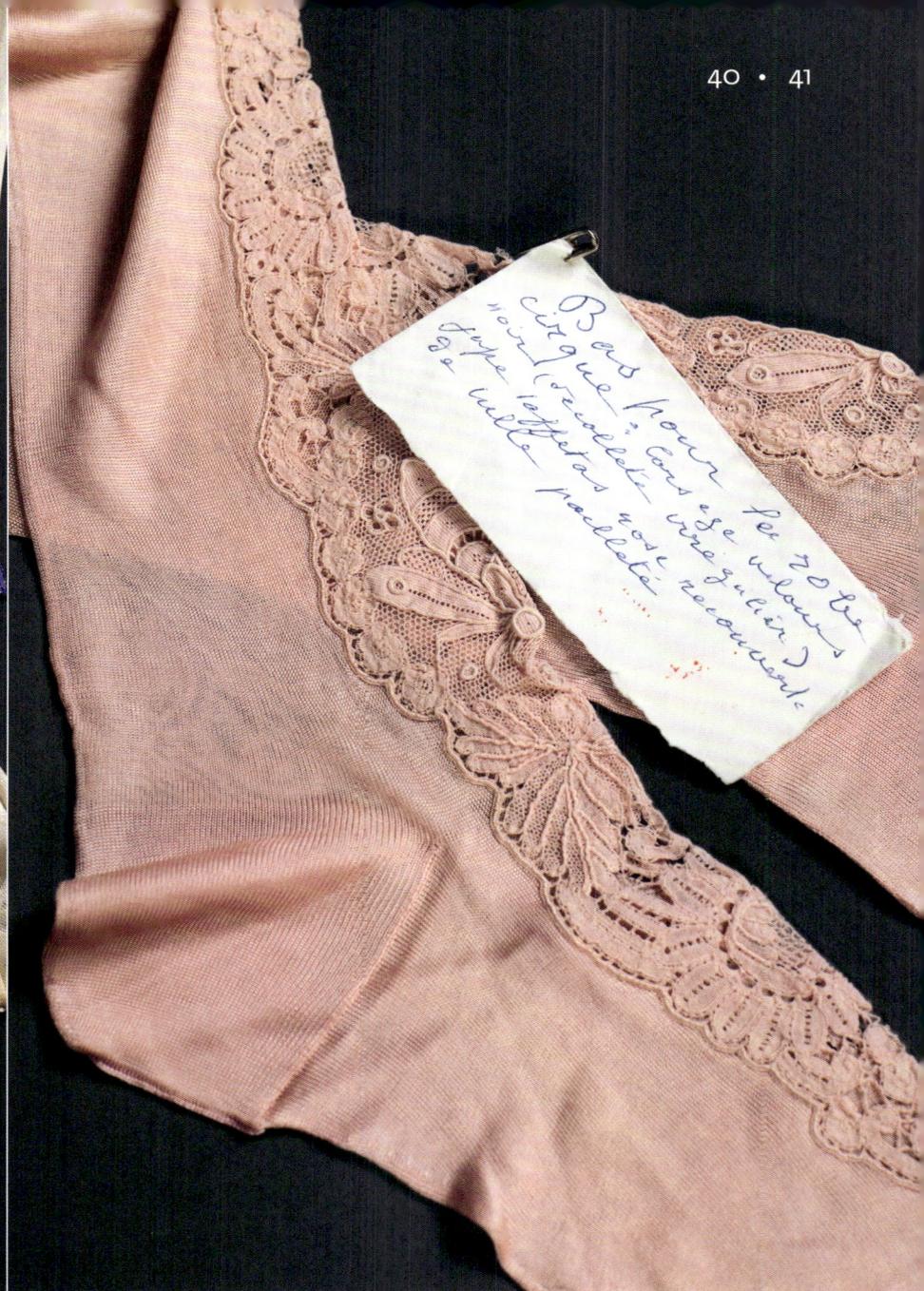

6b

York, she was photographed in the odalisque pose in a sack dress, its sash wrapping her head like a turban, as she lounged on the luxurious cushions and textiles which Paul had brought to promote his oriental styles (fig. 5). Pygmalion-like, Paul claimed that he alone saw her early potential,[9] but her photographs suggest otherwise. They reveal that she, too, was a stylist, in the way she put her clothes together, in her bearing and grace, and in her ease before the camera. In these images (figs. 3, 5 and 6), Denise modelled a new, fashionable type of deportment to her contemporaries.

The photographs also help a modern audience to understand how the garments would have looked on the living figure, now that we can only see them upright on the museum mannequin, owing to conservation requirements. The sight of Denise at her ease over 100 years ago foregrounds the physicality of the body, helping us to imagine how women may have lolled or sprawled in Poiret's designs.

Her stockings, too, so carefully preserved over the years, powerfully evoke the sensory qualities of her wardrobe (no. 6). In the 1920s, as hemlines rose, opaque silk stockings came into vogue. In jewel-like colours, Denise's would have worked

6a. Darns on some of Denise Poiret's stockings

6b. Denise Poiret's handwritten note attached to her stockings

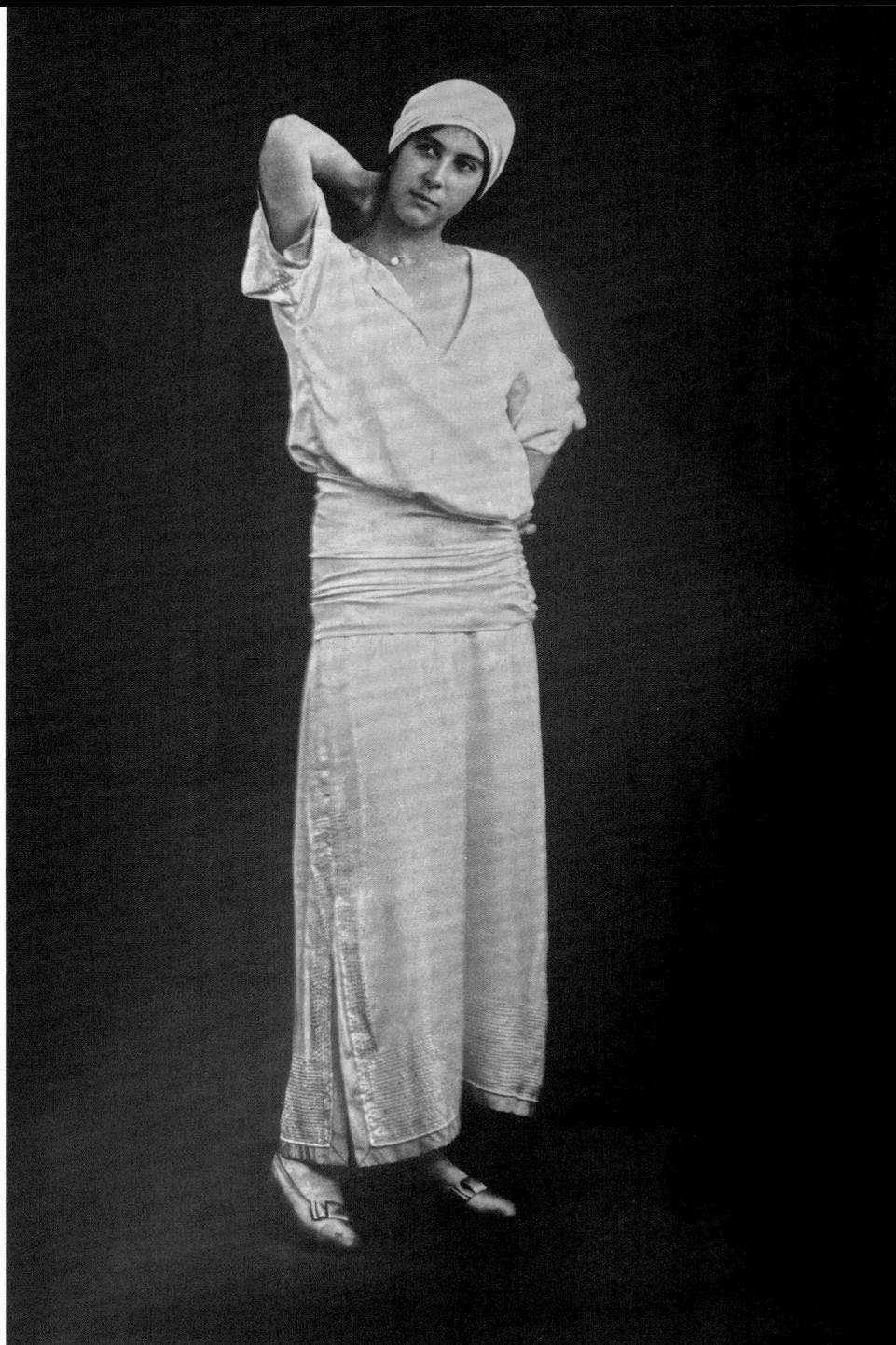

fig. 6

perfectly with the vivid, saturated colours and sheen of Poiret's textiles, such as satin, velvet and brocade.

Worn close enough to the body to invoke its intimacy, stockings are compelling objects in what historians call 'sensory history', with its potential to afford new insights into the physicality of wearing a Poiret outfit. Silent films of the 1920s show fashion models looking flirtatiously into the camera as they sensually pull rolled stockings up their legs. Denise's stockings hold the promise of recovering lost gestures that we can only reconstruct from 1920s fragments – snatches of film, or details from novels, such as the colourful stockings worn by the cosmopolitan and bohemian artist Gudrun Brangwen in D. H. Lawrence's *Women in Love* (1920).

It seems miraculous that these delicate silk stockings survive today, but the careful and meticulous darns on the foot area (no. 6a) show both Denise's frugality and the care she took of all her clothes throughout her life. After her death, her clothes, accessories and domestic linen were found with scraps of paper pinned

fig. 6 Denise Poiret wearing 'Lavallière' dress in ivory, New York, 1913

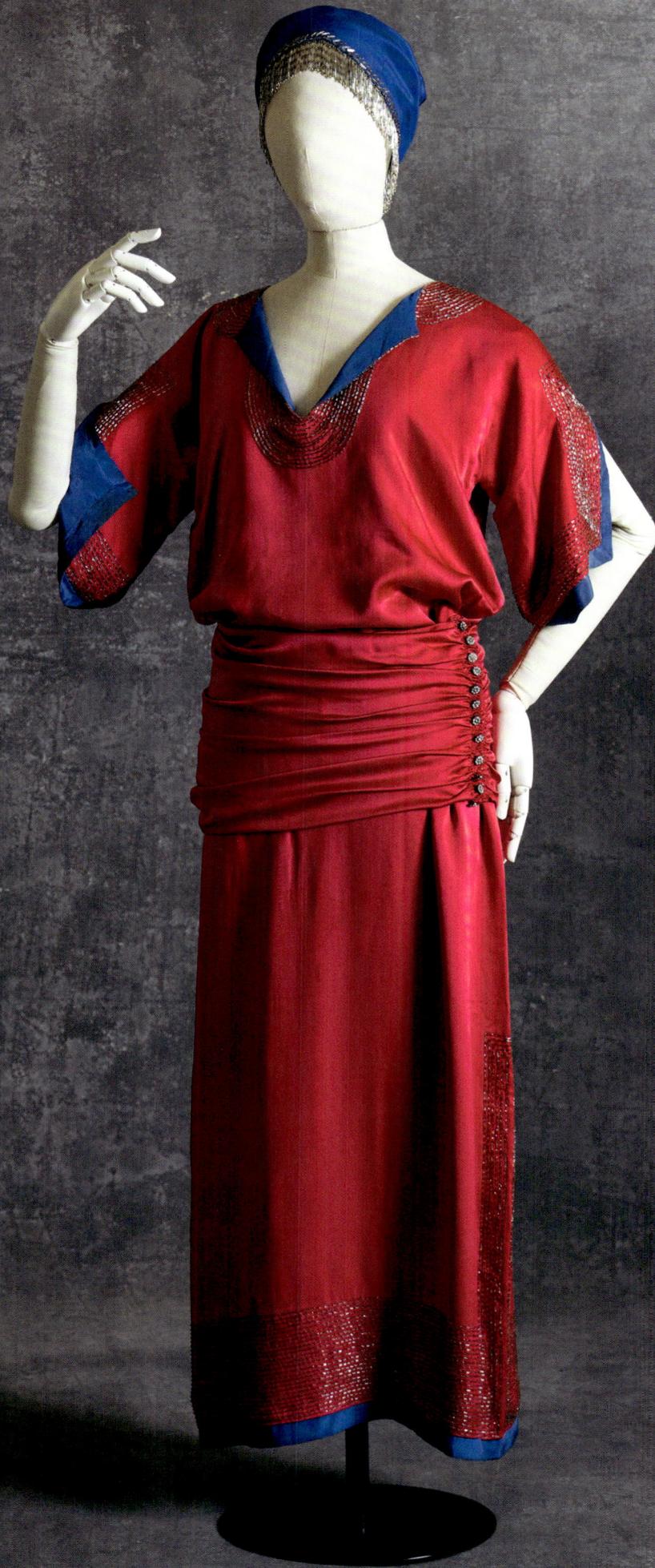

7. Paul Poiret Evening dress and headdress, 'Lavallière', 1911

to them, with handwritten annotations explaining their function and design, as with a pair of lace-trimmed pink silk stockings that went with the dress called 'Circus' (no. 6b). Denise's domestic description of 'Circus' is so clear that it reads like a museum catalogue entry, which underlines the similarity of her care of the garments to that of a museum curator.

Before the Poirets' promotional tour of the US in 1913, Denise used her diary to carefully inventory the dresses she took with her. One page[10] shows that she took three versions of 'Lavallière' in different colourways, listed under 'evening dresses', and these were evidently working dresses as much as they were also part of her personal wardrobe.

Designed in 1911, 'Lavallière' came in black silk satin trimmed with green, in ivory satin trimmed with violet, and in fuchsia trimmed with blue (no. 7). Lined in the contrasting colour, each dress was cut from a single length of satin and decorated by bands of bugle beads at the neck, hem and side slit, giving substance to the lightweight fabric. Constructed without fastenings, they slipped over the head and were fitted to the waist and hips by a separate ruched sash which gave them shape (no. 7a). The only ornamentation came from the applied beadwork and the simple band around Denise's head (no. 7).

'Lavallière' typifies the radical simplicity of Poiret's designs in this period. In New York, Denise was photographed in the ivory version, and the image shows how nonchalantly she wore it, with the same raised left arm crooked behind her head as in her odalisque pose, the same relaxed stance, and the same thoughtful gaze off camera, which seems to locate her in a wider world that defies the viewer's own gaze (fig. 6).

After she divorced her husband in 1928, Denise took all three 'Lavallières' with her. In 1963 she donated the ivory version to the Musée des Arts Décoratifs (MAD) in Paris.[11] The donation marked the beginning of Denise's role in placing the Poiret legacy in the public domain. She donated clothing to MAD in 1963, 1964 and 1969, and photographs in 1956, 1964 and 1971.[12] In 1974–75 she both gave and sold items to London's Victoria and Albert Museum. In this she was assisted by Poiret's first biographer, Palmer White, the author of *Poiret* (1973). White had sought out Denise in her country home at Évecquemont, and Denise had enthusiastically brought out all her Poiret memorabilia for him: trunks full of clothing, letters, personal diaries, press books and photos. Many of these were reproduced for

7a. Detail of ruched sash of 'Lavallière' dress

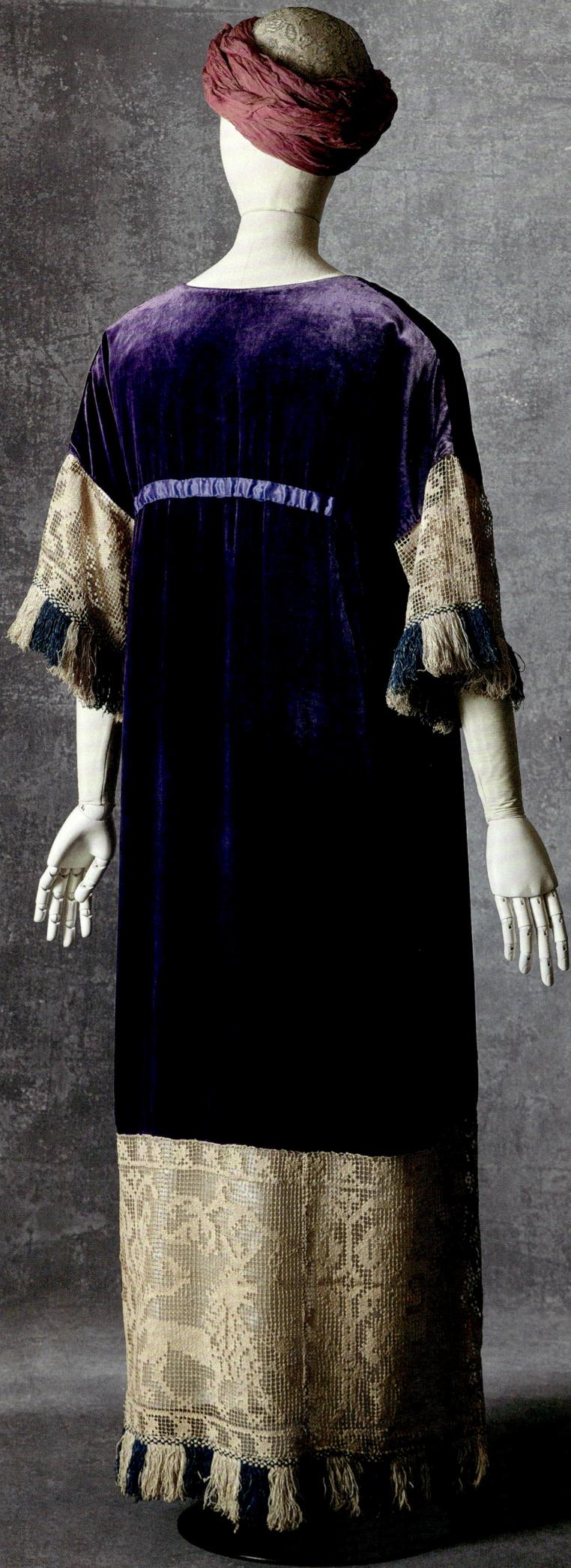

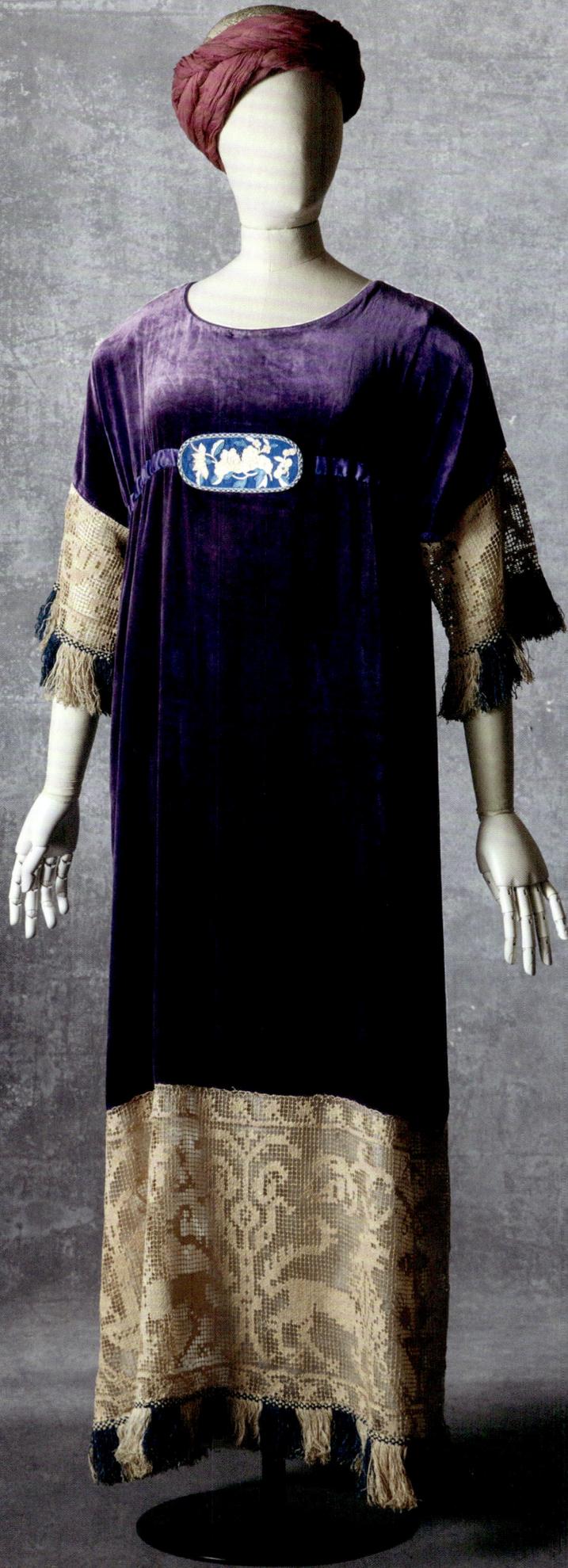

8. Paul Poiret Dress, 'Notre Dame', 1911 and turban, 1923

the first time in White's book, which also contains a postscript by Denise, whose memories so vividly inform its narrative.

In 1974 a retrospective museum exhibition brought Poiret fully into the limelight: *Poiret le Magnifique* at the Musée Jacquemart-André in Paris. In 1976 another exhibition opened at the Fashion Institute of Technology in New York, *Paul Poiret: The King of Fashion*. The ivory 'Lavallière' which Denise had donated to MAD featured in both exhibitions, alongside much of her personal wardrobe.[13] The dress which the young, beautiful and feted Denise had worn in New York in 1913 (fig. 6) now returned to the same city sixty-three years later as a reified museum object.

Denise had kept the other two 'Lavallières', and on her death in 1982 her daughter Perrine inherited the black one, and her son Colin the fuchsia one (no. 7). In 2005 and 2008, more than sixty years after Paul's death, the two 'Lavallières' were put up for auction by the Poiret heirs, along with the remainder of Denise's clothing, accessories and memorabilia; and the fuchsia version found its current owner.[14]

At the Musée Jacquemart-André exhibition in 1974, for the first time Denise gave interviews to the press and radio, revealing something of the life and opinions of a woman who in her youth had spoken only through her clothes, her poise and her taste. Figs. 3 and 7 span the arc of Denise's adult life, from ages twenty-one to eighty-eight. Photographed for *Paris Match* at this time (fig. 7), the eighty-eight-year-old Denise sits below some of the clothing she wore as a young woman, including 'Notre Dame' (1911) (no. 8), which hangs above her, second from right.

After her death, Paris's dedicated fashion museum, the Palais Galliera, staged an important exhibition in 1986 about Poiret and his designer sister, Nicole Groult, and acquired several Poiret dresses for its permanent collection.[15] This was a major factor in establishing Poiret's legacy in fashion history, as the curator Sophie Grossiord has argued.[16]

Long before Poiret's designs came back into prominence, however, Denise had been giving her clothes meticulous care, verging on the curatorial. Her grandchildren recalled how an entire half-floor of her house was reserved for her Poiret dresses, folded in silk tissue paper, and stored in cardboard boxes containing anti-moth treatments. Every spring she got down the boxes and went through them, employing a woman from the village to help her with the annual maintenance and refurbishment of the collection of over 150 garments.[17] Both grandchildren understood this to be due to Denise's strong sense of the importance of the Poiret heritage.

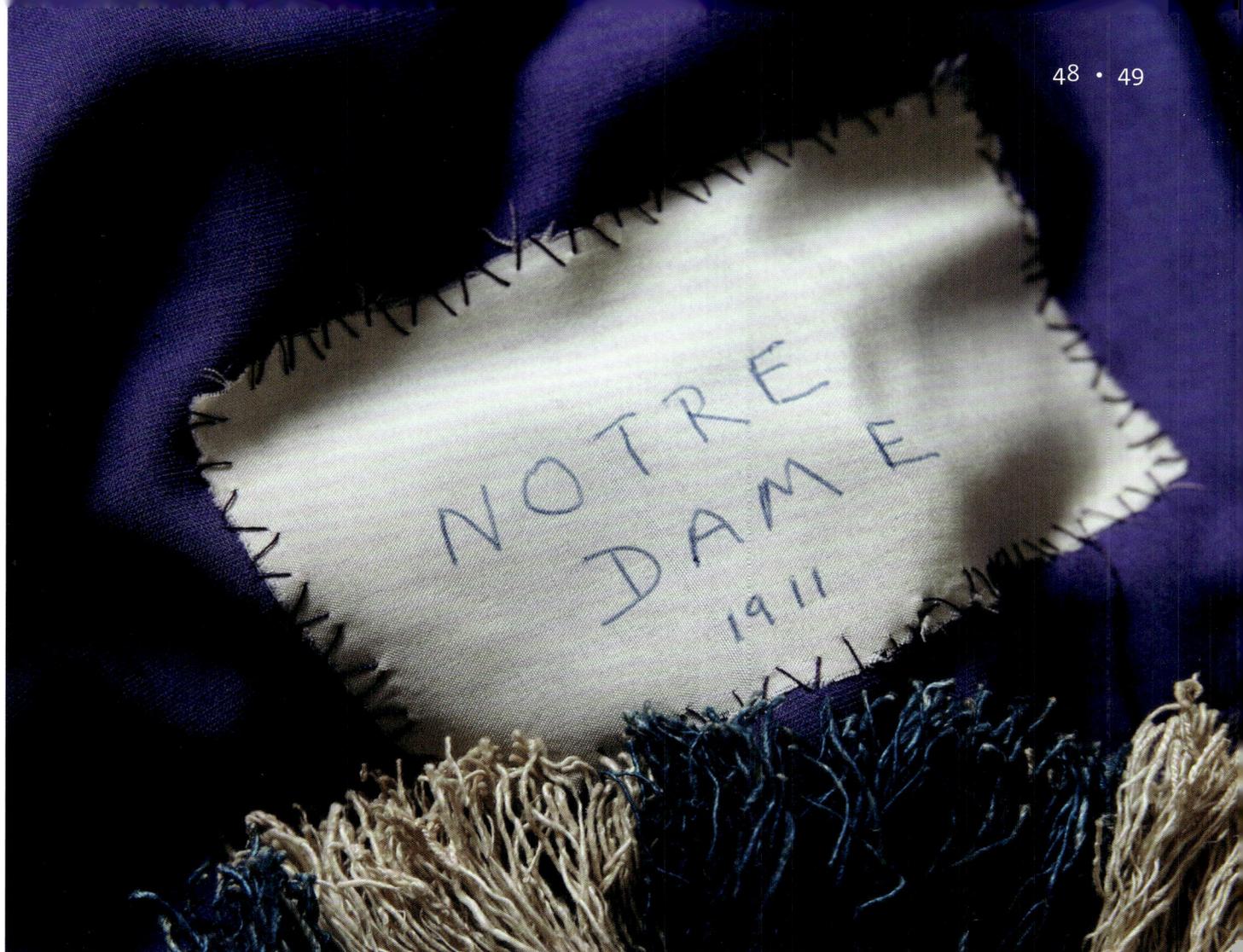

8a

Like many other dresses that she donated to museums, 'Notre Dame' (no. 8) has a handwritten label roughly stitched into its hem, giving the name and date of the dress (no. 8a). These unhemmed labels in cotton or silk fabric are written in biro, suggesting that Denise wrote them in the 1970s (perhaps to further her ambitions for them) rather than at the time the dresses were designed.[18] They show Denise's familiarity with early 20th-century *couture* practices, when model dresses had their name sewn into the hem.

Usually, these labels were stamped with the name, date, price and design registration number of the model. Occasionally, they were handwritten in indelible ink. The key point, however, is that a label in the hem always designated a model dress, made for the fashion show rather than for delivery to a client. Client labels, by contrast, were sewn into a seam higher up (often the raised bust line) behind the official Poiret designer label (the *griffe*). The label in the hem of 'Notre Dame' thus indicates Denise's professional identification with the backstage practices of a functioning *couture* house, and her knowledge of the role of a model dress.

In some ways, Denise remains an enigma, because there are so few written sources about her. But in powerful physical remnants – press and family photographs, darned stockings, the clothes she wore and cared for, and her handwriting over the decades in diaries, letters and labels – vestiges of both the corporeal and the professional Denise survive. Through these indexical traces of her body and her gestures, Denise speaks across the centuries, bringing forgotten histories to vivid life through objects. She offers the opportunity to write an alternative history of

8a. Detail of 'Notre Dame' dress with Denise Boulet-Poiret's handwritten label

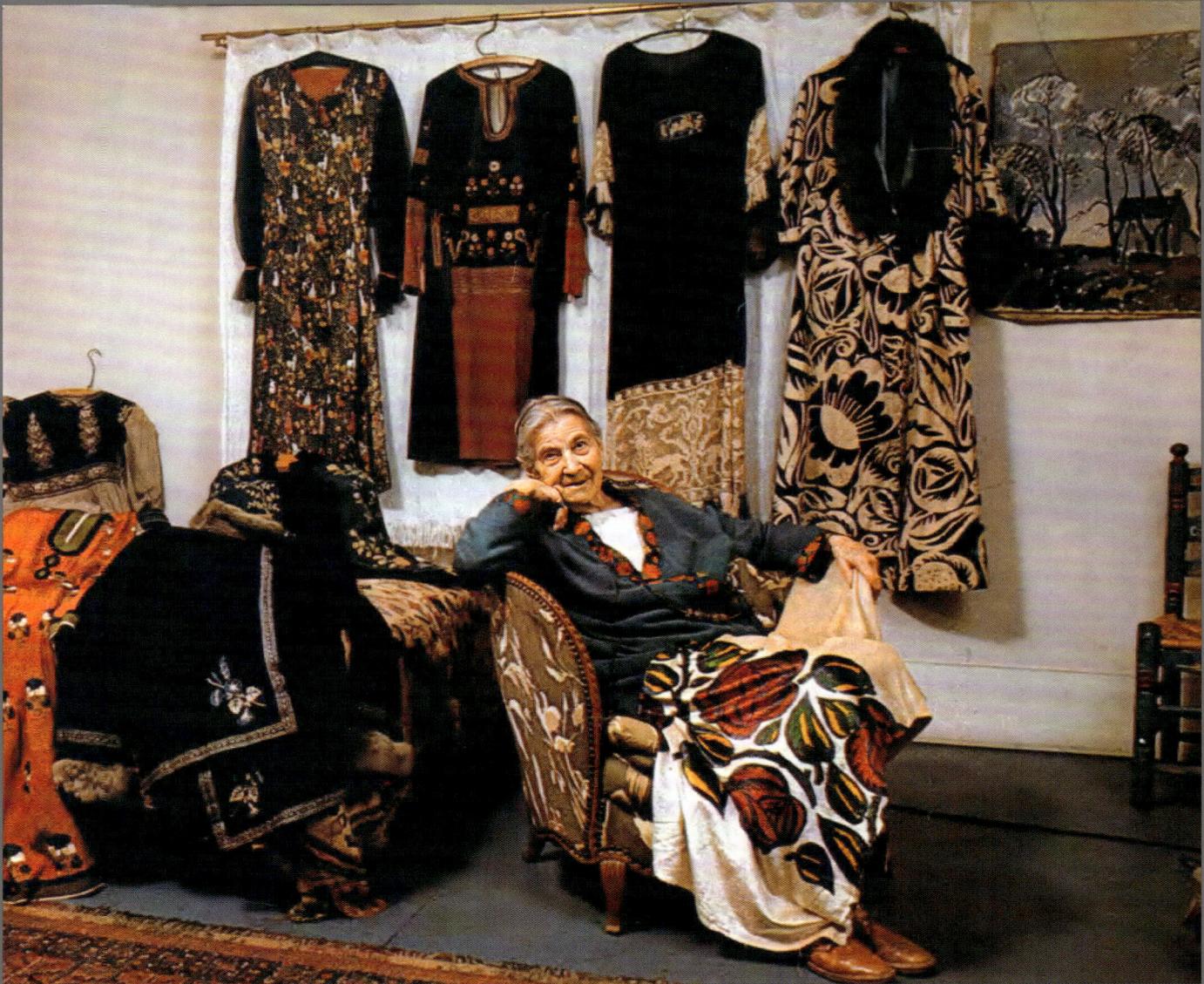

fig. 7 Denise Boulet-Poiret surrounded by her dresses, 1974

fashion via lost and found fashion traces. What happens to 'hemline' history when objects, traces and gestures replace, say, iconic styles, looks or narratives? What, or whom, might we see differently? Already we see Denise, where earlier historians only ever saw Paul.

1. Poiret claimed that he was the first designer to abandon the corset (Poiret 1931, pp. 72–73). In fact, Margaine-Lacroix, Madeleine Vionnet and Lucile had designed versions of corsetless dresses before him (Singer 2023, p. 106). Earlier still, French actresses such as Ève Lavallière boasted that they neither needed nor wore the corset, and the first fashion models often went uncorseted in the early 1900s (Evans 2013, pp. 201–04).

2. Evans 2013, pp. 225–26.

3. Rovine 2009, p. 61; see also Mei Mei Rado's essay, pp. 88–99.

4. Wollen 1993, pp. 1–2.

5. 'Après le divorce, elle est partie avec des malles, des malles et des malles de robes.' (Quoted in Lever, Trame and Wu 2021b, p. 53).

6. Baltimore Museum of Art (inv. BMA 1950.228).

7. Quoted in Lever, Trame and Wu 2021a, p. 43.

8. 'Dans sa maison, elle passait ses journées sur une espèce de sofa, plein, plein, plein de coussins qui étaient recouverts par des tissus qu'avait fait Dufy et d'autres... Elle recevait allongée, d'une façon très charmante, très simple. Elle a gardé jusqu'à la fin de sa vie, certaines positions du corps dont certains mouvements de bras ... toujours avec élégance ... elle se comportait et se tenait fière. Elle se tenait belle.' (Quoted in Lever, Trame and Wu 2021b, p. 52).

9. Poiret 1931, pp. 78–79.

10. Reproduced in PIASA 2005, vol. 2, p. 132.

11. At the time of donation, the Musée des Arts Décoratifs (MAD) was called the Union Française des Arts du Costume (UFAC).

12. Union centrale des arts décoratifs 1999, p. 84.

13. The French catalogue lists the ivory version as number 71, 'La Vallière', but misattributes its date to 1922–25 (Institut de France, Musée Jacquemart-André 1974, p. 29). In the Fashion Institute of Technology catalogue the dress featured as number 49: 'Lavallière'. Gown of ivory satin embroidered in crystal bugle beads, c. 1912; worn by Mme. Poiret' (Paul Poiret: King of Fashion 1976, n.p.).

14. In 2005, Sophie Rang des Adrets, granddaughter of Denise and Paul, daughter of their daughter Perrine de Wilde, sold over 500 lots at PIASA, Paris. In 2008, Denise and Paul's son Colin Poiret and his wife, Hélène, sold 124 lots at Beaussart Lefèvre, Paris. See both auction catalogues: PIASA 2005 and Beaussant Lefèvre 2008.

15. The exhibition was Paul Poiret et Nicole Groult: maîtres de la mode art déco, at the Musée de la mode et du costume, Palais Galliera, 1986. (For catalogue, see Palais Galliera Paris 1986.) Denise's daughter Perrine Poiret de Wilde donated several Poiret items to the museum's permanent collection at the time of the exhibition (Chen, De Ioanni and Hernández 2021, p. 80).

16. Quoted in Chen, De Ioanni and Hernández 2021, p. 182.

17. Antoine Poiret, quoted in Lever, Trame and Wu 2021a, p. 45; and Charlotte Poiret, quoted in Lever, Trame and Wu 2021b, p. 53.

18. Several Poiret dresses in the Palais Galliera in Paris also contain similar handwritten labels. (Emails dated 31 August–20 September 2023 from Sophie Grossiord, curator at Palais Galliera Paris, to Christine Ramphal.)

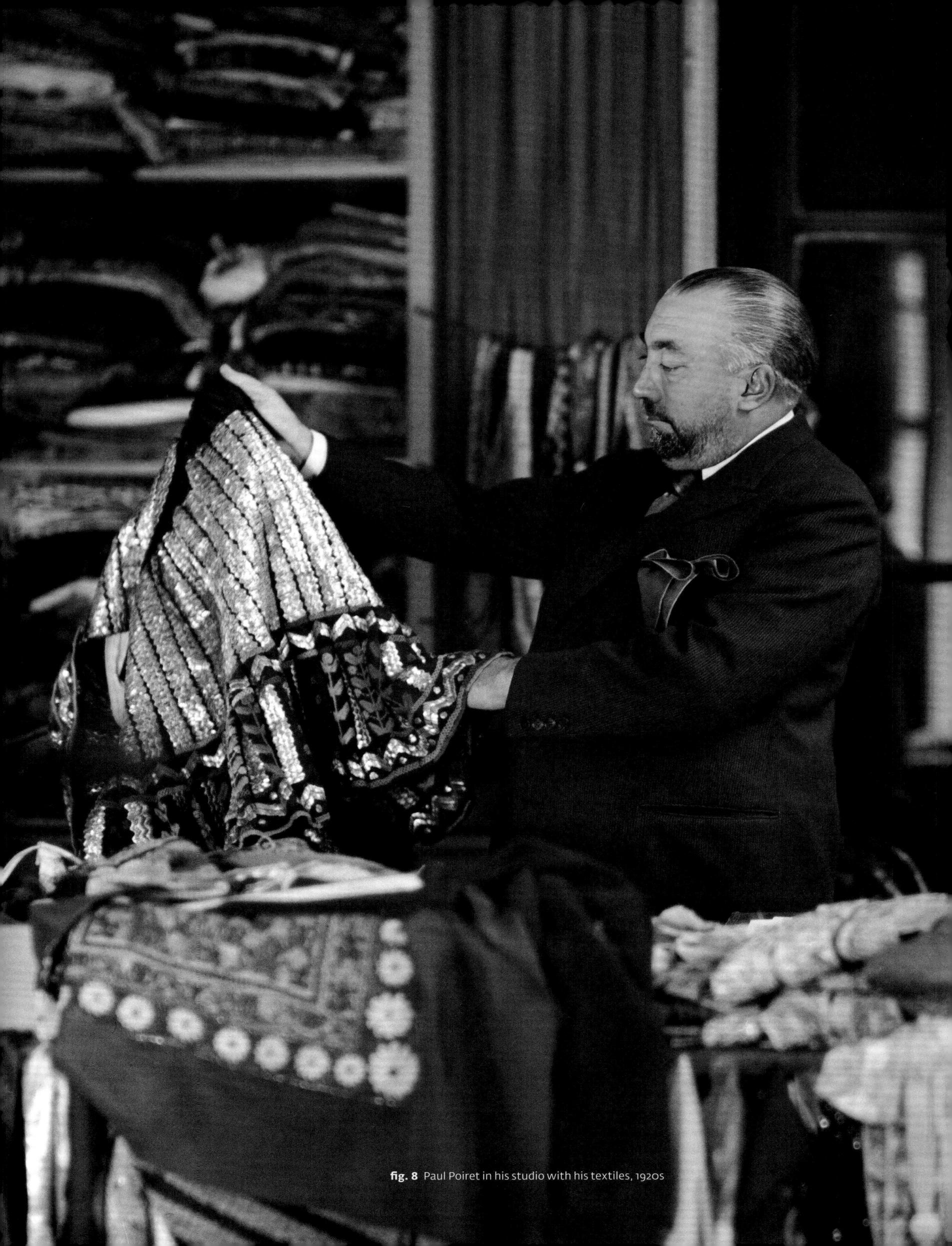

fig. 8 Paul Poiret in his studio with his textiles, 1920s

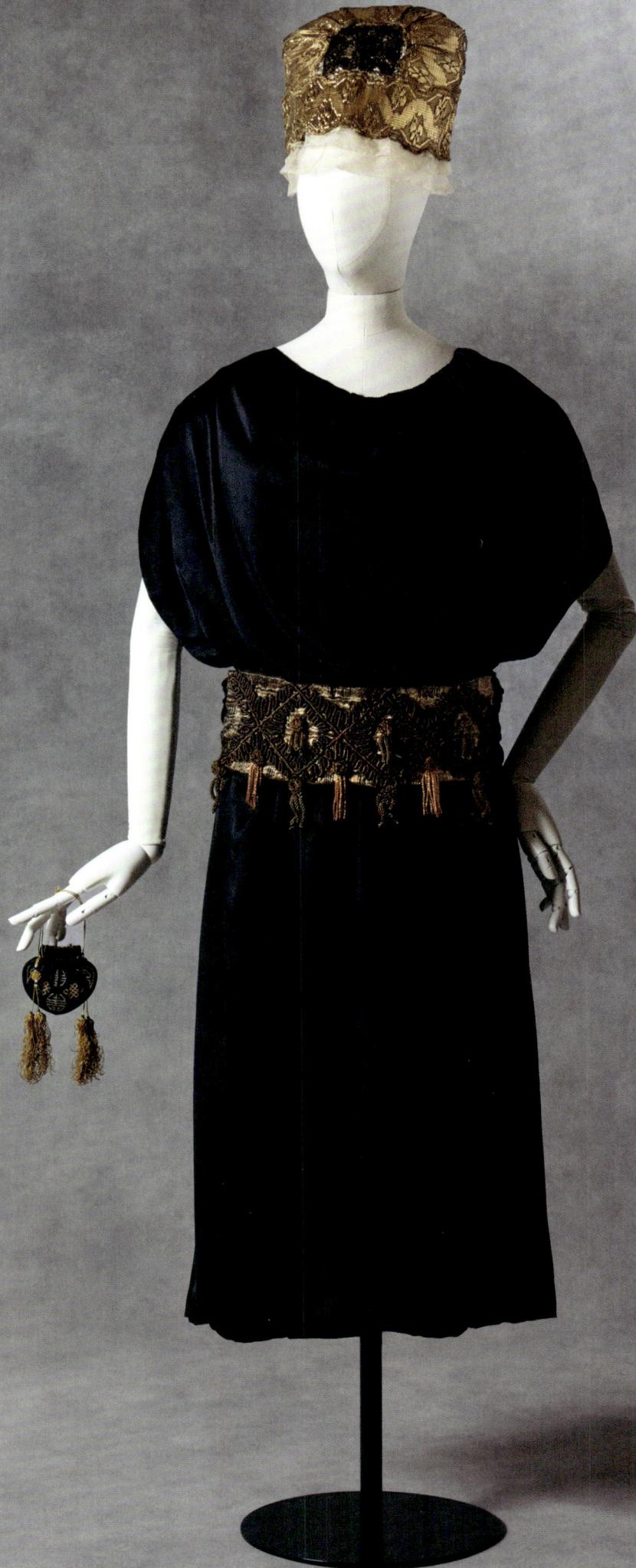

9. Paul Poiret Dinner dress with belt, 1911 and Kokochnik-style hat, c. 1910. Embroidered purse, China, 19th century

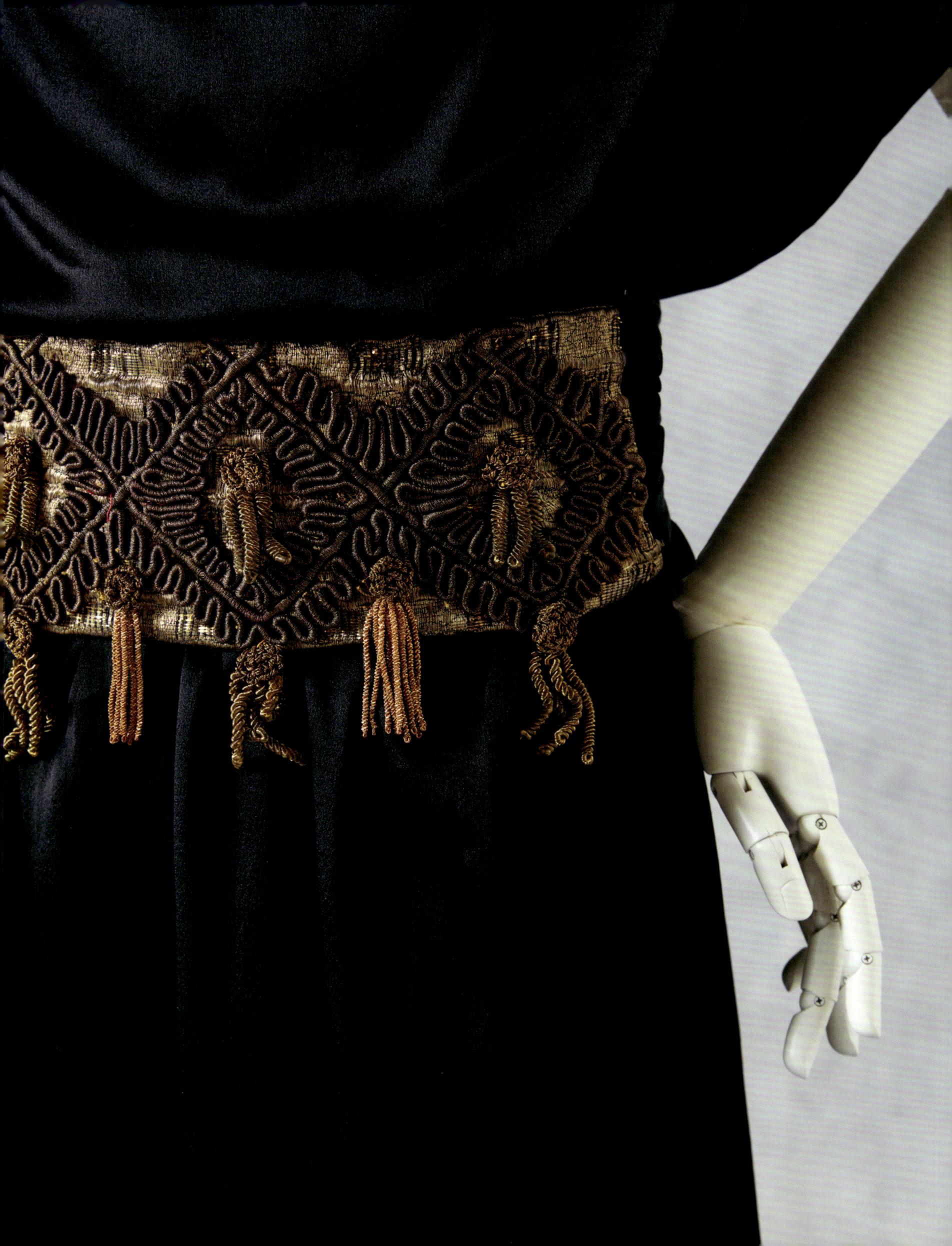

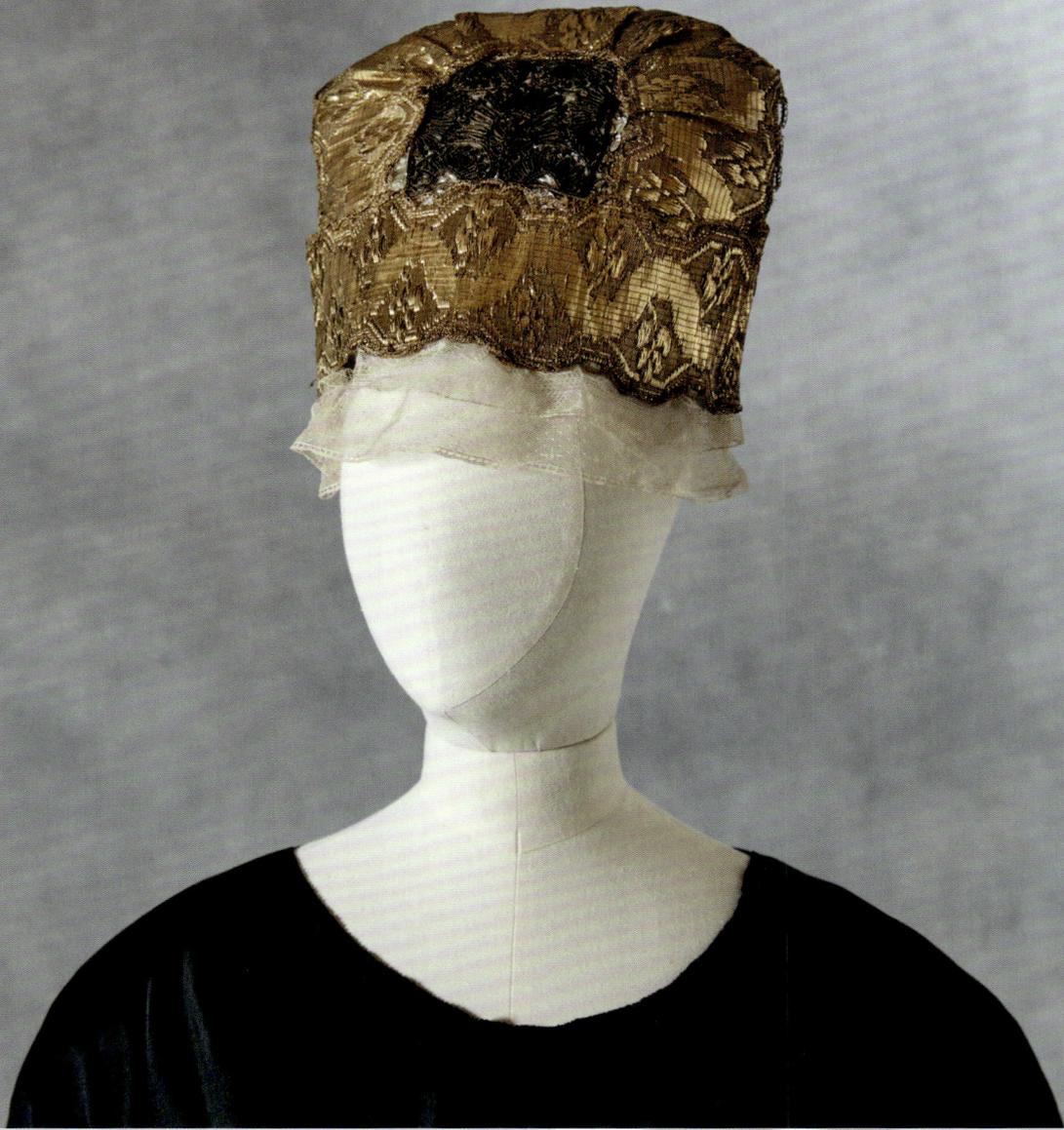

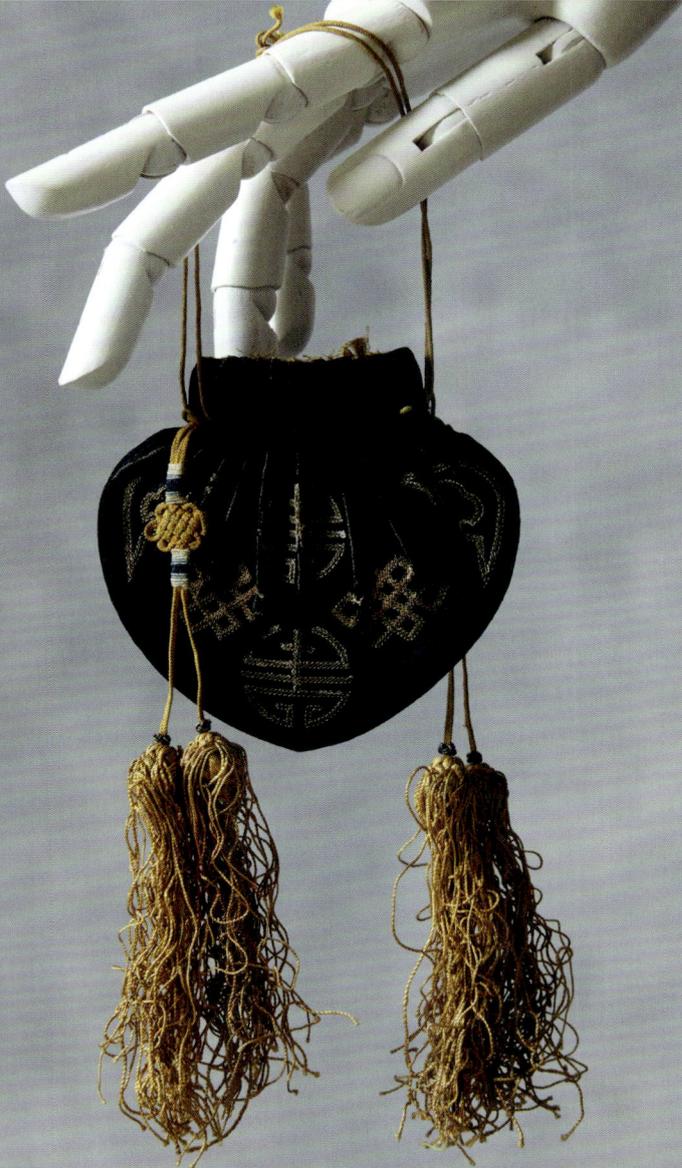

10. Madeleine Panizon for **Paul Poiret** Hat, 'Trocadéro', Summer 1920

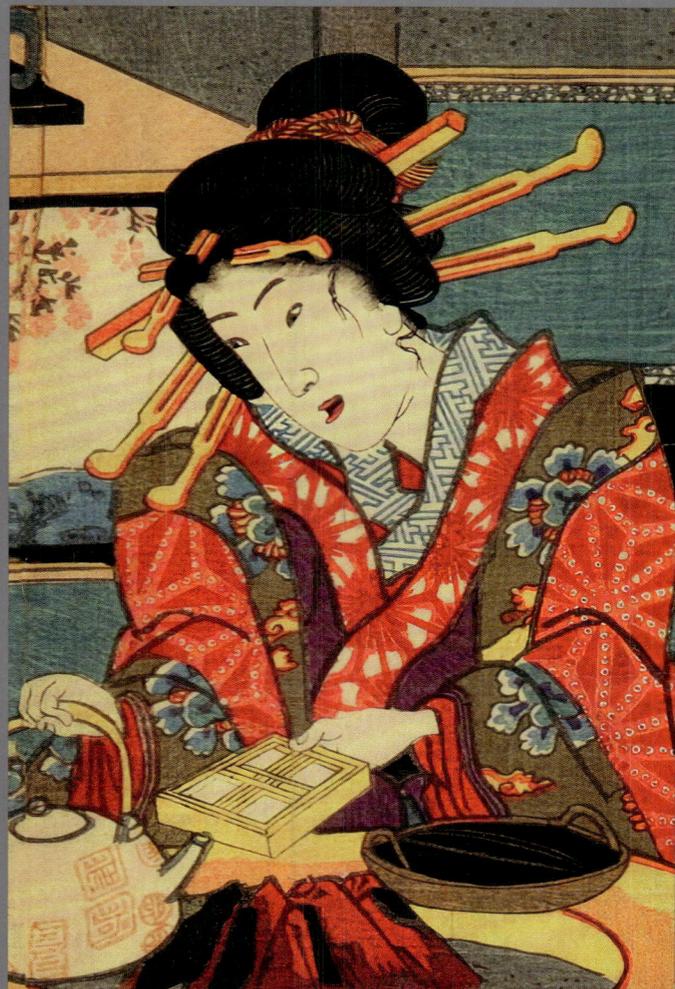

fig. 18 Details from *Comparison of Lovers on a Rainy Night*, by Utagawa Kunisada from the series *Genji in Modern Guise*, 1855

The uppers of these delicate Italian shoes by Luigi Zanotti (no. 22) are made of silk embroidered in Japan and produced for export. The imagery derives from two different woodblock prints. The source for the two figures on the toe box is a print by the Japanese artist Utagawa Kunisada (1786–1865) of scenes from the hugely popular novel *Nise Murasaki Inaka Genji* (A Rustic Genji by a Fake Murasaki).[5] Kunisada produced hundreds of such *Genji-e*, and a print comparable to fig. 18[6] would have served as a template for the embroidery. Other imagery, including the crane roundel, are taken from *Otatsu of the Matsuya at Shinbashi and Asahina Yoshihide* – from the series, *Six Poems of Love and Valour*, 1879, by Tsukioka Yoshitoshi (1839–1892).

Luigi Zanotti (based in Bologna, Italy) marketed himself as a shoemaker of all kinds of shoes to order, including for mountaineers and hikers, according to an advert in a mountaineering publication.[7] It is conceivable that he made these shoes at the request of a customer, who brought the fabric to him. Of course, Zanotti might have come across the embroideries himself.

technique – the piping and edge outline the dress's upper contour and hemline. The large flower bouquet rendered in satin stiches and long-and-short stiches recalls that often seen in Chinese export hangings and shawls. The stylised cloud-head patterns (*ruyi*) embroidered in gold threads provide a framework for the neckline and hemline.

The cross-medium imagination in chinoiserie fashion is exemplified by a 1923 evening dress, poetically titled 'Nuit de Chine', by Jean Patou (no. 23). The intricately beaded motifs of landscapes, animals, plants and ornaments in neon pink unfold on a black silk ground, assimilating the composition and aesthetic of Chinese lacquer panels. Fashion illustrations of the period, especially those by George Barbier, also frequently explored the visual and material dialogues between chinoiserie dress, decorative arts and interiors. A representation of a Beer evening gown published in 1921, for instance, coordinates the porcelain-inspired blossom and scroll patterns in the lady's dress with those in the wallpaper and in the Louis XV-style lacquer commode (fig. 17).

Such depictions helped popularise the concept of a total artistic lifestyle. Another 1923 creation by Patou, a 'Musardise Robe', extracts the structural elements of a deconstructed Han Chinese skirt and remaps them as the decorative scheme of the chemise dress: its rectangular frame with ornamental borders in the front alludes to the central panel of the Chinese skirt placed invertedly, while the vertical decorative strips on the back and the sides resemble embroidered pleats of the Chinese skirt (no. 24). However, the floral sprigs are entirely in the Mughal style. As with other Orientalist couture of this period, the cultural boundary of chinoiserie fashion was malleable and unrestricted.

In this dynamic period in fashion history from the 1910s to the 1920s, largely thanks to exoticism, which went hand-in-hand with historicism, the concepts of dress making and the vision of the clothed body changed dramatically; the decorative repertoires were greatly enriched, and a new era of modernist styles gained full ground. Asian themes were the catalyst and interlocutor of sartorial modernism. An embodied journey of displacement in space and time doubled as fashion's rebellion and a powerful quest into the sartorial future.

1. Bauër 1924–1925, p. 55.
2. Wollen 1988, p. 8.
3. Koda & Bolton 2007, p. 13.
4. Rittenhouse 1913, p. 42.
5. Koda & Bolton 2007, p. 136.
6. Koda & Bolton 2007, pp. 118–21.
7. Milbank 2023, pp. 134–35.
8. Martin & Koda 1994, p. 36.
9. d'Houville 1911, n.p.

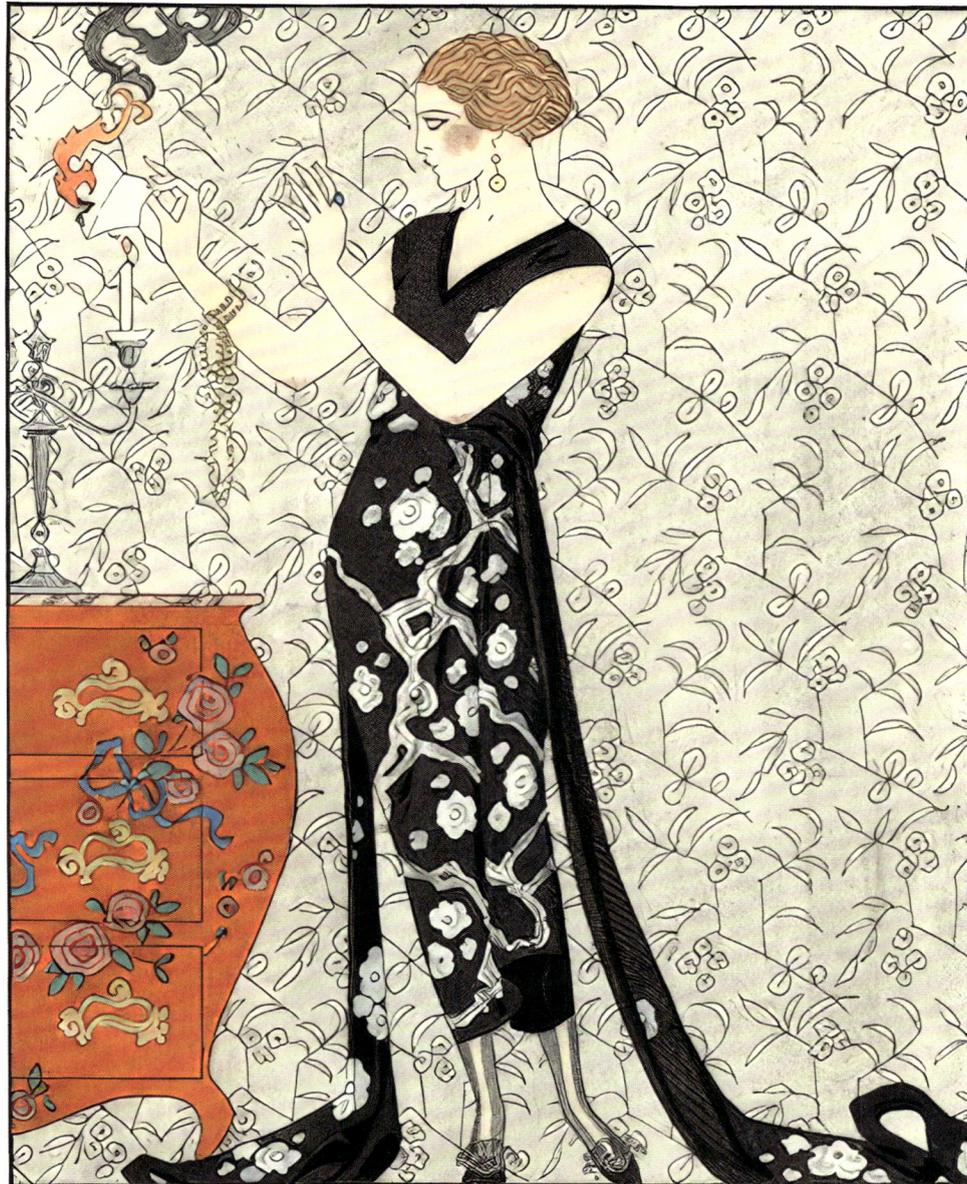

fig. 17

abstraction in art and design, while the black-on-black choice enables a subtle play of light and draws attention to the materiality of textiles (no. 26).

French couture in the 1920s also celebrated Chinese themes. Unlike the Japanese and Middle East influences, which were profound on garment shapes and constructions, the chinoiserie taste largely focused on surface embellishments: ornate motifs, vibrant palettes and rich textures. These drew inspirations from late Qing-dynasty dresses, Chinese export embroideries and other types of Chinese decorative art such as porcelain and lacquer screens. The iconic chemise dress in *les années folles*, or the jazz age – characterised by a tubular shape, dropped waist and raised hem – served as an ideal canvas for elaborate chinoiserie designs.

A circa-1925 evening dress by Callot Sœurs, a leading house in the 1920s chinoiserie fashion, incorporated various Chinese-inspired features (no. 25). A visual drama of colour is achieved by contrasting the acidic green ground with both the bright-pink floral embroidery and the orange piping and hem facing that peeps out to form a thin edge. A clever treatment inspired by popular Chinese embellishing

fig. 17 George Barbier, *Fumée*, *Gazette du Bon Ton*, 1921

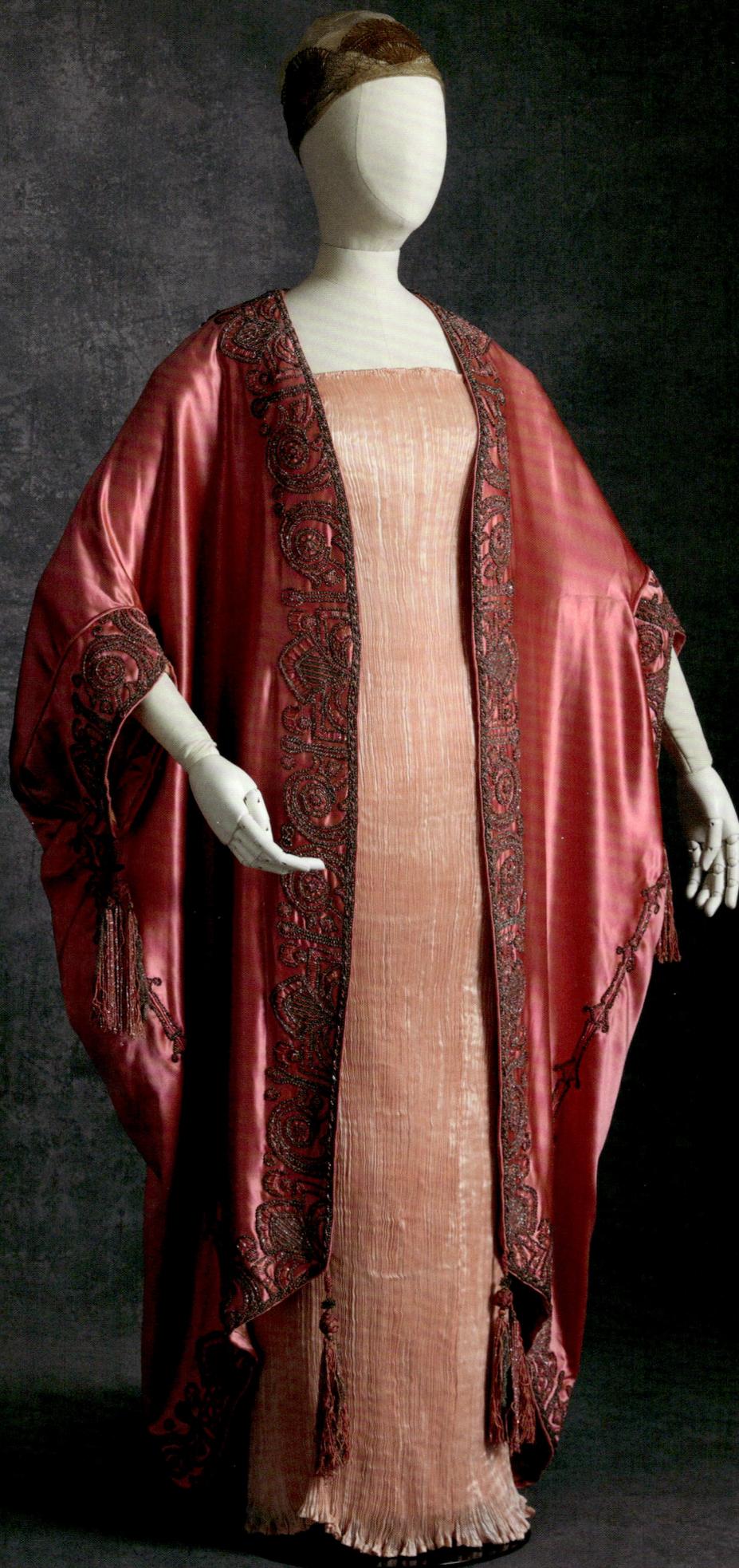

18. **Callot Sœurs** Opera coat or mantle, c. 1915–20,
Adèle Henriette Elisabeth Nigrin Fortuny and **Mariano Fortuny** 'Delphos Dress', Italian, c. 1920 and
Madeleine Panizon for **Paul Poiret**, Hat, c. 1920

textiles and embraced untailored shapes of tunics, capes, wrappers and pleated gowns. A range of sources were present in Fortuny's works – ancient Greek, Byzantine, Italian Renaissance, North African, Middle East and Japanese – but these references were ambiguous, elusive and fragmented, unfolding like resurrected memory and persistently disengaging with the present.

Writing in 1911 under the pen name Gérard d'Houville, French writer Marie de Régnier referred to Fortuny as 'a magician' and commented on the temporality in his creations: 'In general, dresses have only a future before they are worn ... However, these ones seem to already have a past, which will add its melancholic grace to the beauty of those who will wear them tomorrow.'[9] Fortuny's typical designs were exemplified by a mantle made of a black silk velvet with stencilled printed gold motifs of palmette and ornamental leaves. They were at once timeless – in the sense that they conjured up another life and another time without specificity – and intensely avant-garde in their looks and conception (no. 17).

In the 1920s, sartorial forms derived from Eastern prototypes, including the cocoon-shaped coat and the kimono sleeves, had been firmly established in French couture and adopted by various designers (e.g., see no. 18). By this date, the Japonisme that had swept Europe and the United States from the 1860s to the 1910s had passed its heyday, but the idiom of kimono found more intellectual iterations in modern fashion compared with the earlier decades. In the late 19th century, the Japan craze was dominated by wearing export kimonos as indoor robes and a fascination with the imagery in wood-block prints (e.g., see no. 22). In the early 20th century, forward-thinking designers increasingly explored kimono's visual trait and construction concept, transforming and integrating these elements in their works.

A 1928 coat by Lanvin represents an intelligent adaption of the kimono language into a modernist expression of chic and sophistication. Instead of being cut straight as in the kimono, the raglan sleeves that join the body panel along a diagonal seam give a rounded, sloping shoulder line; but the oversized meanders reminiscent of the traditional Japanese *tatewaku* pattern (rising vapour in the shape of vertical waves) are painstakingly matched to create an impression of unbroken planarity, resembling kimono designs which often feature a large motif across narrow textile panels stitched together. The flaps around the cuffs pay tribute to the hanging sleeves of the *kosode*, and they introduce some visual drama to the otherwise sleek and clean silhouette. The *ciré* (glazed) black-wool grosgrain tape creates a bold geometric pattern consonant with the ascending aesthetic in the late 1920s for

fig. 16 Hats and turban originally belonging to Denise Poiret

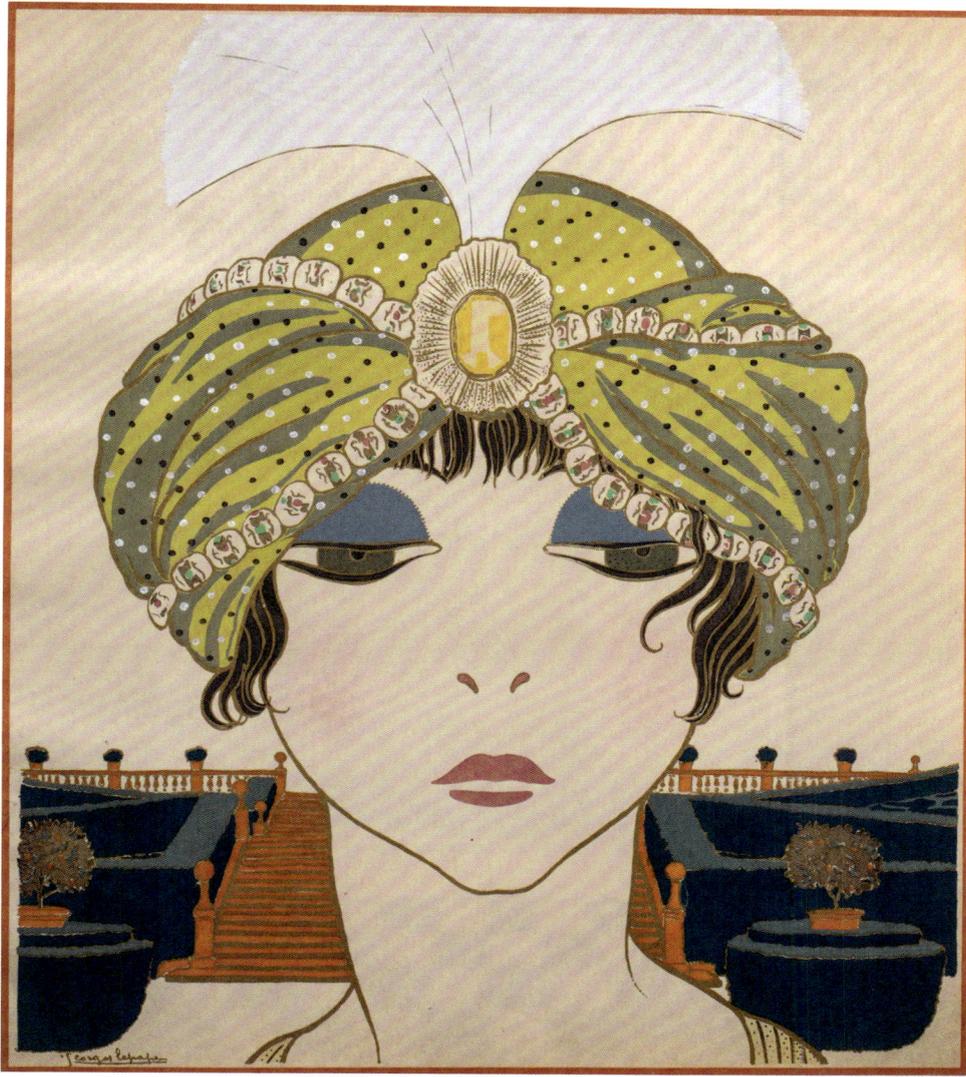

5

languishing in domestic or outdoor settings cultivated a decadent mood associated with such style.

In his historicist approach, Poiret was not content with a straightforward revival, and indeed he frequently melded it with exoticism for a more layered visual effect. In one example, his 1911 dress 'Notre Dame' (no. 8), the high waistline is accentuated by an oblong-shaped Chinese floral appliqué embroidery, a common type of textile goods decorated to shape for accessories, which Poiret probably found in a shop for Asian exports. The strategically placed plaque draws attention to the radical proportion of the dress, while its blue-and-white palette echoes that of the tassle trims along the sleeves and the hem. Moreover, Poiret often accessorised the cylindrical neoclassical gown with a turban or turban-inspired hat, one of his favourite leitmotifs of the oriental (fig. 16).

Poiret was not alone in his anachronistic and multicultural approaches to dress. The versatile Spanish artist and inventor Mariano Fortuny, whose singular designs appealed to Parisian high society and artistically minded clients alike, was a master in enabling a sartorial displacement in time and space. Distancing his creations from the fashion system, Fortuny experimented with hand-dyed, handprinted

5. Illustration from *Les Choses de Paul Poiret vues par Georges Lepape*

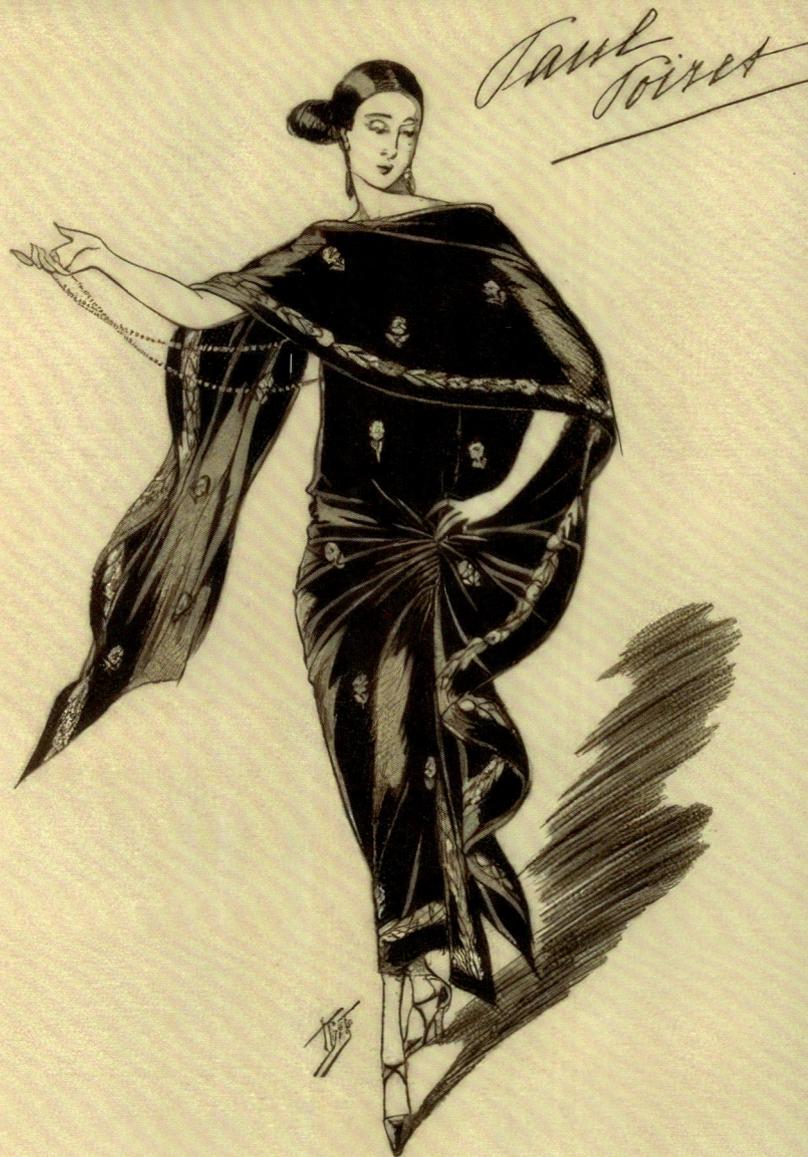

fig. 15 13a

revealing the eclectic spirits and flexible cultural boundaries in the fashion thinking of that time. Madame Grès, whose works consistently drew on the classical goddess dress, also explored the Indian sari during the late 1950s, in part because of the shared aesthetic of swaddling and draping between these two traditions.[8]

Poiret's interests in Indian textiles manifested in other aspects as well, including textile motifs and techniques. His 1922 day dress 'Indiana', for example, features small scattered flowers rendered in chain-stitch embroidery in the Gujarat style (nos. 13 and 13a), and the botehs and half-palmette motifs in his 1923 evening dress 'Persane' or 'Sérail' were informed by mid-19th-century North Indian embroidery (no. 14). Dress styles in the European past equally lent Poiret inspiration for innovation. It is not surprising that his vision of a coherent and autonomous body found resonance in the high-waisted neoclassical style, which was all the rage in the period from circa 1800 to 1815. With a simple columnar shape, a body-clinging soft contour and airy fabrics that graced the natural figure, the style stood out as an anomaly in the Western fashion history dominated by hyperbolic and regulated silhouettes. Poiret's œuvres from 1906 to 1911 centred on this silhouette, and two limited-edition albums printed with the pochoir technique – *Les robes de Paul Poiret* (1908) by Paul Iribe and *Les choses de Paul Poiret* (1911) by Georges Lepape (no. 5) – illustrate various examples. The vignettes in these albums depicting modern women

fig. 15 Paul Poiret, draped evening dress, *L'Art et la Mode*, 1924

13a. Detail of chain-stich embroidery on 'Indiana' dress

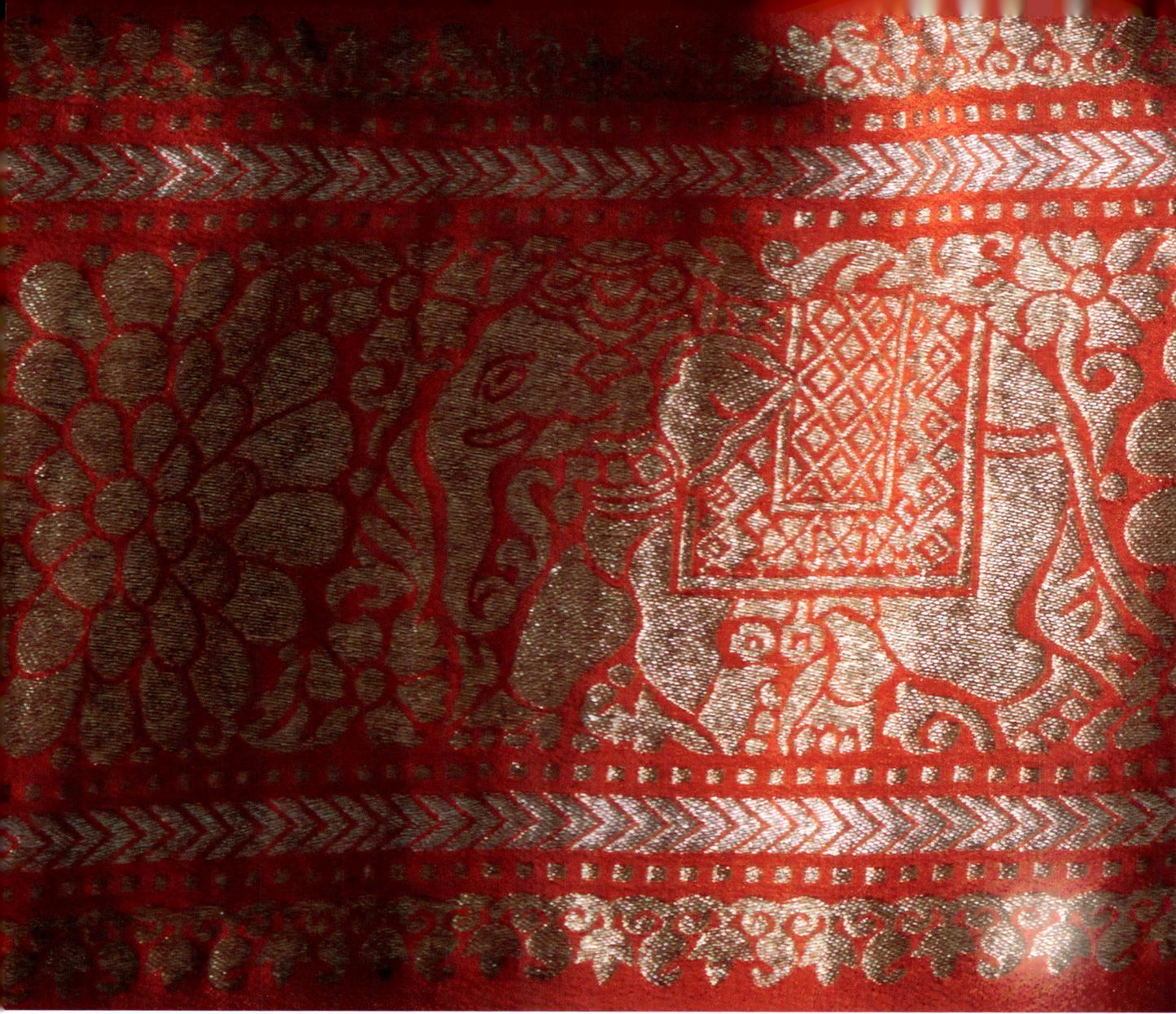

train and the slight ballooning contour in the centre back evokes the sinuous silhouette of Japanese beauties wrapped in the *uchikake* robe (outer robe worn over a *kosode*) as depicted in wood-block prints.

Sari – the quintessential Indian garment as one length of cloth spirally swathed around the body, tucked, and suspended in myriad ways – offered maximum possibilities of wrapping and draping. In the 1920s and the 1930s, Indian dress style captured the imagination of Paris couture, thanks to the influences of Royal Indian socialites Princesses Brinda and Karam of Kapurthala, and Princess Niloufer, who were active there. Poiret adopted the idiom of sari in his 1924 model 'Lure' (no. 15).[7] This evening ensemble consists of a textured gold lamé sheath dress and a long piece of orange silk crêpe attached to it, which is intended to be wound around the body like a sari. The bright-coloured silk, featuring contrasting woven decorations in metallic thread, recalls the sumptuous Kanchipuram silk (made in Tamil Nadu), and the elephant motif especially conveys an Indian flavour.

An illustration published in the French magazine *L'Art de la mode* of that year shows a similar model in a different textile – a black crêpe de Chine with printed floral pattern (fig. 15). In the image, the 'sari' panel gathers on the mannequin's left hip and floats across her chest; the woman's Mannerist gesture with an extended arm and the arrangement of the textile evoke a classic statue in a Roman toga or Greek himation,

15a. Elephant detail on 'Lure' dress

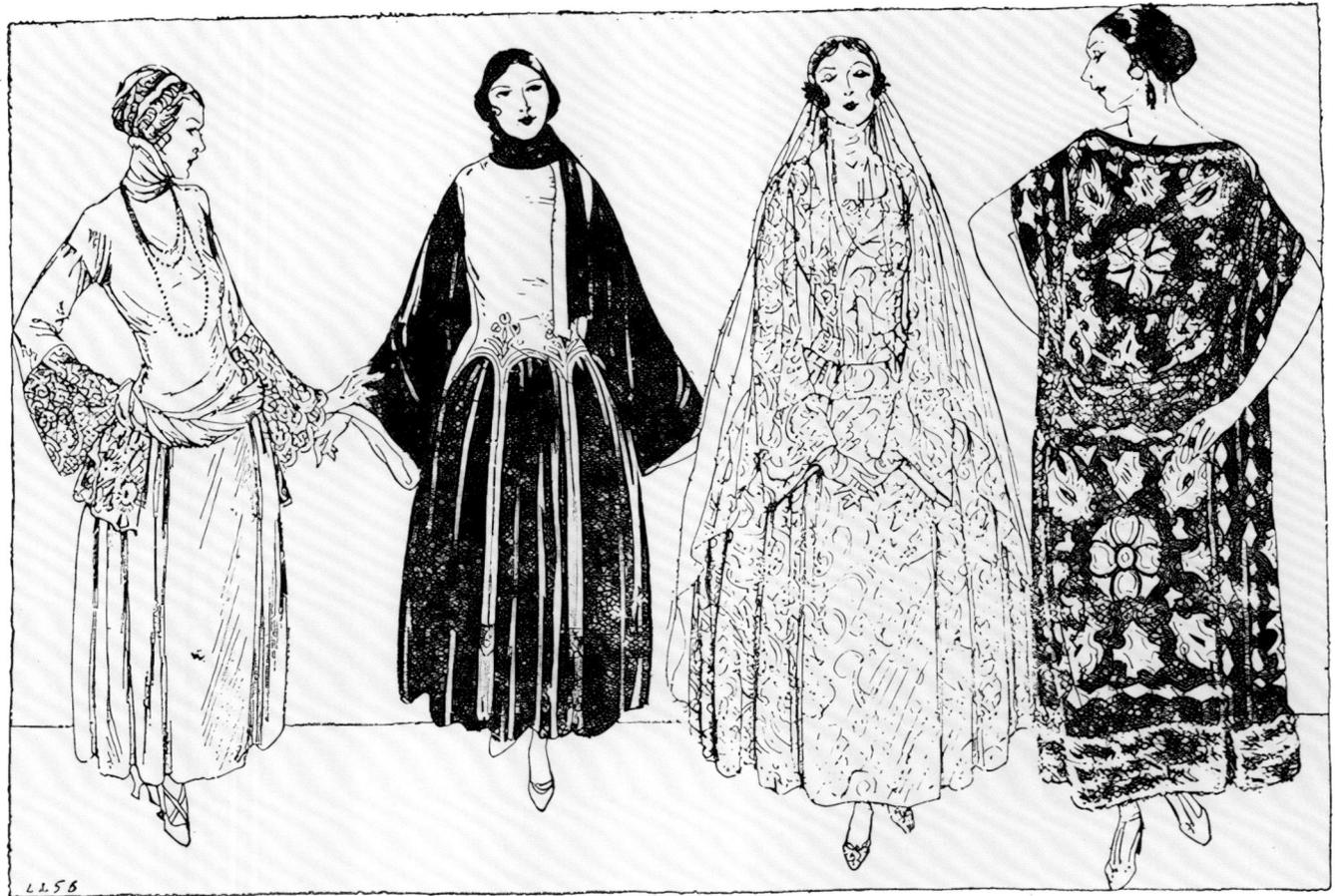

fig. 14

and Middle Eastern kaftan and the Japanese kimono, Poiret adopted the flat cut
– a method of construction based on stitching together rectangular textile pieces
instead of three-dimensional tailoring using patterns. The loose-fitting shape and
the planar approach deviated from the taut and exaggerated form that had
characterised the Western female dress for centuries. Poiret's unstructured, supple
silhouette stressed a more intelligible image of the body and highlighted its vivacity.
In 1913, American *Vogue* crowned Poiret as the 'prophet of simplicity'.[4]

A striking example of Poiret's flat-cut gown can be seen in the 'Mosaïque' dress
worn by Denise Poiret, the wife and muse of the designer, to attend his niece's
wedding in 1921 (no. 12 and fig. 10). The dress hung from Denise's shoulder and
enveloped her body with an insouciant flair (fig. 14). Its voluminous shape and
minimal tailoring showcase the opulent textile – a dusty purple silk velvet brocaded
with gold lamé floral patterns in a large repeat. The velvet was probably chosen
to echo the Italian Renaissance theme of the event,[5] but the ultra-modern shape
of the dress was a far cry from the Renaissance court gown. Japanese citation is
also at play here, as the stylised central motif in the textile resembles a Japanese
imperial crest of chrysanthemum.

Wrapping and draping were another experimental technique that Poiret employed
with virtuosity, especially in his signature style of the cocoon-shaped coat constructed
of one continuous length of fabric. The model 'Paris' (1919), in the Metropolitan
Museum of Art (inv. 2005.207), represents an ingenious interplay between the
two-dimensional fabric and the three-dimensional body.[6] Its graceful twist and

fig. 14 'Creations of Paul Poiret [...] for the Wedding of his Niece', including the
'Mosaïque' dress worn by Denise Poiret, *Women's Wear Daily*, 1921

I n presenting the 1924–25 collection of Paul Poiret in the highbrow fashion magazine *Gazette du Bon Ton*, journalist Gérard Bauër writes, '... the art of the master is so consummate and his taste tempers the fecundity of his imagination so well that, under his sceptre, Byzantine and the [French] Consulate, and the Middle Age and China, form the most harmonious kingdoms'.[1] This comment could equally capture the characteristic of French haute couture in the 1910s and 1920s, a splendid period when historicism and exoticism nourished the sartorial imagination and drove fashion forward.

Leading couturiers of the time, notably Paul Poiret and Callot Sœurs, and the artist-designer Fortuny, freely interpreted and assimilated elements from different times and cultures. Asian themes – inspired by Chinese, Japanese, Indian and Middle Eastern sources – furnished haute couture with a plethora of visual, material and conceptual languages, and they were intertwined with those derived from African, Russian or historical Western European prototypes. The result was not a brash pastiche or cacophony simply gratifying a masquerading desire or nostalgia, but revolutionary modern looks that fundamentally changed the course of fashion and redefined the feminine body.

Poiret was indisputably a pioneer and a major player in this wave of Orientalism/ eclectic modernism. The British filmmaker and writer Peter Wollen argues that Poiret and the Ballets Russes, both immensely popular in the 1910s and 1920s, represented 'a pivotal moment in the emergence of modernism'.[2] They broke with the visual canon in art and fashion and destabilised the conventional norm of body and gender. Modernism here is not defined reductively as a progression towards abstraction in art and a pursuit of functionality in design. Indeed, the rich ornamentations, complex surface effects and sensuality in Poiret s works were the very opposite of these values selected and celebrated by later theorists. Poiret constantly searched for freedom in dress in styles outside the current fashion cycle, but his innovations often quickly became the new trend and were widely imitated.

Orientalism, so central to Poiret's repertoire, served as his creative force and subversive apparatus. He was renowned for advancing a liberated silhouette for women by abandoning the petticoat and corset in the beginning of the 20th century, an effort also shared by contemporary designers such as Lucile (a.k.a. Lady Duff Gordon) and Madeleine Vionnet.[3] Inspired by the Greek chiton, the North African

G EAST

re in the early 20th century

MEI MEI RADO

LOOKIN

Asian influence on haute coutu

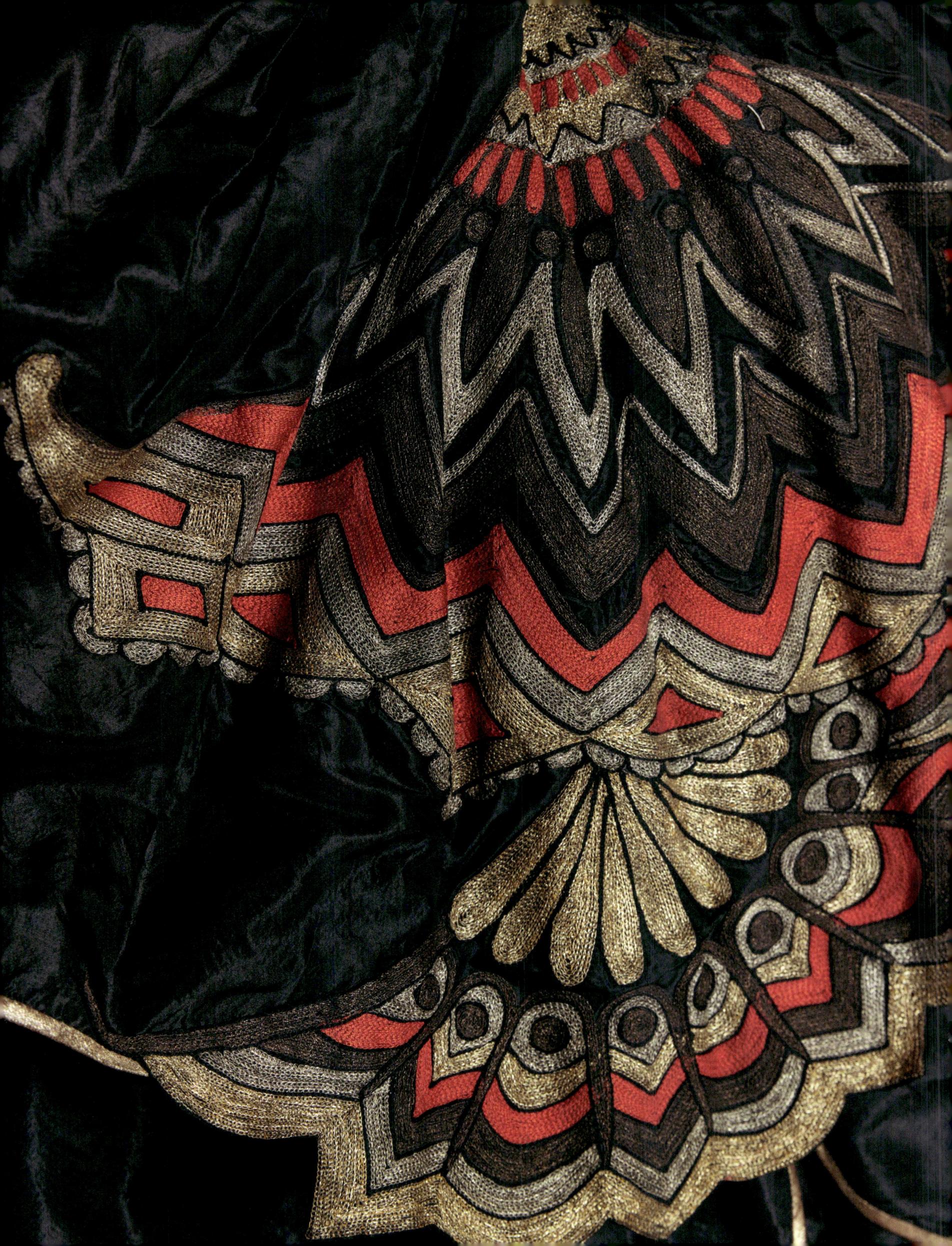

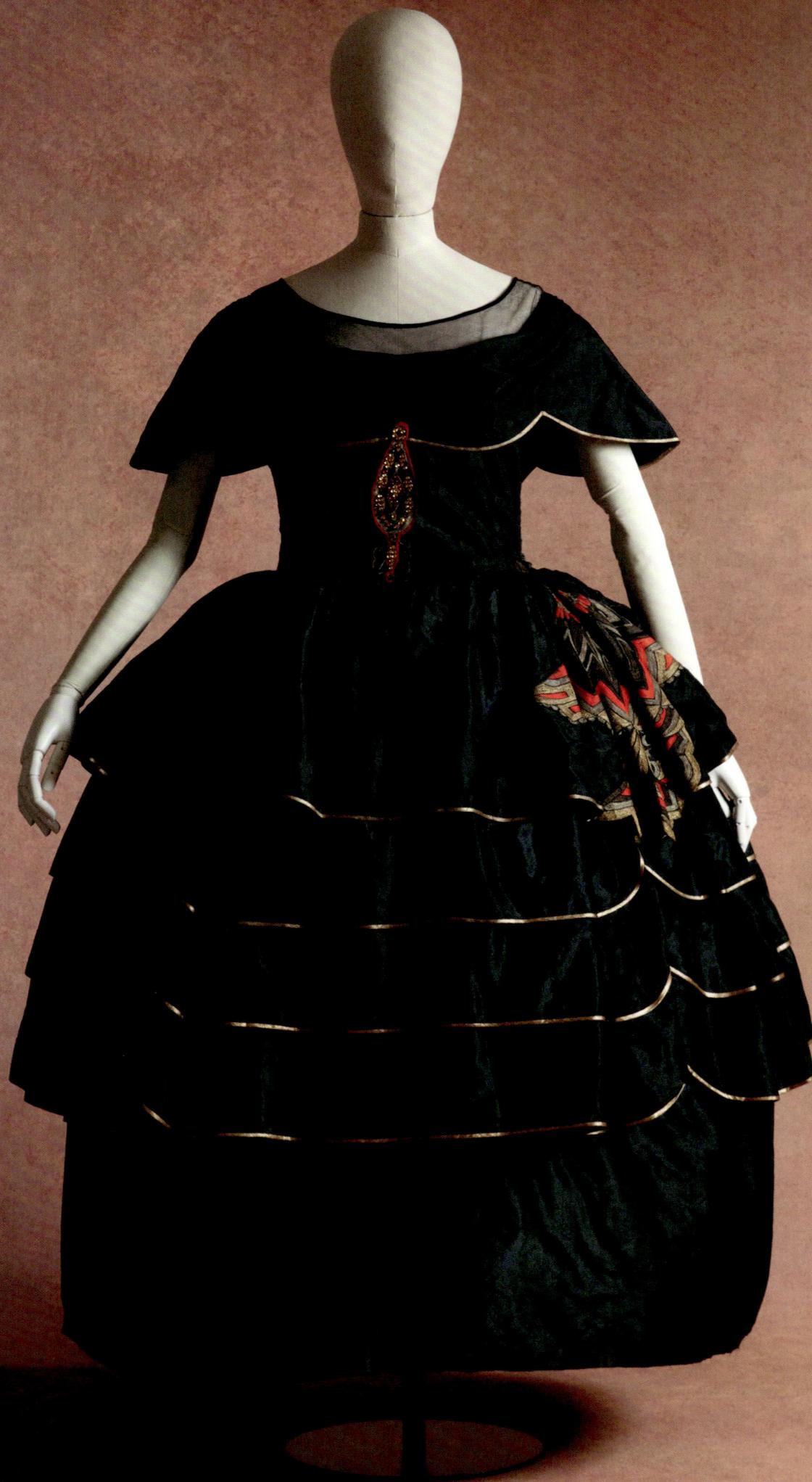

21. Jeanne Lanvin Evening dress or robe de style, 'Barcena', 1922–23

fig. 13 Modèle 'Dessinateur', Jeanne Lanvin, 1922/23

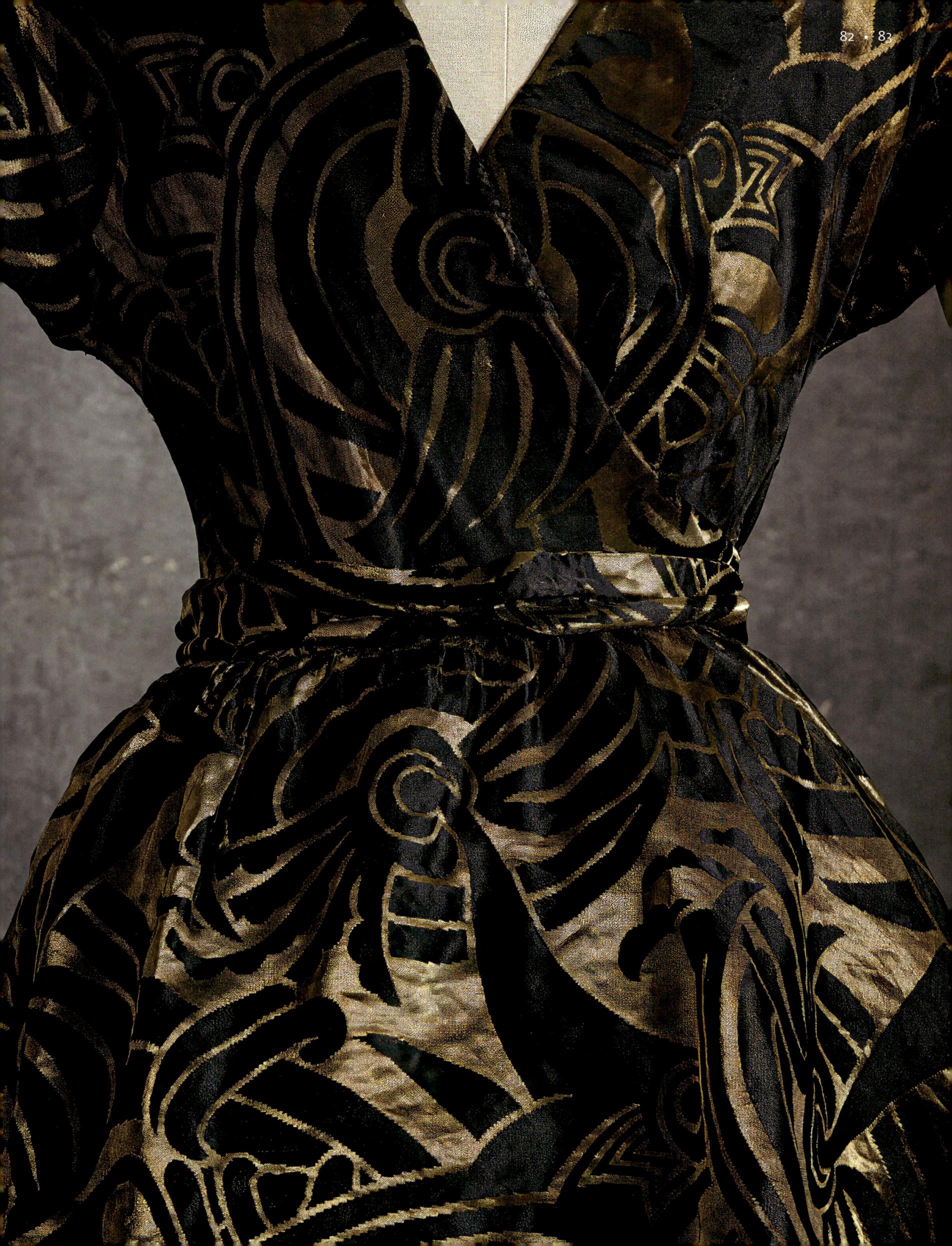

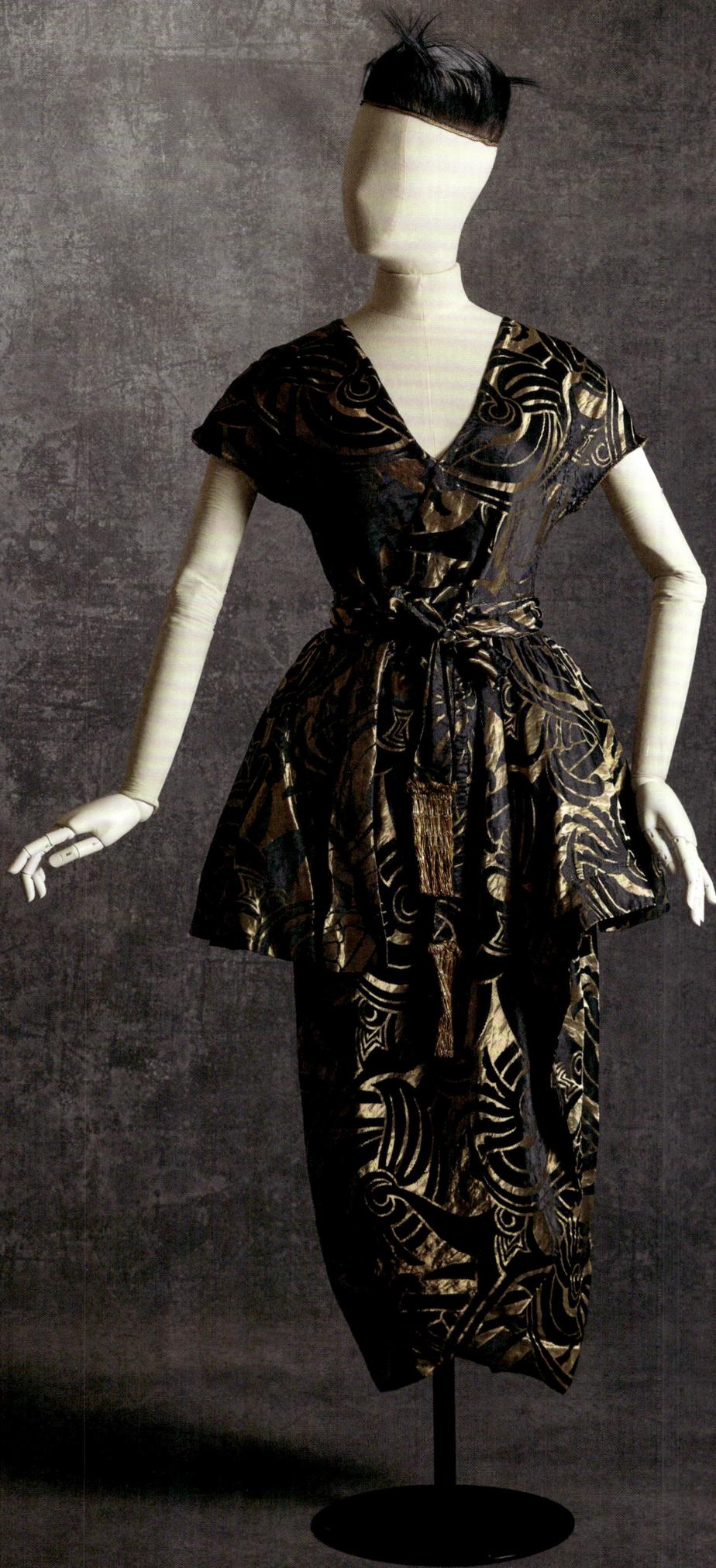

20. Madeleine & Madeleine Evening dress, c. 1920 and **Paul Poiret** Headband, c. 1919

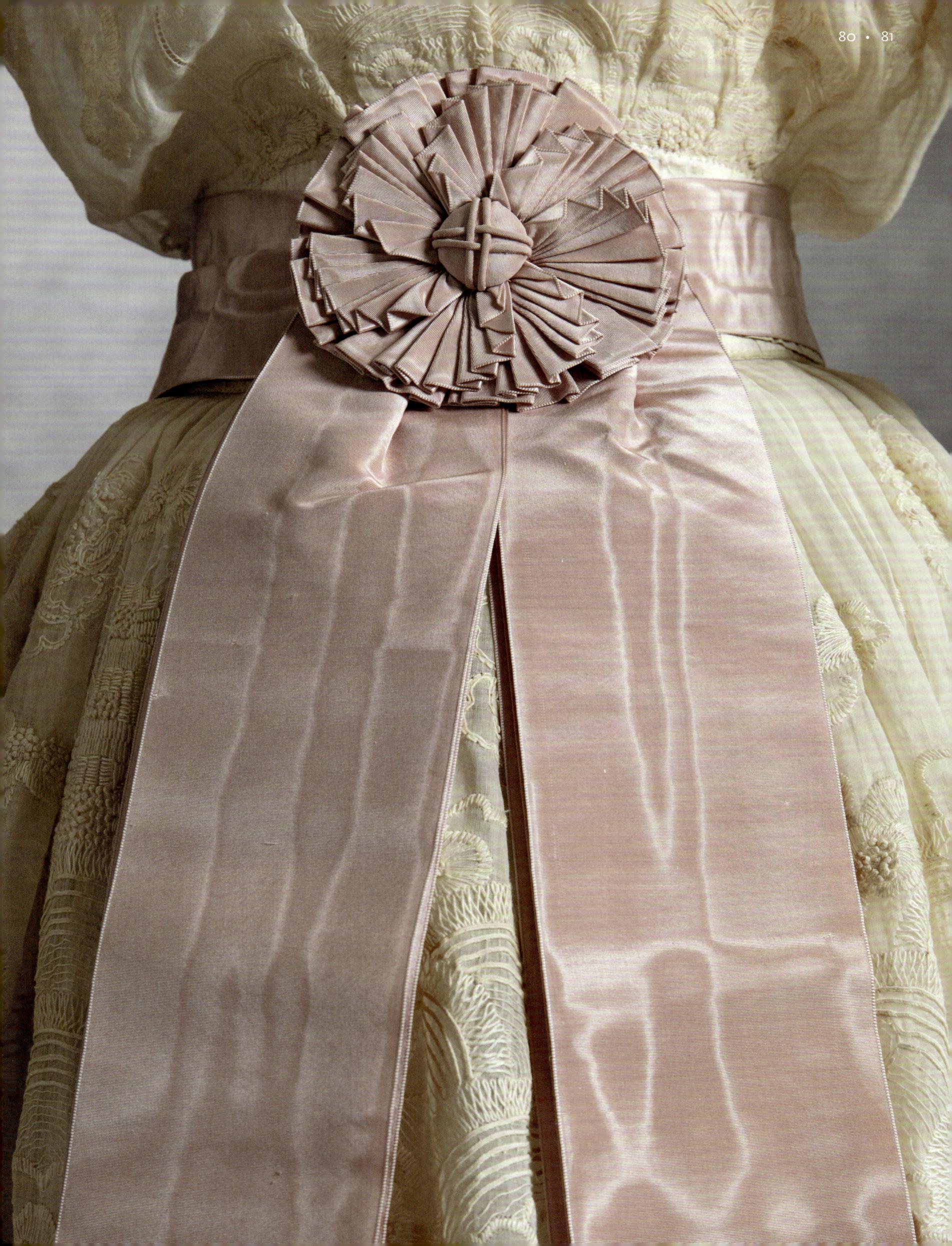

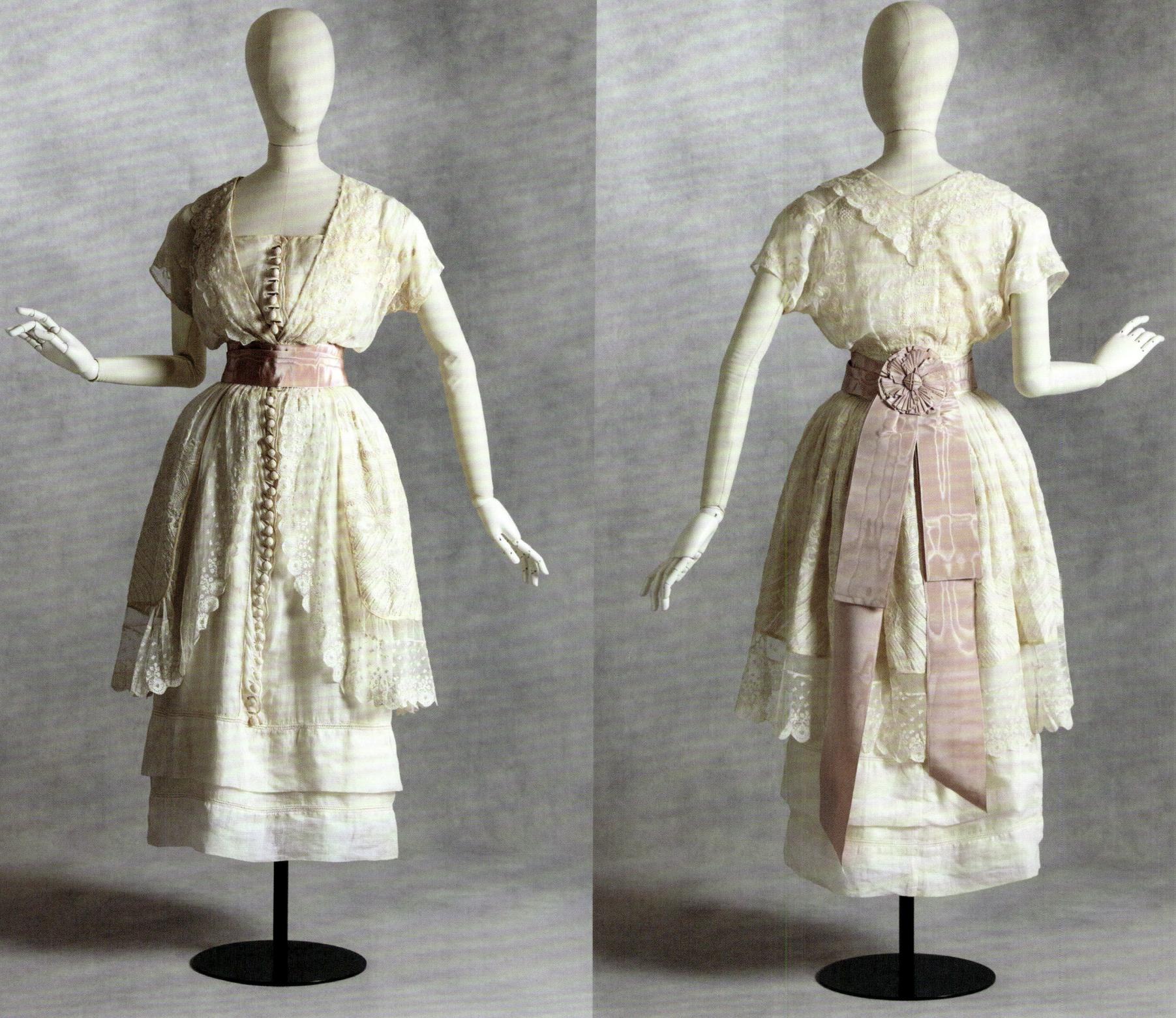

19. Callot Sœurs Day dress, Summer 1920

Founded by the four sisters Marie Gerber, Marthe Betrand, Régine Tennyson-Chantrell and Joséphine Crimont, Callot Sœurs began as a lingerie and lace shop. In 1895, the company became a couture house, which was soon admired for its elegant and opulent dresses (see no. 3), and became known for its frequent use of design elements from Turkey, the Middle East, China and Japan (see also nos. 18 and 25).

In this example, the Eastern influences are not immediately apparent. The delicate cotton voile dress has tone-on-tone white cotton embroidery, the imagery of which – flowers and clouds with a pagoda or temple rising from the centre back – suggests a Chinese inspiration. This is further confirmed by the *lishui-* (sea wave-) inspired embroidery around the hem of the knee-length tablier. These series of parallel diagonal lines were usually embroidered in multi-coloured silk around the hem of Chinese robes,[4] but here they are rendered in subtle white and are thus visible only to the keen observer.

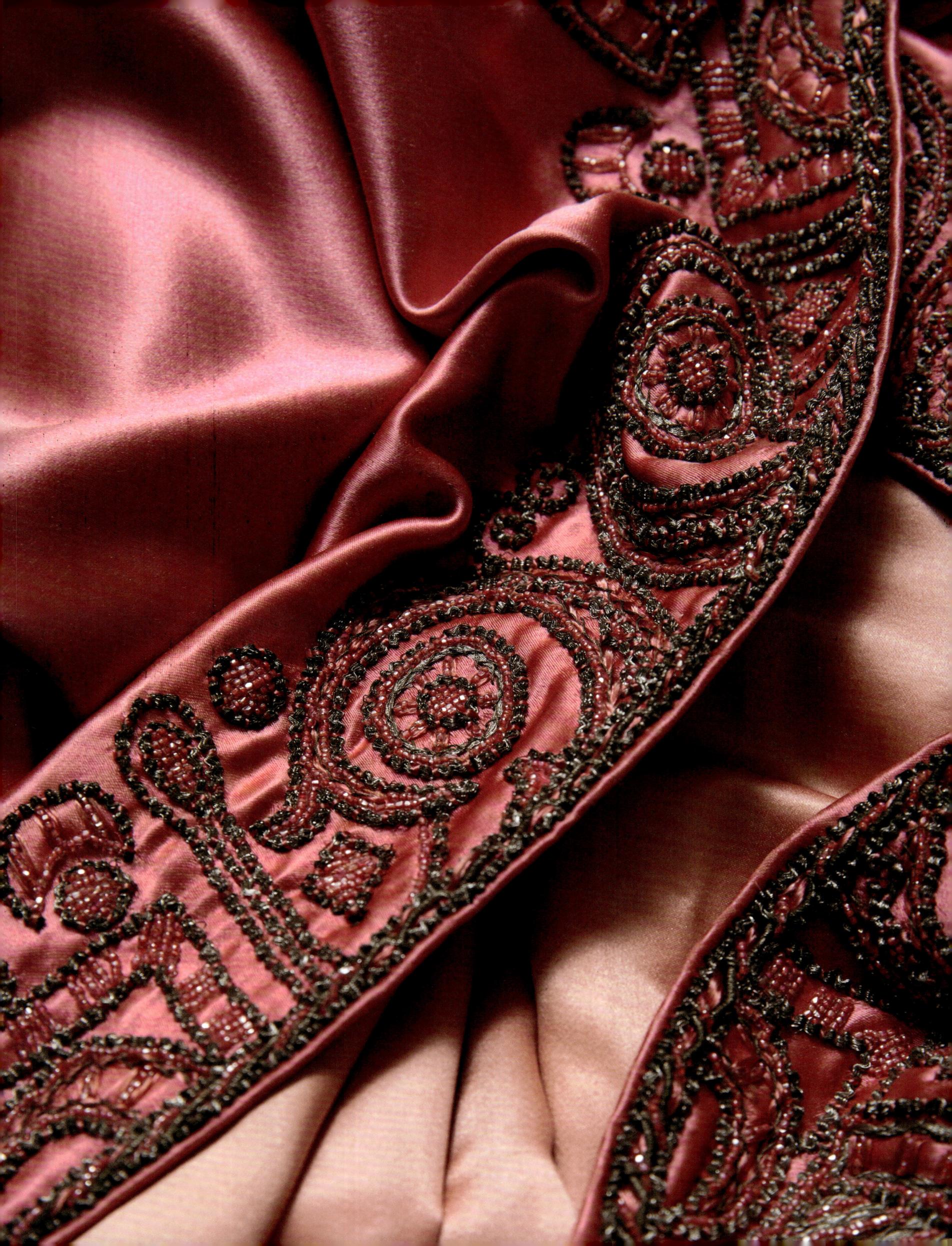

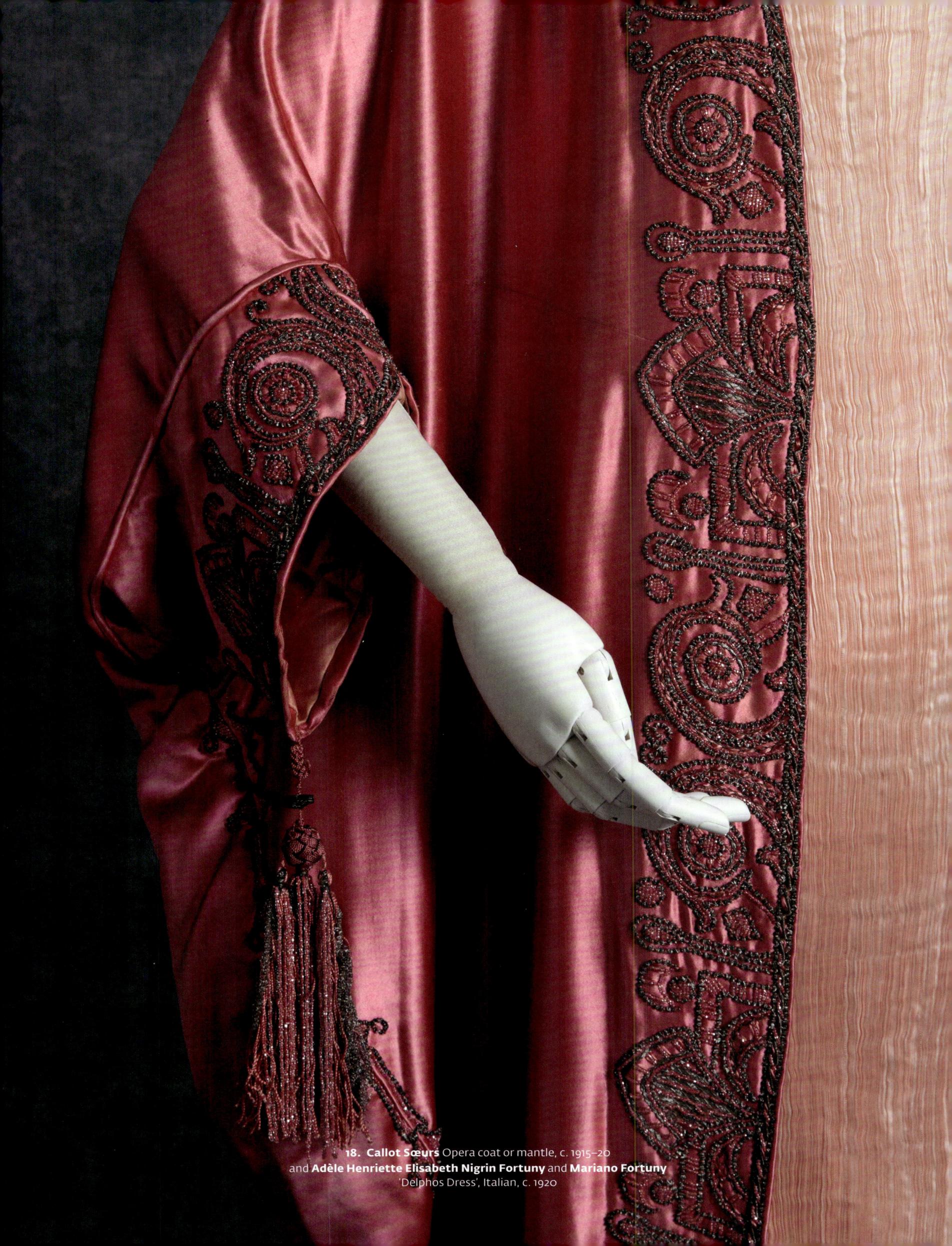

18. **Callot Sœurs** Opera coat or mantle, c. 1915–20
and **Adèle Henriette Elisabeth Nigrin Fortuny** and **Mariano Fortuny**
'Delphos Dress', Italian, c. 1920

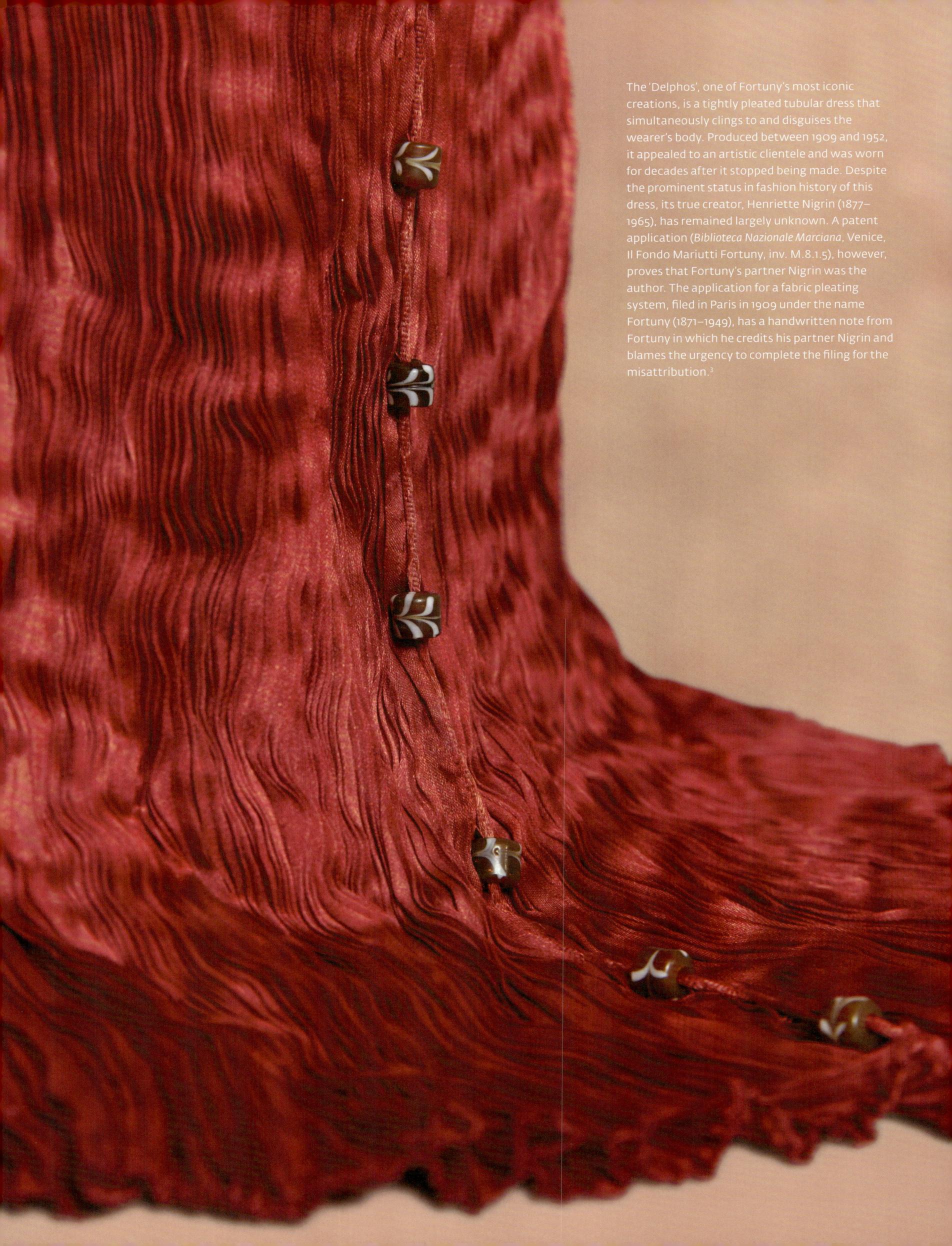

The 'Delphos', one of Fortuny's most iconic creations, is a tightly pleated tubular dress that simultaneously clings to and disguises the wearer's body. Produced between 1909 and 1952, it appealed to an artistic clientele and was worn for decades after it stopped being made. Despite the prominent status in fashion history of this dress, its true creator, Henriette Nigrin (1877–1965), has remained largely unknown. A patent application (*Biblioteca Nazionale Marciana*, Venice, Il Fondo Mariutti Fortuny, inv. M.8.1.5), however, proves that Fortuny's partner Nigrin was the author. The application for a fabric pleating system, filed in Paris in 1909 under the name Fortuny (1871–1949), has a handwritten note from Fortuny in which he credits his partner Nigrin and blames the urgency to complete the filing for the misattribution.[3]

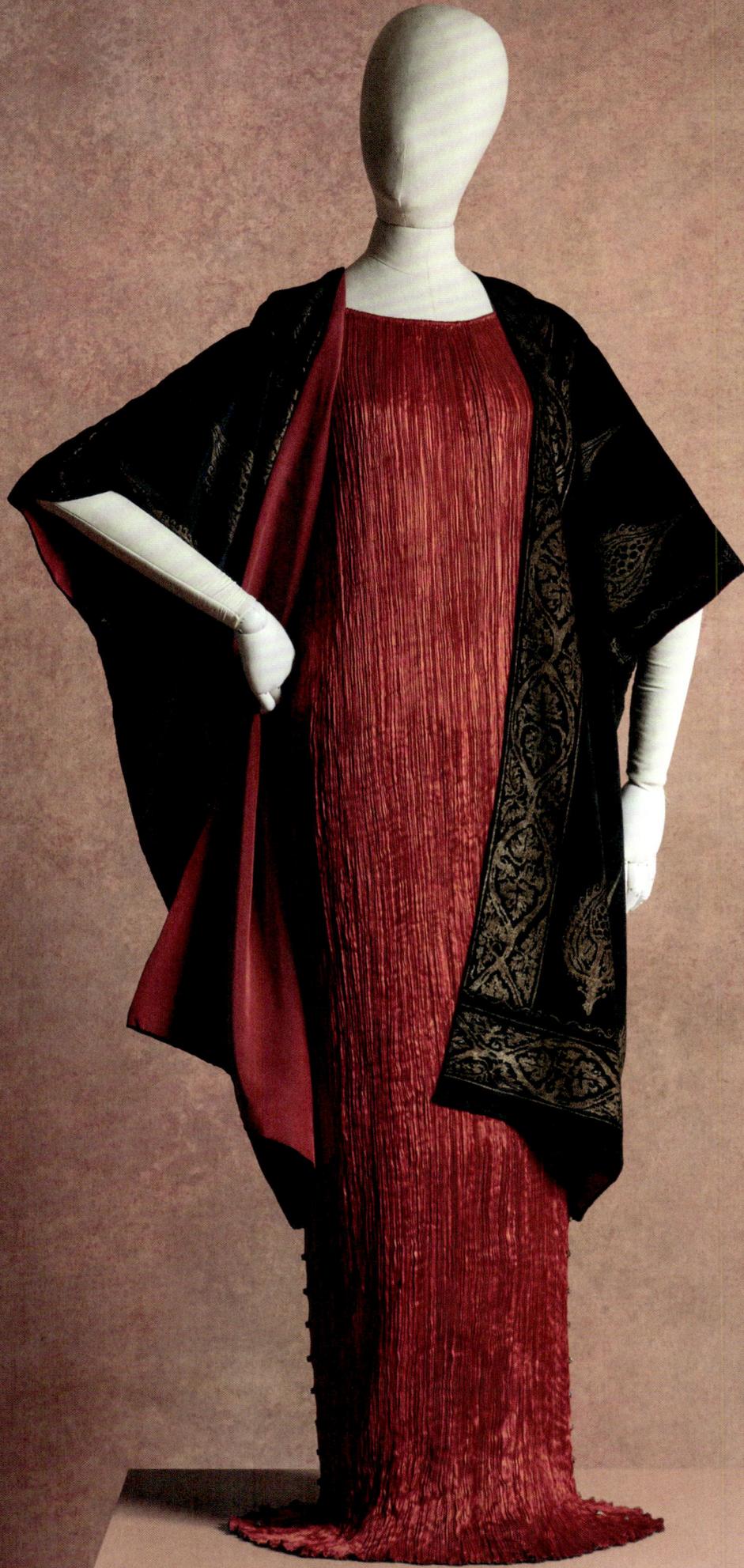

17. **Mariano Fortuny** Jacket, Italian, c. 1910–20s
and **Adèle Henriette Elisabeth Nigrin Fortuny** and **Mariano Fortuny**,
'Delphos Dress', Italian, c. 1910–20s

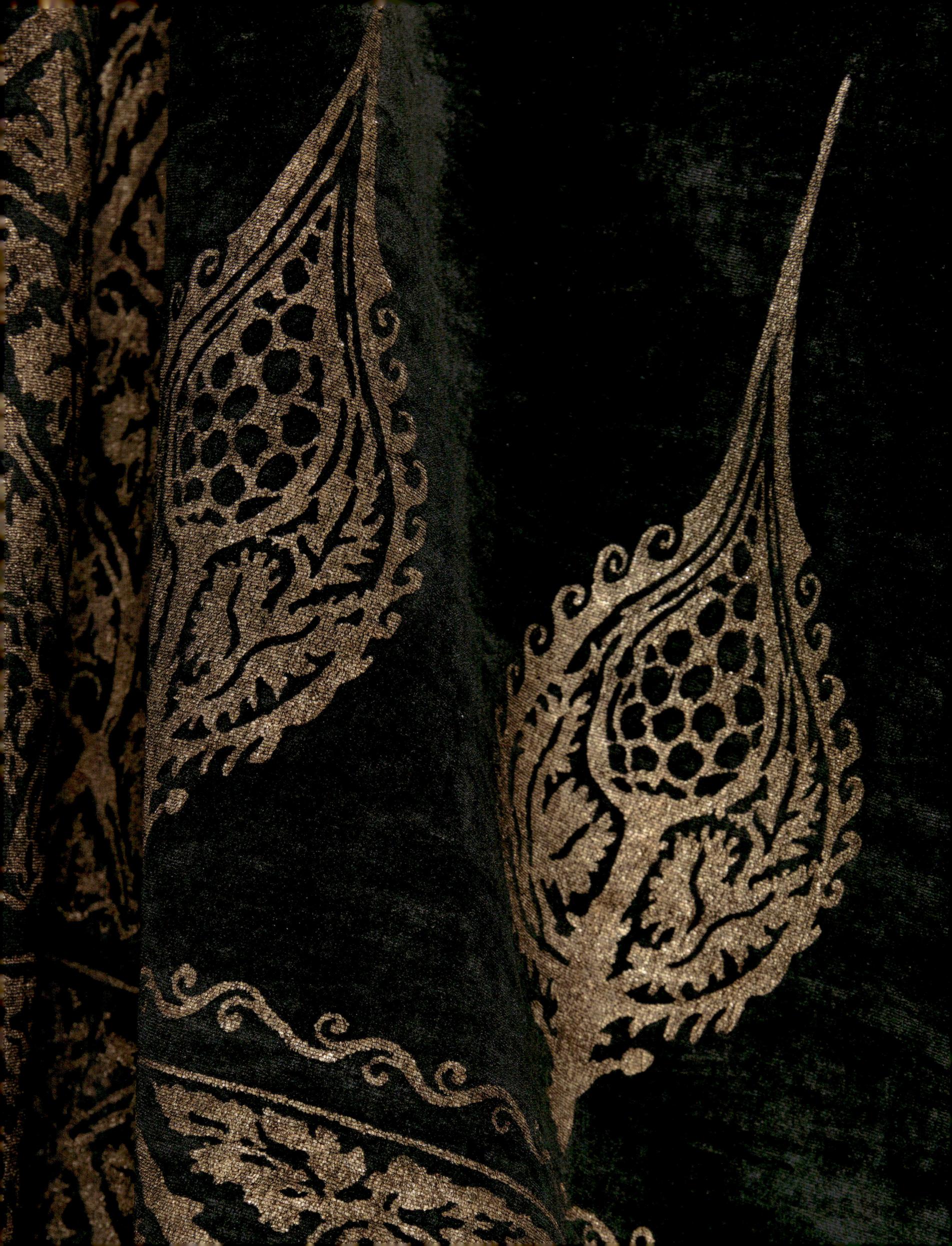

17–26

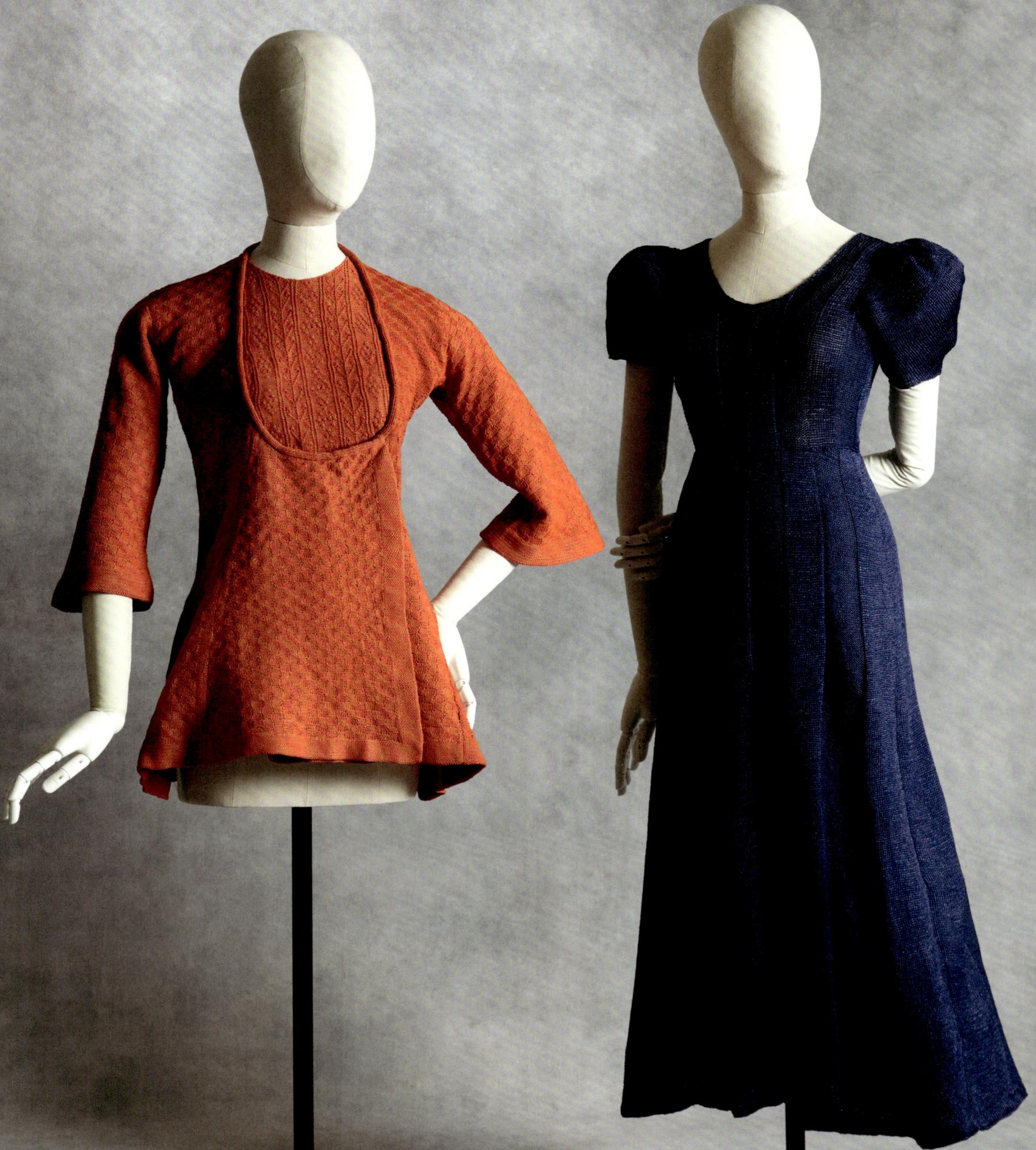

16.1. & 16.2. Denise Poiret
Angarkha-shaped knitted jacket and knitted dress, c. 1928

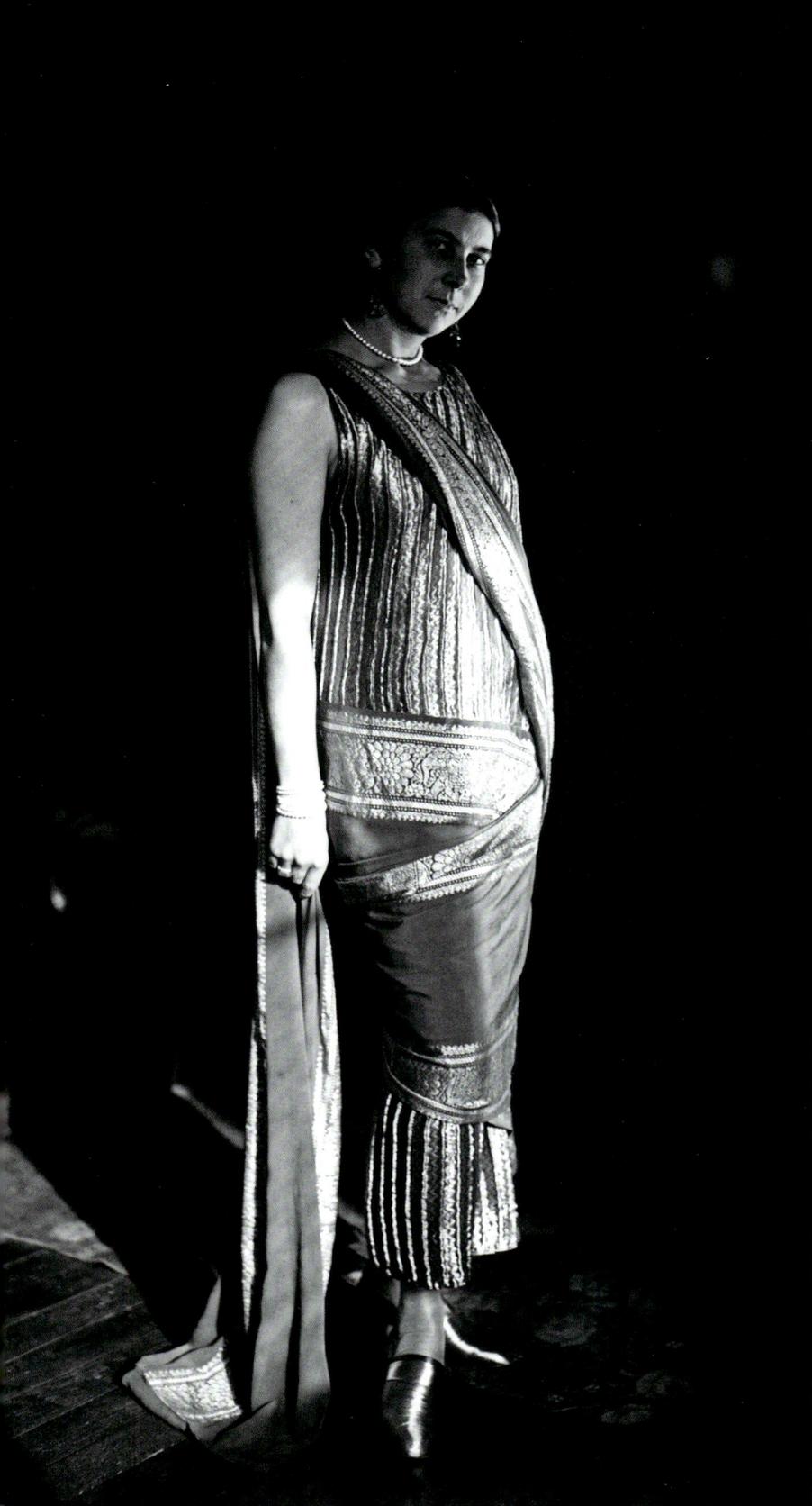

fig. 12 Denise Poiret wearing the 'Lure' evening dress, 1924

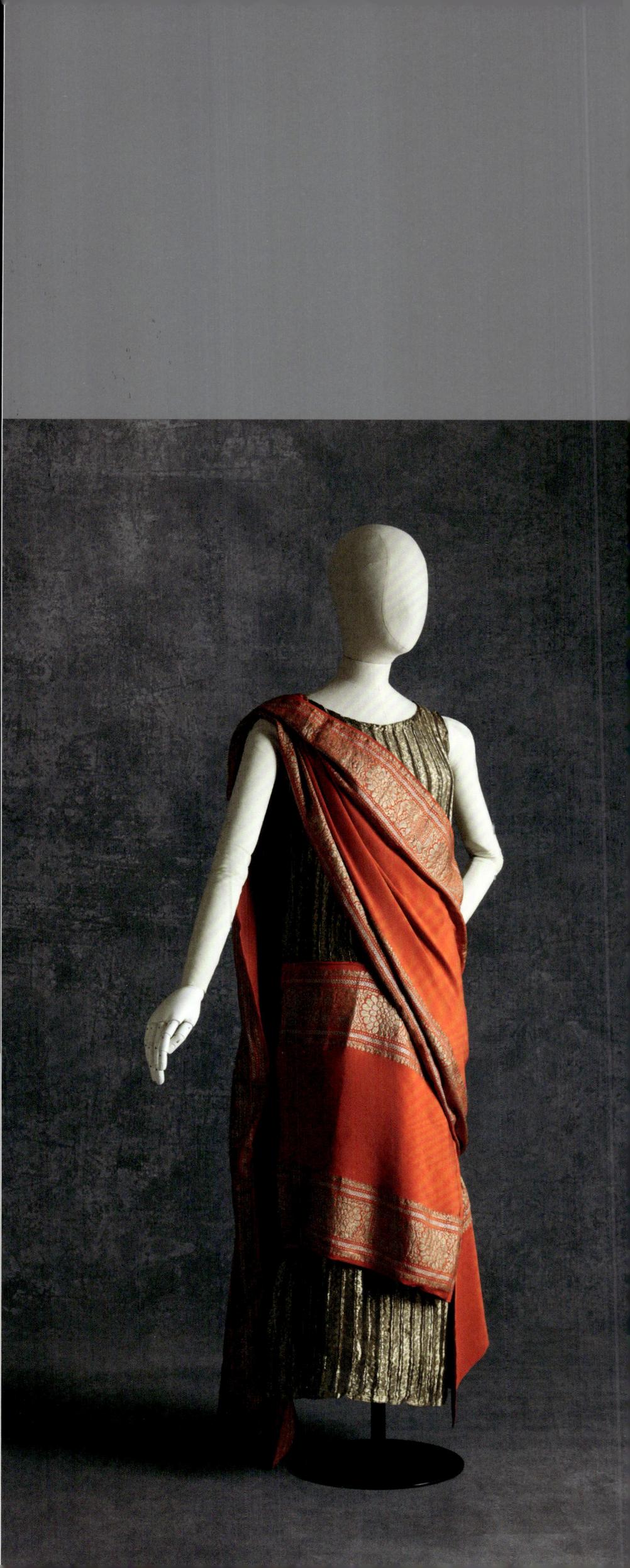

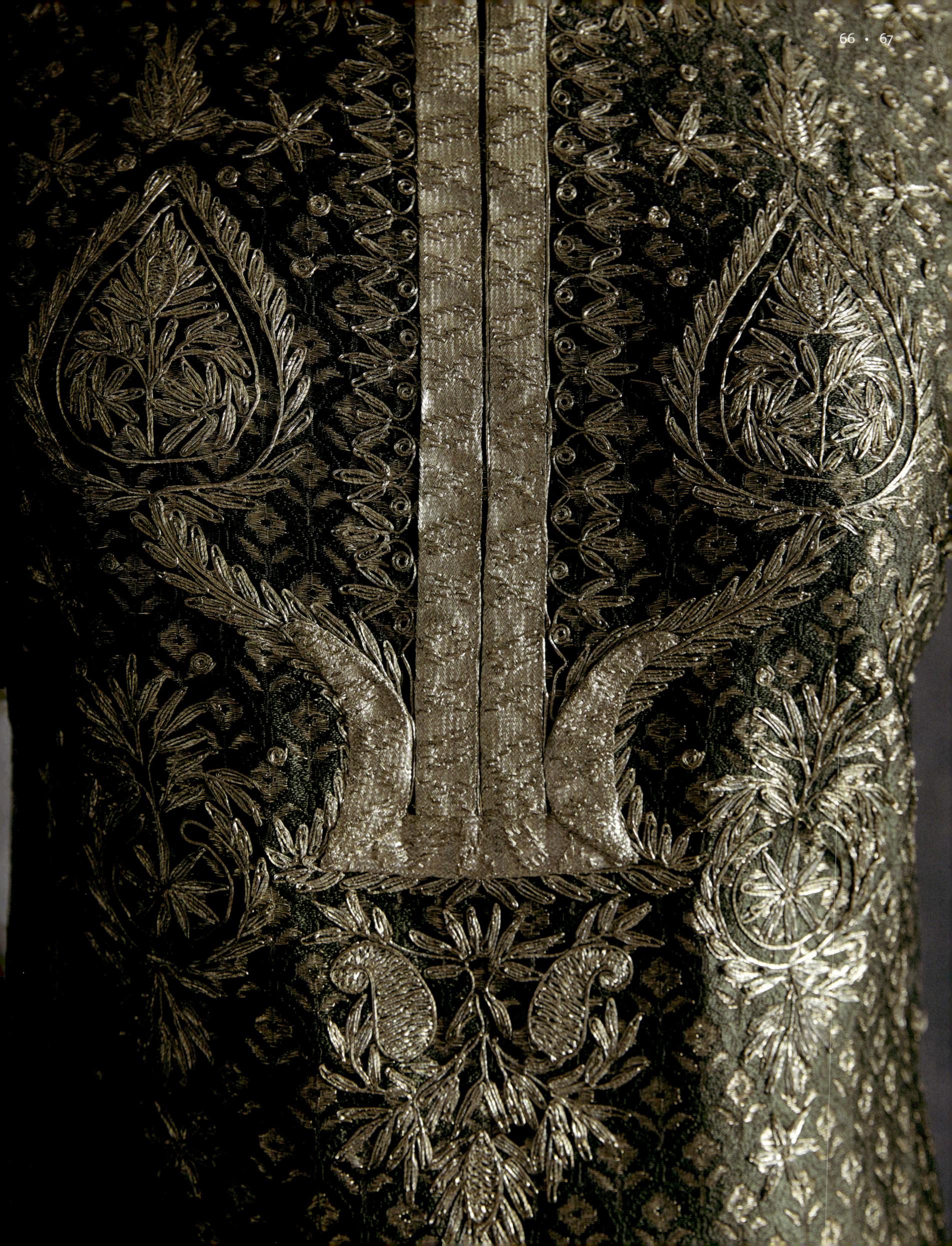

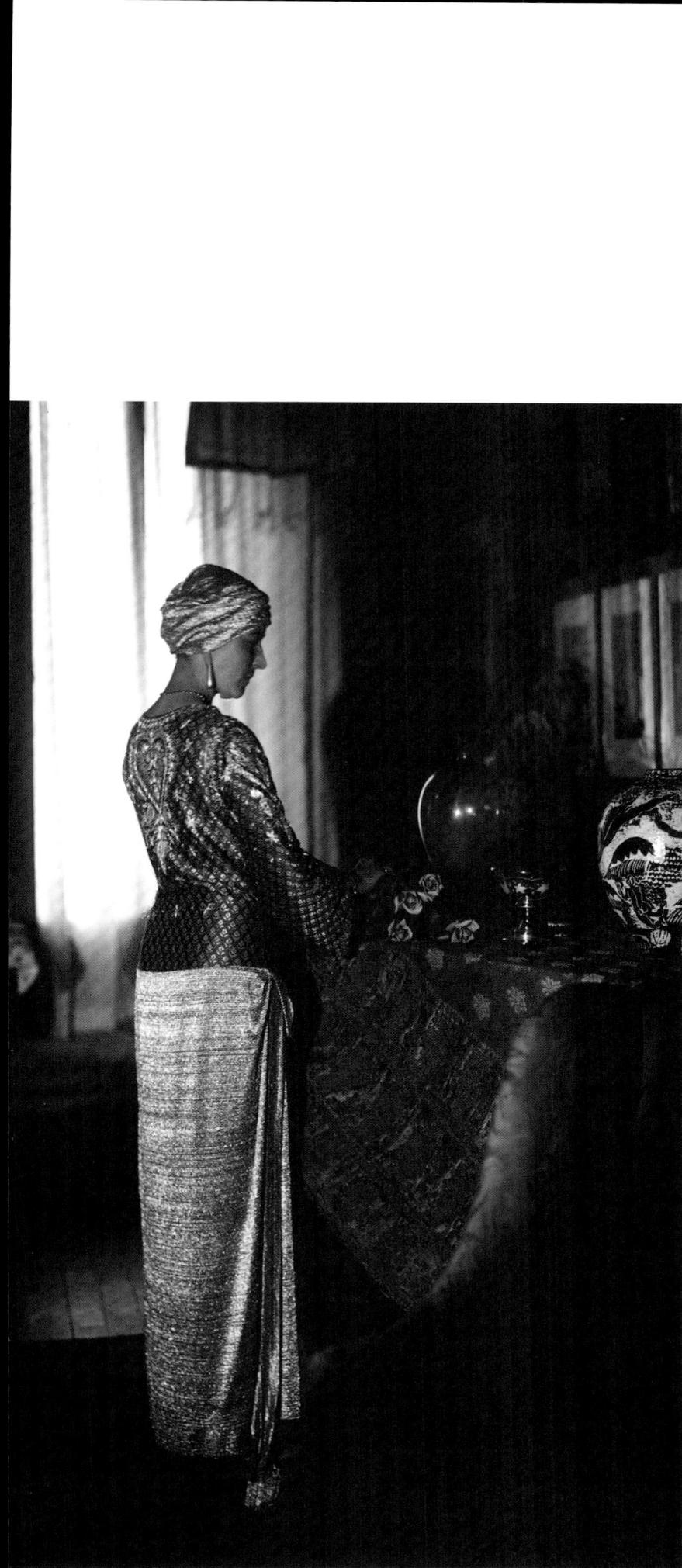

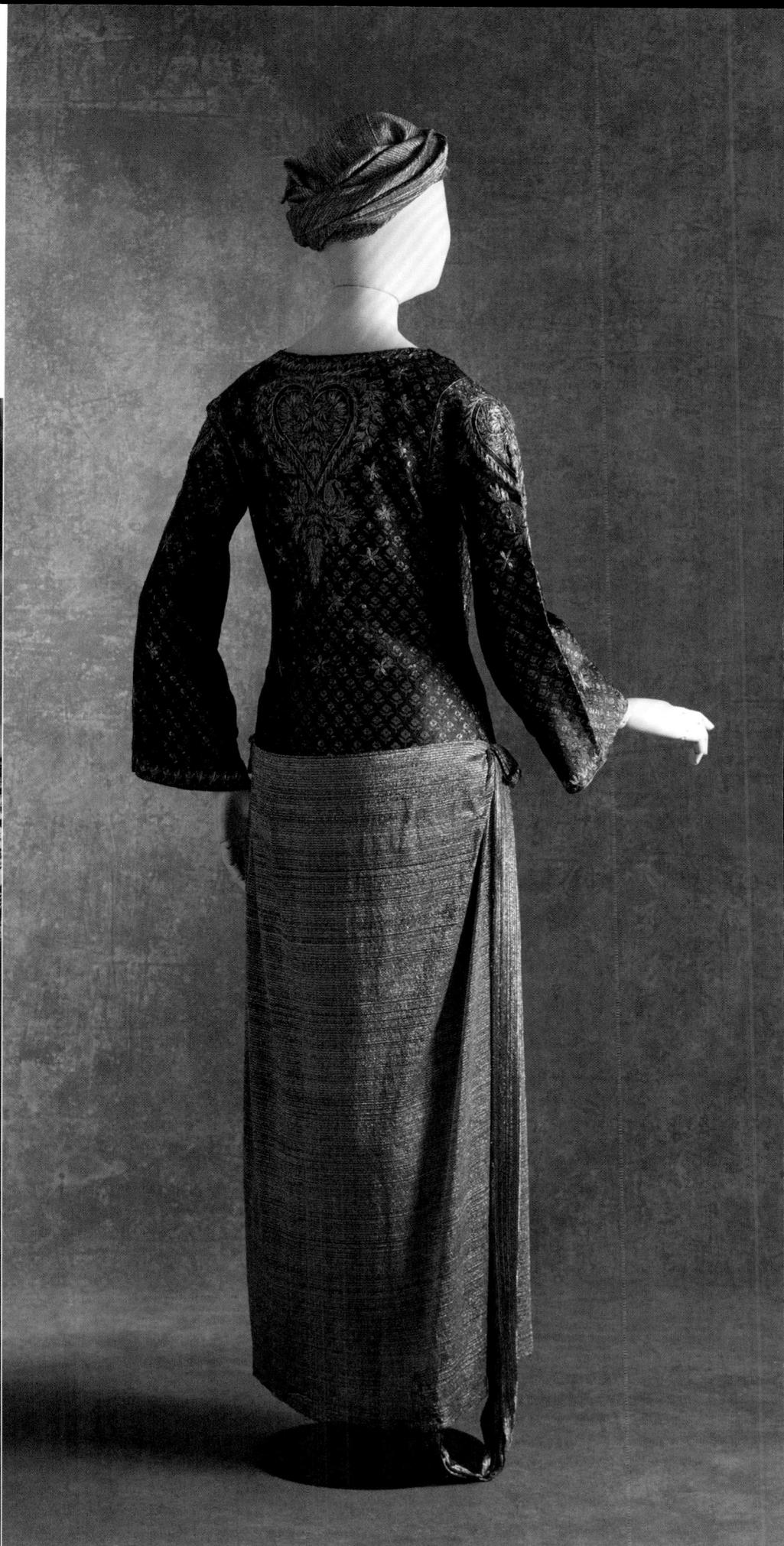

fig. 11 Denise Poiret wearing the 'Persane' evening dress
and turban, c. 1923

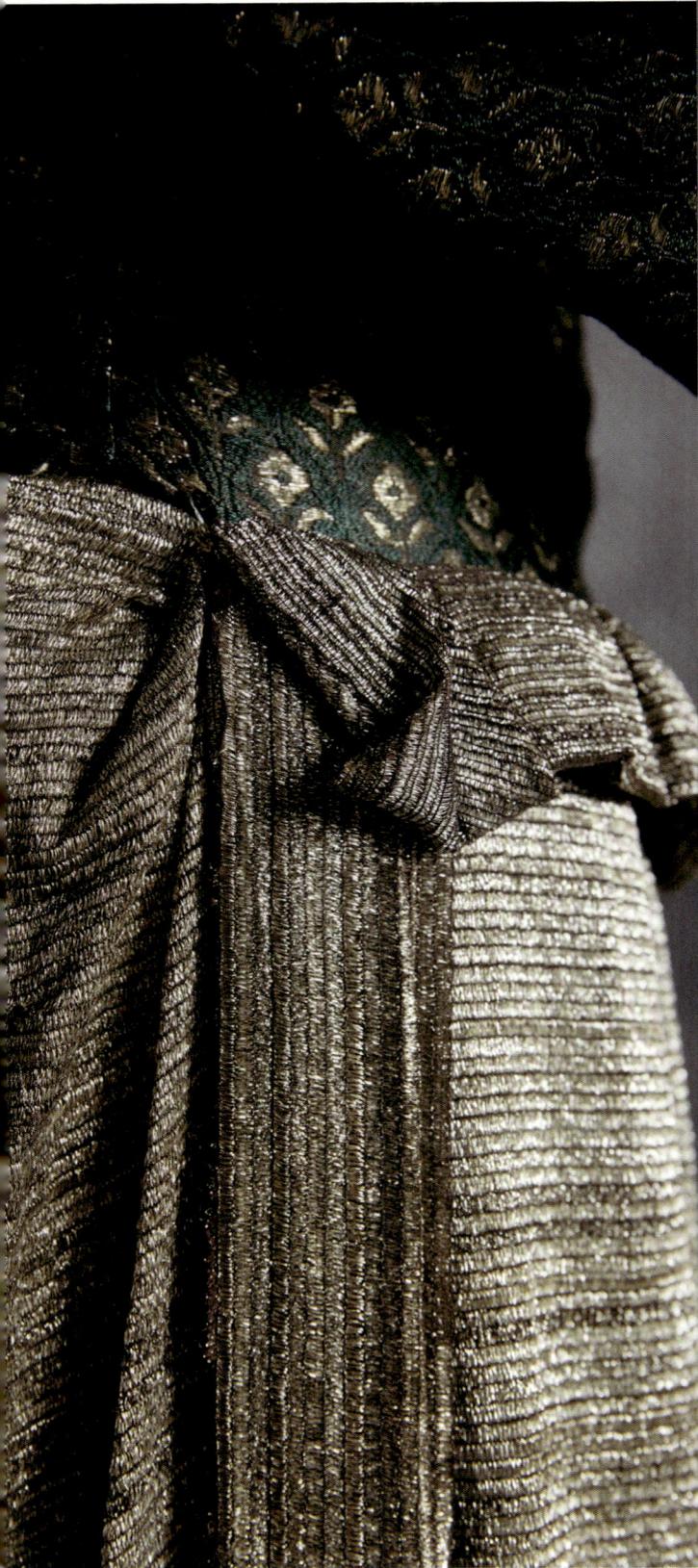

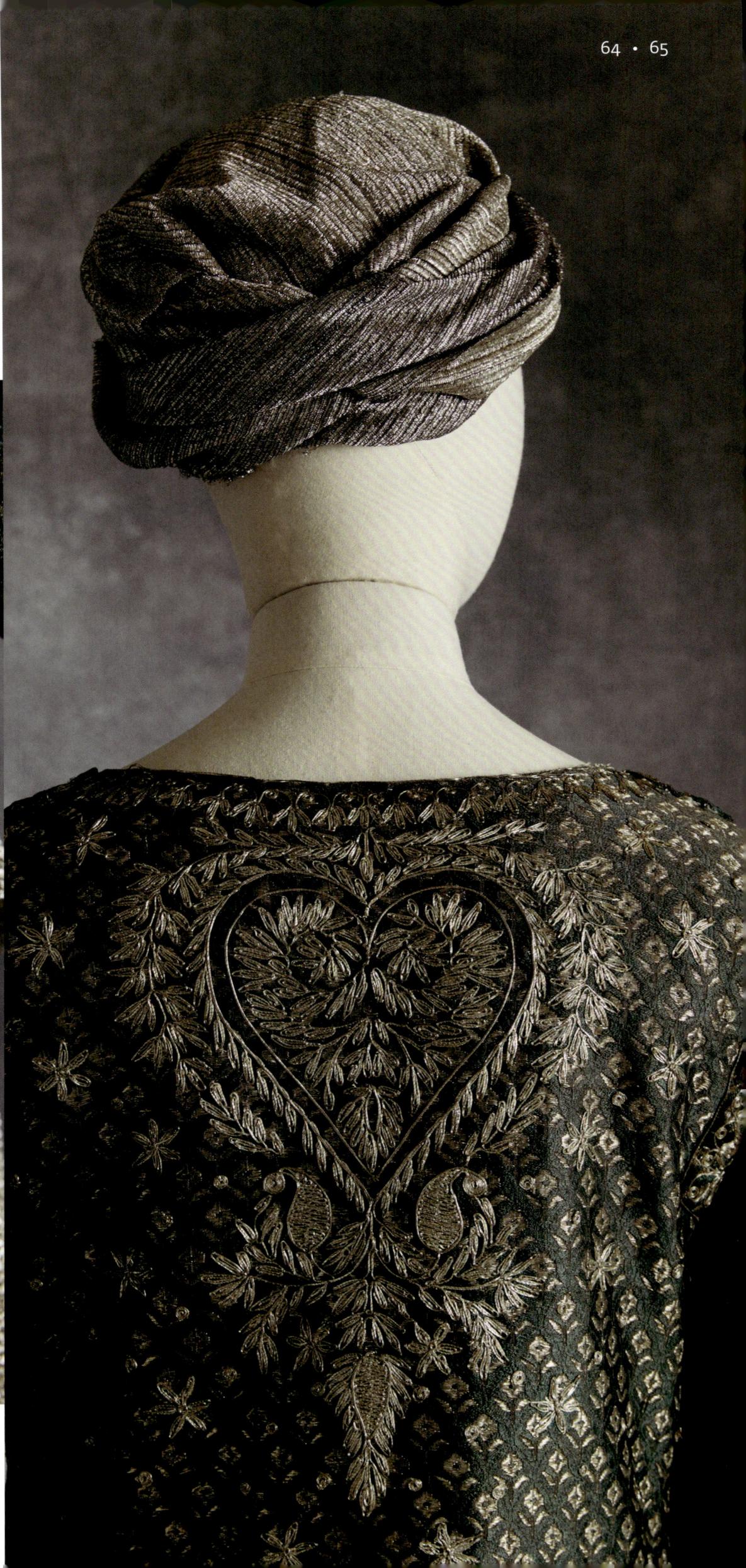

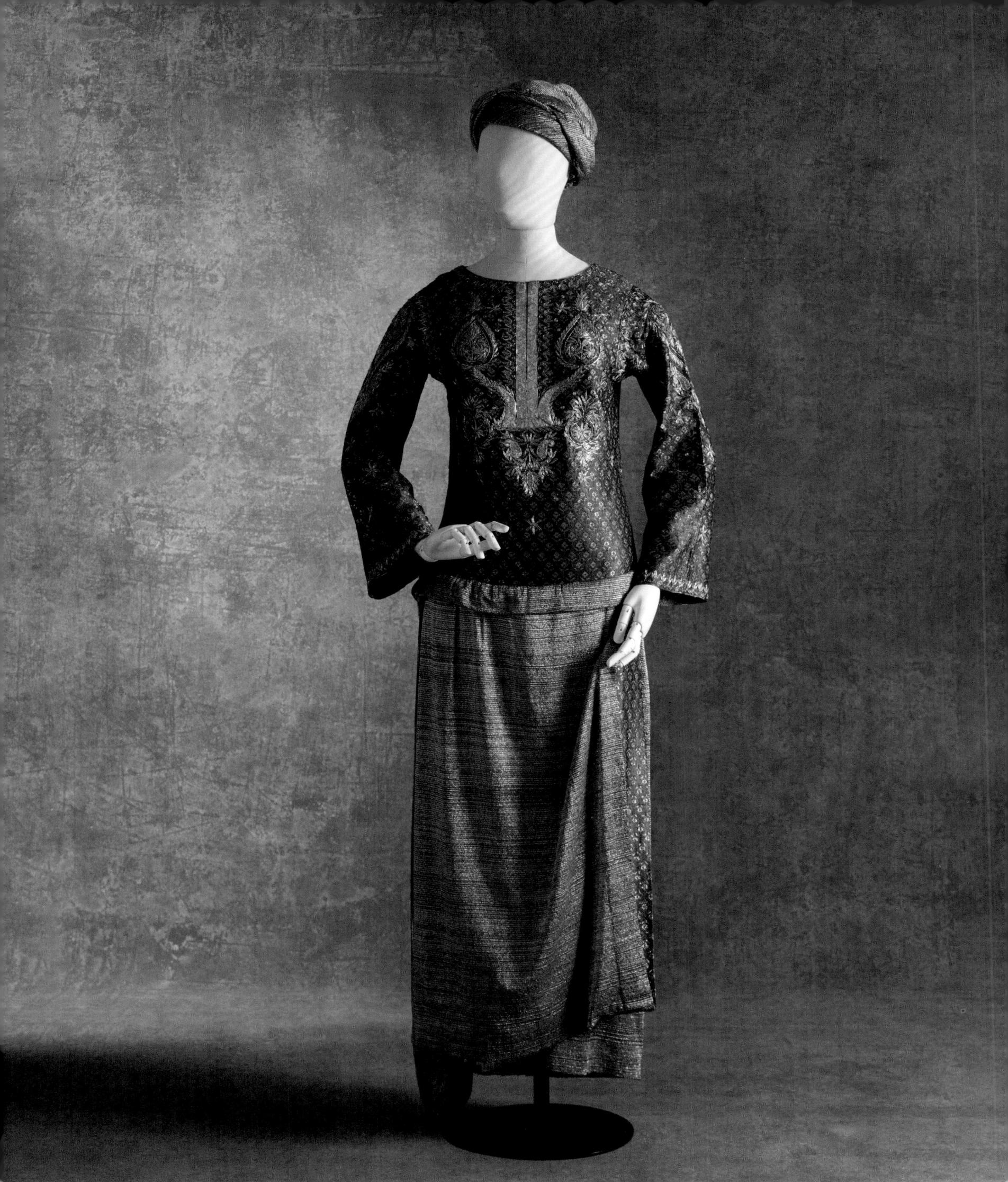

14. Paul Poiret Evening dress and turban, 'Sérail' or 'Persane', Spring/Summer 1923

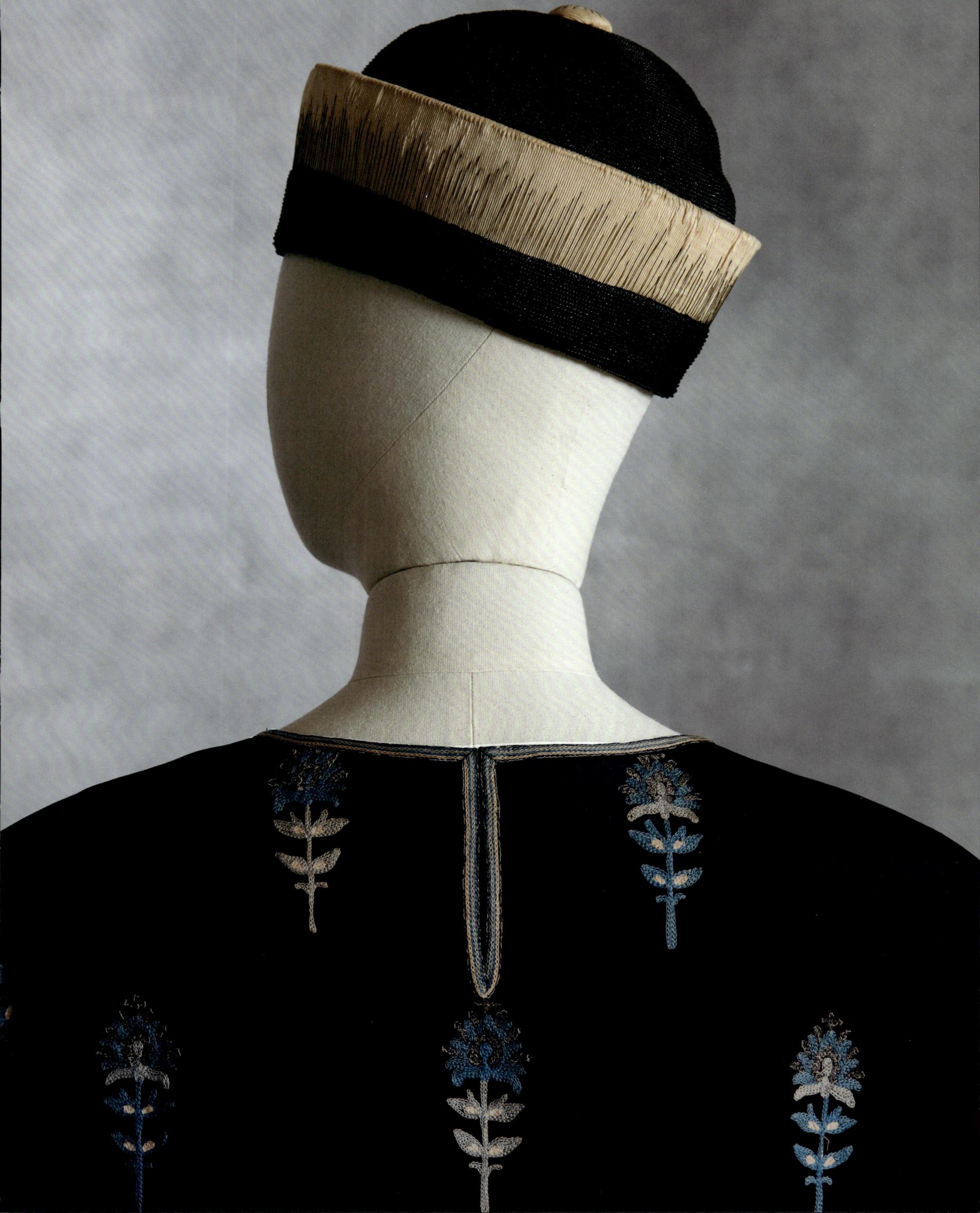

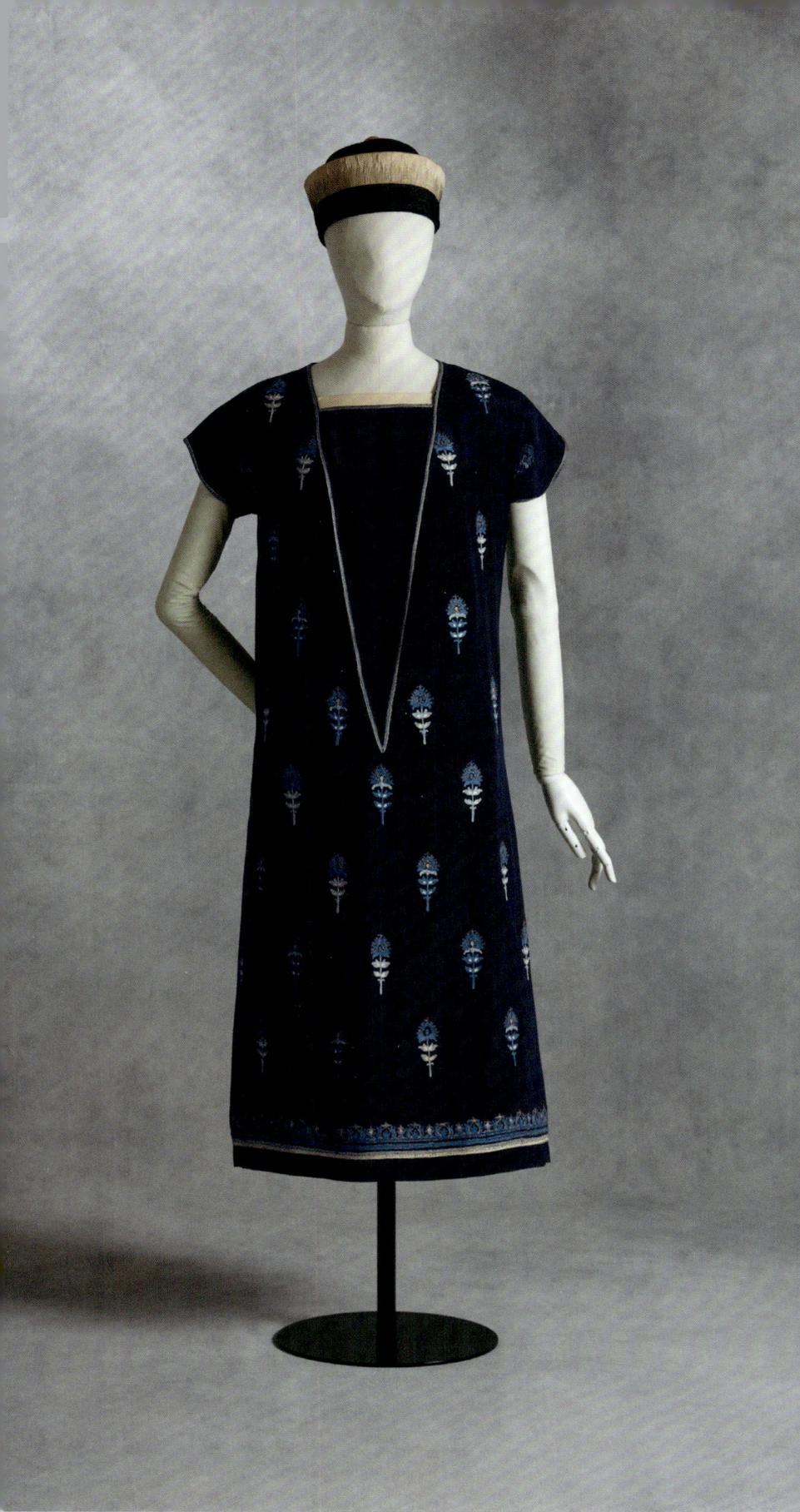

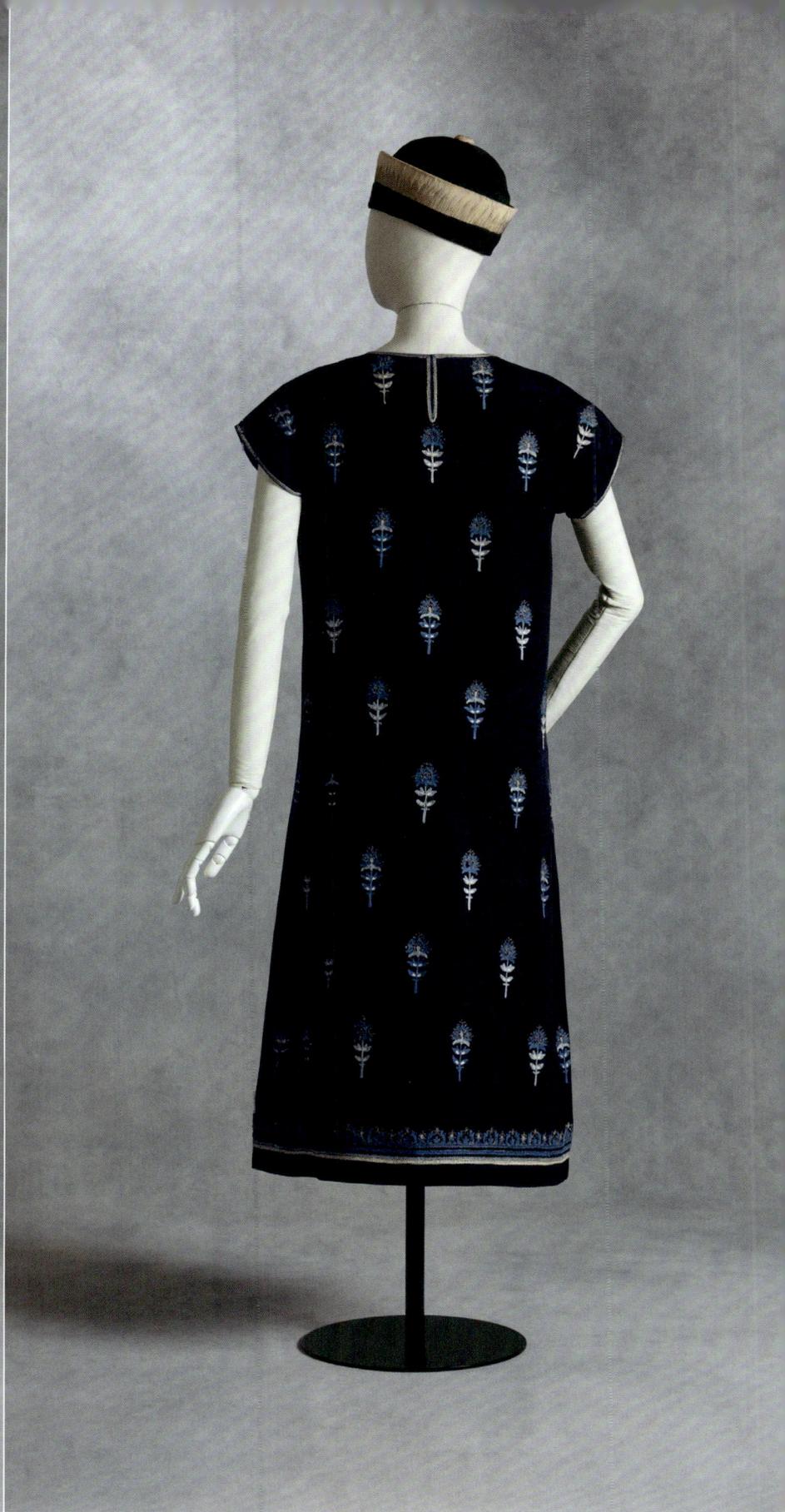

13. Paul Poiret Day dress, 'Indiana' and matching hat, 1922

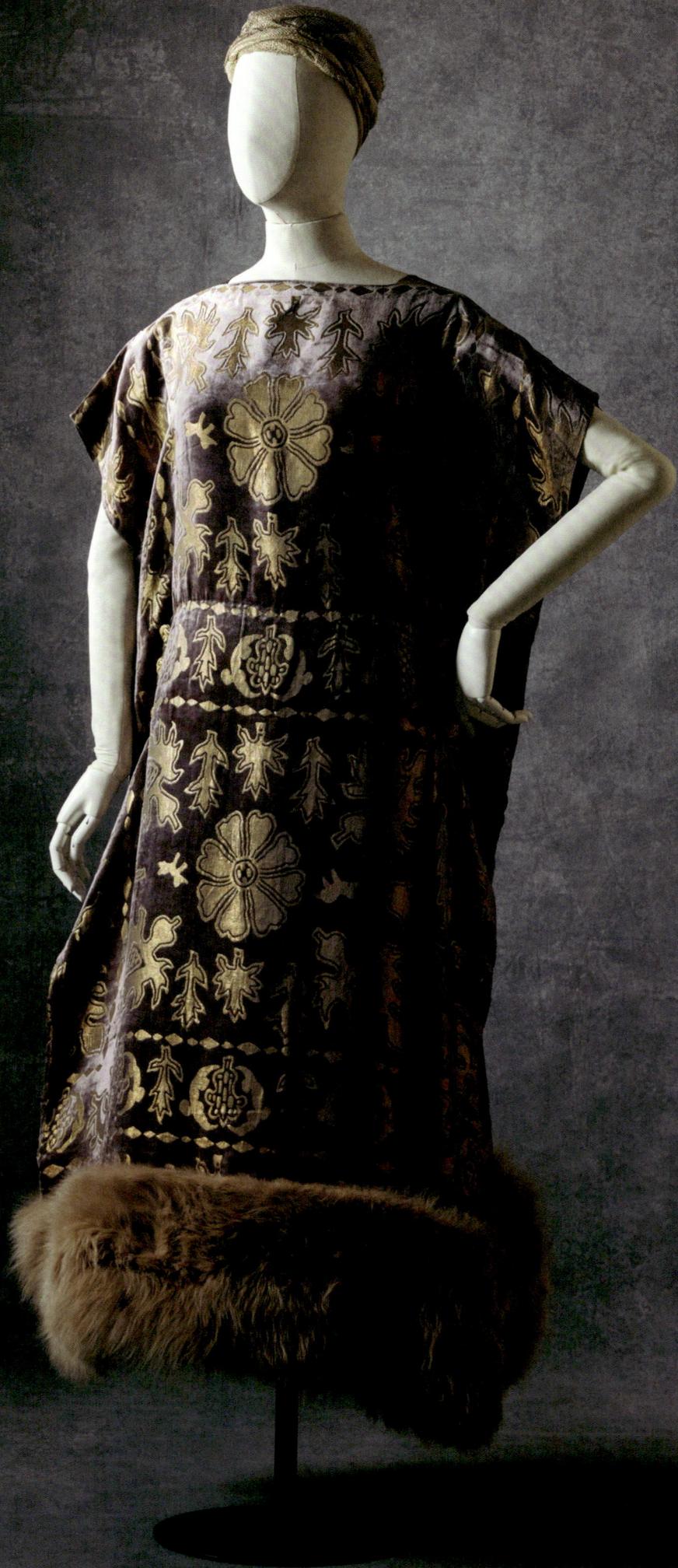

12. Paul Poiret Dress, 'Mosaïque', Autumn/Winter 1921 and metallic head wrap, 1910s–20s

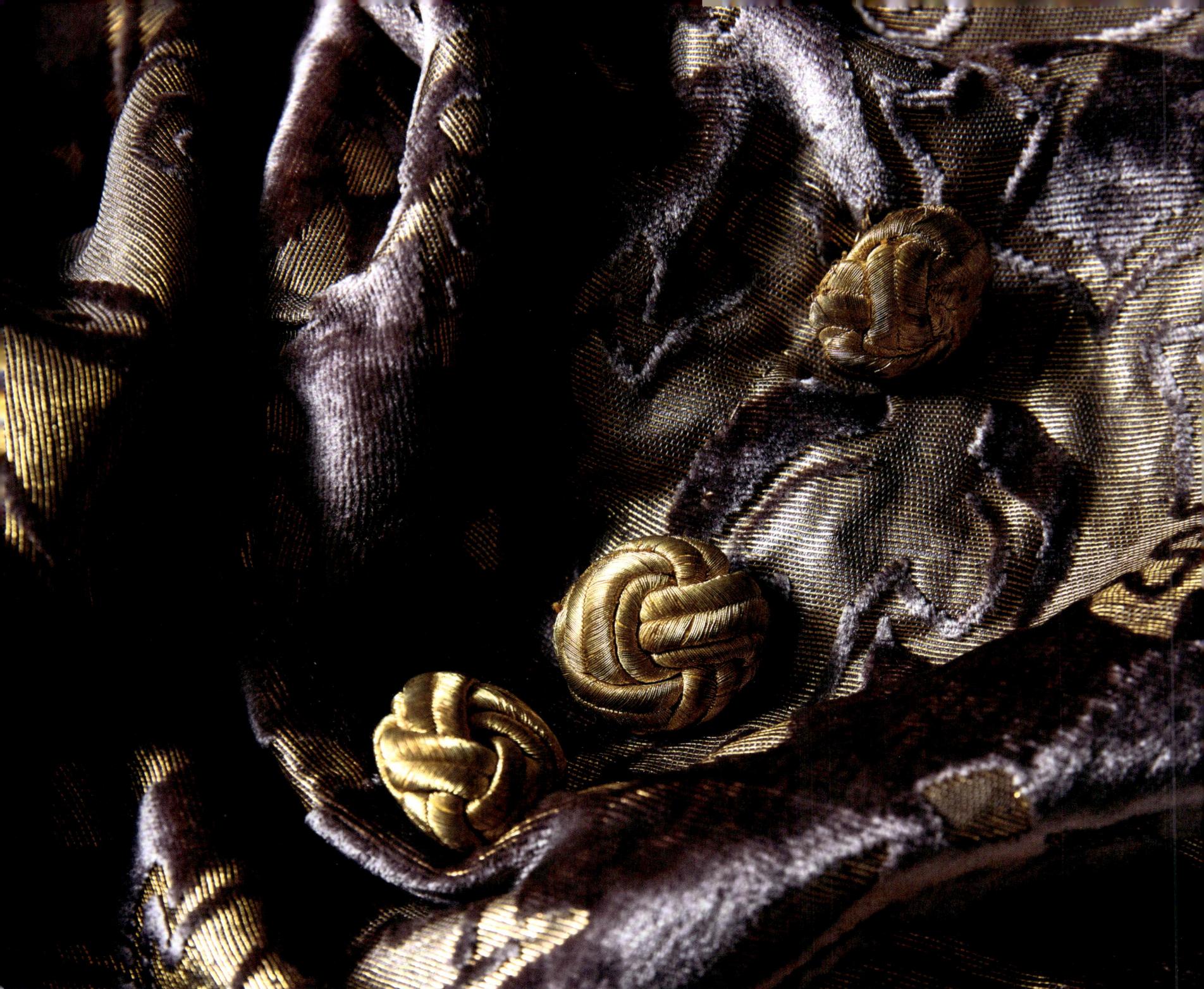

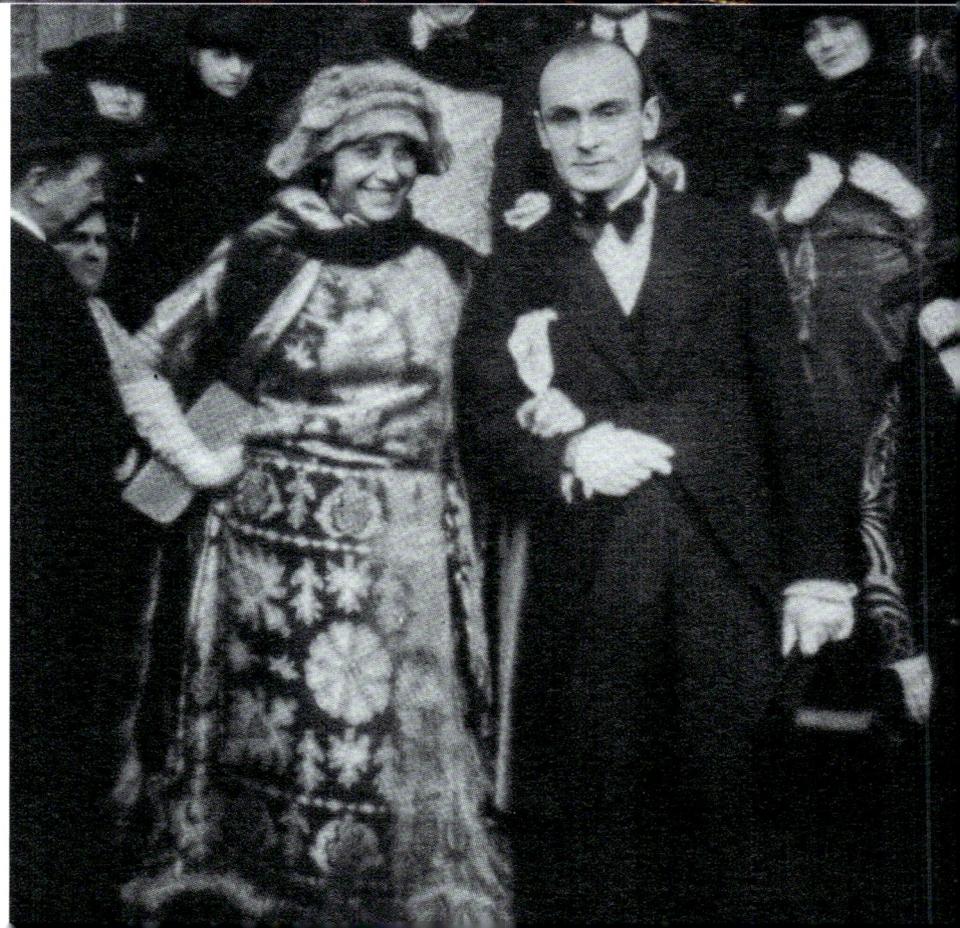

fig.10 Denise Poiret wearing the 'Mosaïque' dress at the
wedding of Paul Poiret's niece, 1921

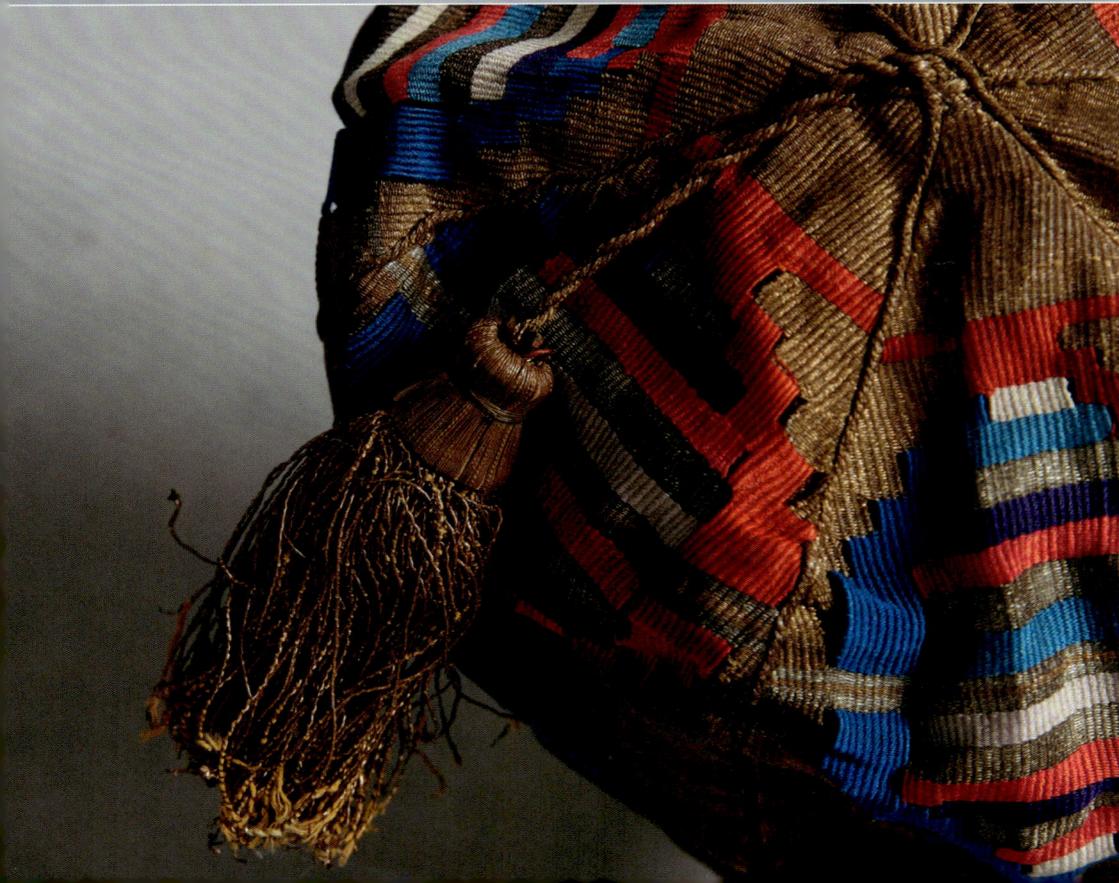

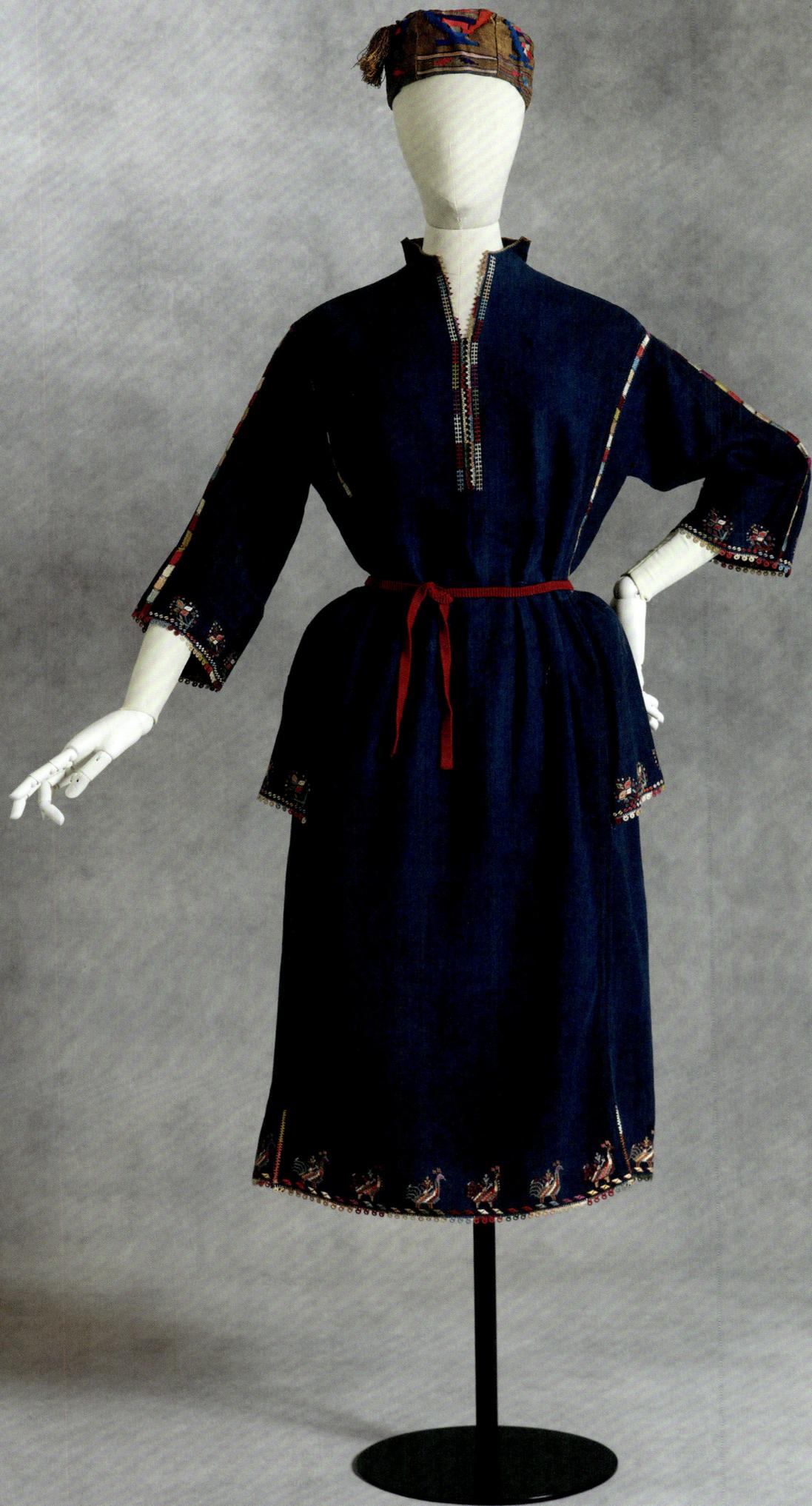

11. Paul Poiret Dress, c. 1920. Cap, Middle Eastern, c. 1900

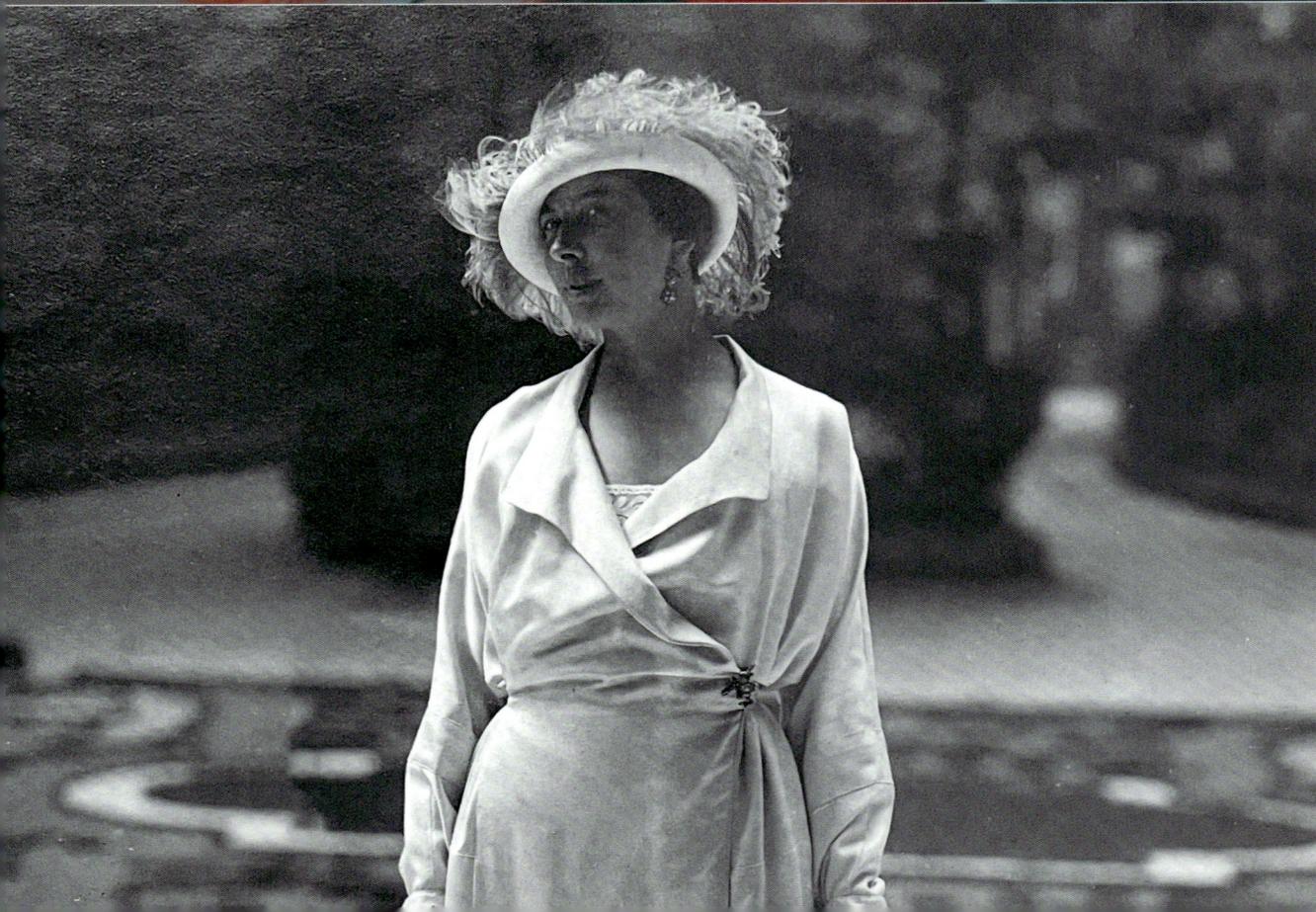

fig. 9 Denise Poiret wearing the 'Trocadéro' hat, 1920

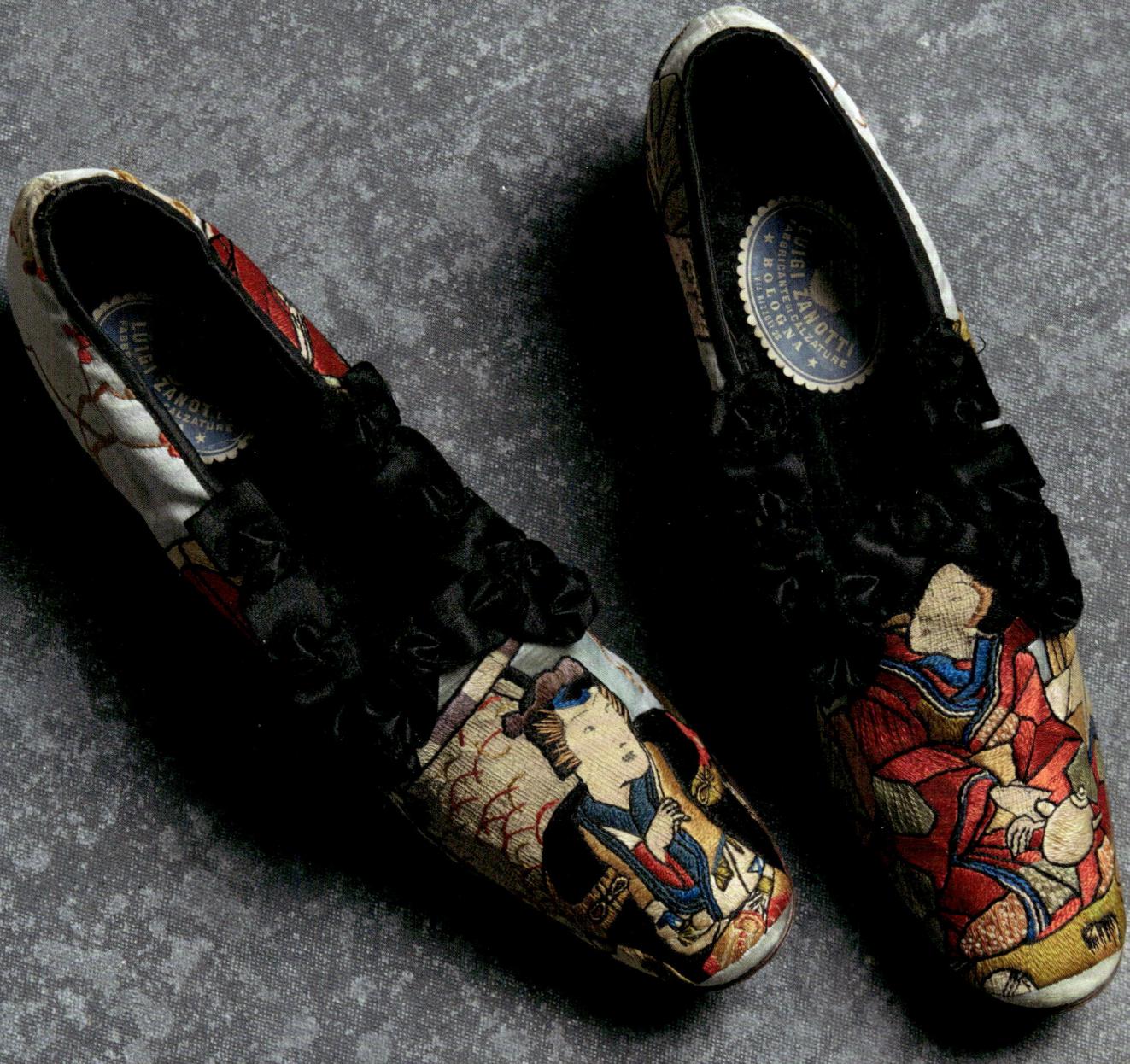

22. Luigi Zanotti Shoes covered in Japanese embroidered silk, Italian, c. 1875

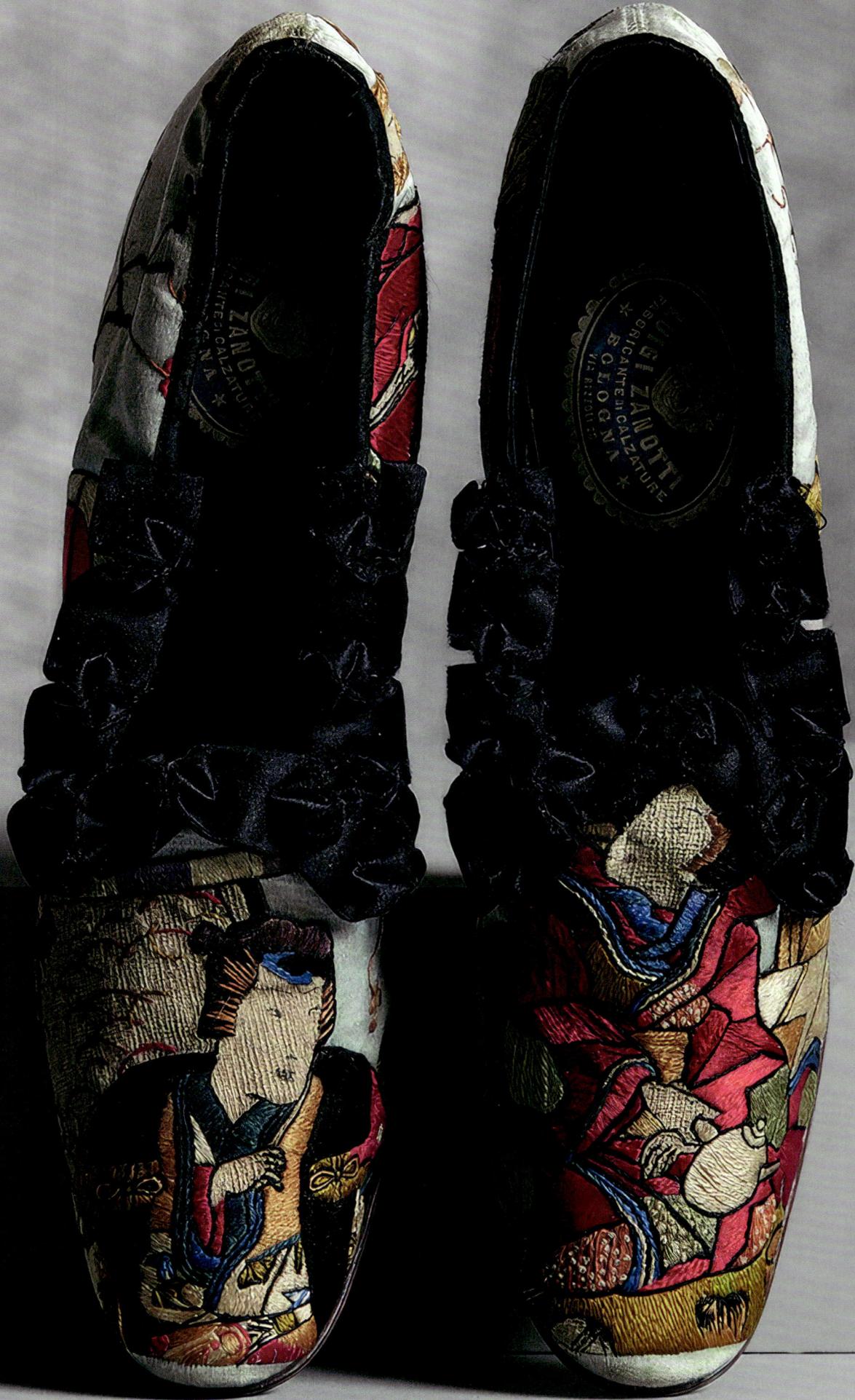

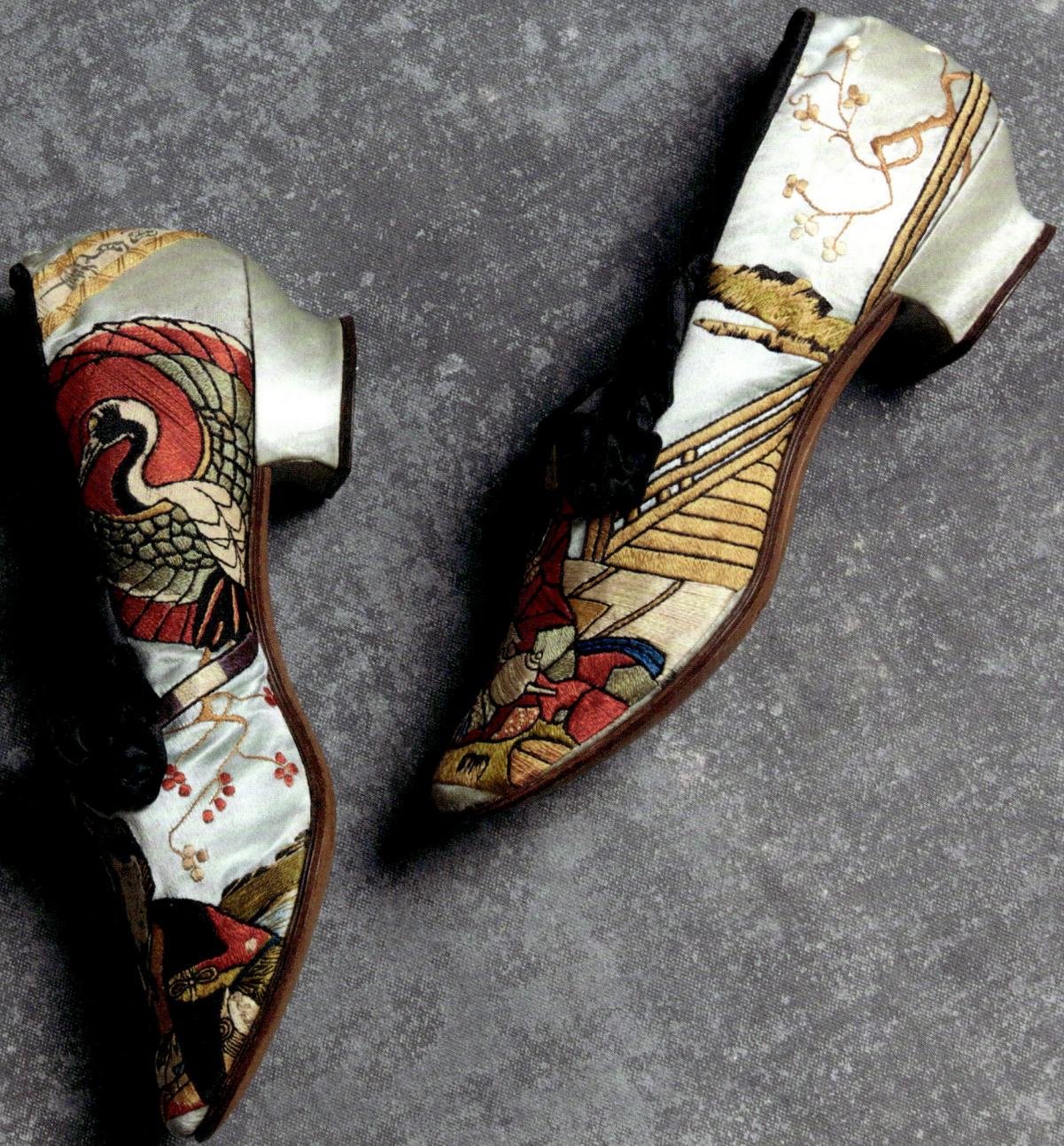

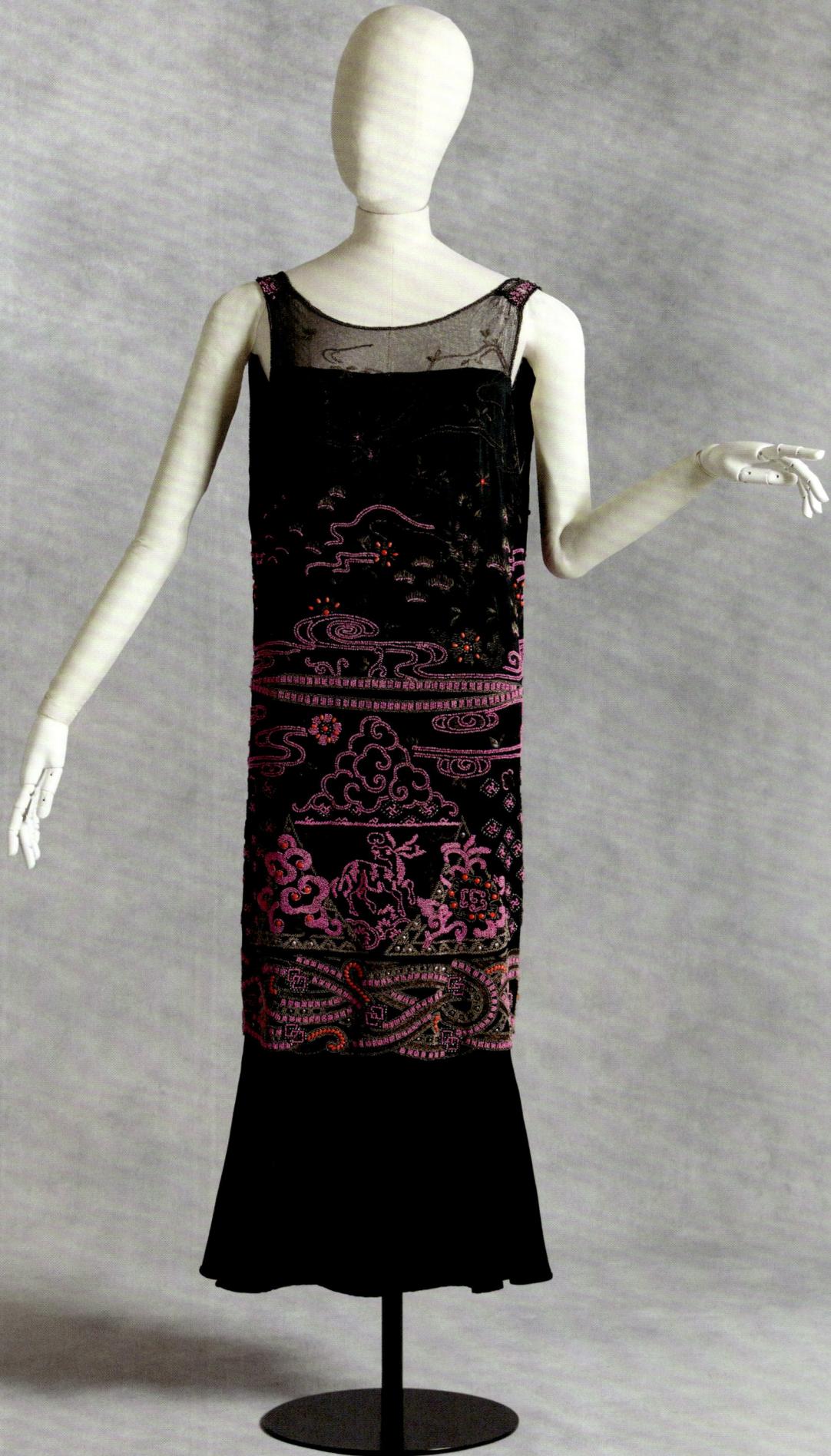

23. Jean Patou Evening dress, 'Nuit de Chine', 1923

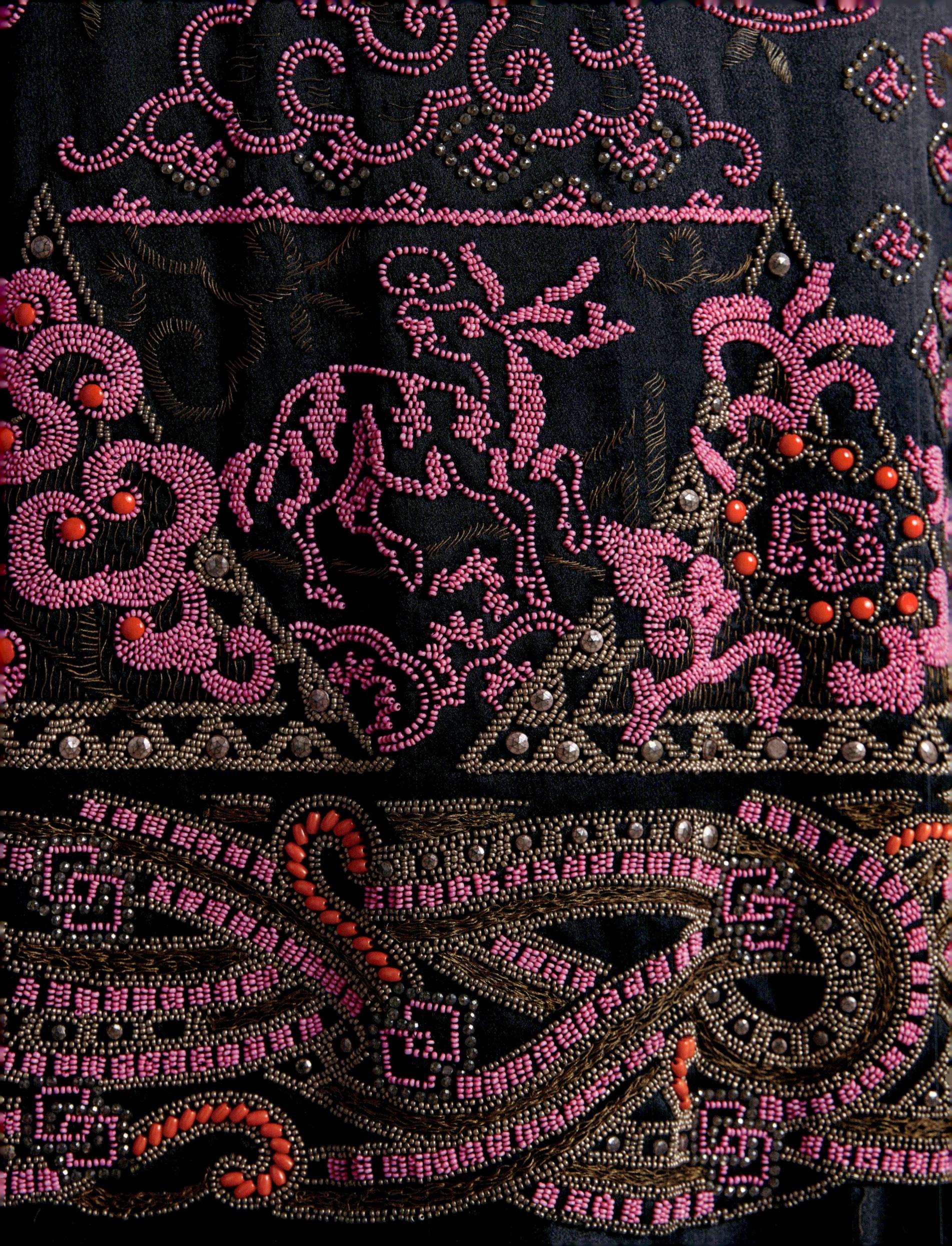

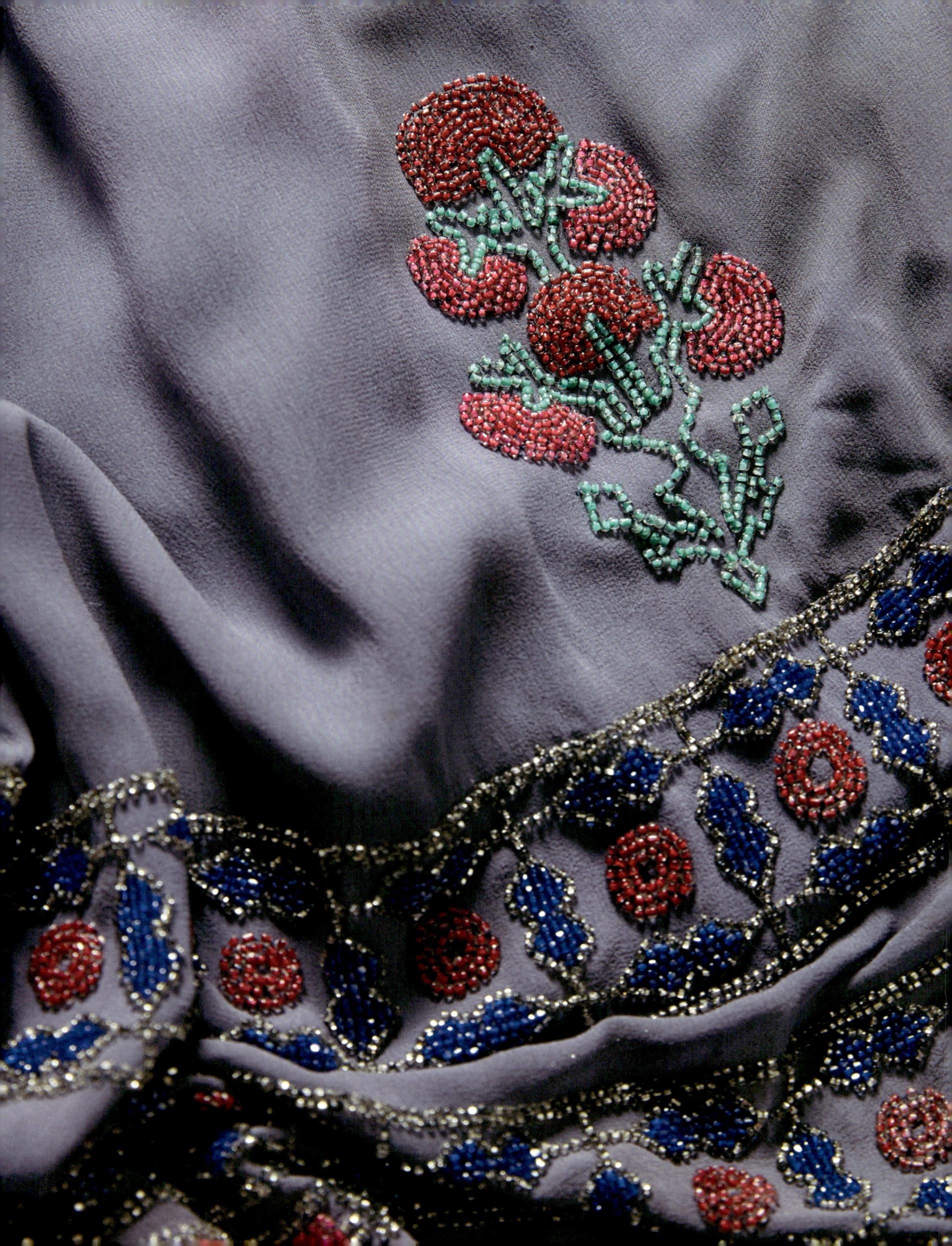

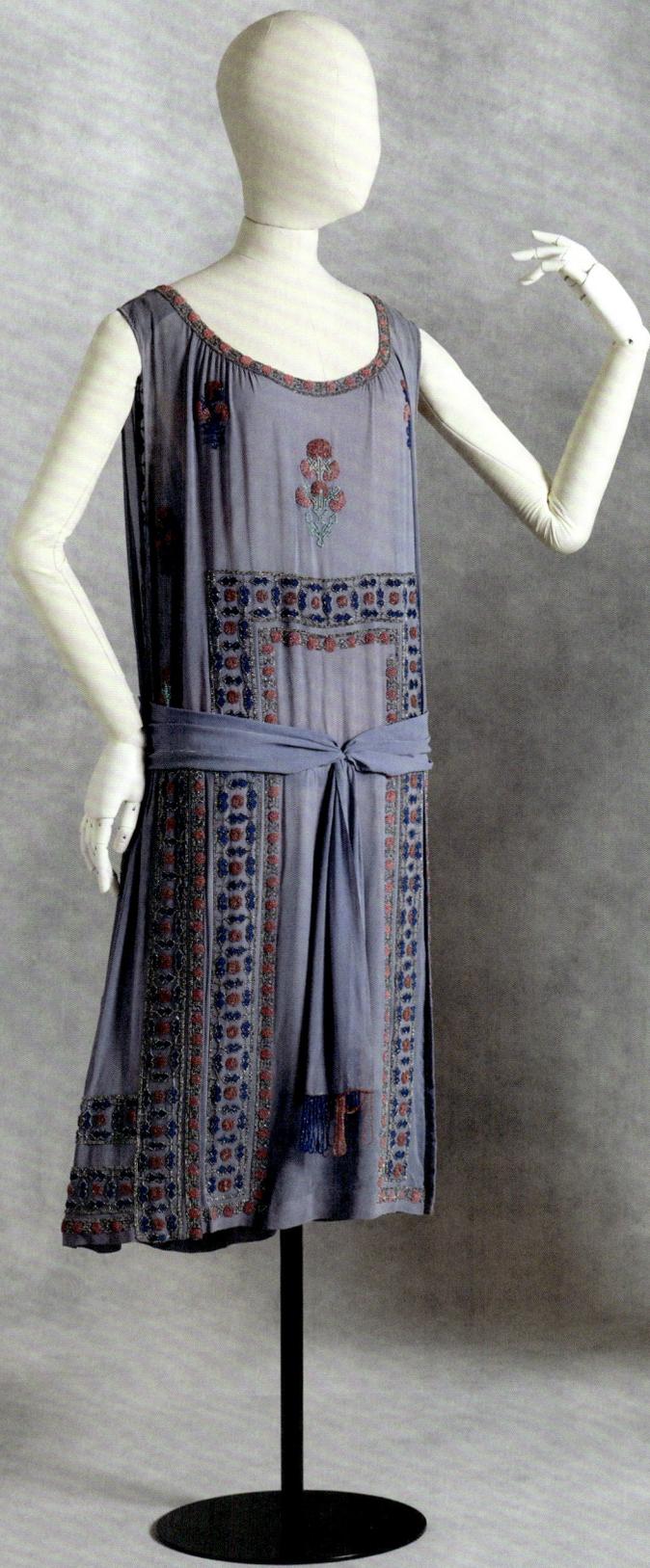

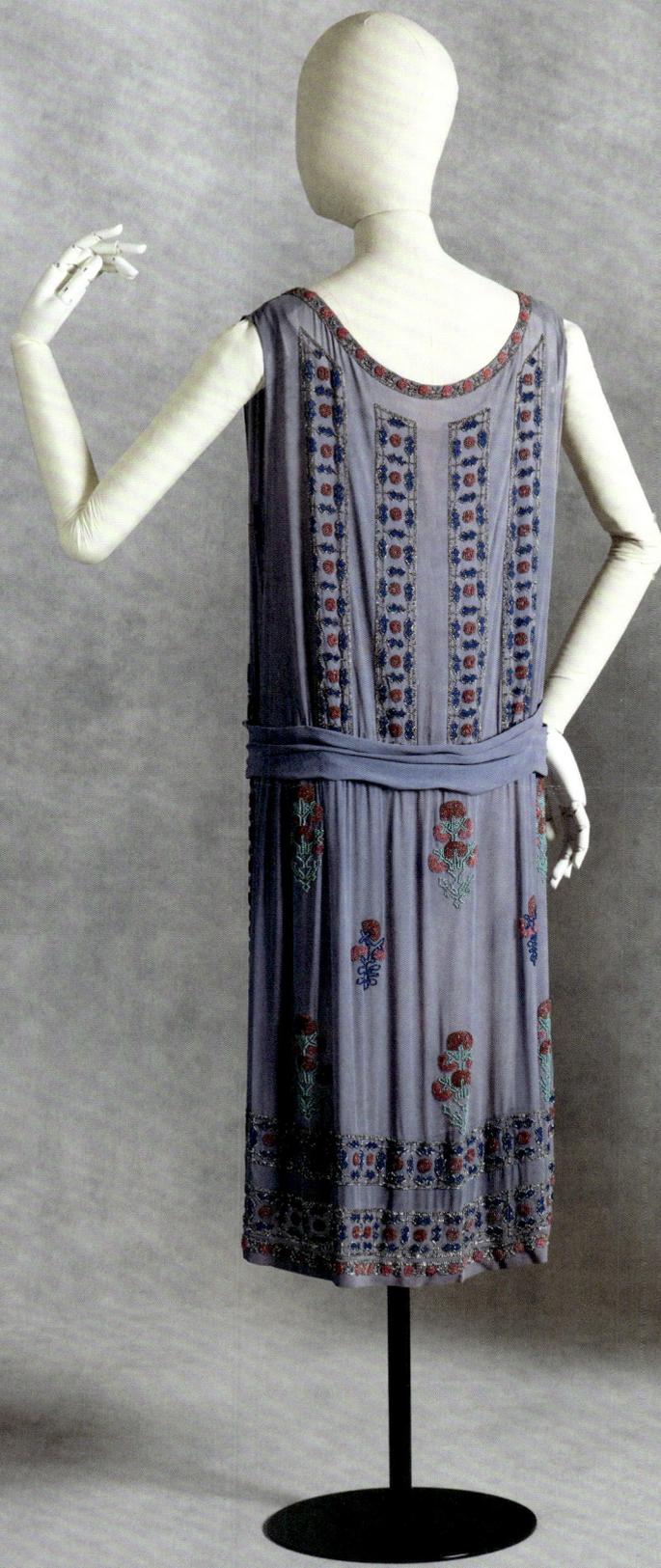

24. Jean Patou Evening dress, 'Musardise', 1923

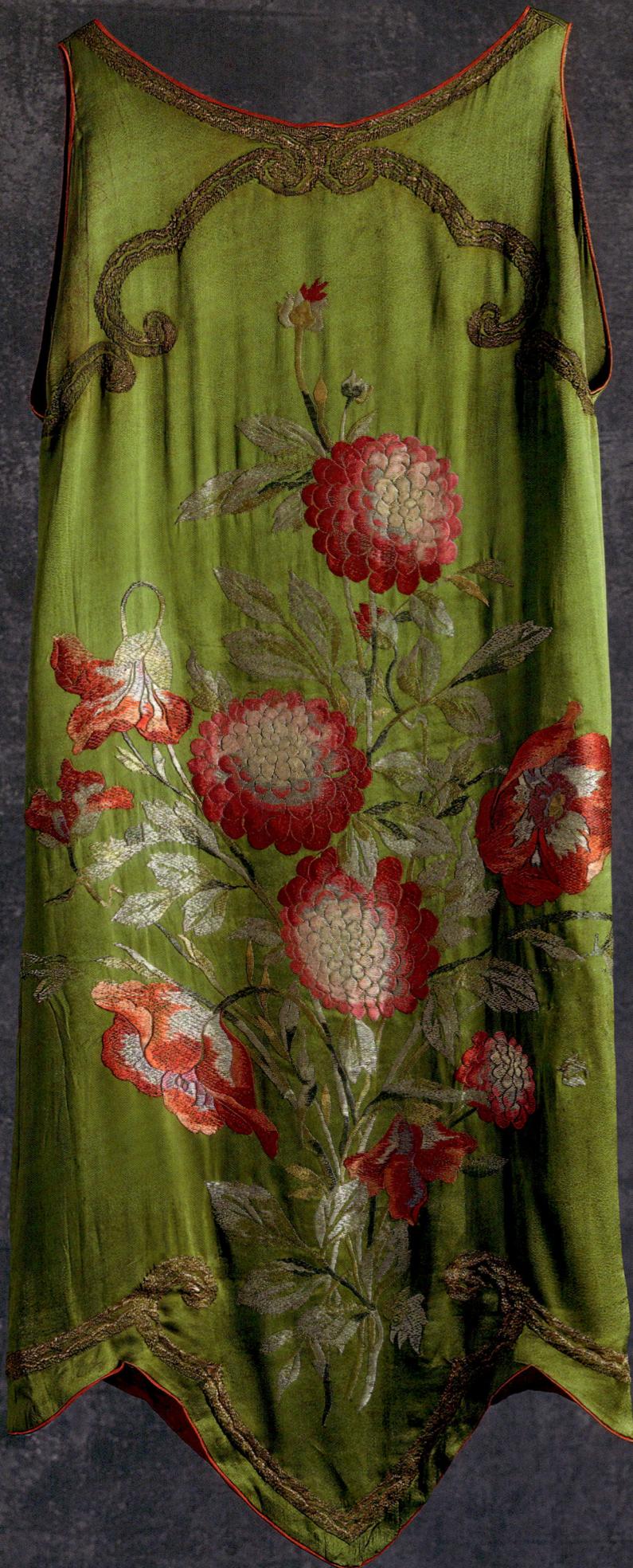

25. Callot Sœurs Evening dress, c. 1925

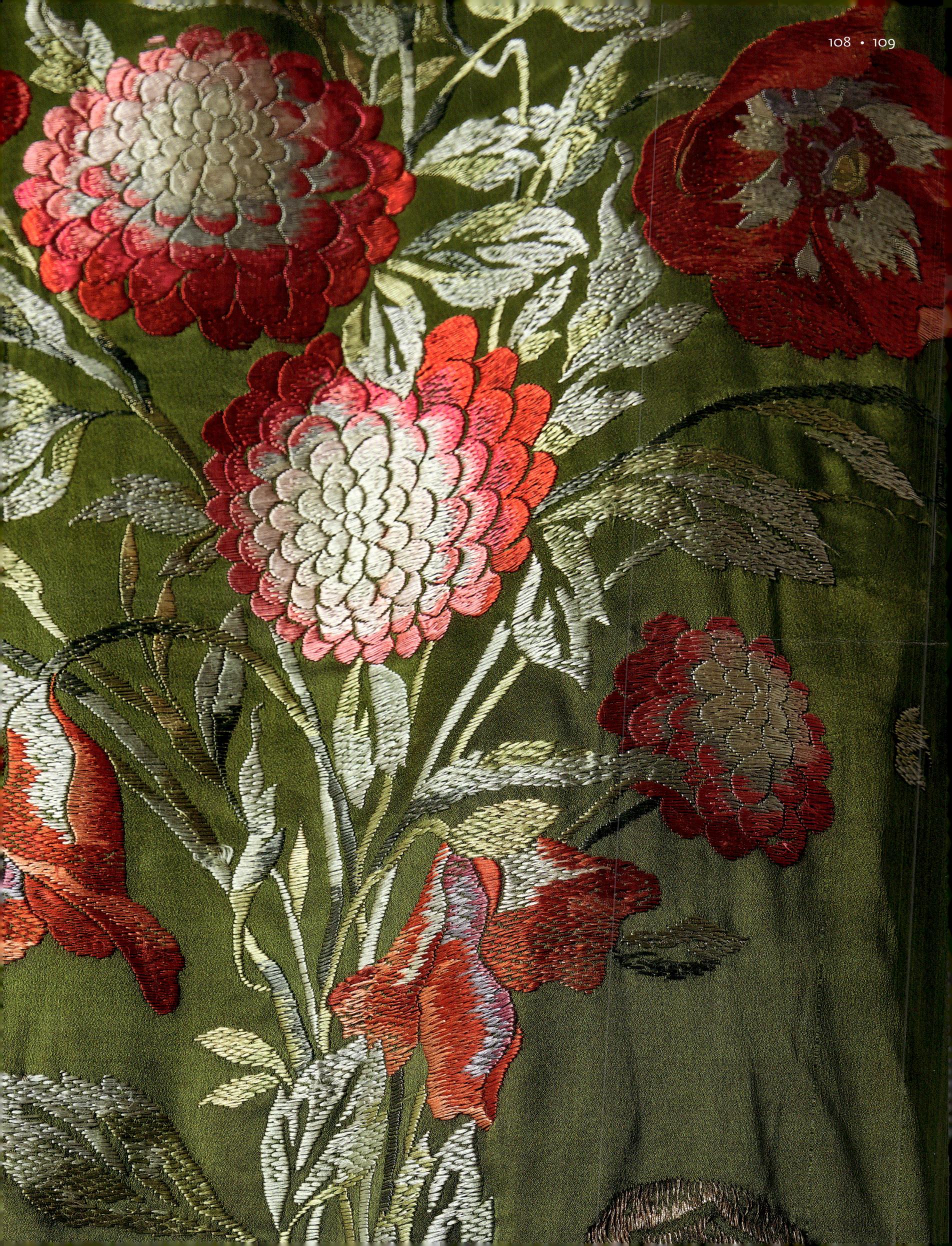

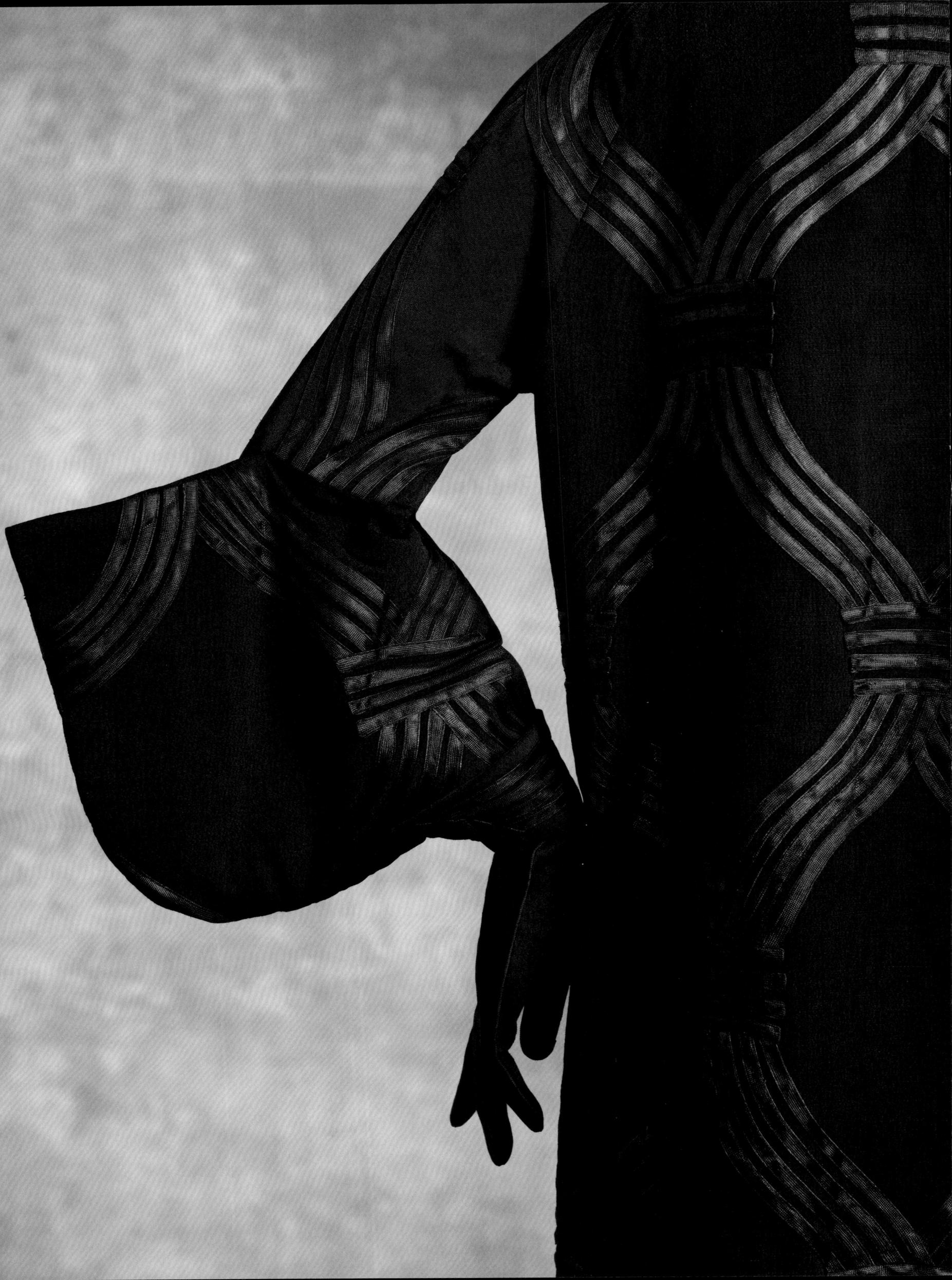

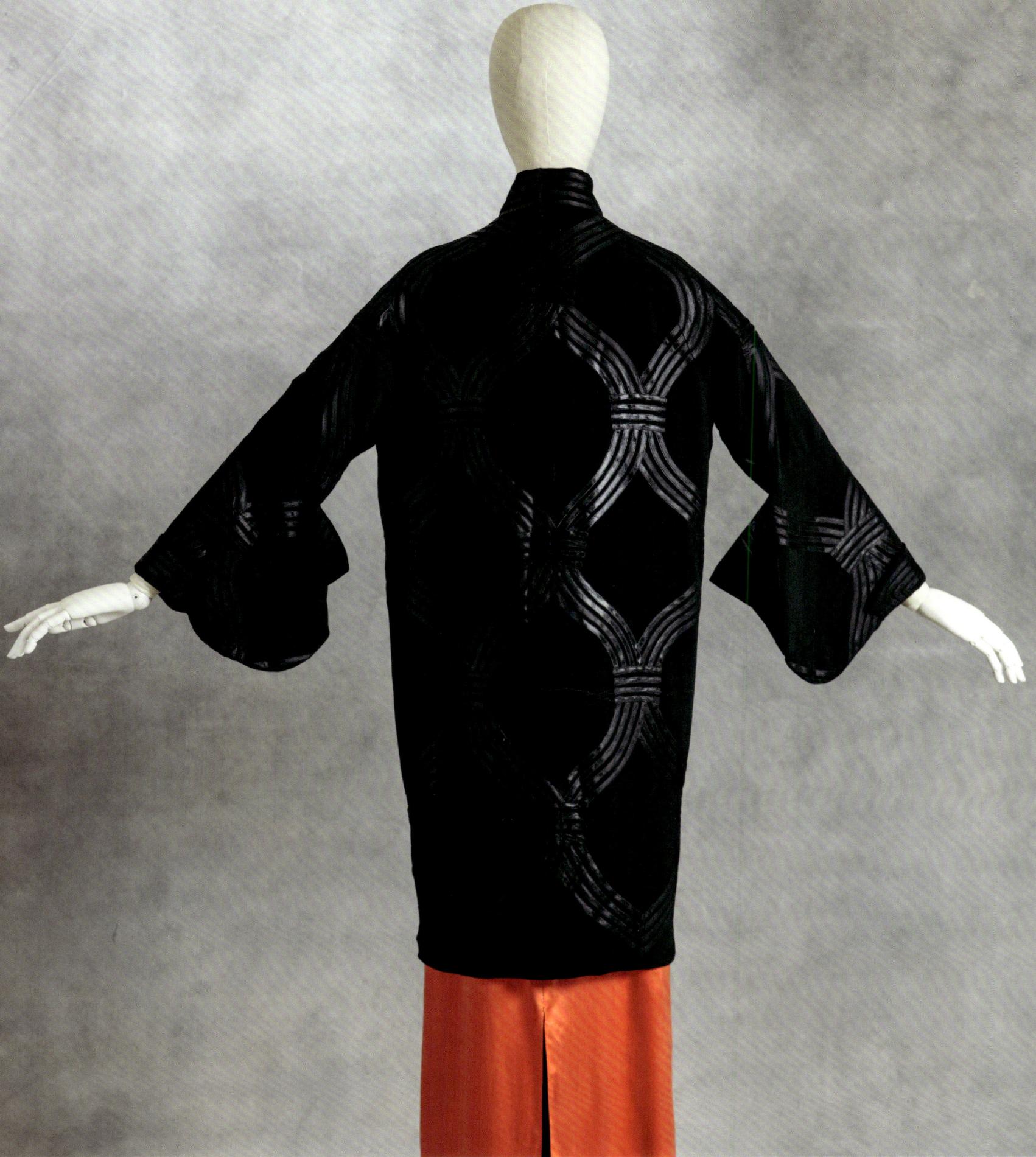

26. Jeanne Lanvin Evening coat, Summer 1928

27–33

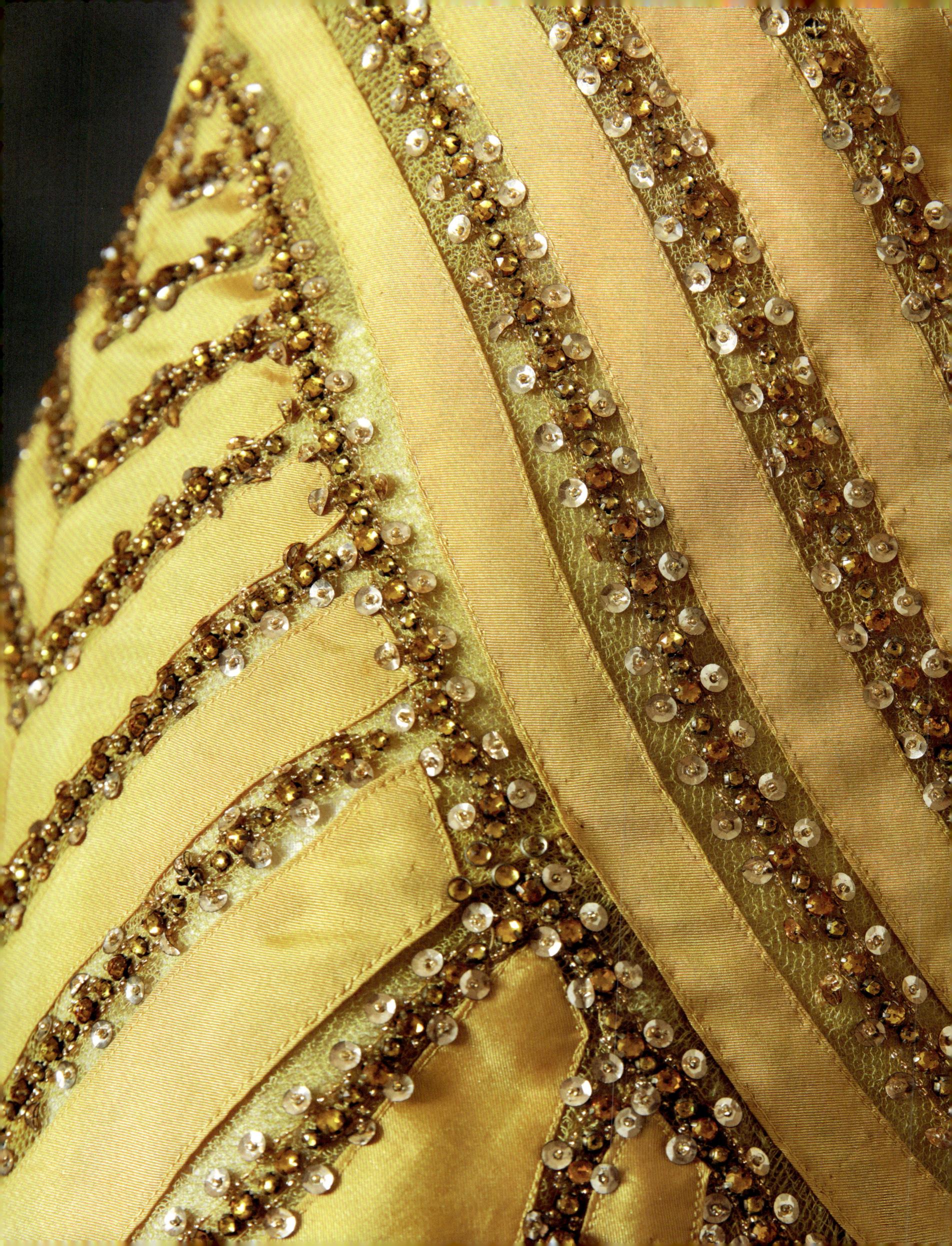

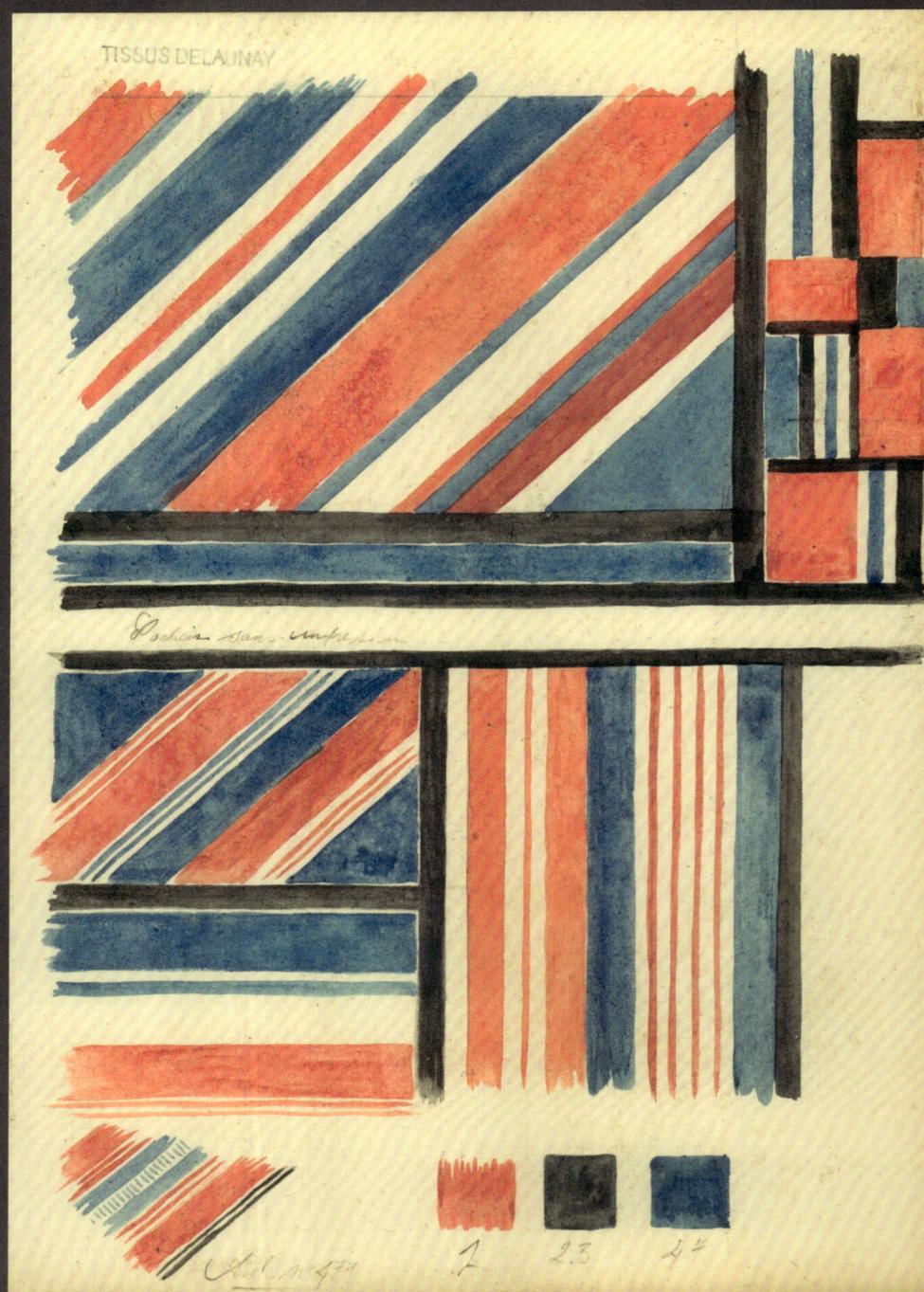

fig. 19 Sonia Delaunay, textile design, after 1929

Sonia Delaunay (1885–1979), a singular multidisciplinary artist who is duly recognised as a pioneer of pictorial abstraction, had a lifelong passion for expressing herself through fashion and fabric design. Intricately hand-printed or stencilled in pure colour and striking contrasts, with an emphatic imperfection of line, Delaunay's textiles were conceived to have the appearance of being painted with a brush. These trademarked and internationally acclaimed *Tissus Simultanés* of the 1920s and early 1930s successfully bridged the artistic and the commercial. Her artful garments and accessories entered the modernist canon and were widely celebrated alongside the most radical and desirable art and architecture of the interwar period. This *pochette*, in Delaunay's favourite colours of red and blue, possesses the constructive clarity and balanced play of lines that were characteristic of her work in all media around 1930.

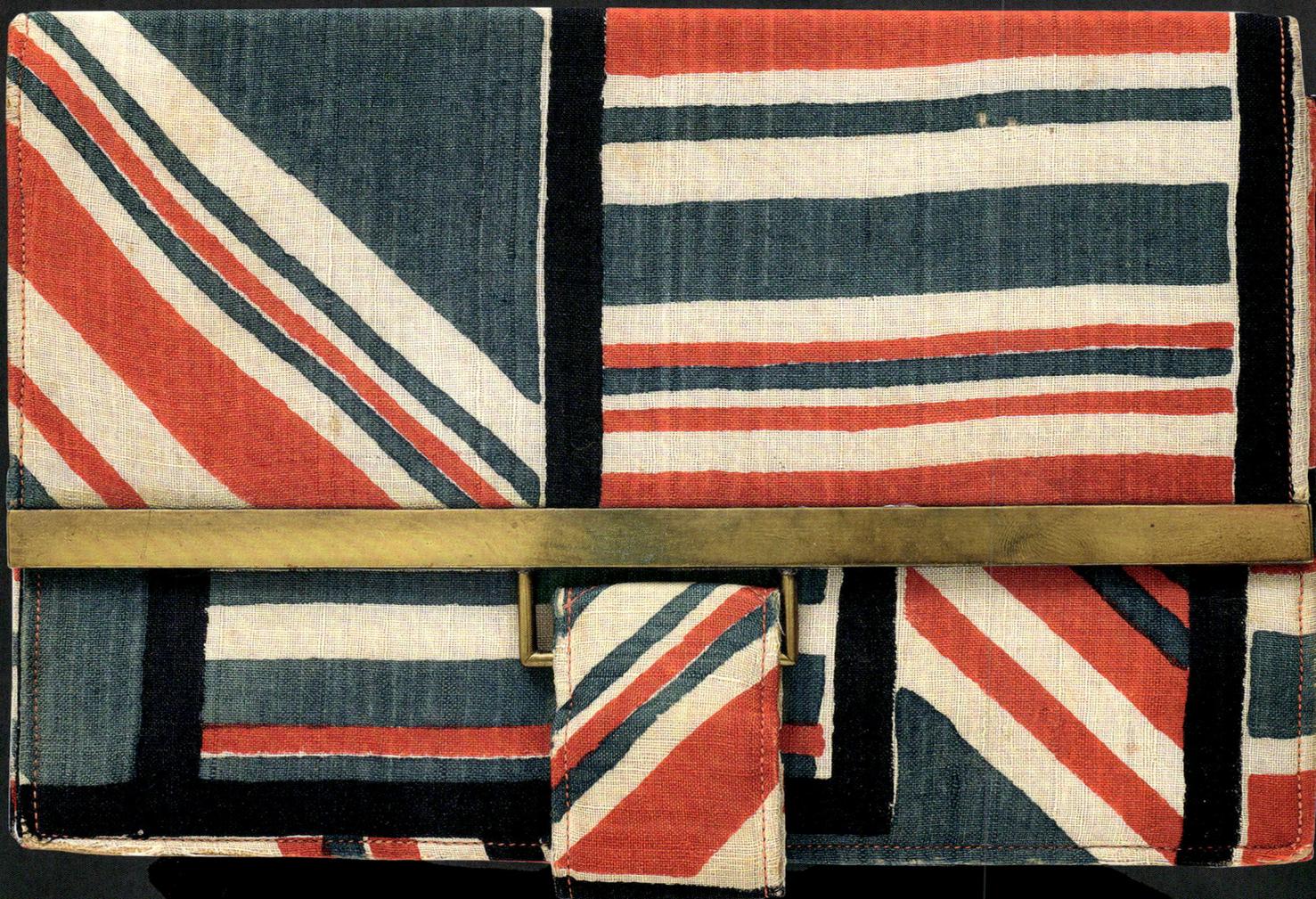

27. **Sonia Delaunay** *Pochette*, c. 1930

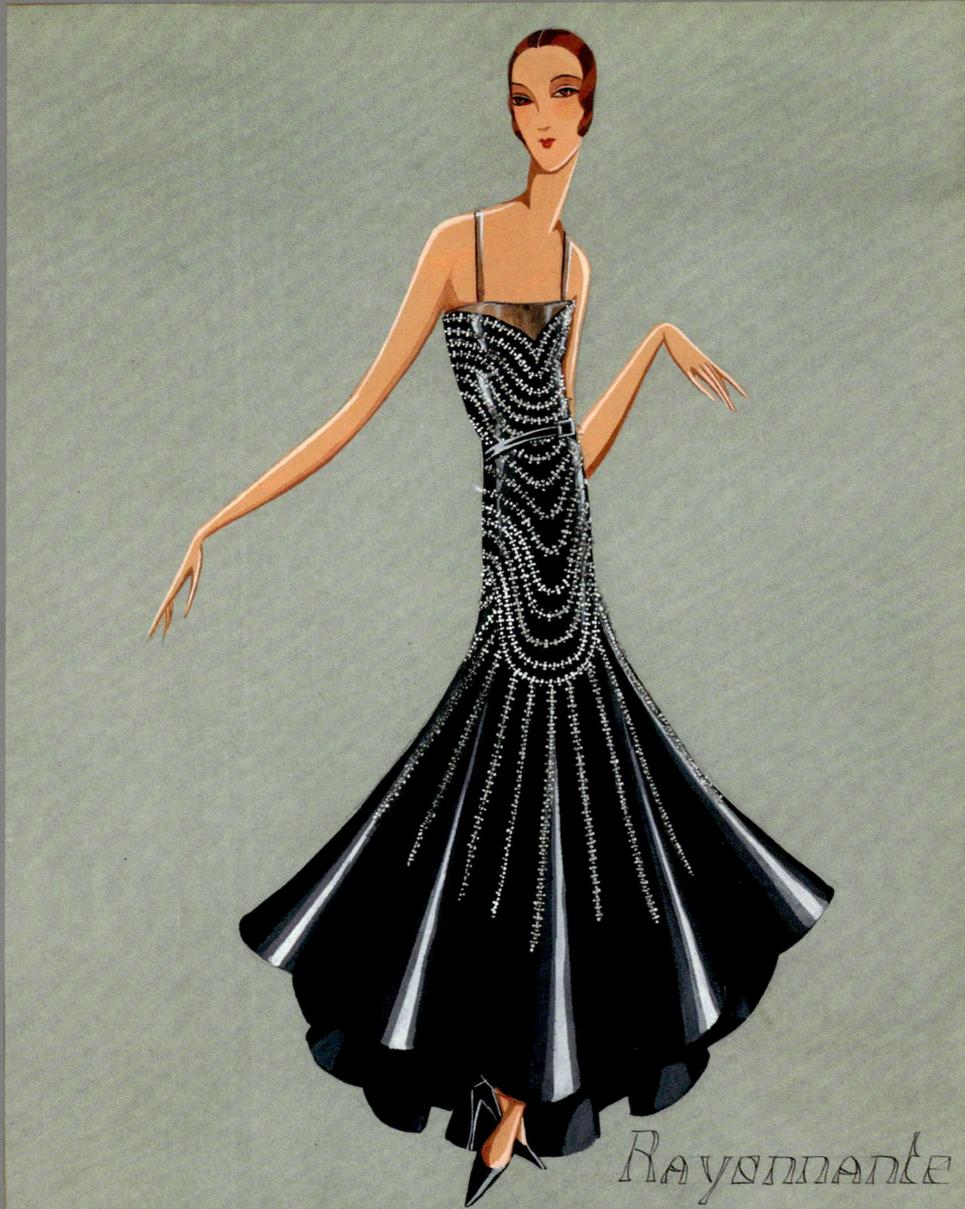

fig. 20 Modèle 'Rayonnante', Jeanne Lanvin, 1929/30

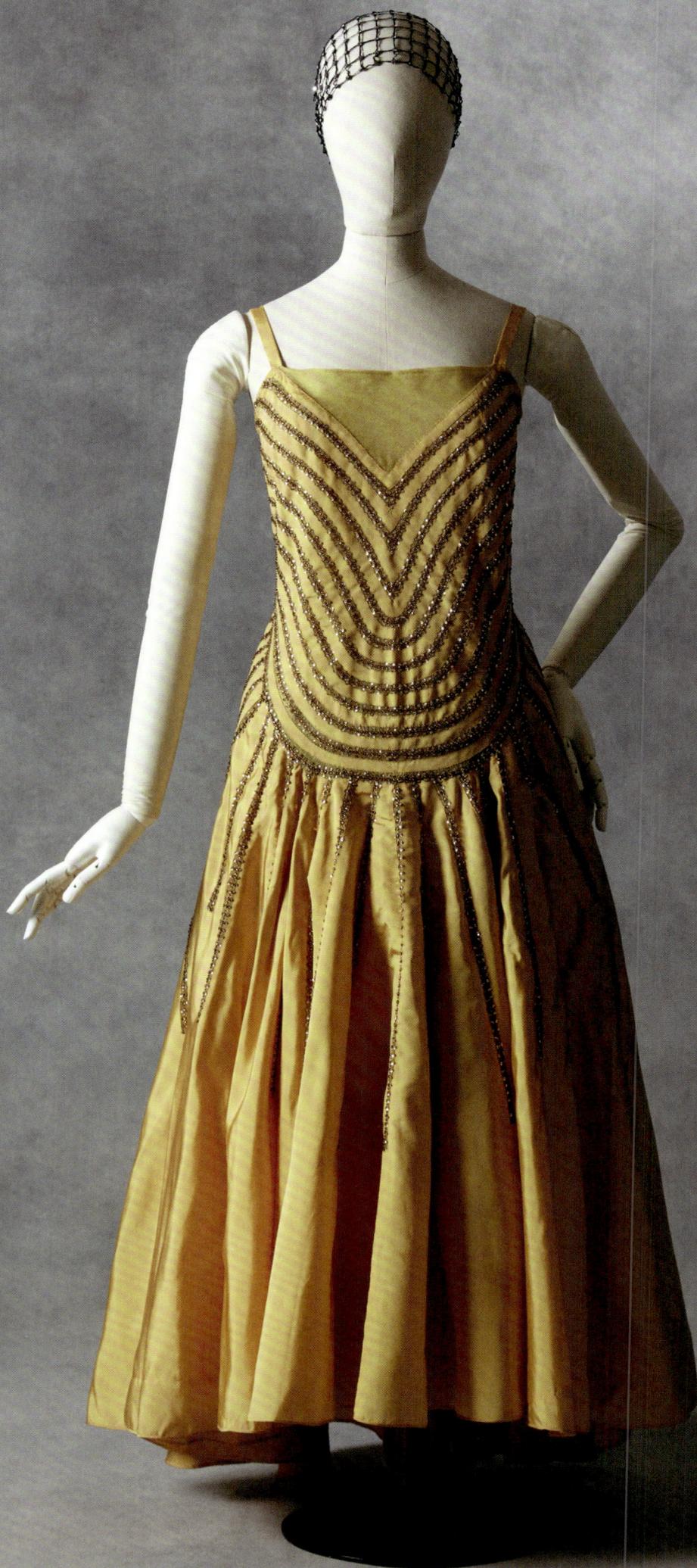

28. Jeanne Lanvin *Evening dress, 'Rayonnante', Winter 1929 and*
Paul Poiret *Headdress, c. 1911*

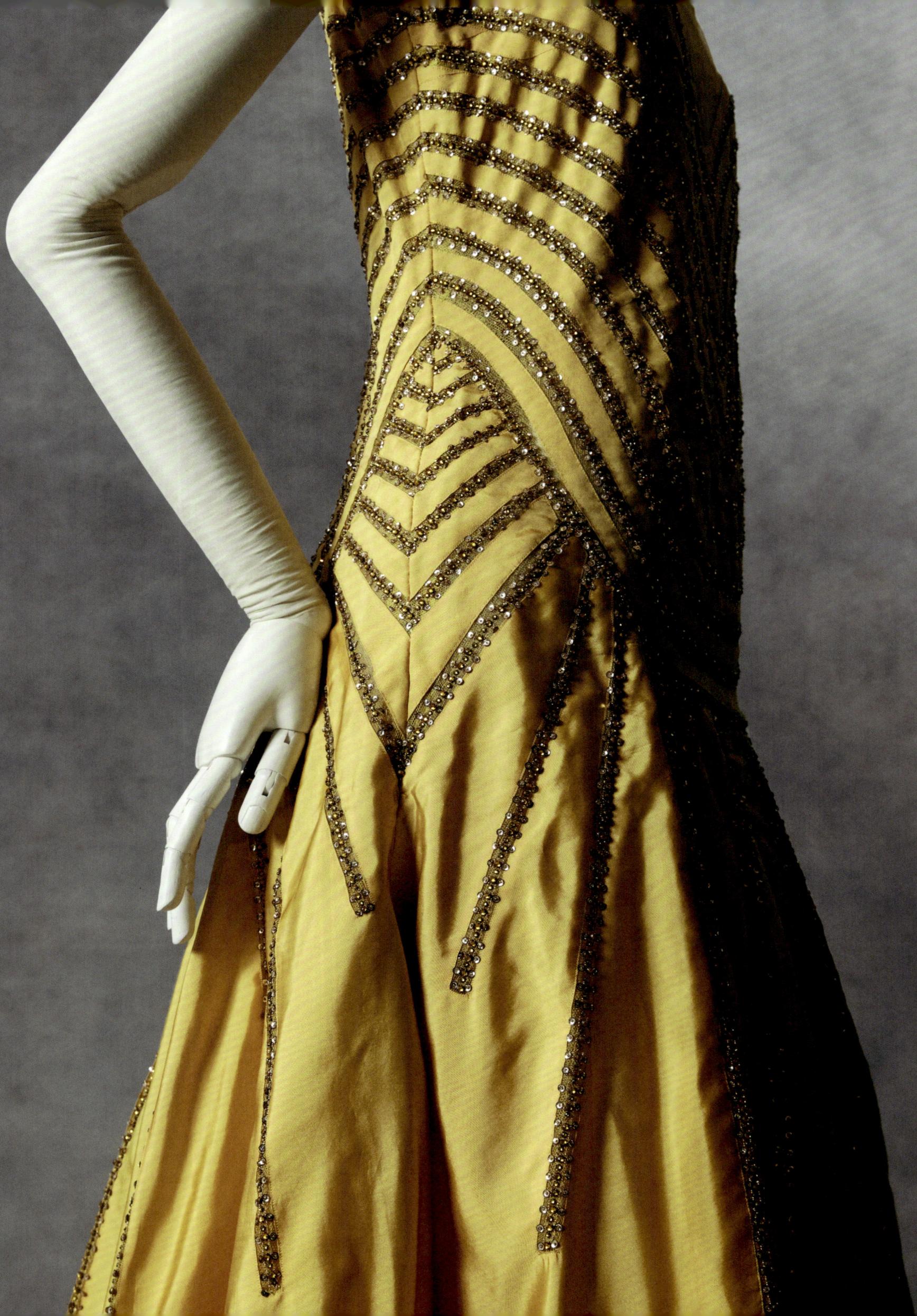

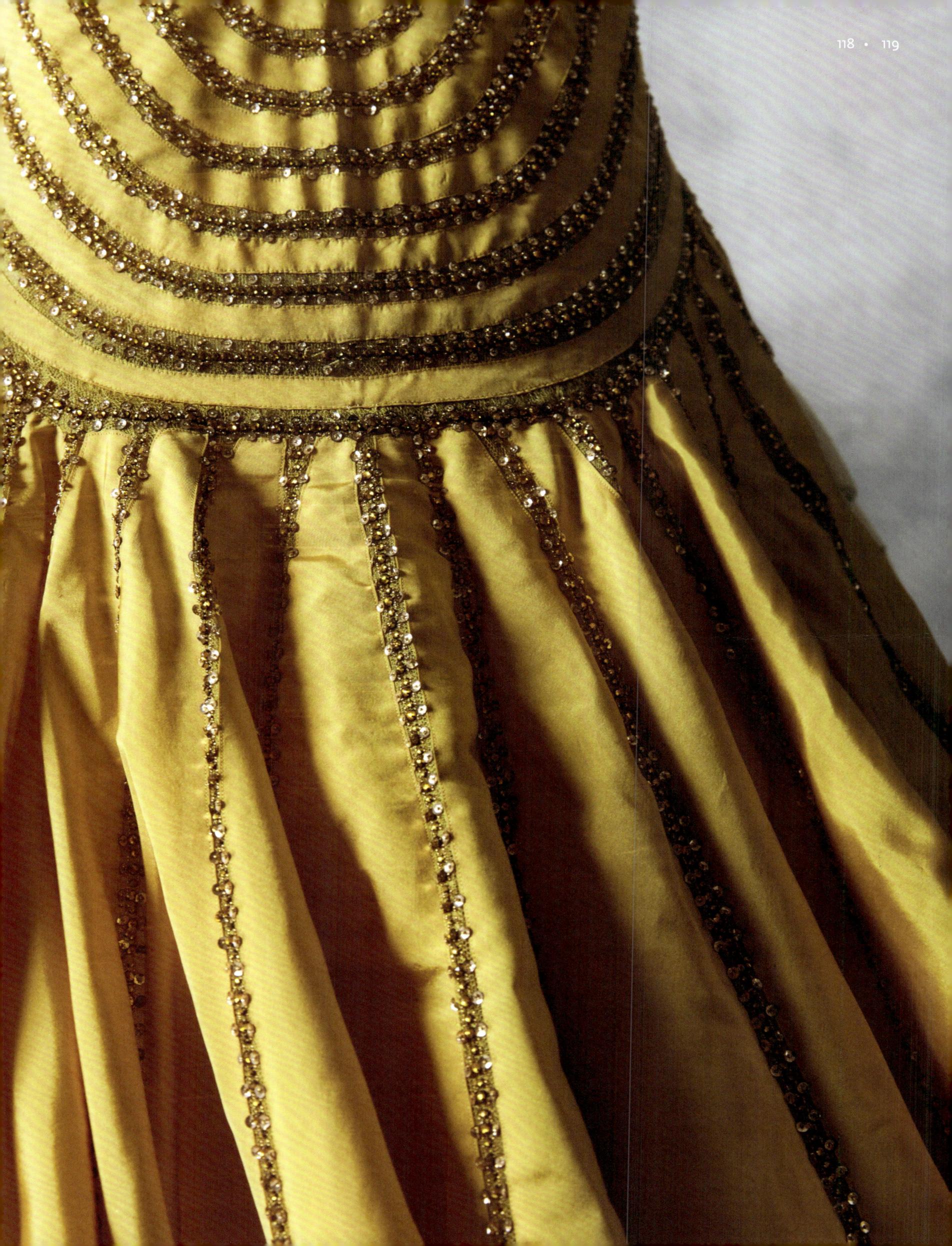

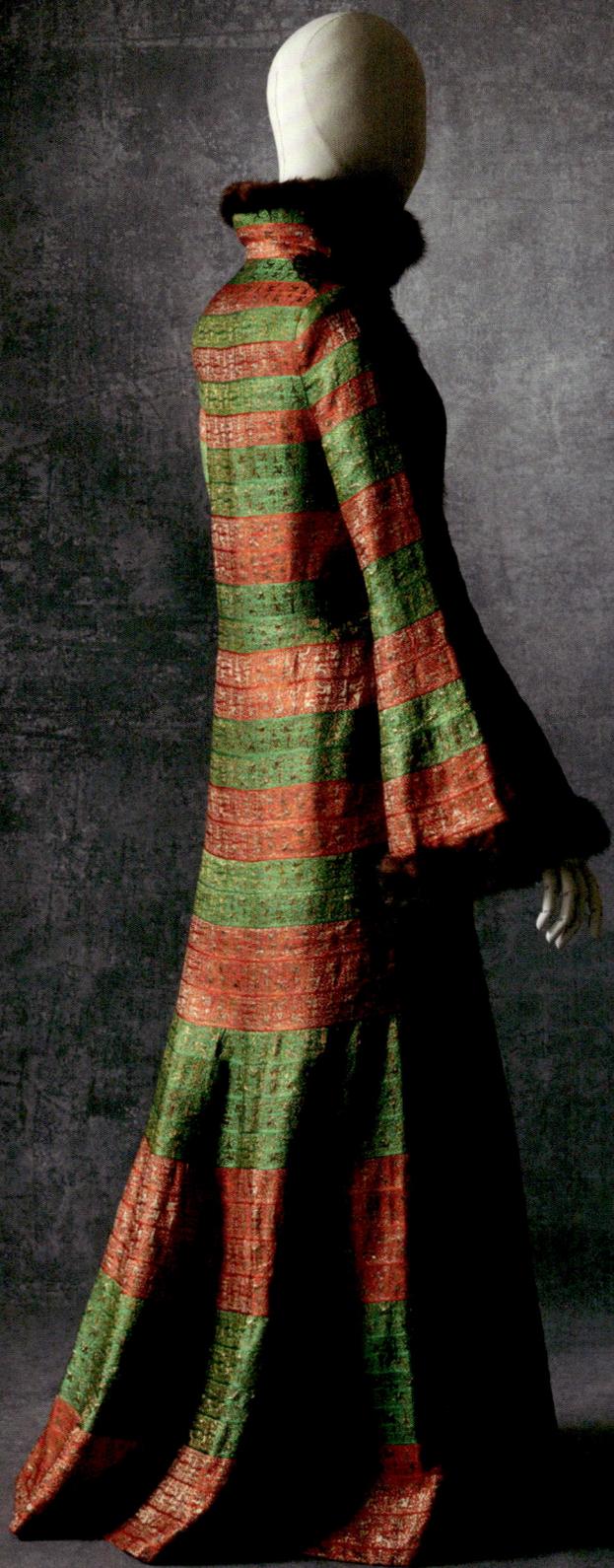

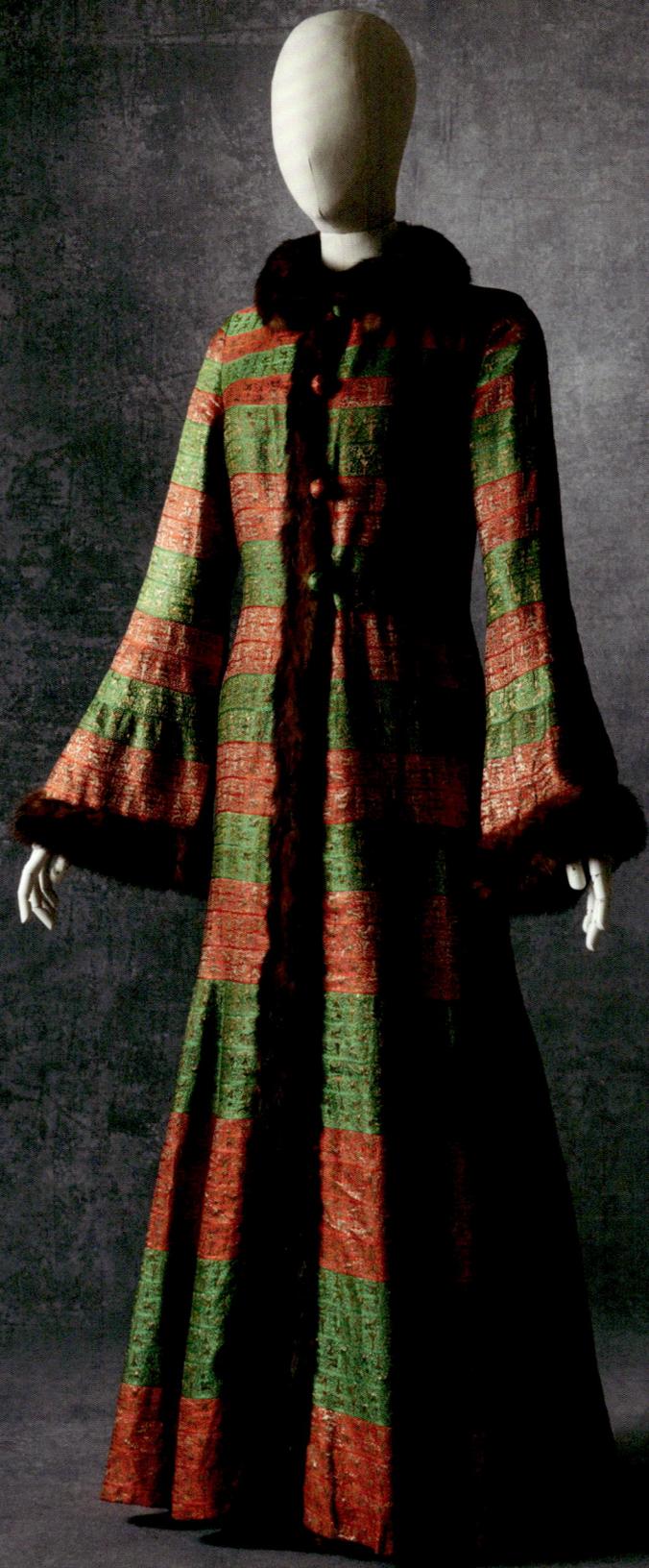

29. **Maggy Rouff** Evening coat, London, c. 1931

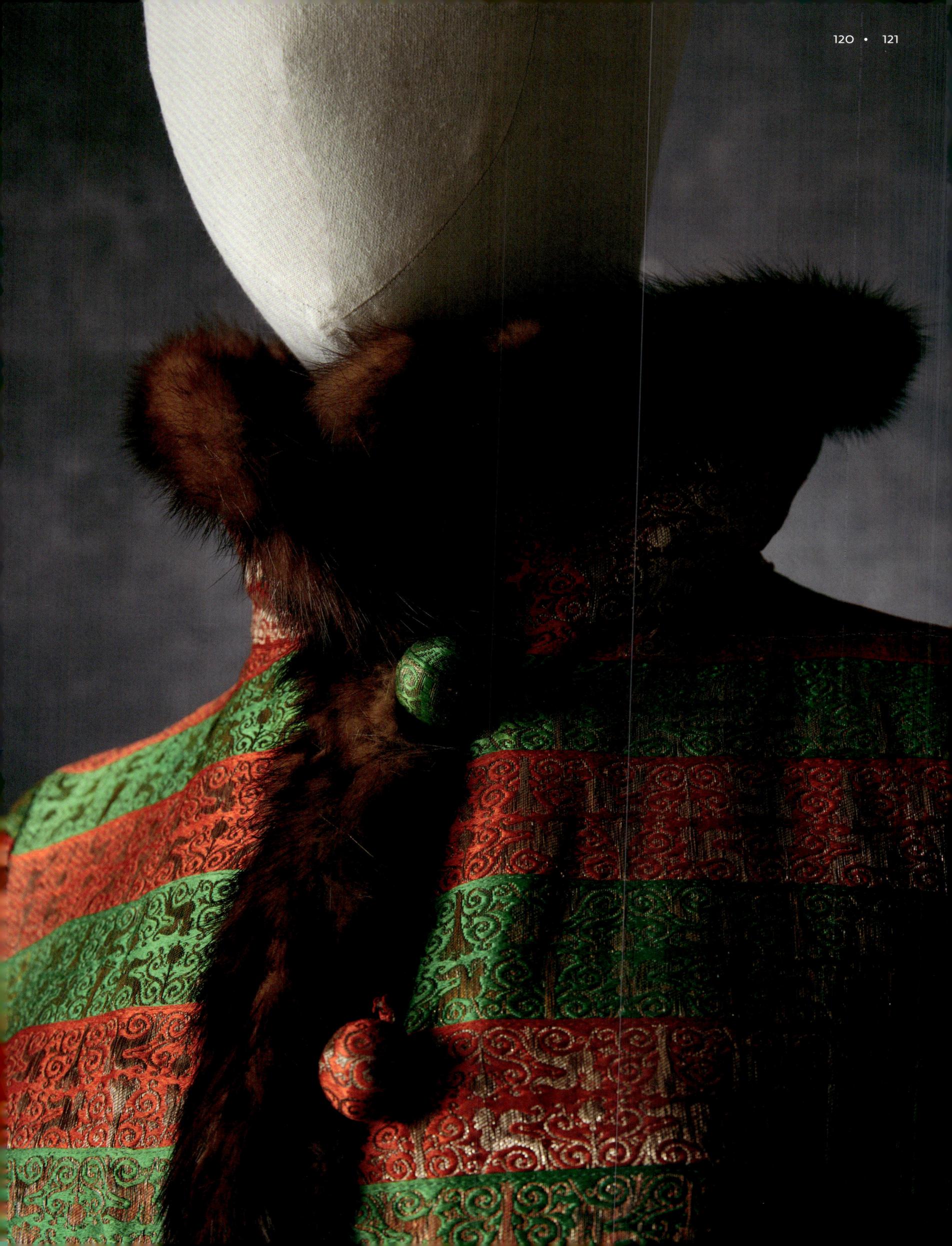

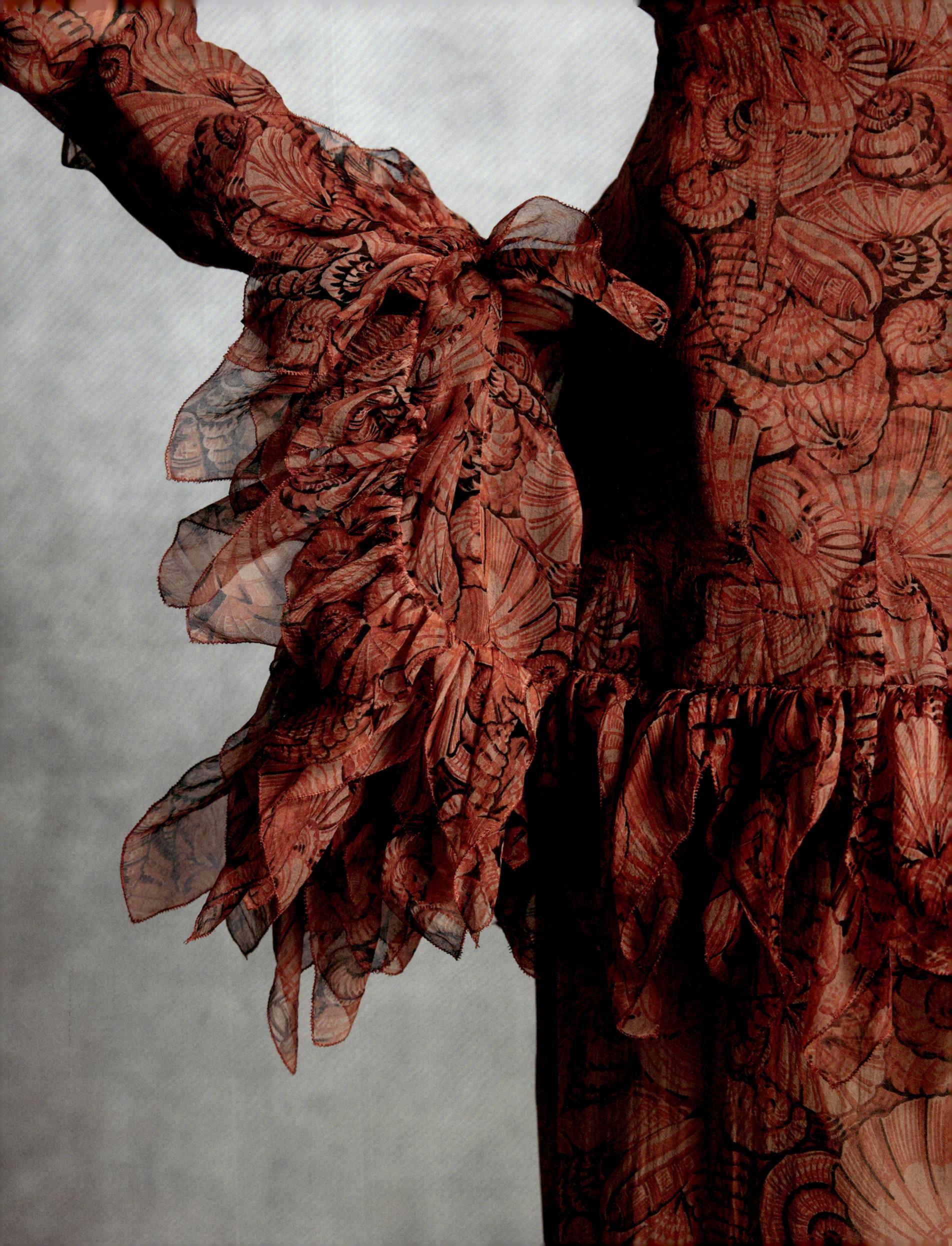

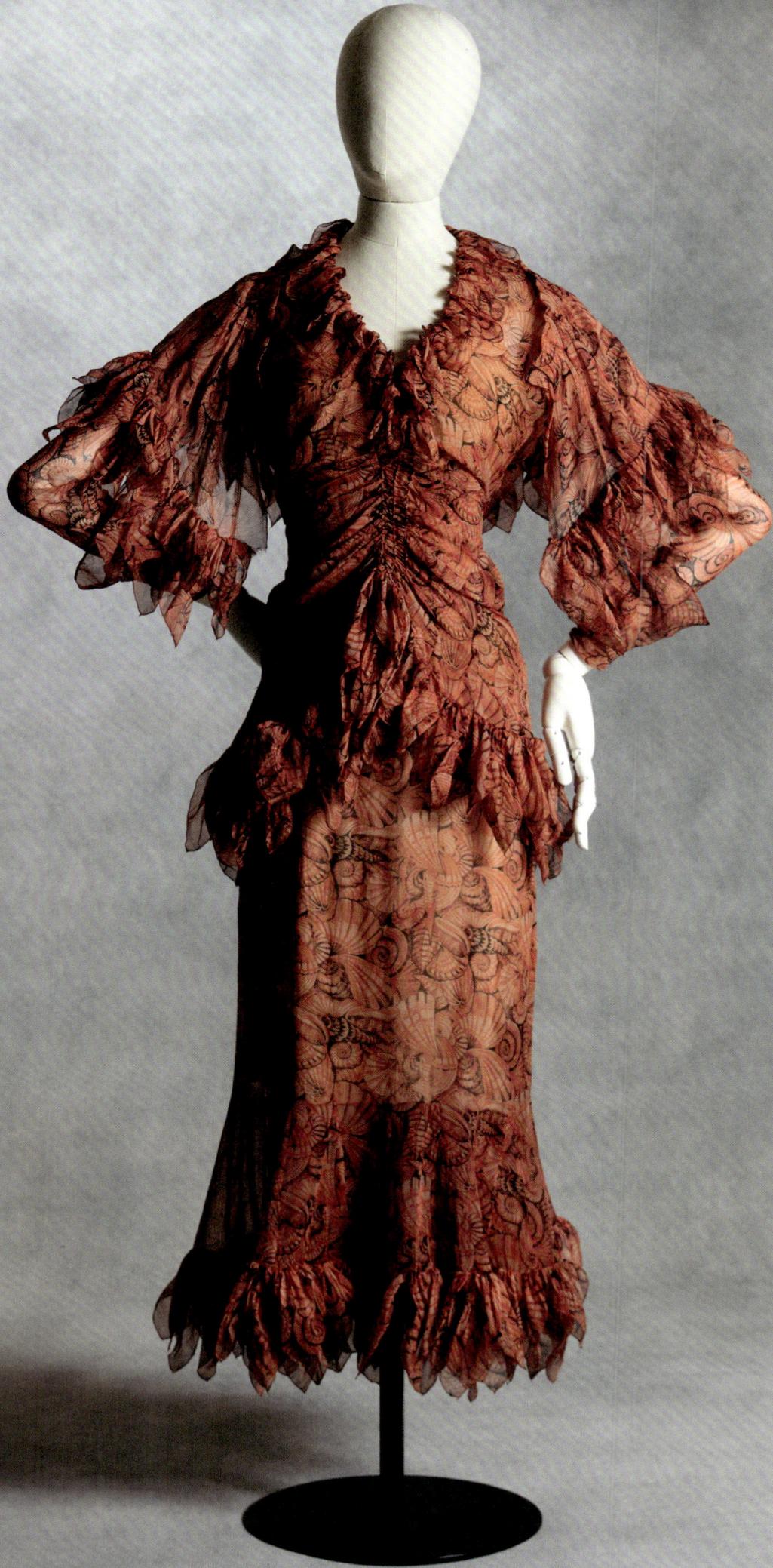

30. Jeanne Lanvin Day ensemble, Summer 1931

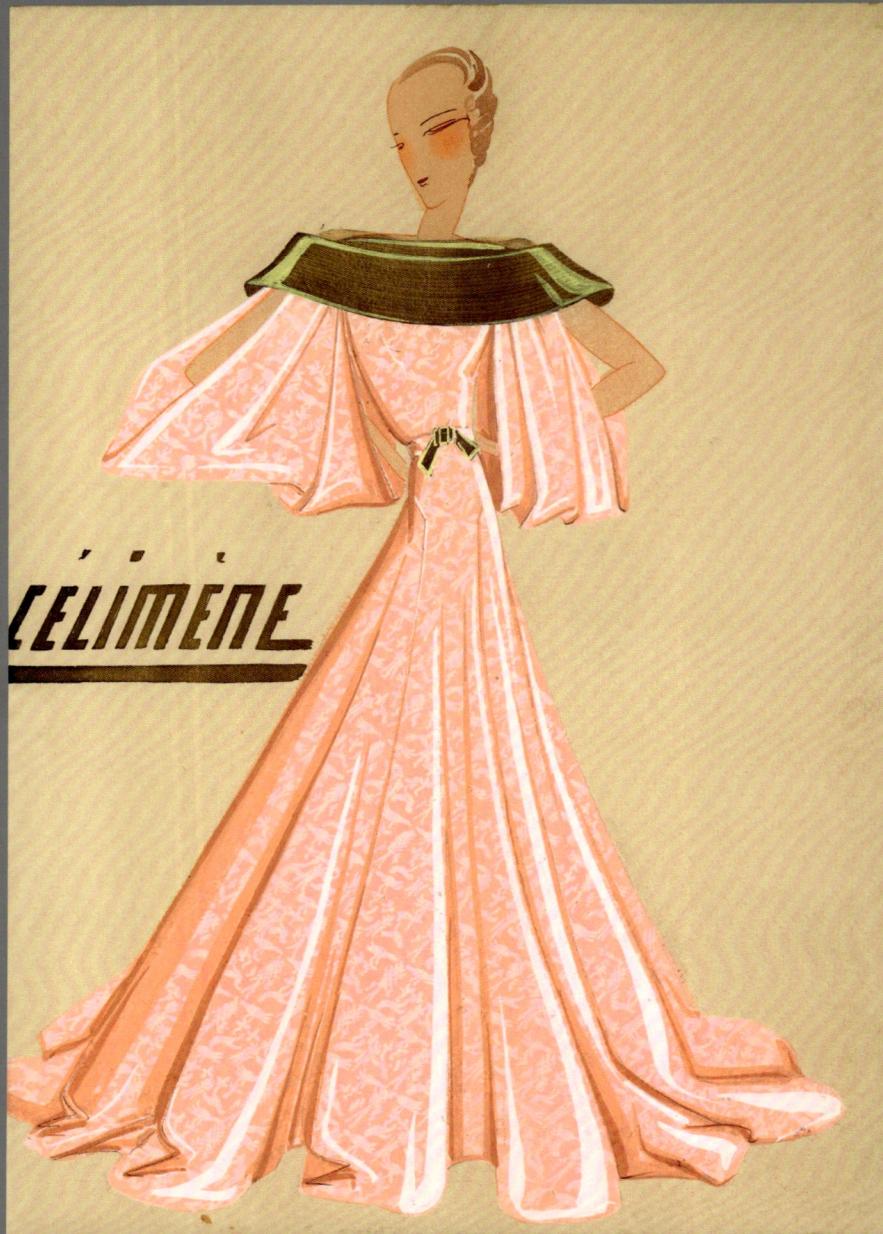

fig. 21 Modèle 'Célimène', Jeanne Lanvin, 1935

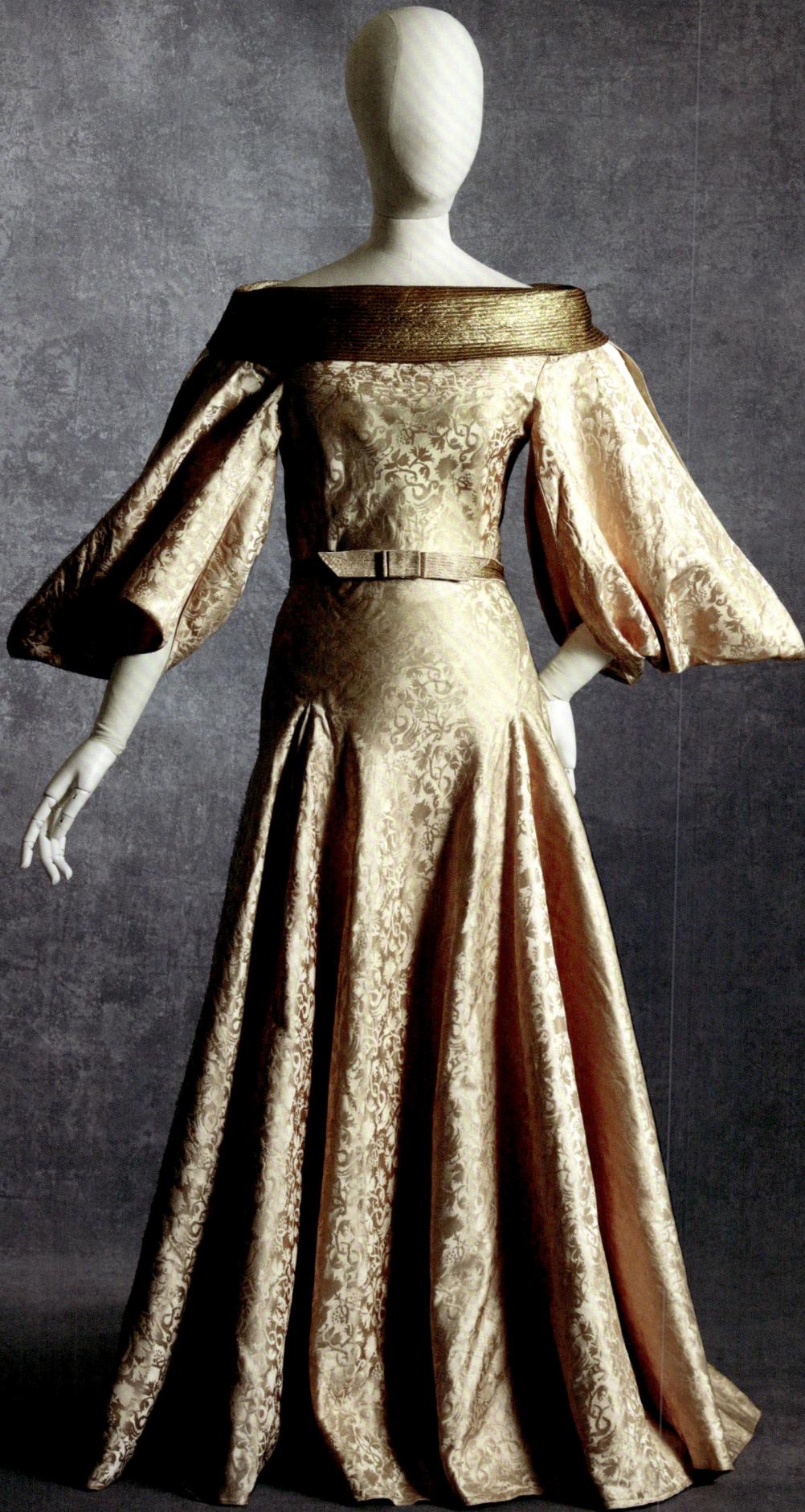

31. Jeanne Lanvin Evening gown, 'Célimène', Spring/Summer 1935

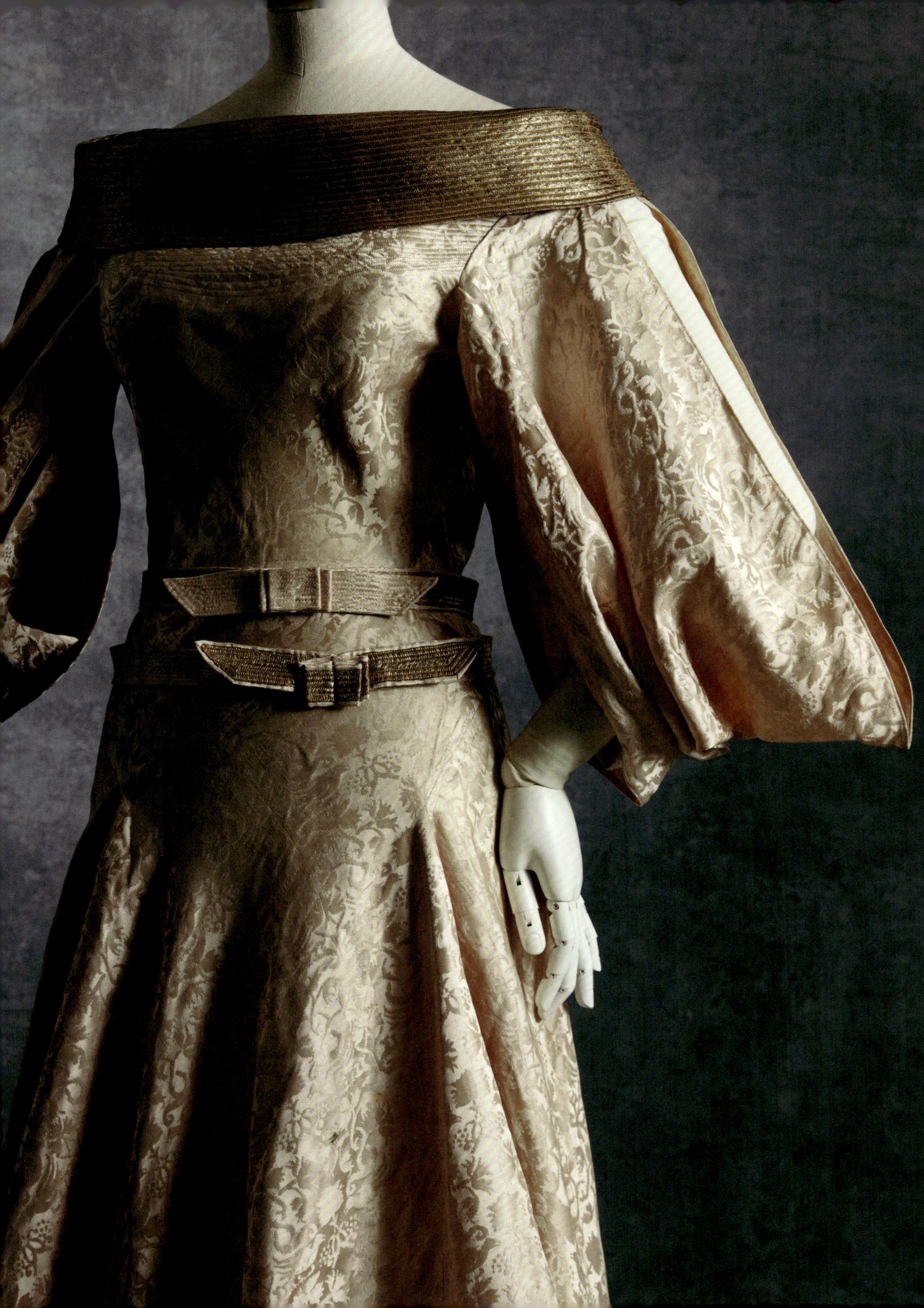

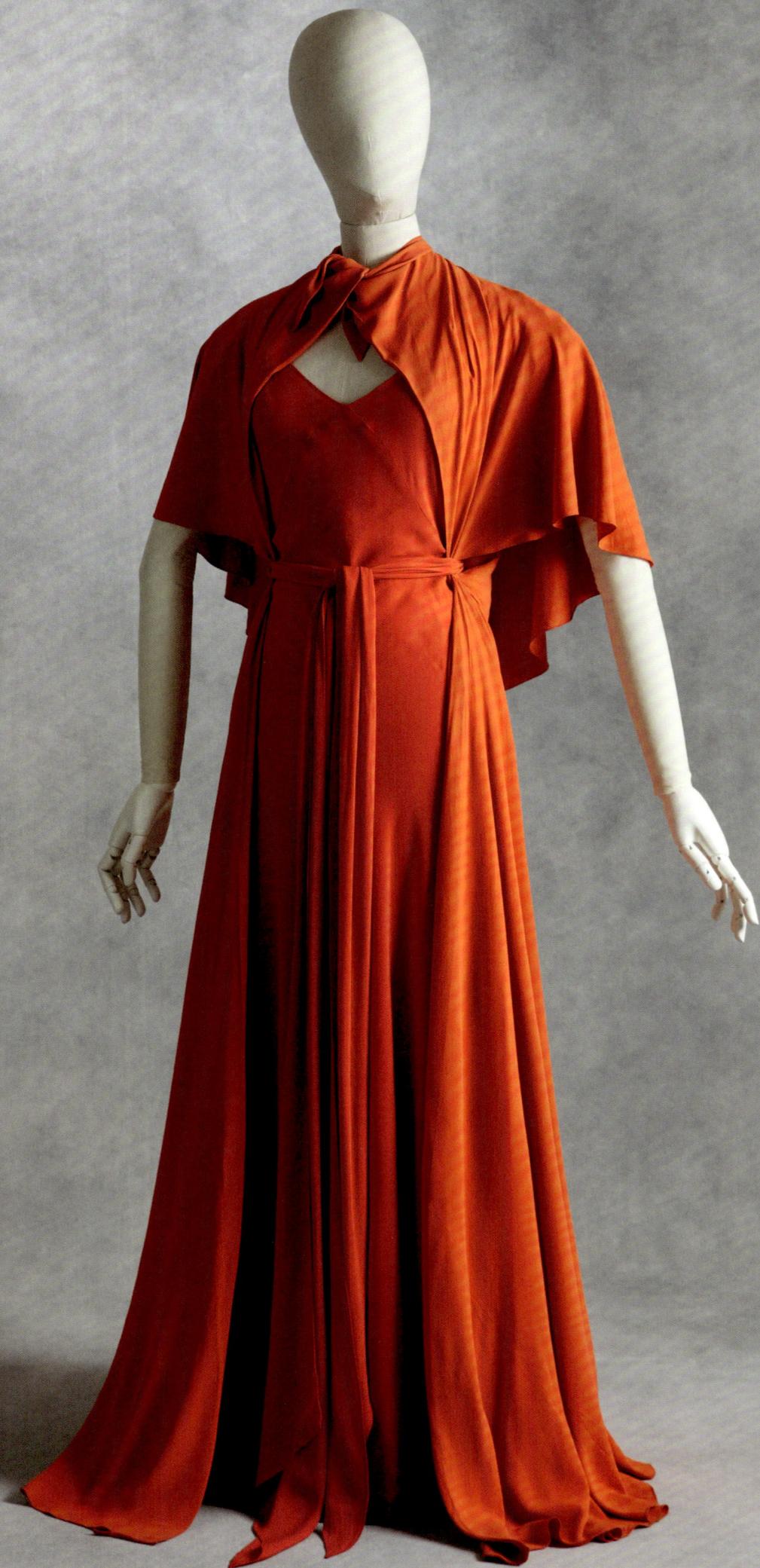

32. Madeleine Vionnet Evening dress and cape, 'Tango', c. 1934

A PRINC
IN VOGU

ESSENCE

a brief essay on Niloufer

BETÜL BAŞARAN

ADDITIONAL RESEARCH BY CHRISTINE RAMPHAL

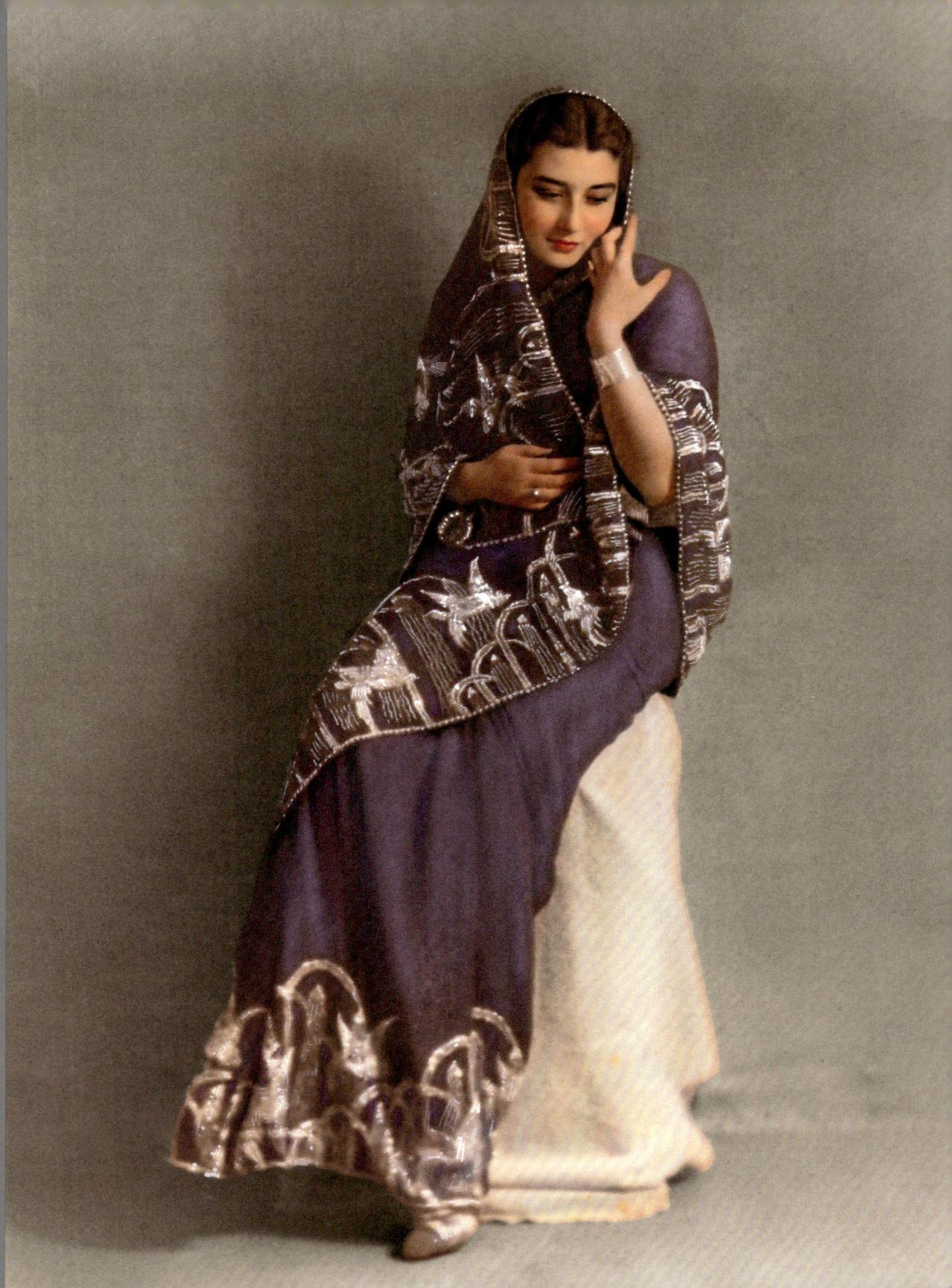

figs. 22a,b & c Three hand-coloured photographs of Princess Niloufer in a sari, c. 1935

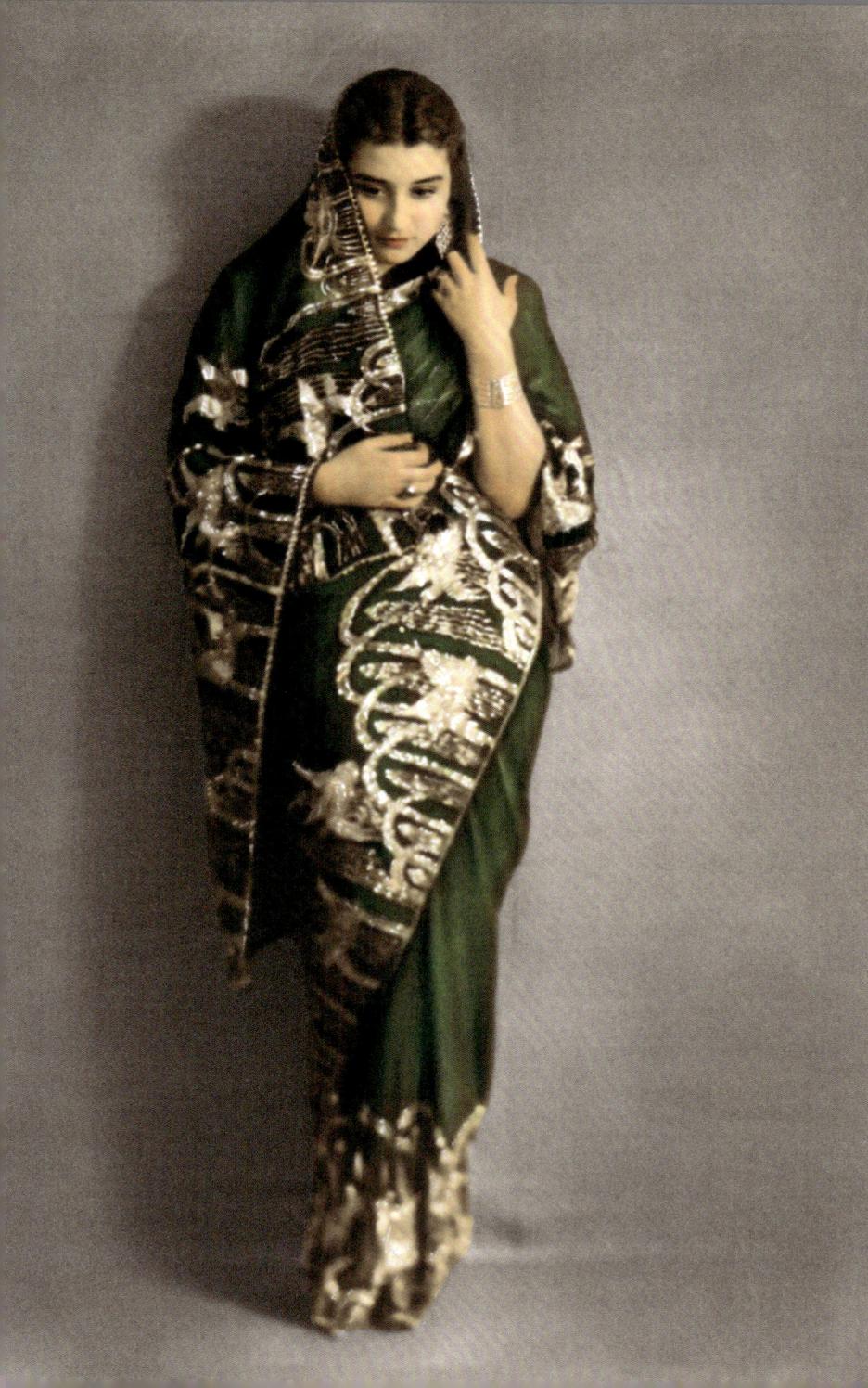

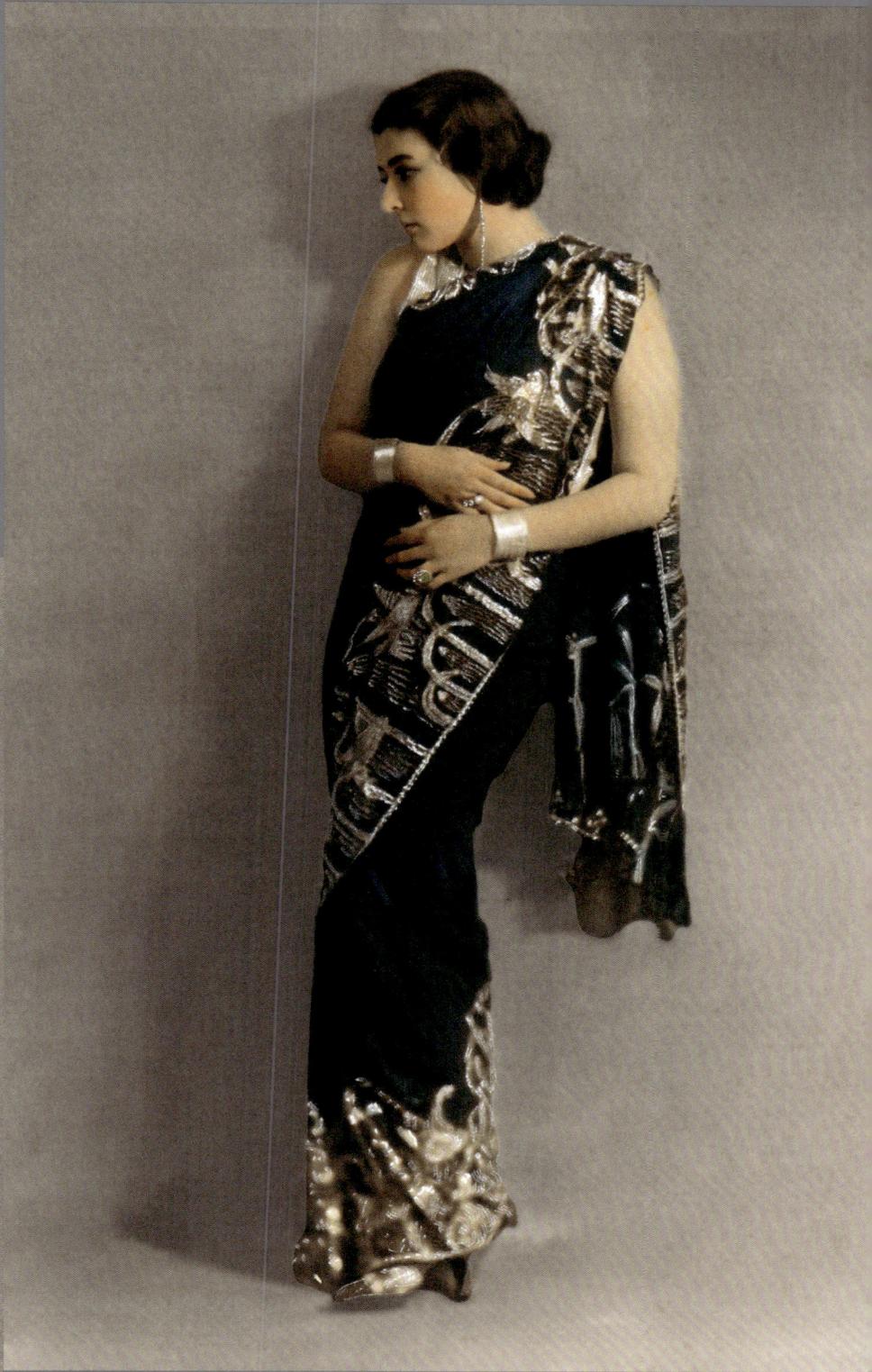

A custom-made handbag, a pair of riding trousers, two dresses by Jean Patou and a *robe d'intérieur*.[1] These items in the collection once belonged to a woman known as Princess Niloufer. Niloufer (1916–1989) – an Ottoman princess raised in France and married aged fifteen into the royal Hyderabad family – is today remembered for her impactful philanthropic work, the Princess Niloufer Women and Children's Hospital, and not least for her style and transcending beauty. More obscure is her patronage of French haute couture houses, starting in the early 1930s. However, through the objects in the collection, contemporary sources and photographs, the picture of a princess navigating juxtaposing worlds emerges.

Niloufer Hanımsultan was born in Istanbul during the First World War. Her mother, Adile Sultan, was a granddaughter of the Ottoman monarch Sultan Murad V. She raised her daughter on her own, after her husband, Damad Moralızade Selaheddin Ali Bey, died of the Spanish flu when Niloufer was two years old.

In 1924 the secular Turkish republic that replaced the Ottoman monarchy also abolished the Islamic Caliphate and subsequently deported all members of the Ottoman royal family. The deposed last caliph, Abdulmejid Khan, settled in southern France, and many exiled family members followed suit. Adile Sultan moved there with her eight-year-old daughter, raising her with very limited means.

The survival of the exiled Ottomans largely depended on financial contributions from various Muslim leaders. The largest and most reliable stipend came from the Nizam of the princely state of Hyderabad, Mir Osman Ali Khan, Asaf Jah VII, widely recognised as the richest man in the world.[2] In November 1931, Princess Durru Shehvar, daughter of the last caliph, married the crown prince Azam Jah, while her cousin Niloufer was matched with his younger brother, Moazzam Jah. The double wedding at the Palais Carabacel in Nice was written about in the international press (fig. 23). On the wedding day the two bridegrooms wore traditional brocaded *sherwanis* and *dastars*[3] and were holding bejewelled ceremonial swords. By contrast their two young brides were dressed in white satin dresses and veils, reflecting French wedding fashion and their European upbringing.[4]

As a part of these marriage alliances, the Nizam significantly increased his financial aid. Years later, Niloufer would tell a reporter that her mother's poor health and the debt that they had accumulated in France had led her to consent to the arranged marriage at the tender age of fifteen.[5]

fig. 23

fig. 24

fig. 25

Hyderabad and its court were renowned for high culture, literature and music, and Niloufer's new life there provided her with many luxuries (figs. 24 & 25). This contrasted with the social restrictions faced by women on the subcontinent. *Purdah*, meaning curtain, referred to the practice of women's seclusion prominent among some Hindu and Muslim communities. It involved limited interactions between women and men outside clearly defined boundaries, as well as modest clothing concealing the female body and face, practices subject to religious, regional and class variations.[6] Among the nobility it was common for women to ride in cars or carriages with curtains for privacy.

fig. 23 Wedding portrait of Azam Jah and Princess Durru Shehvar, and Princess Niloufer and Moazzam Jah, with Caliph Abdulmejid II seated in the centre, November 1931

figs. 24 & 25 Prince Moazzam Jah and Princess Niloufer on horseback, 1930s

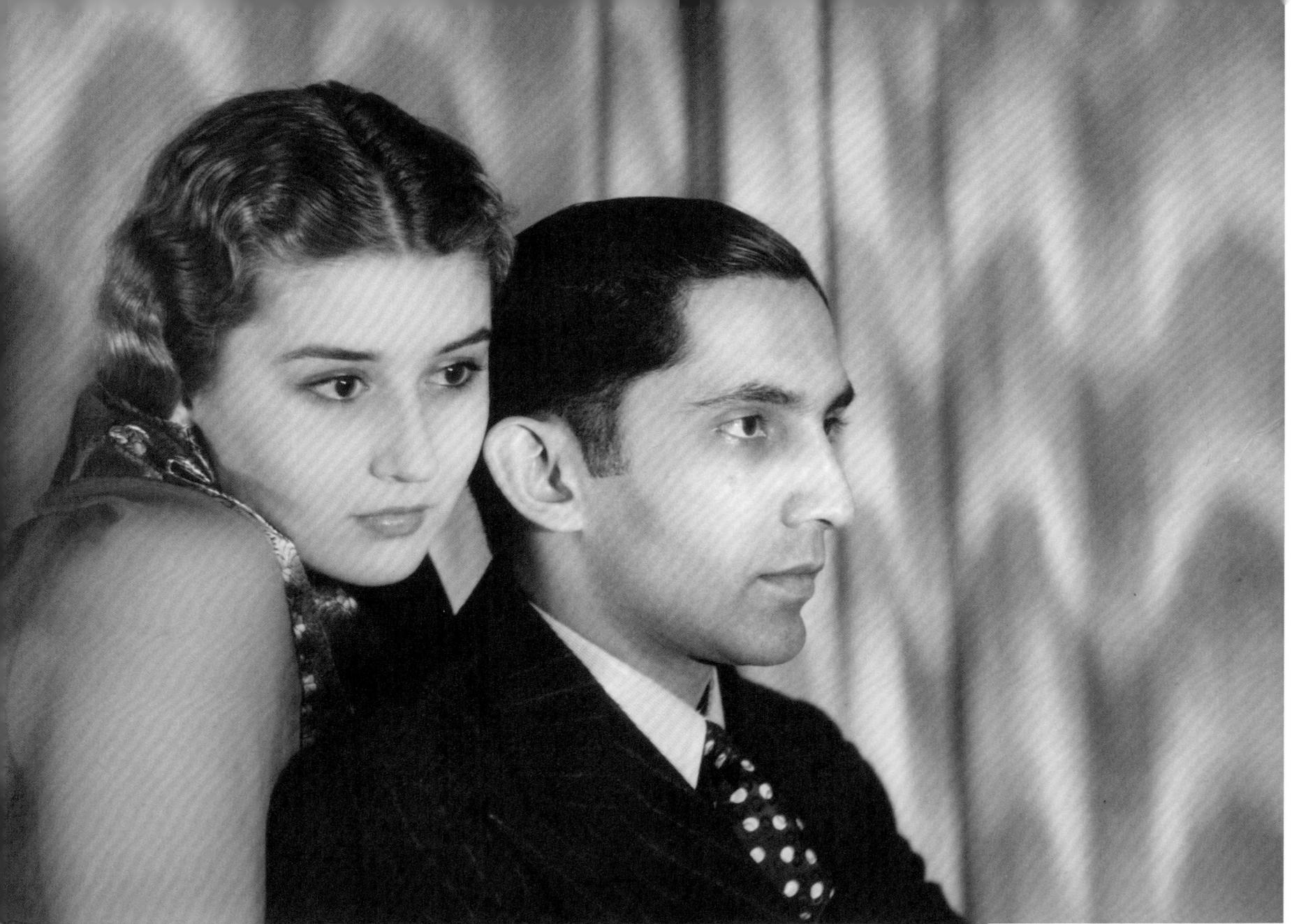

fig. 26

When the princesses arrived in 1932, some women had come out of *purdah* in Hyderabad, but those in the Nizam's court continued to live in separate quarters, called the *zenana*. As part of the marriage negotiations, the Nizam agreed that the princesses would not be expected to keep strict *purdah*.[7] Niloufer and Durru Shehvar lived with their husbands in separate palaces, instead of in the *zenana*, and soon became the public face of the royal family.

The Nizam proudly appeared with them at official functions. Even though this was a break from tradition, he wanted to fashion himself as a beneficent monarch committed to modernising Hyderabad. Both princesses liked to host mixed parties, which became part of the Hyderabad court society after their arrival; and *purdah* barriers began breaking down among the elite.[8]

Photographs from throughout the 1930s show Princess Niloufer dressed exclusively in saris, the traditional Indian garment she learnt to tie on the sea voyage from France to India after her wedding.[9] A photograph of Niloufer and Moazzam Jah from this period shows a glamorous young couple (fig. 26). Looking back to the wedding photograph, we see that the cultural sartorial roles have now been reversed. Niloufer is wearing a sari with a wide, brocaded metallic border, and her husband is sporting a tailored pinstriped suit, shirt and tie. The

fig. 26 Princess Niloufer and Moazzam Jah, c. 1935
fig. 27 Princess Niloufer photographed by Horst P. Horst, French *Vogue*, 1939

fig. 27

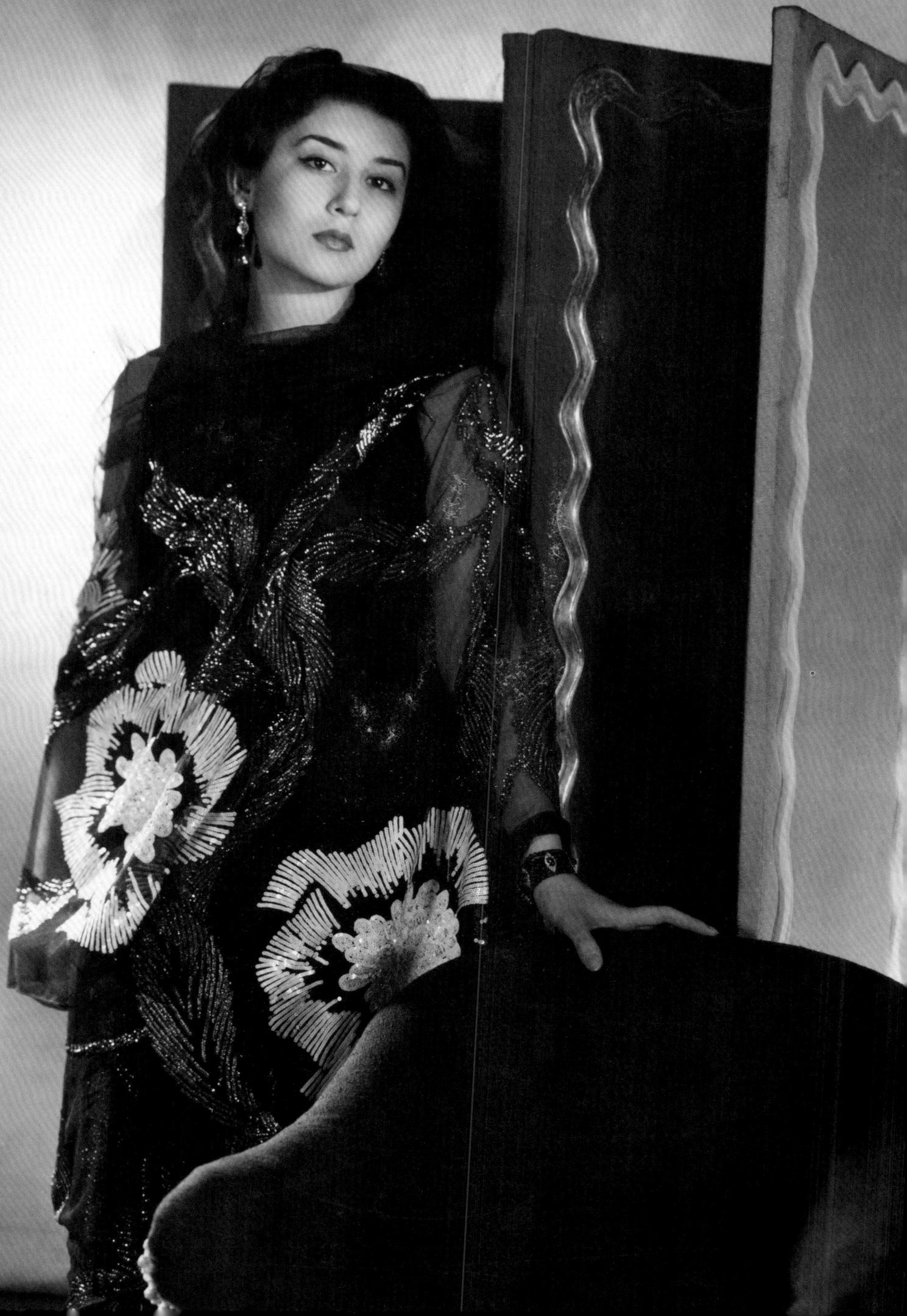

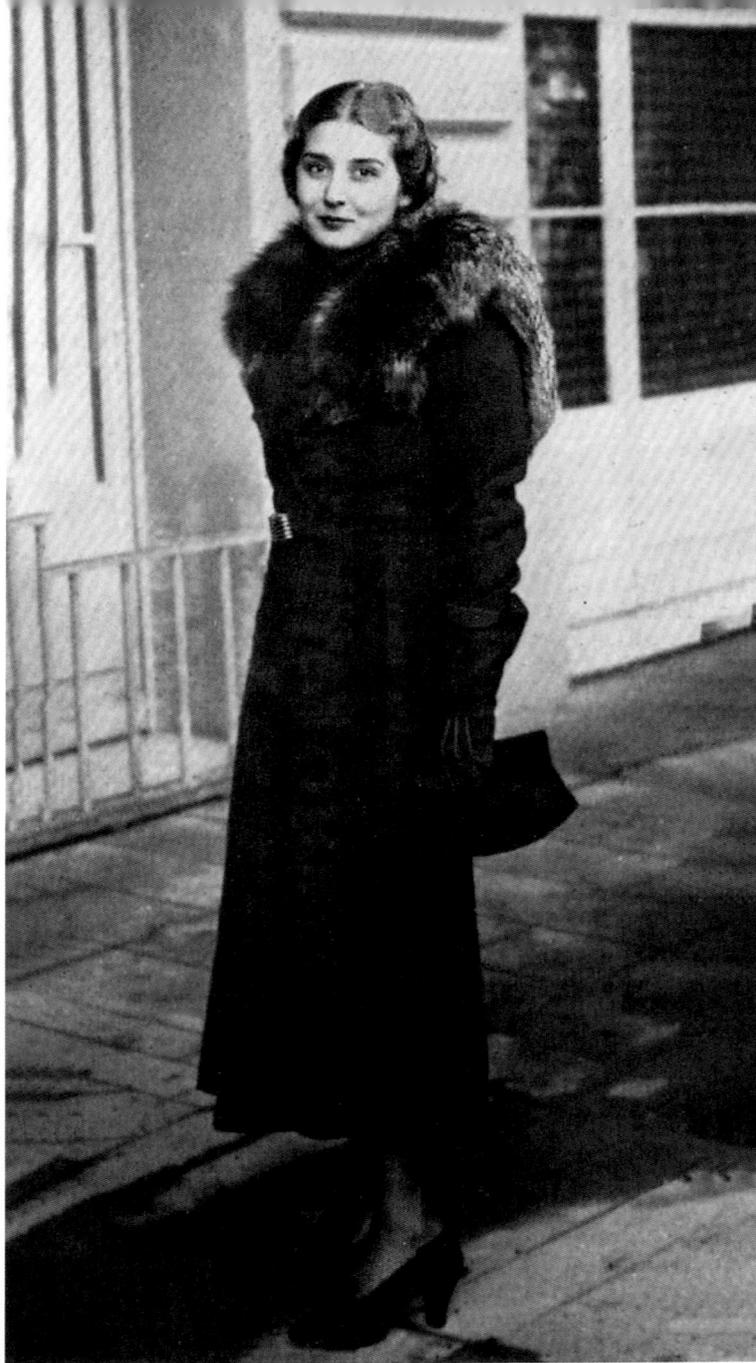

fig. 28

sari here is of a traditional design, but Niloufer would gradually develop her own style of sari. She favoured silk chiffons, tulles or crêpes, and was inspired by contemporary European textiles. Her husband, known for his exquisite taste, designed her jewellery.[10]

The delicate fabrics of her saris featured bold, dramatic embellishments of sequins, beads and metallic embroideries. They expressed a sensibility influenced by both East and West.[11] She commissioned her saris from the workshop of Mr Madavdas in Bombay, after designs by Mlle Fernande Cecire,[12] and also wore saris made by couturiers such as Jeanne Lanvin, Jacques Griffe[13] and Mainbocher. By wearing saris by French couturiers, Niloufer was following in the footsteps of other Indian princesses. Whether or not in purdah, from the late 19th century onwards Indian princesses began ordering their trousseaux in Europe. Recognising the value of the Indian market, Parisian couturiers produced fashionable chiffons in sari length.[14]

In July 1939, just before the start of the Second World War, an arresting picture of Niloufer in a sari, taken by the celebrated fashion photographer Horst P. Horst, was published in French Vogue (fig. 27). Niloufer leans against a paravent. Her hair

fig. 28 Princess Niloufer, March 1935

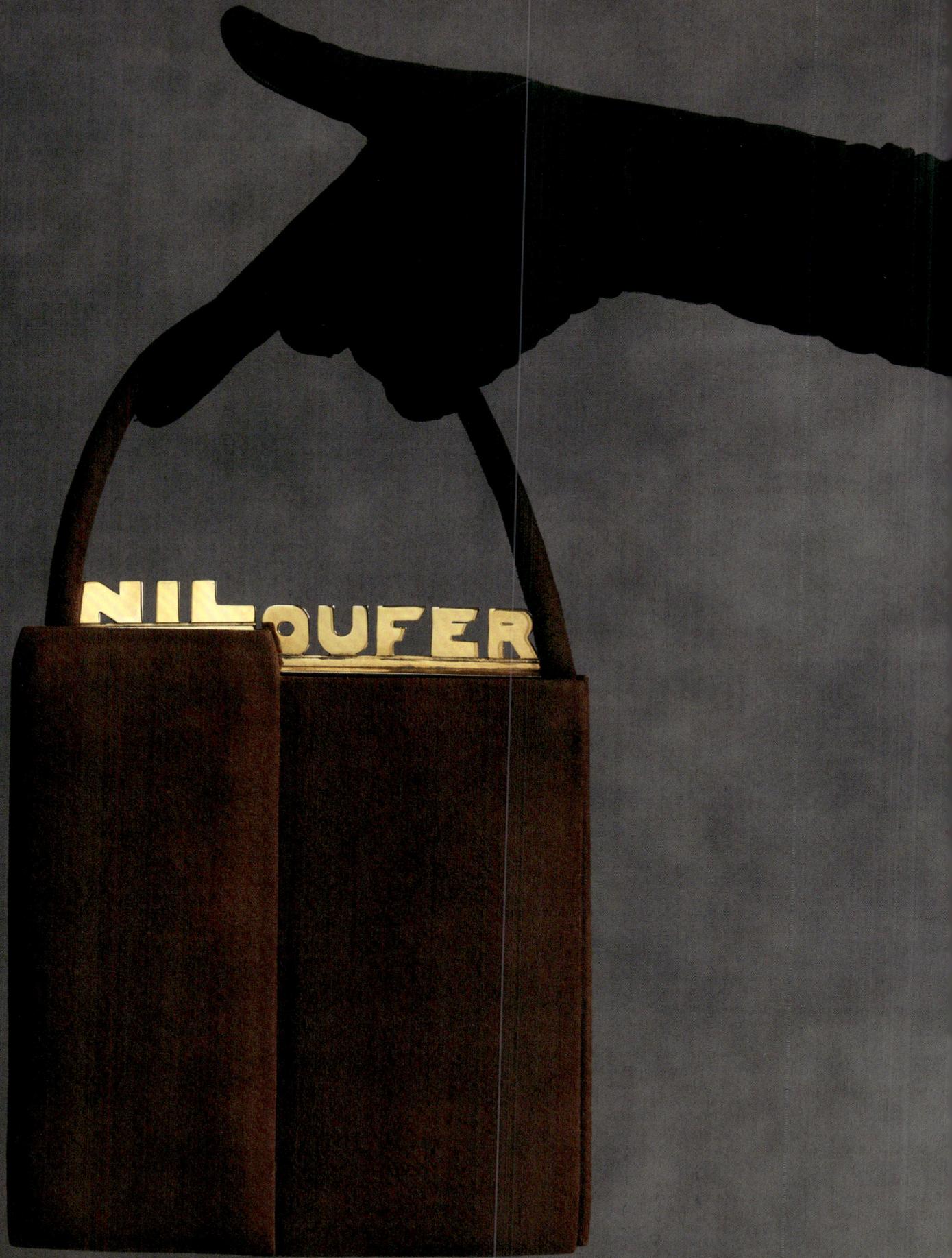

33.1. Handbag 'Niloufer', c. 1934

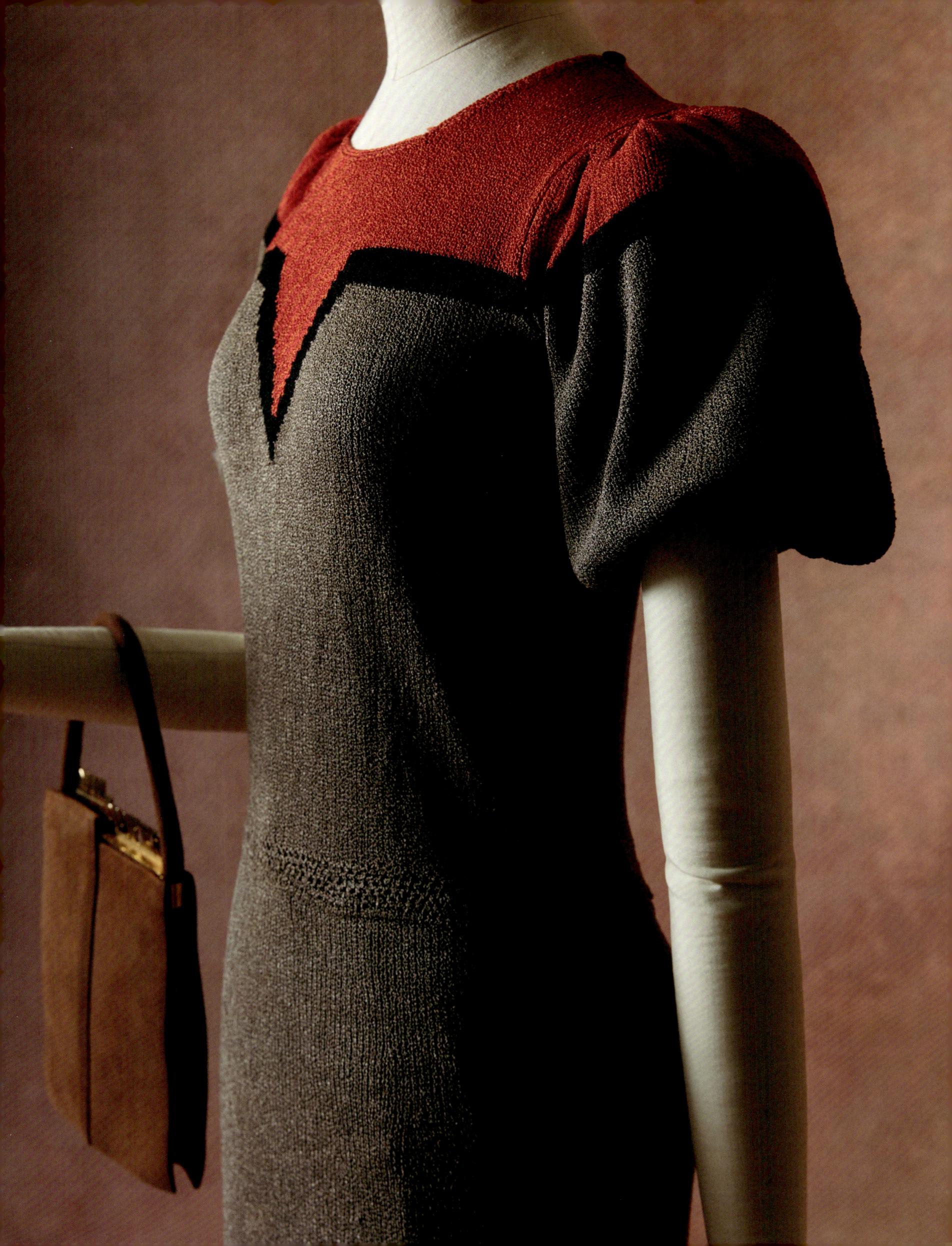

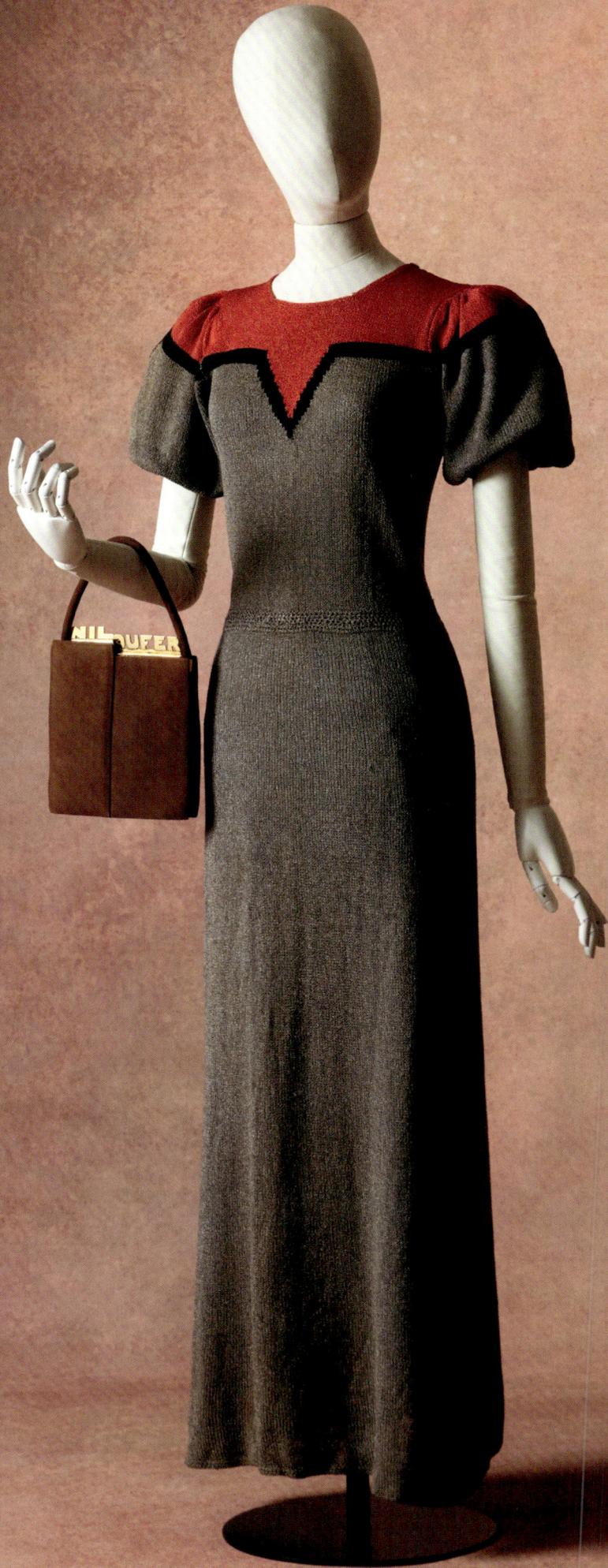

33.2. Jean Patou Knitted dress, c. 1935

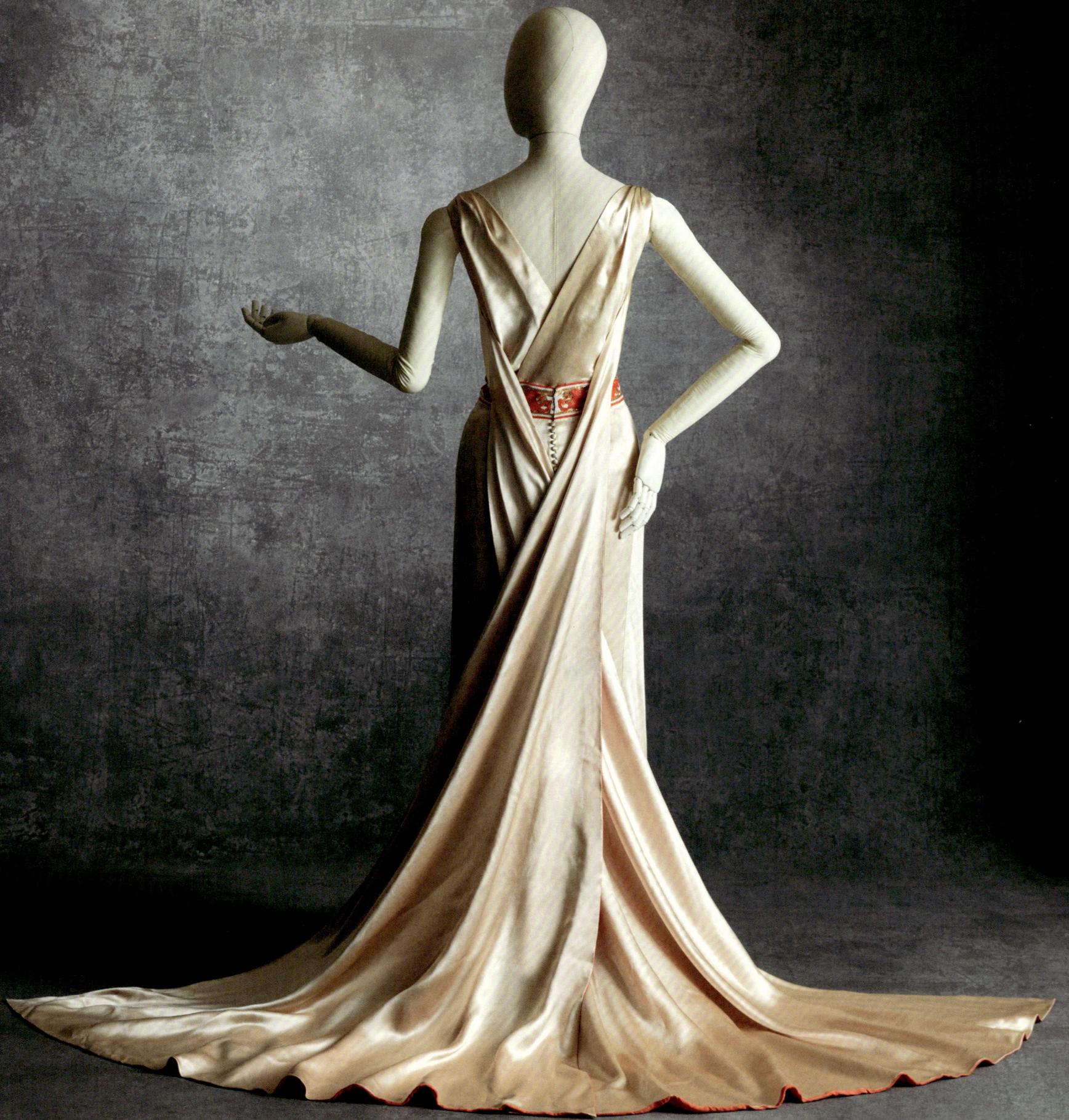

33.3. **Jean Patou** Evening gown, 1936

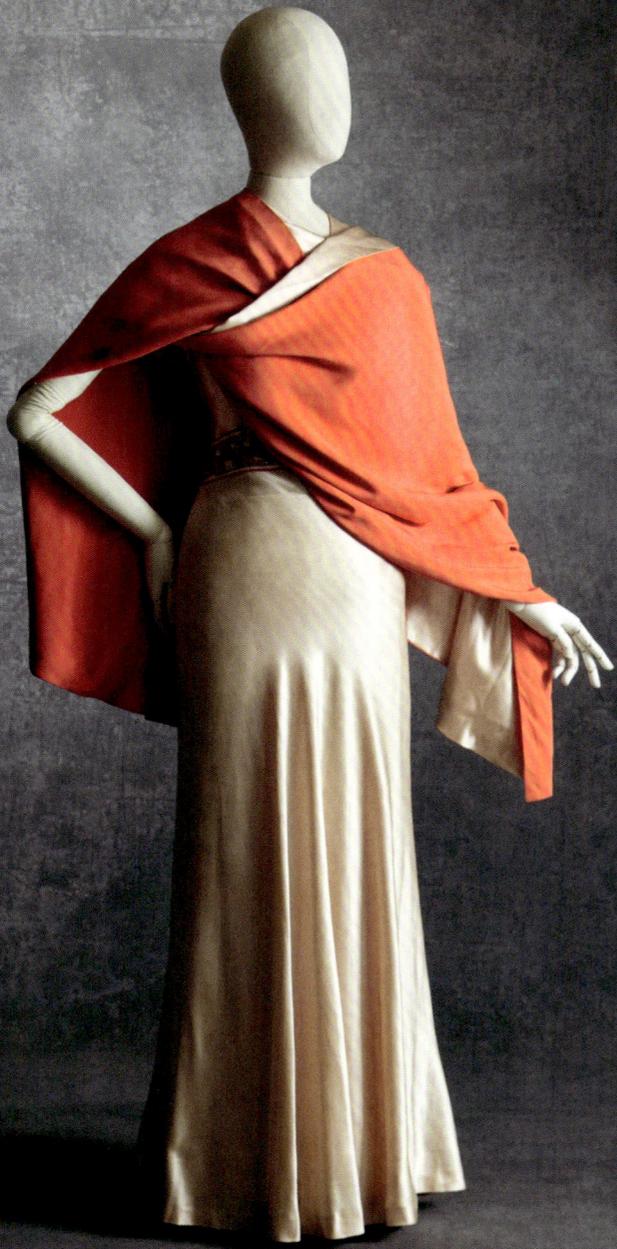

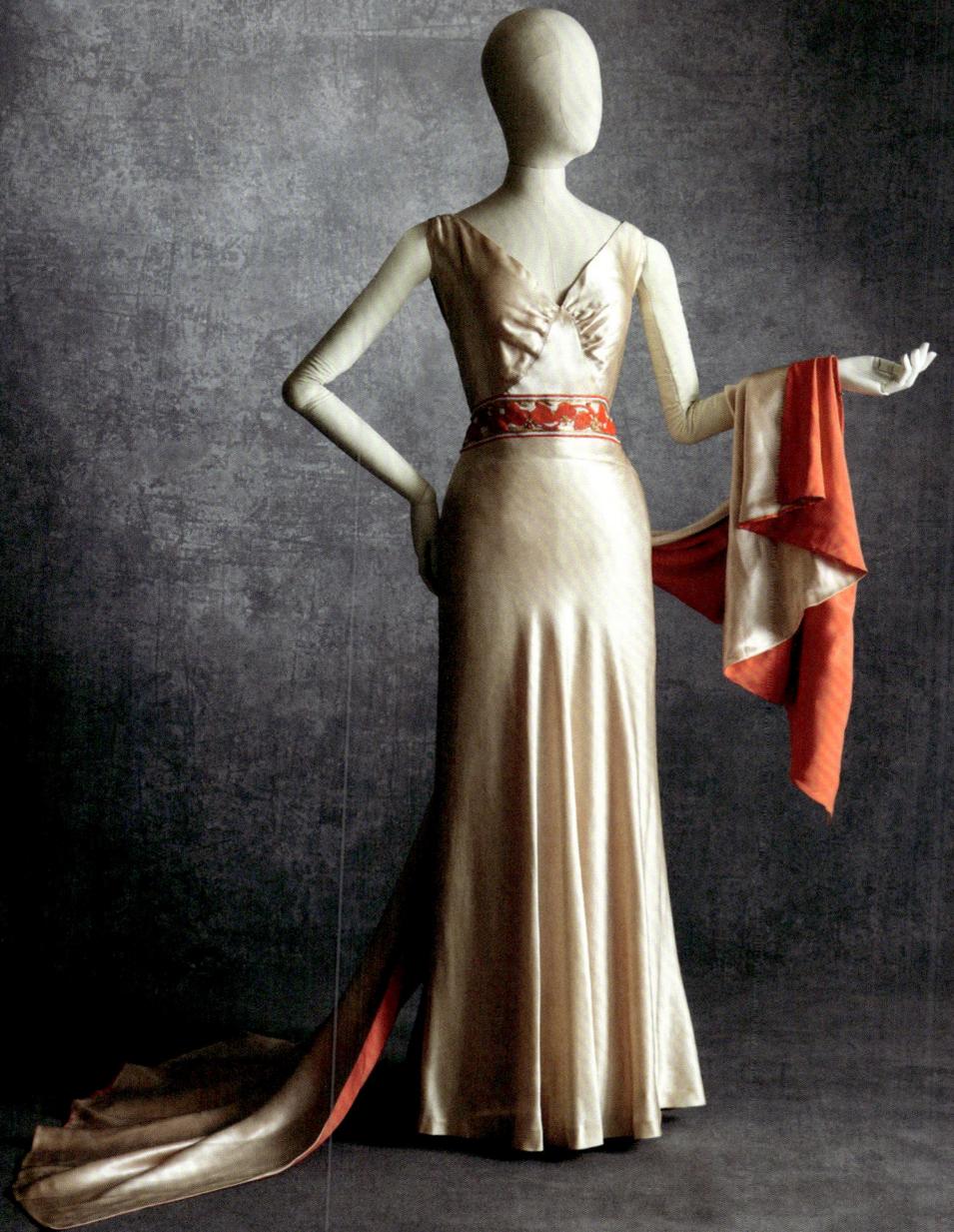

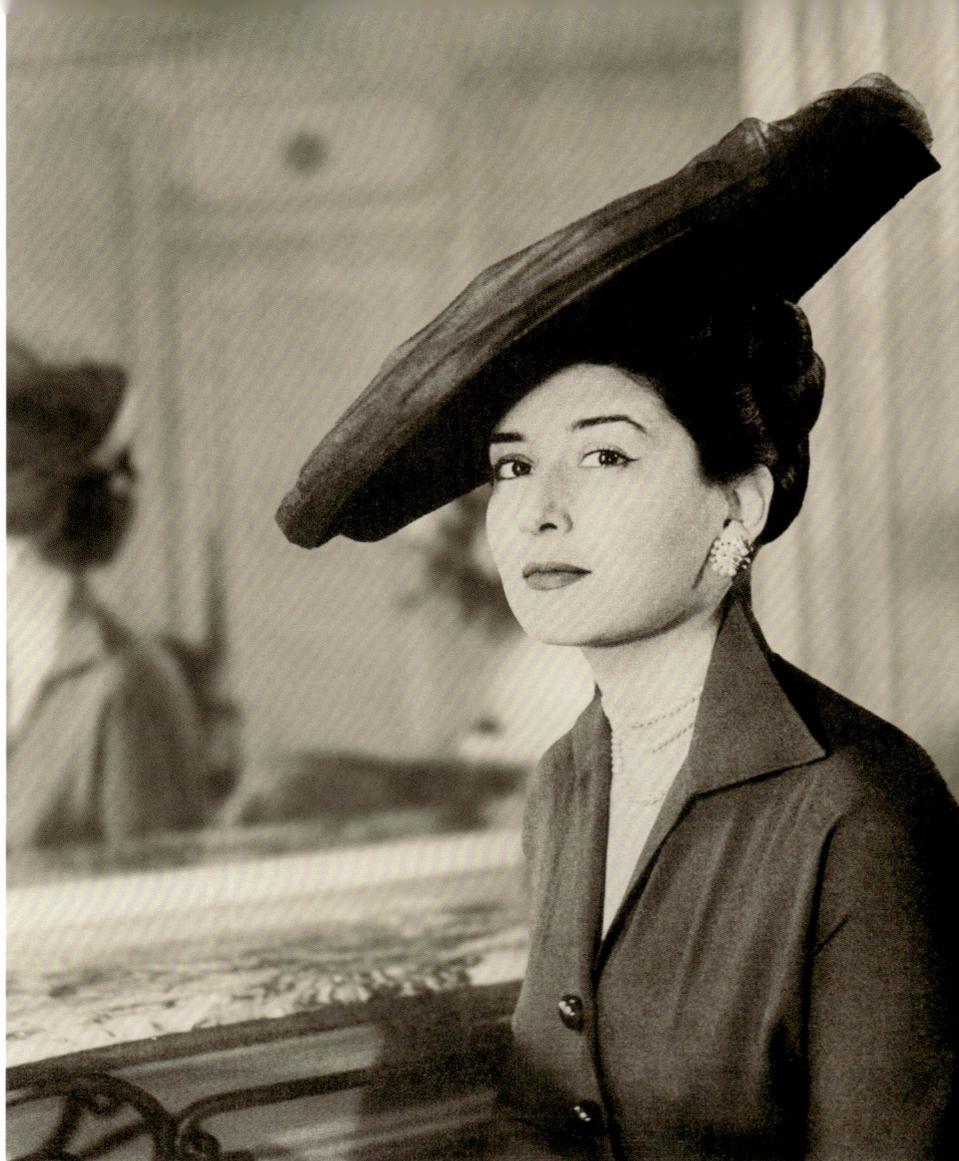

fig. 29

is loose and her gaze inscrutable. She wears a sari made of dark-blue tulle, embroidered with a bold floral design.[15] The sheerness of the fabric shows her bare arms, a clue that this is not an Indian sari but one made for her by the couturier Mainbocher.[16] He was an American-born couturier, and was closely associated with dressing Indian royalty. After relocating to New York from occupied Paris in 1940, he went on to create dresses inspired by the sari for his American clientele.[17]

It was during the 1930s that Niloufer travelled frequently to Europe, either with her husband or other companions. These trips, some of which lasted several months, allowed her and her husband to mix with international high society and to spend time with her mother. They would also have given her the opportunity to visit and order from couturiers. Throughout the decade, thanks to her financial resources, she was able to acquire dresses and ensembles by couturiers such as Jean Patou, Augustabernard and Maggy Rouff.[18] The two dresses by Jean Patou (nos. 33.2 and 33.3) were probably ordered on her trip in 1935.

Possibly because of her status as a member of the Hyderabad royal family, or for other unknown reasons, no photographs of her in Western dress or couture from the 1930s are known, with the exception of one (fig. 28) published in *Le Journal des étrangers*.[19] Here she does not pose but is caught unaware, on her way somewhere. Her hair is set and she is wearing an elegant *breitschwanz* coat embellished with two pekan furs, one on each shoulder; in her left hand she is holding a *breitschwanz* clutch, and she is wearing black suede heels.

fig. 29 Princess Niloufer wearing Jacques Fath, Paris, late 1940s
fig. 30 Princess Niloufer, photographed by Antony Beauchamp, 1947

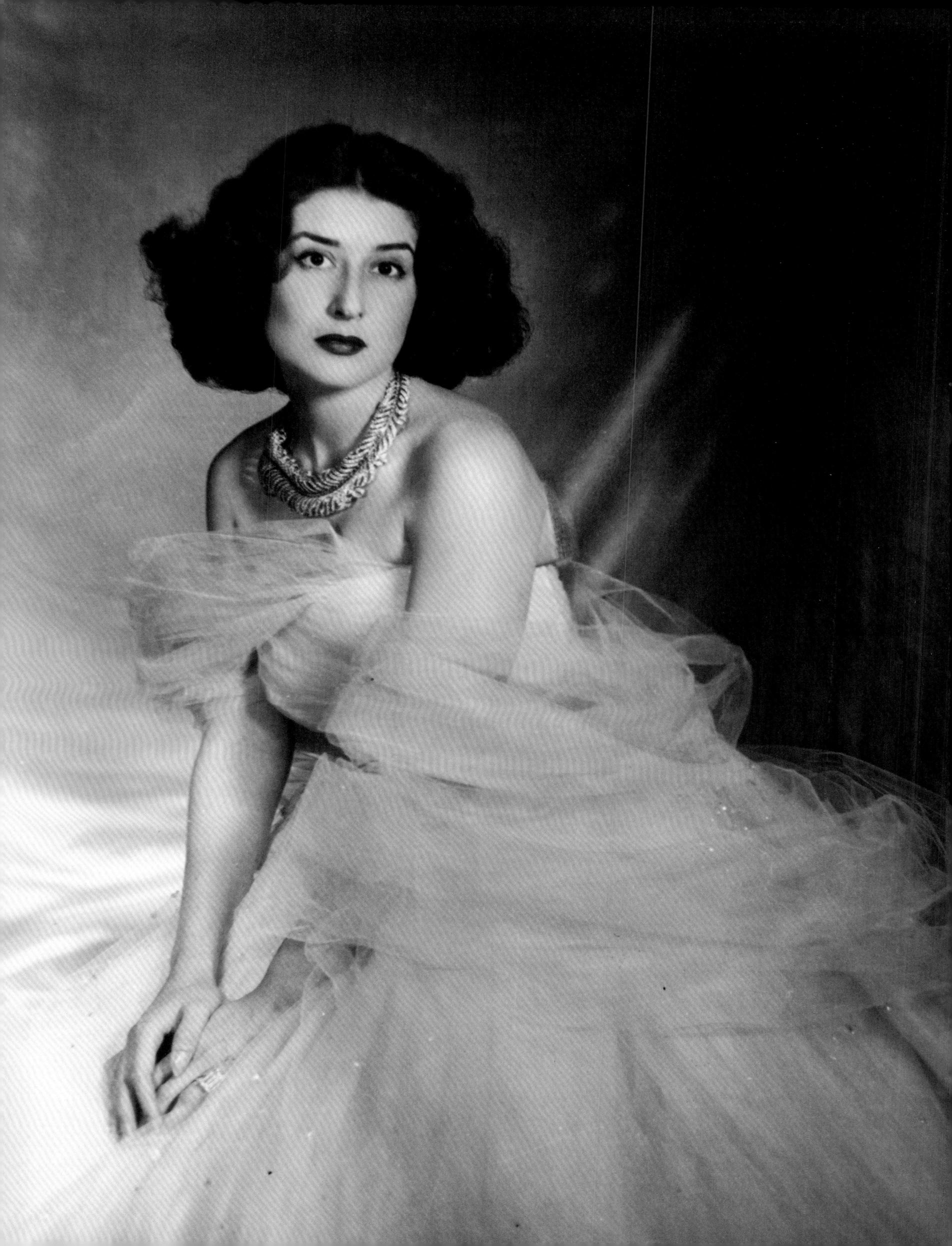

Correspondence between Niloufer and her mother before the Second World War reveals her love of fur, with repeated inquiries regarding fur prices and the latest models. Although most of the time far away from France and its fashion, Niloufer regularly requested that her mother send her French fashion magazines, corsets, shoes, cosmetics, perfumes and handbags.[20] After the war, Niloufer was frequently mentioned in the French press and in these short articles one glimpses how she was seen and often exoticized:

There are four of them: three are dressed in saris — the long, draped dress worn by Indian women. But it's the fourth, in European costume, that you look at as she leaves her hotel on the Champs-Elysees: Princess Niloufer, or Nenufar, accompanied by her ladies-in-waiting. She speaks French like you and me, and studied in Nice. Born in Constantinople, granddaughter of the last Sultan of Turkey, she married the Prince of Hyderabad in 1931. The Nizam, who rules over a country one and a half times the size of France, has an annual income of 3 million pounds (more than 2 billion francs) and a huge jewellery fortune. Niloufer simply wears a splendid ring. The Nizam lives in a palace with 2,500 rooms, owns 600 cars and drives an old Ford. The princess has just arrived in Paris for three months, to buy dresses from Dior and Griffe and to applaud her favourite actor, Gérard Philipe, at the theatre.[21]

During and after the war, acutely aware of her privileged position, Niloufer dedicated her time in Hyderabad to social welfare projects, focusing primarily on women's and children's health. While still in her twenties, Niloufer had written to her mother about wanting to establish a medical facility for women. Post-war, she secured funds and a land allocation from the Nizam's government to begin construction. She laid the foundation stone in 1949, and the hospital was inaugurated in 1953. The Niloufer Hospital for Women and Children is today cherished as her most notable accomplishment.[22]

Her marriage to Moazzam Jah, which remained childless, was not a happy one. In the midst of the crisis following India's partition and the police action in 1948, Moazzam Jah married a second wife, and Niloufer moved permanently to France, obtaining a divorce in 1952.[23] She lived with her mother in Paris, continuing to patronise couture houses despite reduced financial circumstances following her divorce. When, in 1963, she married the American Edward Pope, the couple remained in Paris.

Niloufer died in 1989 and was buried alongside her mother, Adile Sultan, in the Muslim cemetery of Bobigny. Her wardrobe was dispersed, and a Lanvin sari and dress by Madame Grès were donated to the Musée des Arts Décoratifs, Paris;[24]

thirty-four saris and documents were given to the Museum at the Fashion Institute of Technology (FIT), New York;[25] and in 1992 a group of couture dresses was sold at auction.[26]

Today, through the little that remains of princess Niloufer in the form of her letters, photographs, belongings and fruits of her charitable endeavours, an image materialises of a self-determined Muslim woman who forged her own path.

1. Nos. 33.1.–33.5.

2. Ahlawat 2009, pp. 190–91.

3. Headdress worn by Hyderabadi nobility.

4. It was reported that Durru Shehvar's train was 10 metres long and that her dress was designed by the Maison Marie-Thérèse, Nice (*L'Éclaireur du Dimanche Illustré* November 1931, p. 3). It is unknown who designed Niloufer's wedding dress.

5. Bardakçı 2008, p. 105.

6. Rahman 2019, pp. 89–91.

7. Oriental and India Office Collections (OIOC), British Library, London, R 2/73/101 and the National Archives of India (NAI) R/73/101 include confidential correspondence between Osman Ali Khan, Abdulmejid Khan and the British Resident Keyes, as well as reports regarding the marriage alliances, also discussing the issue of *purdah*.

8. Minault 1998, p. 273.

9. Princess Niloufer Collection, The Booth Family Center for Special Collections, Georgetown University, Washington D.C. The collection is open to researchers and includes correspondence between Niloufer and her mother, Adile Sultan, in Ottoman and modern Turkish and French.

10. Email correspondence between Princess Esra Jah and Francesca Galloway, July 2024.

11. McNeil 2008, p. 46.

12. Felscher 1997, n.p.

13. Princess Niloufer's sari by Jeanne Lanvin from 1947 is in the Musée des Arts Décoratifs, Paris (inv. UF 92-28-1). In September 1948 she was photographed in French *Vogue* wearing a sari by Jacques Griffe (p. 29).

14. Jaffer 2009, p. 207.

15. This sari by Mainbocher is now in the collection of The Museum at FIT, New York (inv. 92.135.5).

16. 'De l'Inde, la princesse Niloufer d'Hyderabad. Sari en tulle bleu brodé de jais blanc et vert, Mainbocher.' Qtd. in French *Vogue* July 1939, p. 27.

17. Milbank 2023, p. 140.

18. Around twenty-two lots from Niloufer's wardrobe were sold at a Millon & Robert auction (8 April 1992).

19. *Journal des étrangers* 1 March 1935, p. 27.

20. Princess Niloufer Collection, Booth Family Center for Special Collections, Georgetown University, Washington D.C.

21. *La princesse a 600 voitures*, qtd. in *Elle* 4 May 1948, p. 3.

22. For a brief overview, see Başaran 2023 and the author's forthcoming book about Princess Niloufer.

23. It was widely reported in the press that Niloufer was paid a million rupees (£75,000) when she divorced Prince Moazzam Jah. See for example *Herald Express* 11 November 1952, p. 5.

24. See inv. UF 92-28-1 and inv. UF 91-36-1 ABC.

25. The exhibition *The Saris of Princess Niloufer* was held at the Museum at FIT in 1997–98; two of Niloufer's saris were exhibited at *Exoticism* at the Museum at FIT in 2007–08; and her Mainbocher sari was exhibited at the *MAHARAJA. The Splendour of India's Royal Courts* exhibition at the Victoria and Albert Museum, 2009–10.

26. See Millon & Robert 1992.

34 – 51

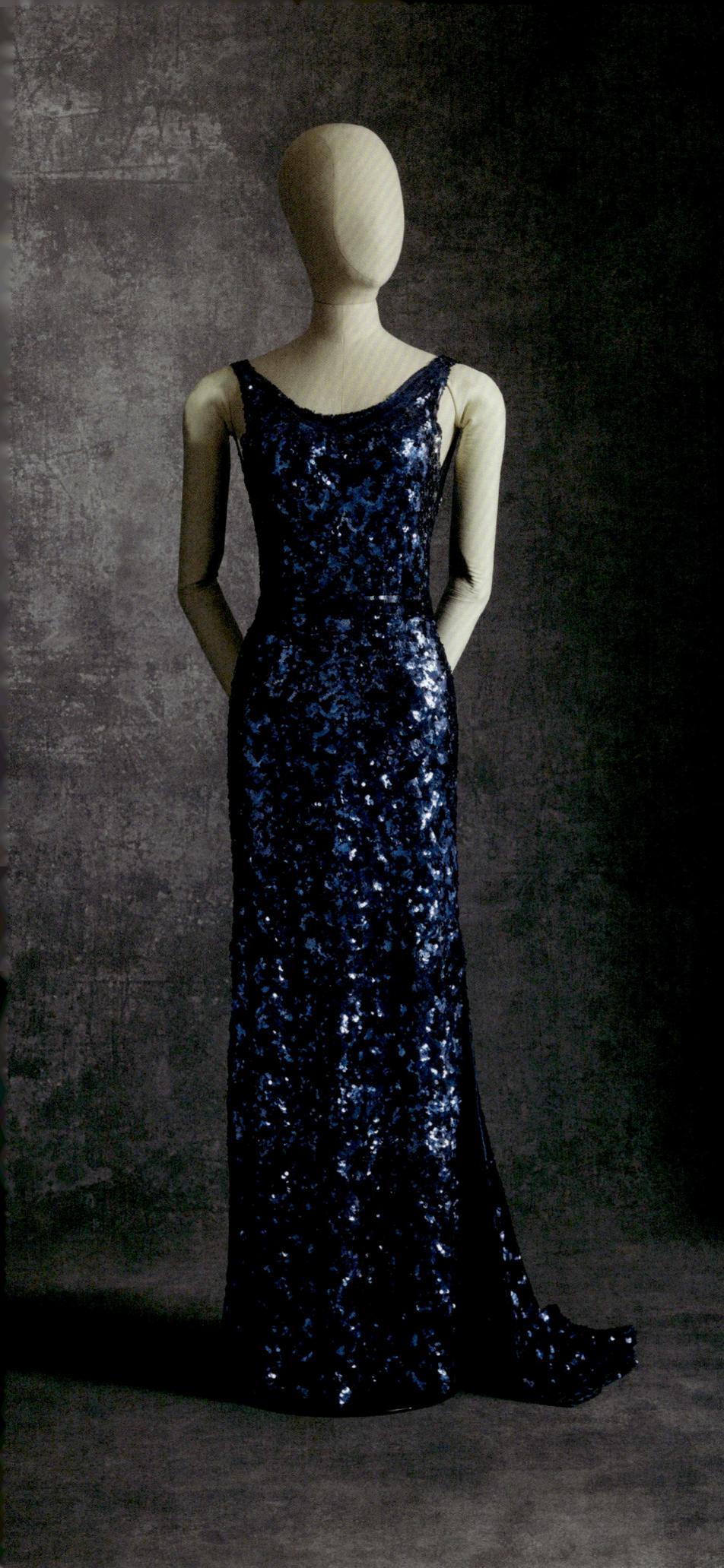

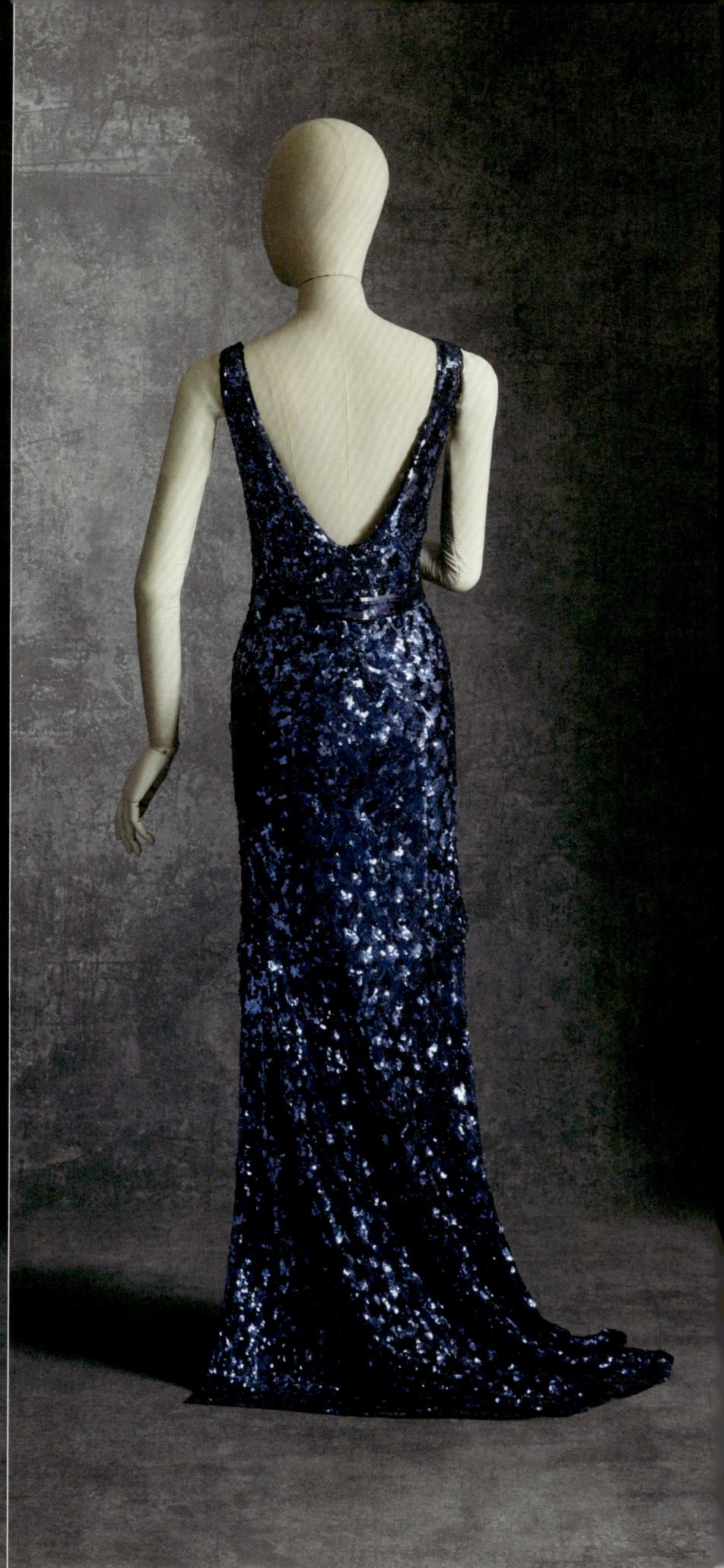

34. Gabrielle Chanel Evening dress, c. 1935

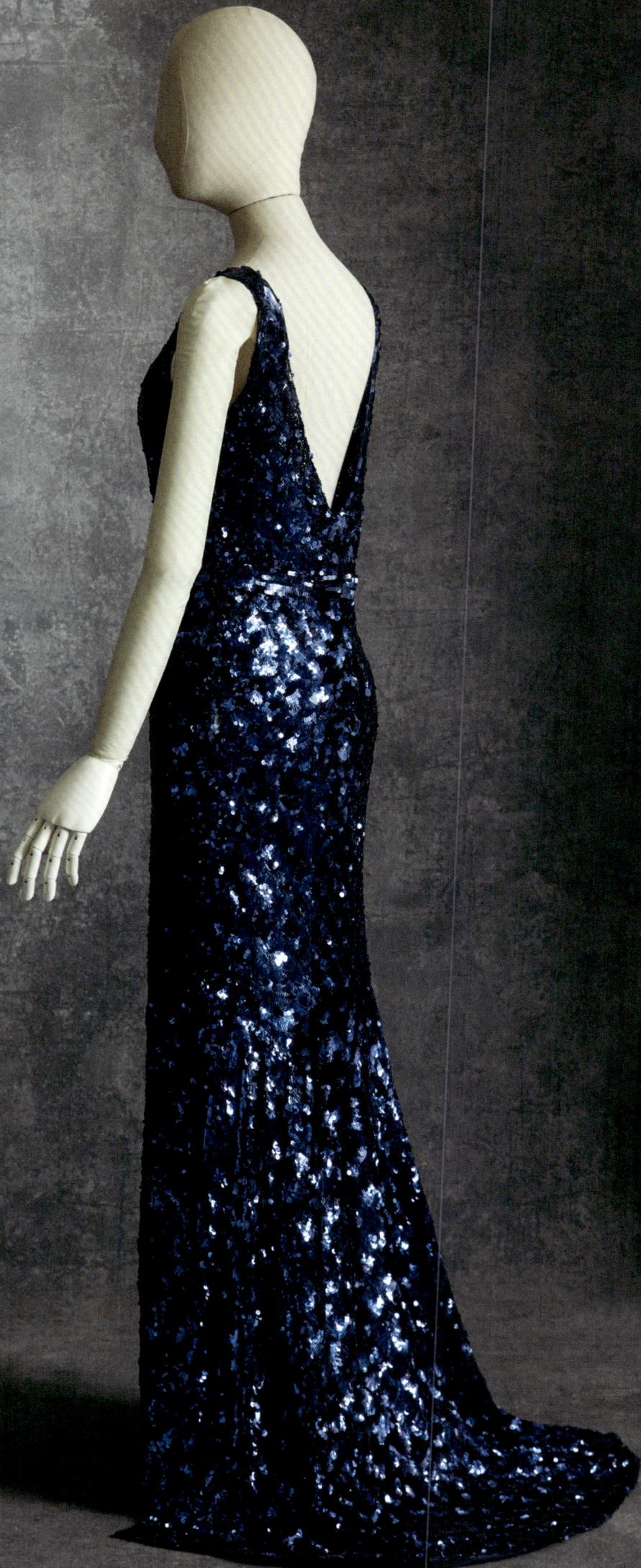

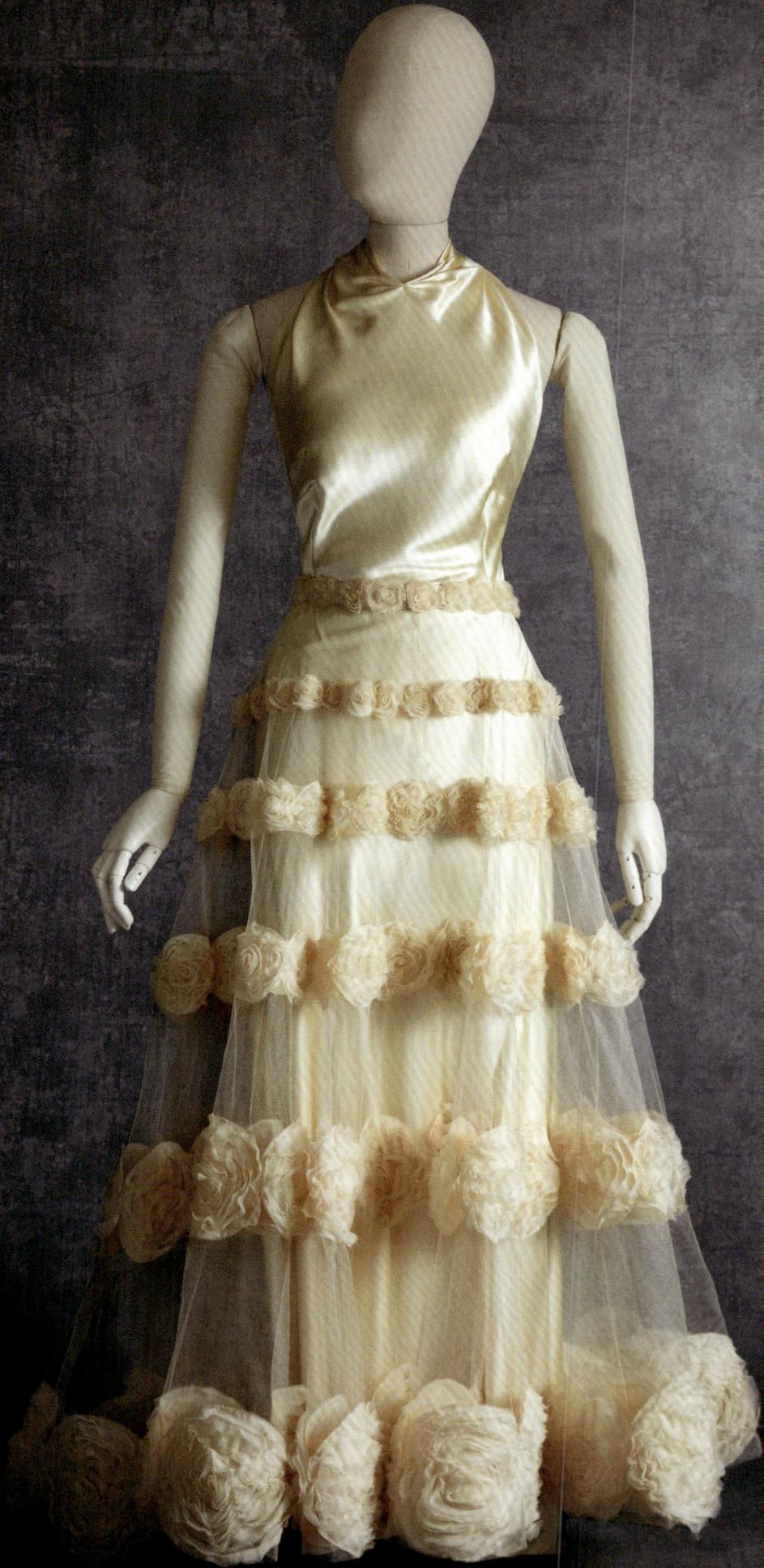

35. **Madeleine Vionnet** Evening skirt, 'Carnival', Autumn/Winter 1936

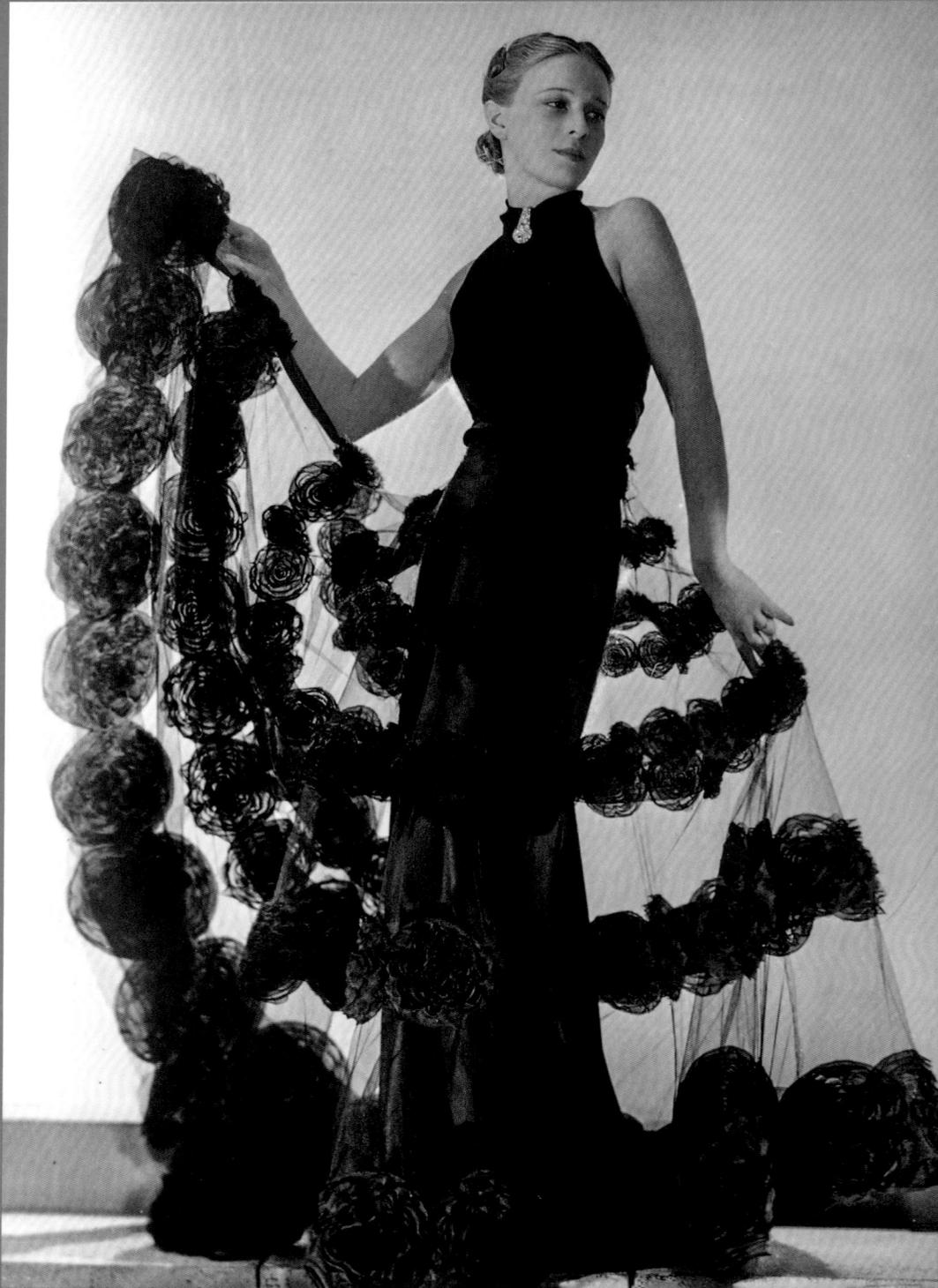

fig. 31 Sonia Colmer, Vionnet's favourite model, photographed by Georges Saad, wearing the 'Carnival' ensemble, 1936

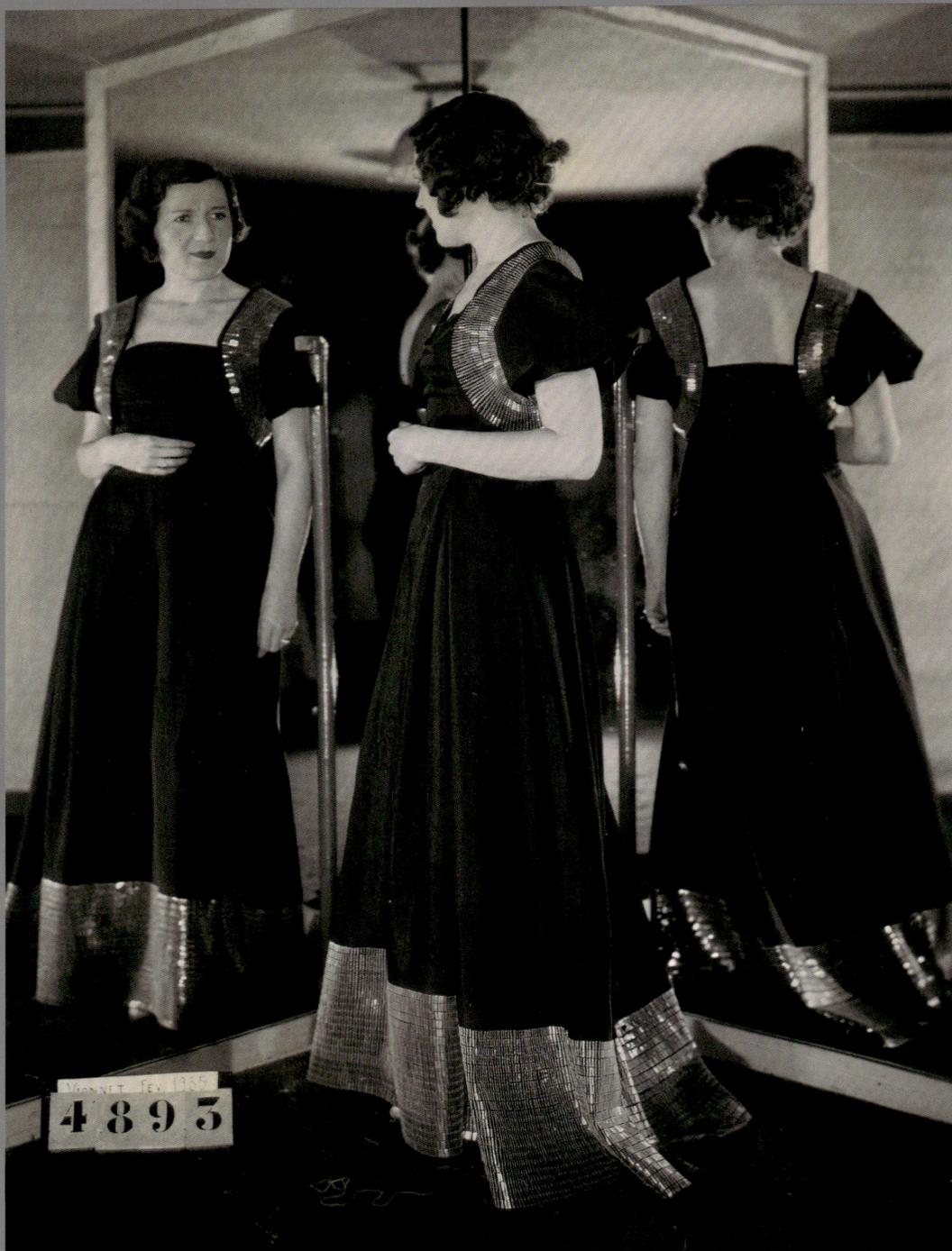

fig. 32 Registration photograph (*Dépôt de modèle de Madeleine Vionnet*), February 1935

Madeleine Vionnet (1876–1975) founded her own couture house in Paris in 1912, having previously worked for Callot Sœurs and Doucet. Vionnet was one of the great fashion innovators, and also a master of perfection. Acutely aware of the copyists who imitated her designs, she was one of the leading couturiers who sought to protect the copyright of her work through the French courts. Vionnet compiled registration books containing images of her creations, as did nearly all the couturiers. From 1928 she began to use two mirrors, allowing three different views of the same garment in a single photograph. This was further refined in the early 1930s, when she placed two mirrors at right angles, as in fig. 32.

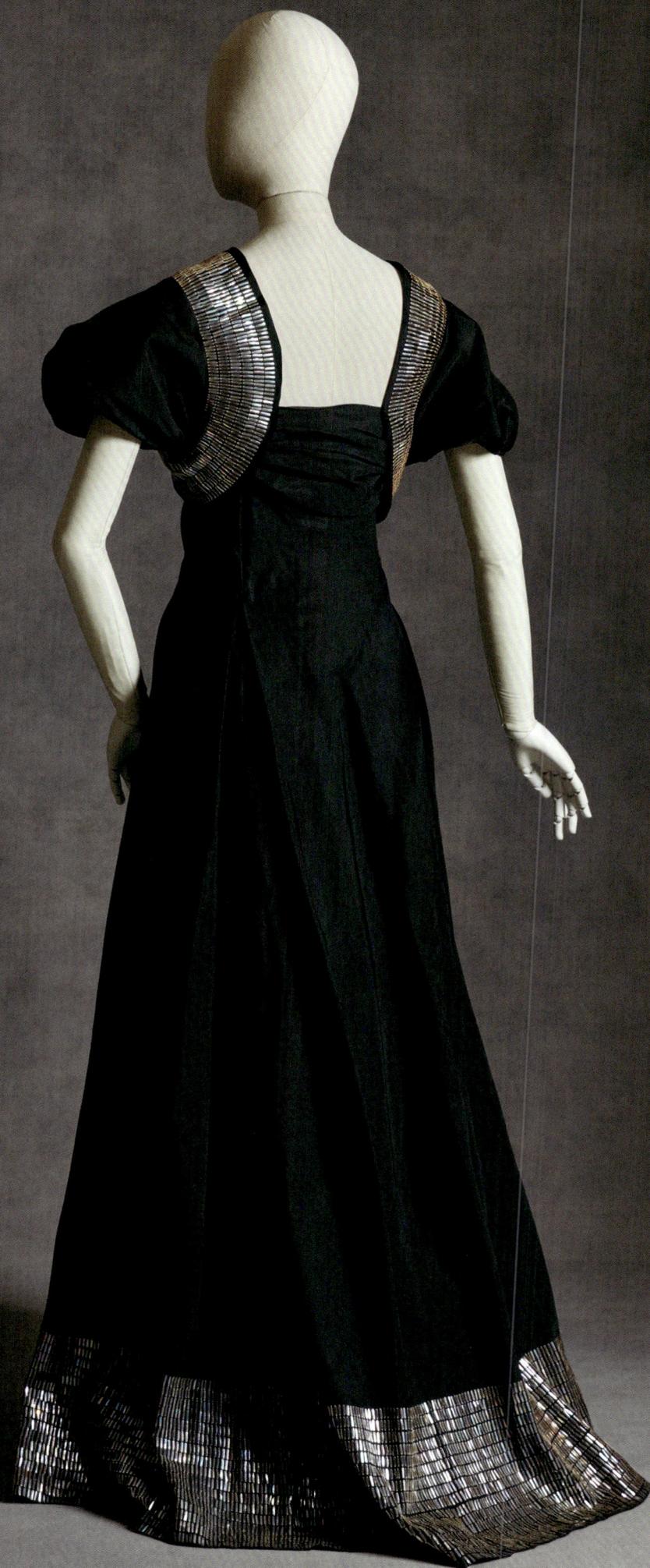

36. Madeleine Vionnet Evening gown, Summer 1935

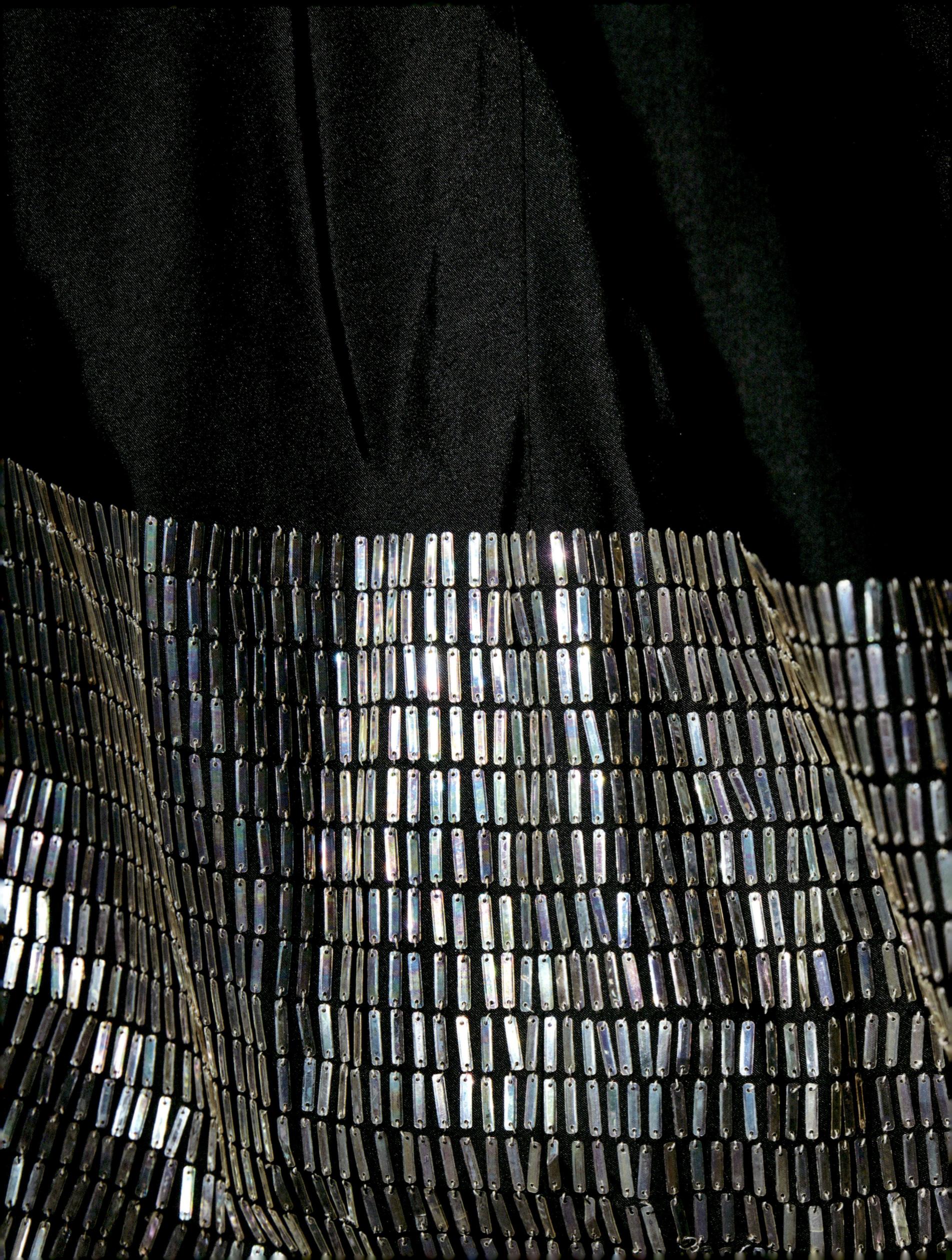

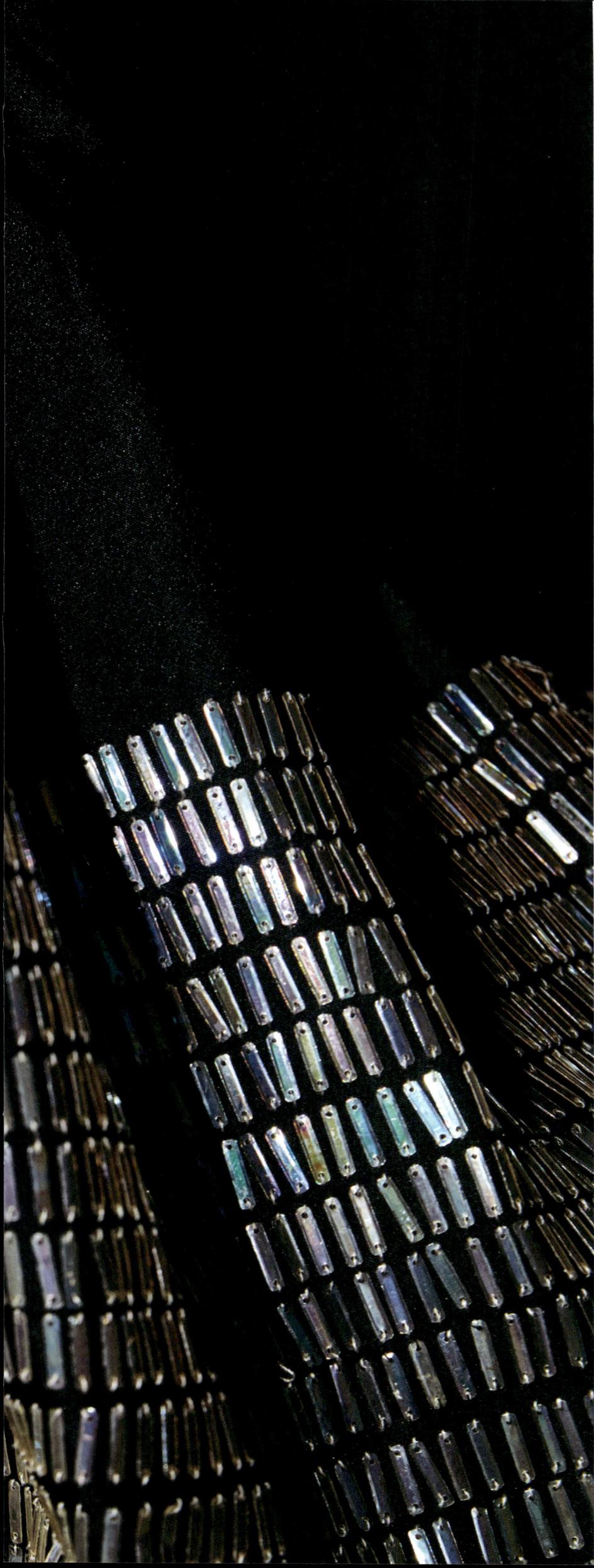

37. Alix Asymmetrical coat, c. 1935–37 and **Elsa Schiaparelli** Headdress, c. 1940

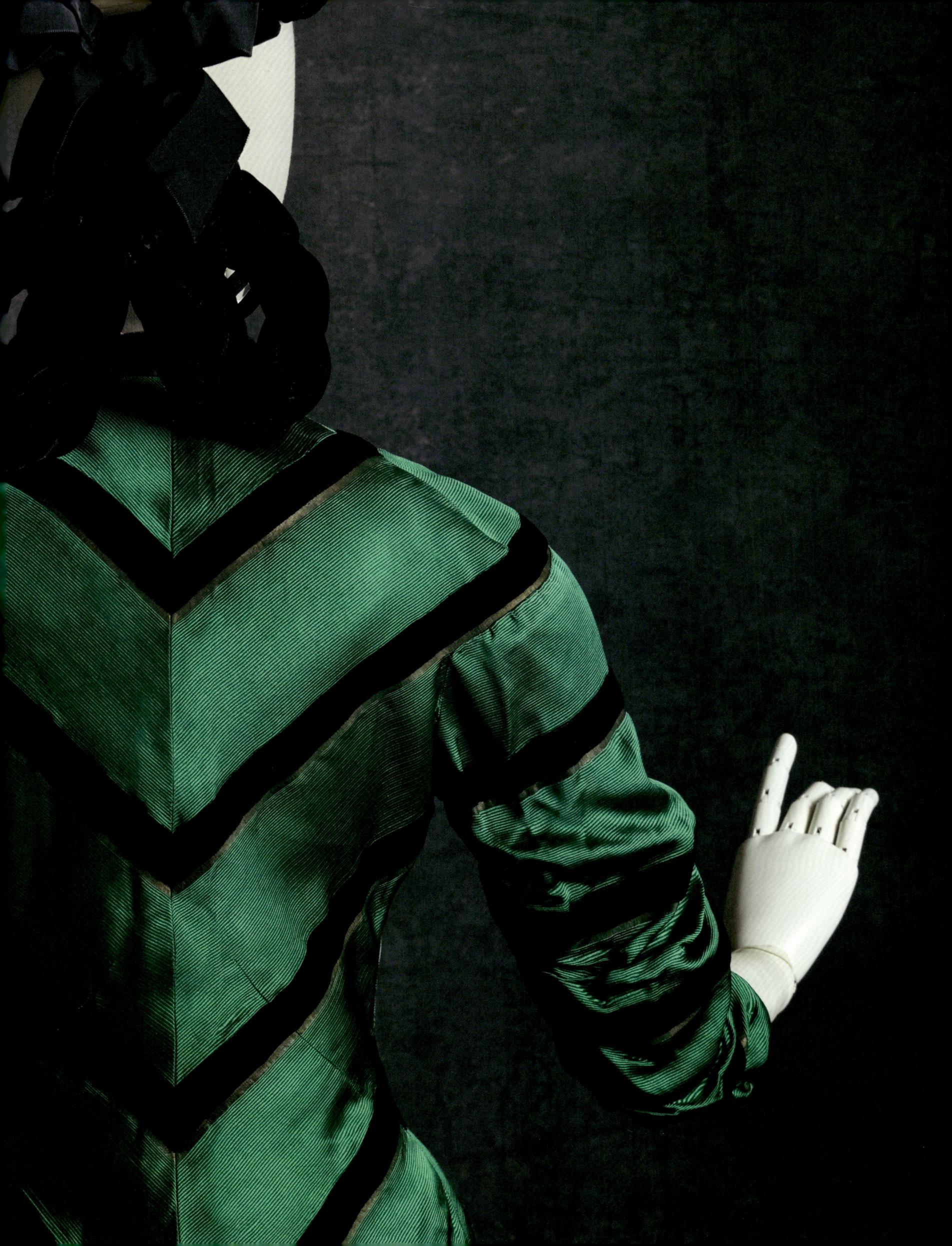

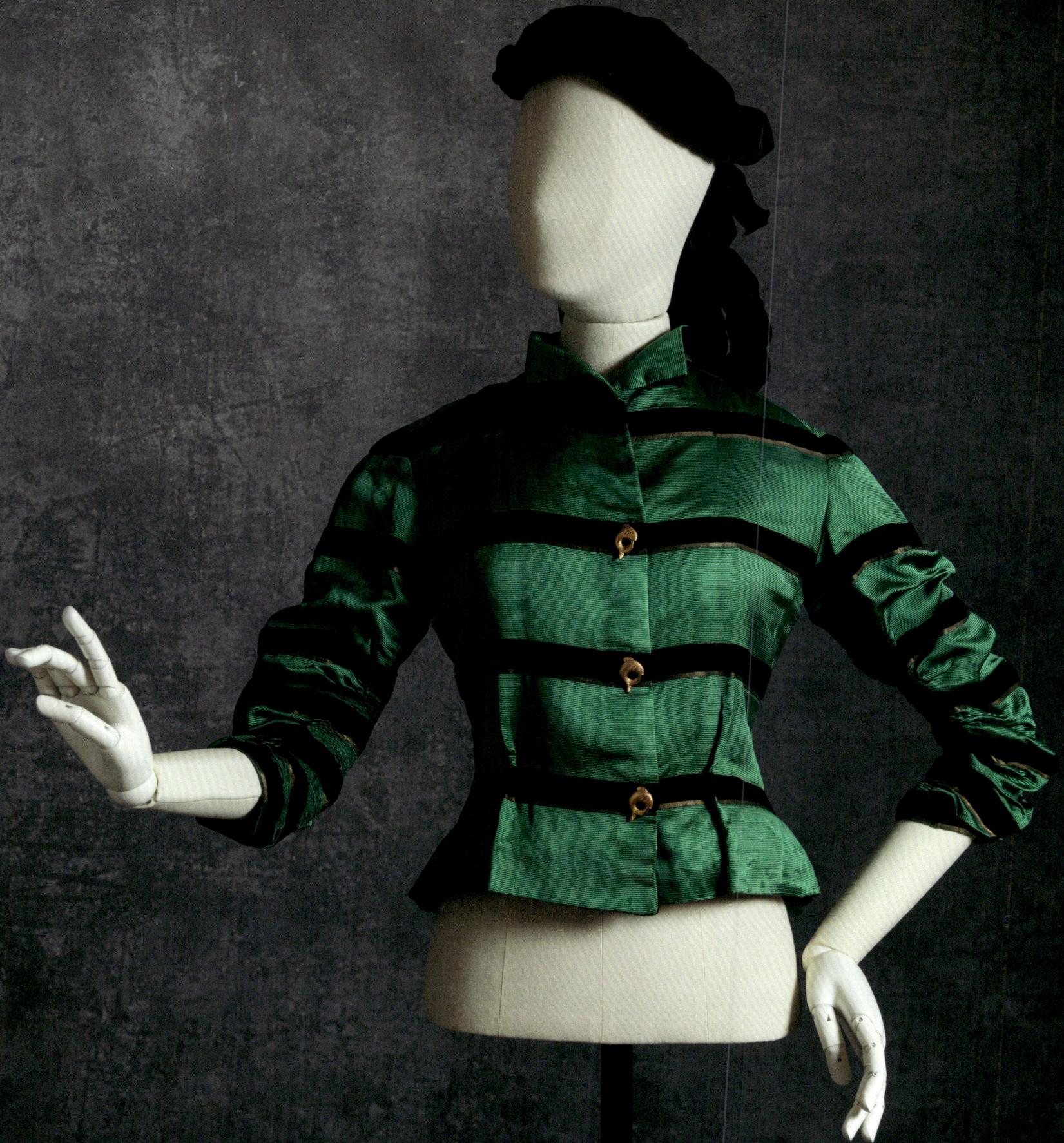

38. Elsa Schiaparelli Afternoon or evening jacket, Winter 1935

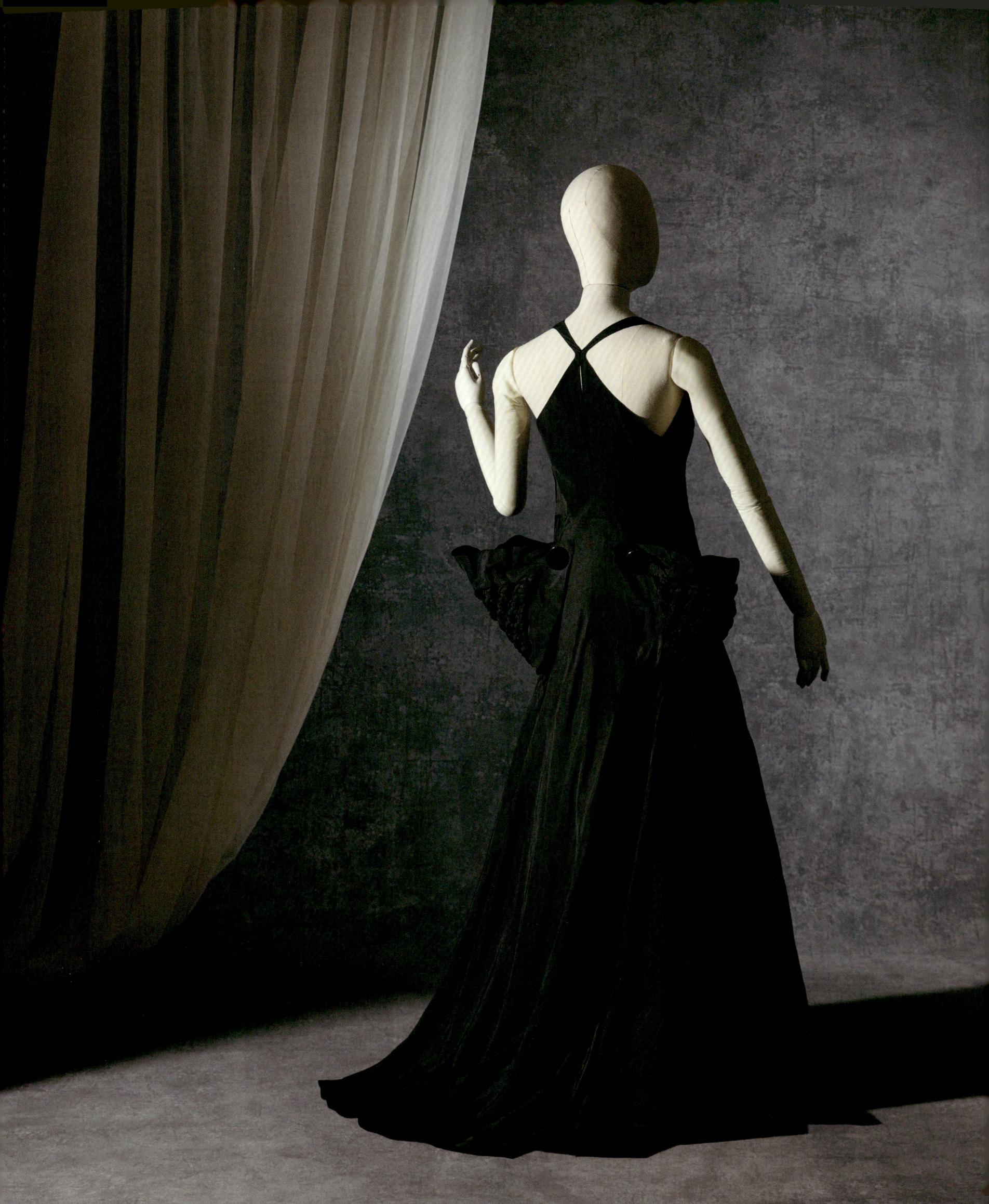

39. Jeanne Lanvin Evening gown, 'La Nuit', Winter 1936–37

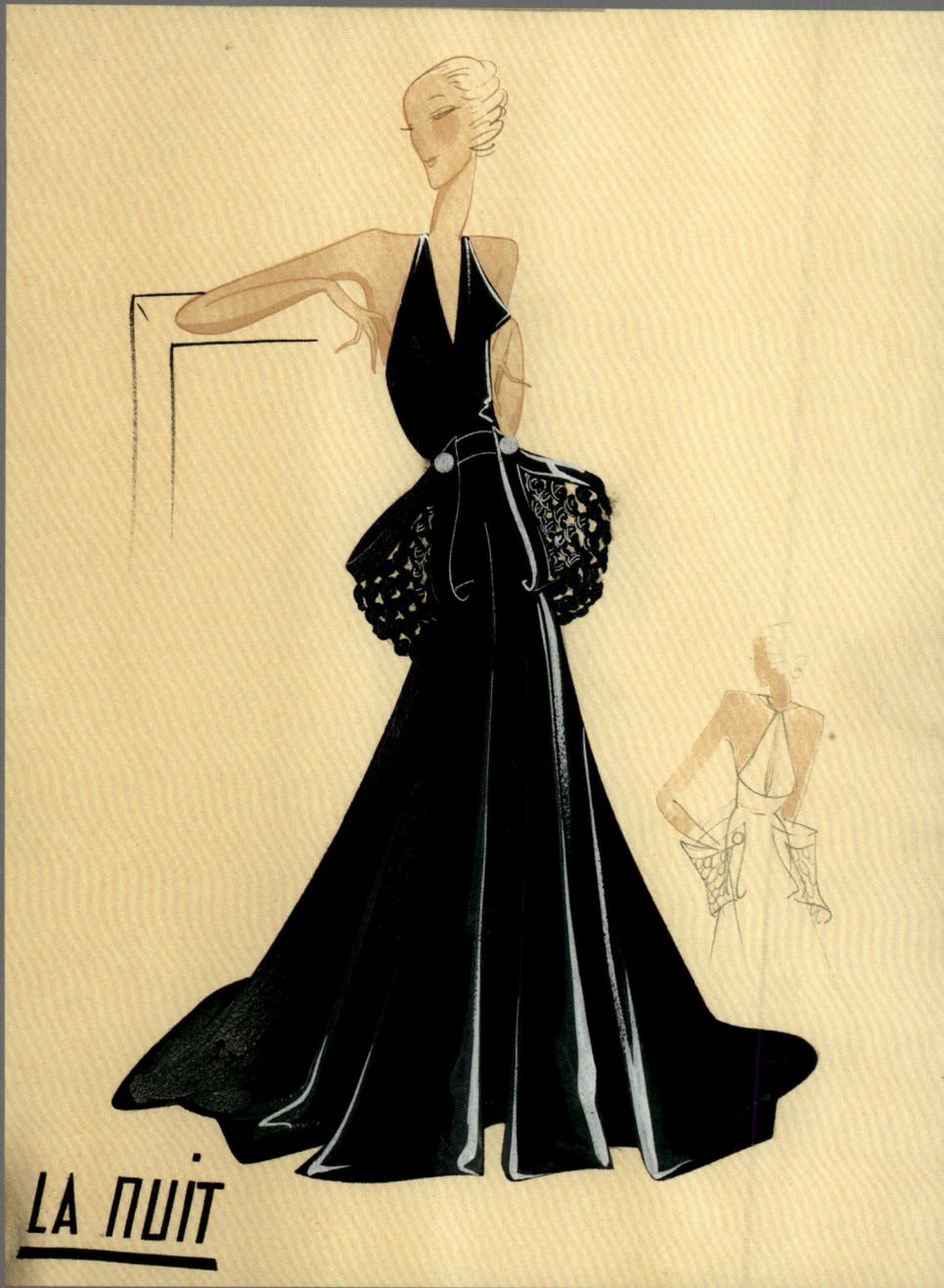

fig. 33 Modèle 'La Nuit', Jeanne Lanvin, 1936

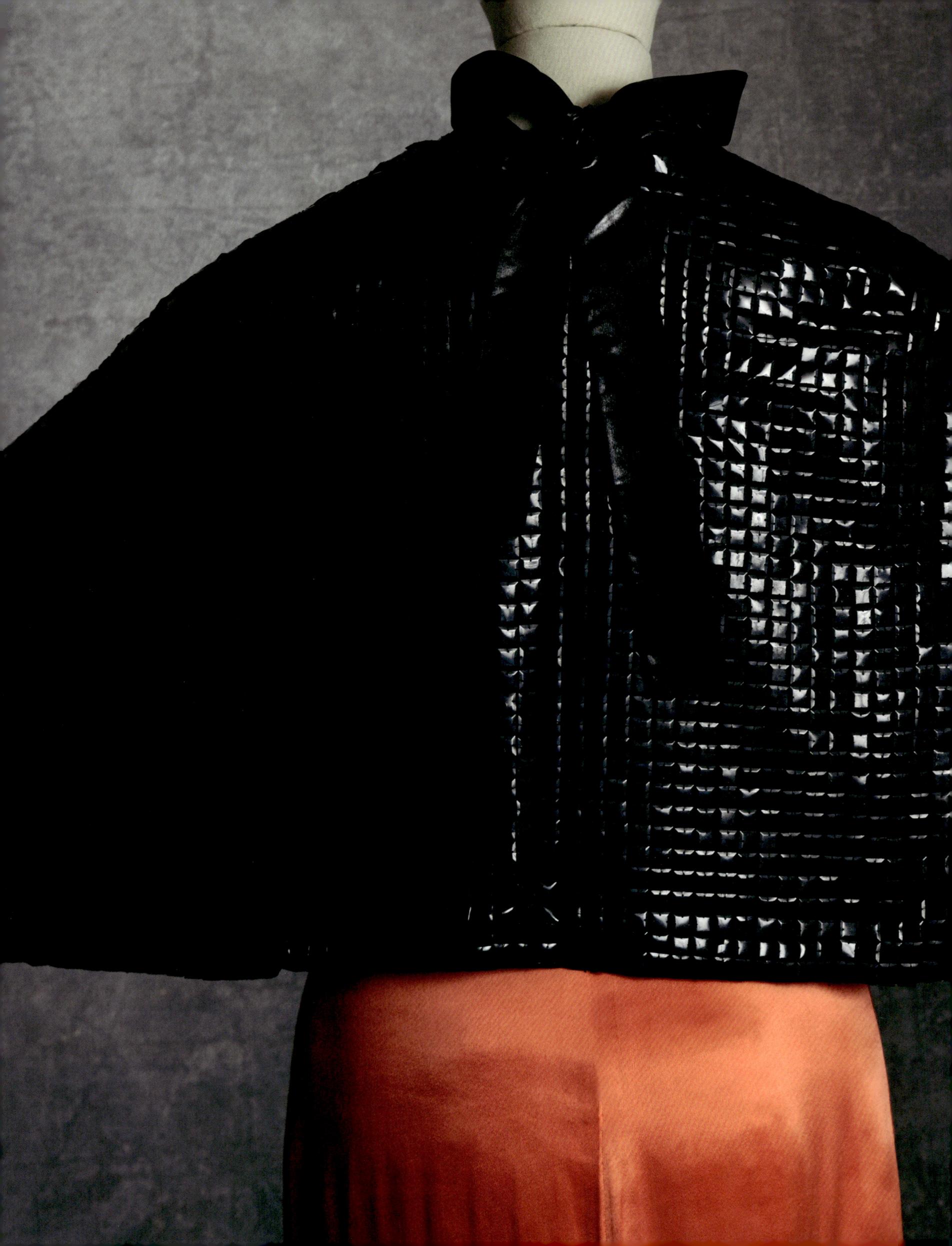

40. Bruyère Evening jacket, c. 1934–35

41. Hermès Bathing suit, 'Zodiaque', 1938

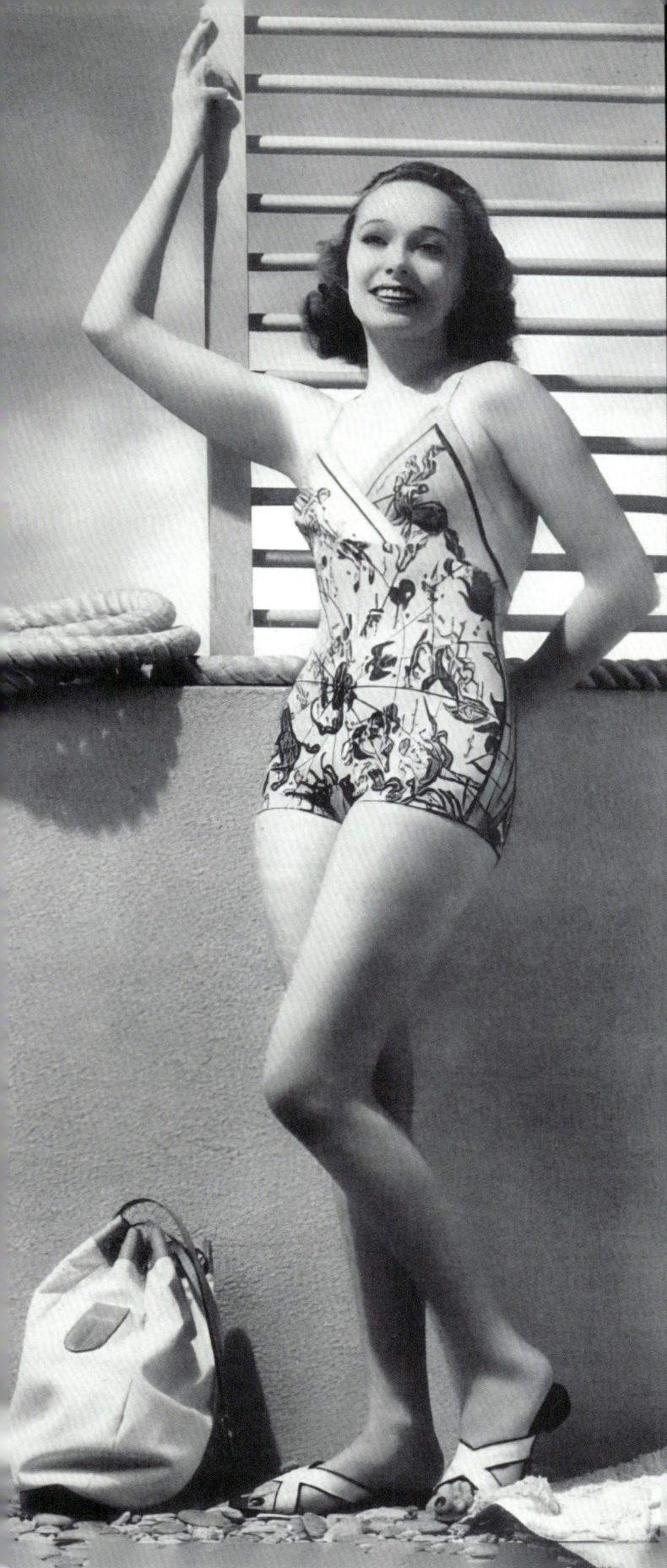

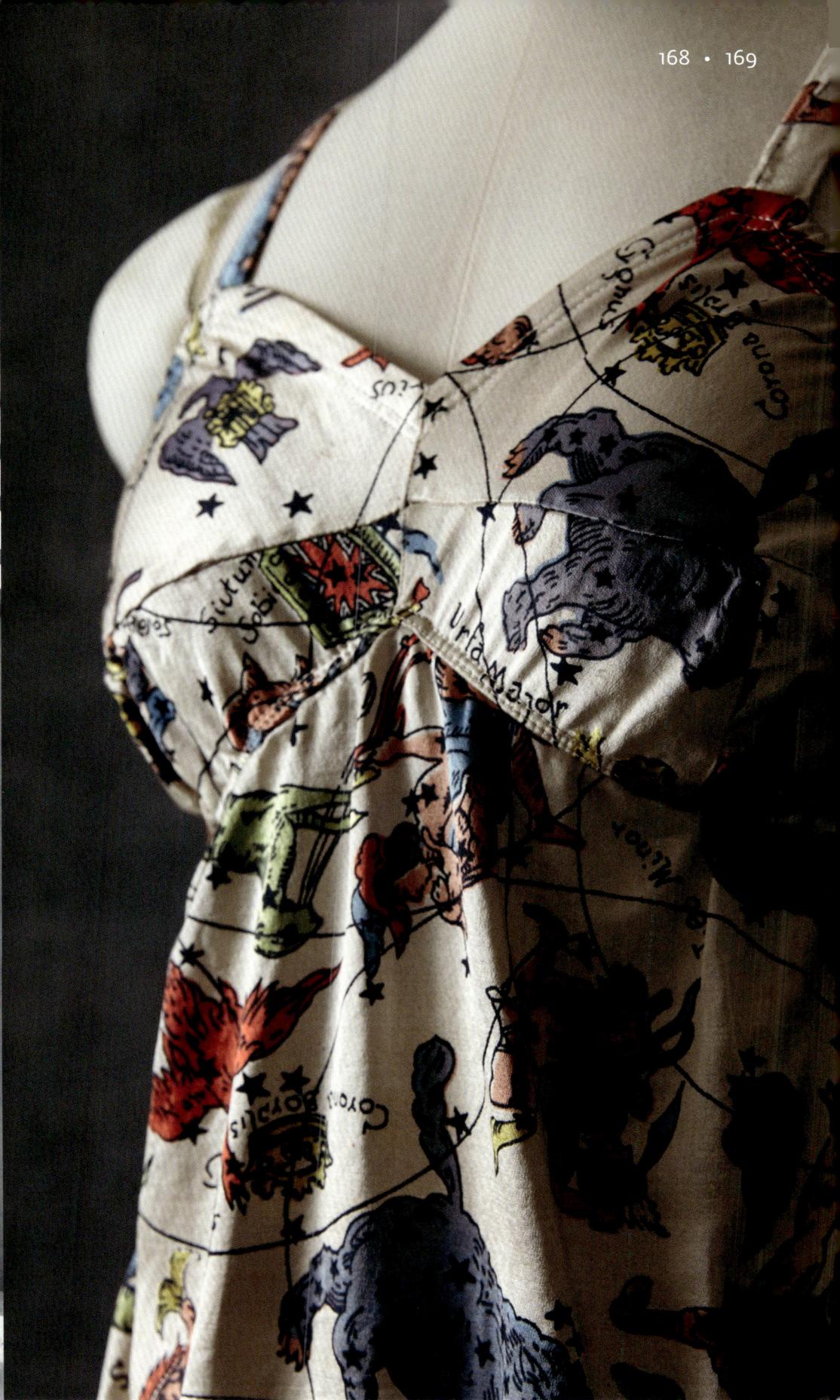

fig. 34 Model posing in Hermès bathing suit, 1938

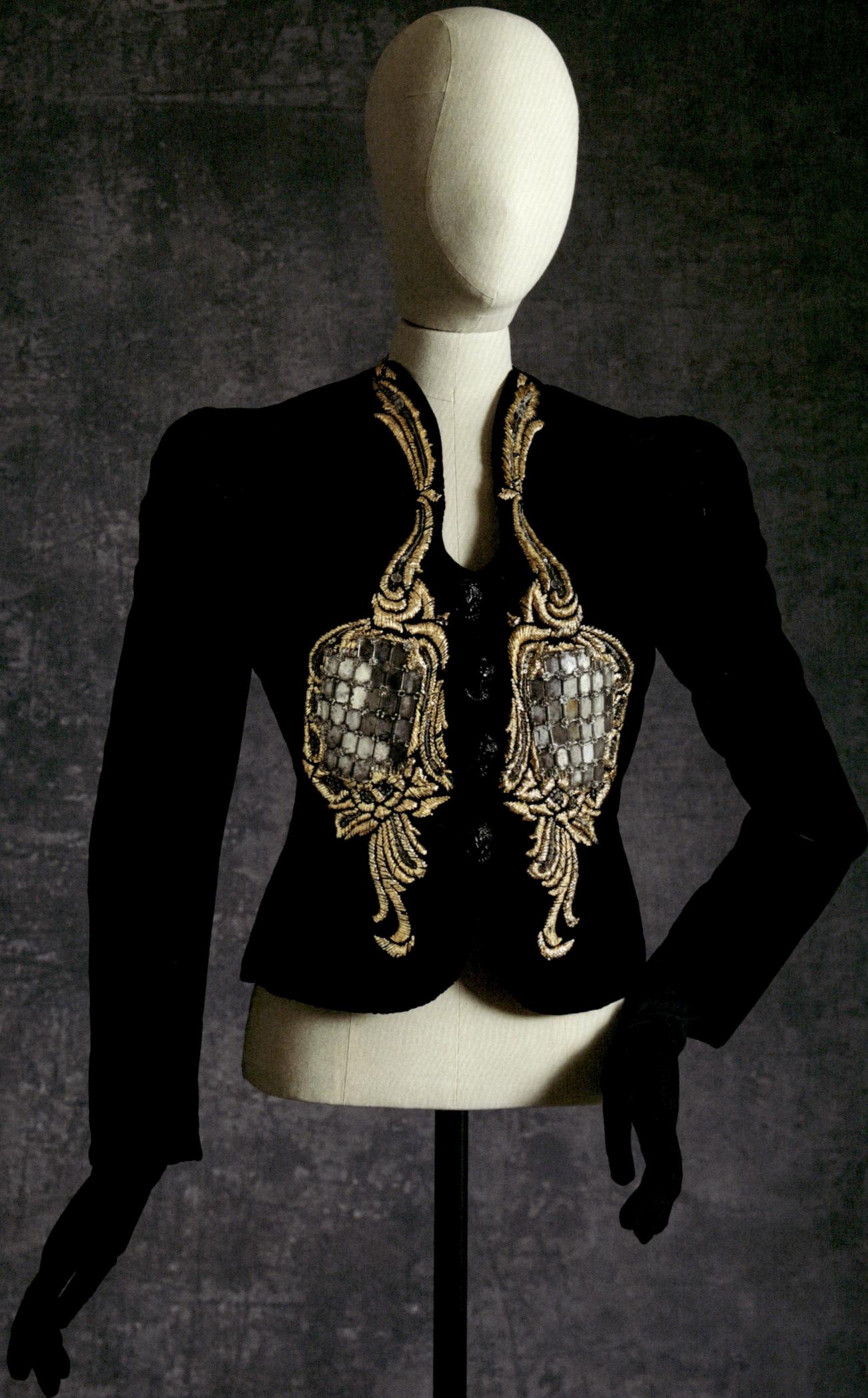

42. **Elsa Schiaparelli** Evening jacket, Spring 1939

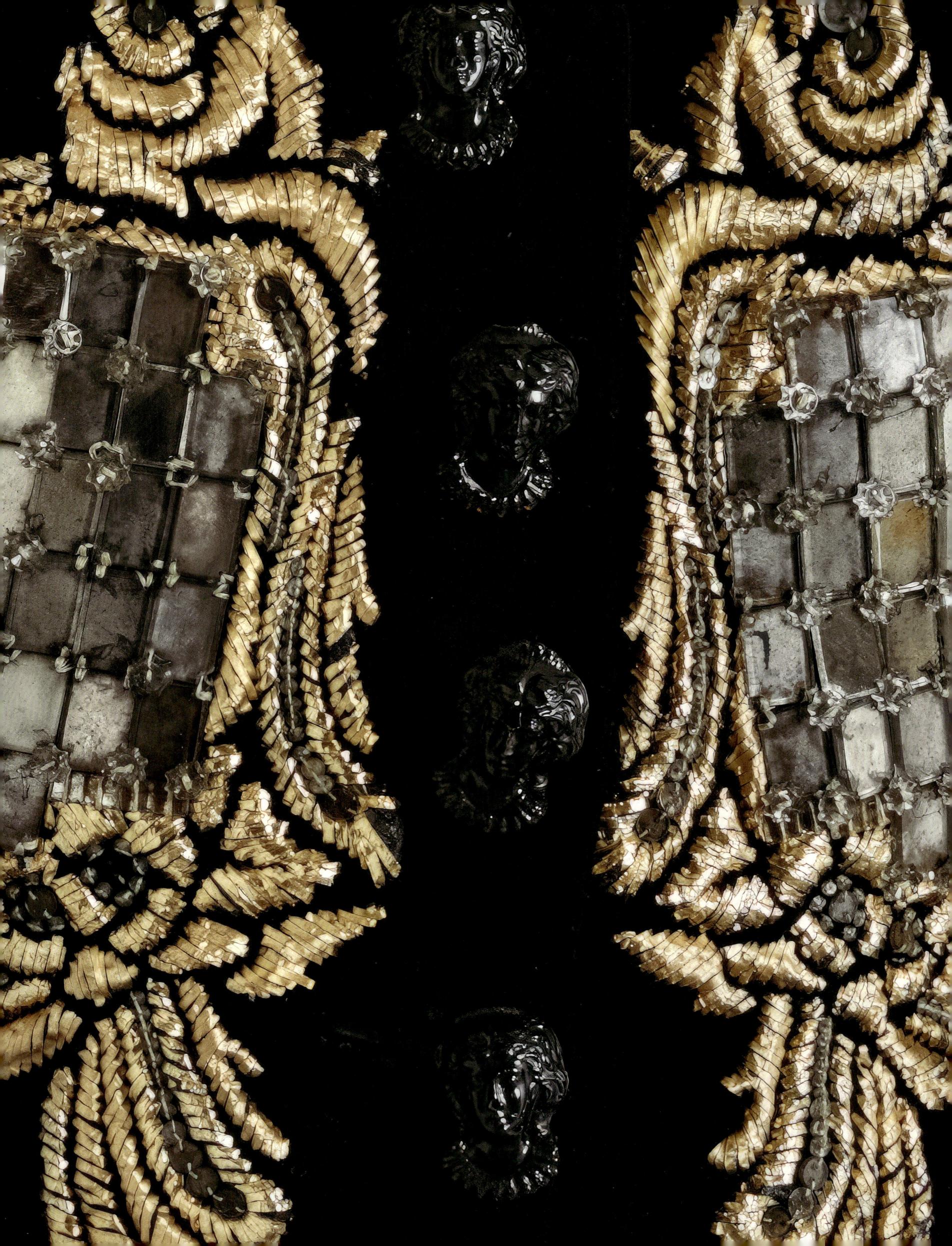

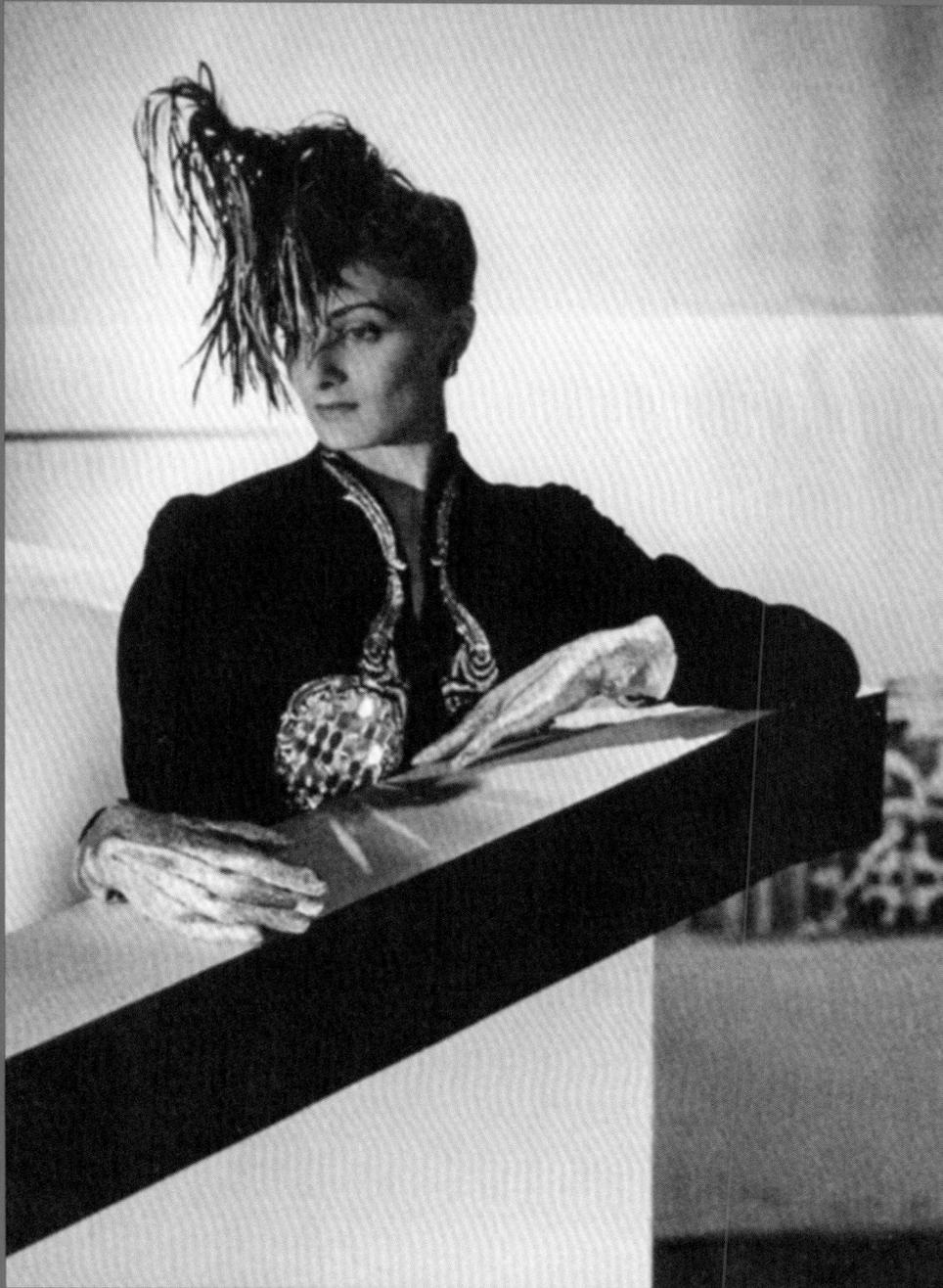

fig. 35 Lyla Zelensky photographed by Horst P. Horst, French *Vogue*, 1938

The jacket came from the 'Cosmique' collection (often referred to as 'Zodiaque' or 'Astrologique'), which was one of Elsa Schiaparelli's most celebrated collections. The theme revolved around the esoteric mysteries of the constellations, the stars of the cosmos (as a tribute to her uncle, Giovanni Schiaparelli, a famous astronomer and director of the Milan observatory) and, by extension, the sun, a powerful symbol of the reign of Louis XIV.[8] The collection featured luxurious velvets and brightly coloured wools embellished with extraordinary gilt metal embroidery, which was executed by Maison Lesage, haute couture embroiderers.[9]

The jacket features a pair of oversized Baroque-style gilt-framed hand mirrors, each made up of multiple smaller mirror panels, with the handles curving around the neck. For more conservative clients Schiaparelli offered a plain wool day suit with oversized buttons in the shape of black plastic hand mirrors.[10]

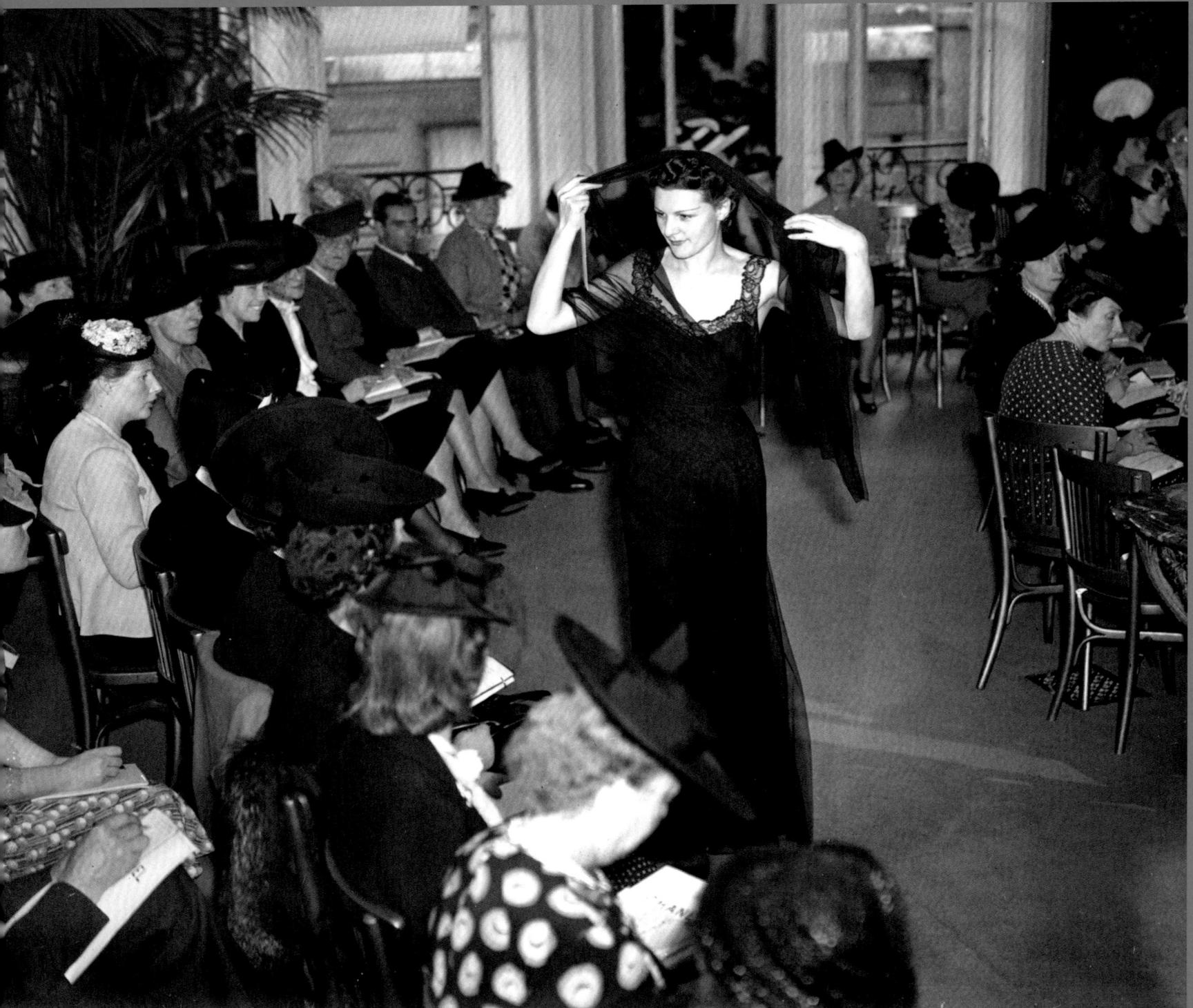

fig. 36 Model wearing the dress opposite on Chanel's final runway in August 1939, before Chanel closed her couture house that September at the outbreak of the Second World War

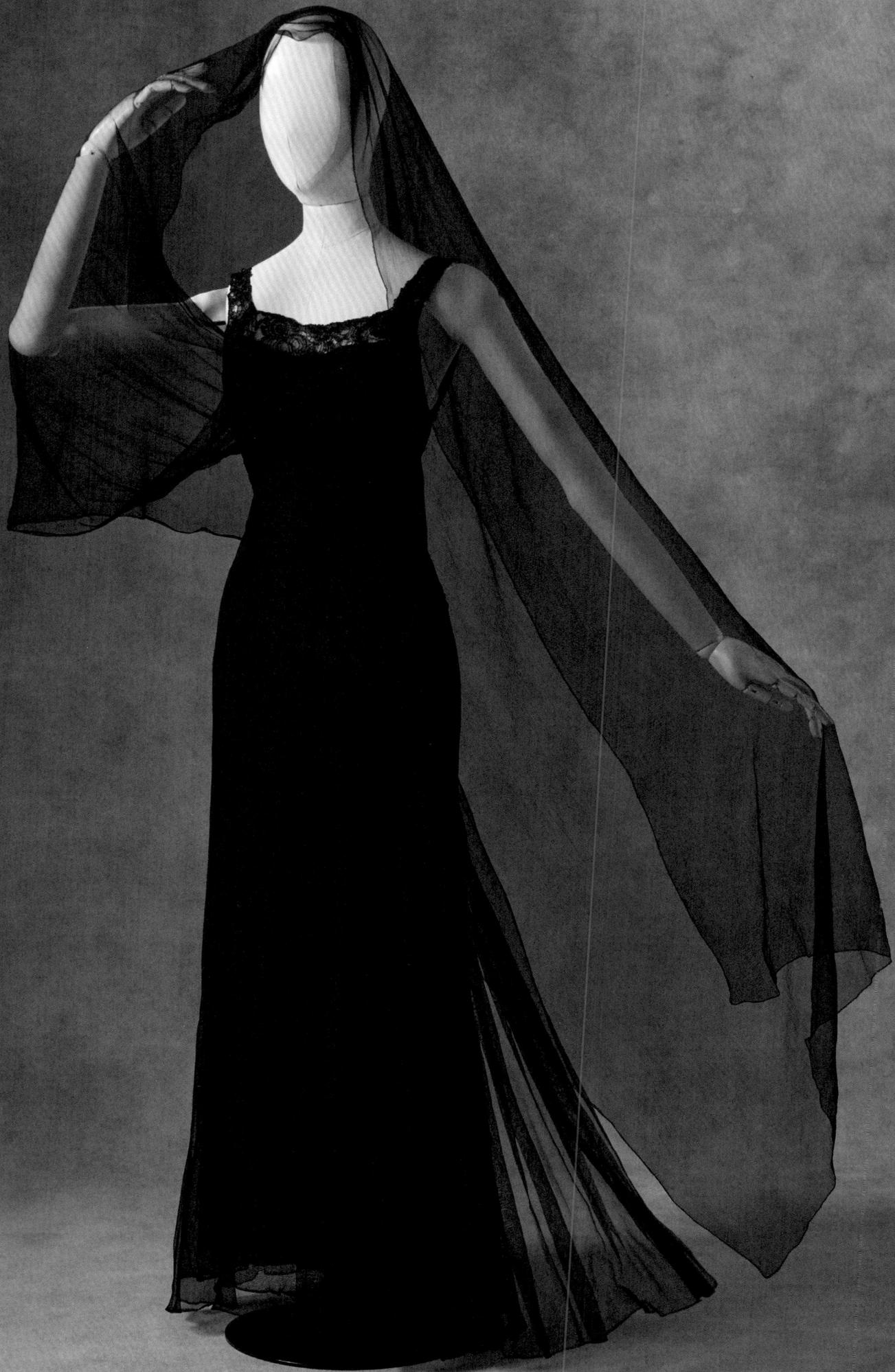

43. Gabrielle Chanel Evening dress with chiffon veil, Autumn/Winter 1939

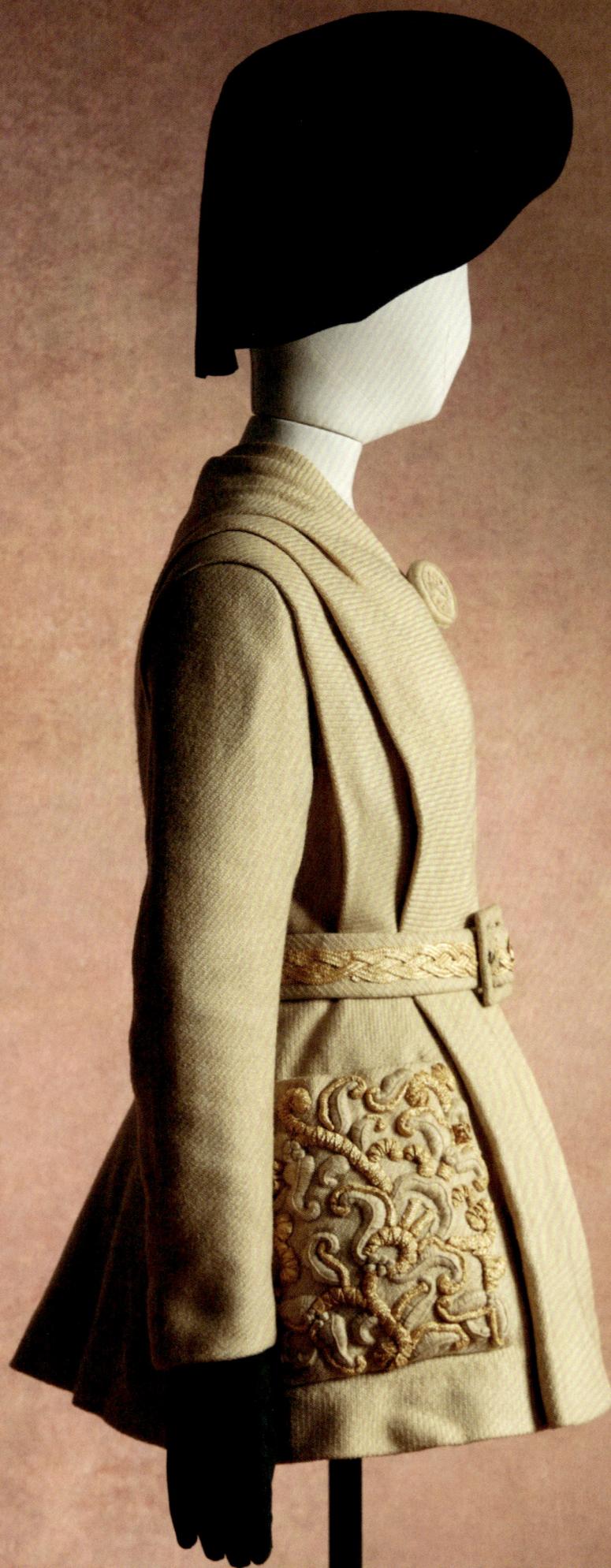

44. **Jacques Fath** Jacket, c. 1944–45 and **Jeanne Lanvin** Hat, c. 1944

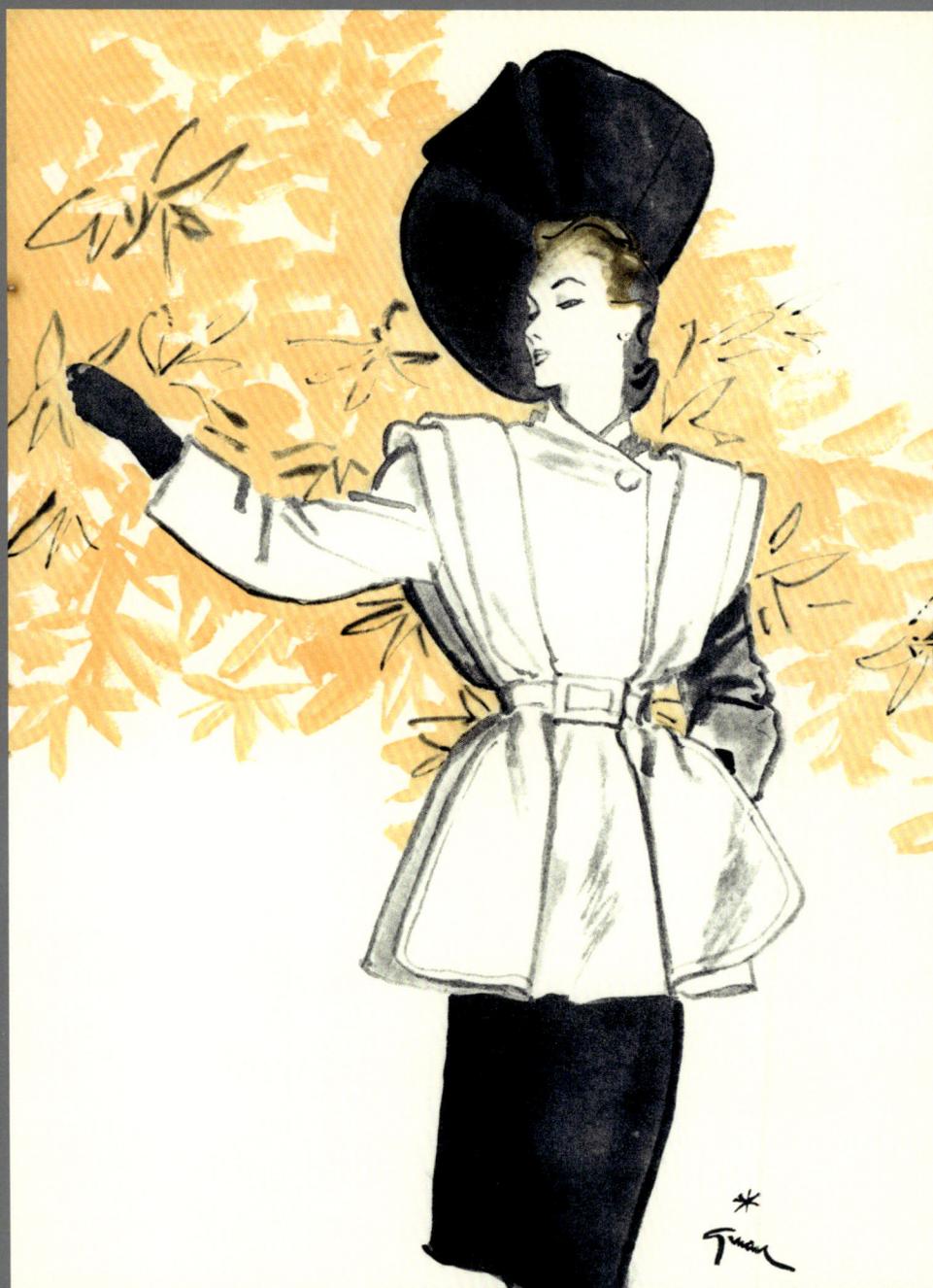

fig. 37 Illustration by René Gruau of a Jacques Fath ensemble, 1945

Jacques Fath (1912–1954) opened his Parisian couture house in 1937 and continued production during the Second World War. He was a faithful customer of haute couture embroiderers Maison Lesage, who created the raised embroidery on the pockets of this jacket using wool and straw.[11] Since traditional couture materials were not easily available during the war, Albert Lesage 'exercised his ingenuity by adapting embroidery to natural substances: animal and vegetable fibers, straw from cereal grasses, raffia from palm trees, flax from herbs'.[12]

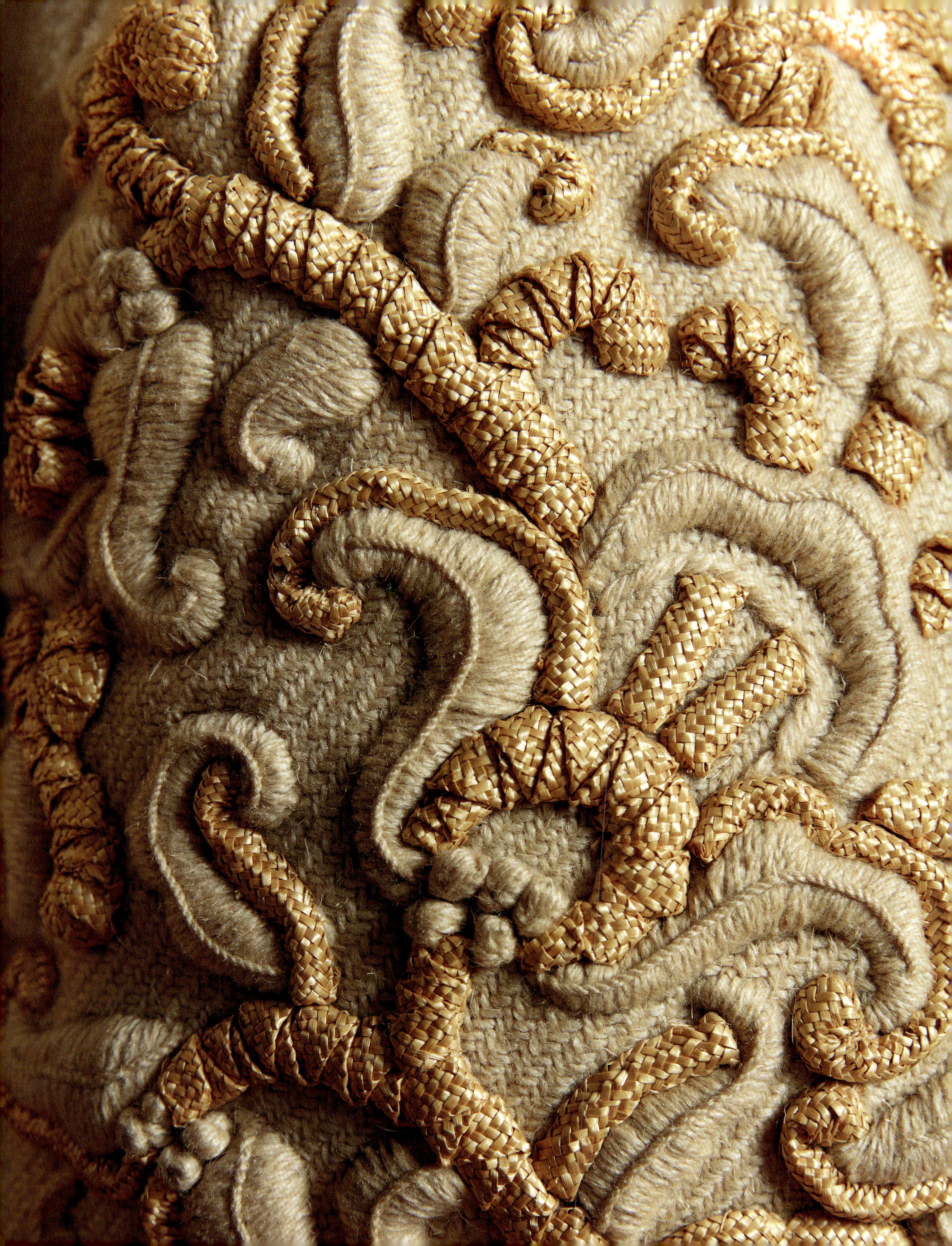

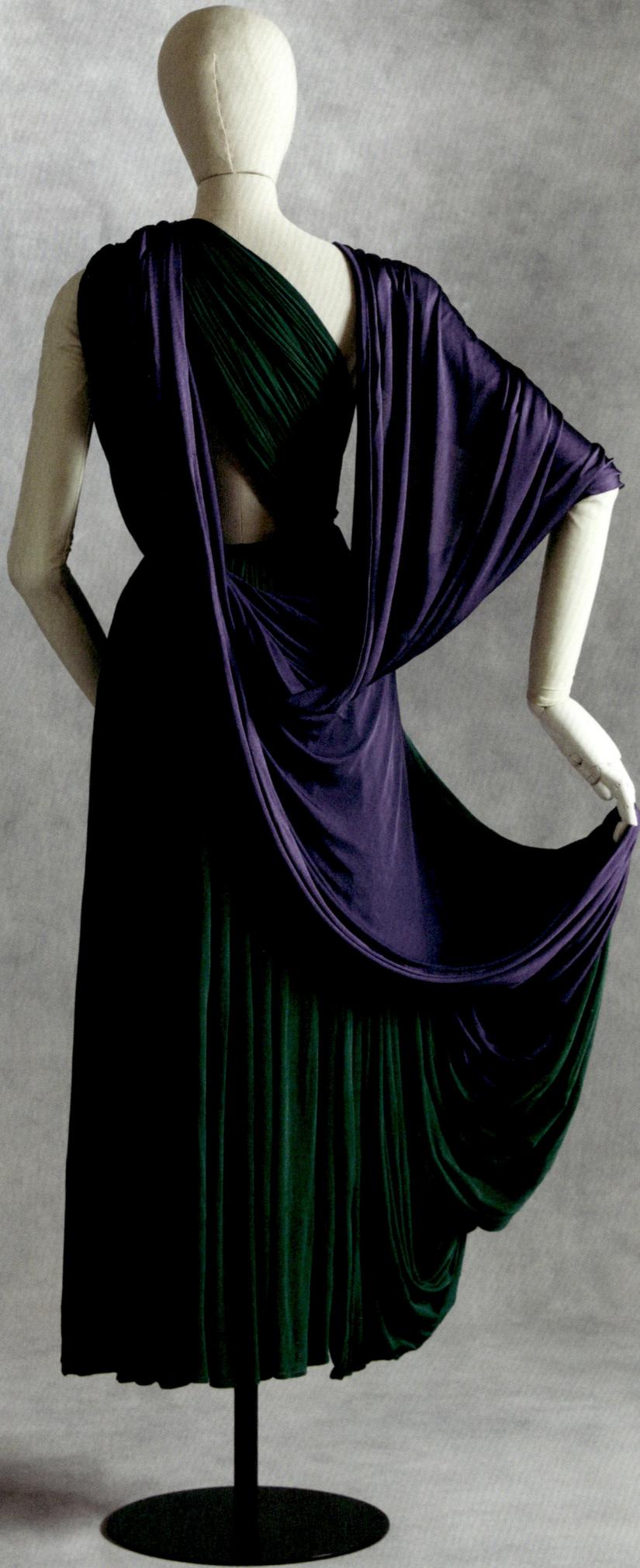

45. Grès Evening dress, 1946

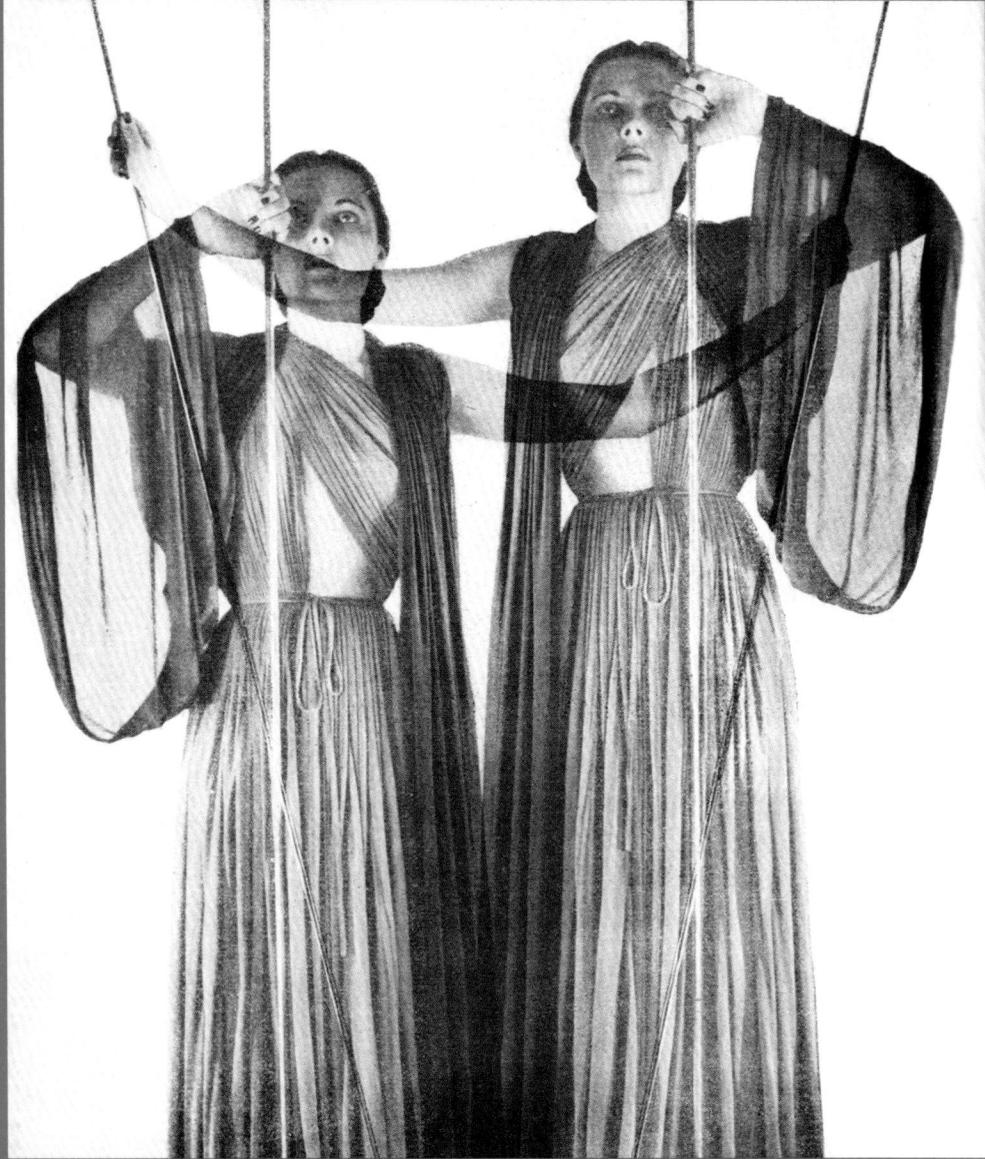

fig. 38 Model wearing silk jersey Grès dress, photographed by Philippe Pottier, 1946

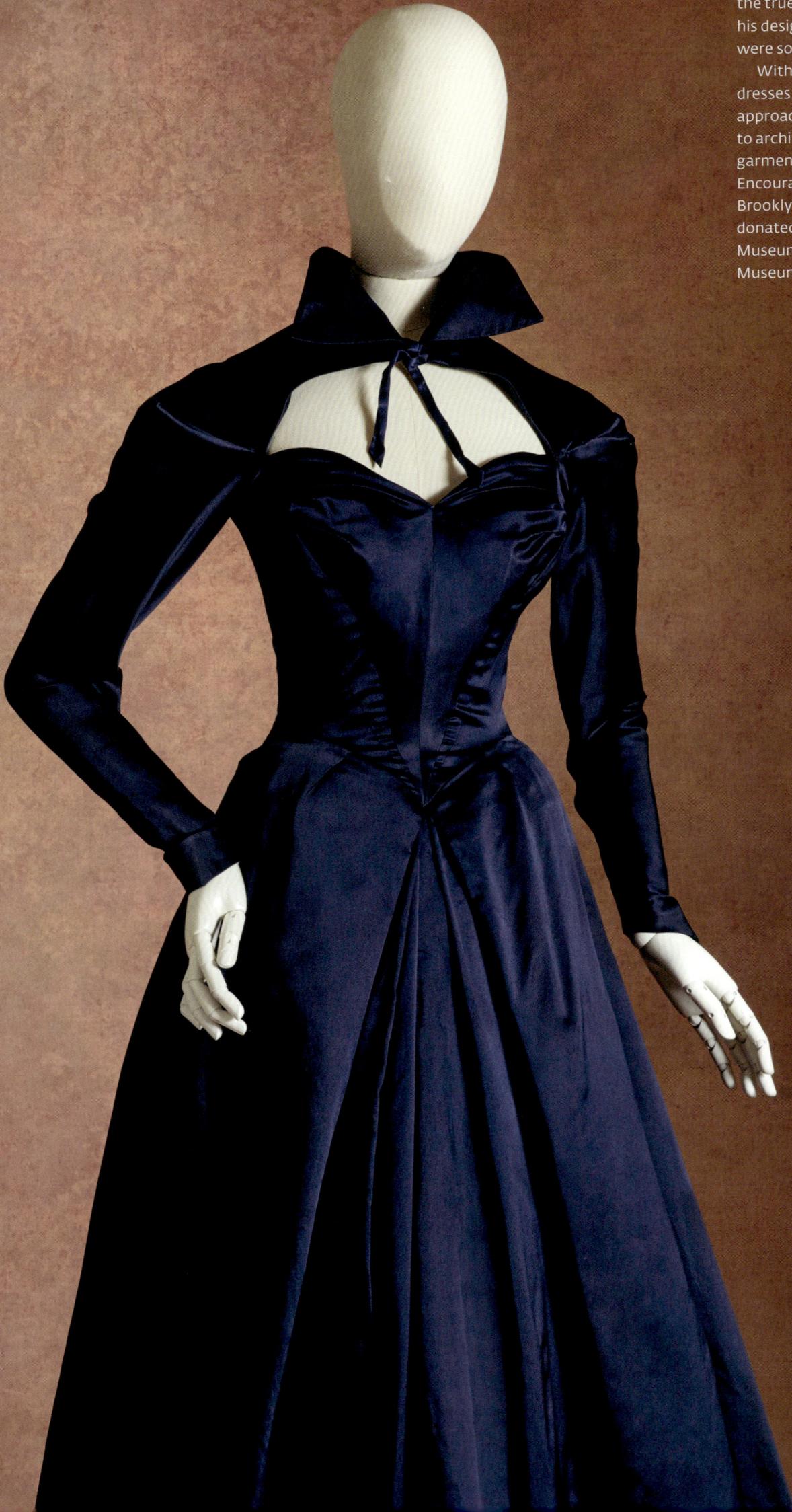

British-born Charles James (1906–1978) is considered to be the only American to work in the true couture tradition. In the 1940s and 1950s his designs, with their strong sculptural forms, were sought after by American high society.

With a strong sense of the importance of his dresses, and wishing to promote his unique approach to the study of the body, James began to archive his patterns, toiles and finished garments to illustrate his development process.[13] Encouraged by James, who donated to the Brooklyn Museum, a number of his clients donated to the same museum (now Brooklyn Museum Costume Collection at the Metropolitan Museum of Art).[14]

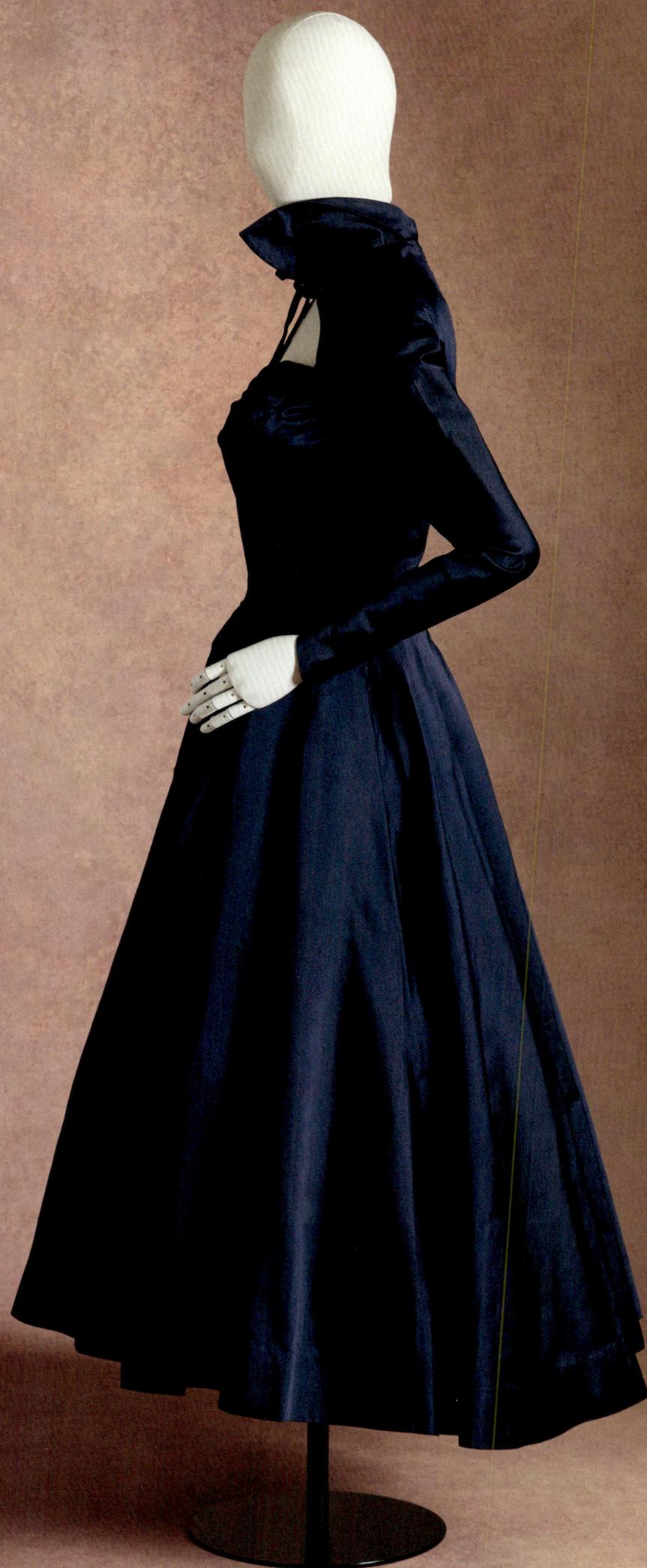

46. Charles James Cocktail dress, 'Infanta', American, 1946–50

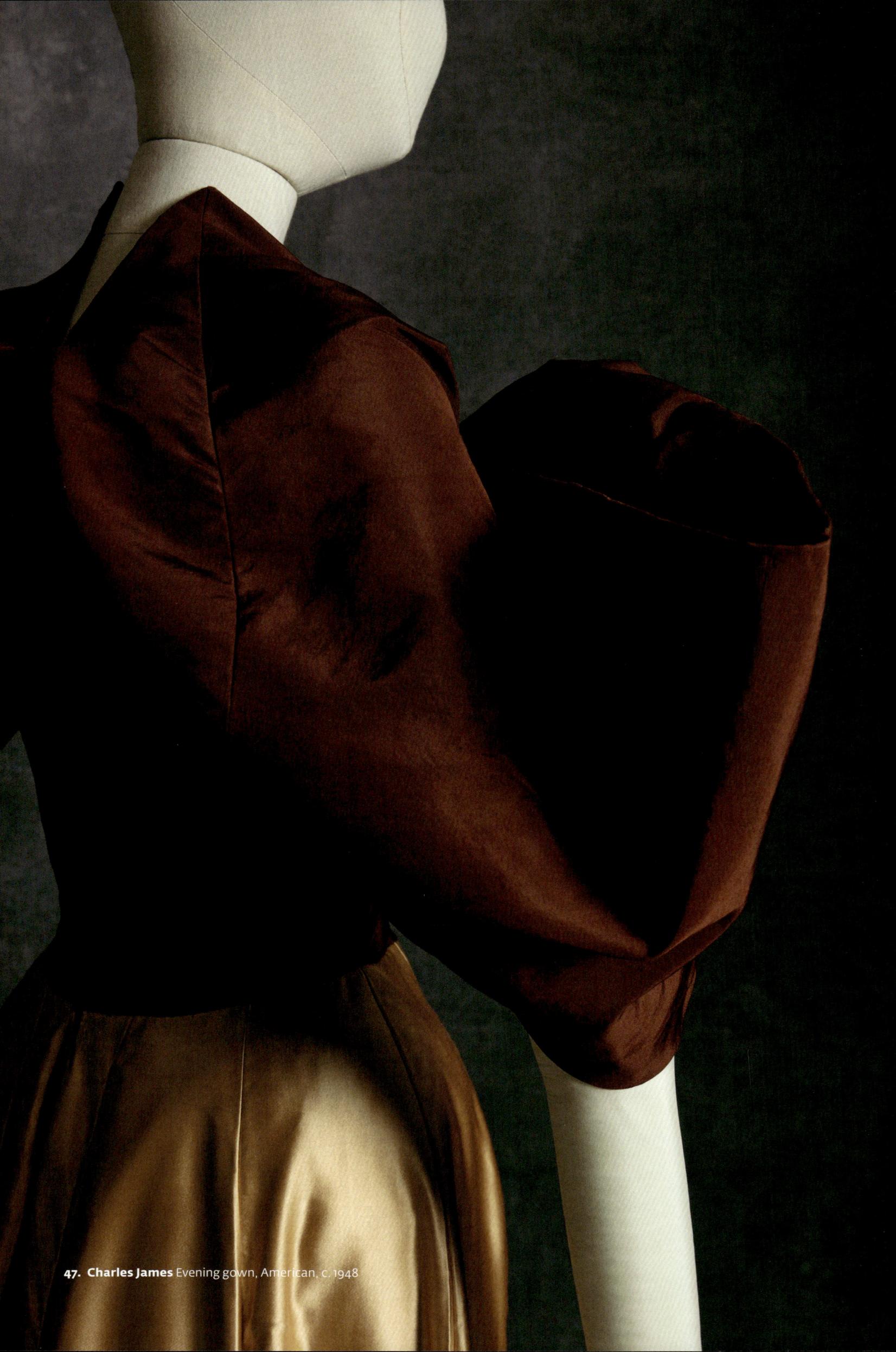

47. **Charles James** Evening gown, American, c. 1948

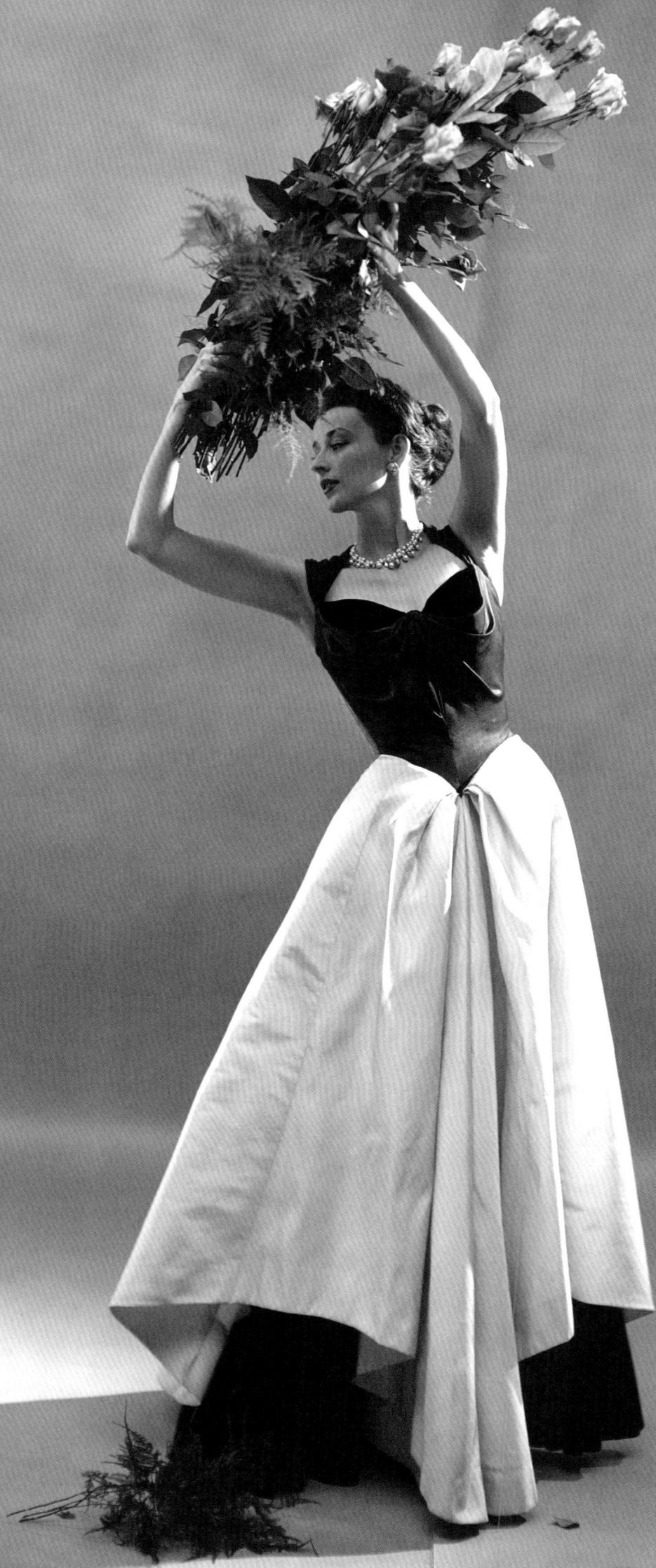

fig. 39 Model wearing a Charles James dress (similar to no. 47),
photographed by Cecil Beaton, March 1948

48. Claire McCardell Bathing suit/playsuit, American, c. 1945

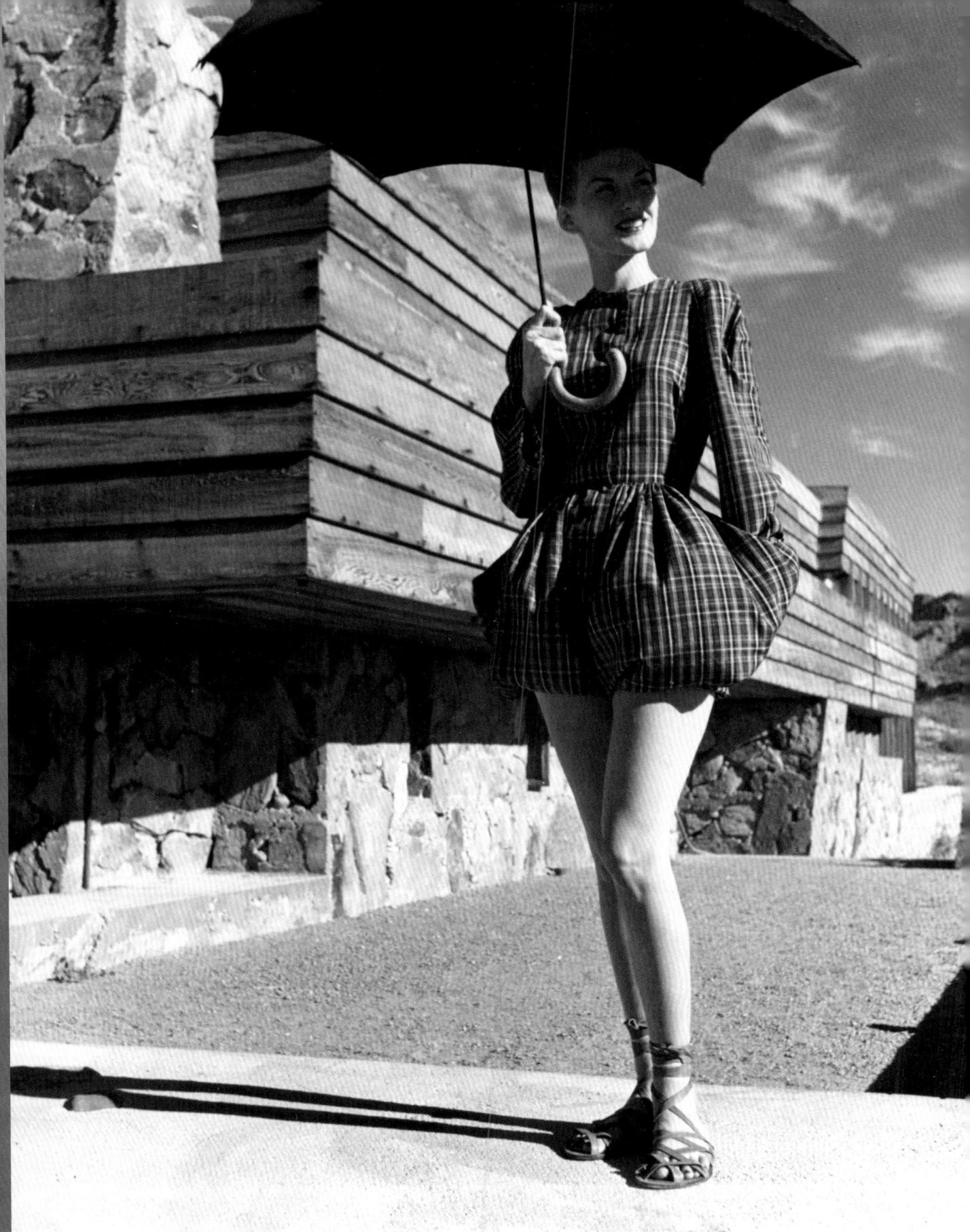

fig. 40 Model wearing a Claire McCardell playsuit, photographed by Louise Dahl-Wolfe, 1942

The American designer Claire McCardell (1905–1958) is credited with having created a style of casual dress that was without precedent, designing affordable clothes for the American woman. Her simple use of natural fabrics such as cotton, denim and wool, combined with flattering silhouettes and ingenious design, filled a gap in women's fashion. McCardell designed many variations of bathing suits, playsuits and rompers.

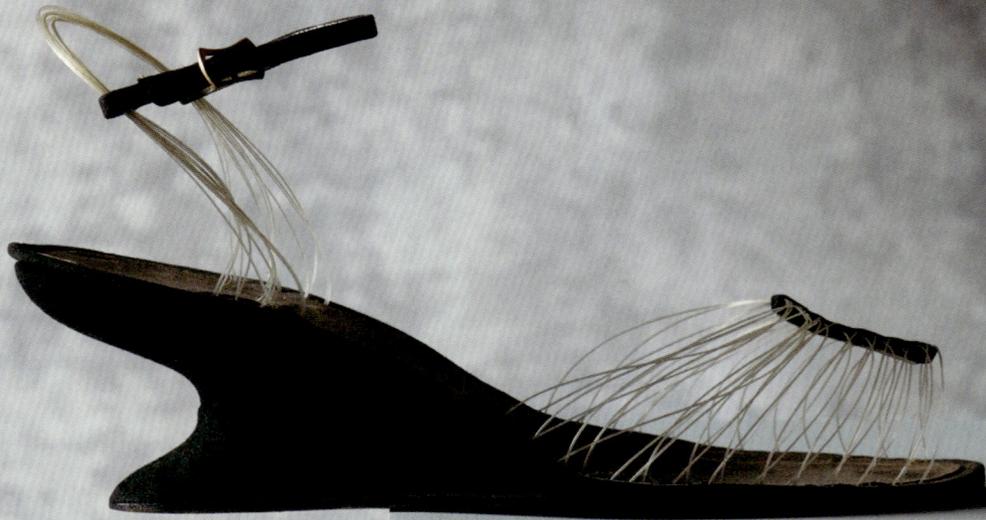

49. Salvatore Ferragamo 'Invisible' sandals, Italian, 1947

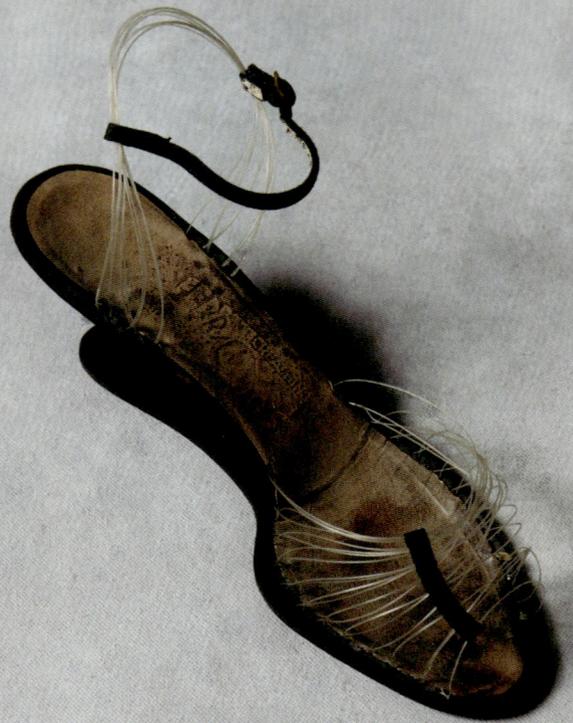

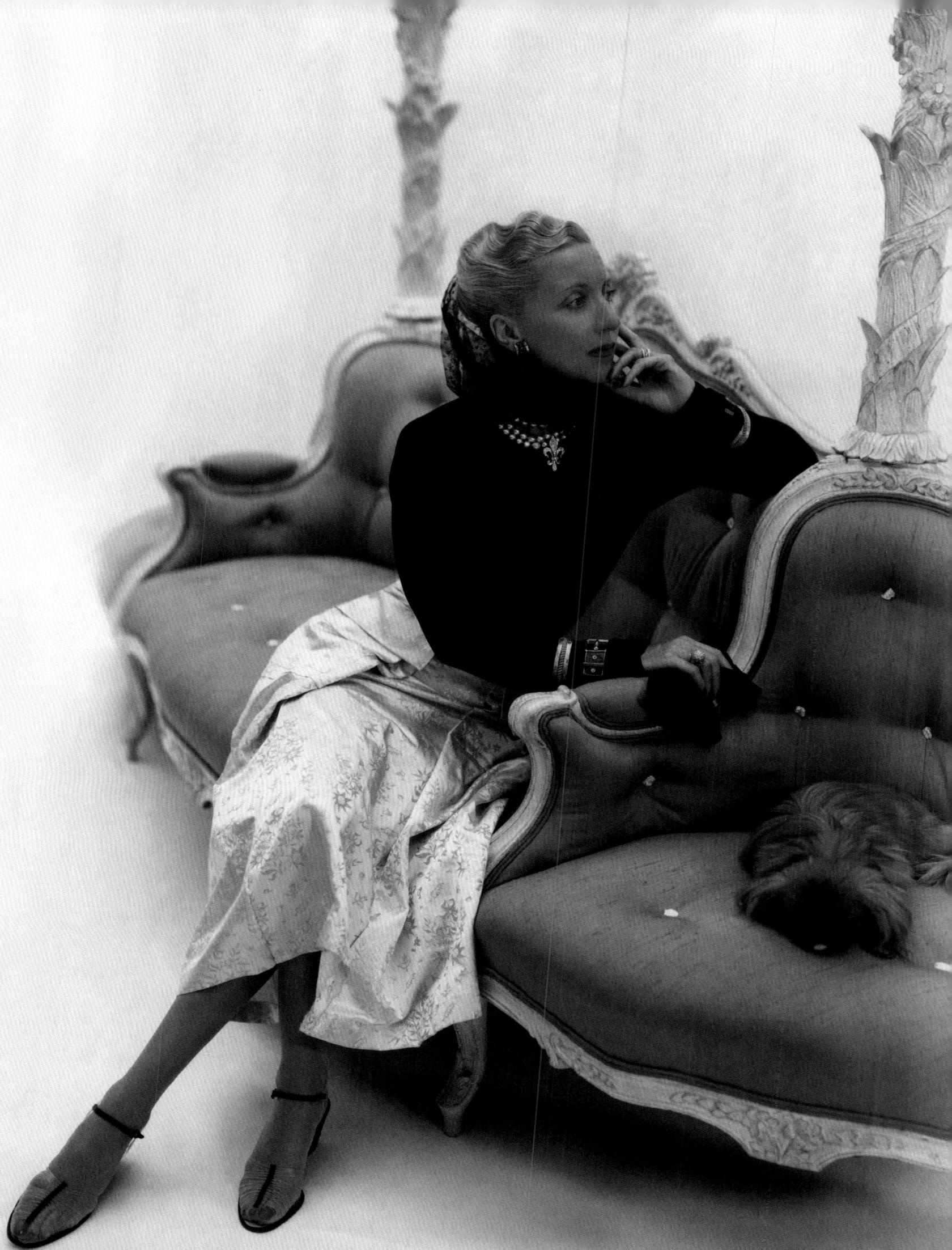

fig. 41 Mrs John Rawlings wearing Salvatore Ferragamo
'Invisible' sandals, photographed by John Rawlings, October 1947

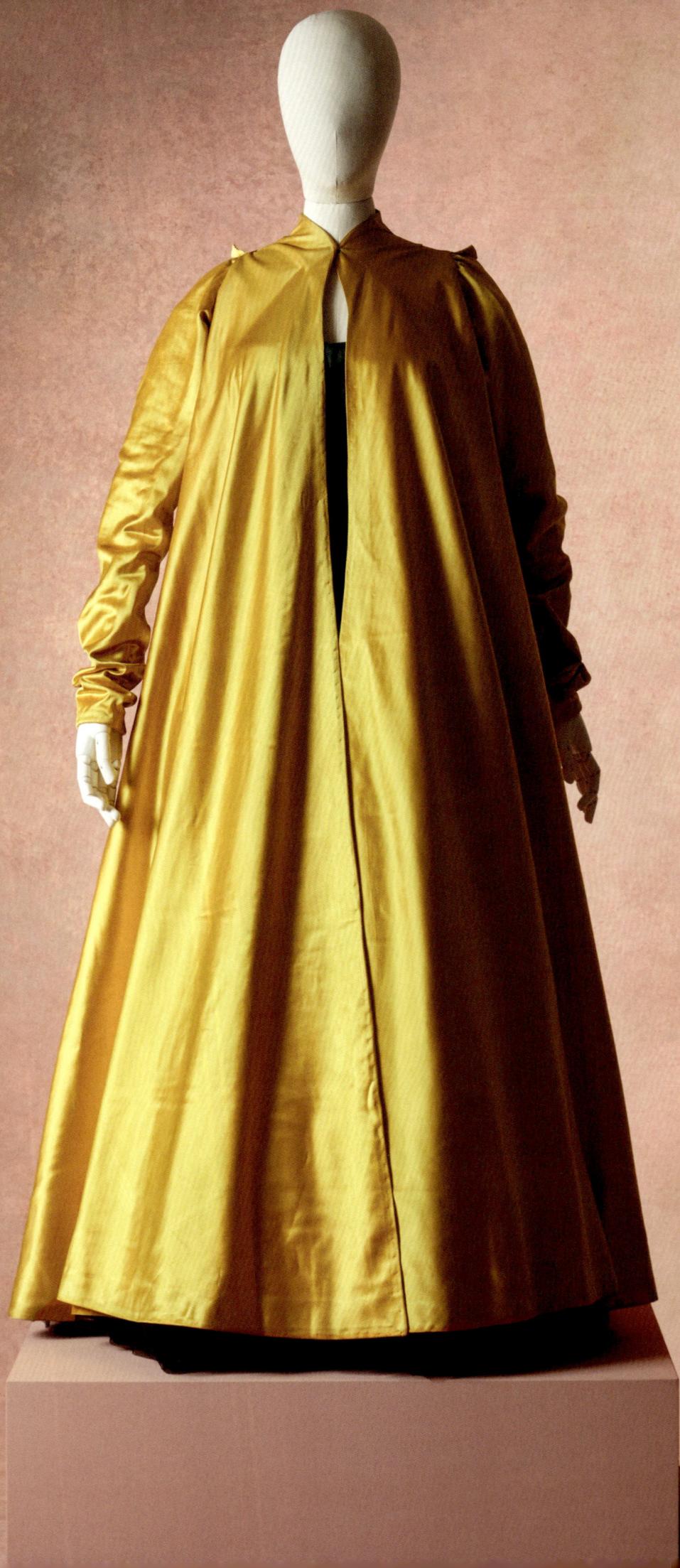

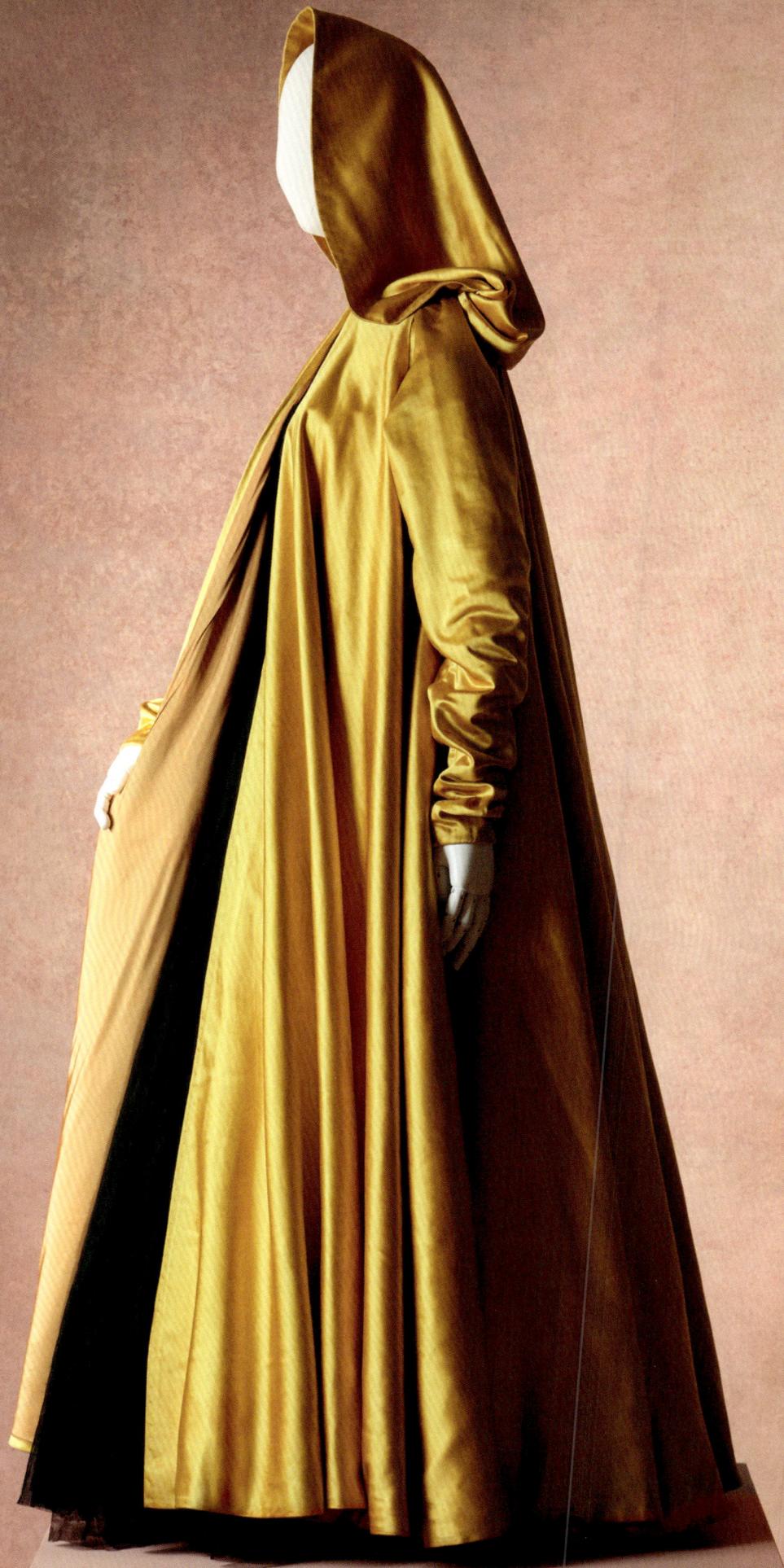

50. Jacques Fath Evening cape, c. 1947

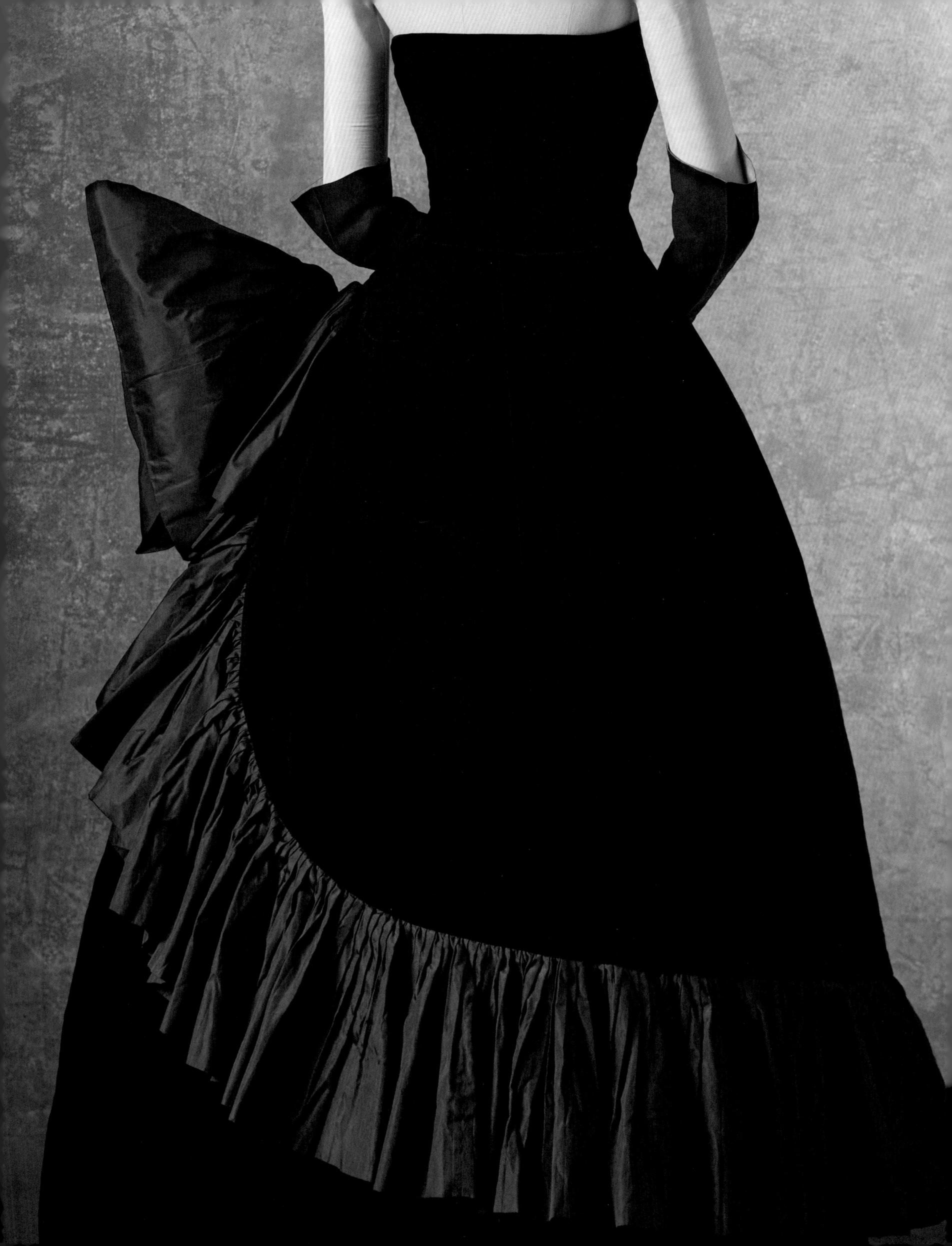

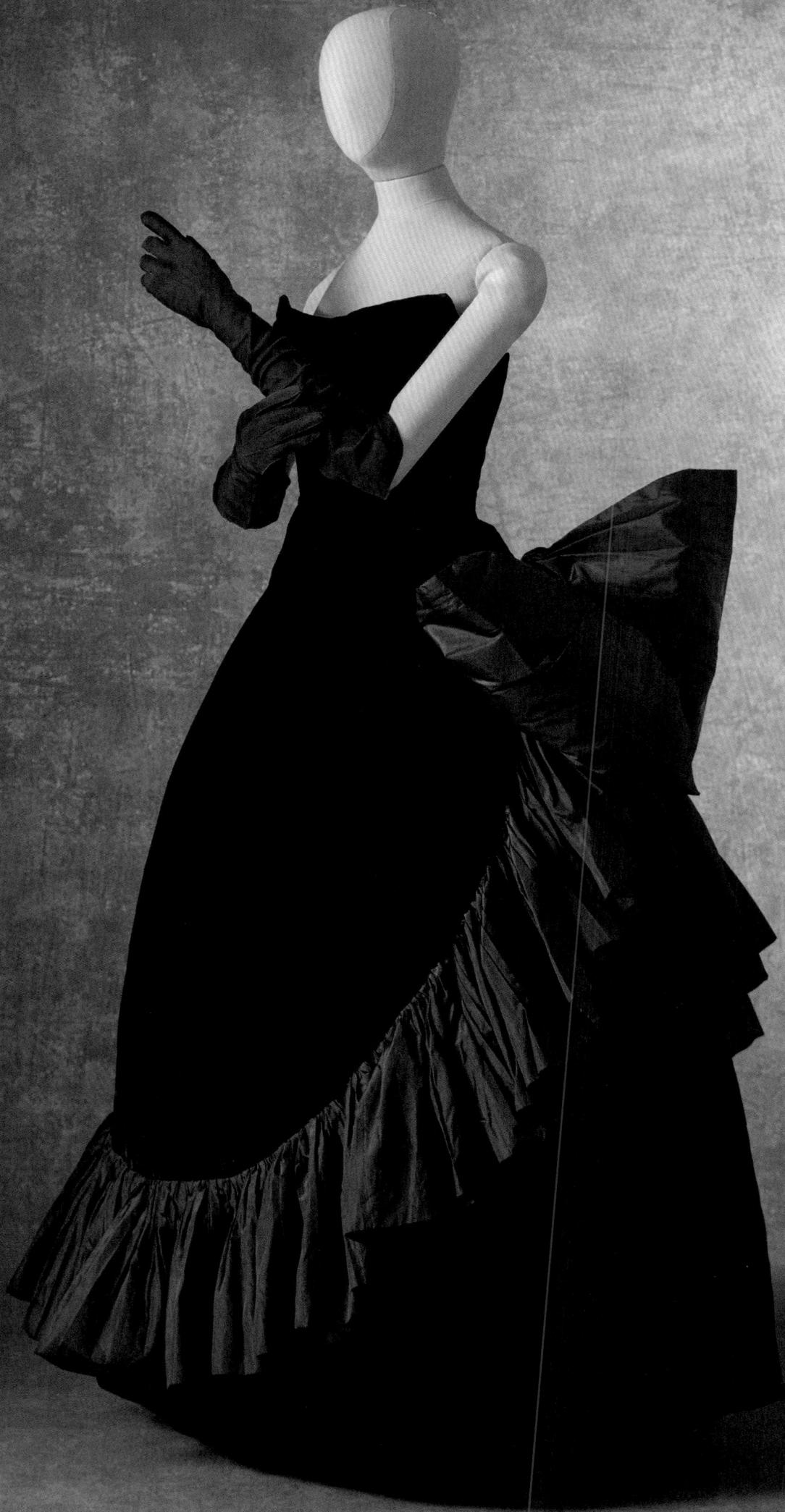

51. Maggy Rouff Ballgown, c. 1948

5^2-90

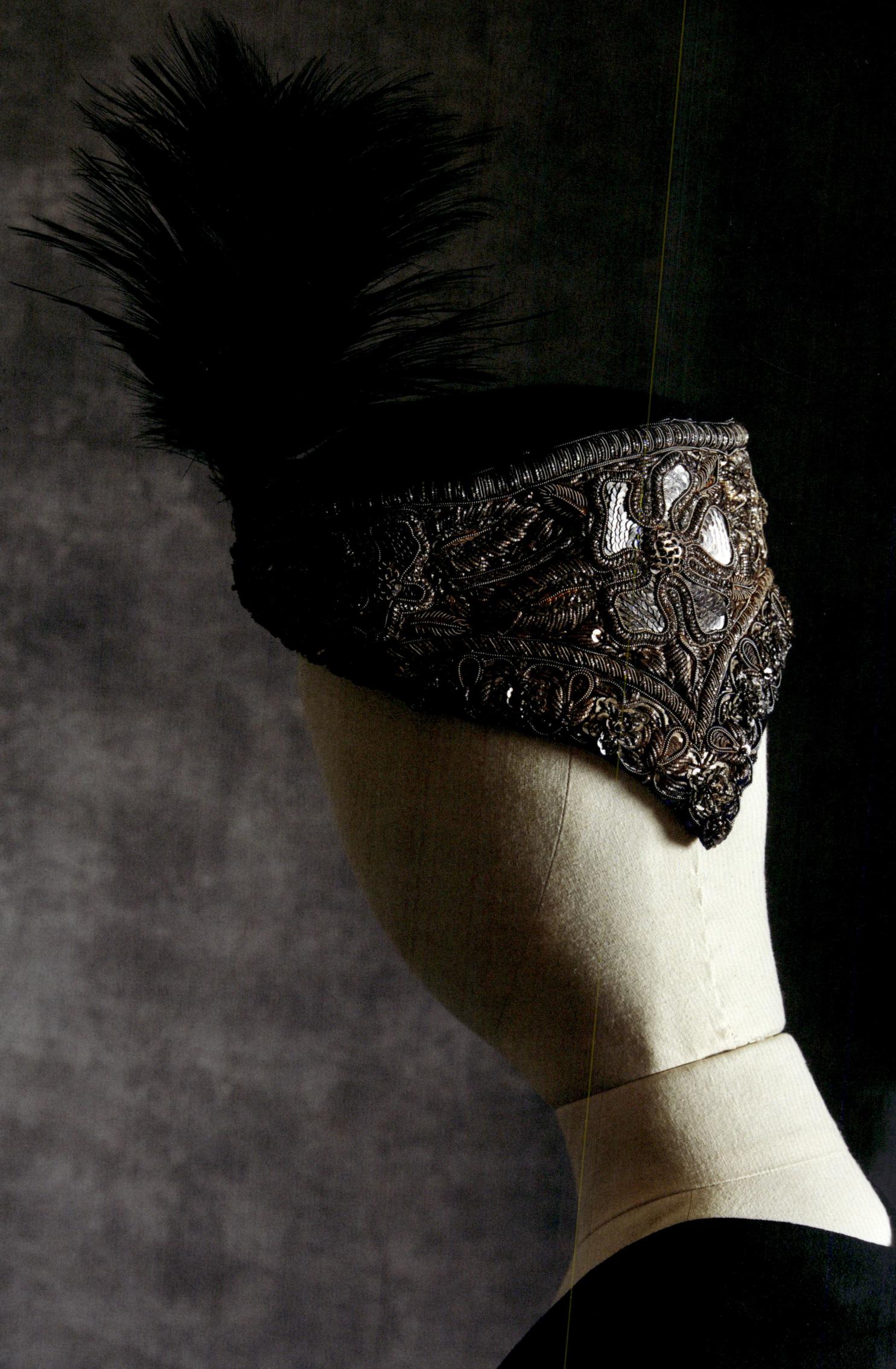

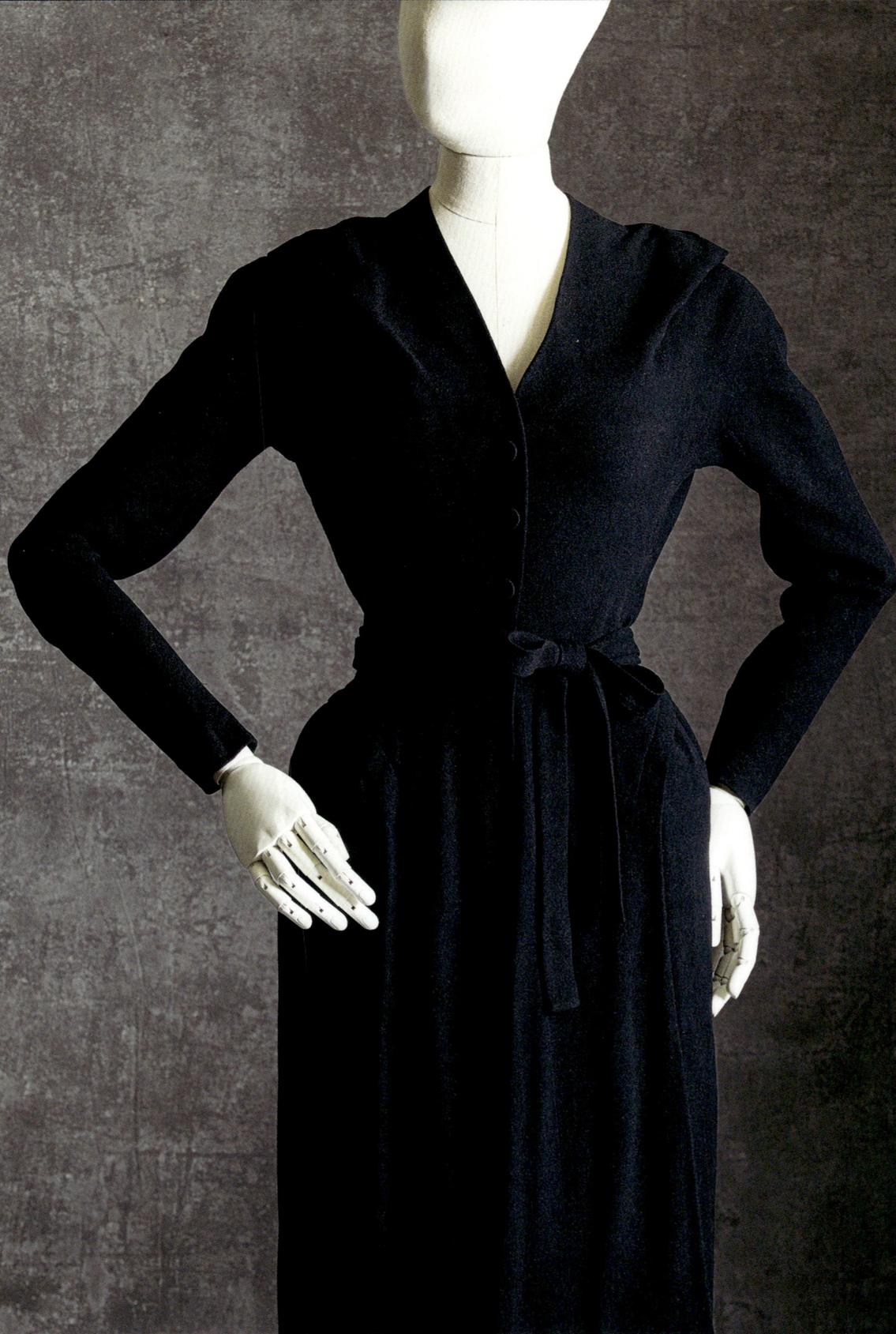

52. Cristóbal Balenciaga Dinner or cocktail dress, c. 1948

Cristóbal Balenciaga (1895–1972), the Basque-born couturier, opened his first documented dressmaking house in 1917 in San Sebastian, Spain. In 1937, at the age of forty-two, he established himself in Paris in the Avenue Georges V. However, unknown to most of Balenciaga's clients were the three couture houses that traded under the EISA label (an abbreviation of his mother's name). These houses – located in San Sebastian, Madrid and Barcelona – were reopened by Balenciaga after the end of the Spanish Civil War, offering garments that often followed his Parisian designs. Interestingly, some of his employees either began their working life or were sent for a spell of training at one of the Spanish houses.[15]

53. Cristóbal Balenciaga Hat, c. 1946

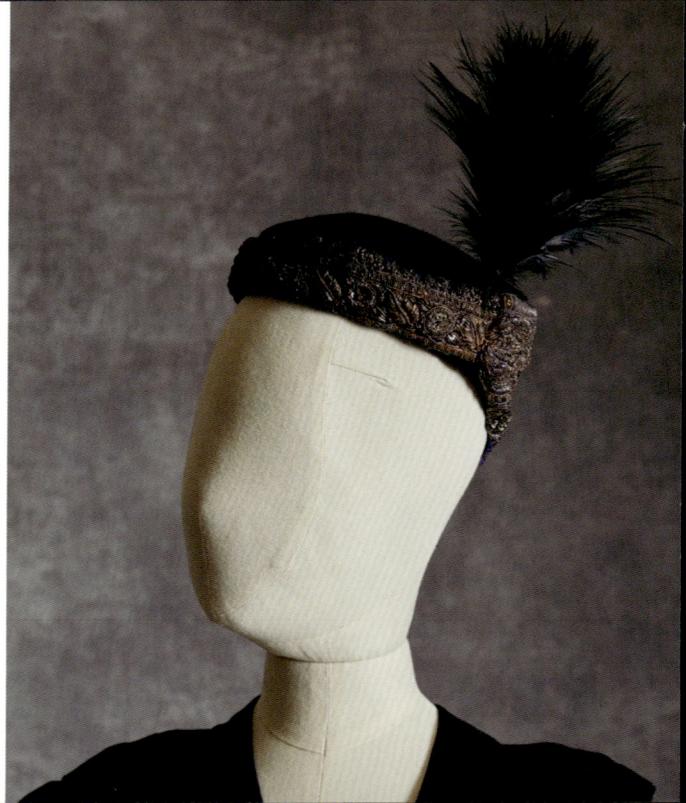

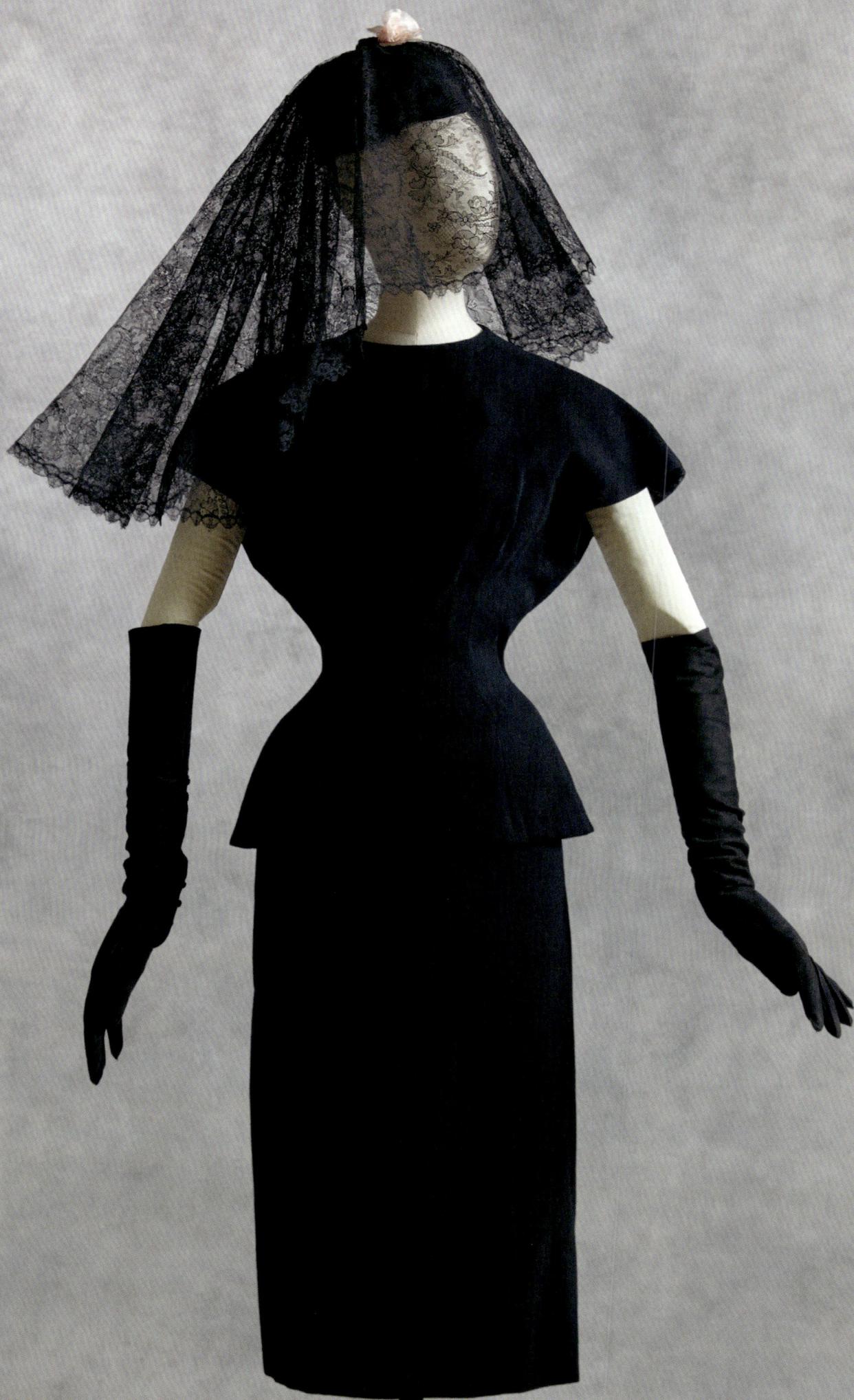

54. EISA (Cristóbal Balenciaga) Day or and lace-covered cocktail ensemble, Spanish c. 1950 hat, Spanish, c. 1967

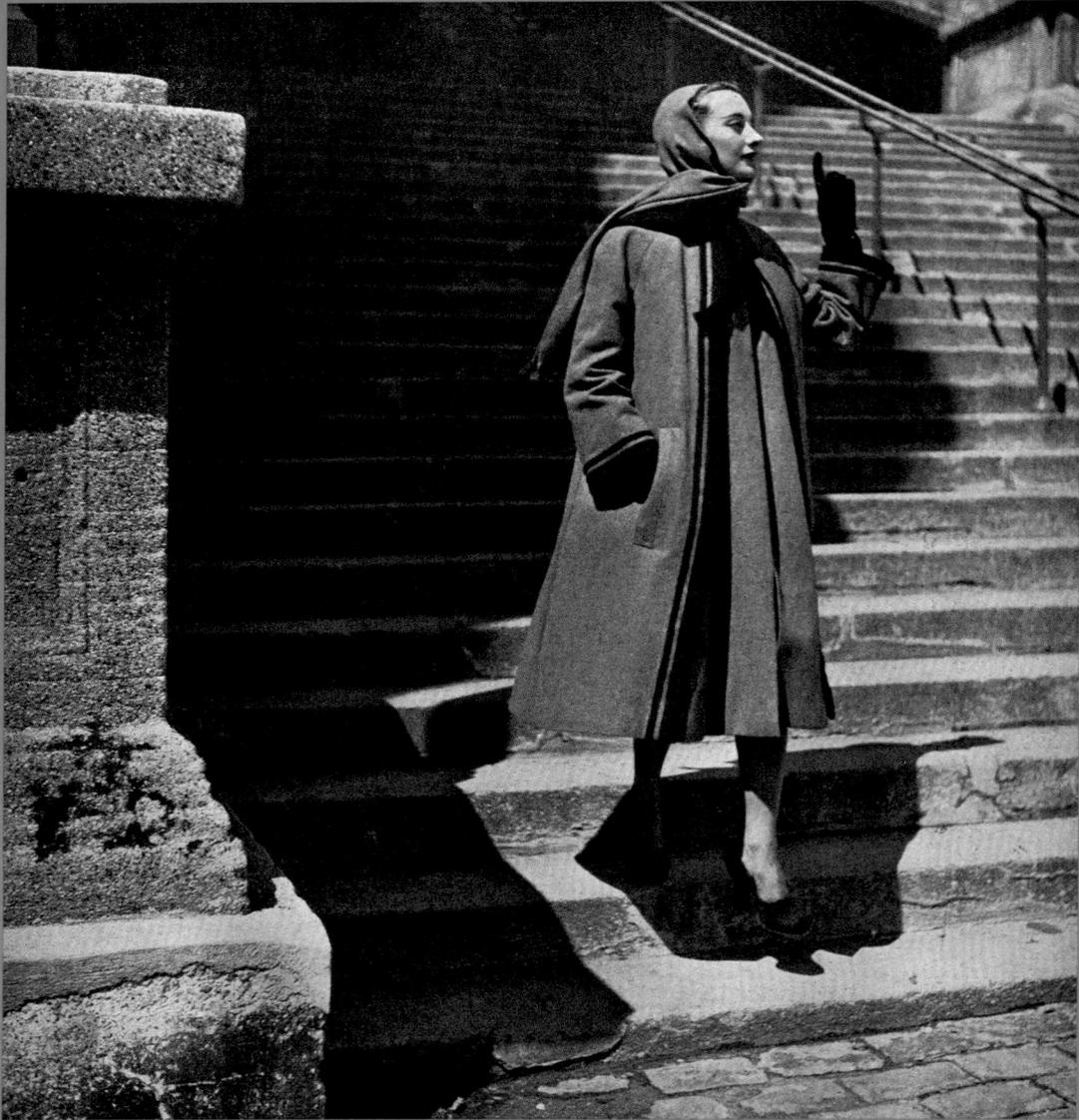

fig. 42 Model wearing Christian Dior 'Briquette' coat, September 1950

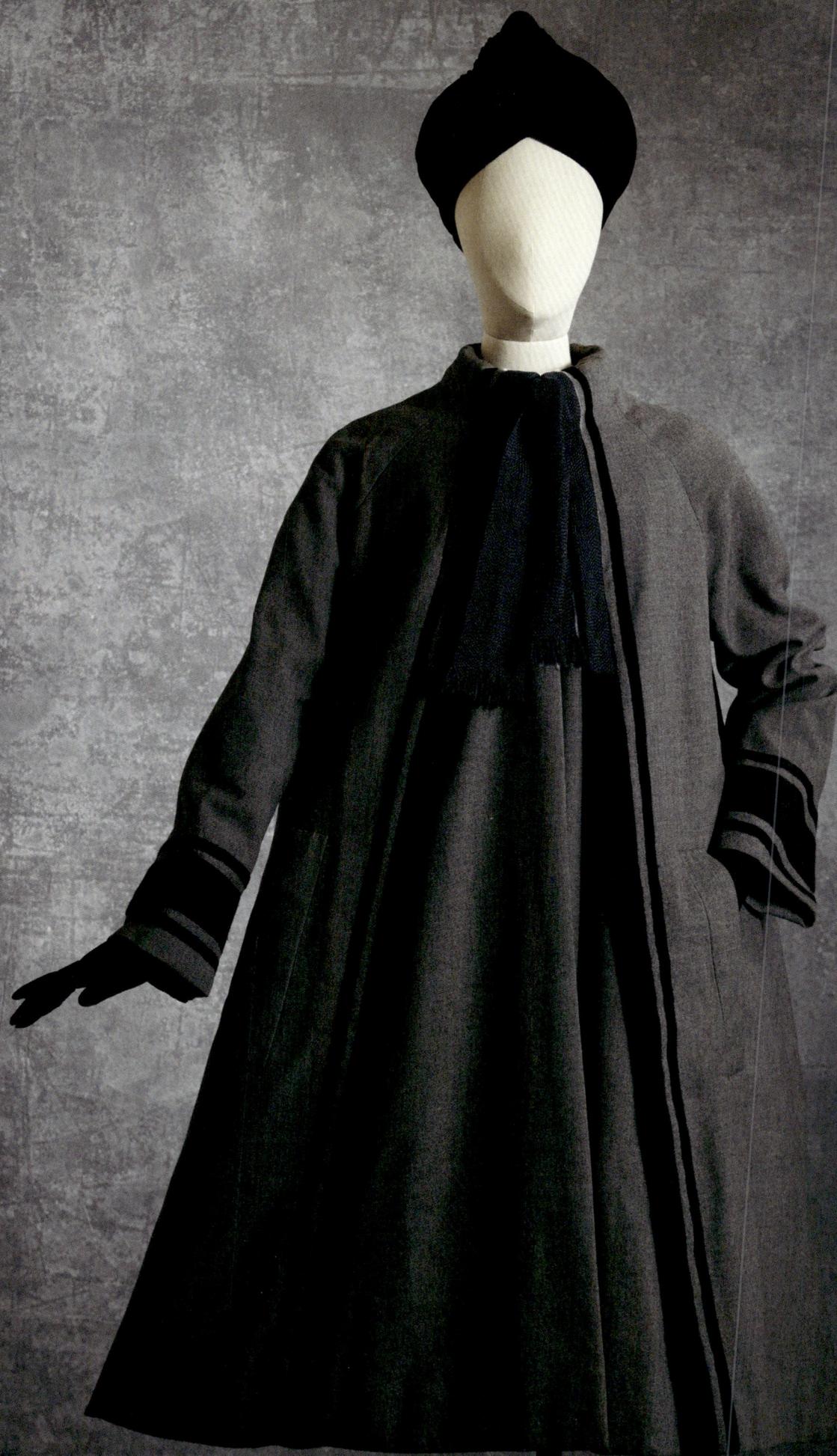

55. Christian Dior Coat 'Briquette', Autumn/Winter 1950–51, 'Ligne Oblique' and **Paulette** Turban hat, c. 1942

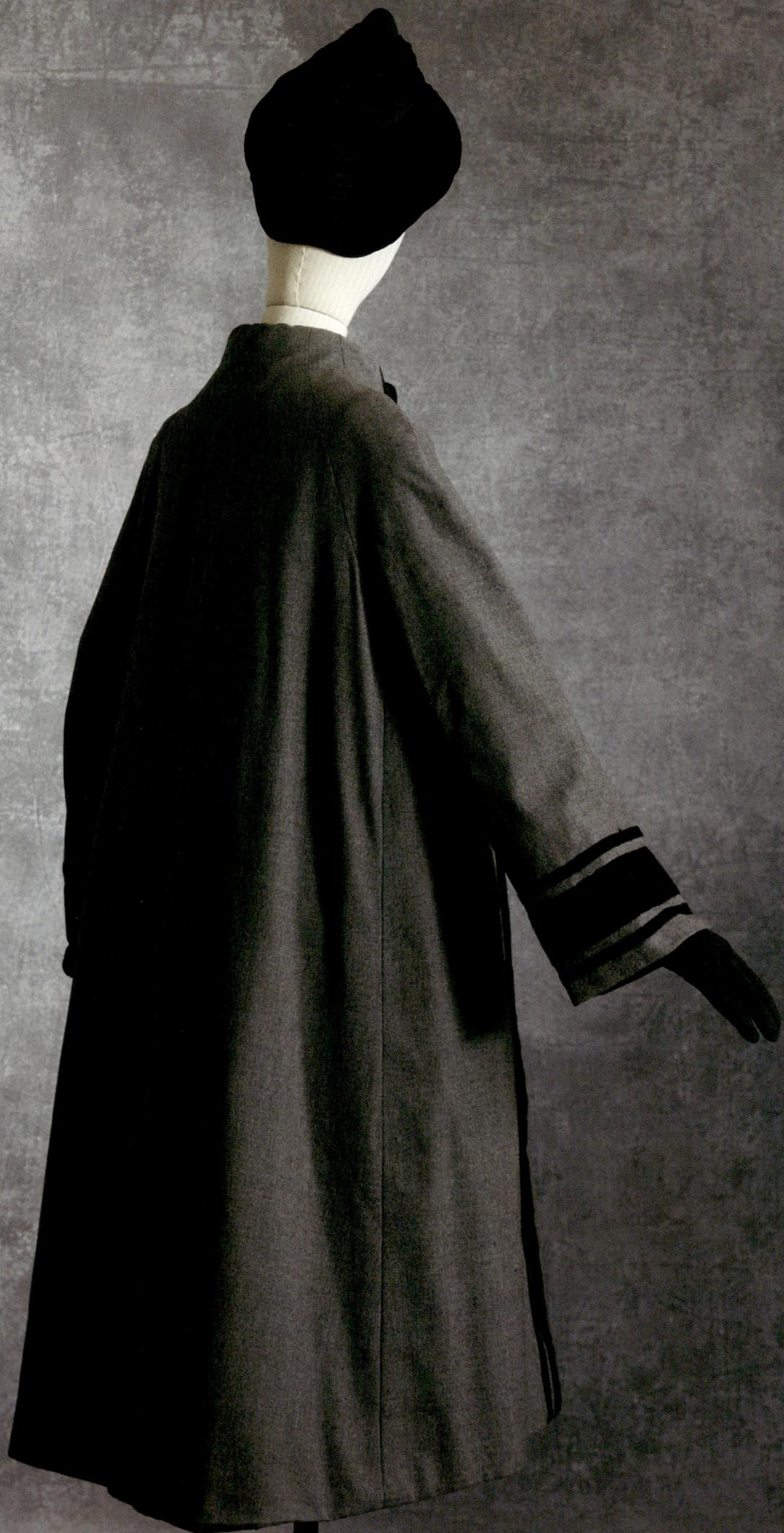

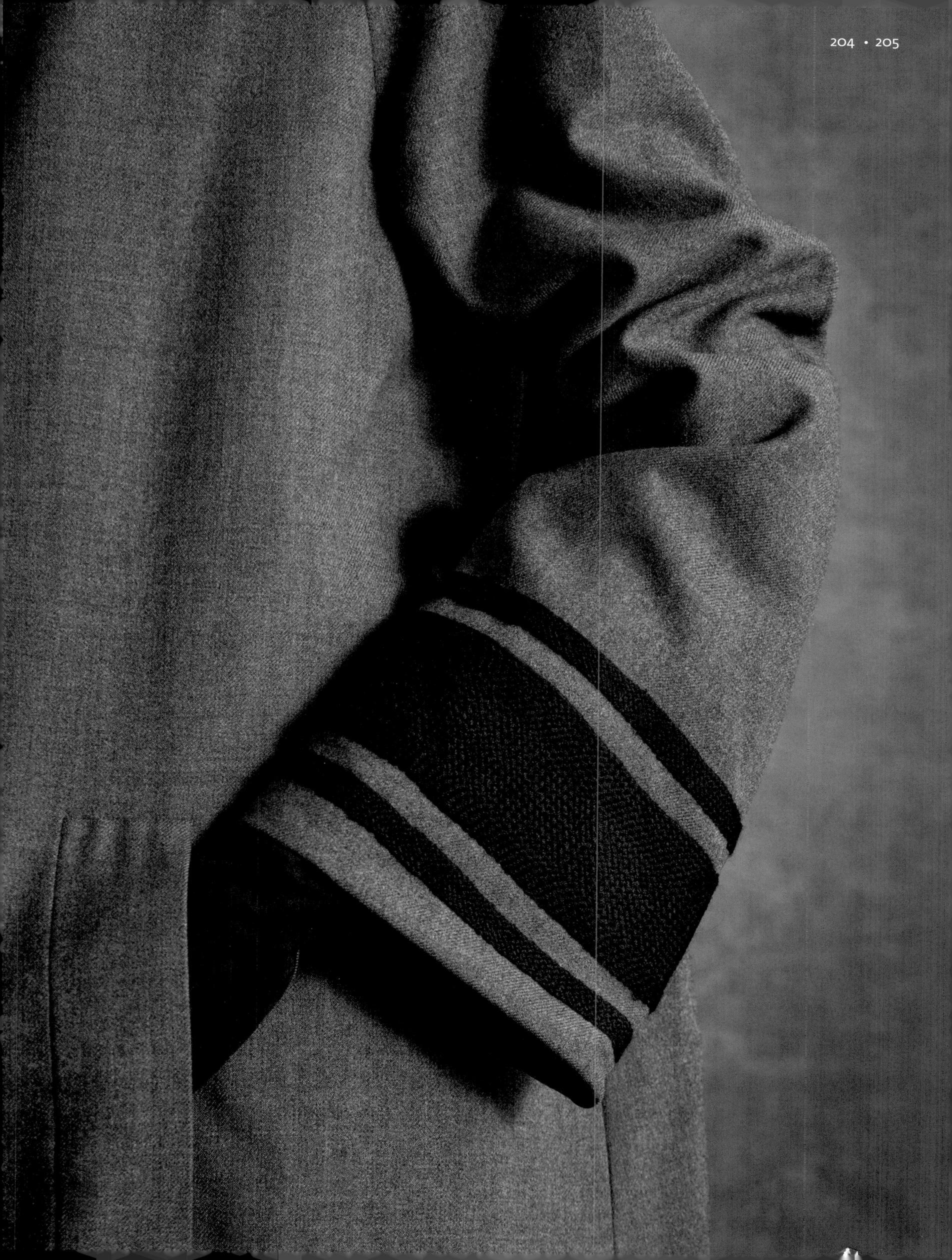

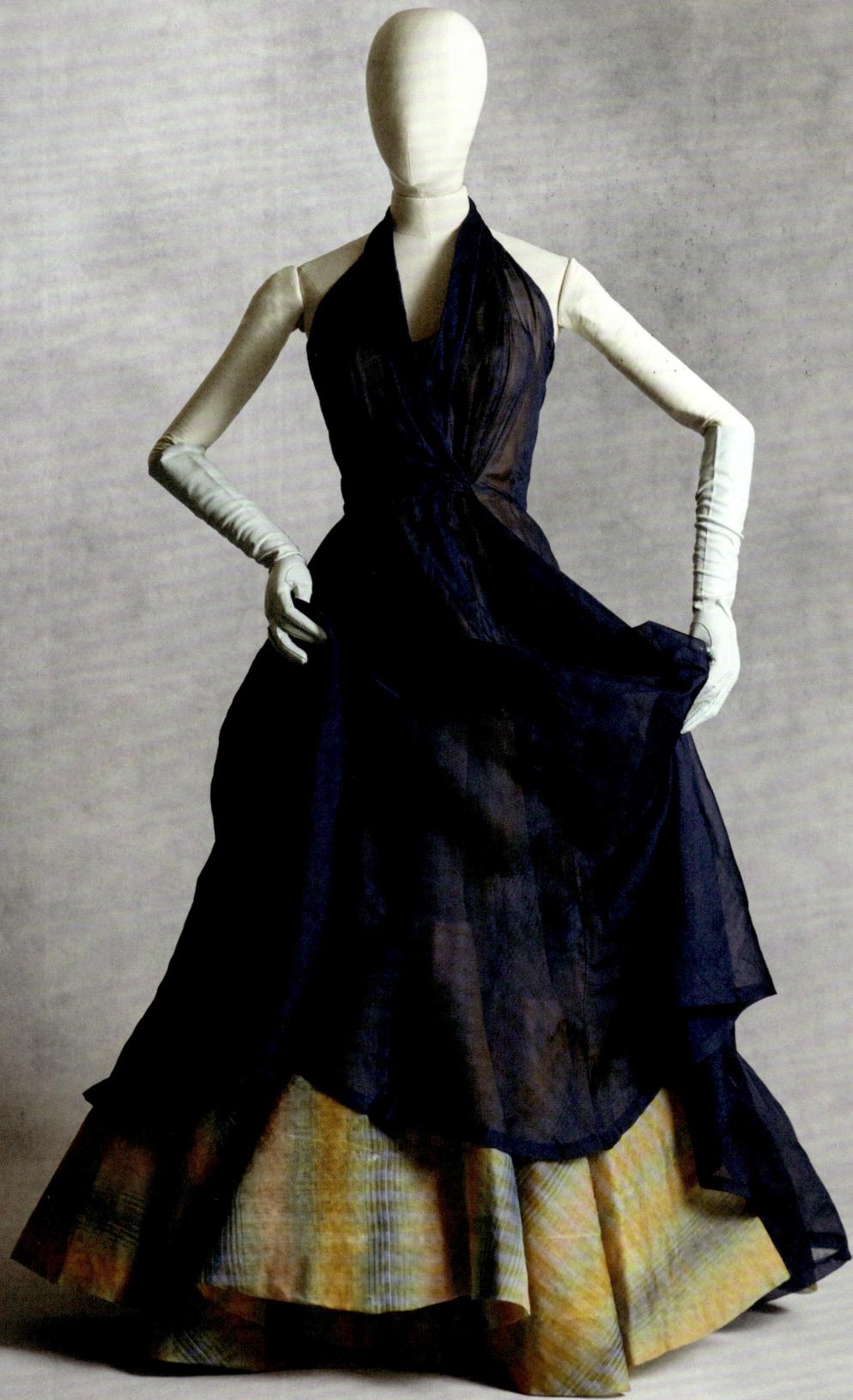

56. **Elsa Schiaparelli** Evening gown, c. 1947–50

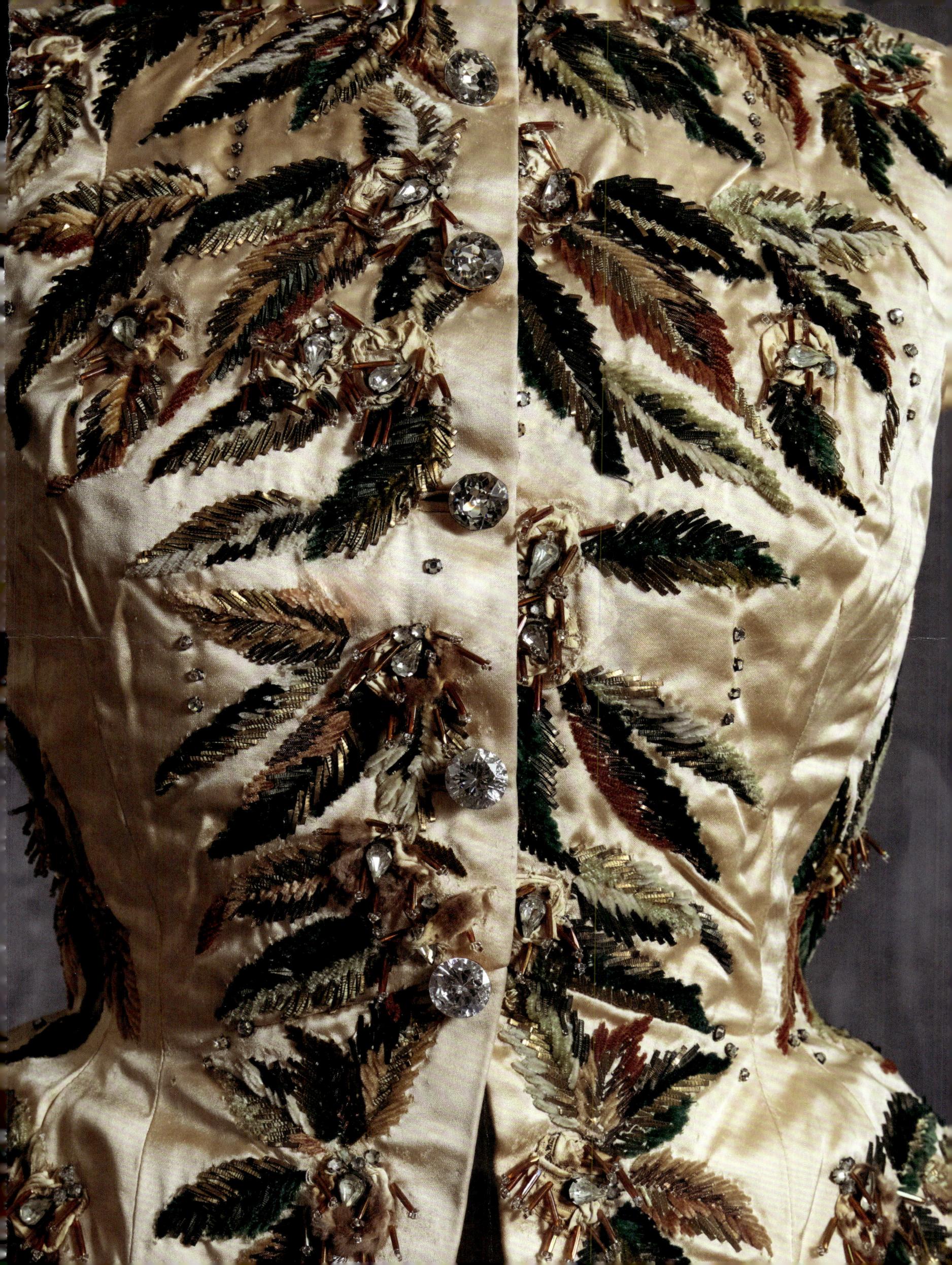

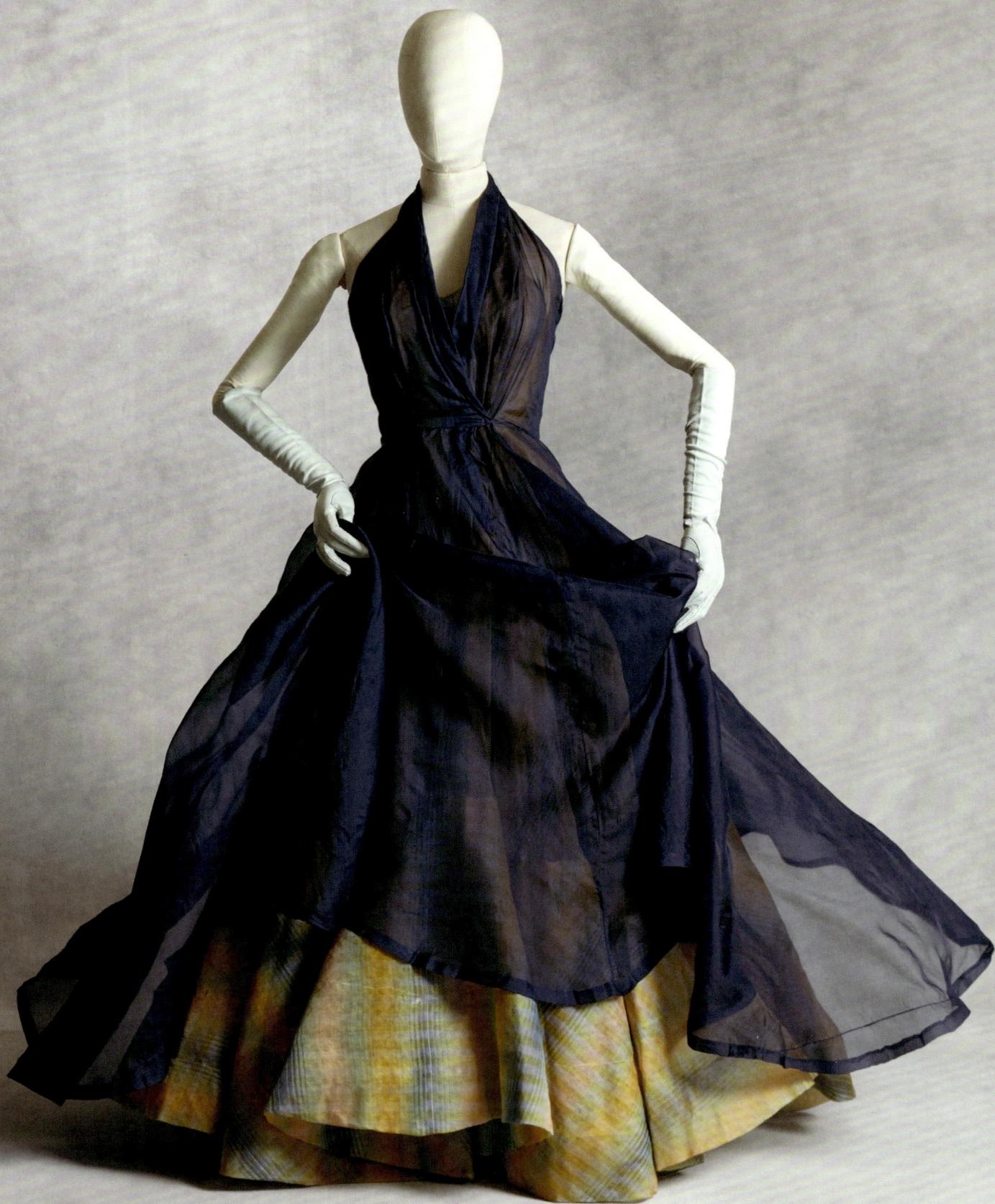

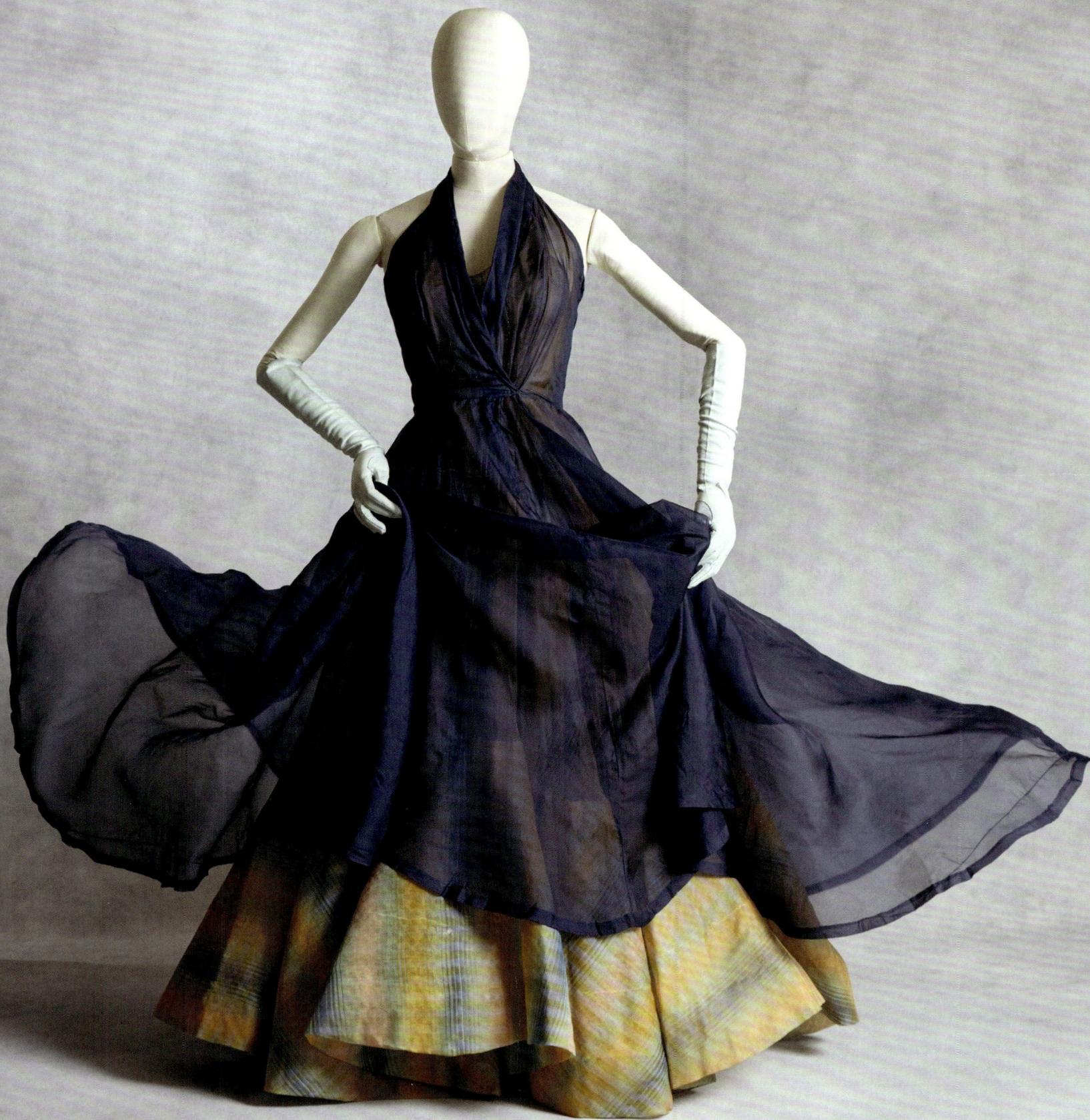

In 1947, at the age of twenty, Hubert de Givenchy (1927–2018) was employed by Elsa Schiaparelli as artistic director of her boutique in the place Vendôme. Schiaparelli promised him more responsibility for the boutique's collection but did not want him to participate in designing the couture, with a few exceptions such as this evening gilet with matching gloves and a similar evening jacket (now in the Musée des Arts Décoratifs). The design for the jacket, signed by Givenchy, is in the archive of Maison Schiaparelli. Givenchy remained at Schiaparelli for four years, before opening his own couture house.[16]

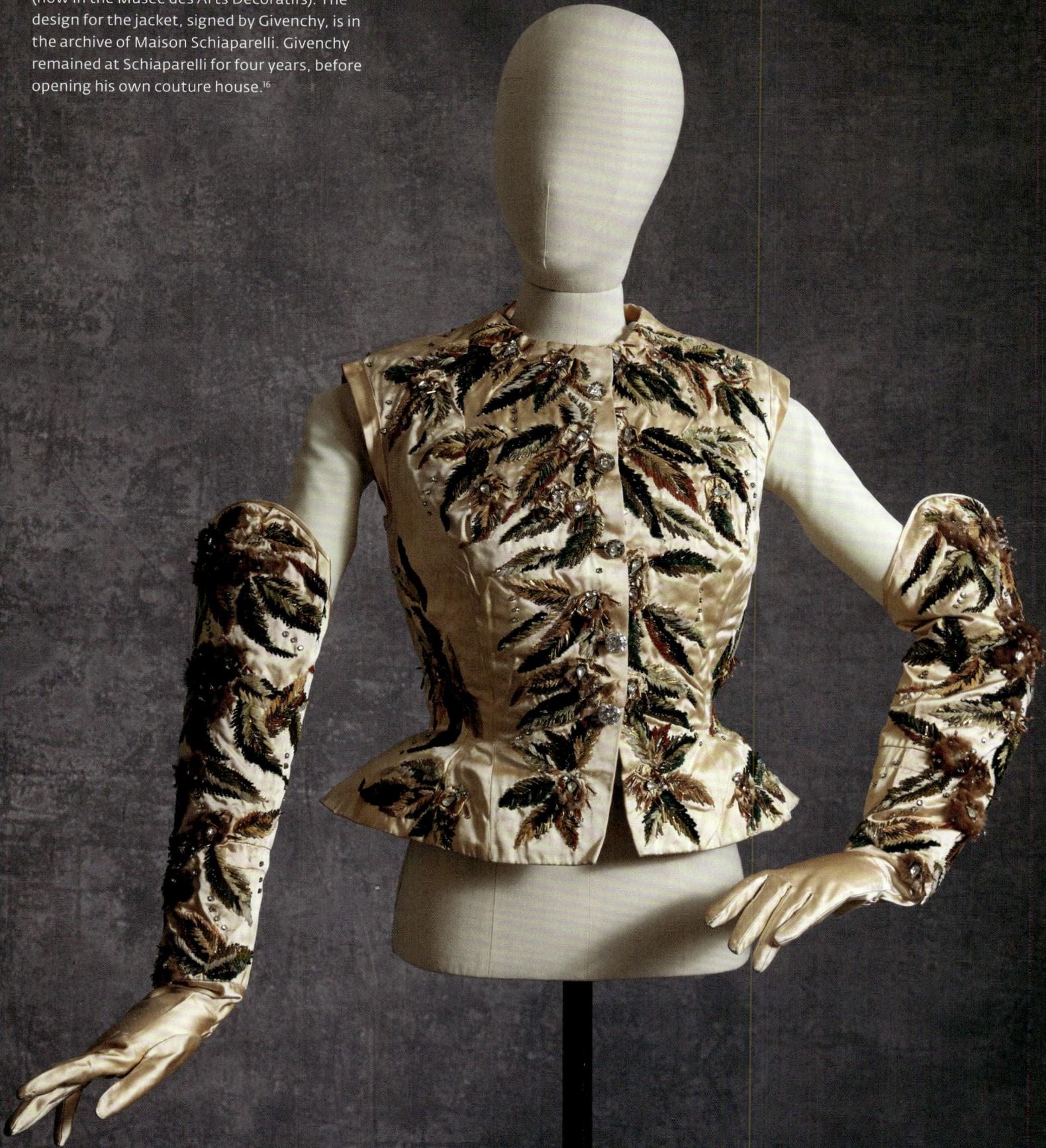

57. Elsa Schiaparelli (Hubert de Givenchy) Evening waistcoat with matching gloves, Spring 1951

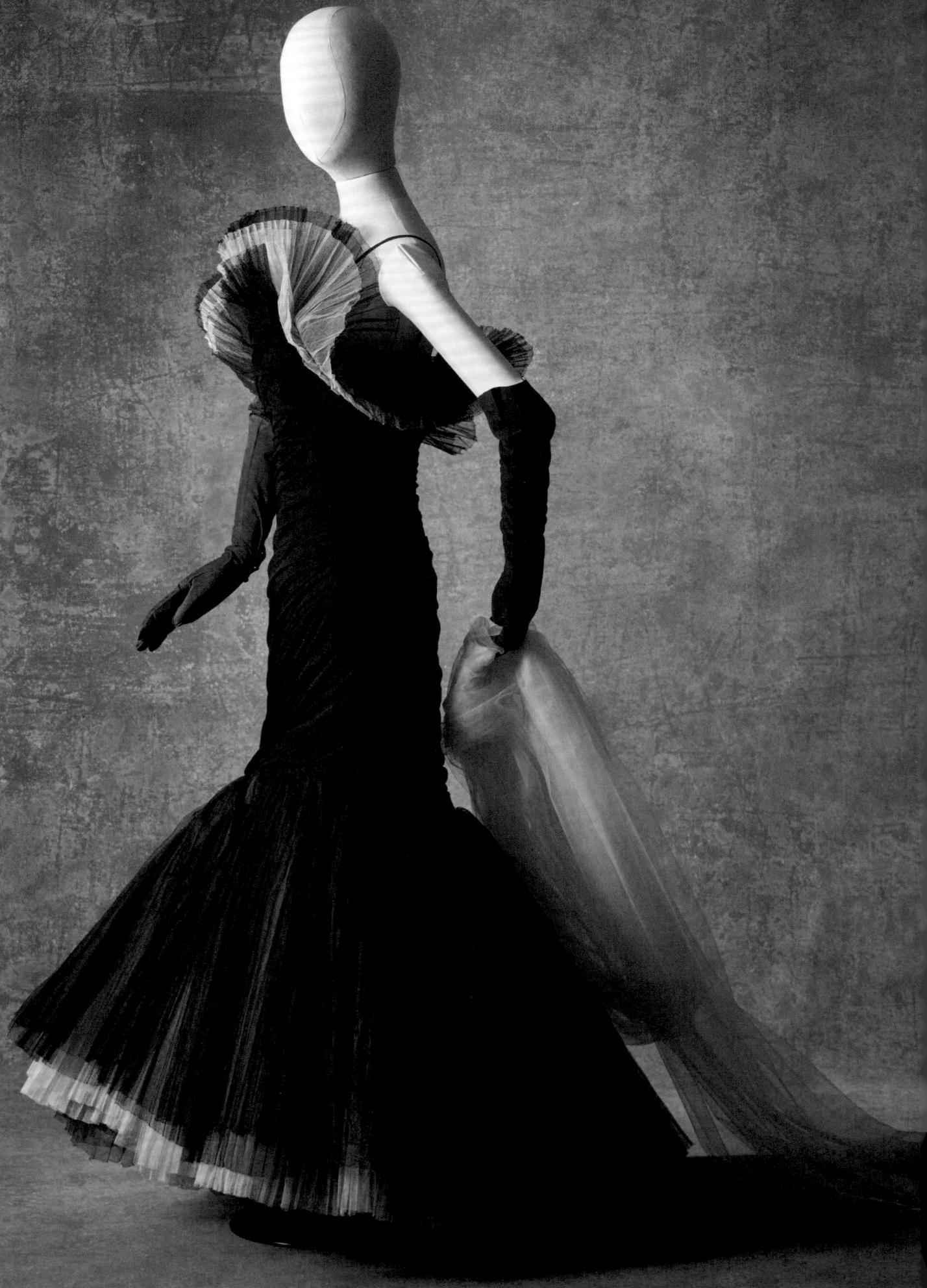

58. **Jacques Fath** Evening gown, c. 1950

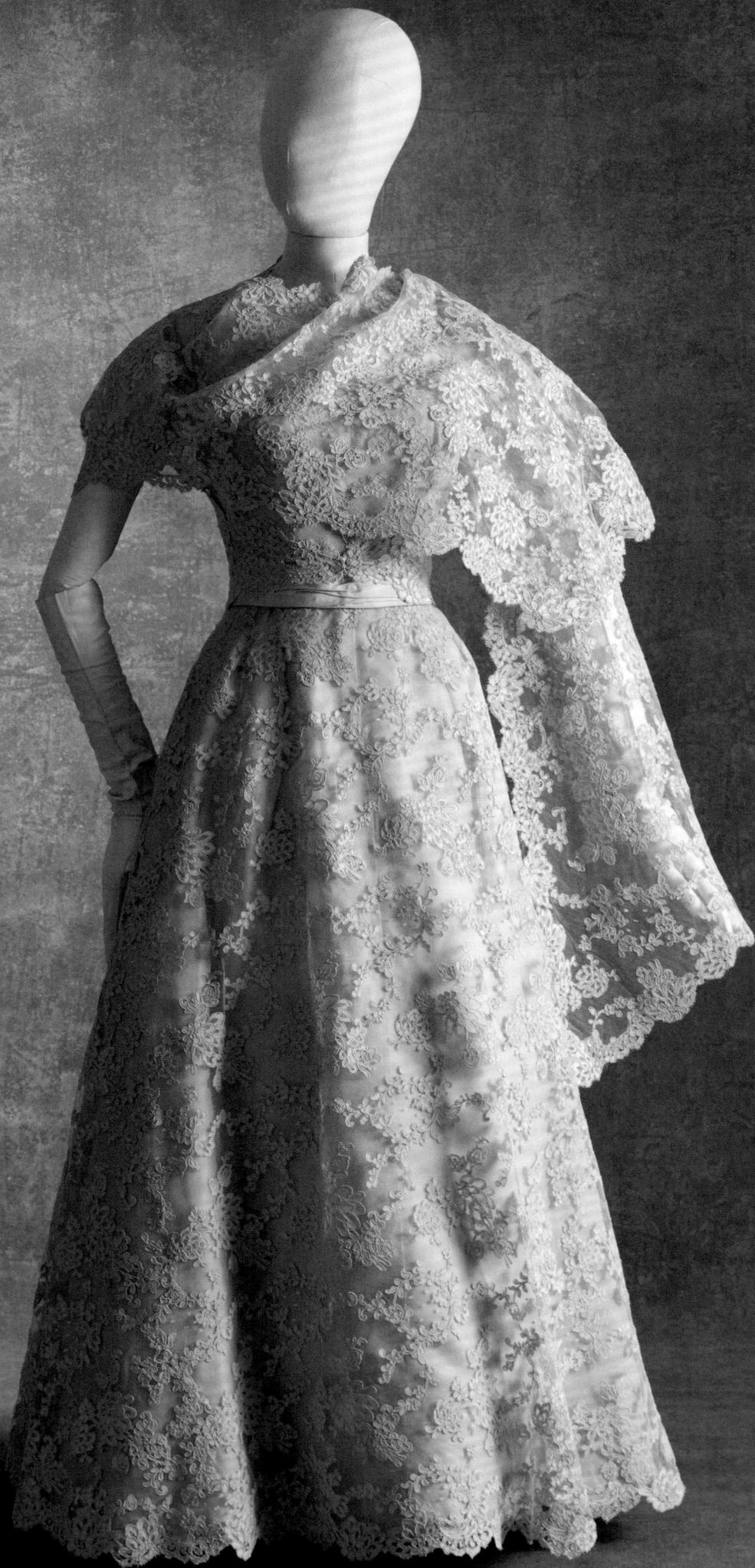

59. Cristóbal Balenciaga Evening dress and bolero, Spring 1952

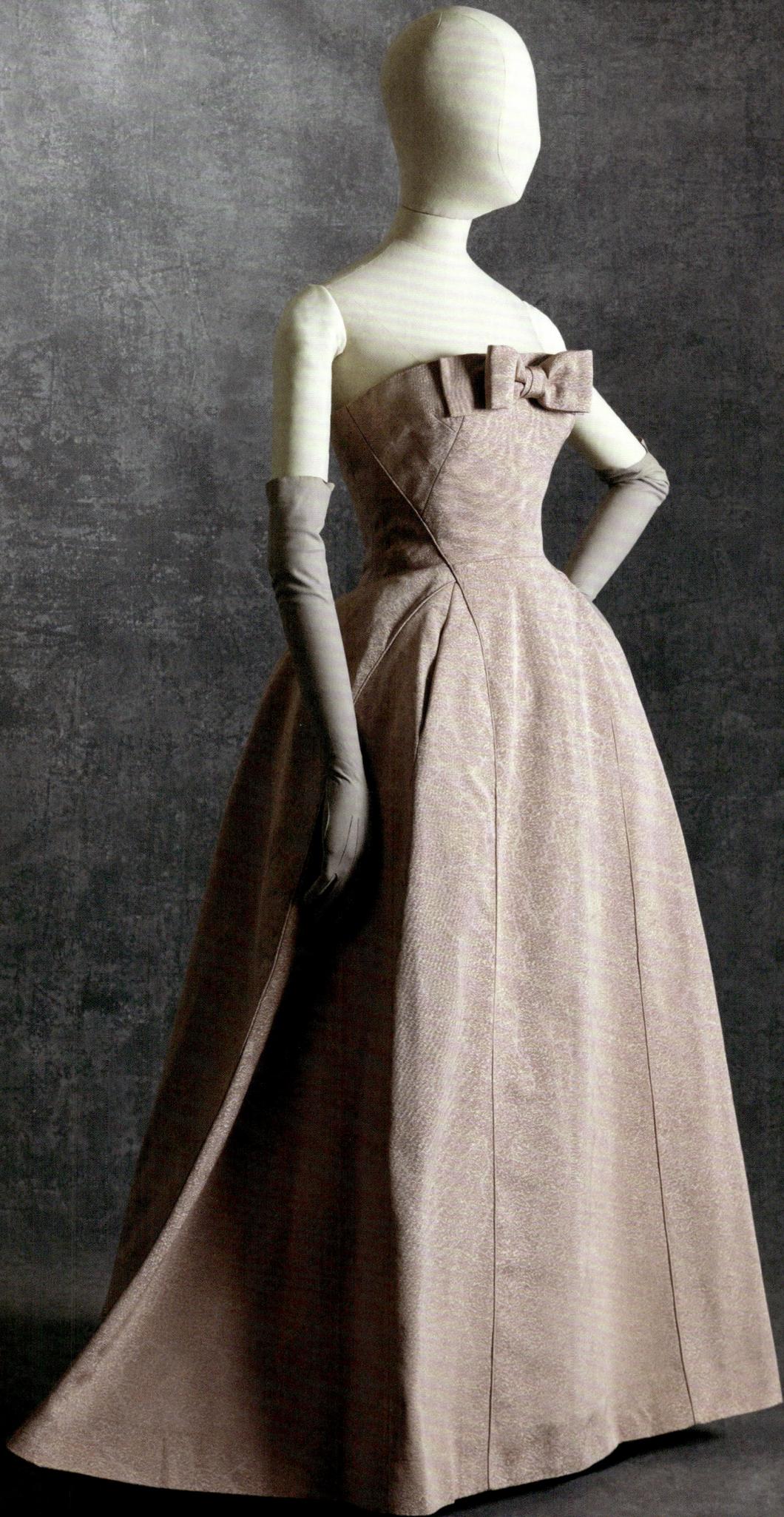

60. Christian Dior Ballgown, possibly 'Clorinde', c. 1952

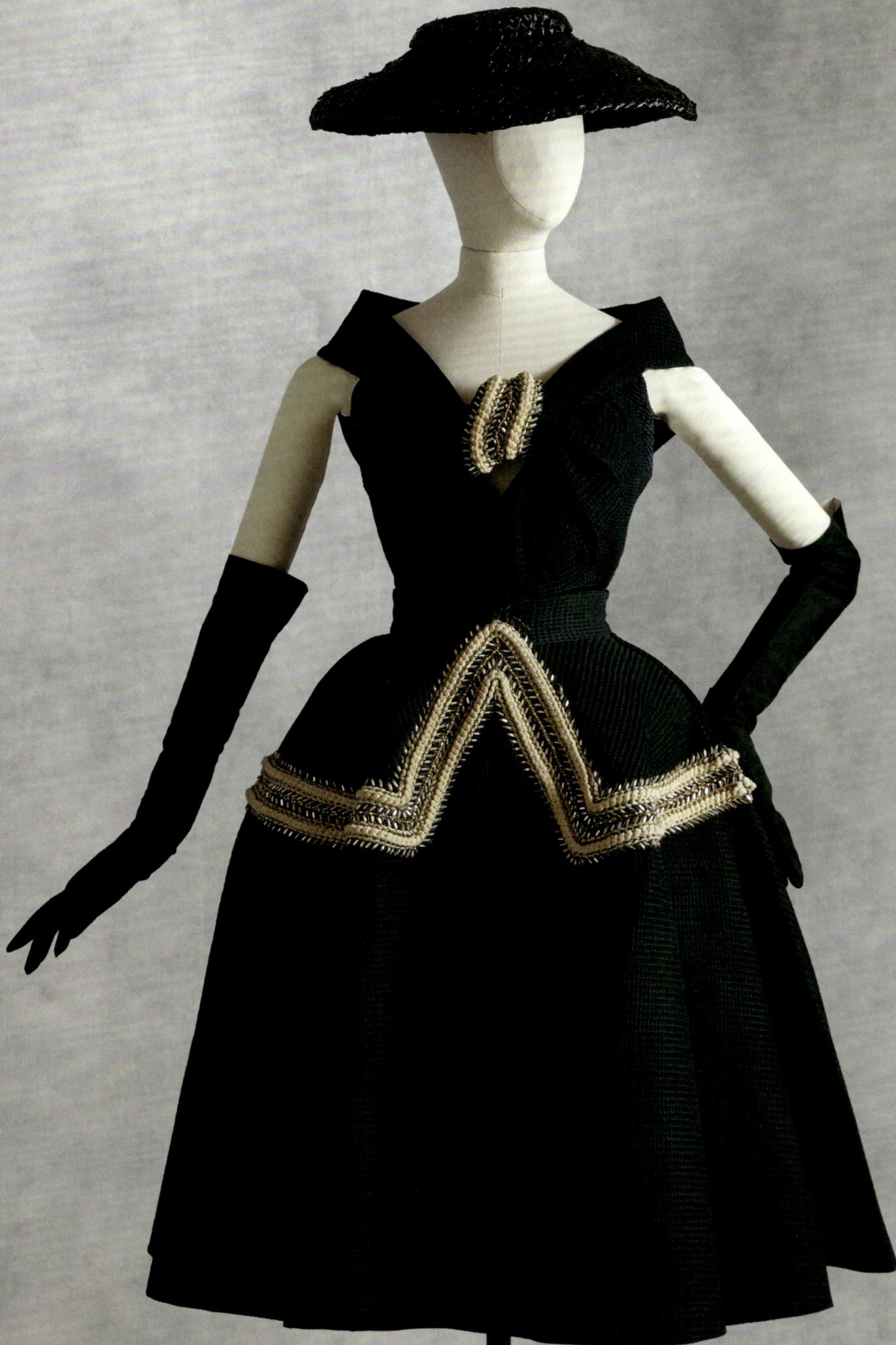

61. Lanvin-Castillo Day ensemble, Spring Boutique, 1954 and **EISA (Cristóbal Balenciaga)** Hat, c. 1950

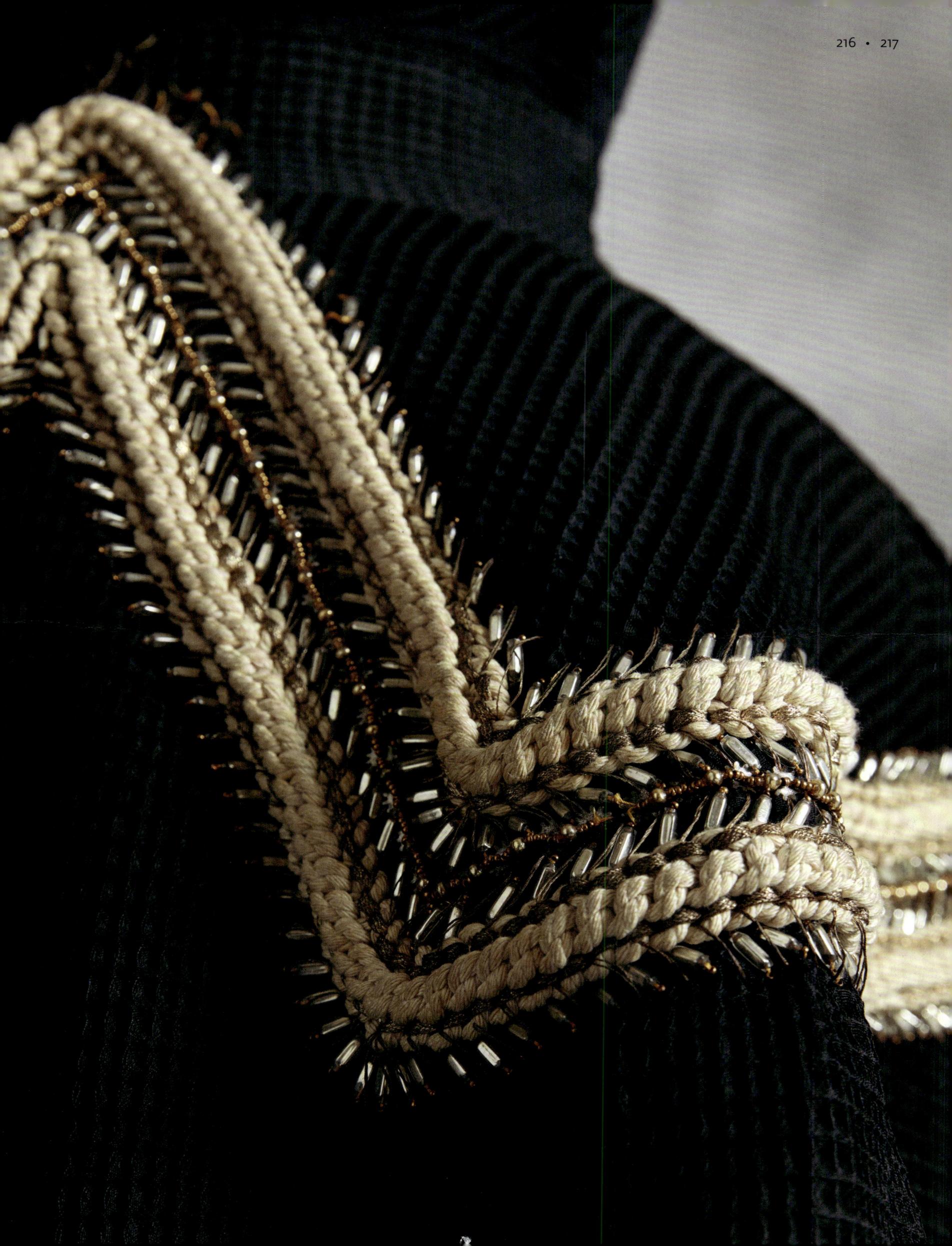

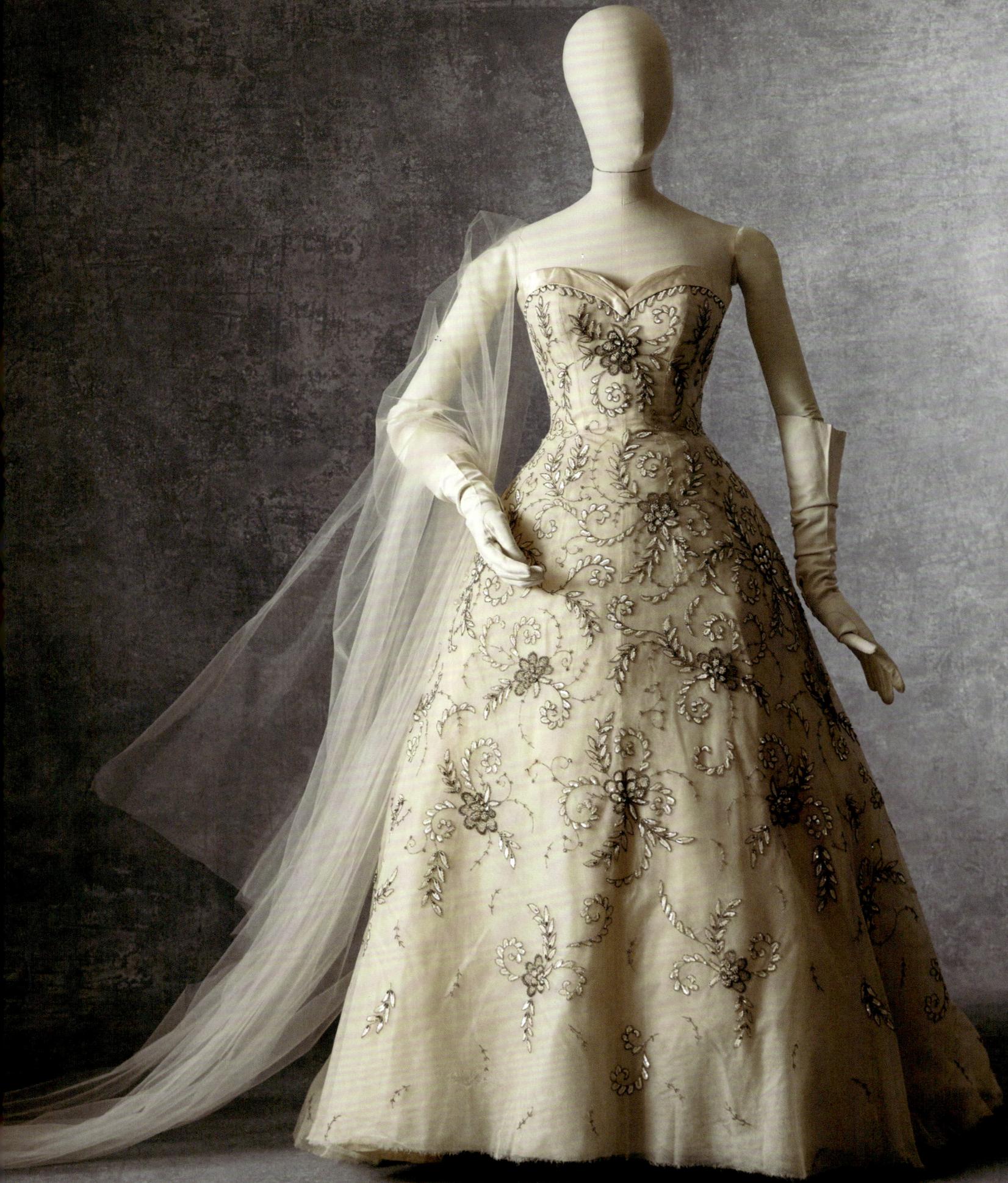

62. Jacques Fath Ballgown 'Sandrine', Spring/Summer 1954
fig. 43 Jacques Fath adjusting 'Sandrine' ballgown, 1954

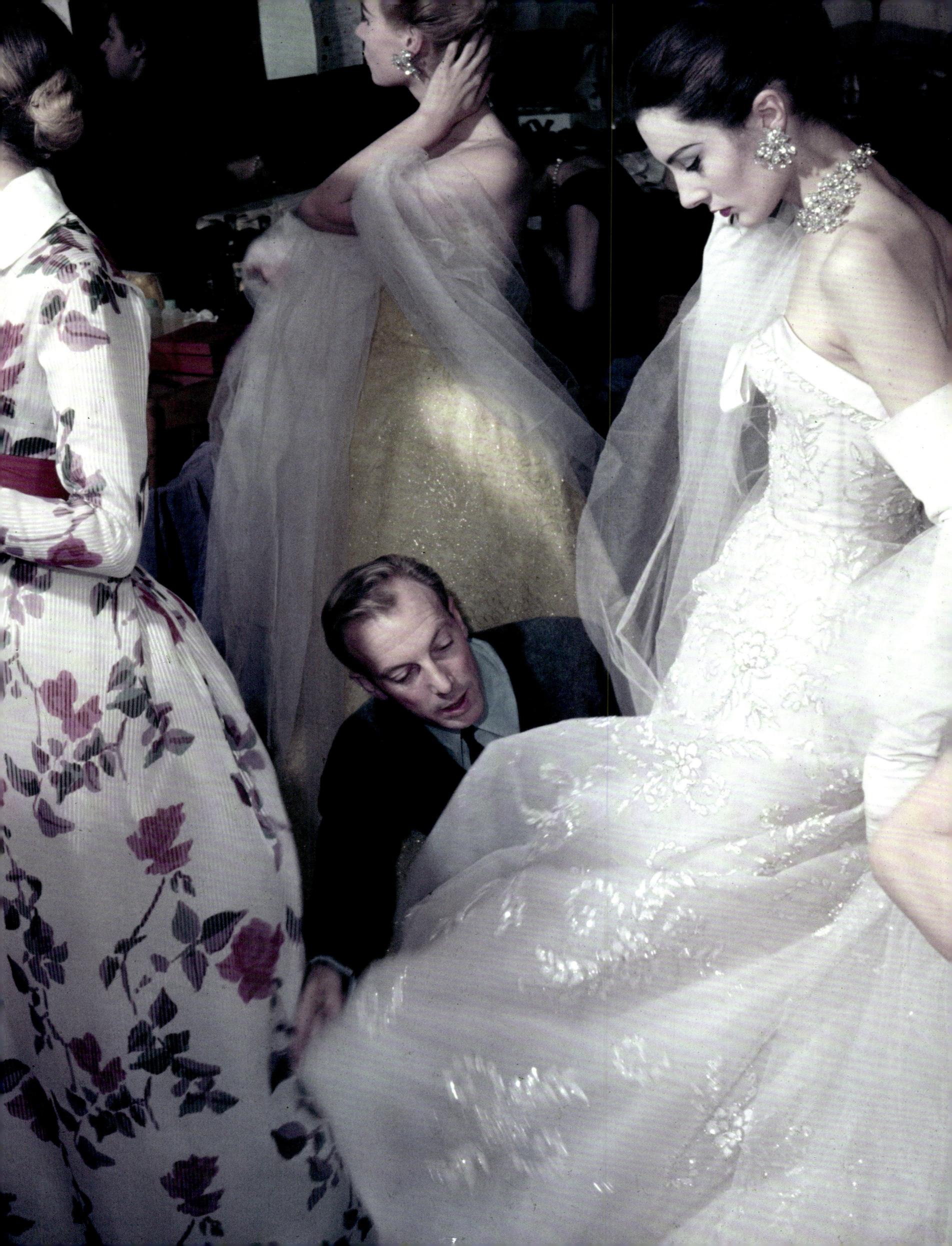

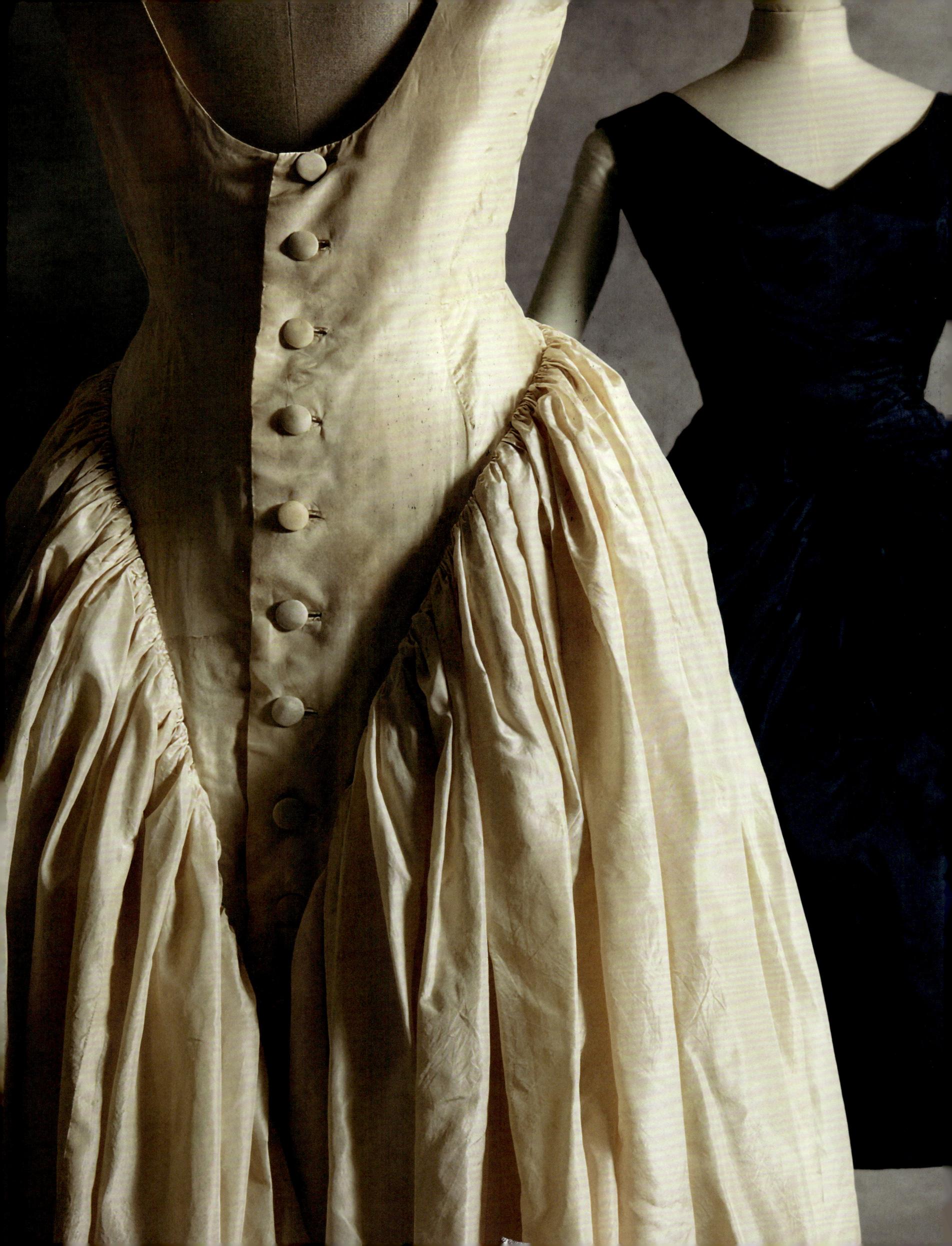

fig. 44 Model (right) wearing a Hubert de Givenchy dress, photographed by Philippe Pottier, March 1954

63. Hubert de Givenchy Cocktail dress, c. 1954 (left)
64. Jacques Fath Cocktail dress, c. 1955 (right)

Madame Grès, born Germaine Émilie Krebs (1903–1993), whose career spanned the 1930s to the 1980s, was a couturière who would long outlive her couture contemporaries. Her *nom de plume*, Alix, was also the name of the couture house she ran with Julie Barton in the 1930s (see no. 37). In 1940, she sold her shares in Alix and, with the proceeds from the sale and the assistance of the Chambre Syndicale de la Couture, opened her own couture house in 1942 under the name Grès[17] (see also nos. 45, 89 and 90).

Her dresses, which often required large amounts of fabric, were draped and manipulated directly on the body, with a preference for textiles such as paper taffeta or silk jersey. Despite a move from couture to prêt-à-porter in the 1960s, she remained committed to the former. In a 1977 interview, she said: 'One must have courage to be a couturier ... Each season, a couture collection is judged on the strength of the designs you present. It is like you are nude for the whole world to see.'[18]

65. Grès Evening dress, late 1950s

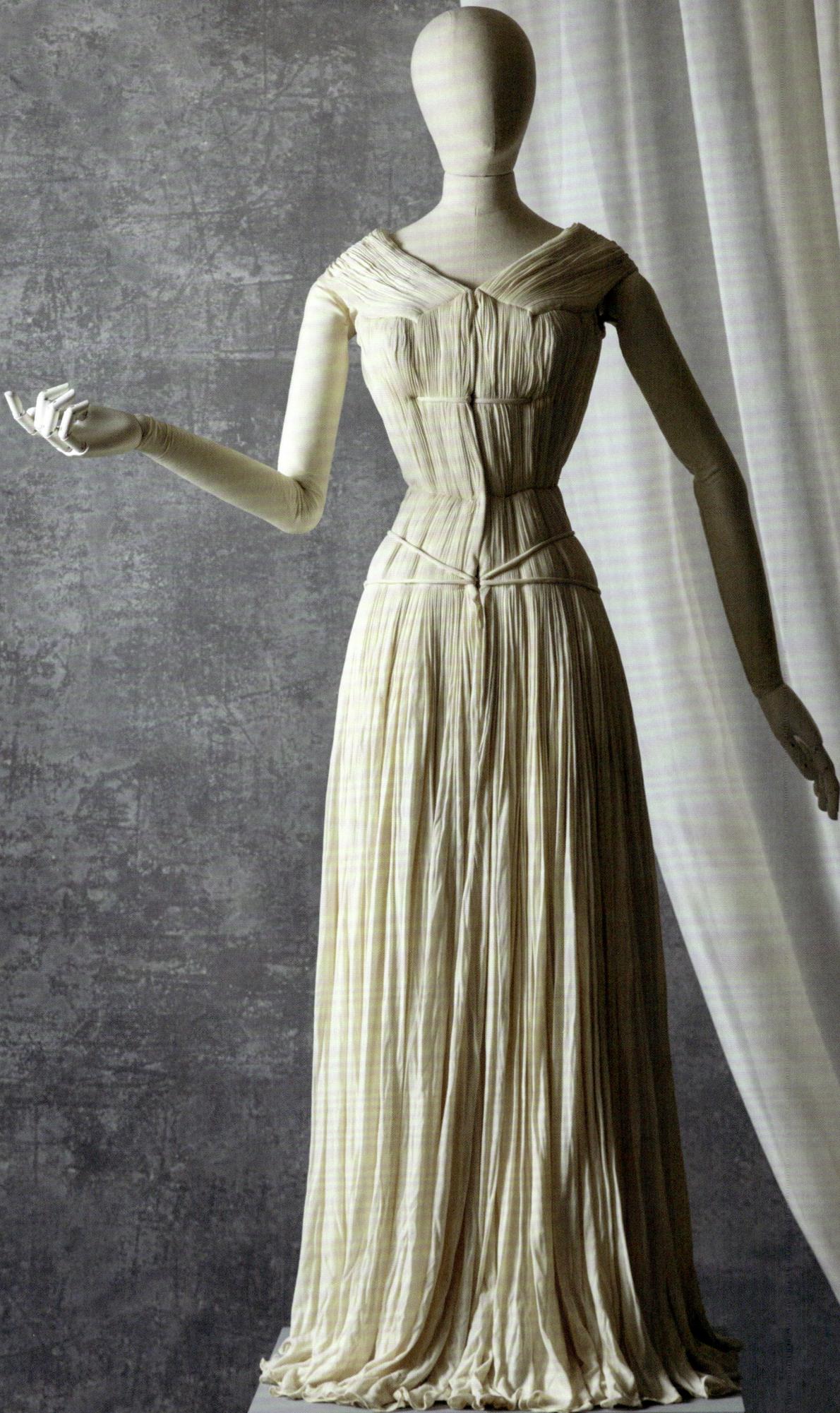

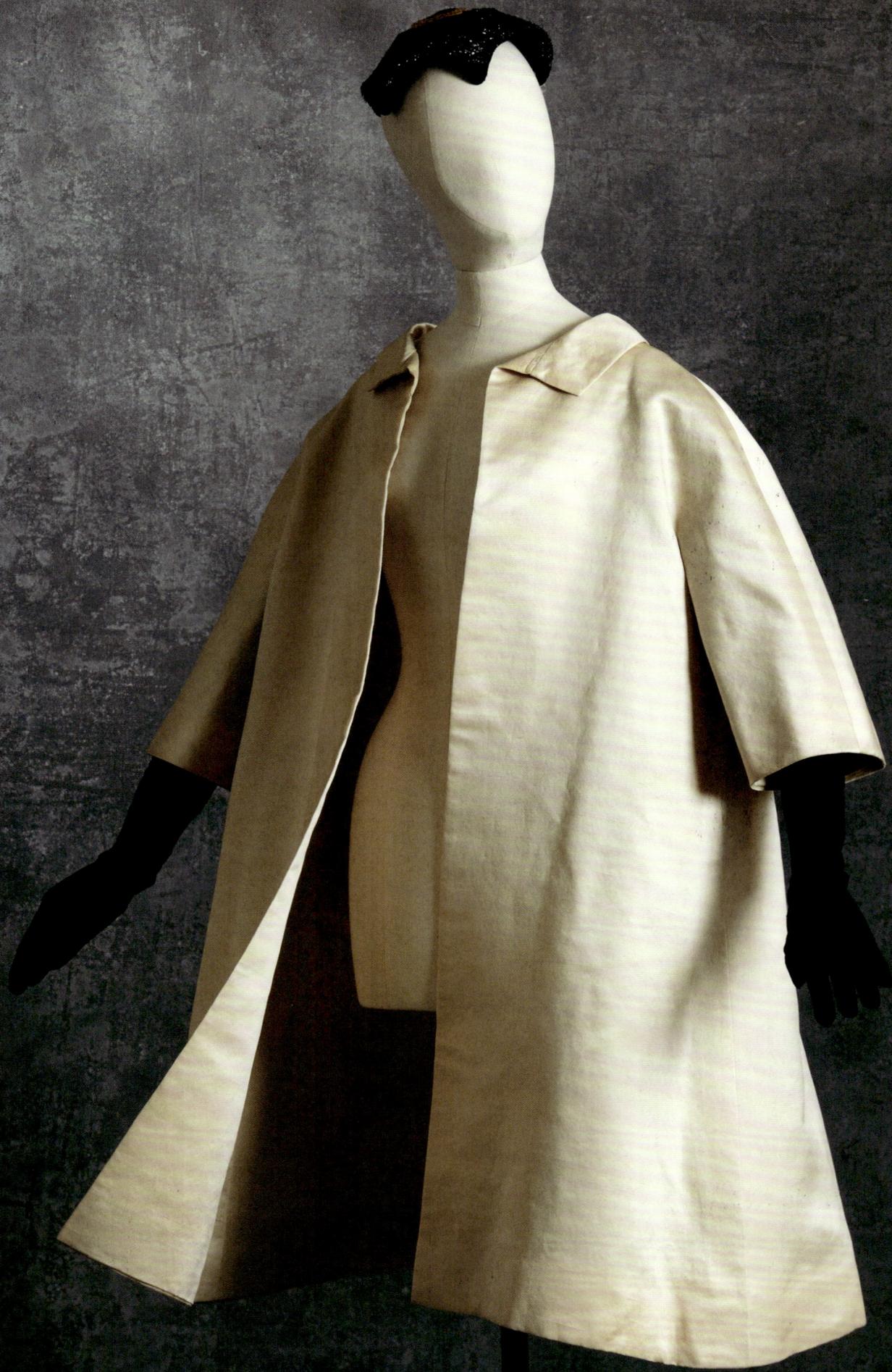

66. Cristóbal Balenciaga Evening coat, c. 1959 and hat, 1950s

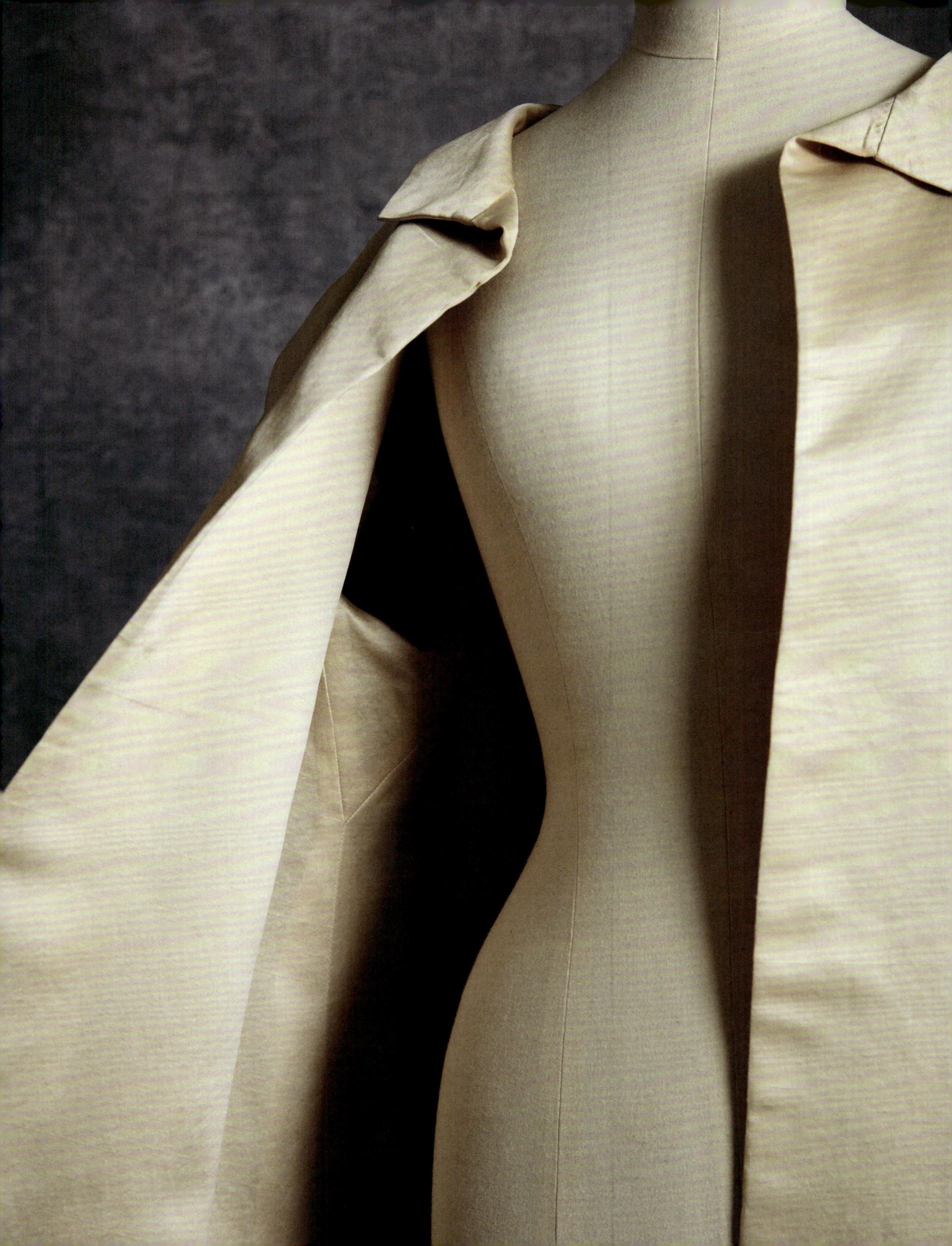

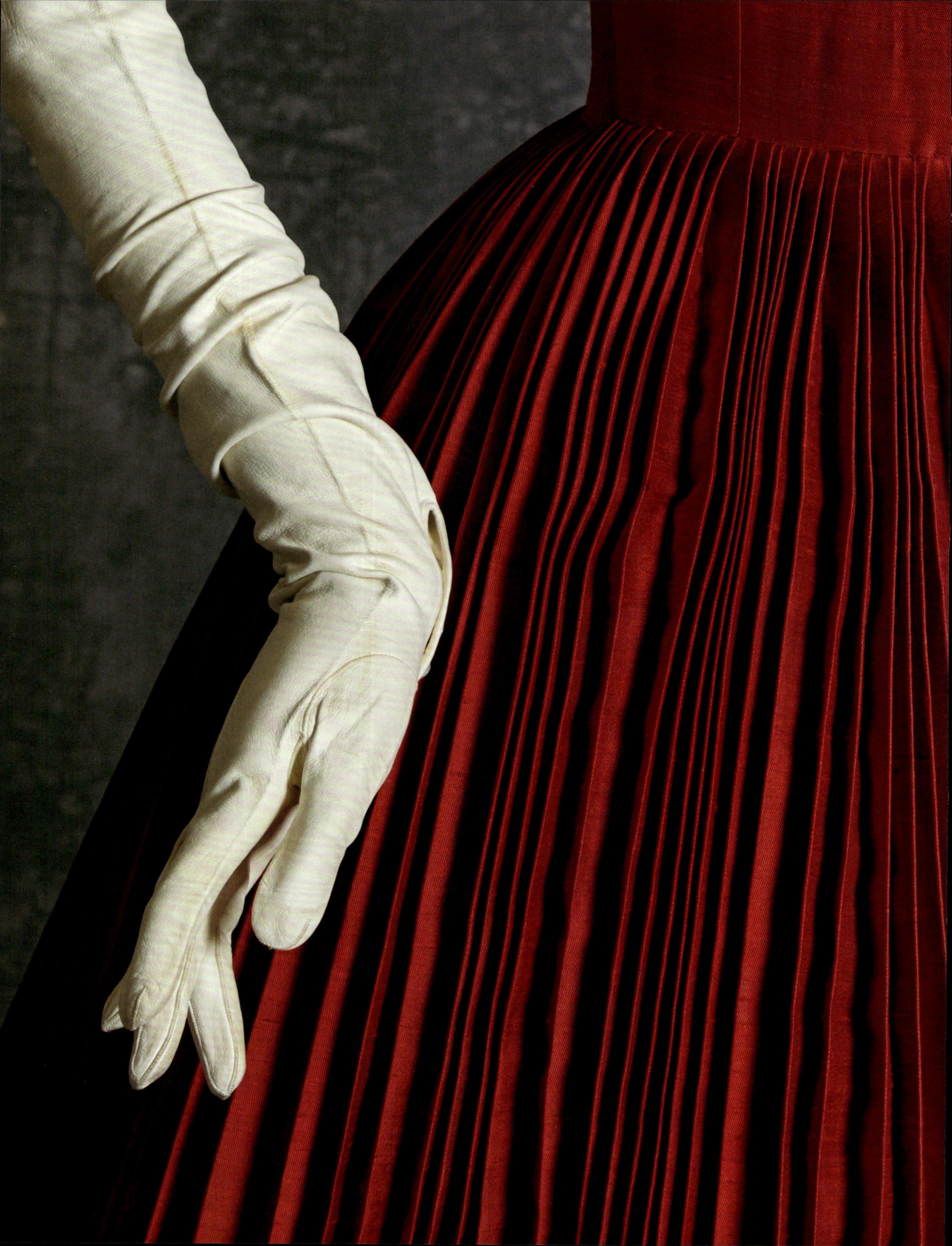

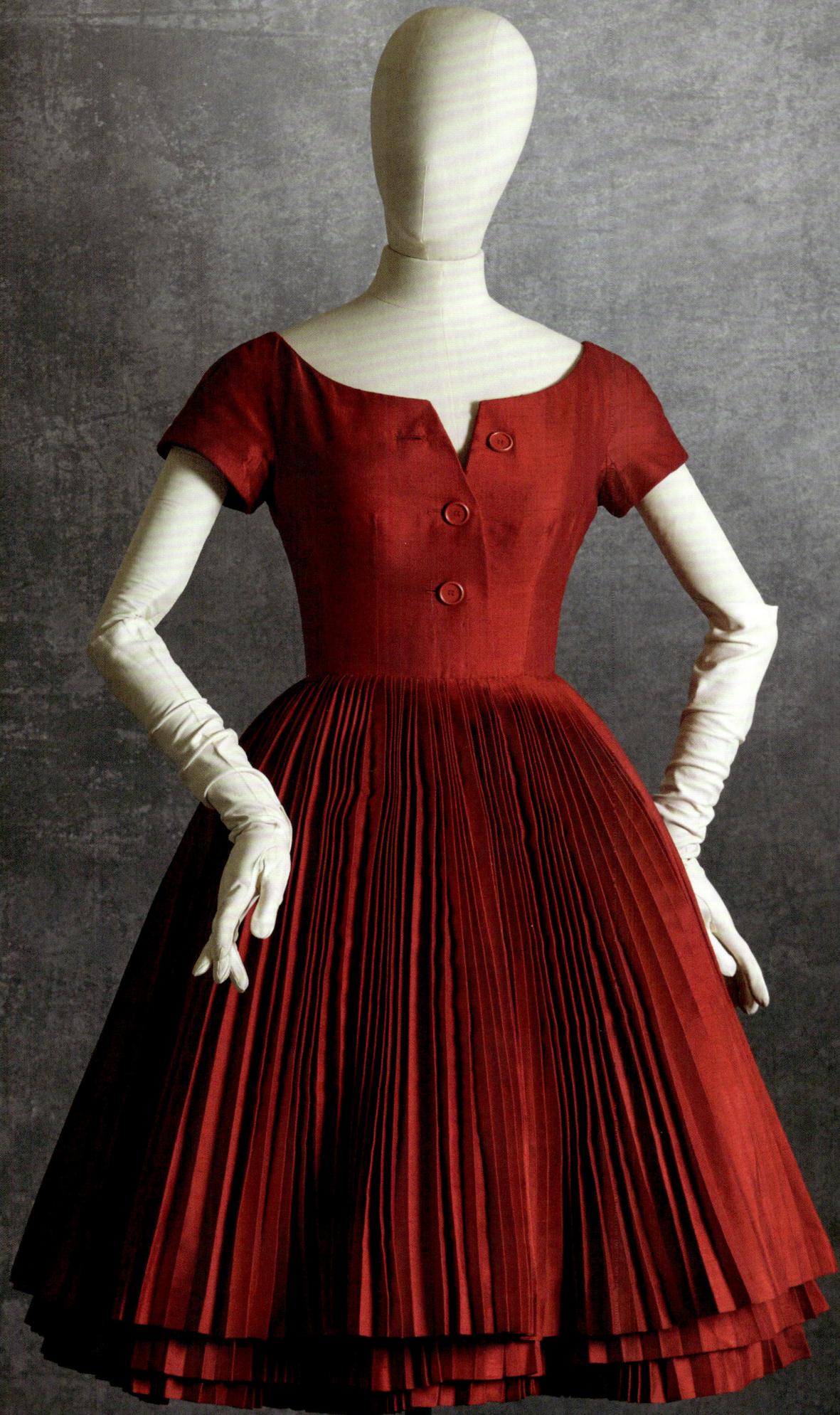

67. Christian Dior (Yves Saint Laurent) Cocktail dress, Spring/Summer 1959
'Ligne Longue – Silhouette Naturelle'

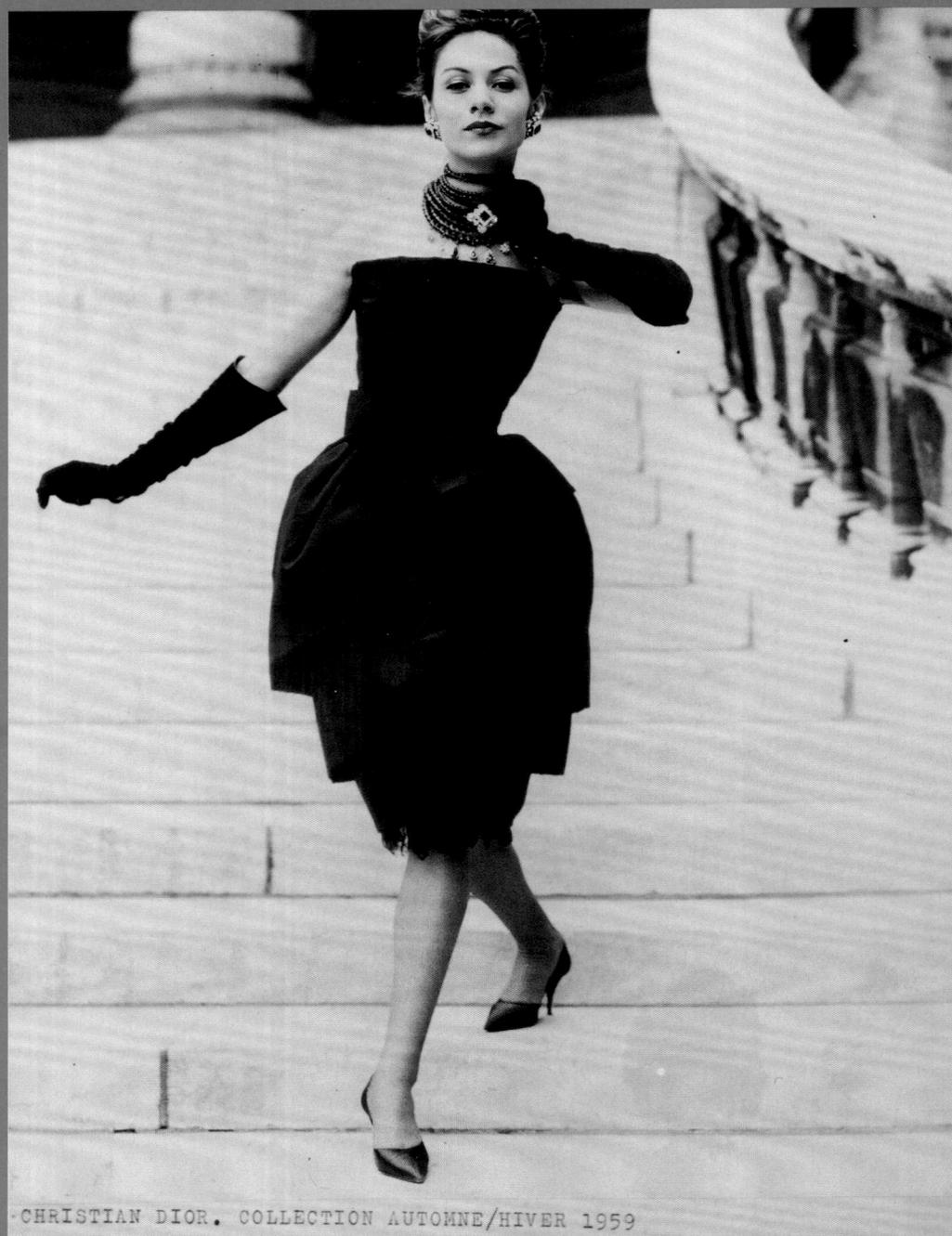

CHRISTIAN DIOR. COLLECTION AUTOMNE/HIVER 1959

fig. 45 Model wearing Christian Dior 'Artemise' cocktail dress, 1959

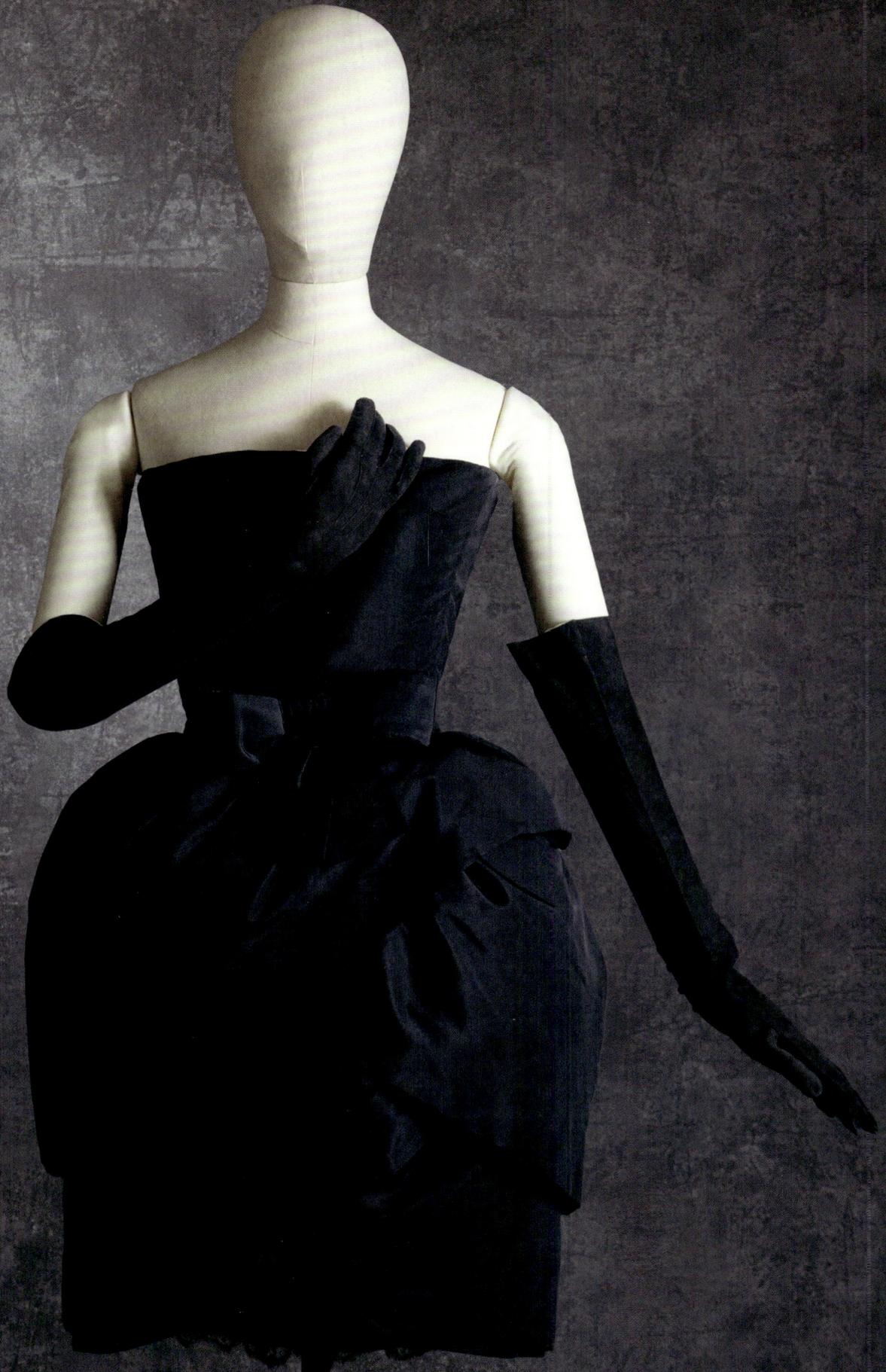

68. Christian Dior (Yves Saint Laurent) Cocktail dress, 'Artemise', Autumn/Winter 1959

In Cristóbal Balenciaga, the textile manufacturers found a discerning client who was interested in experimenting with innovative textiles and mixes of fibres, and who even collaborated in the development of new ones. In the late 1950s Balenciaga worked closely with his friend Gustav Zumsteg, co-owner of Abraham Ltd, a converter company based in Zurich (and one of the main textile suppliers for Balenciaga)[19] to create silk gazar,[20] which was used for this dress. This crisp and light fabric enabled Balenciaga to design silhouettes that stood away from the body and held their shape.

Zumsteg co-organised the first retrospective on Balenciaga at the Museum Bellerive, Zurich in 1970: *Balenciaga: Ein Meister der Haute Couture*.[21]

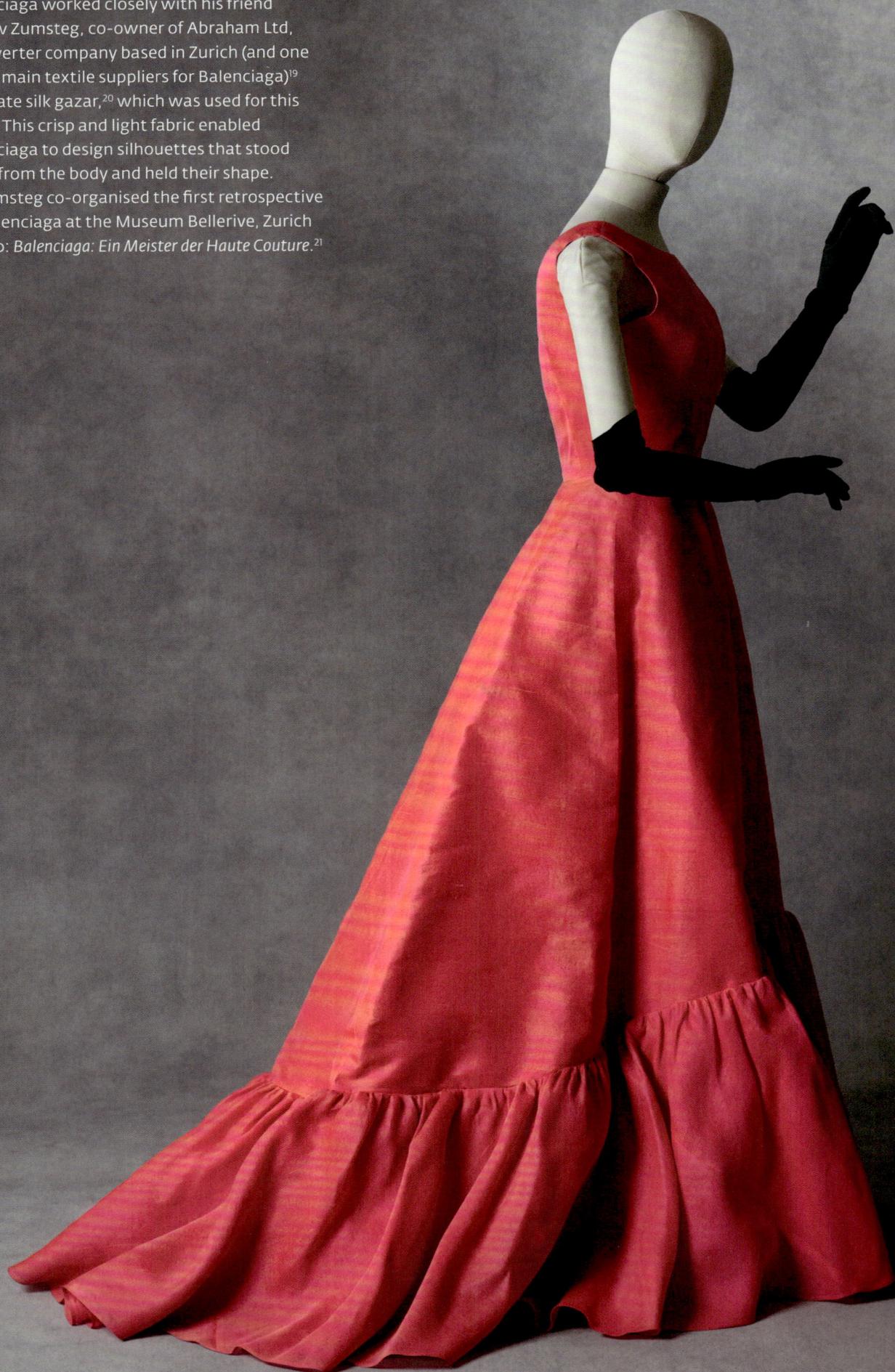

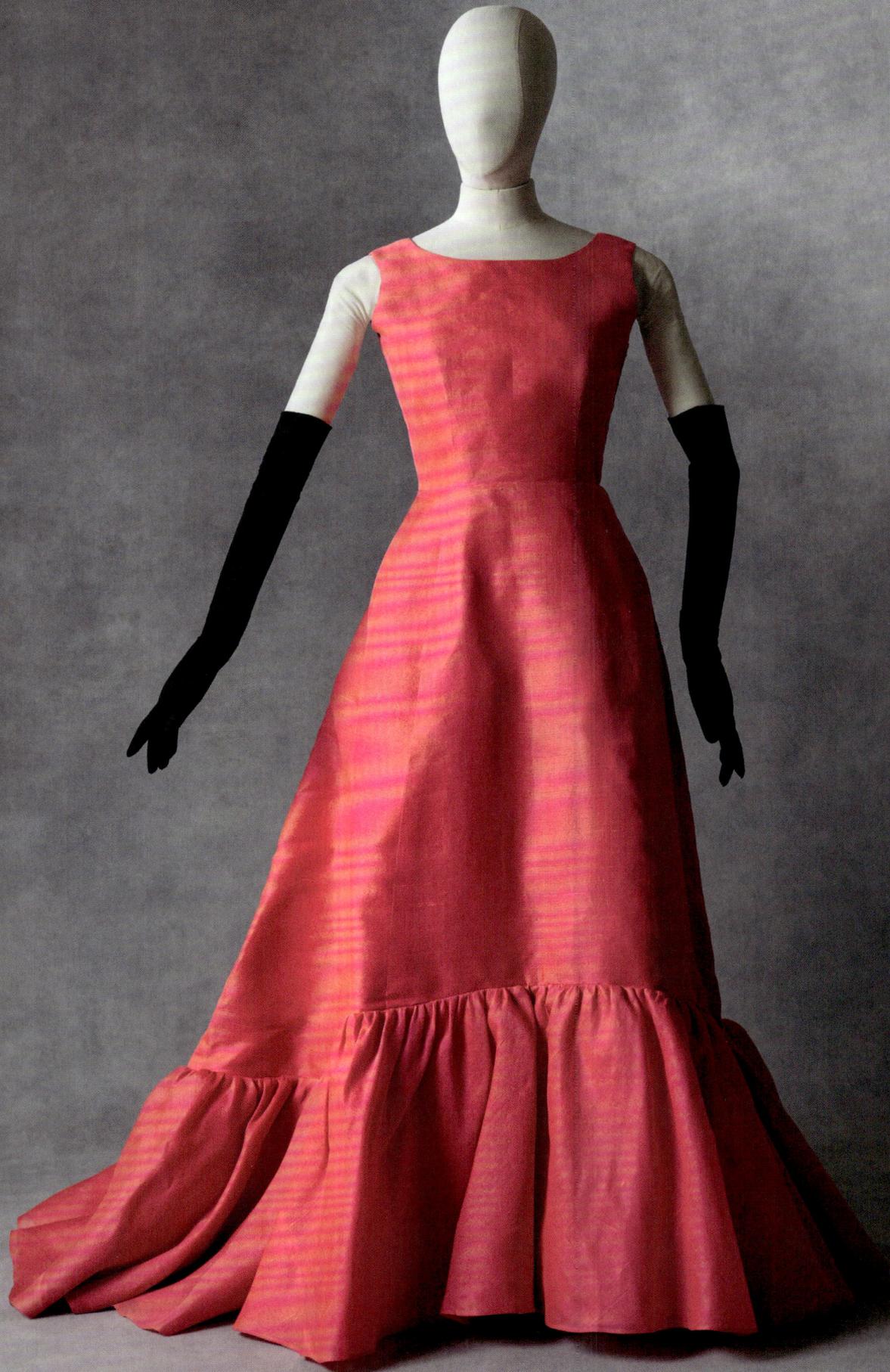

69. Cristóbal Balenciaga *Evening dress, Spring 1961*

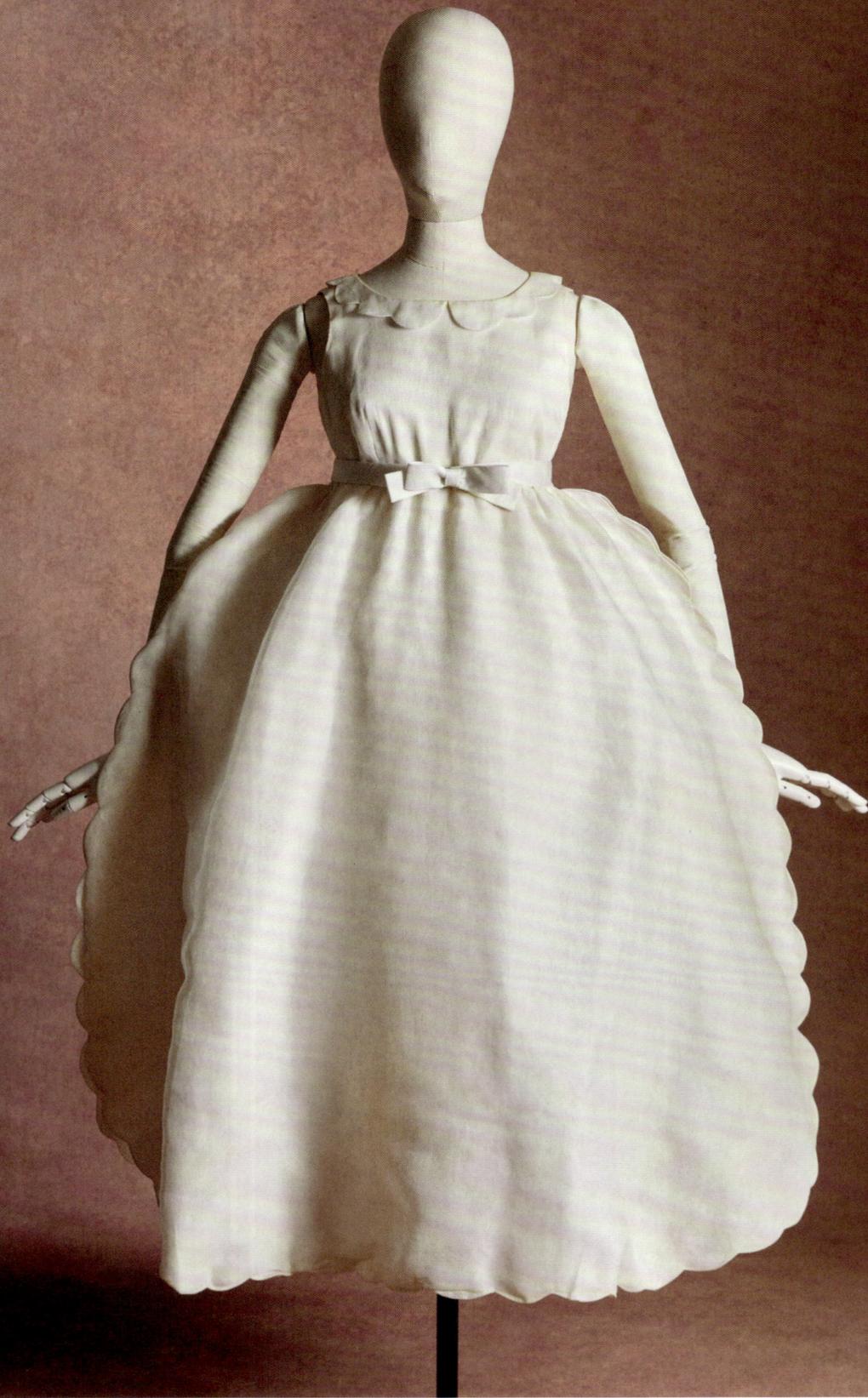

70. **André Courrèges** Evening or bridal dress, c. 1962

71. **André Courrèges** Ballerinas, 1965

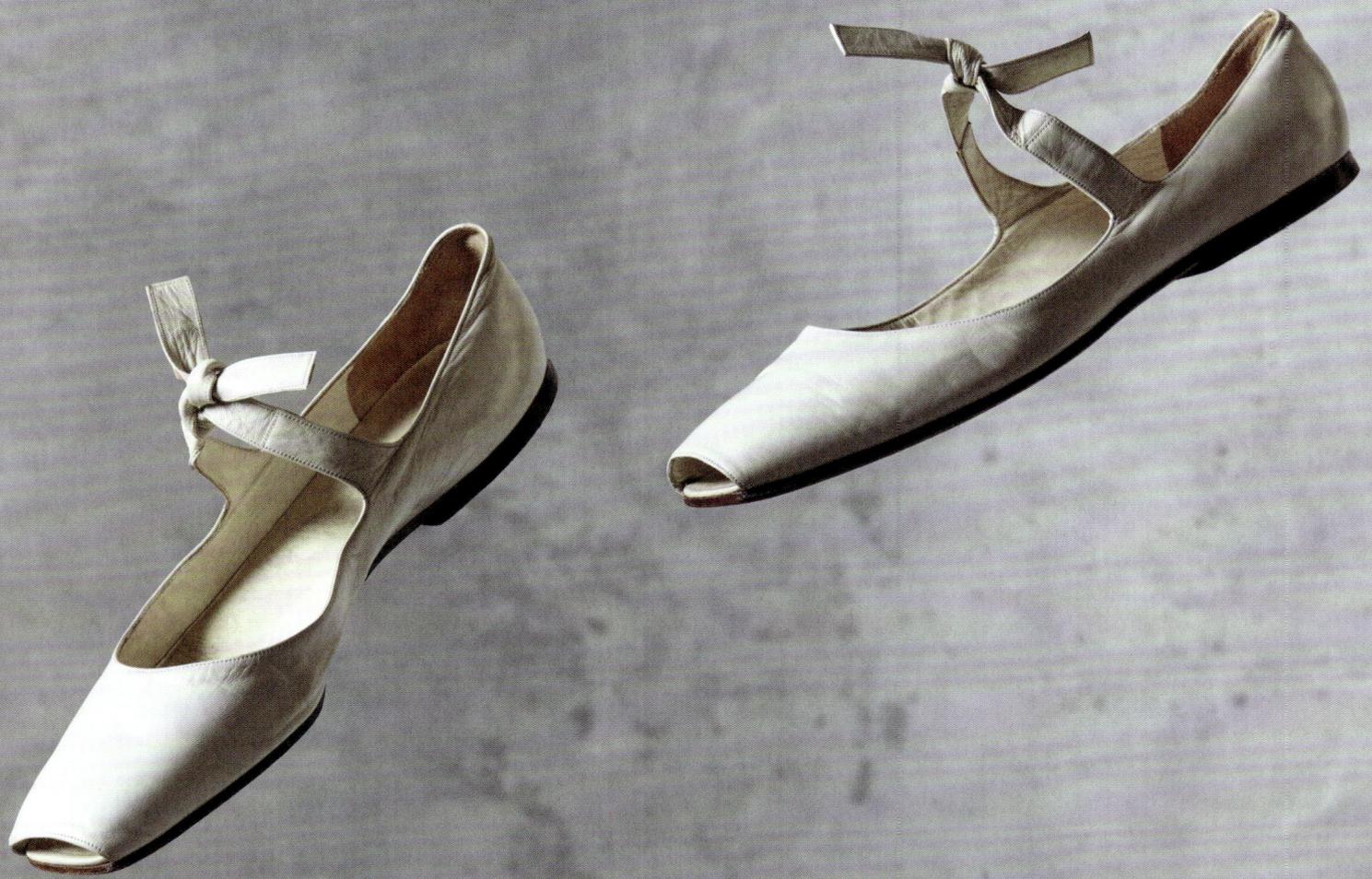

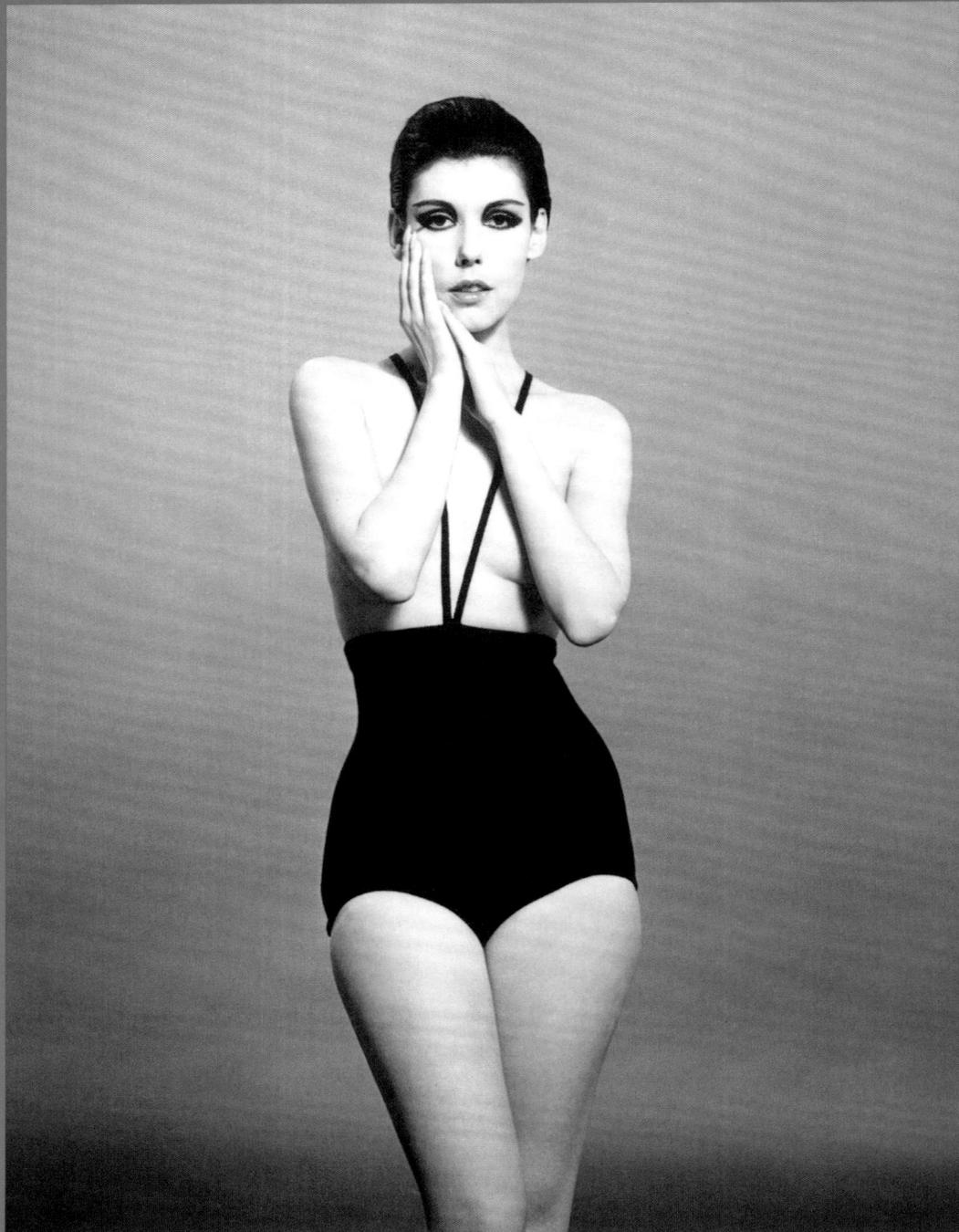

fig. 46 Peggy Moffitt in Rudi Gernreich Monokini

The media was scandalised in 1964 when Austrian-born American designer Rudi Gernreich (1922–1985) launched the Monokini, essentially a topless bathing suit. Nonetheless, it became a commercial success, and 3,000 Monokinis were sold.

While the top of the suit consists of only two thin straps, the bottom is conservative by the standards of the day. It provides ample coverage and is crafted out of a wool material popular for bathing apparel in Victorian times.

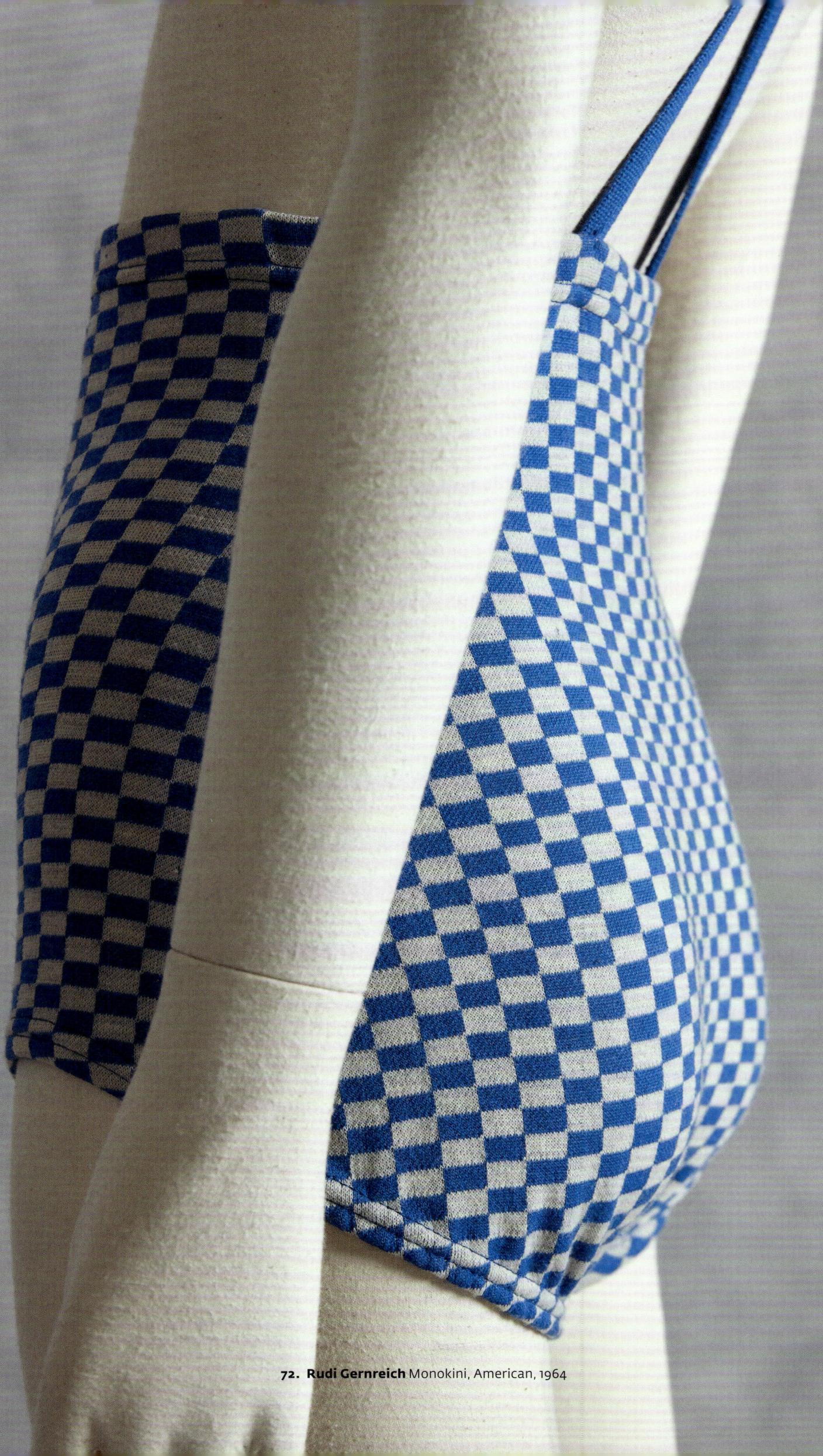

72. Rudi Gernreich Monokini, American, 1964

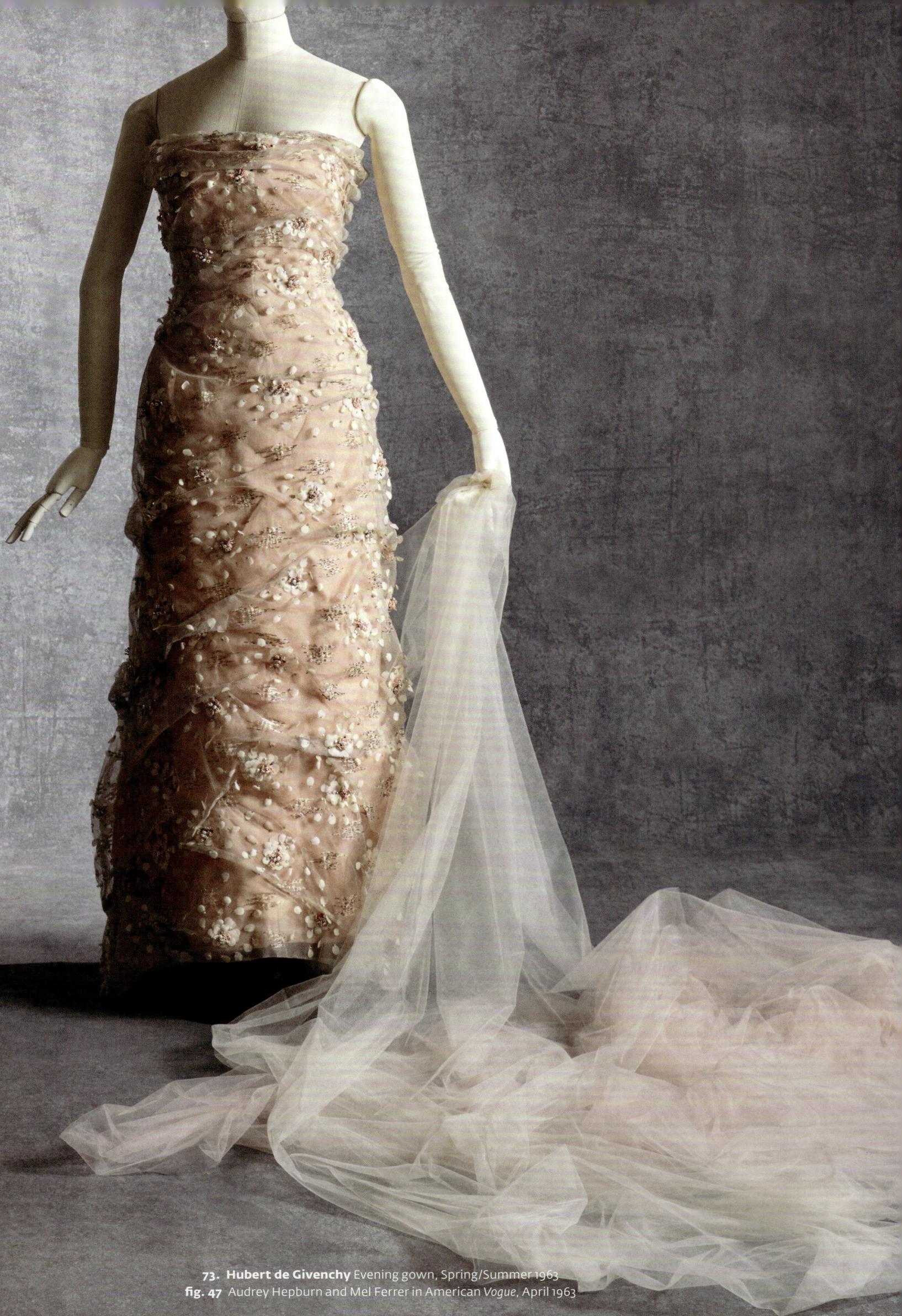

73. Hubert de Givenchy Evening gown, Spring/Summer 1963
fig. 47 Audrey Hepburn and Mel Ferrer in American *Vogue*, April 1963

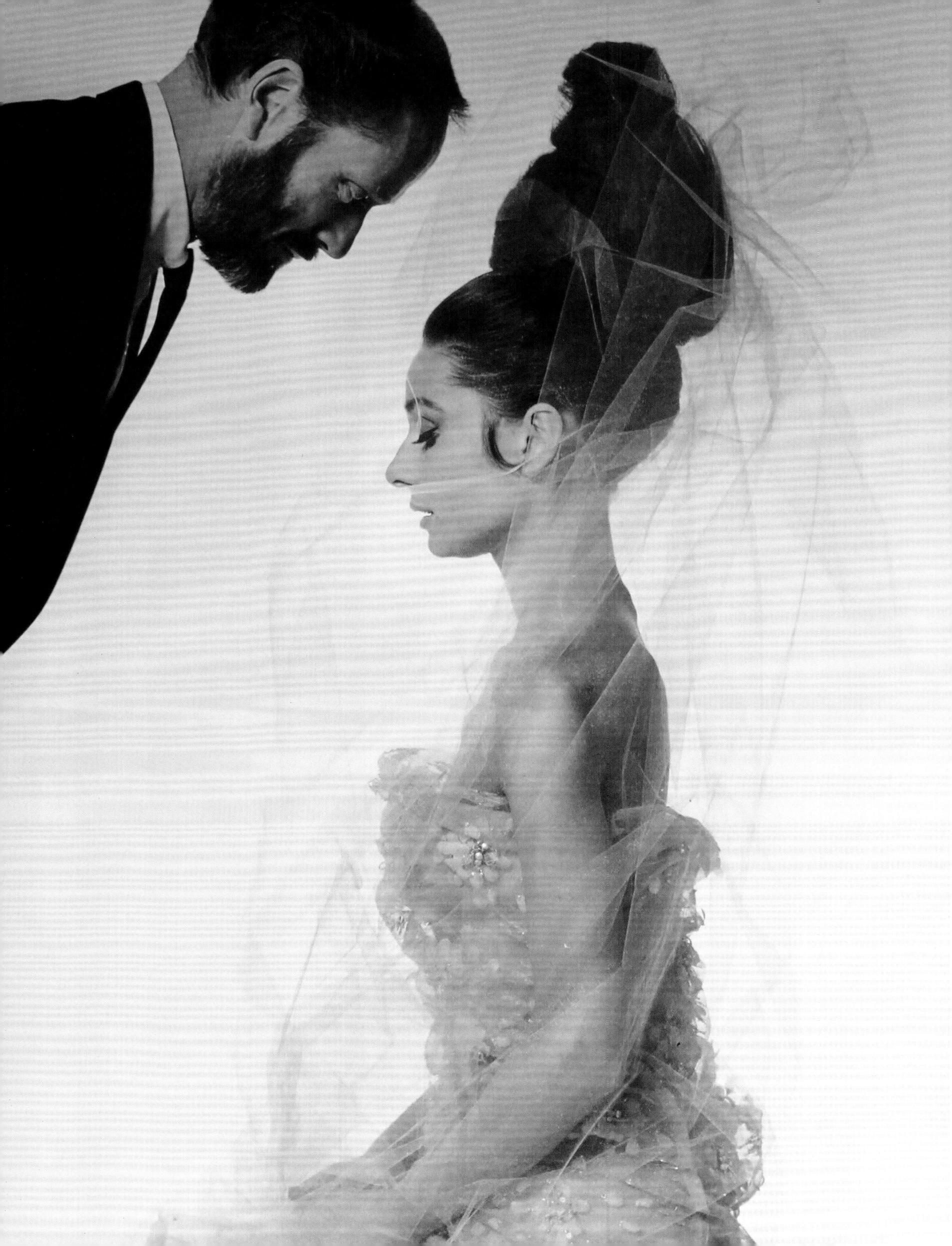

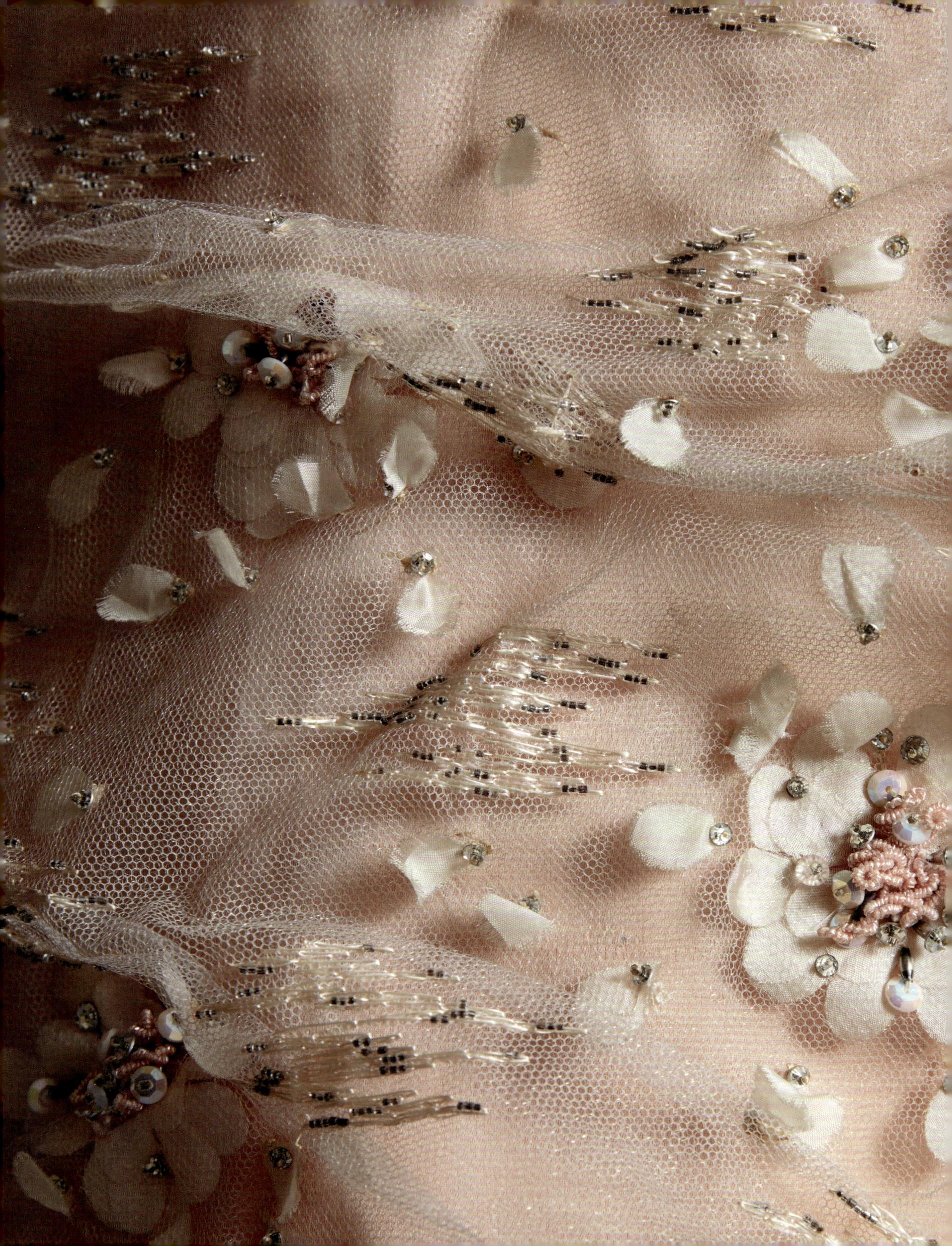

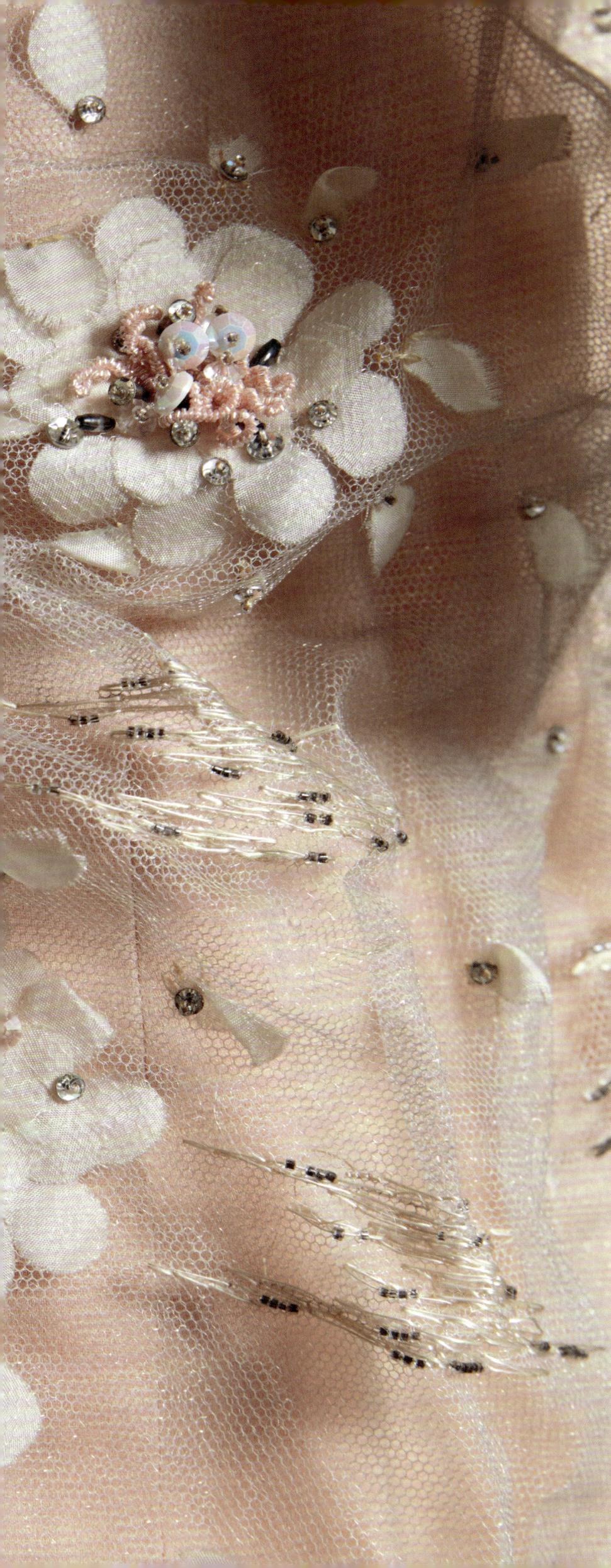

'The Givenchy Idea', an article in American *Vogue* (15 April 1963), features Audrey Hepburn photographed in five Givenchy gowns by Bert Stern. On the opening page, she is seen wearing this dress and posing with her husband, Mel Ferrer. In the *Vogue* photograph, the ethereal quality of the gown is emphasised through the extra tulle that envelops Hepburn like a cocoon.

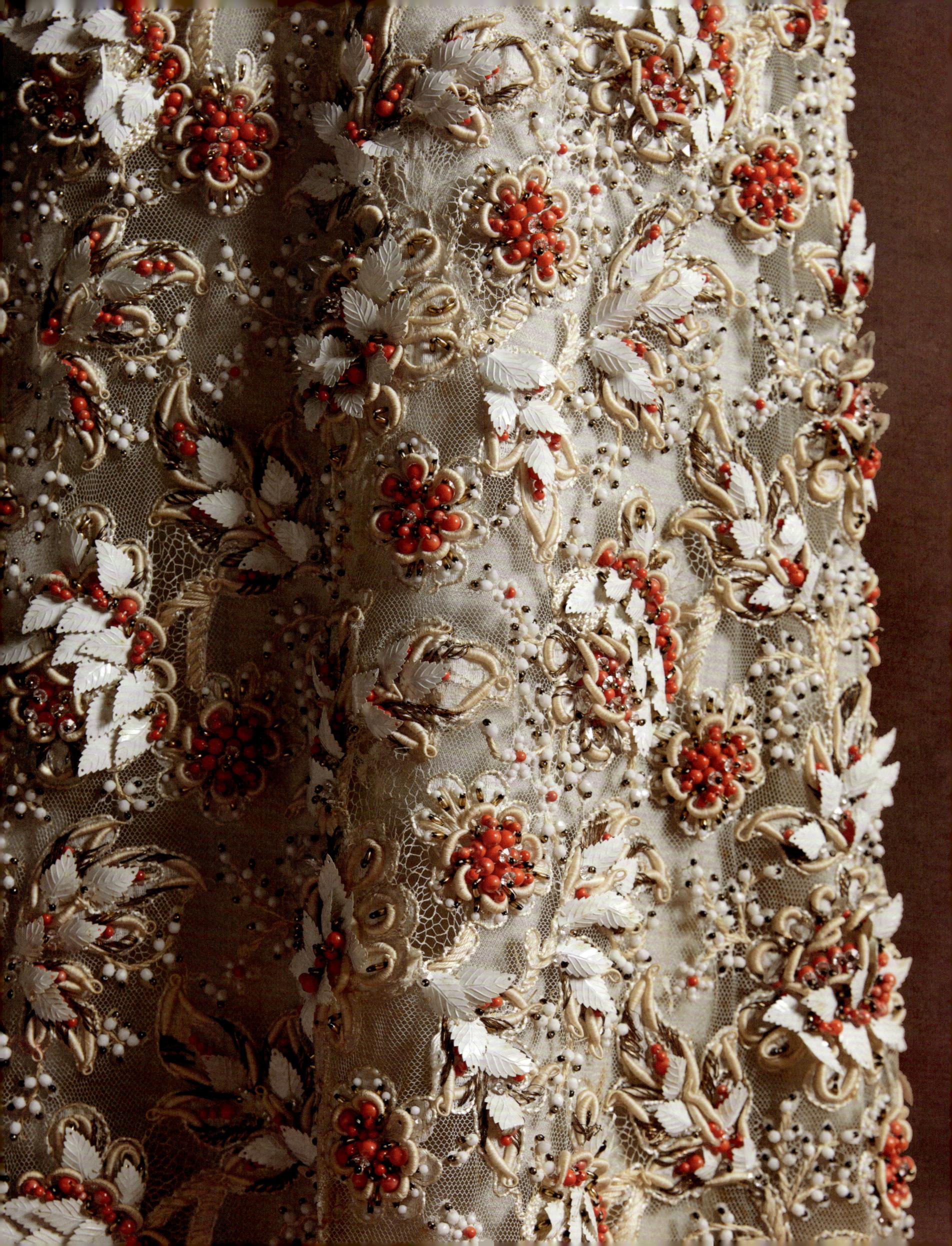

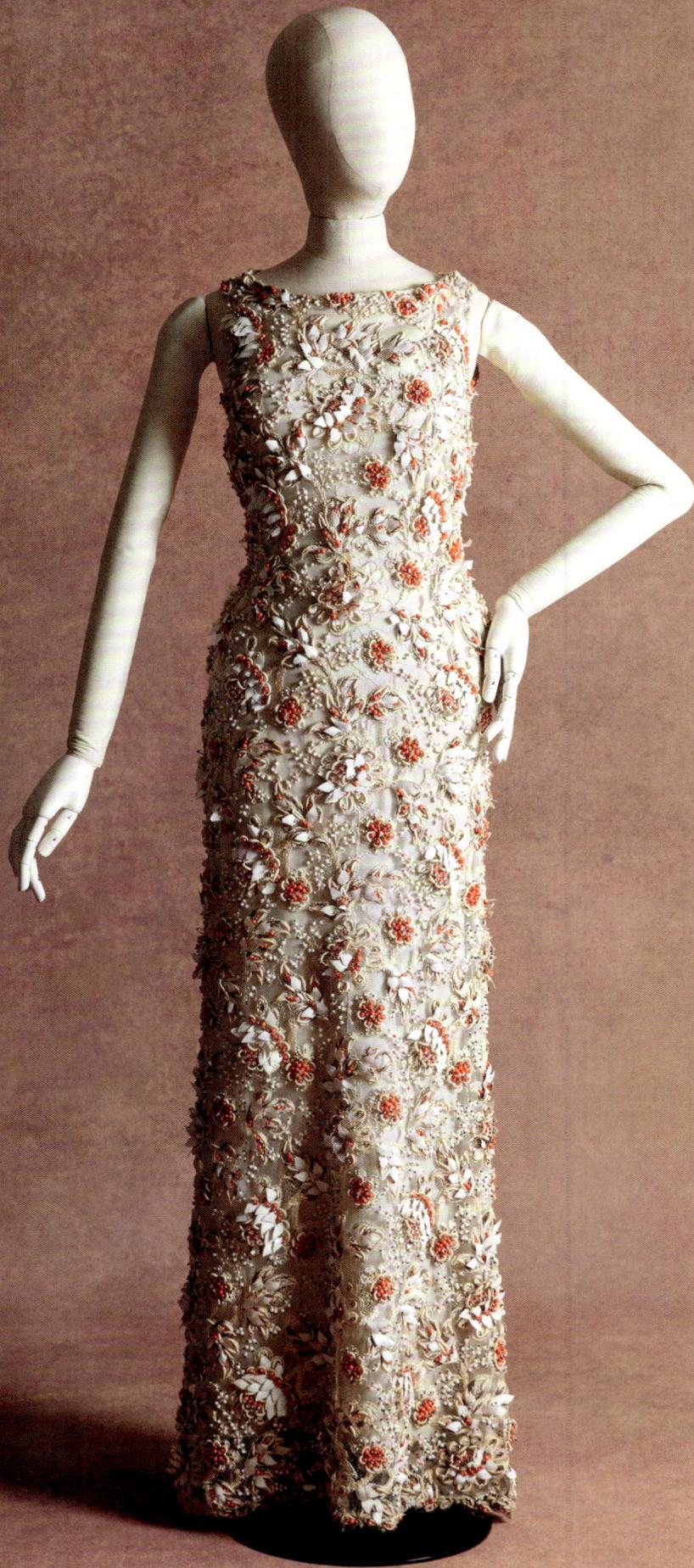

74. Cristóbal Balenciaga Evening dress, Spring 1965

75

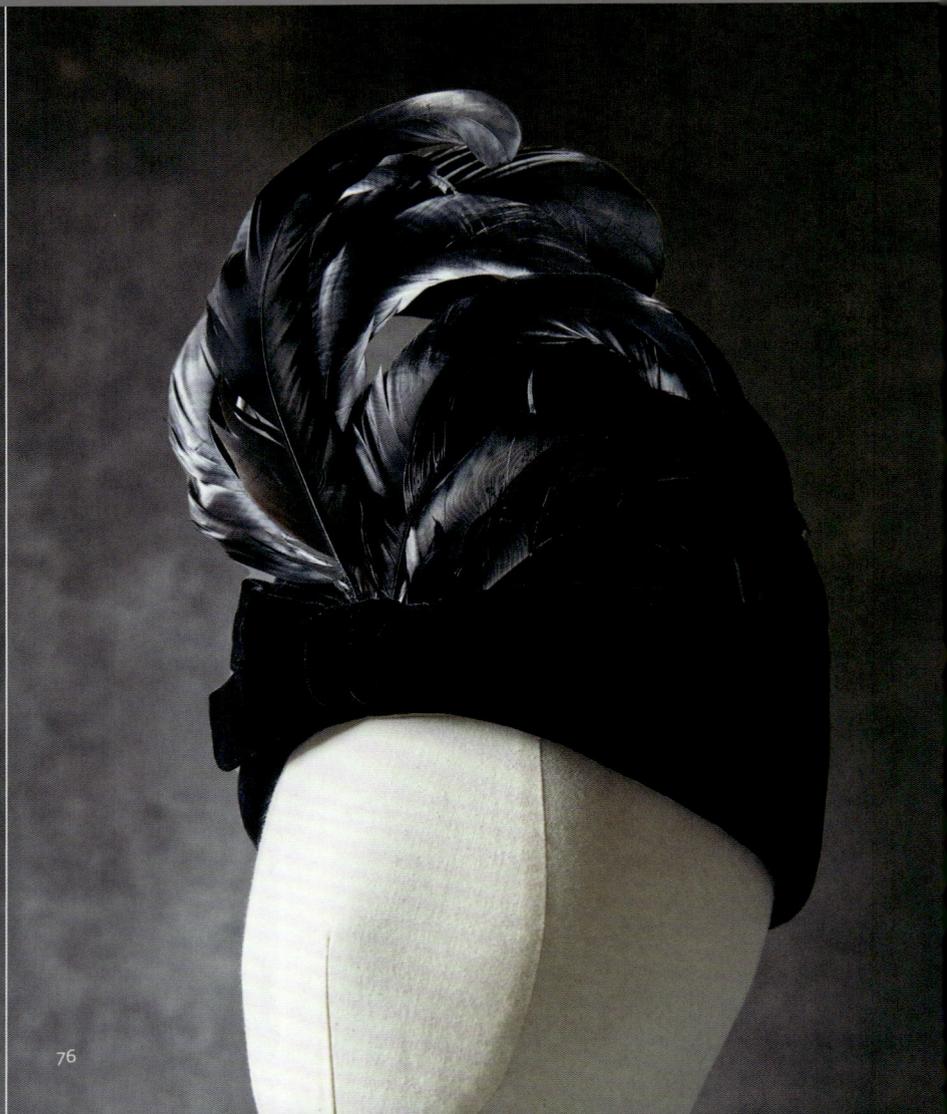

76

75. **Jeanne Lanvin** Hat, c. 1944
76. **EISA (Cristóbal Balenciaga)** Hat with cockerel cockade, c. 1965
77. **EISA (Cristóbal Balenciaga)** Straw hat, 1967
78. **Jeanne Lanvin** Plaited straw hat, c. 1943
79. **Jeanne Lanvin** *Coiffe* (cap), 'Rango', c. 1934

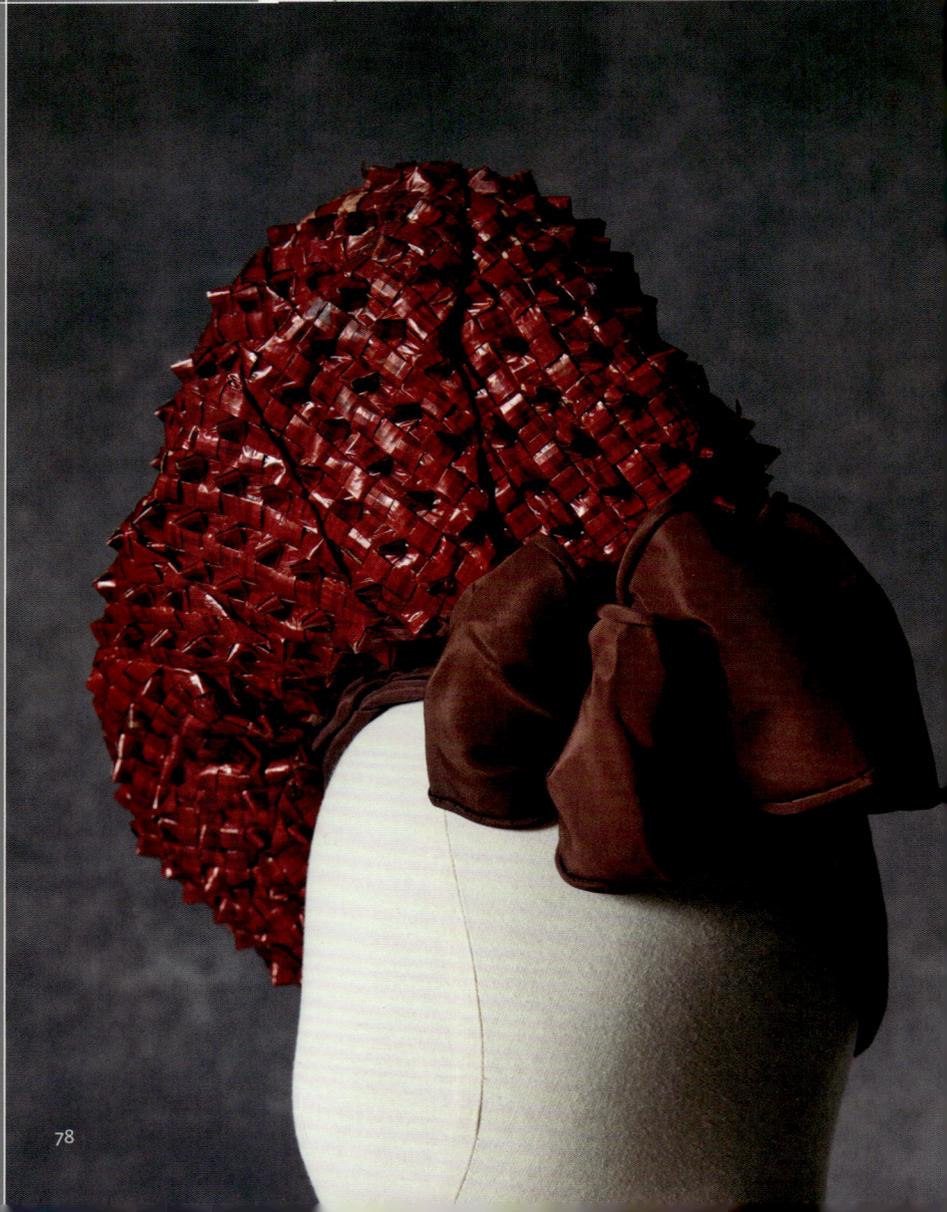

78

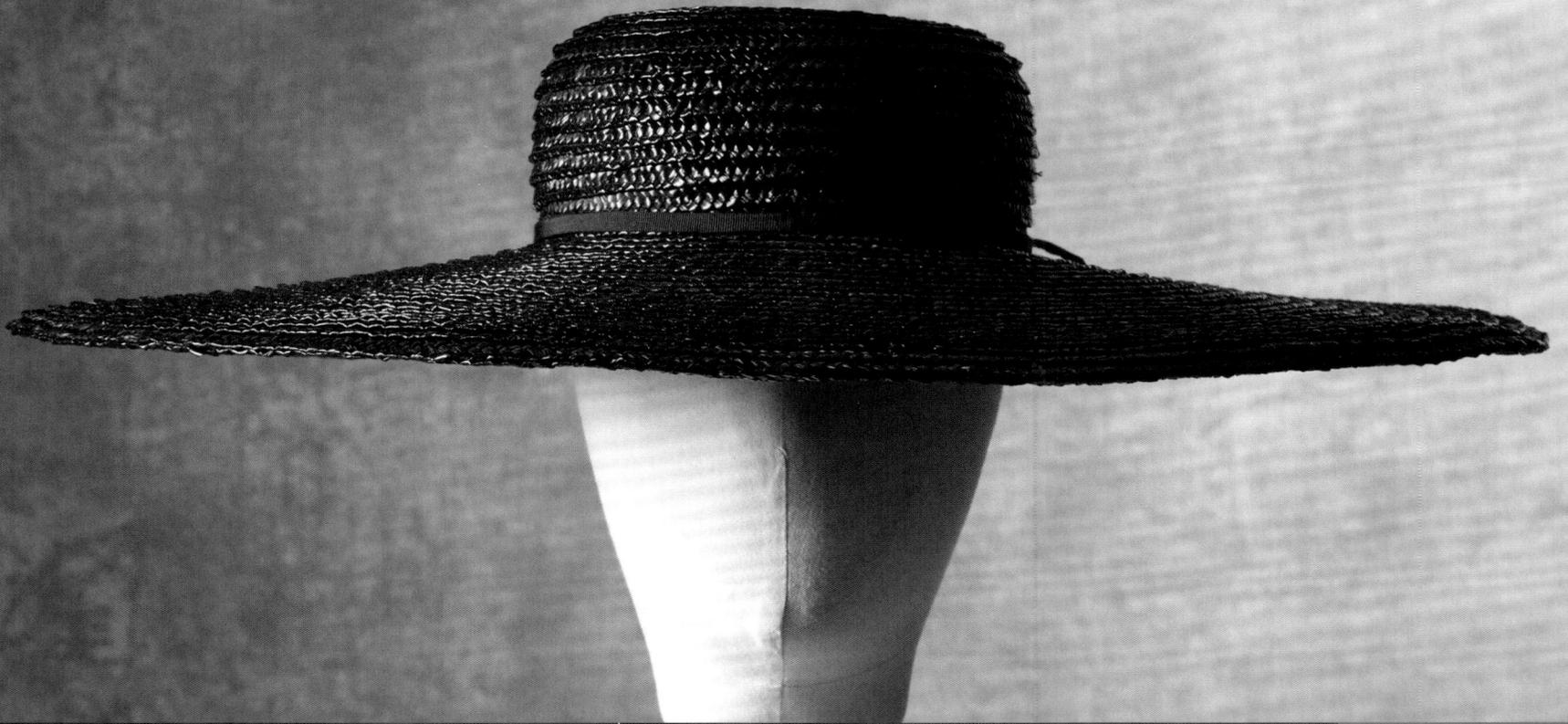

77

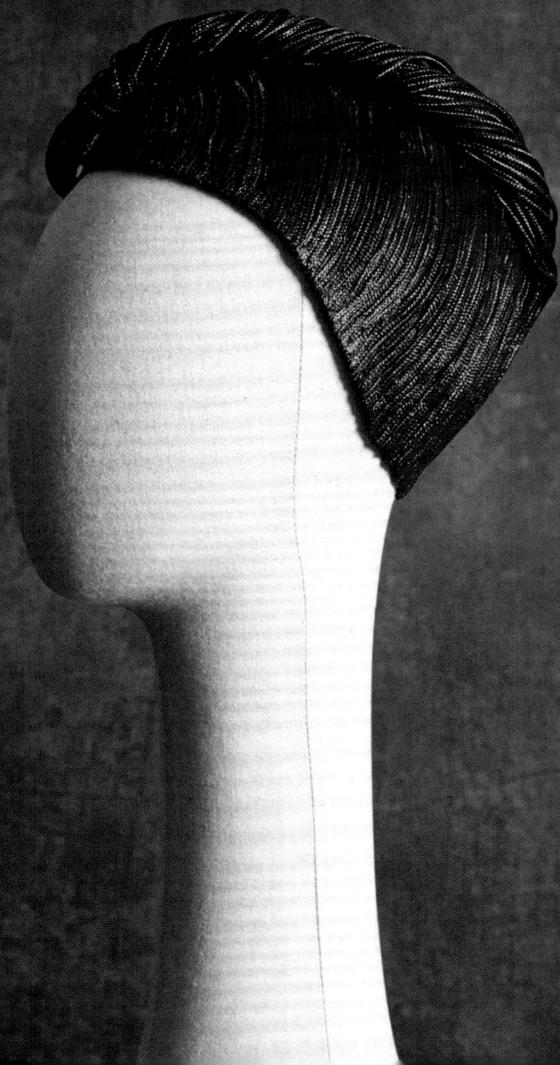

79

79

LET'S K
THE CO

the future-present in 1960s Fren

ILL
UTURE

rh fashion

ALEXIS ROMANO

F

resh-faced yet provocative, the model stares ahead, her eyes peeking out under a shaggy mass of hair and four letters in large type – 'ELLE' (fig. 48). With her palest pink lip gloss and black eye-liner, she delicately surfaces from the twilight ground. Although only a hint of her clothing was visible in the picture frame – a mini-dress by Paco Rabanne of chain-linked plates – it would have been recognisable to viewers. That week in 1966 (the year Rabanne launched his line), 'elle', the universal *she*, was the dreamy and stylish pop singer Françoise Hardy, photographed by Jean-Marie Périer for the magazine's cover.

Instantly readable to us now, it's one of those pictures that encapsulates a cultural moment, one full of shifts and tensions. Other images and objects are seared in the collective imagination, that also conjure up a specific notion of 1960s futurism, tied to a group of avant-garde French designers – from flat white boots and straight pantsuits, to black motorcycle jackets, plastic appliqués and metallic dresses. Integrating high fashion and pop culture, Hardy, one of the faces of the youthful *yéyé* generation, served as a model to several.[1]

Rabanne counted among the couturiers Pierre Cardin, André Courrèges, Emanuel Ungaro and Yves Saint Laurent who in 1968, along with Mary Quant, Rudi Gernreich, Tiger Morse, 'Baby' Jane Holzer and Edie Sedgwick, were named 'fashion revolutionaries' by the New York trade journal *Women's Wear Daily*. Working (mainly) within haute couture, the established and elite made-to-measure production, these designers seemed preoccupied with a new value system – aligned with social liberation and developing technologies. This clash of tradition and new, concerning values, materials and methods, produced some of the most iconic design in fashion history, as this essay explores.

Parallel tensions in social and political spheres gestated between conservative and liberal national factions, leading to the events of May 1968 – all while the country had been grappling with its violent decolonisation and loss of cultural identity from the immediate post-war years. Design in this period was in part conceived with subcultural expression, social anxiety and a utopian future in mind, in the wider contexts of the Cold War, the Space Race and the dawn of postmodernism. Likewise, Périer's photograph made the assertion that fashion was not bound by the traditional constraints of fabric, but open to boundless possibilities – and in this case read as subversive, even violent.

fig. 48 Françoise Hardy wearing a Paco Rabanne dress,
photographed by Jean-Marie Périer for the cover of *ELLE*, July 1966

Many commented on couture's existential crisis during the post-war period, reaching a high point in the mid-1960s. The journalist Michel Legris noted in 1966 how 'haute couture is slowly changing its function [as it] questions its purpose and future'.[2] Legris considered the movement to open fashion up to new definitions and greater access, to expand fashionable output via ready-to-wear and licences, away from the grip of couture alone. This 'democratisation' as he wrote, could be seen to be in line with the post-war 'social revolution' and industrial development.[3] During a time when *le style* – a French interpretation of good (readymade) design for everyone[4] – influenced fashion, the art and fashion writer Claude-Salvy warned in 1966 that couturiers 'will no longer be the only "creators of fashion"'.[5]

This was vocalised by many of the designers themselves. In 1967 André Courrèges spoke of a 'revolution' in aesthetic, technical and commercial terms, in which he considered himself a leading voice.[6] He pondered the issue of diffusion and how it would work within couture, suggesting lower prices and fewer fittings, new distribution networks, and even machine manufacture.[7] He acknowledged that 'Life has changed enormously... And couturiers today mustn't reserve their creations for a few privileged women.'[8] Rather, Courrèges affirmed his interest in 'the life of everyone every day'.[9] These 'revolutionary' ideas were rooted in a post-war interest in the quotidian amid rapid modernisation, from philosophers such as Henri Lefebvre, which connected to the ways in which fashion was increasingly advertised to women, as a reflection of everyday life.[10]

French women's experience during the post-war period was one of flux, where civic change and professional opportunity were presented but not always delivered in reality. Long-awaited legislation for their rights arrived in the mid-1960s, concerning marriage and contraception, at which point the body became a contested site – of politics, and autonomy.[11] Although most couturiers didn't explicitly discuss these debates, we must read their interpretations of the dressed body in this context. Women were on heightened display, in any case, as the microcosm of fashion illustrated. The model Twiggy seemed acutely aware of this scrutiny, when photographed by Bert Stern for a 1967 US *Vogue*. Dressed in the latest from the Paris couture collections, including a beaded mini-dress by Yves Saint Laurent, she was surrounded by filmed images of herself on television screens.[12]

Echoing Courrège's awareness of the lifestyles of the youth market and modern women, Saint Laurent proclaimed – in connection to Rive Gauche (est. 1966), his ready-to-wear line and boutique – 'Long live the street.'[13] Saint Laurent, who was purportedly ousted as creative director at Christian Dior at the start of the decade

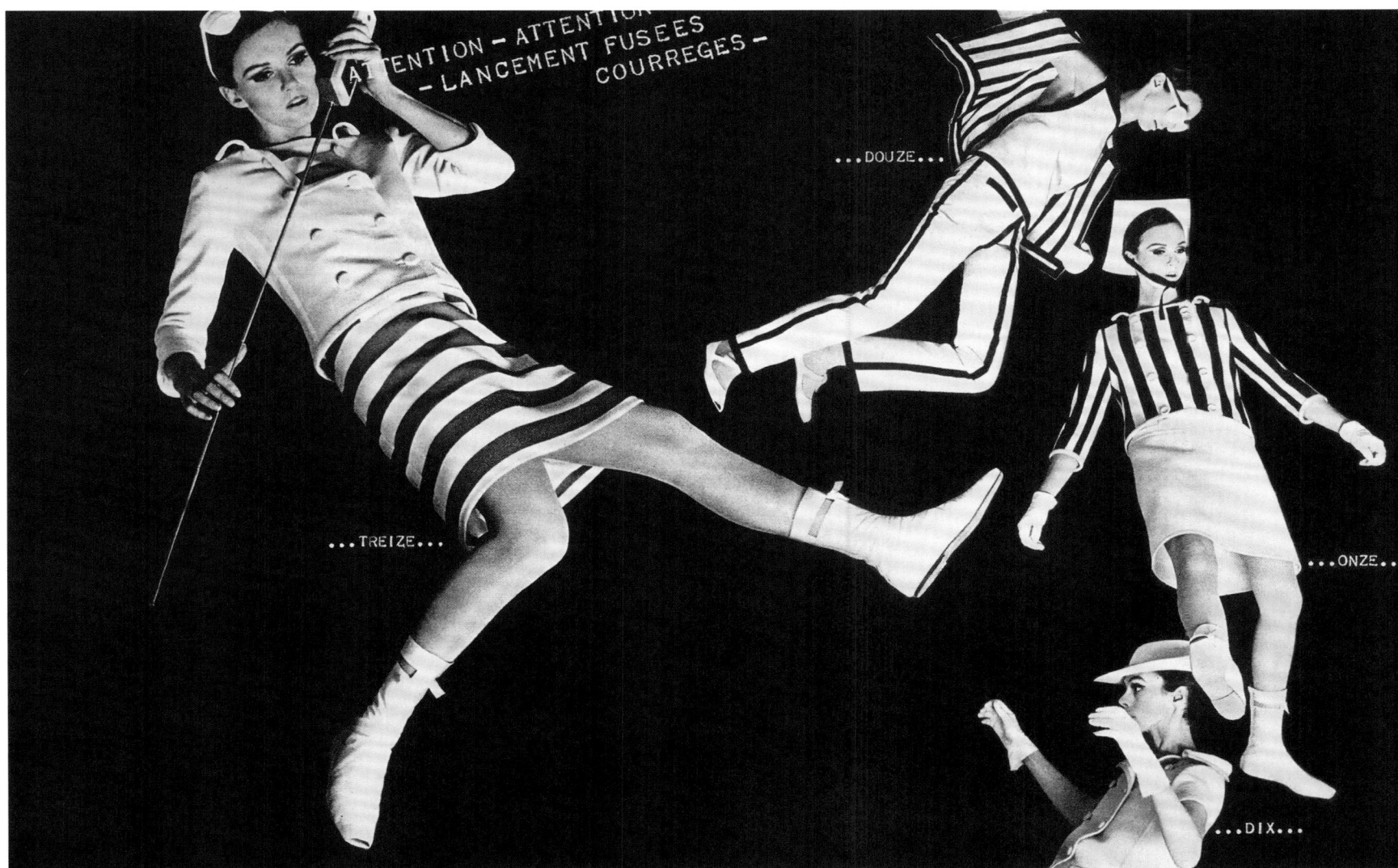

fig. 49

for his streetwear references, created designs under his own label that reflected changing conceptions of gender and society, including his first tuxedo suit for women in 1966, sheer and cut-out garments, and his 1967 'African' collection, which was documented in an image of Twiggy.

Saint Laurent's Autumn/Winter 1968 collection included mini-dresses and tunics embroidered with an all-over pattern of star and floral motifs of iridescent rhinestones, crystals and silver beads by Lesage, evoking 'a shimmering desert night sky' – perhaps a reference to the designer's Algerian heritage.[14] Some examples in brown suede with fringed hems clearly evoke casual 'street' styles, revealing Saint Laurent's ideas on the future-present of fashion (no. 80).

This was the creative framework of Paco Rabanne, who was committed to modernising fashion, notably through materials used – ideas he expounded on in a news report from January 1967. According to Rabanne, fashion should observe the use of metals and other non-traditional materials in other art forms; he found it 'absolutely ridiculous to continue to dress women in fabrics like in the 19th century'.[15] His early experiments in fashion and materials occurred in the creative space of *stylisme*, where

fig. 49 'Dix Onze Douze Treize, pour Courrèges ', photographed by Peter Knapp, 1965

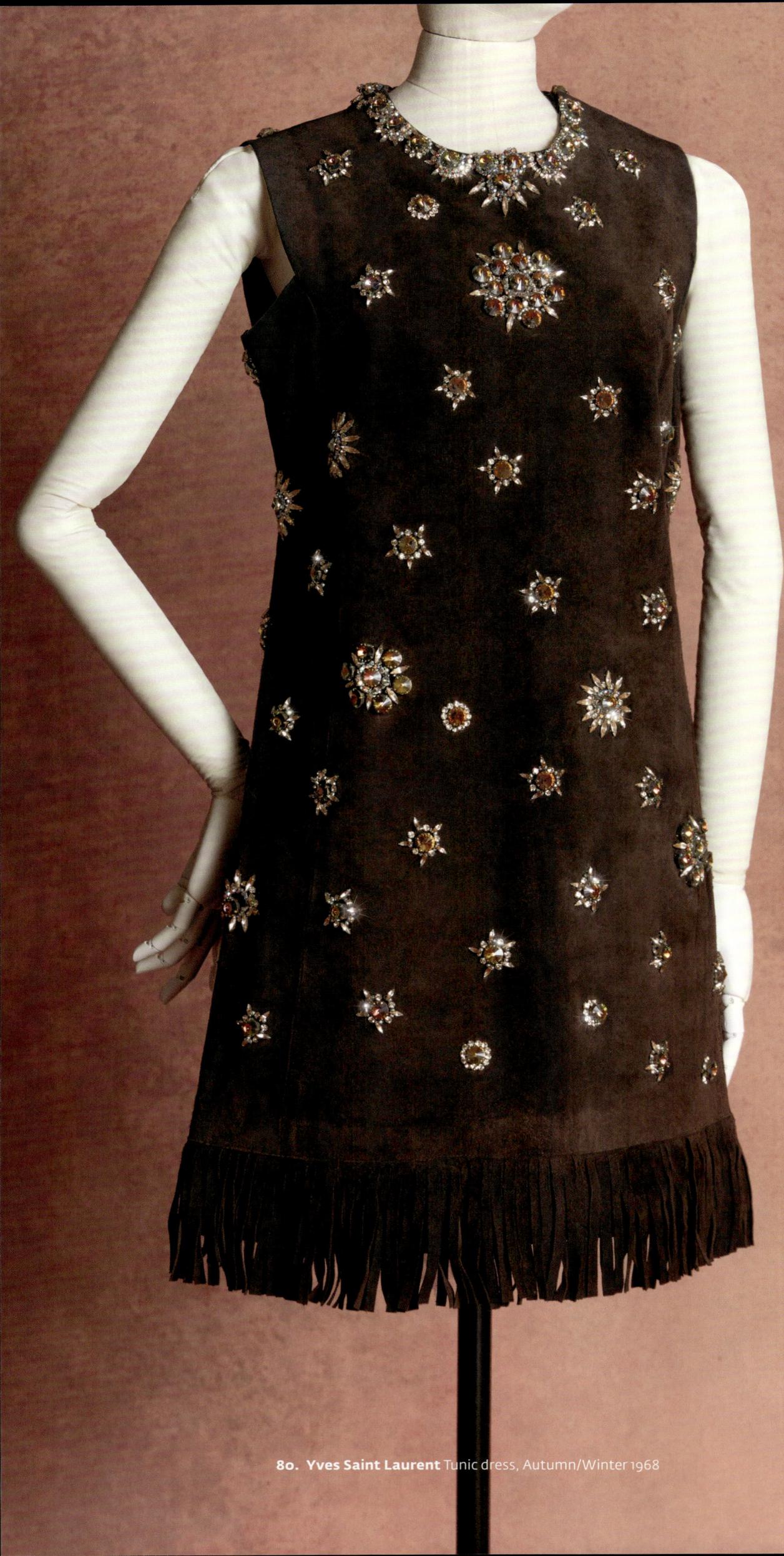

80. **Yves Saint Laurent** Tunic dress, Autumn/Winter 1968

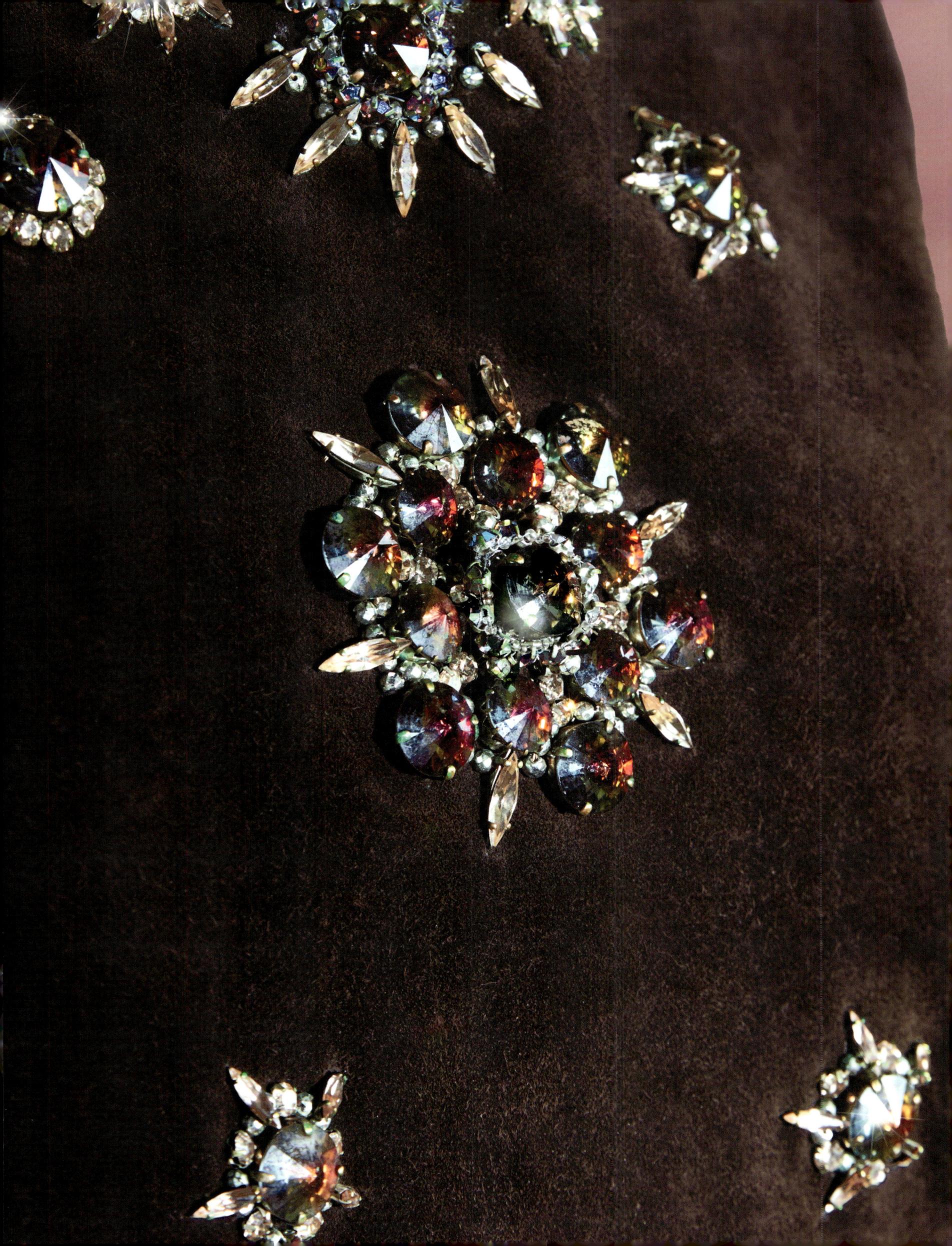

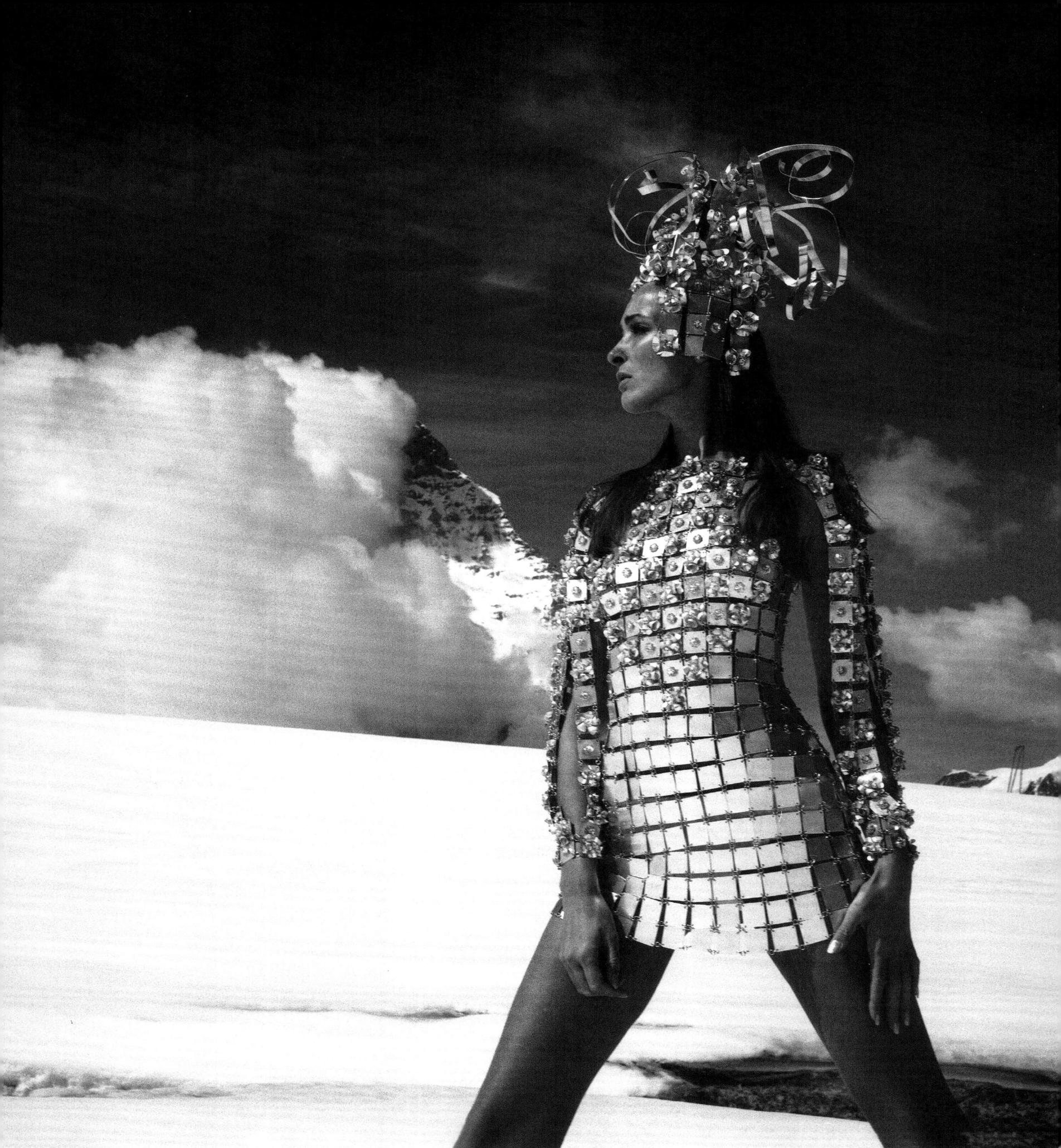

fig. 50 Maud Bertelsen wearing Paco Rabanne mini-dress, photographed by Gunnar Larsen, 1968

he crafted embroideries and accessories (earrings, helmets, visors and glasses) in Rhodoïd for the designers Emmanuelle Khanh and Christiane Bailly.

A rigid plastic material, Rhodoïd came in sheets of various colours, which could easily be cut and refashioned; it was formative to Rabanne's sartorial thinking. From there he developed his own outfits, including boleros made of Rhodoïd discs, which were bought up by Paris's trendy ready-to-wear boutiques.[16] This technique formed the basis of dresses from his early collections in 1966. A mini-dress from 1968 of linked metal discs, with floral embellishments on the bodice and sleeves (no. 81) explores this construction further. Worn with an elaborate headdress that resembled kinetic art, this and other garments were show-stoppers, as evidenced from a clientele that included performers – from Hardy to the singer Béatrice Arnac, who wore Rabanne's 'chain-mail' evening dress of knitted cotton mesh and silver metal discs on stage (no. 82).

Both garments adhered to fashionable silhouettes, and traditional garment elements such as sleeves and cuffs. Yet the integration of novel materials formed the heart of Rabanne's creative practice, which subverted the cut-and-sew formula of dressmaking and borrowed from jewellery and other methods of making. The above-cited news report took place within Rabanne's atelier, portrayed as a space of creative freedom and liberty, complete with dancing models. Close-ups of the designer showed him wielding pliers (as opposed to needle and thread).

When asked why he dressed women in metal, Rabanne replied, 'Well why not? Fashion is freedom and the fashion creator can, I believe, do everything [...] why not metal, why not leather, Rhodoïd, paper, other materials of tomorrow?'[17] (He went on to make paper dresses in 1967, and the 'Giffo' plastic mould dress in 1968.) In her writings on Rabanne, fashion historian Lydia Kamitsis noted, 'As metals introduced a breach with the materials generally employed in these fields, it came to represent Modernism.'[18] Contained in some conceptions of modernism was a distinct looking ahead, a 'future-present' in the context of the Space Age movement.

This is evidenced in one depiction of Rabanne's mini-dress by the Danish photographer Gunnar Larsen (fig. 50). Here the model Maud Bertelsen looks outward, surveying a dramatic, mountainous landscape that evokes sci-fi spaces. Captured in black-and-white, the garment's plates reflect the snowy expanse, integrating body into the snowscape. Larsen joined other photographers such as Peter Knapp in being captivated by the increasing reality of space travel, which gained momentum after the launch of the Sputnik satellite in 1957 (fig. 49). Charles

de Gaulle brought France into the Space Race in 1960, resulting in the foundation of the Centre National d'Etudes Spatiales in 1961.

These efforts built on post-war values of technological modernisation and productivity campaigns in France; they also chimed with the work of Rabanne, Pierre Cardin and André Courrèges. According to design historian Jane Pavitt, 'The Space Race not only provided an enduring stream of technological innovations and material developments that could be adapted to everyday use, but also a host of imaginative possibilities for how products, clothing, environments – even the human body – might be redesigned in the future.'[19]

Some of these designs, such as Cardin's red-and-white vinyl 'Apollo' helmet (no. 83) exhibited 'a concern to insulate the wearer against the shock of the new, and to equip him or her to deal with the onslaught of information and experience that the modern world had to offer'.[20] This included straight pantsuits and A-line mini-dresses that evoked space suits, many stemming from Cardin's avant-garde 'Cosmos' collections from 1965.

The use of vinyl, which brought to mind the smooth surfaces of aeronautical equipment (and was in fact one of the post-war materials deriving from the petrochemical industries), served similar aims. Cardin and Courrèges often worked with heavyweight woollen jerseys, which facilitated easy movement but were rigid enough to maintain sculptural shapes, integrating vinyl appliqués to complete the aesthetic of futurism (nos. 83 & 84 and fig. 51).

These designs drove new bodily gestures and a fashion language – from Cardin's self-described 'style cosmonaute'[21] to Rabanne's 'robes importables'. This is how Rabanne announced his work to the world, via his first fashion showing at the Hotel Georges V in Paris in 1966. *Manifesto: Twelve Unwearable Dresses in Contemporary Materials* featured barefoot models, atonal music by Pierre Boulez, and purportedly shocked audiences. Of this collection Rabanne said, 'By pushing certain experiences to the limit, it is possible to change people's attitudes.'[22]

Designing in a fundamentally tumultuous period, grappling with a disconnect between contemporary ideals and the realities of haute couture production, these makers helped shaped 1960s ideas of the future. And, critically, they contested the dictatorial system of fashion, inviting consumers to ponder the future-present and to (re)consider their own fashion manifestos.

fig. 51 Pierre Cardin, illustration, 1966, Palais Galliera

* 'Let's kill the couture. I mean kill it in the sense of the way it is now. The idea of presenting a collection every six months is finished. Ready-to-wear and couture should meld. Creation can take place all year-round.' Emanuel Ungaro quoted in Russell 1968, pp. 1, 12.

1. See Hill 2017, pp. 137–67.
2. Legris 1966a (author's translation).
3. Ibid.
4. See Romano 2012, pp. 75–91.
5. Claude-Salvy 1966, pp. 119–20 (author's translation).
6. Cézan 1967, pp. 143–44.
7. Legris 1966b, p. 19.
8. Cézan 1967, p. 130 (author's translation).
9. Ibid.
10. See Romano 2022.
11. Twenty years after universal suffrage was won, in 1965 amendments to the national marriage law gave women equal status in that institution and in 1967 birth control was legalised.
12. See American *Vogue* 15 March 1967, p. 66.
13. See Thévenon 1965.
14. 'Dress', Metropolitan Museum of Art, inv. 2018.36.
15. 'Paco Rabanne' 1967 (author's translation).
16. Kamitsis 1996, pp. 23–24.
17. 'Paco Rabanne' 1967.
18. Kamitsis 1996, p. 66 (author's translation).
19. Pavitt 2008, p. 10.
20. Ibid.
21. *Dim Dam Dom* 1966.
22. Cited in Kamitsis 1996, p. 46.

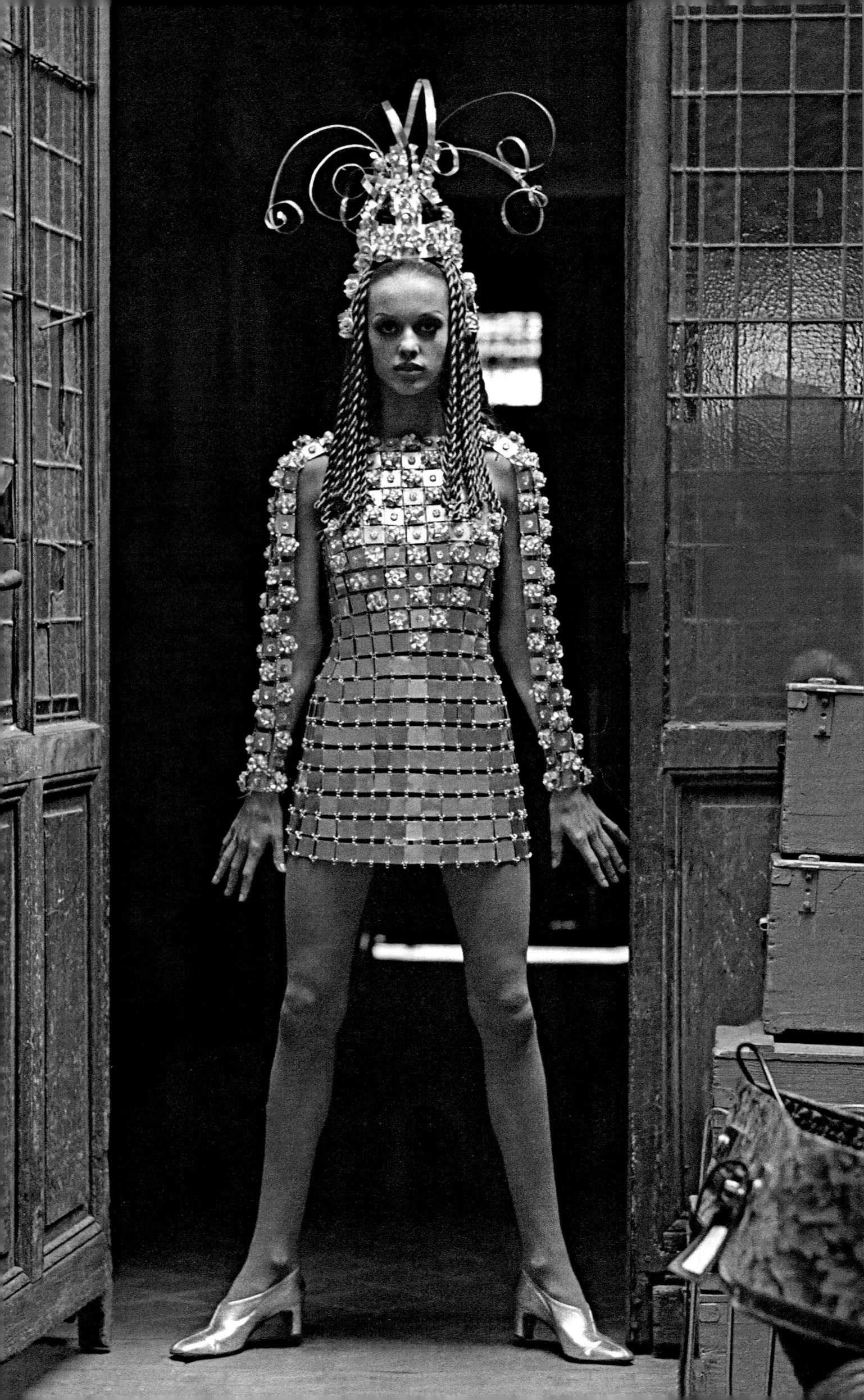

fig. 52 Model wearing Paco Rabanne mini-dress, July 1968

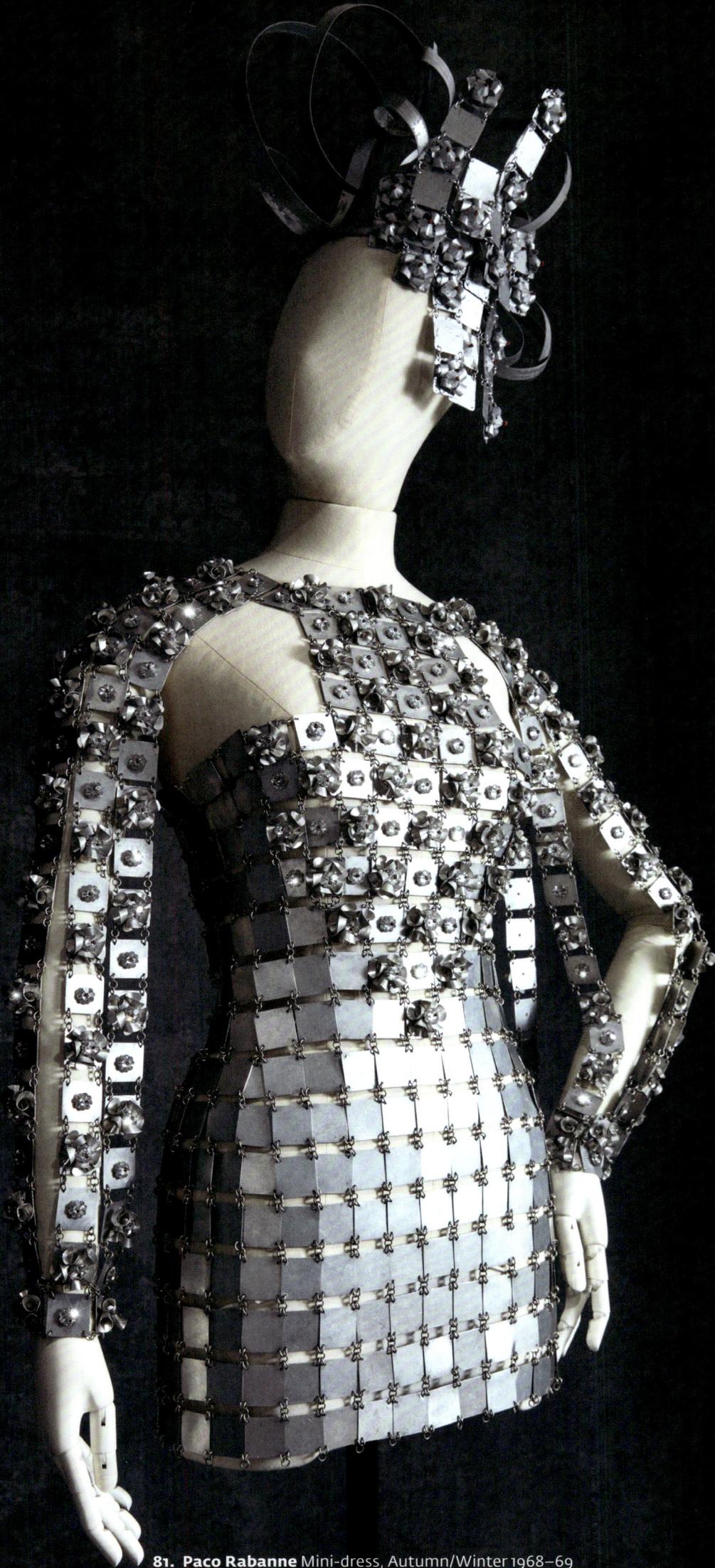

81. Paco Rabanne Mini-dress, Autumn/Winter 1968–69

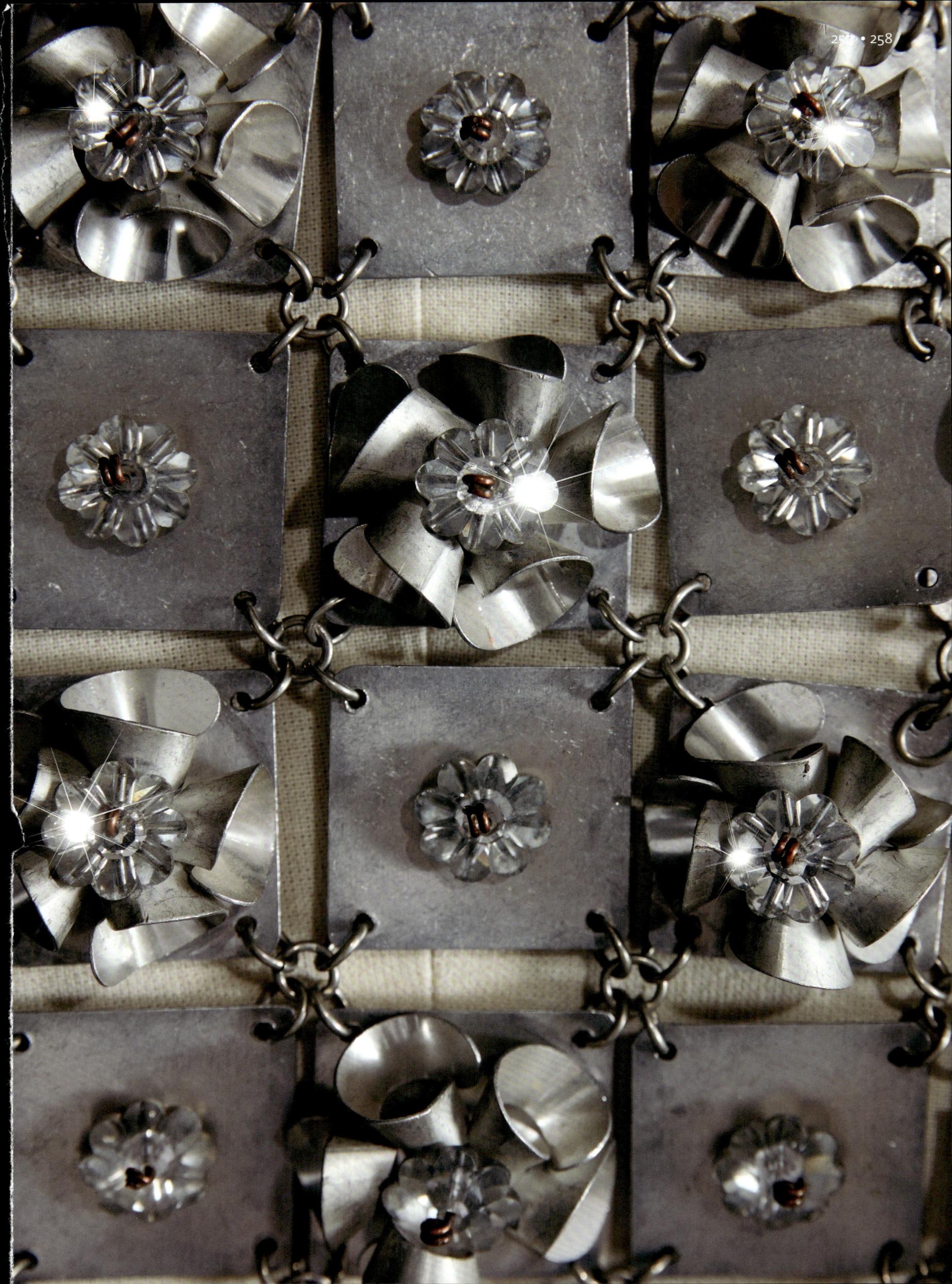

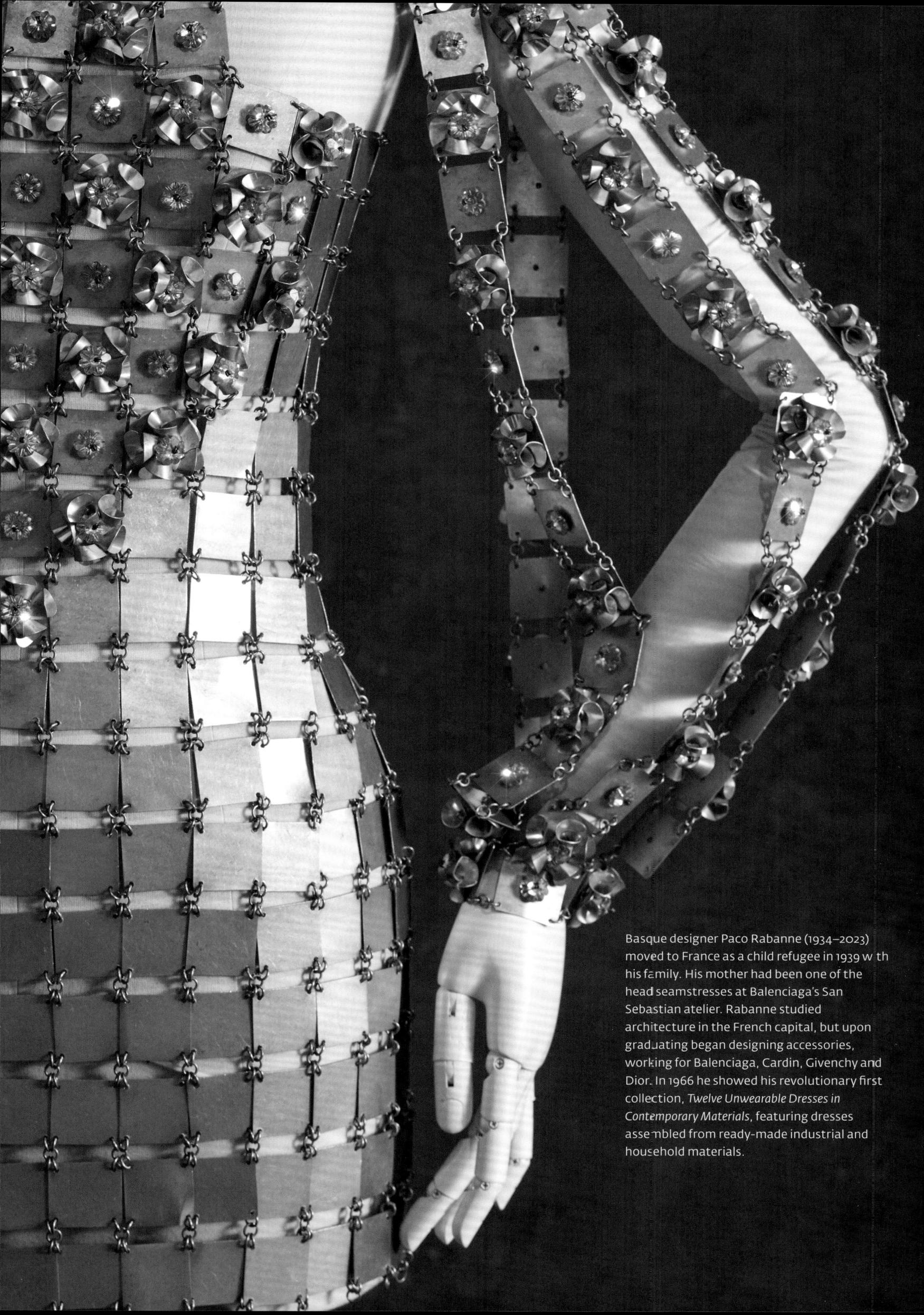

Basque designer Paco Rabanne (1934–2023) moved to France as a child refugee in 1939 with his family. His mother had been one of the head seamstresses at Balenciaga's San Sebastian atelier. Rabanne studied architecture in the French capital, but upon graduating began designing accessories, working for Balenciaga, Cardin, Givenchy and Dior. In 1966 he showed his revolutionary first collection, *Twelve Unwearable Dresses in Contemporary Materials*, featuring dresses assembled from ready-made industrial and household materials.

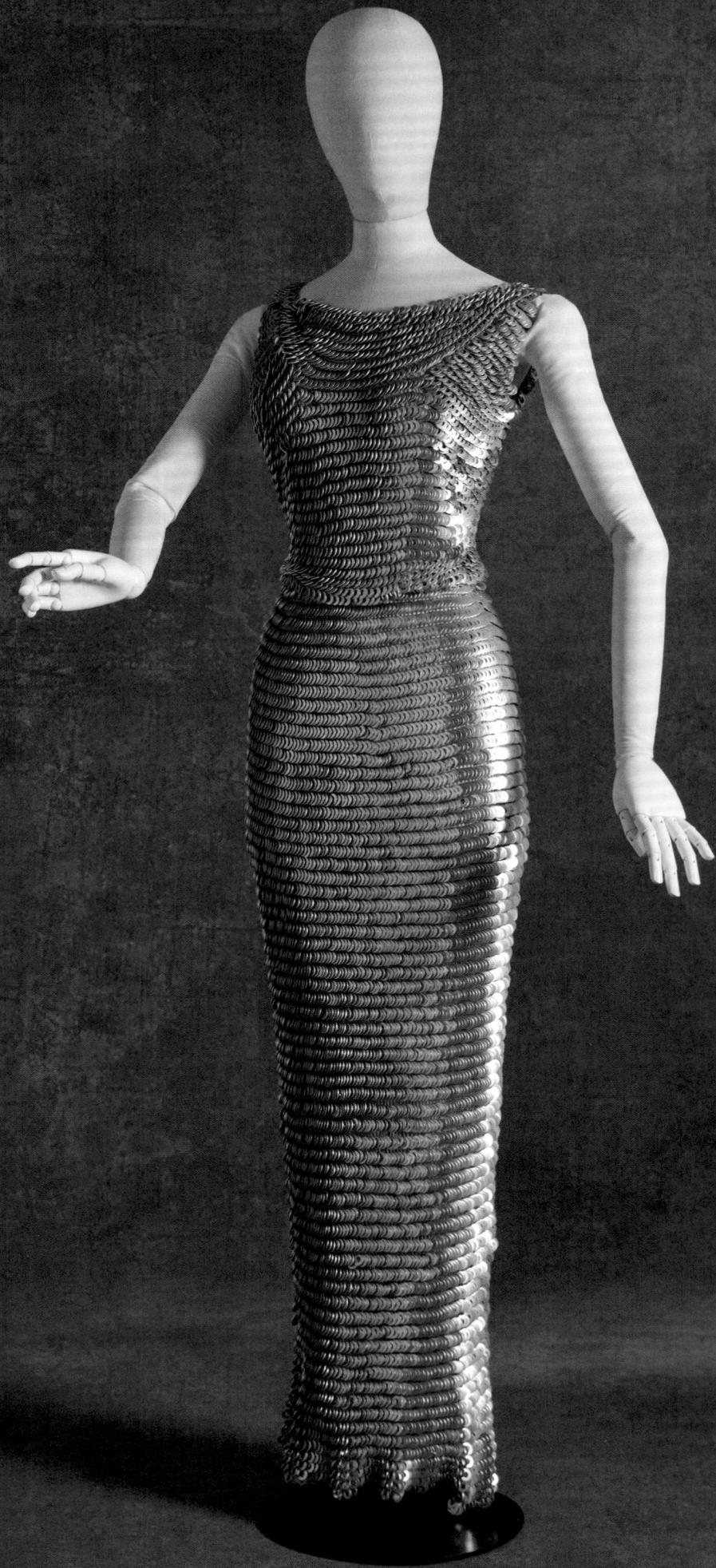

82. Paco Rabanne Evening dress, Autumn/Winter 1967–68

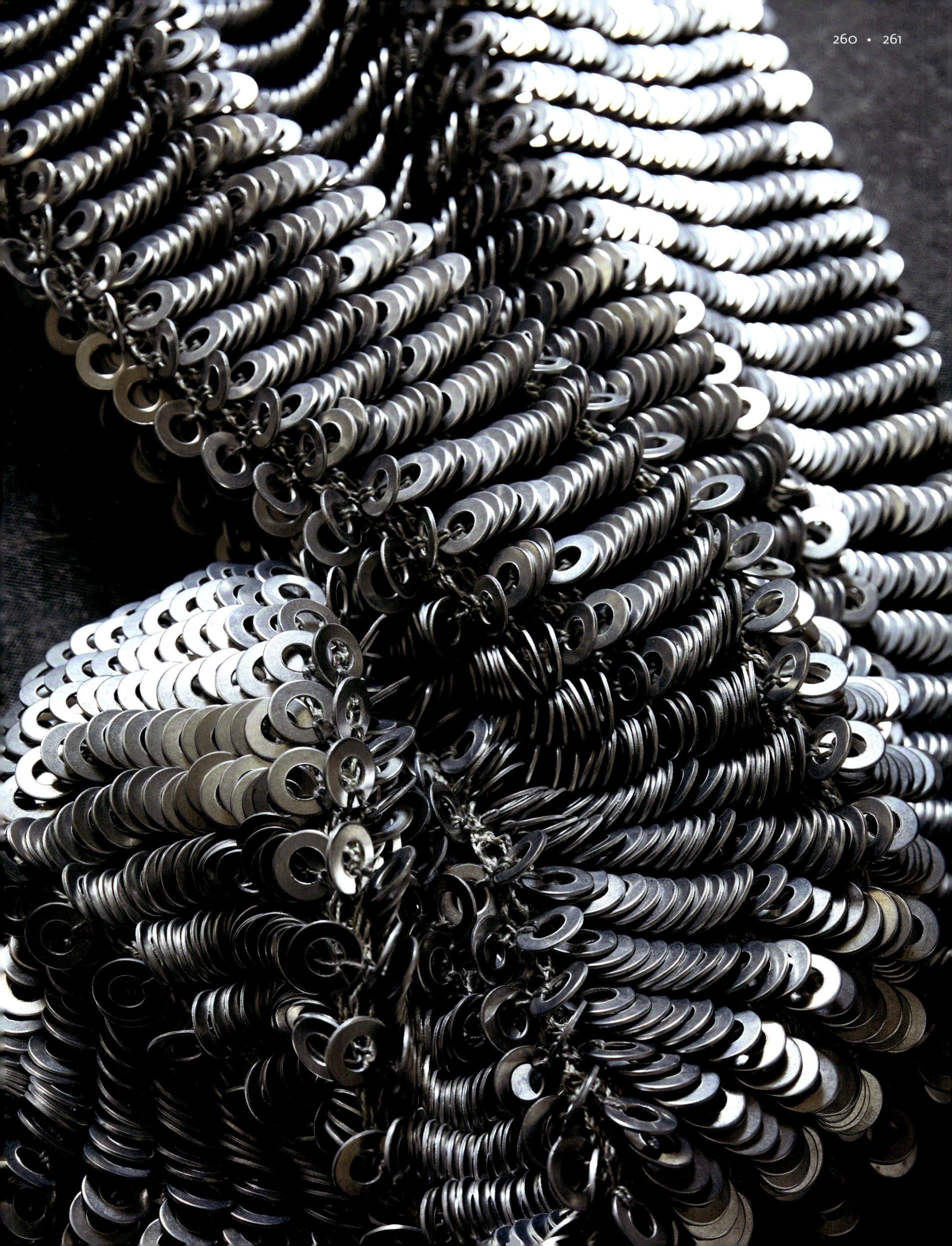

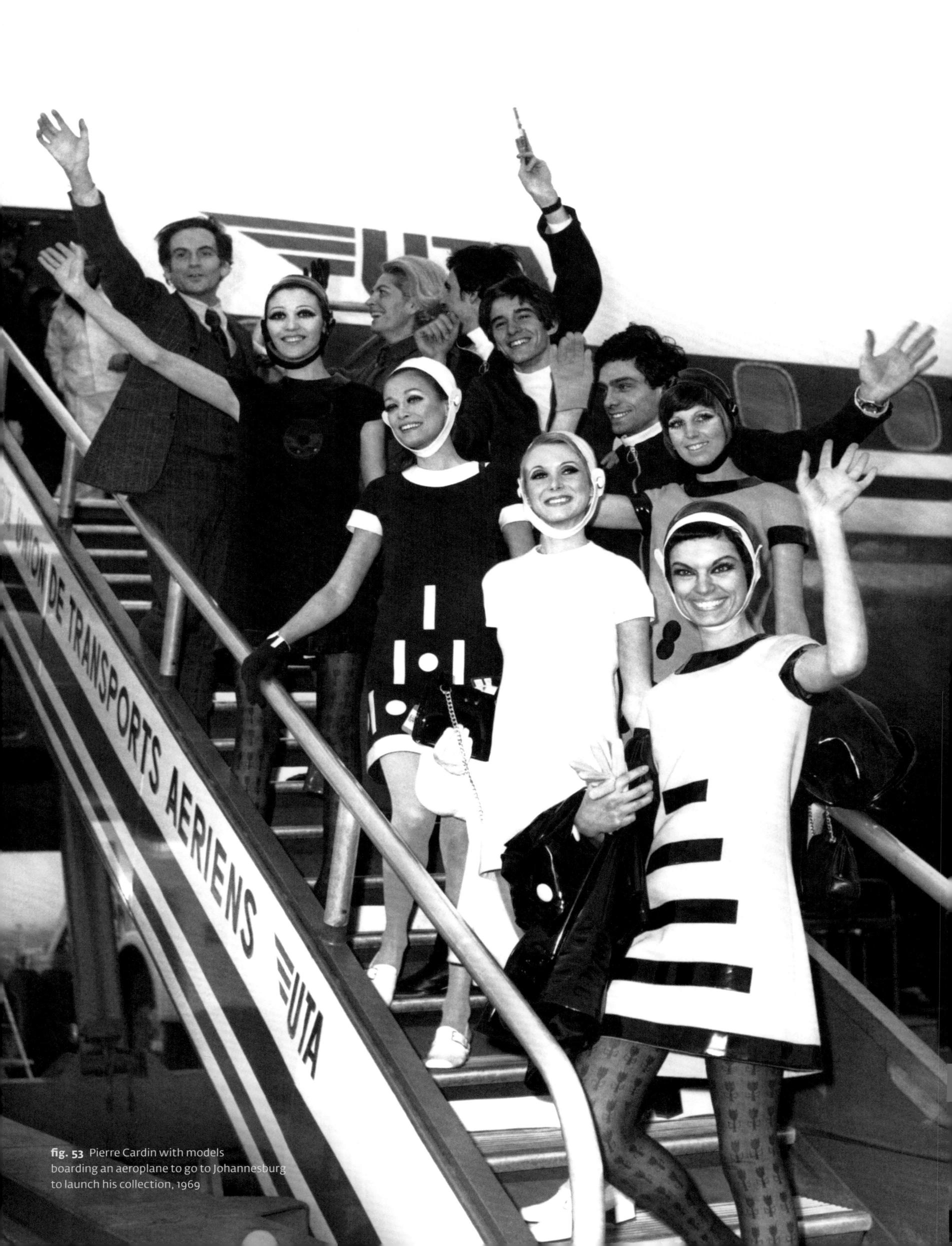

fig. 53 Pierre Cardin with models boarding an aeroplane to go to Johannesburg to launch his collection, 1969

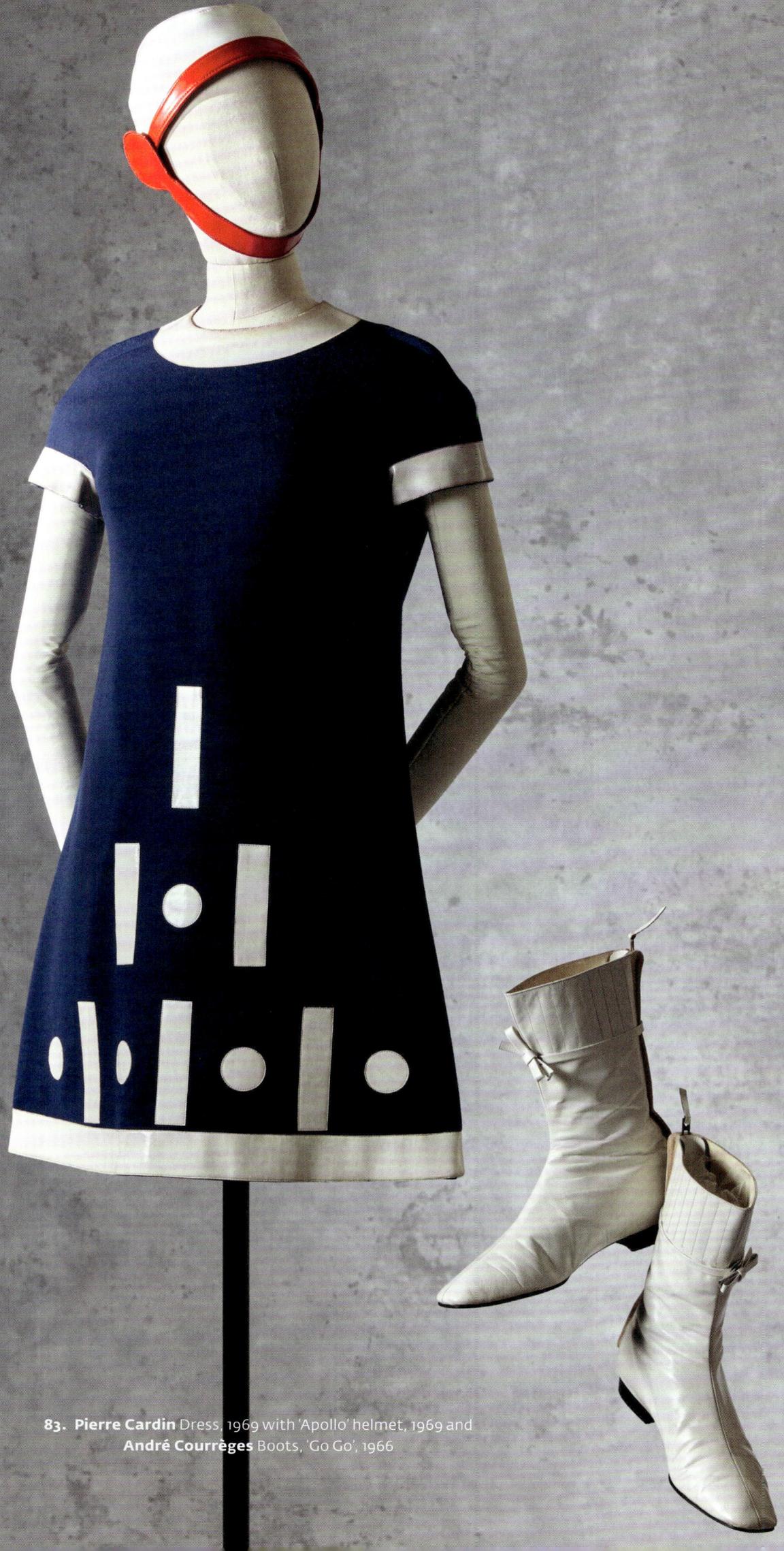

83. Pierre Cardin Dress, 1969 with 'Apollo' helmet, 1969 and
André Courrèges Boots, 'Go Go', 1966

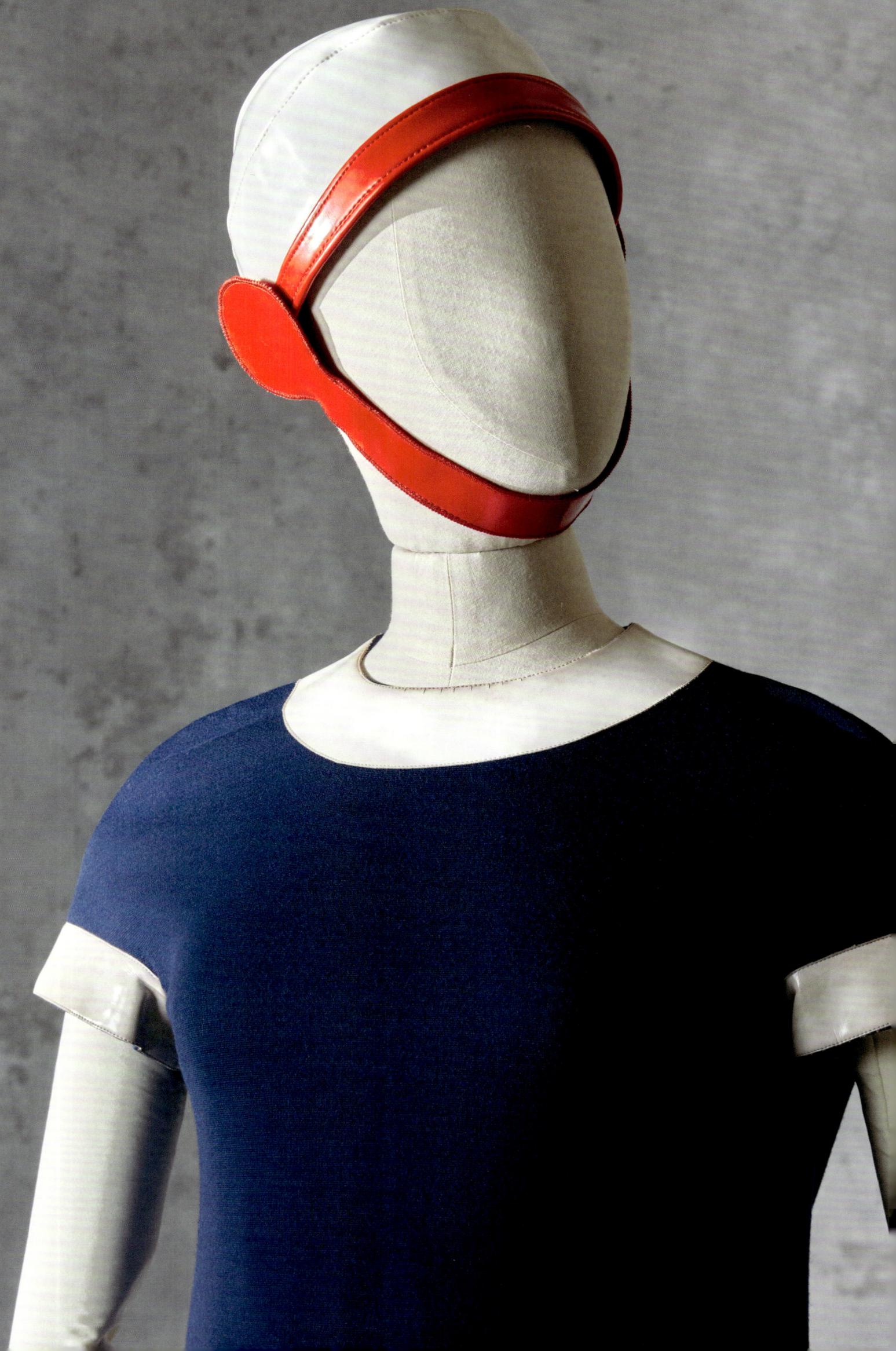

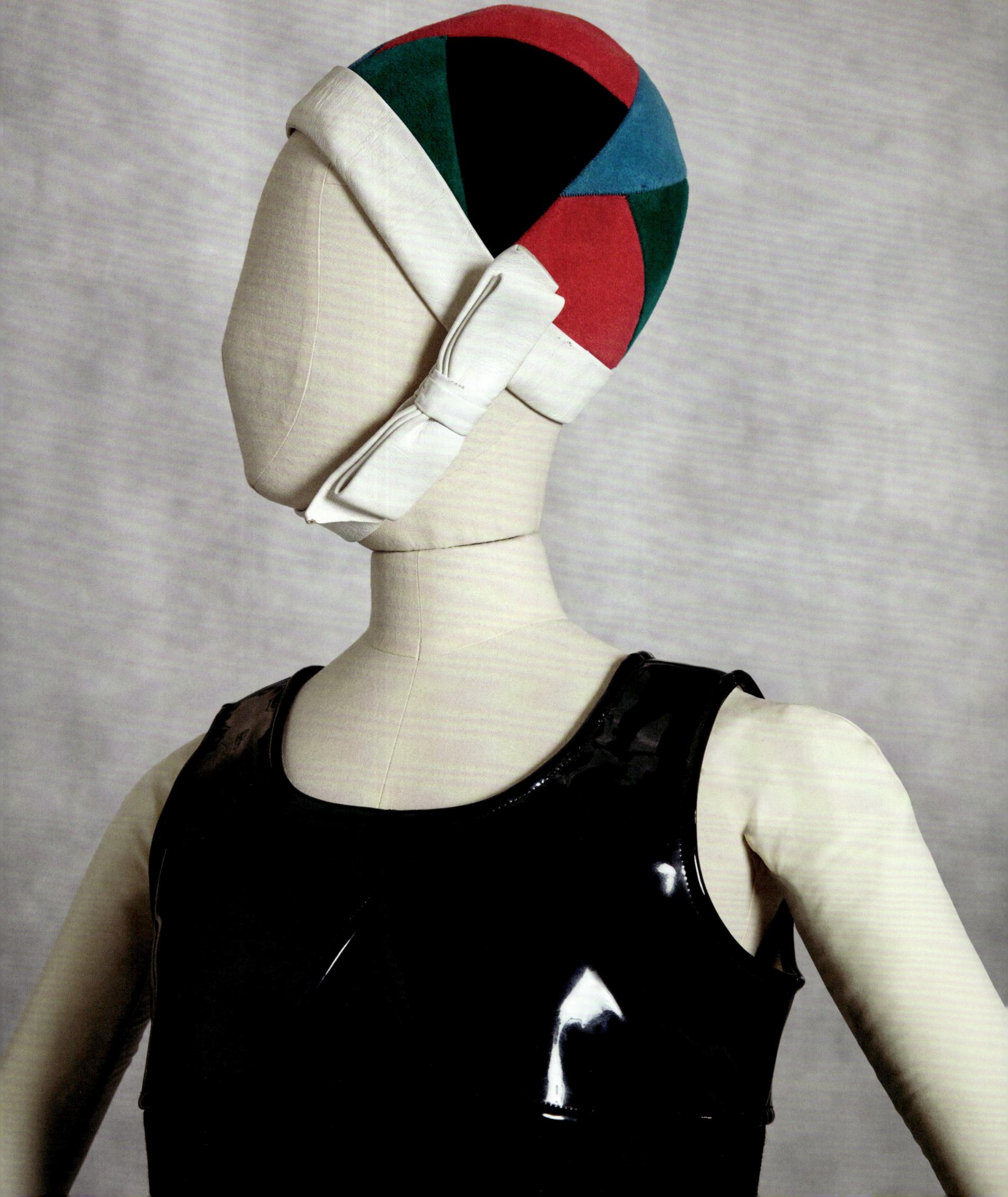

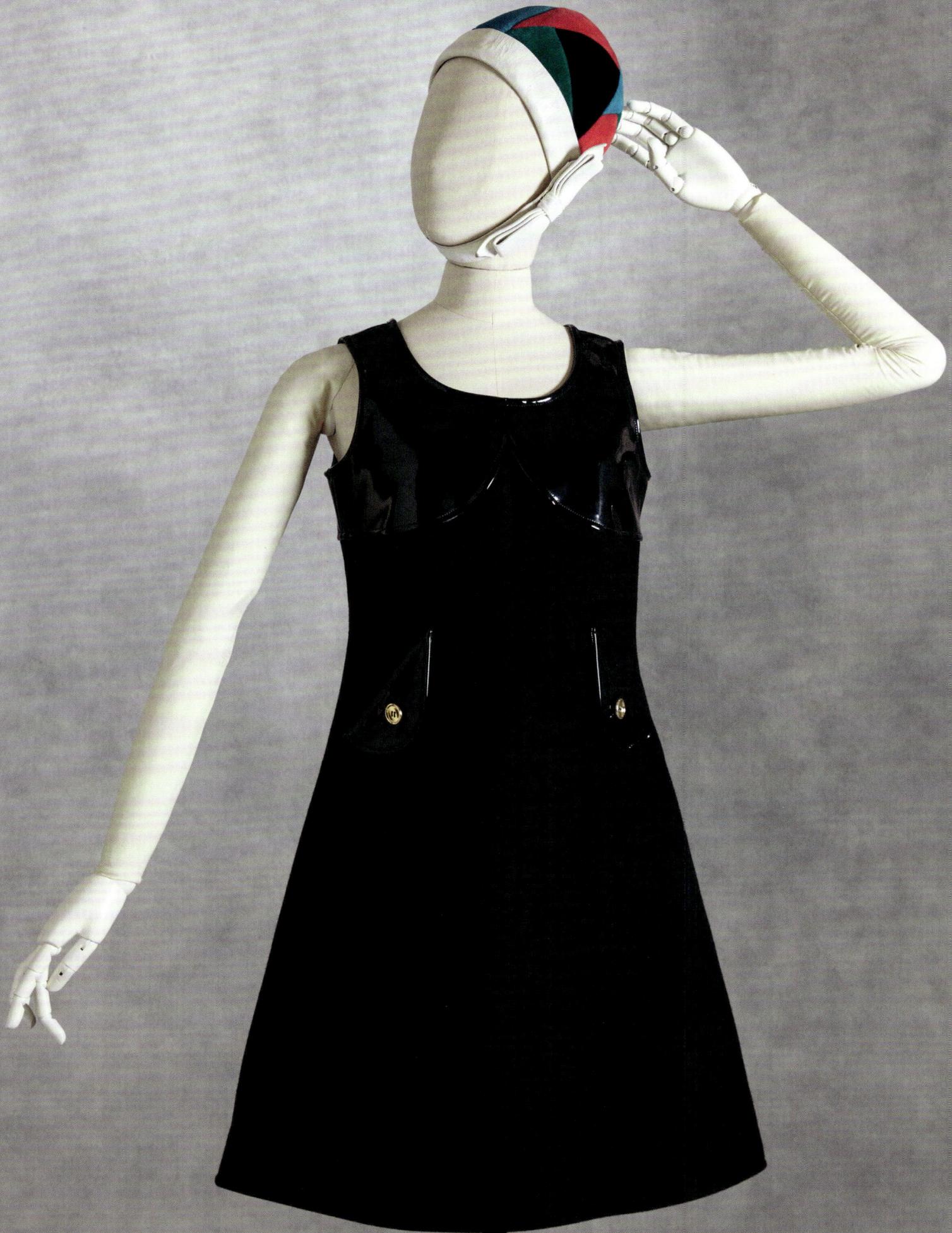

84. **André Courrèges** Dress, 1969 and **Yves Saint Laurent** Helmet hat, c. 1965

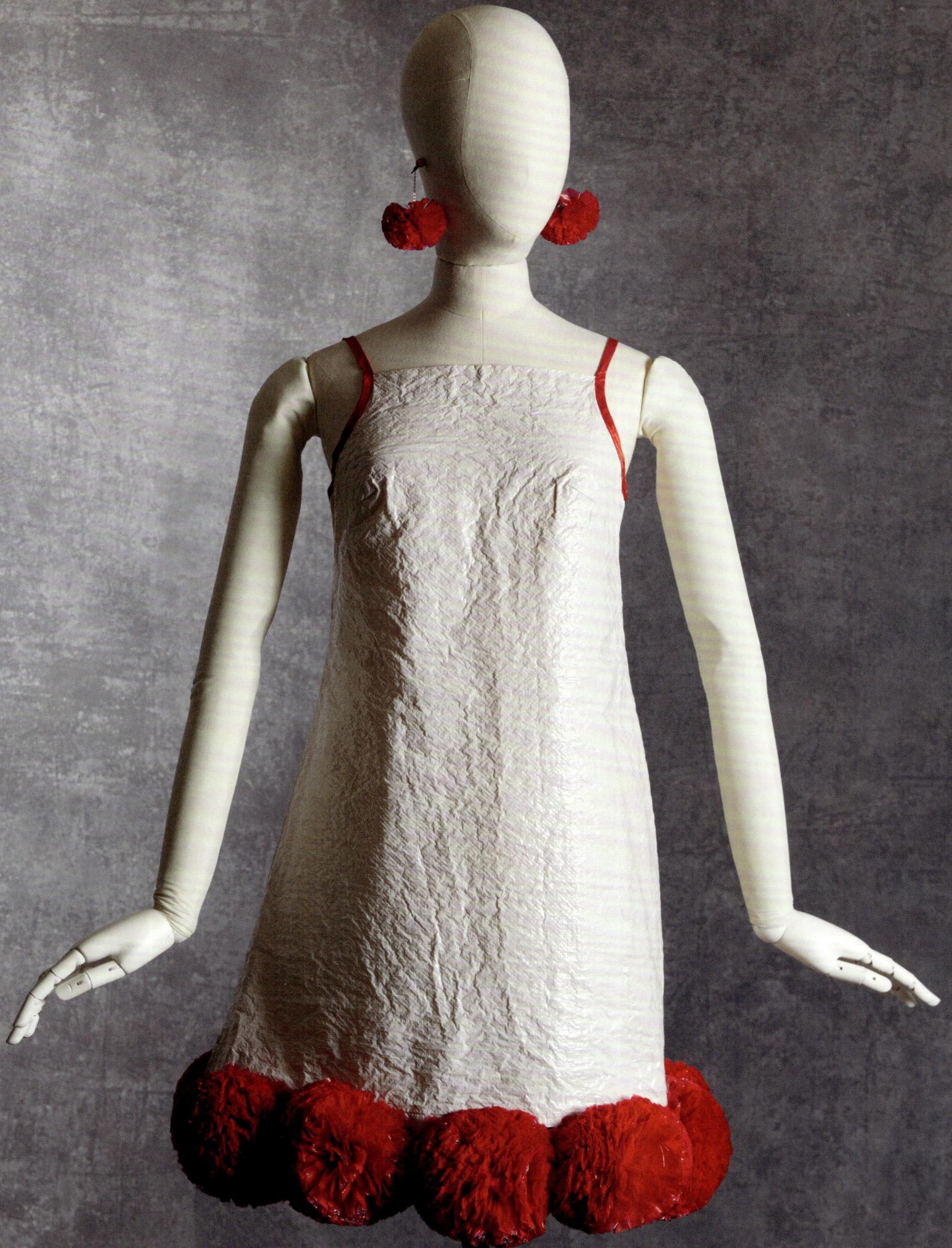

85. Miss Paper Dress and earrings, American, 1967

86. Harry Gordon Mini-dress, 'Mystic Eye', American, 1968

87. Campbell Soup Company 'Souper dress', American, c. 1967

Disposable dresses emerged in the mid-1960s, initiated by industrial manufacturers that operated outside the realm of fashion. These garments functioned as promotional vehicles to advertise products and were made from non-woven materials.

 In the early 1960s Andy Warhol produced screen-printed works featuring Campbell's Soup tins. Campbell Soup Company cleverly capitalised on the public knowledge of the pop artist's work by releasing these paper dresses featuring their soup tins.[22]

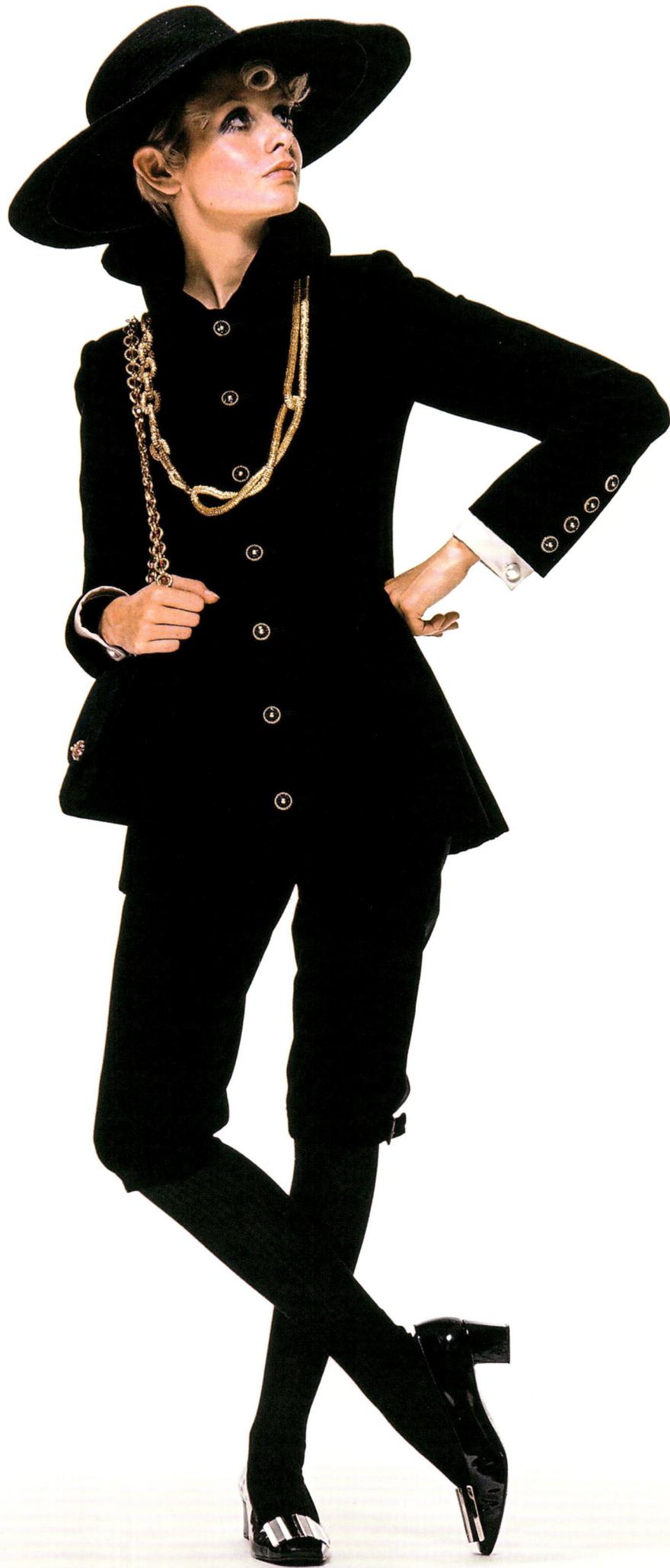

fig. 54 Twiggy wearing Yves Saint Laurent evening suit with hat,
photographed by Ronald Traeger, 1967

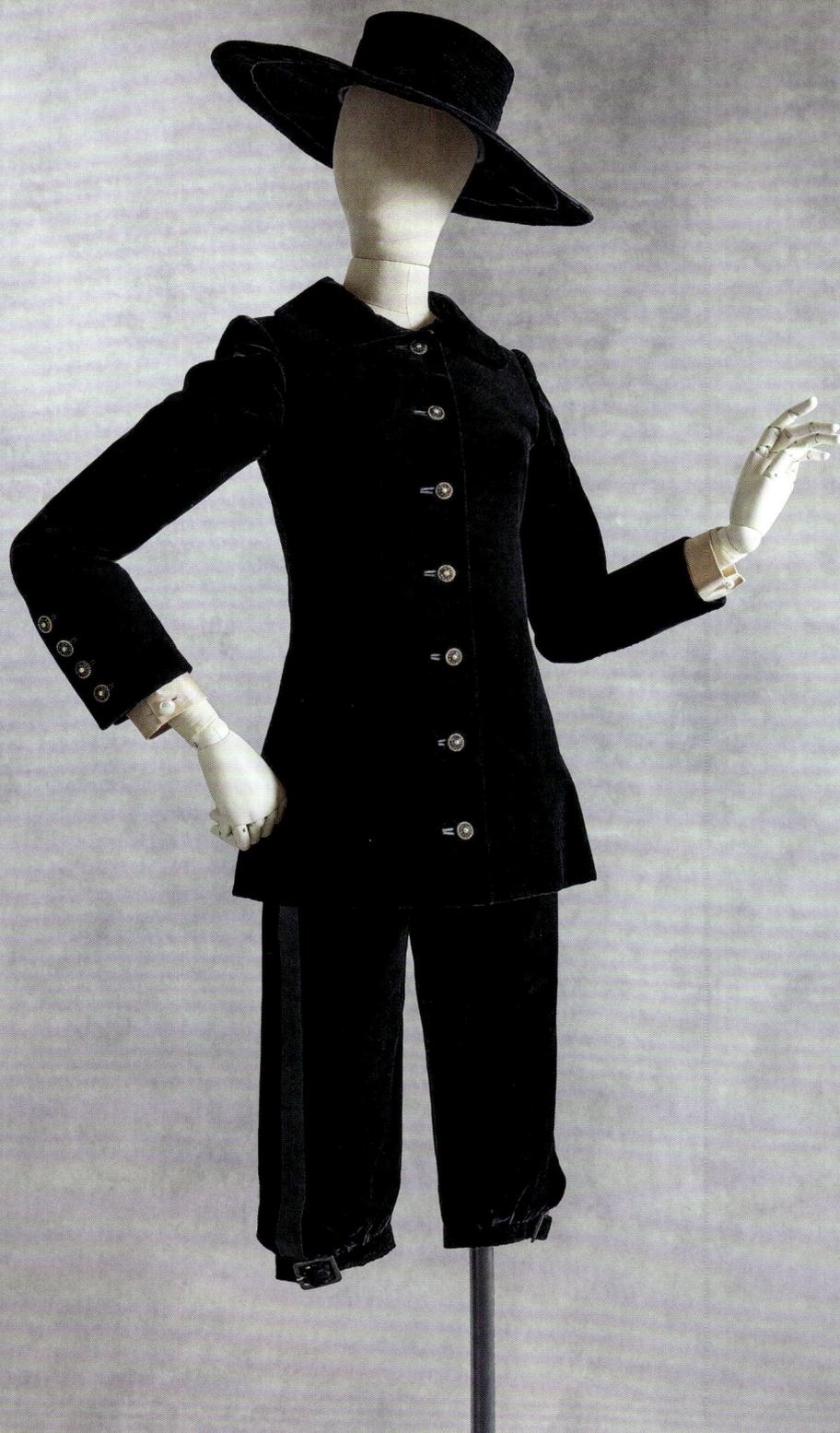

88. Yves Saint Laurent Evening suit with hat,
Autumn/Winter 1967–68 and
Roger Vivier 'Pilgrim Pumps', 1967

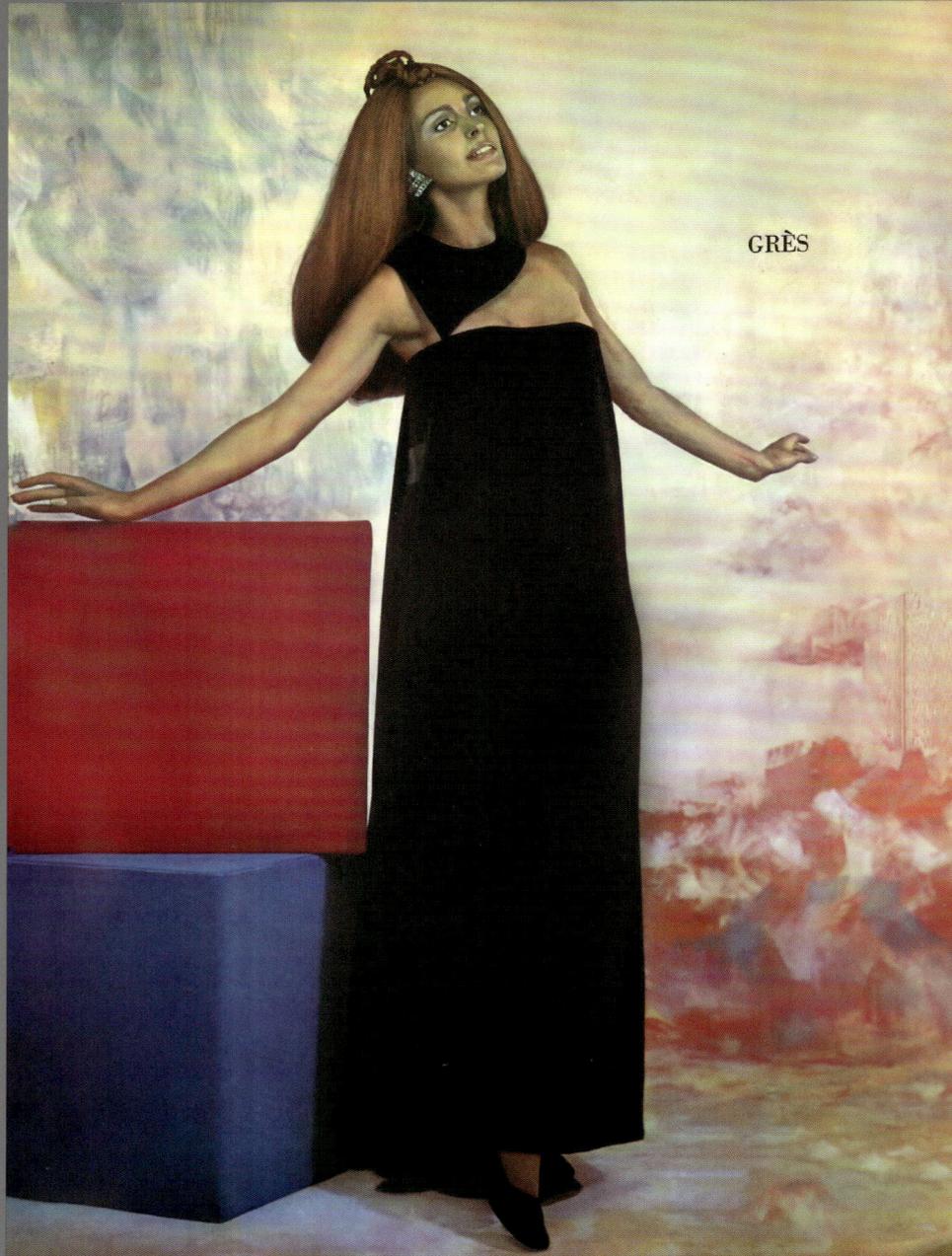

GRÈS

fig. 55 Model wearing Grès black velvet evening dress, 1968

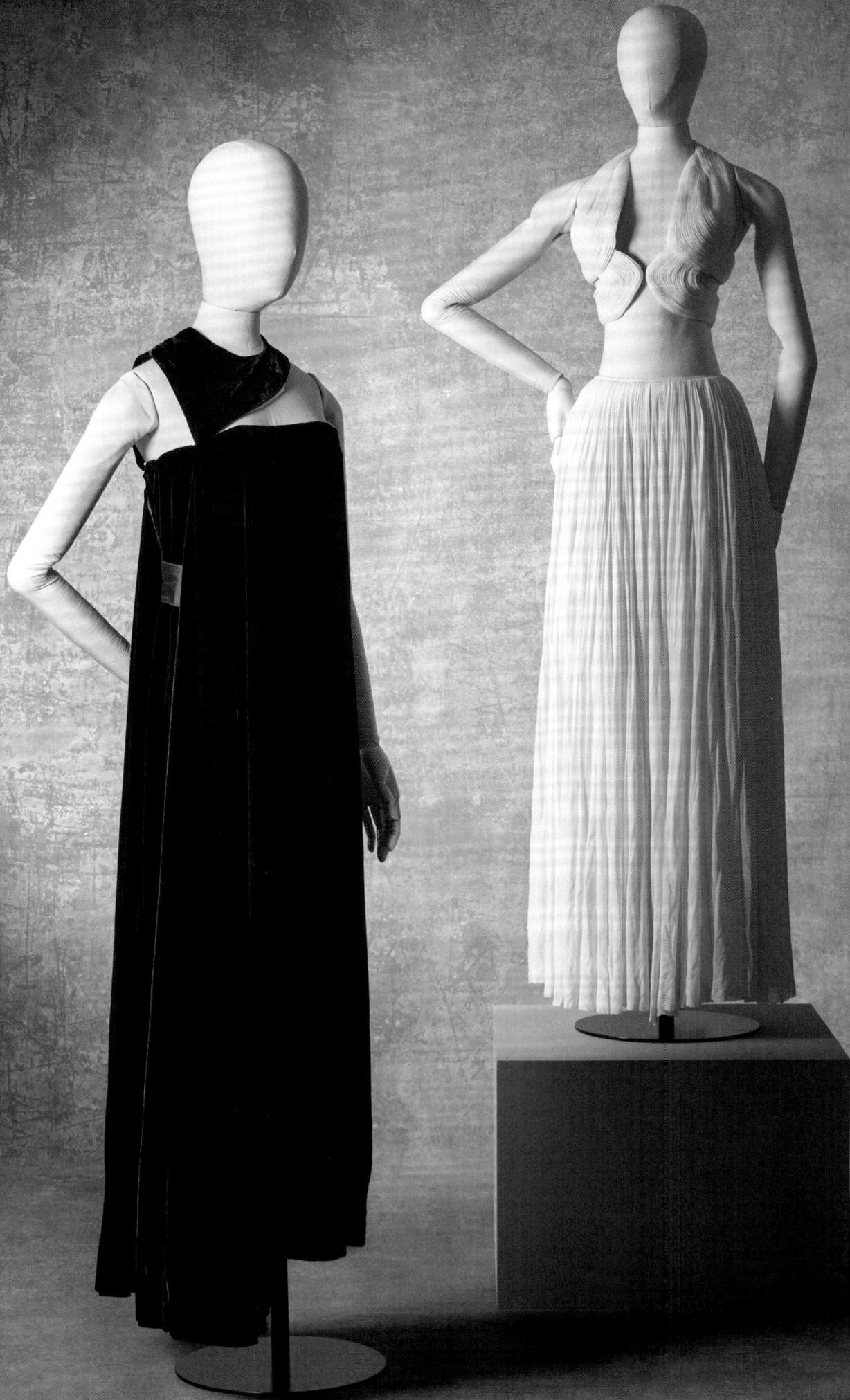

89. Grès Evening dress, Autumn/Winter 1968 **90. Grès** Evening dress, Spring/Summer 1975

91 – 93

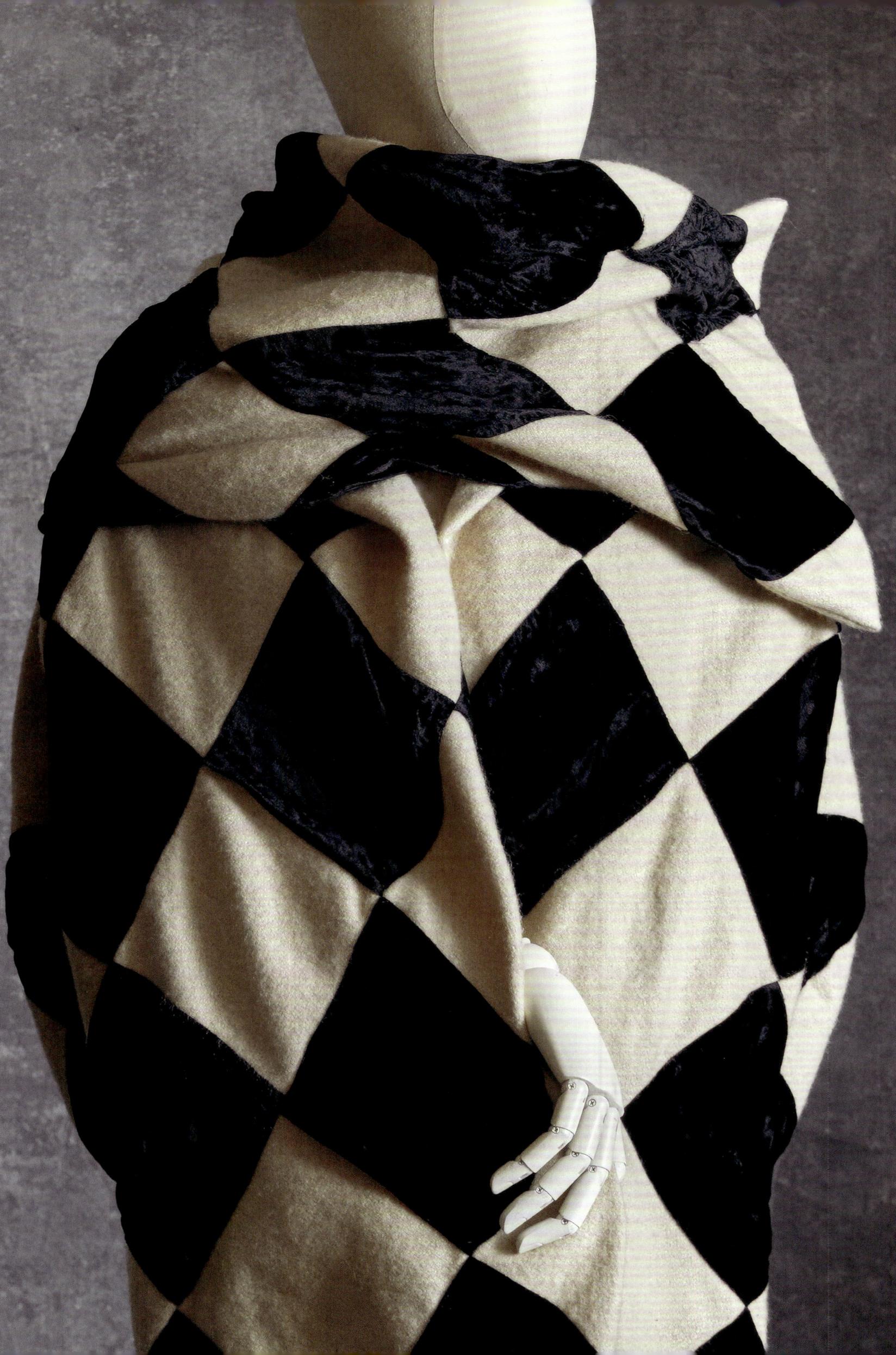

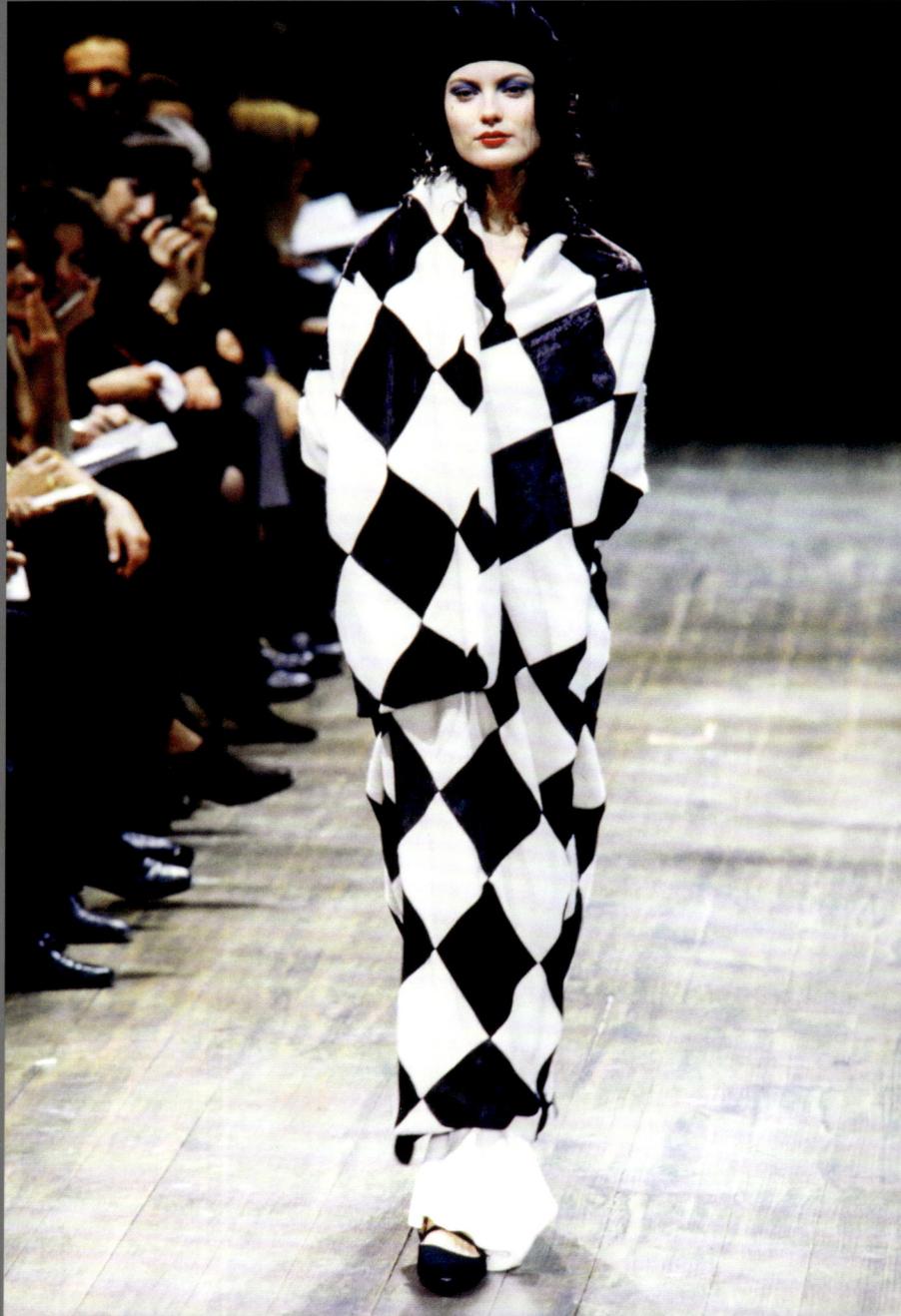

fig. 56 Shalom Harlow wearing Yohji Yamamoto chequered coat
on the Paris runway, 1997

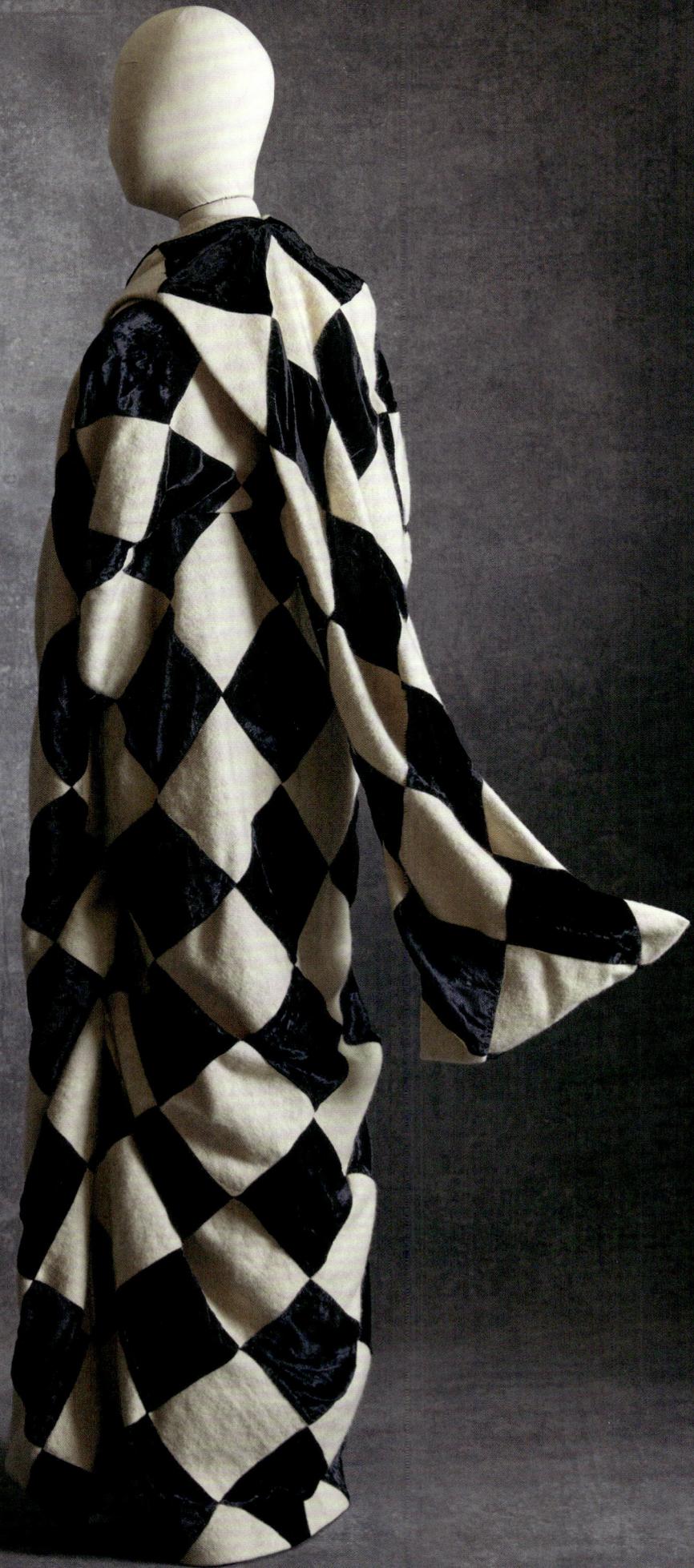

91. Yohji Yamamoto Chequered coat, Japanese, Autumn/Winter 1997–98

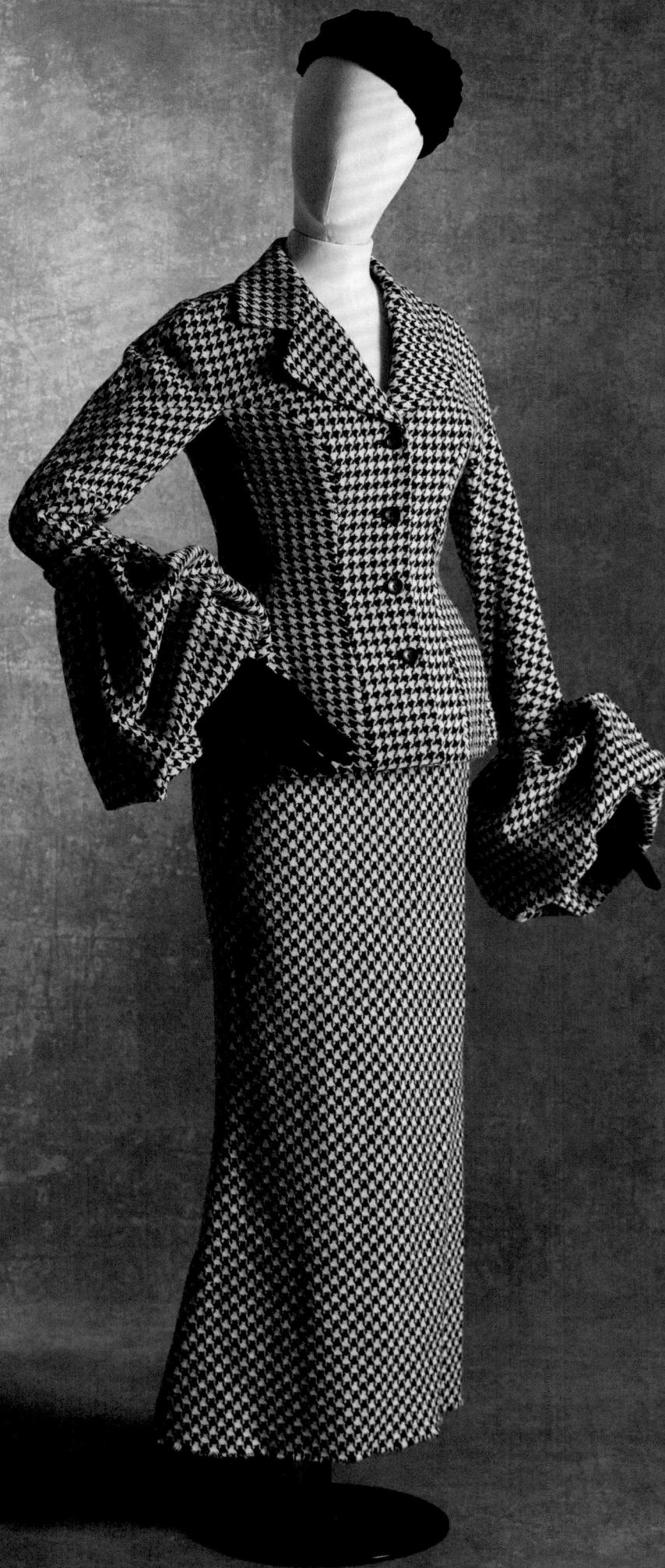

92. Yohji Yamamoto Suit, Japanese, Autumn/Winter 2003–04 and **Caroline Reboux** Hat, c. 1950

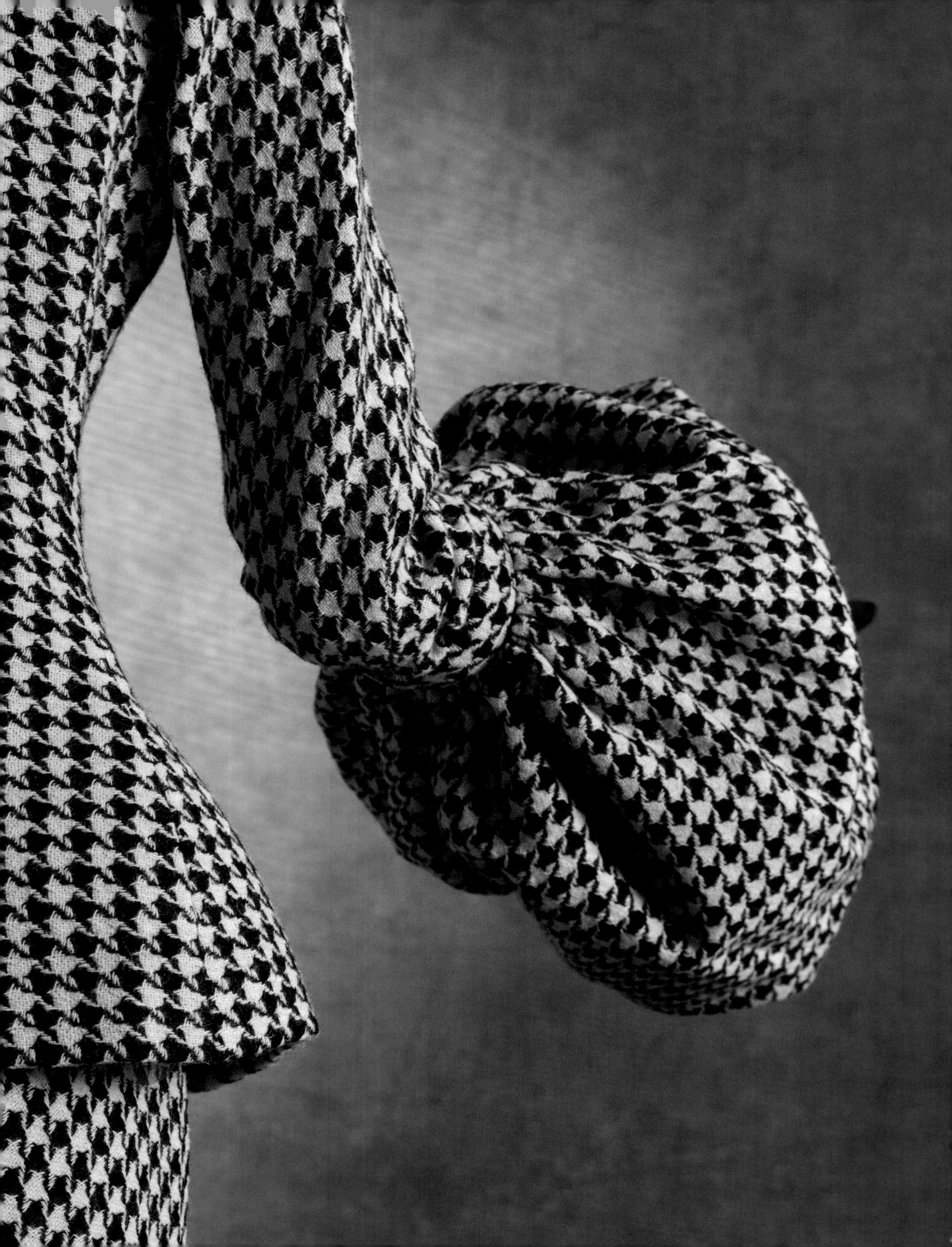

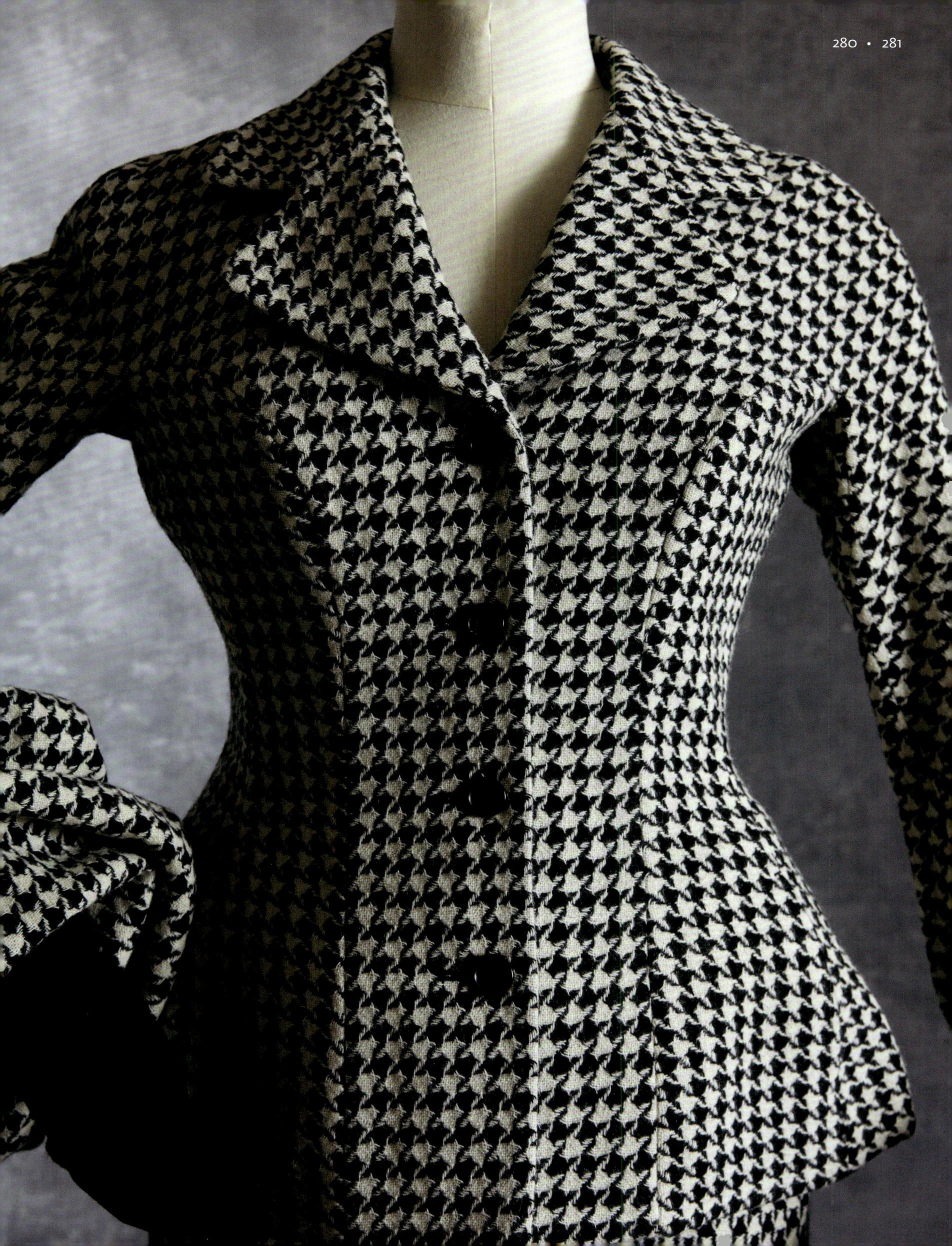

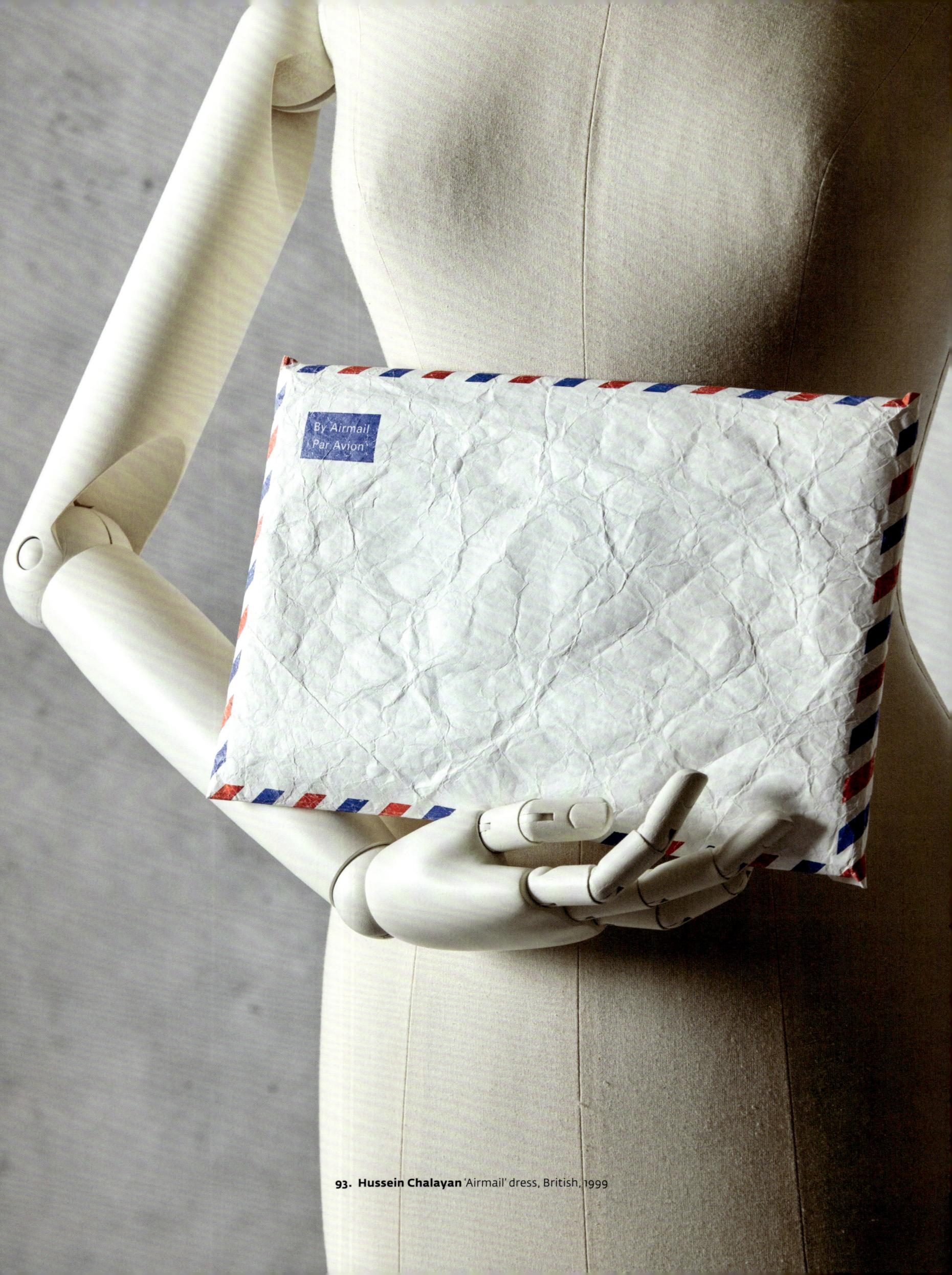

93. Hussein Chalayan 'Airmail' dress, British, 1999

By Airmail
Par Avion

These flaps are removable for ease of wearing

Seal with sticker

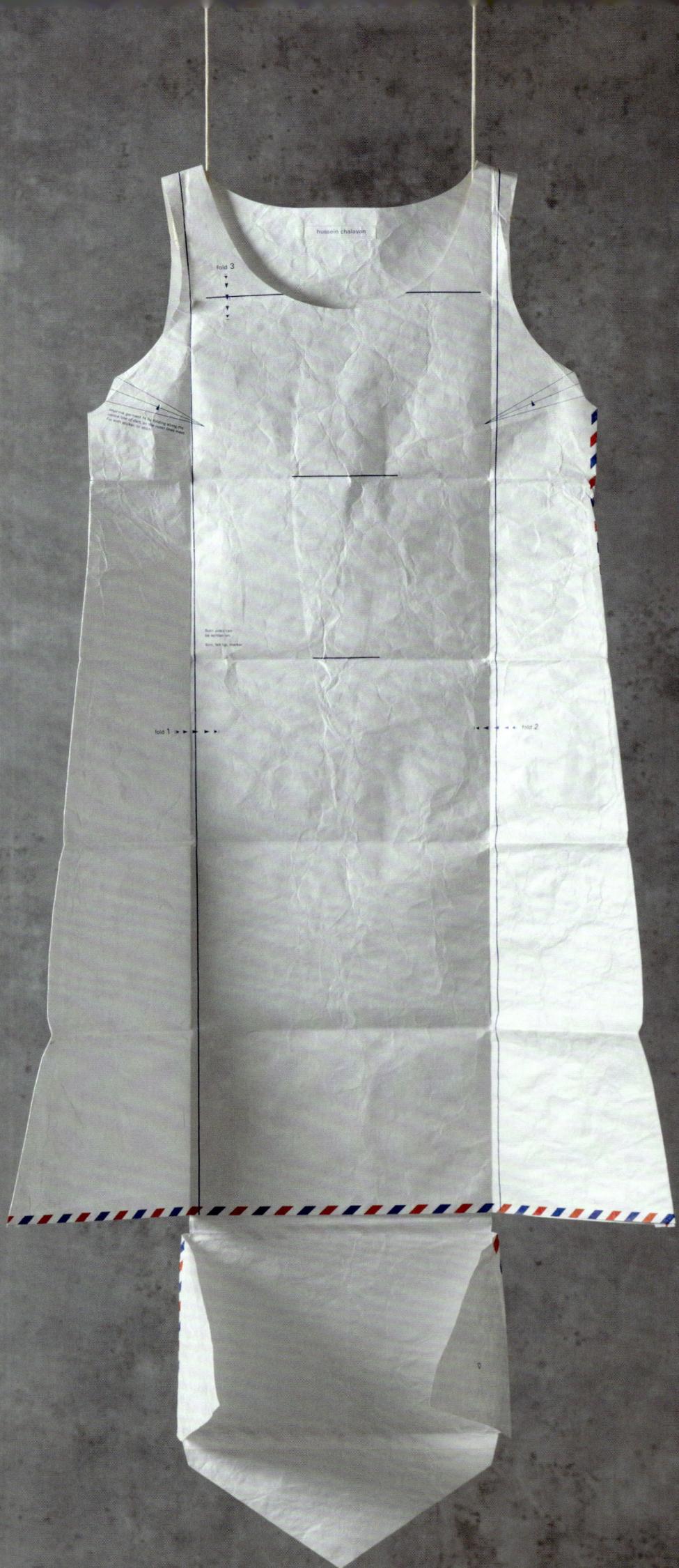

'When I was seven, I was sent to England from North Cyprus to study in boarding school, and I pretty much felt separated from my mother. I felt I was too young to really go abroad, and in those days it was very expensive to communicate by telephone. So we used to write aerogram letters to each other. Many years later, I decided to look at this situation and created the Airmail clothing series, which is a dress you can write on, you can spray perfume on, you can wear, you can wash. And I like here the idea that you can send a dress to a loved one, and maybe this dress can become a token for your absence or your presence.'[23]

Hussein Chalayan, 2015

Notes to captions

1. Calahan & Zachary 2015, pp. 7–8.
2. Ibid., p. 35.
3. See Ferretti 2017, p. 102 and Huber 2023, p. 180.
4. *Lishui* is a set of parallel diagonal (either straight or wavy), multicoloured sea-waves/line patterns embroidered around the bottom hem and cuffs of some of the court robes of the Qing dynasty (1644–1912).
5. *Nise Murasaki Inaka Genji* (A Rustic Genji by a Fake Murasaki) by Ryūtei Tanehiko (1783–1842) was a parody of the early 11th-century *Genji monogatari* (Tales of Genji) by Murasaki Shikibu.
6. Utagawa Kunisada (1786–1865), *Comparison of Lovers on a Rainy Night*, from the series *Genji in Modern Guise*, 1855, Victoria and Albert Museum (inv. E.14697:23-1886).
7. Bombicci 1881, n.p.
8. Carron de la Carrière 2022, p. 126.
9. Mauriès 2022, pp. 85–86.
10. Blum 2020.
11. Mauriès 2022, p. 118.
12. White 1994, p. 74.
13. Koda, Reeder, Rucci, Scaturro & Petersen 2014, p. 54.
14. Coleman 1982, p. 7.
15. Miller 2017, pp. 90–91.
16. Carron de la Carrière 2022, pp. 186, 189.
17. Mears 2007, pp. 16, 18.
18. McEvoy 1977, p. 6.
19. Musée Historique des Tissus Lyon 1985, p. 50.
20. Miller 2017, pp. 65–66; see also Georg & Köhler 2010, pp. 184–89.
21. Monti 2021, p. 4.
22. Bolton 2019, p. 110.
23. Chalayan 2015.

catalogue

*unless otherwise stated, all garments and accessories are French
**unless indicated, all garments and accessories are labelled

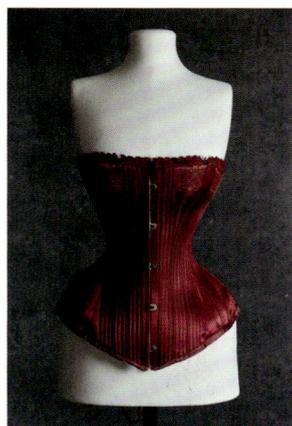

1.
À La Spirite
Nineteen-inch corset
Silk satin, cotton twill lining
American, c. 1893

Notes
Cotton label sewn to lining: *À La Spirite / Awarded Gold Medals: / Paris Exposition, 1889 / Chicago, 1893*

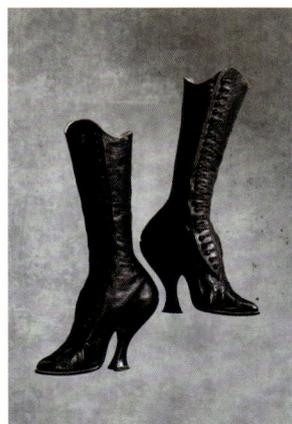

2.
Pair of fetish buttoned boots
Leather, silk lining
Heel height at highest point 13 cm
European, c. 1895

Comparable examples
See a pair of boots in the Victoria and Albert Museum (inv. T.108A-1958).

Notes
See Henri de Toulouse-Lautrec's lithograph *La Troupe de Mademoiselle Eglantine*, from 1895, for an illustration of a similar style of boot (Metropolitan Museum of Art, inv. 32.88.5).

3.
Callot Sœurs
Evening dress
Silk tulle, silk satin, metallic threads, lace, silk and silver net, silver tissue, pearls, glass beads
c. 1913

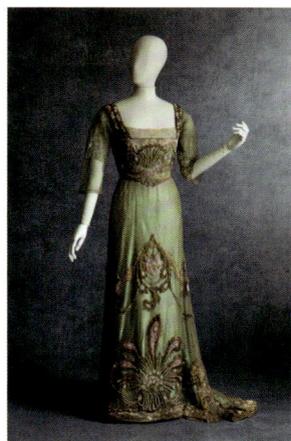

3.

4.
Jeanne Lanvin
Bridesmaid dress
Organdie, cotton tape, cotton appliqué flowers, silk lining
1912

Provenance
This is one of seven bridesmaid dresses worn by young women at a wedding for a member of Jeanne Lanvin's family in July 1912. *Mlle Maurice* is written in pencil on the label at the interior waist.

Published
Les Modes July 1912, p. 9 (fig. 2)
Merceron 2007, p. 114

Comparable examples
See *Les Modes* June 1912, p. 15, for an afternoon dress of similar style; and *Les Modes* September 1912, cover, for an illustration of Ève Lavallière in a similar dress.

Notes
A drawing relating to this model is with the Patrimoine Lanvin (album 1912).

5.
Georges Lepape
Les Choses de Paul Poiret vues par Georges Lepape (The Things of Paul Poiret as seen by Georges Lepape), album with twelve illustrations
Pochoir
1911

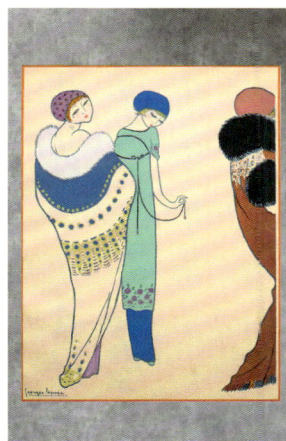

5.

6.
Stockings
Silk, cotton or lamé
1910–1925

Provenance
Denise Boulet-Poiret
After her divorce in 1928, Denise reverted to using her maiden name of Boulet. Later in life, for things connected with Paul Poiret, she would sign Denise Boulet-Poiret.

Exhibited
Poiret: King of Fashion, The Metropolitan Museum of Art, 2007

Notes
Some of the stockings are labelled Gastineau, a Parisian company that specialised in hosiery.

7.
Paul Poiret
Evening dress and headdress, 'Lavallière'
Silk satin, silk crêpe, glass bugle beads
Unlabelled
1911

Provenance
Denise Boulet-Poiret

Exhibited
Poiret le magnifique, Musée Jacquemart-André, 1974 [ivory version exhibited]
Paul Poiret: King of Fashion, The Galleries at F.I.T., 1976 [ivory version exhibited]
Diaghilev and the Golden Age of the Ballets

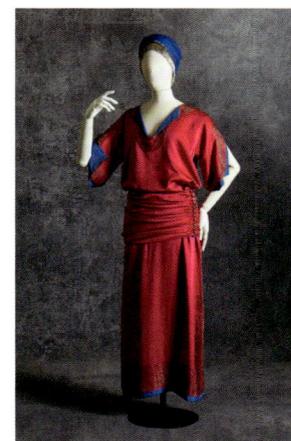

7.

Russes, Victoria and Albert Museum, 2010–11

Published
Galahead 1974, cover and pp. 62–63 [photograph by Helmut Newton of Denise Boulet-Poiret with several models wearing garments from her wardrobe, including one to her left wearing the fuchsia 'Lavallière' with blue headdress; visible in background on cover]
Pritchard (ed.) 2010, p. 65

Further reading
White 1973, p. 80
Institut de France, Musée Jacquemart-André 1974, cat. 71 [the catalogue lists the ivory version of 'Lavallière' as no. 71, 'La Vallière', but misattributes its date to 1922–25 (Institut de France, Musée Jacquemart-André 1974, p. 29)]
Paul Poiret: King of Fashion 1976, no. 49

Comparable examples
The dress was made in three colourways: ivory and purple, black and green, fuchsia and blue. The ivory 'Lavallière' version is in the Musée des Arts Décoratifs, Paris (inv. UF 63-18-7). For the black 'Lavallière' version, see PIASA 2005, vol. 1, p. 175; vol. 2, pp. 203–04.

Yvonne Deslandres notes that: 'The creations proliferated, from a flowing sheath of pearls with a small square train to the supreme purity of the white satin dress called 'Lavallière', of which Madame Poiret owned many different versions in rainbow colours, and whose low belt indicates better than all the high waists of the time that an incredible fashion revolution had taken place.'[1]

A dress of identical cut to 'Lavallière' in embroidered linen is in the Palais Galliera, Paris (inv. GAL2008.1.1).[2]

Notes
For Paul Poiret's promotional tour of the USA in 1913, Denise carefully inventoried the dresses she was taking

with her in her diary. One double page shows that she packed the three colourways of 'Lavallière', listed under 'evening dresses'.[3]

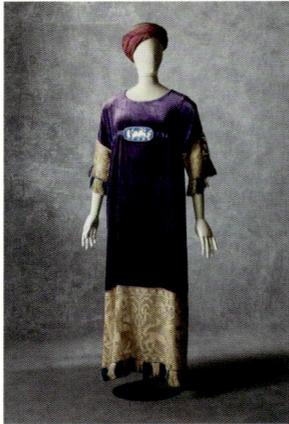

8.
Paul Poiret
Dress, 'Notre Dame'
Silk velvet, antique Chinese floral appliqué embroidery and European linen filet net with large-scale pattern of lions flanking stylised plants, linen fringe
Unlabelled
1911

Provenance for ensemble
Denise Boulet-Poiret

Published
Caviglioli 1974, p. 53
Galahead 1974, pp. 62–63 [photograph by Helmut Newton of Denise Boulet-Poiret with several models wearing garments from her wardrobe, including the 'Notre Dame' dress]

Comparable examples
'Toujours' (1911), a dress of identical cut and design in a mouse-grey silk velvet, is in the Victoria and Albert Museum (inv. T.387-1976), and was given to the museum by Denise Boulet-Poiret in 1976.

Notes
Small (13 × 7 cm) rectangular ivory silk patch sewn by hand onto the inside of the hem of the skirt, inscribed *NOTRE DAME / 1911* in blue biro, in Denise Boulet-Poiret's hand.

Paul Poiret
Turban, originally worn with the 'Ispahan' ensemble
Silk mousseline, silver-wrapped thread net
Unlabelled
1923

Exhibited
Poiret: King of Fashion, The Metropolitan Museum of Art, 2007

Further reading
French *Vogue* April 1923, illustration, p. 11

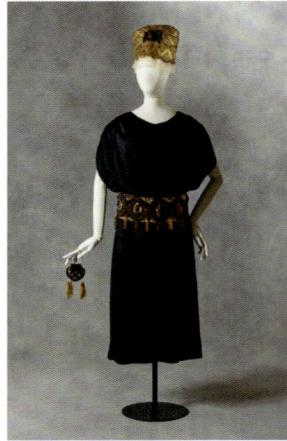

9.
Paul Poiret
Dinner dress with belt
Silk satin, gold cording, fringe
Unlabelled
1911

Provenance for ensemble
Denise Boulet-Poiret

Exhibited
Diaghilev and the Golden Age of the Ballets Russes, Victoria and Albert Museum, 2010–11

Paul Poiret
Kokochnik-style hat
Gold and silver foil, gold thread, silk taffeta, lace
c. 1910

Exhibited
Diaghilev and the Golden Age of the Ballets Russes, Victoria and Albert Museum, 2010–11

Embroidered purse
Silk
China, 19th century

10.
Madeleine Panizon for Paul Poiret
Hat, 'Trocadéro'
Silk, dyed ostrich feathers
Summer 1920

Provenance
Denise Boulet-Poiret

Exhibited
Poiret le magnifique, Musée Jacquemart-André, 1974
Poiret: King of Fashion, The Metropolitan Museum of Art, 2007

Published
White 1973, p. 160

Notes
Paul Poiret's atelier was able to create millinery. However, he also worked with a number of milliners, most notably Madeleine Panizon, who created several headdresses for Denise.

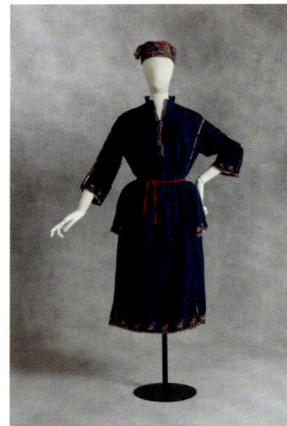

11.
Paul Poiret
Dress
Linen, embroidered with polychrome silks and silver-wrapped thread
Unlabelled
c. 1920

Provenance for ensemble
Denise Boulet-Poiret

Comparable examples
Images of several comparable Poiret dresses are preserved among the registration photographs from 1920 at the Archives de Paris (see in particular 10 February 1920, no 3, modèle no. 578 (AdP D12U10 300)).

Middle Eastern cap
Silk, gold cord
Unlabelled
c. 1900

Notes
A scalloped cardboard label is attached to the tapestry-woven cap and written in ink are the numbers: *26 21*

12.
Paul Poiret
Dress, 'Mosaïque'
Silk voided velvet, fox-fur trim
Unlabelled
Autumn/Winter 1921

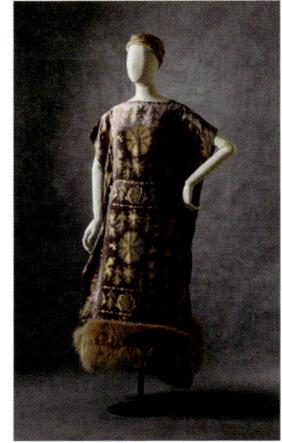

12.

Provenance for ensemble
Denise Boulet-Poiret

Exhibited
Poiret le magnifique, Musée Jacquemart-André, 1974
Poiret: King of Fashion, The Metropolitan Museum of Art, 2007

Published
Institut de France, Musée Jacquemart-André 1974, cat. 66
Koda & Bolton 2007, pp. 136–39

Further reading
Women's Wear Daily 25 November 1921, illustration, pp. 3, 36 (fig. 14)

Notes
This ensemble was worn by Denise Poiret at the wedding of Germaine Bolvin, the niece of Paul Poiret (fig. 10). It appears to have been shown in the designer's Fall/Winter 1921 collection under the name 'Mosaïque'. See the registration photographs preserved at the Archives de Paris, 9 August 1921, no. 11, modèle no. 5709 (AdP D12U10 304), inscribed on the verso: *Mosaïque 2134*.

Paul Poiret
Metallic head wrap
Gold lamé
Unlabelled
1910s–20s

Exhibited
Poiret: King of Fashion, The Metropolitan Museum of Art, 2007

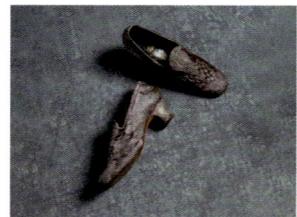

12a.
André Perugia
Heeled shoes covered in matching fabric
Silk voided velvet, leather
1921

Provenance
Denise Boulet-Poiret

Notes
Paul Poiret discovered André Perugia in 1914 in Nice. Perugia went on to design shoes for Poiret's couture house and for Denise Poiret. He established his own shop in 1921 and went on to collaborate with other couturiers such as Elsa Schiaparelli, and designed shoes for clients including Josephine Baker, among others.[4]

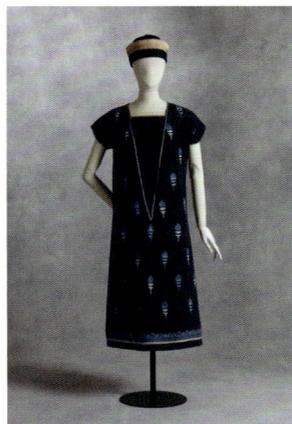

13.
Paul Poiret
Day dress, 'Indiana', with matching hat
Dress: silk crêpe de Chine; Hat: straw, silk taffeta
1922

Provenance
Denise Boulet-Poiret

Notes
A photograph of Denise Poiret taken in 1923 shows her wearing this ensemble.[5]

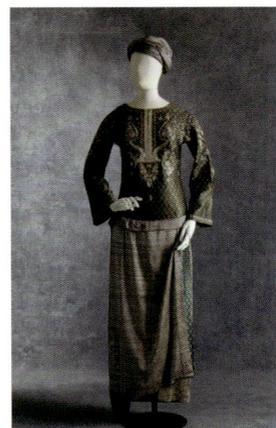

14.
Paul Poiret
Evening dress and turban, 'Sérail' or 'Persane'
Silk with silver filé brocade, silver lamé, silver braid embroidery
Spring/Summer 1923

Provenance
Denise Boulet-Poiret

Exhibited
Poiret: King of Fashion, The Metropolitan Museum of Art, 2007
India in Fashion, Nita Mukesh Ambani Cultural Centre, Mumbai, 2023

Published
Galahead 1974, pp. 62-63 [photograph by Helmut Newton of Denise Boulet-Poiret with several models wearing garments from her wardrobe, including one facing Denise wearing this evening dress and turban; visible in background on cover]
Deslandres 1986, p. 194
Koda & Bolton 2007, pp. 162–65

Further reading
Art Goût Beauté May 1923, illustration, n.p.

Comparable examples
Of the same design and with the same embroidery is a white satin wedding dress, 'Sérail', from 1923, in the Palais Galliera, Paris (inv. 1973.61.1).

Notes
Denise Poiret wore this dress to the last dinner held in Poiret's home-cum-atelier on the avenue d'Antin.[6]
The dress has been interchangeably called 'Sérail' or 'Persane'. It seems that the ensemble was originally presented as part of Poiret's Spring/Summer 1923 collection under the name of 'Sérail'. See the registration photographs of ensemble at the Archives de Paris, 13 February 1923, nos. 499 and 500, modèle no. 6502 (AdP D12U10 308), inscribed on the verso 3576 *Sérail*.

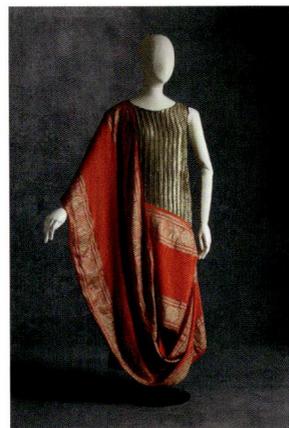

15.
Paul Poiret
Evening dress, 'Lure'
Gold lamé, silk crêpe
Unlabelled
1924

Provenance
Denise Boulet-Poiret

Published
Deslandres 1986, pp. 188–89

Further reading
Milbank 2023, p. 140

Notes
The registration photograph of this dress is preserved at the Archives de Paris, 29 January 1924, no. 7206, modèle no. 82 (AdP D12U10 310), inscribed on the verso: 4230 *Lure*.

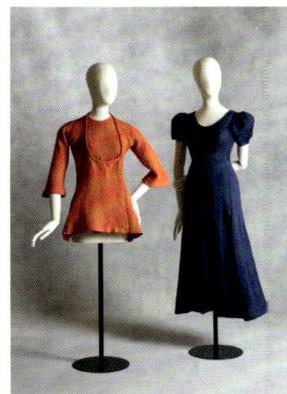

16.1.
Denise Poiret
Angarkha-shaped knitted jacket
Linen
Unlabelled
c. 1928

16.2.
Denise Poiret
Knitted dress
Linen
Unlabelled
c. 1928

Provenance
Denise Boulet-Poiret

Notes
Denise Boulet-Poiret started to produce knitted clothes as a source of income after her divorce from Paul Poiret in 1928.[7]

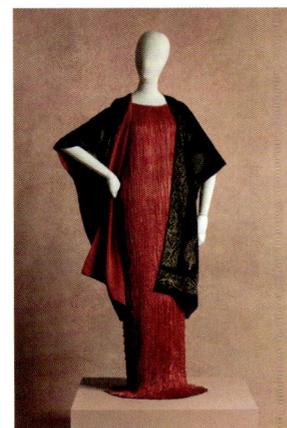

17.
Mariano Fortuny
Jacket
Silk velvet, silk, metallic pigment
Italian, c. 1910–20s

Adèle Henriette Elisabeth Nigrin Fortuny
Mariano Fortuny
'Delphos Dress'
Silk, Venetian glass beads
Italian, c. 1910–20s

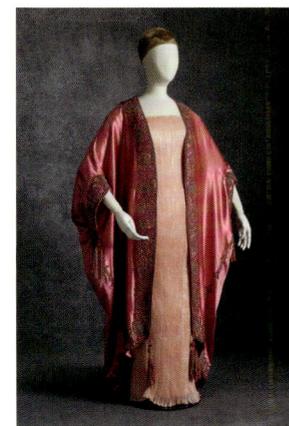

18.
Callot Sœurs
Opera coat or mantle
Satin, metallic threads, glass beads
c. 1915–20

Adèle Henriette Elisabeth Nigrin Fortuny
Mariano Fortuny
'Delphos Dress'
Silk, Venetian glass beads
Italian, c. 1920

Madeleine Panizon for Paul Poiret
Hat
Woven horsehair, applied gold passementerie, bobbin lace
Unlabelled
c. 1920

Provenance
Denise Boulet-Poiret

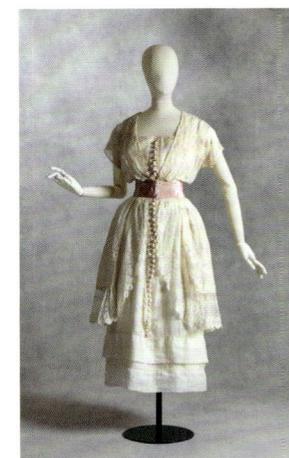

19.
Callot Sœurs
Day dress
Cotton voile, silk tulle, chiffon, satin, mousseline
Summer 1920

Provenance
Lady Avery (1875–1959)

Comparable examples
Images of several comparable dresses are preserved among the registration photographs at the Archives de Paris (see in particular 26 February 1920, no. 443 (AdP D12U10 79 5140), inscribed on the verso: *Pré Catelan*).

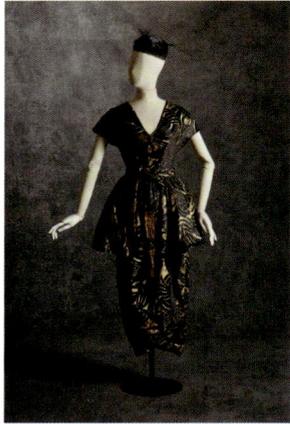

20.
Madeleine & Madeleine
Evening dress
Silk and gold lamé damask
c. 1920

Paul Poiret
Headband
Monkey fur, metallic woven ribbon
Unlabelled
c. 1919

Provenance
Denise Boulet-Poiret

Exhibited
Poiret: King of Fashion, The Metropolitan Museum of Art, 2007

Notes
A very similar headband was worn with the 'Faun' evening dress (also known as 'Mythe').[8]

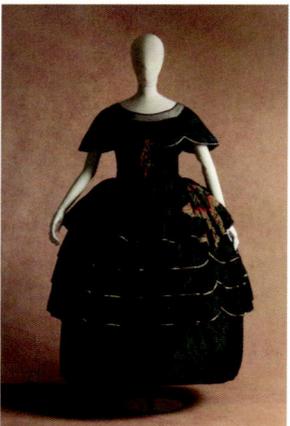

21.
Jeanne Lanvin
Evening dress or *robe de style*, 'Barcena'
Silk taffeta, net, gold lamé tape, gold, silver and red silk threads
1922–23

Provenance
Cátalina Bárcena (1888–1978); Spanish actress

Notes
A registration photograph at the Archives de Paris confirms that this model was known as 'Barcena' (28 March 1923, no. 6606, modèle no. 4 (AdP D6U10 333), inscribed on the verso: *Barcena*). This dress is one of a group of Lanvin dresses that were commissioned by Cátalina Bárcena during the 1920s for herself and for the stage. She was an ambassador for Lanvin's clothes and they used her name in advertisements. Another of Bárcena's dresses from this period is in the Victoria and Albert Museum (inv. T.54-2013).

There are two drawings for this dress with the Patrimoine Lanvin. One is labelled 'Dessinateur' (fig. 13) and one 'Bichara' (see album 1922/23).

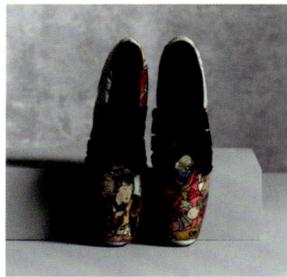

22.
Luigi Zanotti
Shoes covered in Japanese embroidered silk
Silk, leather
Italian, c. 1875

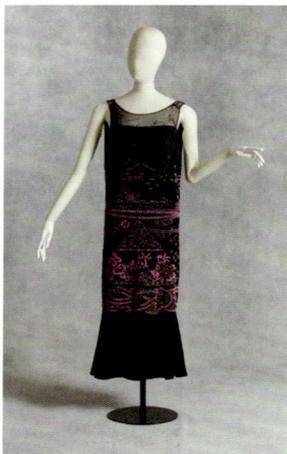

23.
Jean Patou
Evening dress, 'Nuit de Chine'
Silk satin, silk tulle, glass beads
1923

Provenance
Jean Patou family

Published
Polle 2013, pp. 28–29

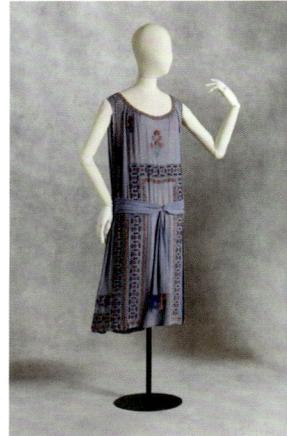

24.
Jean Patou
Evening dress, 'Musardise'
Silk chiffon, glass beads
1923

Provenance
Jean Patou family

Published
Polle 2013, pp. 160–61

Notes
The house of Patou shortened this dress around 1927, when hemlines changed.

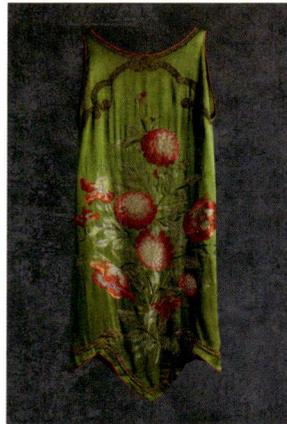

25.
Callot Sœurs
Evening dress
Satin, silk floss, metallic thread
c. 1925

Comparable examples
A virtually identical dress is in the Victoria and Albert Museum (inv. T.73-1958).

26.
Jeanne Lanvin
Evening coat
Silk crêpe, glazed (*ciré*) black wool grosgrain tape
Summer 1928

Comparable examples
An identical coat is in the Metropolitan Museum of Art (inv. 1979.574.1).

26.

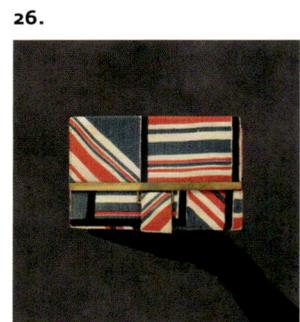

27.
Sonia Delaunay
Pochette
Printed cotton
c. 1930

Exhibited
Maison Sonia Delaunay and the Atelier Simultané, Kunstmuseen Krefeld, 2022–23
Sonia Delaunay Living Art, Bard Graduate Center Gallery, New York, 2024

Published
Dorogova & Baudin 2022, p. 81
Dorogova & Microulis 2024, p. 339

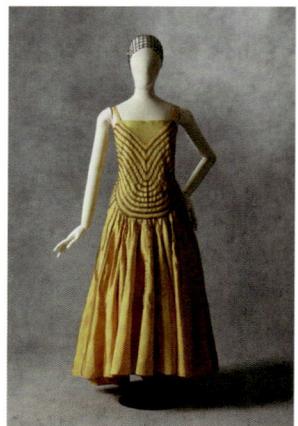

28.
Jeanne Lanvin
Evening dress, 'Rayonnante'
Silk faille, silk tulle, sequins, yellow rhinestones
Winter 1929

Provenance
Helen Larson (1915–1998)
Larson, based in Los Angeles, owned a

successful film costume rental business and put together an important fashion collection. Part of her collection is now in the FIDM Museum, Los Angeles.

Further reading
Roger-Viollet press image from an unknown source (RV 2458-16)
Harper's Bazaar November 1929, p. 81 [photograph by Baron de Meyer of black version]

Notes
A drawing for 'Rayonnante' (1929/30) (fig. 20) is with the Patrimoine Lanvin.

Paul Poiret
Headdress originally worn with the 'Nénuphar' opera coat
Plaited silk ribbon, rhinestones
Unlabelled
c. 1911

Provenance
Denise Boulet-Poiret

Exhibited
Poiret le magnifique, Musée Jacquemart-André, 1974
Poiret: King of Fashion, The Metropolitan Museum of Art, 2007

Published
Institut de France, Musée Jacquemart-André 1974, cat. 43

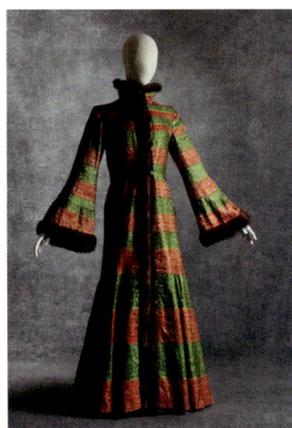

29.
Maggy Rouff
Evening coat
Silk ribbon brocaded with silver wrapped silk thread, mink, silk-satin lining
London, c. 1931

Comparable examples
A comparable evening coat by Maggy Rouff in a different fabric and with ermine trim is in The Metropolitan Museum of Art (inv. C.I.59.37.1).[9]

30.
Jeanne Lanvin
Day ensemble
Chiffon, silk crêpe de Chine
Summer 1931

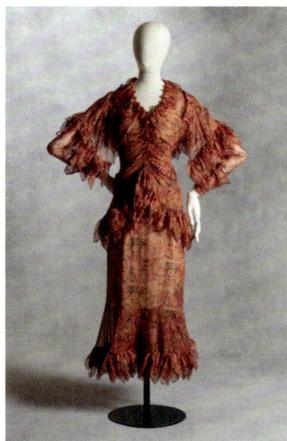

30.
Comparable examples
This model appears to be an amalgam of several models using the same distinctive fabric that Lanvin designed for her Summer 1931 collection (in total there were eleven variations), all with nautical names. It is closest to, and may be a variant of, the dress called 'Île Mystérieuse', although that appears to be a one-piece garment rather than an ensemble and features a two-tiered skirt (see Archives de Paris, 5 February 1931, no. 9, modèle no. 13338 (AdP D6U10 344)).

Notes
A drawing for 'Île Mystérieuse' from the Summer 1931 collection is with the Patrimoine Lanvin.

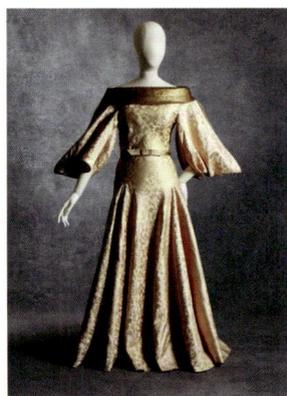

31.
Jeanne Lanvin
Evening gown, 'Célimène'
Rayon damask, gold lamé
Spring/Summer 1935

Further reading
Women's Wear Daily 8 March 1935, p. 1 [where the model shown is called 'Psyche']

Notes
There is a photograph by Studio 21bis of a woman playing the piano wearing this gown (Palais Galliera, inv. K1258). A drawing for 'Célimène' (1935) (fig. 21) is with the Patrimoine Lanvin.

32.
Madeleine Vionnet
Evening dress and cape, 'Tango'

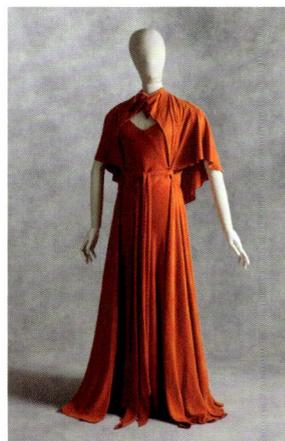

32.
Silk crêpe de Chine
Unlabelled
c. 1934

Published
Demornex 1990, pp. 64–65

Notes
The dress and cape are deliberately of two differing shades of tangerine.

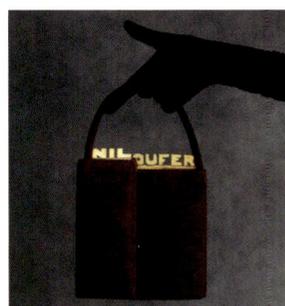

33.1.
Handbag, 'Niloufer'
Suede, metal
c. 1934

Provenance
Princess Niloufer

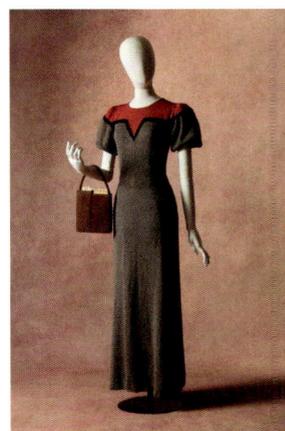

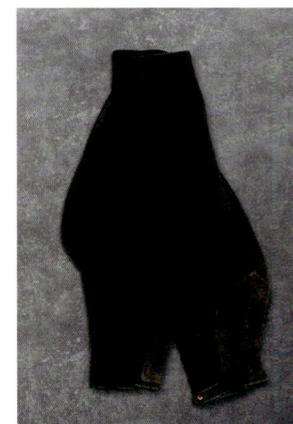

33.2.
Jean Patou
Knitted dress
Silk
Unlabelled
c. 1935

Provenance
Princess Niloufer

Notes
A drawing for a similar model from the house of Patou is in the Musée des Arts Décoratifs, Paris (inv. UF D 94-8-99-125).

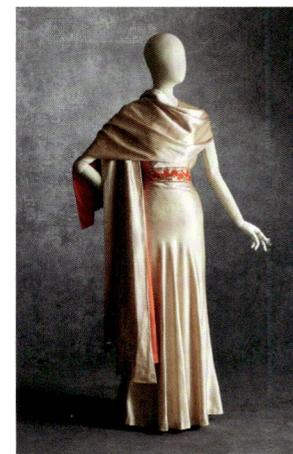

33.3.
Jean Patou
Evening gown
Silk satin, silk crêpe, glass beads
Autumn 1936

Provenance
Princess Niloufer

33.4.
John Burton Secunderabad
Riding trousers
Wool, leather
Indian, 1934

Provenance
Princess Niloufer

Notes
John Burton was a Scottish draper and tailor from Secunderabad, in India. He worked for the Hyderabadi Royal family.
Inscribed on the label there is a handwritten note in ink which states: *Princess Nilfur / Begum 4.4.34.*

33.5.
***Robe d'intérieur* with *faux* sleeves**
Silk velvet, silk chiffon lining, fur
Late 1930s

Provenance
Princess Niloufer

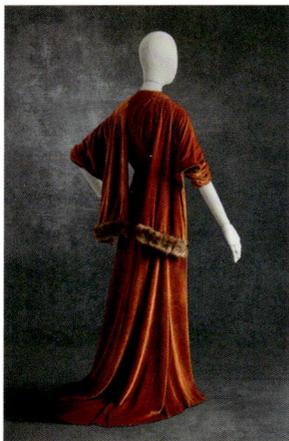

33.5.

34.
Gabrielle Chanel
Evening dress with overall scalloped
sequin design
Silk tulle, sequins
Unlabelled
C. 1935

Provenance
Yvette Prade (née Rigaud) (1912(?)–2011)
Prade was a known Chanel client,
and another dress from her wardrobe
is with the Patrimoine de Chanel.

Comparable examples
Similar blue sequined dresses by
Chanel are in the Victoria and Albert
Museum (inv. T.339-1960) and in the
Ohio State University Historic
Costume & Textiles Collection (inv.
HCT.1988.318.84).

35.
Madeleine Vionnet
Evening skirt, 'Carnival'
Silk tulle, silk chiffon
Unlabelled
Autumn/Winter 1936

Provenance
Lady Foley (née Greenstone, 1888–
1968)

Further reading
Harper's Bazaar October 1936,
photograph, p. 130

35.

American *Vogue* 1 December 1936,
illustration, p. 84
Demornex 1990, p. 259

Comparable examples
This skirt is the only known example in
cream; all other examples of the
ensemble are in black: one in the
Metropolitan Museum of Art (inv.
C.I.52.24.3a-b), one in the Musée des
Arts Décoratifs, Paris, donated by
Madeleine Vionnet (inv. UF 52-18-100
AB), and another (skirt only) in the
Fondation Alaïa.

Notes
The registration photograph depicting the
black version of this ensemble is in the
Archives de Paris, 13 August 1936, no. 17759,
modèle no. 4201 (AdP D12U10 650).
For the design, see Bibliothèque
Historique de la Ville de Paris (inv.
8-ICOR-0090, F.50v-F.51r).
Lady Foley was a major client of
Vionnet's. Her other Vionnet garments
are in the collections of the Metropoli-
tan Museum of Art, the Victoria and
Albert Museum, the National Gallery of
Australia, Canberra, the Fashion
Museum, Bath, the Bowes Museum
and the Fondation Alaïa.

36.
Madeleine Vionnet
Evening gown
Silk taffeta, paillettes
Unlabelled
Summer 1935

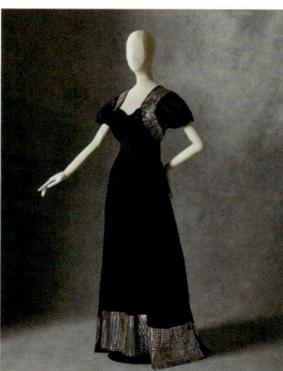

36.

Published
Demornex 1990, pp. 278–81

Notes
The registration photograph (*Dépôt de
modèle de Madeleine Vionnet*) for this
gown is in the Musée des Arts Décorat-
ifs, Paris (no. 4893) (fig. 32). For the
design, see Bibliothèque Historique de
la Ville de Paris (inv. 8-ICOR-0078,
F.29v-F.30r).

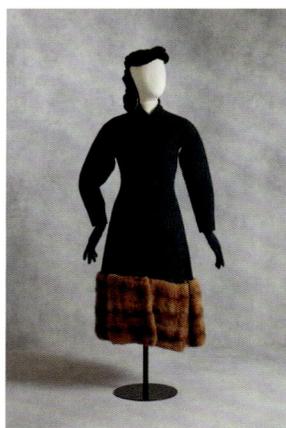

37.
Alix
Asymmetrical coat
Wool, fox fur, padded silk lining
C. 1935–37

Elsa Schiaparelli
Headdress
Silk velvet, silk faille
C. 1940

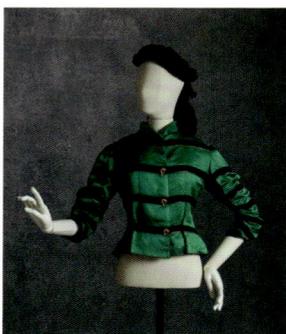

38.
Elsa Schiaparelli
Afternoon or evening jacket
Ribbed silk woven with black velvet and
gold metallic stripe
Winter 1935

Further reading
Mode Pratique 11 January 1936, cover

Notes
A drawing showing the red version of
this jacket is in the Musée des Arts
Décoratifs, Paris (inv. UFD73-21-873).

39.
Jeanne Lanvin
Evening gown, 'La Nuit'
Silk taffeta
Winter 1936–37

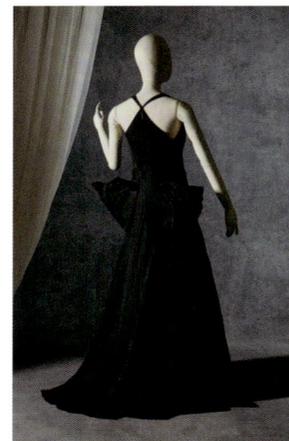

39.
Provenance
Princess Jean Poniatowski

Further reading
*L'Officiel de la Couture et de la Mode de
Paris* November 1936, illustration, p. 28

Notes
A drawing for 'La Nuit' (fig. 33) is with the
Patrimoine Lanvin (see album 1936, p. 53).

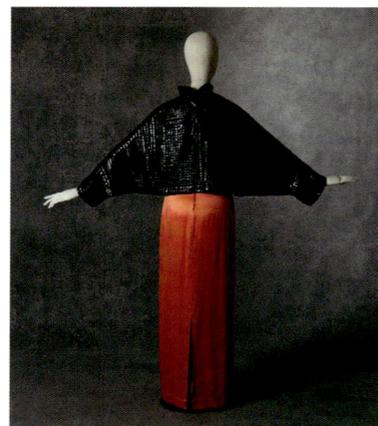

40.
Bruyère
Evening jacket
Silk satin, paillettes
C. 1934–35

Notes
In a short archival video from a 1934
'Maison Bruyère' fashion show, we see
various scenes of women modelling
afternoon and evening wear for
buyers. One model is filmed seated,
wearing a dress of silk crêpe and
embellished with the same paillettes
as the present evening jacket.[10]

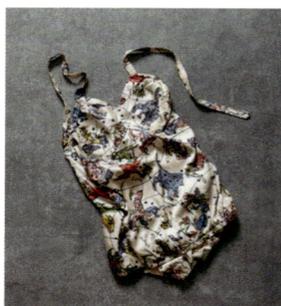

41.

41.
Hermès
Bathing suit, 'Zodiaque'
Stretch sateen
1938

Further reading
Femina June 1938, advertisement,
p. 64 (fig. 34)
Jardin des Modes June 1938, cover
Rester Jeune Summer 1938, cover

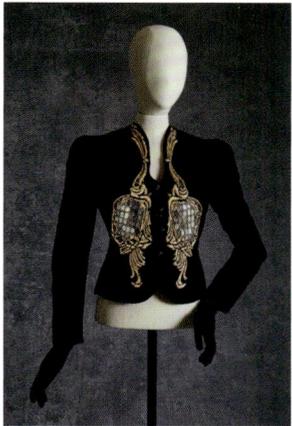

42.
Elsa Schiaparelli
Evening jacket
Silk velvet, silk crêpe, glass, faceted
beads, mirror, plastic
Spring 1939
Embroidery by Maison Lesage

Provenance
Brenda Gurschner (c. 1911–2006)
Born Bertha Davidoff, she married Cyril
Millward in 1931 and separated from him
around 1939, then changed her name to
Brenda Ward. She later married the
Tyrol-born artist Herbert Gurschner.
This jacket is labelled *model 65887* and
there is an indistinct inscription by
hand on the label: *Mrs Ward*
Brenda Gurschner donated a
Schiaparelli evening ensemble to the
Victoria and Albert Museum (inv.
T.235&A-1976).

Further reading
Wilcox 2014, p. 70

Comparable examples
Two further jackets are in museum
collections. One, like the present
example, labelled *Schiaparelli / 21 place
Vendôme Paris / Printemps 1939*, is in the
Metropolitan Museum of Art
(inv. C.I.50.34.2). A second jacket,
labelled *Schiaparelli / London*, is in the
National Gallery of Victoria
(inv. 2019.461.a-b).

43.
Gabrielle Chanel
Evening dress with chiffon veil
Silk chiffon, lace, tulle
Autumn/Winter 1939

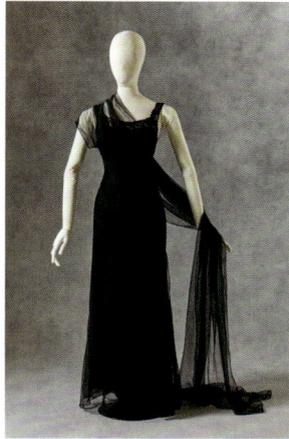

43.
Notes
A photograph taken in August 1939 in
Paris shows a model wearing the same
dress on Chanel's final runway (fig. 36).
When France declared war on
Germany in September of 1939,
Gabrielle Chanel closed her couture
house, declaring that 'This is no time
for fashion.' She reopened it in 1954.

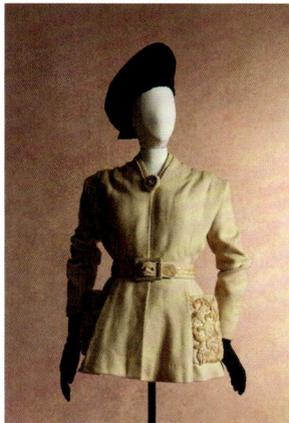

44.
Jacques Fath
Jacket
Wool twill, plaited straw
Unlabelled
c. 1944–45
Embroidery by Maison Lesage

Further reading
Plaire - Numéro De Luxe 1945, illustration,
n.p. (fig. 37)

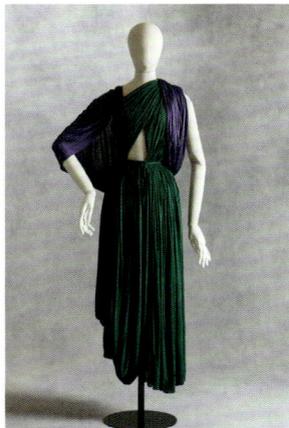

45.

45.
Grès
Evening dress
Silk jersey
Unlabelled
c. 1946

Further reading
Femina November 1946, illustration, p. 79
La Femme Chic Noël 1946, photograph,
p. 42 (fig. 38)

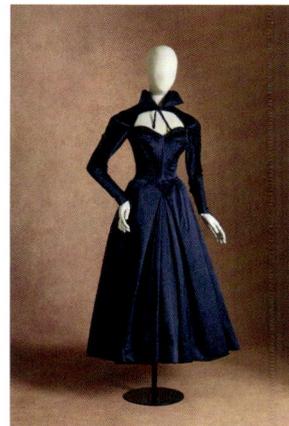

46.
Charles James
Cocktail dress, 'Infanta'
Silk satin
American, 1946–50

Comparable examples
An identical version in grey faille, gifted
by Muriel Bultman Francis, is in the
Metropolitan Museum of Art (inv.
2009.300.447).[11]

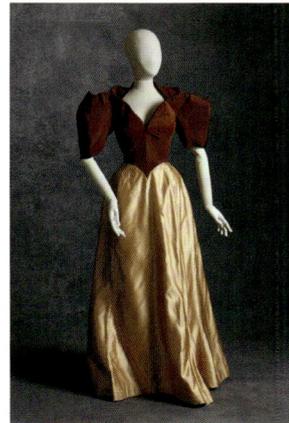

47.
Charles James
Evening gown
Silk faille, silk satin
Unlabelled
American, c. 1948

Provenance
Muriel Bultman Francis (1908–1986)

Comparable examples
A variation of this dress, in silver and
dark-grey silk with a sculptural shorter
skirt, is in the Chicago History Museum
(inv. 1960.487a), and a ballgown with
over-bodice, in black and silver satin is

in the Phoenix Art Museum (inv.
2008.61.A). Both gowns also play with
the same idea of origami sleeves and
colour blocking.
Another variation of this dress,
photographed by James's school friend
Cecil Beaton, is published in American
Vogue 1 March 1948, p. 215 (fig. 39).

Notes
Muriel Bultman Francis, a public
relations specialist and philanthropist,
donated twenty-one pieces designed
by James to the Brooklyn Museum,
probably encouraged by James.[12] (The
Brooklyn Museum Costume Collection
is now at the Metropolitan Museum of
Art.)

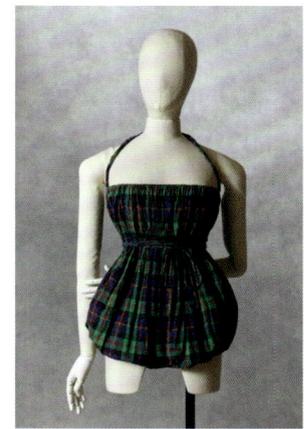

48.
Claire McCardell
Bathing suit/Playsuit
Cotton
American, c. 1945

Notes
Labelled: *claire mccardell clothes / by
townley*

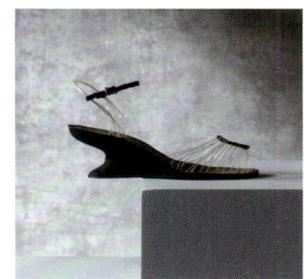

49.
Salvatore Ferragamo
'Invisible' sandals
Nylon thread, black suede, beige kid,
wood, leather
Italian, 1947

Further reading
American *Vogue* 15 October 1947,
photograph, p. 137 (fig. 41)

Comparable examples
Identical pairs are in the Victoria and
Albert Museum (inv. T.391&A-1989) and
the Los Angeles County Museum (inv.
AC1992.246.1). A pair in gold leather is in

the Metropolitan Museum of Art (inv. 2009.300.3781a-b).

Notes
Salvatore Ferragamo (1898–1960) was aware of the importance of comfort and innovation for his impressive client list. He launched the wedge heel (used in this example) in 1937. It was successful because of the comfort it afforded the wearer.

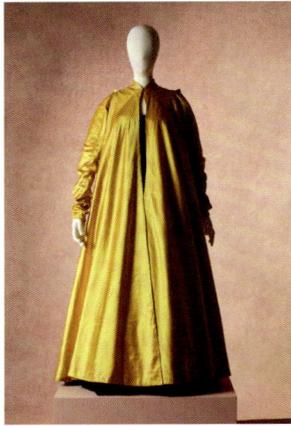

50.
Jacques Fath
Evening cape with detachable hood and sleeves
Silk satin
c. 1947

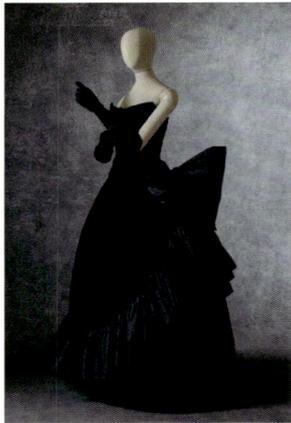

51.
Maggy Rouff
Ballgown
Velvet, silk, tulle, satin lining
c. 1948

Comparable examples
Other Maggy Rouff gowns similar in style are illustrated in French *Vogue* April 1948, pp. 53 and 100.

52.
Cristóbal Balenciaga
Dinner or cocktail dress
Wool
c. 1948

Notes
A dress with similarities of construction, dated to 1947, is in the collection of The Metropolitan Museum of Art (inv. 1984.55a-b).

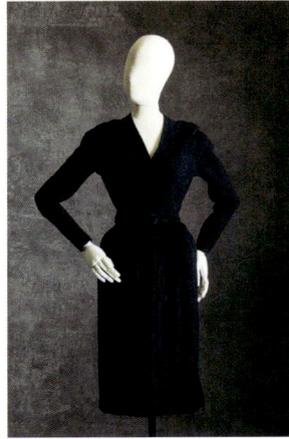

52.

53.
Cristóbal Balenciaga
Hat
Wool felt, velvet, metallic threads, sequins, beads
c. 1946

Exhibited
India in Fashion, Nita Mukesh Ambani Cultural Centre, Mumbai, 2023

Notes
This hat references an Indian nobleman's headwear and the feather appears to mimic a *sarpech* (turban ornament). The metal thread embroidery with sequins and beads could be of Indian origin.

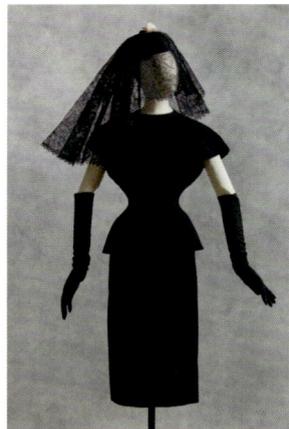

54.
EISA (Cristóbal Balenciaga)
Day or cocktail ensemble
Wool crêpe, silk crêpe
Spanish, c. 1950

54.
EISA (Cristóbal Balenciaga)
Lace-covered hat
Lace, pink rose
Spanish, c. 1967

Further reading
A version is published in American *Vogue* 15 April 1967, p. 72.

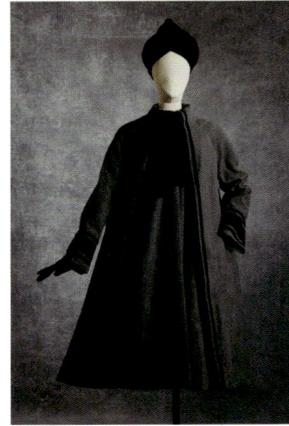

55.
Christian Dior
Coat, 'Briquette'
Wool twill, wool tape, silk velvet lining
Autumn/Winter 1950–51, 'Ligne Oblique'

Further reading
Harper's Bazaar September 1950, illustration, p. 241 (fig. 42)
Fury & Sabatini 2017, p. 46

Paulette
Turban hat
Silk velvet, felt
c. 1942

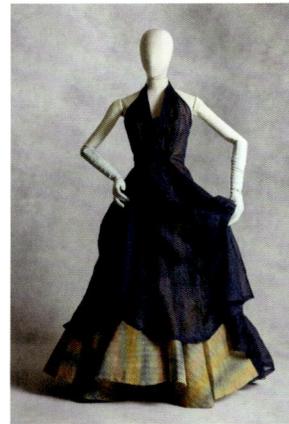

56.
Elsa Schiaparelli
Evening gown
Silk organza, silk taffeta
c. 1947–50

57.
Elsa Schiaparelli (Hubert de Givenchy)
Evening waistcoat with matching gloves
Silk satin, glass beads, rhinestones, chamois leather, fur, chenille, silk taffeta

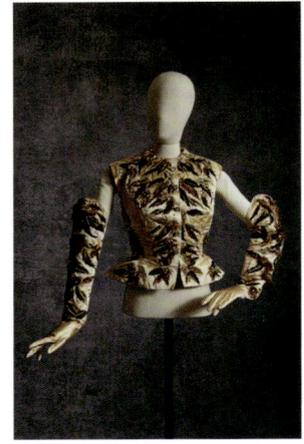

57.
Spring 1951
Embroidery by Maison Lesage

Further reading
White 1986, pp. 138–39
Fondation de la Mode 1989, pp. 196–98
White 1994, pp. 68–69
Carron de la Carrière 2022, pp. 186–89

Comparable examples
An evening jacket with the same chestnut motif embroidery is in Musée des Arts Décoratifs, Paris (inv. UF 73-21-54).[13]

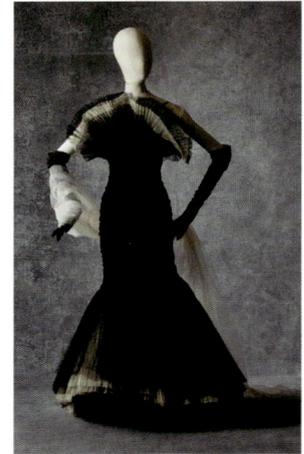

58.
Jacques Fath
Evening gown
Cotton, synthetic fibre
c. 1950

Comparable examples
An identical dress is in the Metropolitan Museum of Art (inv. 1976.117.1).

59.
Cristóbal Balenciaga
Evening dress and bolero
Lace, silk faille, organza, horsehair
Spring 1952

Provenance
Elizabeth Parke Firestone (1897–1990)

Notes
Elizabeth Parke Firestone, wife of

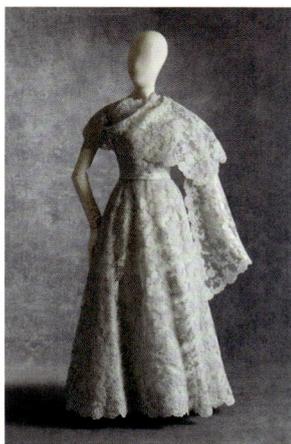

59.
tyre magnate Harvey S. Firestone, Jr, was an important client of Balenciaga and was in the privileged position of being able to negotiate changes in styles with the couturier.[14] A letter from Mrs Firestone to her *vendeuse* Alice Laporte at Balenciaga, from April 1955, contains an order for seven dresses and suits, and gives very clear instructions in terms of material to be used, length of hemlines, height of armholes, changes to the number of buttons and extra fabric to be sent to M. Delicata to have matching shoes made (Henry Ford Museum, inv. 89.492.1697.62).
Firestone's gowns by couturiers such as Christian Dior and Cristóbal Balenciaga are in the collections of the Metropolitan Museum of Art and the Henry Ford Museum.

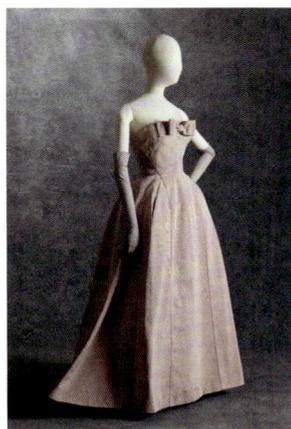

60.
Christian Dior
Ballgown, possibly 'Clorinde'
Silk moiré, tulle, organza
c. 1952

61.
Lanvin-Castillo
Day ensemble
Cotton, glass beads, metallic floret sequins, gold thread, twisted yarn
Spring Boutique, 1954

Notes
After Jeanne Lanvin's death, Antonio del

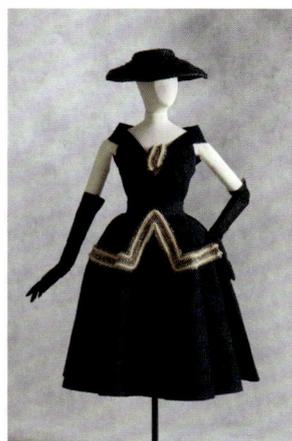

61.
Castillo was hired as head designer in 1950 and remained with the house until 1962.

EISA (Cristóbal Balenciaga)
Hat
Raffia
Spanish, c. 1950

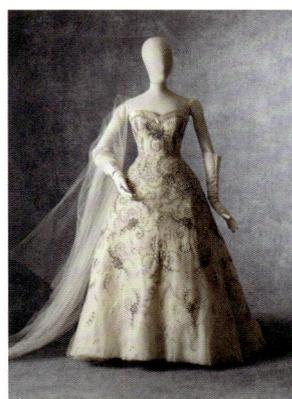

62.
Jacques Fath
Ballgown, 'Sandrine'
Tulle, satin, horsehair, glass beads, paillettes
Spring/Summer 1954

Exhibited
Jacques Fath: Les années 50, Musée Galliera, 1993, no. 39

Published
Guillaume 1993, pp. 156, 159

Further reading
Paris Match February–March 1954, photograph, n.p. (fig. 43)

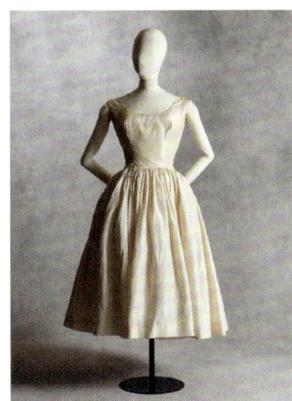

63.

63.
Hubert de Givenchy
Cocktail dress
Silk taffeta, net
c. 1954

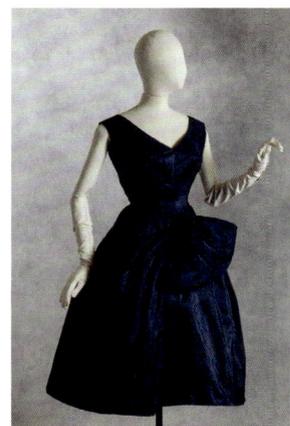

64.
Jacques Fath
Cocktail dress
Silk taffeta
c. 1955

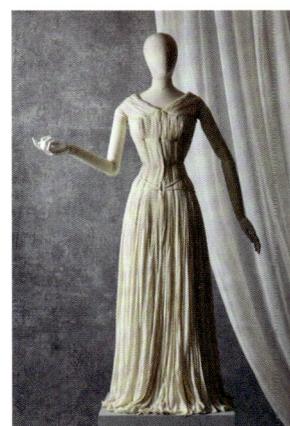

65.
Grès
Evening dress
Silk jersey
Late 1950s

Exhibited
Madame Grès, la couture à l'oeuvre, Musée Galliera at the Musée Bourdelle, 2011

Published
Saillard 2011, pp. 59, 199, cat 50

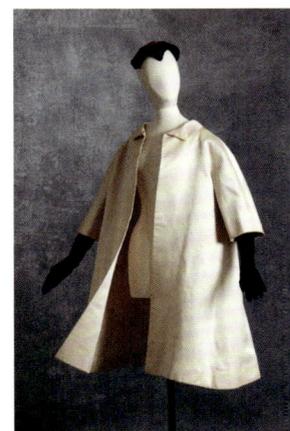

66.

66.
Cristóbal Balenciaga
Evening coat
Silk satin
c. 1959

Provenance
Tina Chow (1950–1992)

Published
Martin & Koda 1992, pp. 60, 62–63

Notes
Tina Chow was a model, a jewellery designer and a couture collector. She assembled a large and important collection of twentieth-century fashion, some of which was exhibited in *FLAIR: Fashion collected by Tina Chow* (organised by the Fashion Institute of Technology, New York and the Kyoto Costume Institute) in 1992. Her collection ranged from the vernacular to the couture and included pieces by Cristóbal Balenciaga, Mariano Fortuny, Paul Poiret, Madeleine Vionnet, Charles James and Elsa Schiaparelli.[15] She sometimes wore pieces from her collection, especially her 'Delphos' dresses.

Cristóbal Balenciaga
Hat
Lurex plush, velvet, horsehair, gold braid
Unlabelled
1950s

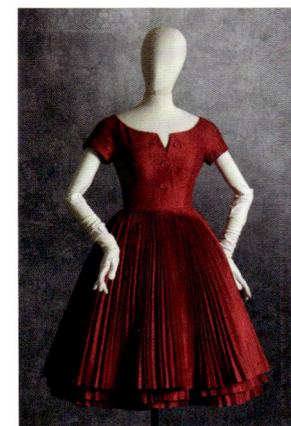

67.
Christian Dior (Yves Saint Laurent)
Cocktail dress
Slubbed silk twill weave
Spring/Summer 1959 'Ligne Longue – Silhouette Naturelle'

Comparable examples
A similar dress from the 'Ligne Longue' collection is called 'Hazel'.[16]

68.
Christian Dior (Yves Saint Laurent)
Cocktail dress, 'Artemise'
Silk faille, lace, organza, tulle, nylon, horsehair
Autumn/Winter 1959

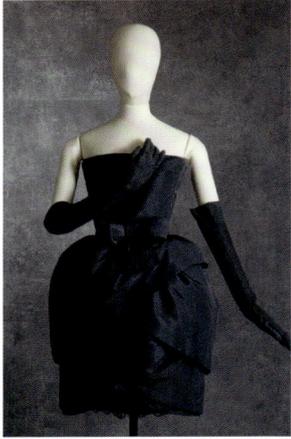

68.

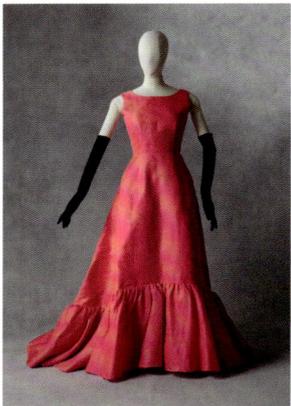

69.
Cristóbal Balenciaga
Evening dress
Silk gazar, rayon taffeta lining,
horsehair
Spring 1961

Comparable examples
An identical dress and matching stole
are in the collection of the Fondation
Alaïa, Paris.[17] A similar dress of yellow
gazar is in the Musée des Arts
Décoratifs, Paris (inv. 69-10-13AB).

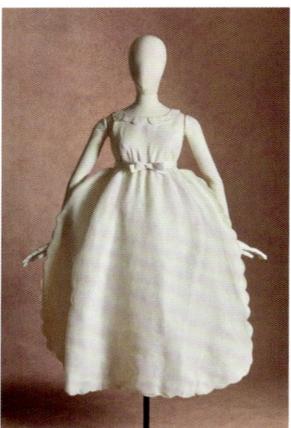

70.
André Courrèges
Evening or bridal dress
Silk organdie, organdie
c. 1962

71.
André Courrèges
Ballerinas
Leather
1965

71.

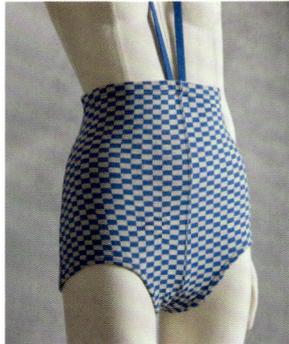

72.
Rudi Gernreich
Monokini
Wool
American, 1964

Further reading
Fukai 2002, p. 596

Comparable examples
Different colourways of this swimsuit
are in the Museum at the Fashion
Institute of Technology (inv. 2003.73.1),
the Cincinnati Art Museum (inv.
1989.50), the Metropolitan Museum of
Art (inv. 1986.517.13) and the Kyoto
Costume Institute (inv. AC10127 99-27).

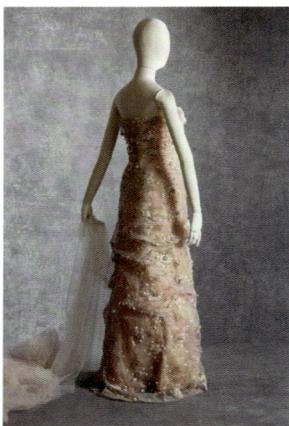

73.
Hubert de Givenchy
Evening gown
Silk organza, silk tulle, taffeta, satin,
mother of pearl, glass beads, sequins,
rhinestones
Spring/Summer 1963

Published
American *Vogue* 15 April 1963,
pp. 64–65 (fig. 47)

Notes
Hubert de Givenchy's S/S 1963
collection featured several designs

with this ruched and draped style.[18]
The almost oversized effect is one of
the signatures of this season. The
dress does not feature a couture
number underneath the label, which
indicates that this was the runway
sample, and most likely the example
worn by Audrey Hepburn for the *Vogue*
photoshoot.[19] This is confirmed by the
dimensions, which correspond nearly
exactly to Hepburn's measurements.[20]
Hepburn is known to have borrowed
runway samples from Givenchy for
photoshoots and events, while also
acquiring haute couture pieces for her
personal wardrobe. No other examples
of this design are known.

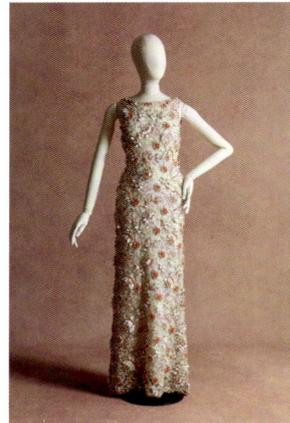

74.
Cristóbal Balenciaga
Evening dress
Embroidered silk net, silk crêpe, plastic
beads, bugle beads
Spring 1965

75.
Jeanne Lanvin
Hat
Wool felt
c. 1944

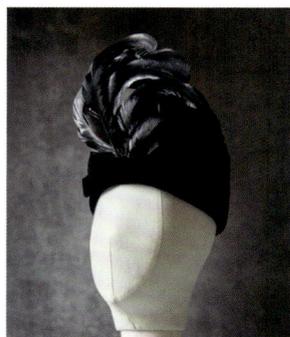

76.

76.
EISA (Cristóbal Balenciaga)
Hat with cockerel cockade
Silk velvet, cockerel feathers
Spanish, c. 1965

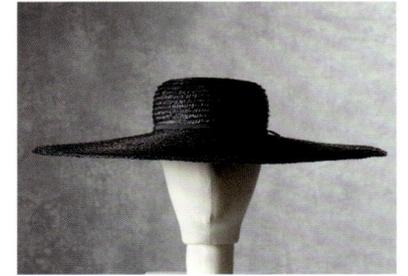

77.
EISA (Cristóbal Balenciaga)
Straw hat
Plaited straw
Spanish, 1967

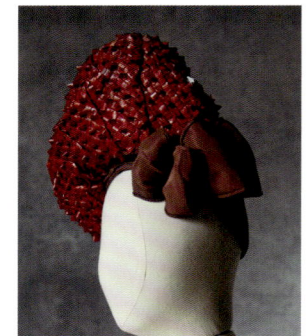

78.
Jeanne Lanvin
Hat
Silk, plaited straw
c. 1943

79.
Jeanne Lanvin
Coiffe (cap), 'Rango'
Glazed (*ciré*) grosgrain cord
c. 1934

Notes
This *coiffe* is part headdress part
wig, and gives the illusion of a
hairstyle.
A coat from 1928 using comparable
tape is in the Palais Galliera (inv.
GAL1979.108.1).[21]
A drawing for 'Rango' (1934) is with the
Patrimoine Lanvin.

80.
Yves Saint Laurent
Tunic dress

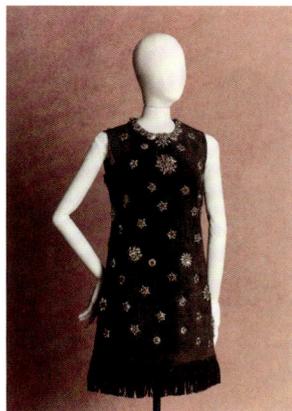

80.
Suede, embroidered with rhinestones, faceted marquis crystals and faceted silver beads
Autumn/Winter 1968

Further reading
Vreeland 1968, pp. 116–17 [a variant of this dress is seen in a photograph by Irving Penn of Marisa Berenson, worn with a magenta satin poet's blouse and black velvet trousers]

Comparable examples
Another version of this dress, with differently coloured beading, is in the Metropolitan Museum of Art (inv. 1977.59.6).

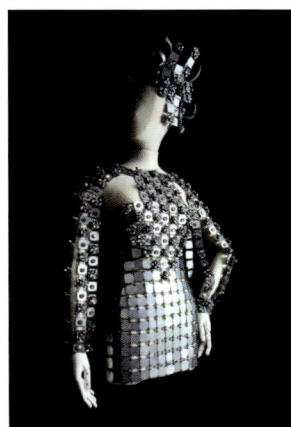

81.
Paco Rabanne
Mini-dress (shown with headdress reconstruction)
Metal plates, rings and curls; paste florets
Unlabelled
Autumn/Winter 1968–69

Provenance
This dress belonged to a friend of Paco Rabanne, who used to sell his dresses in her Geneva boutique between 1967 and 1971.

Comparable examples
An identical dress is in the Costume Museum of Canada, Winnipeg.

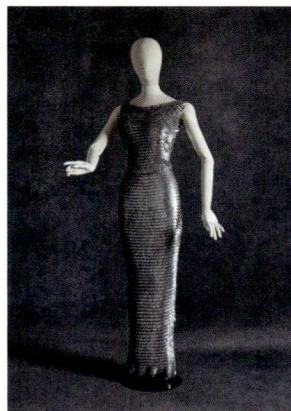

82.
Paco Rabanne
Evening dress
Knitted cotton mesh, metal washers
Unlabelled
Autumn/Winter 1967–68

Provenance
Béatrice Arnac (1931–2020)

Notes
Arnac, a French singer, songwriter and actress, wore this gown on stage. She also wears it on the cover of a self-titled LP, released in 1969 by Disques Vogues (photographed by Philip E. Fresco).

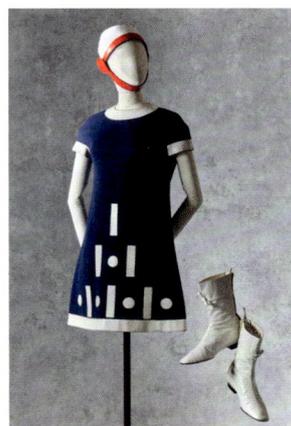

83.
Pierre Cardin
Dress
Wool jersey, vinyl appliqués
1969

Further reading
L'Officiel de la Couture et de la Mode de Paris March 1969, dress worn in advert for Jersey 'Le point de Paris' de J. Léonard, n.p.

Comparable examples
An identical dress is in the Museum at the Fashion Institute of Technology, New York (inv. 80.261.9).

Pierre Cardin
Helmet, 'Apollo'
Vinyl, wool felt lining
1969

Further reading
Similar Pierre Cardin astronaut or 'Apollo' helmets were featured in L'Officiel de la Couture et de la Mode de Paris March 1969.[22]

André Courrèges
Boots, 'Go Go'
Leather, Velcro
1966

Comparable examples
Identical pairs are in the Victoria and Albert Museum (inv. T.109&A-1974) and the Fashion Institute of Design and Merchandising Museum, Los Angeles (inv. 2008.5.47AB).

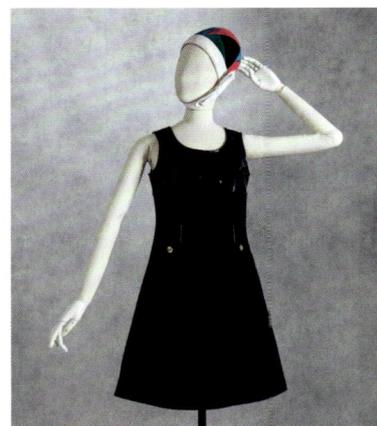

84.
André Courrèges
Dress
Wool, vinyl
1969

Comparable examples
An identical dress is in the Museum of Fine Arts, Houston (inv. 99.516).

Yves Saint Laurent
Helmet hat
Felted wool, leather
c. 1965

Comparable examples
The same hat in a different colourway is in the Philadelphia Museum of Art (inv. 2009-169-1).

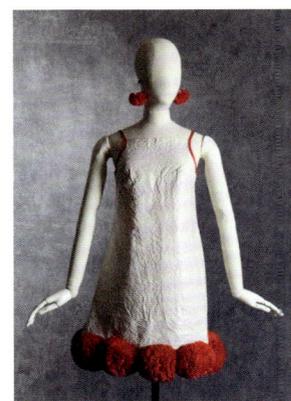

85.
Miss Paper
Dress and earrings
Plastic-coated paper, plastic pom-poms
American, 1967

Comparable examples
An identical dress with blue pom-poms is in the Museum of the City of New York (inv. 67.92.1).

Notes
The label states: *Warning: Do not wash or dry clean. Fabric is fire-resistant, but becomes dangerously flammable after washing.*

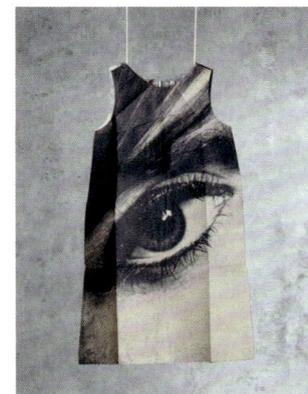

86.
Harry Gordon
Mini-dress, 'Mystic Eye'
Printed 'paper' (75% rayon and 25% nylon)
American, 1968

Comparable examples
Identical dresses are in various museum collections such as the Kyoto Costume Institute (inv. AC9754 99-1-1), the Fine Arts Museums of San Francisco (inv. 1999.41) and the Metropolitan Museum of Art (inv. 2018.583).

Notes
Harry Gordon (1930–2007) designed this dress as one of a group of five 'poster' dresses. The original packaging suggests to the wearer: 'When you're finally tired of wearing it, why not … Cut open all the seams and hang it on your wall as a poster … or cover pillows … or wrap packages … or as your collection grows, sew them together to make a bedspread or curtains or a table-cloth.'

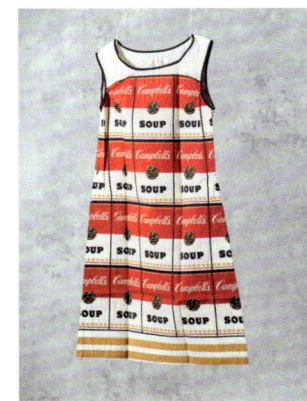

87.
Campbell Soup Company
'Souper dress'
Screen-printed wood pulp and cotton
American, c. 1967

Comparable examples
Identical dresses are in the Museum of Fine Arts Boston (inv. 2003.135), the Metropolitan Museum of Art (inv. 1995.178.3) and the Kyoto Costume Institute (inv. AC9561 98-14-2).

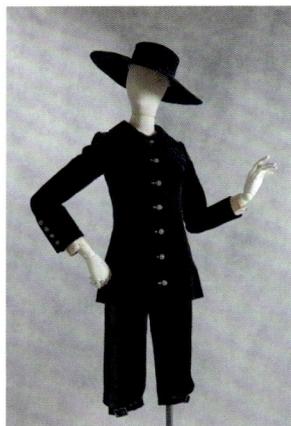

88.
Yves Saint Laurent
Evening suit with hat
Silk velvet, satin, faux-pearl cufflinks, faceted stones, grosgrain ribbon, nylon lining to hat
Autumn/Winter 1967–68

Further reading
French *Elle* August 1967, photograph, n.p. [for a photograph of Twiggy in an identical suit from the same photoshoot, see fig. 54]
New York Times 1 August 1967, illustration, p. 26
L'Officiel de la Couture et de la Mode de Paris September 1967, photograph, p. 110
Bergé 1997, pp. 20, 75 [image of Jean Shrimpton in a similar suit]
Menkes & Flaviano 2019, p. 109

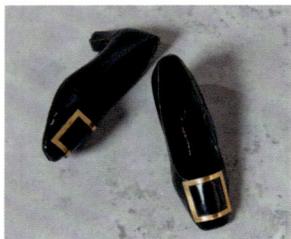

88a.
Roger Vivier
'Pilgrim Pumps', paired with no. 88
Patent leather, goldtone metal buckle
1967

Notes
With the low-heeled buckled 'Pilgrim Pumps', used by Yves Saint Laurent in the ground-breaking 1965 Mondrian collection, Roger Vivier (1907–1998) responded effortlessly to the new aesthetic of the 1960s. For a generation of fashionable women it was the go-to shoe and was worn by Catherine Deneuve in Luis Buñuel's 1967 seminal film *Belle de Jour* to signal her character's 'haute bourgeoise' status.[23]

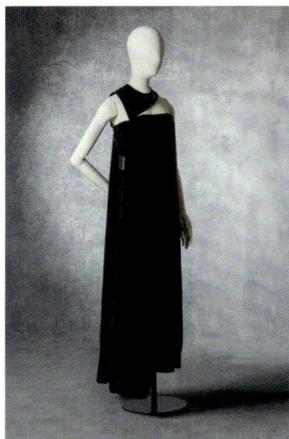

89.
Grès
Evening dress
Silk velvet
Autumn/Winter 1968

Further reading
L'Officiel de la Couture et de la Mode de Paris September 1968, advertisement, n.p. (fig. 55)

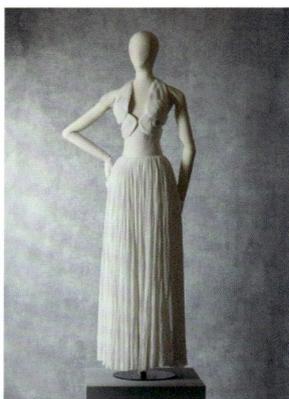

90.
Grès
Evening dress
Silk jersey
Spring/Summer 1975

Further reading
New York Times 10 October 1975, photograph, p. 42

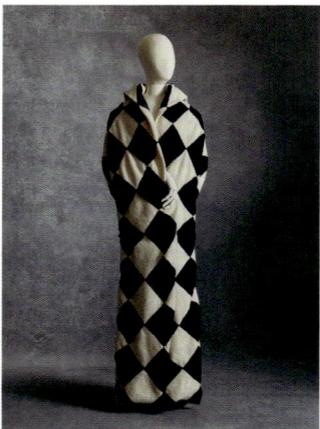

91.
Yohji Yamamoto
Cape coat
Wool bouclé, panné velvet, nylon lining
Japanese, Autumn/Winter 1997–98

Comparable examples
Another example was exhibited in *Yohji Yamamoto*, Victoria and Albert Museum, 2011

Further reading
Fukai, Vinken, Frankel & Kurino 2010, pp. 190–91 [photograph by Annie Leibovitz, published in American *Vogue* (September 1997), shows model wearing the coat]

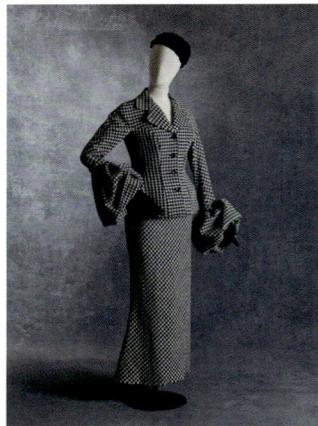

92.
Yohji Yamamoto
Suit
Wool houndstooth, cupro lining
Japanese, Autumn/Winter 2003–04

Further reading
Fukai, Vinken, Frankel & Kurino 2010, pp. 192–93 [black silk crêpe de Chine version published]

Caroline Reboux
Hat
Velvet, silk lining
c. 1950

93.
Hussein Chalayan
Dress, 'Airmail'
Tyvek
British, 1999

Comparable examples
'Airmail' dresses are in the Metropolitan Museum of Art (inv. 2013.588a-b), the Central Saint Martins Museum & Study Collection (inv. FA.47.CC) – Chalayan's alma mater – and the National Museums of Scotland (inv. K.2015.4).

A Tyvek jacket version was worn by Björk on the cover of her 1995 album *Post*.

Notes
Hussein Chalayan's (1970–) Tyvek dress, printed with a patten replicating airmail stationary, folds into an envelope. Referencing the paper clothes from the 1960s, the dress is characteristic of the designer's conceptual approach to fashion. The design and fabric of this dress encouraged the owner to customise it and mail it, thus making the consumer an integral part of the design process. The dress was produced in an edition of around 200.

Notes to catalogue

1. Deslandres 1986, p. 103.
2. See Beaussant Lefèvre 2008, lot 52, p. 21.
3. Reproduced in PIASA 2005, vol. 2, p. 132.
4. Blackman 2015, pp. 118–20.
5. PIASA 2005, vol. 2, p. 173.
6. Koda & Bolton 2007, p. 162.
7. Information given at the time of the PIASA auction in 2005 by Denise Boulet-Poiret's granddaughter Sophie Rang des Adrets; see also Cora Ginsburg 2020, pp. 8–11.
8. See Palais Galliera 1986, p. 187.
9. Illustrated in Martin & Koda 1994, p. 69.
10. Video of Maison Bruyère fashion show 1934.
11. See also Coleman 1982, p. 130, cat. 154.
12. Ibid.
13. See Carron de la Carrière 2022, pp. 186–89.
14. Miller 2007, p. 28.
15. Martin & Koda 1992, p. 19.
16. See Benaïm 2017, pp. 126–27.
17. See Saillard 2020, n.p.
18. Samson & Madsen 2023, pp. 166–67.
19. 'The Givenchy Idea', article in American *Vogue* 15 April 1963, pp. 64–73, 146.
20. Bust: 82 cm; Waist: 60.5 cm; CB: 141 cm.
21. See Palais Galliera Paris 2015, pp. 252–53, 307, cat. 65.
22. See *L'Officiel de la Couture et de la Mode de Paris* March 1969, cover, J. Léonard advertisement, p. 6.
23. Blackman 2015, p. 121.

Bibliography

Ahlawat, Deepika (2009) 'Nizam Osman Ali Khan Asaf Jah of Hyderabad', in Jackson, Anna and Jaffer, Amin (eds) *Maharaja: The Splendour of India's Royal Courts*. London: V&A Publishing, pp. 190–91.

Art Goût Beauté (1923), May, illustration, n.p.

Bardakçı, Murat (2008) *Son Osmanlılar*. Istanbul: Inkilap.

Başaran, Betül (2023) 'Women's Transnational Networks and Philanthropic Work in Hyderabad State before Partition', *Mulberry Magazine*, St Mary's College of Maryland, Spring.

Bauër, Gérard (1924–1925) 'Les collections des grands couturiers pour la saison 1924–1925: Chez Paul Poiret', *Gazette du Bon Ton*, no. 2, pp. 54–56.

Beaussant Lefèvre (2008) *Vêtements et accessoires provenant de la garde-robe de Denise Boulet-Poiret*. Auction catalogue. Auction experts Chombet & Sternbach.

Benaïm, Laurence (2017) *Dior by Yves Saint Laurent: Yves Saint Laurent: 1958–1960*. New York: Assouline Publishing.

Bergé, Pierre (1997) *Yves Saint Laurent Fashion Memoir*. London: Thames & Hudson.

Blackman, Cally (2015) 'The Rise of the Celebrity Shoe Designer', in Persson, Helen (ed.), *Shoes: Pleasure & Pain*. London: V&A Publishing, pp. 114–23.

Blum, Dylis (2020), 'Elsa Schiaparelli and the Art of Illusion', 2 April, https://www.ngv.vic.gov.au/essay/elsa-schiaparelli-and-the-art-of-illusion/.

Bolton, Andrew, Regan, Jessica and Huber, Mellissa (2019) *In Pursuit of Fashion: The Sandy Schreier Collection*. New York: Metropolitan Museum of Art.

Bombicci, Luigi (1881) *L'Appennino Bolognese: Descrizioni e Itinerari*. Bologna: Tipografia Fava e Garagnani.

Bowles, Hamish (2023) *India in Fashion: The impact of Indian Dress and Textiles on the Fashionable Imagination*. London: Nita Mukesh Ambani Cultural Centre, Rizzoli Electra.

Brix, Walter (2003) *Der goldene Faden – Bestandskatalog der Textilien aus China, Korea und Japan im Museum für Ostasiatische Kunst*. Cologne: Wienand Verlag.

Bucher, Antoine and Pecorari, Marco (2021) *Alaïa and Poiret: Exploring Fashion Heritage*. Paris: The New School Parsons Paris and the Fondation Azzedine Alaïa.

Bucher, Antoine and Montagne, Nicolas (2006) *Paul Poiret*. Lens: Diktats.

Calahan, April and Zachary, Cassidy (2015) *Fashion and the Art of Pochoir: The Golden Age of Illustration in Paris*. London: Thames & Hudson.

Carron de la Carrière, Marie-Sophie (ed.) (2022) *Shocking: Les mondes surréalistes d'Elsa Schiaparelli*. Paris: Musée des Arts Décoratifs.

Caviglioli, François (1974) 'Les robes 74 c'est la mode de grand'mère', *Nouveau Paris MATCH*, no. 1292, 9 February, pp. 53–57.

Cézan, Claude (1967) *La mode: phénomène humain*. Paris: Edouard Privat.

Chalayan, Hussein (2015) 'My Life as an Outsider', TED talk, March, https://www.youtube.com/watch?v=-gMZeqI_3Uw.

Chen, Jun, De Ioanni, Maria Ida and Hernández, Renata (2021) 'Interview with Sophie Grossiord, Fashion Curator at Palais Galliera Musée de la mode de la Ville de Paris, Paris 29th March 2021', in Bucher, Antoine and Marco Pecorari (eds), *Alaïa and Poiret. Exploring Fashion Heritage*. Paris: The New School Parsons Paris and the Fondation Azzedine Alaïa, pp. 79–83.

Claude-Salvy (1966) *Le Monde et La Mode*. Paris: Hachette.

Coleman, Elizabeth Ann (1982) *The Genius of Charles James*. New York: The Brooklyn Museum.

Cora Ginsburg (2020) *A Catalogue of 20th Century Costume & Textiles*. New York: Cora Ginsburg LLC.

Da Costa, Bernard (1965) 'Cardin, Courrèges, Saint-Laurent, Venet. The Four Young Lions of Paris Fashion', *Réalités*, November, pp. 48–53.

De la Haye, Amy (2011) *Chanel – Couture and Industry*. London: V&A Publishing.

Demornex, Jacqueline (1990) *Madeleine Vionnet*. New York: Rizzoli.

Deslandres, Yvonne (1986) *Poiret*. Paris: Éditions du Regard.

Dim Dam Dom (1966) TV series. Office national de radiodiffusion télévision française, produced by Daisy de Galard, 29 July.

Dorogova, Waleria and Baudin, Katia (eds) (2022) *Maison Sonia Delaunay*. Berlin: Kunstmuseen Krefeld, Hatje Cantz.

Dorogova, Waleria and Microulis, Laura (2024) *Sonia Delaunay Living Art*. New York: Bard Graduate Center, Yale University Press.

Du Roselle, Bruno (1973) *Crise de la Mode; la révolution des jeunes et la mode*. Paris: Fayard.

L'Éclaireur du Dimanche Illustré (1931), no. 458 XII Année, November, front cover, pp. 1–3.

Elle (1948), French edition, 'La princesse a 600 voitures', no. 178 4 May, p. 3.

Elle (1967), French edition, August, photograph, n.p.

Evans, Caroline (2013) *The Mechanical Smile: Modernism and the First Fashion Shows in France and America, 1900–1929*. New Haven: Yale University Press.

Felscher, Lynn (1997) *The Saris of Princess Niloufer*, exhibition brochure. New York: The Museum at the Fashion Institute of Technology.

Femina (1938), June, advertisement, p. 64.

Femina (1946), November, illustration, p. 79.

Ferretti, Daniela (2017) 'Henriette Fortuny, portrait d'une muse', in Da Roit, Christina and Caloi, Ilaria (eds), *Mariano Fortuny: Un Espagnol à Venise*. Palais Galliera Paris Musées, pp. 101–04.

Fondation de la Mode (1989) *LESAGE Maître-Brodeur 1880–1988*. Tokyo: Toppan Printing.

Fukai, Akiko (2002) *Fashion: A History from the 18th to 20th Century*. Taschen: Collection of the Kyoto Costume Institute.

Fukai, Akiko, Vinken, Barbara, Frankel, Susannah and Kurino, Hirofumi (2010) *Future Beauty: 30 Years of Japanese Fashion*, ed. by Ince, Catherine and Nii, Rie. London: Merrell Publishers.

Fury, Alexander and Sabatini, Adélia (2017) *Dior Catwalk*. London: Thames & Hudson.

Galahead, Philippe (1974), *Réalités*, April, cover and pp. 62–63.

Georg, Matthias and Köhler, Bettina (2010) 'Herausfordernde Zusammenarbeiten, Bedeutung und Beitrag der Firma Abraham zur Entwicklung der Mode', in Schweizerisches National Museum, *Soie Pirate Geschichte der Firma Abraham*, vol. 1. Zurich: Scheidegger & Spiess, pp. 184–89.

Grumbach, Didier (1993) *Histoires de la Mode*. Paris: Seuil.

Guillaume, Valérie (1993) *Jacques Fath*. Paris : Paris Musées, Société nouvelle Adam Biro.

Harper's Bazaar (1929), November, photograph, p. 81.

Harper's Bazaar (1936), October, photograph, p. 130.

Harper's Bazaar (1950), September, photograph, p. 241.

Herald Express (11 November 1952) 'Received £75,000', p. 5.

Hill, Colleen (ed.) (2017) *Paris Refashioned 1957–1968*. New Haven and London: Yale University Press.

d'Houville, Gérard (1911) 'Un Magicien', *Le Figaro*, 1 May, n.p.

Huber, Mellissa (2023) 'The "Delphos" Gown. A History Hidden in Plain Sight', in Huber, Mellissa and Van Godtsenhoven, Karen (eds), *Women Dressing Women: A Lineage of Female Fashion Design*. New York: The Metropolitan Museum of Art, pp. 180–81.

Institut de France, Musée Jacquemart-André (1974) *Poiret le Magnifique*, preface by Julien Cain. Paris: Musée Jacquemart-André.

Jackson, Anna and Jaffer, Amin (eds) (2009) *Maharaja: The Splendour of India's Royal Courts*. London: V&A Publishing.

Jaffer, Amin (2009) 'Indian Princes and the West', in Jackson, Anna and Jaffer Amin (eds) *Maharaja: The Splendour of India's Royal Courts*. London: V&A Publishing, pp. 194–227.

Jardin des Modes (1938), vol. 18, no. 258, 1 June, cover.

Journal des étrangers (1935), 1 March, photograph, p. 27.

Kamitsis, Lydia (1996) *Paco Rabanne, les sens de la recherché*. Paris: Michel Lafon.

Koda, Harold and Bolton, Andrew (2007) *Poiret*. New York: Metropolitan Museum of Art; New Haven: Yale University Press.

Koda, Harold, Reeder, Jan Giler, Rucci, Ralph, Scaturro, Sarah and Petersen, Glenn (2014) *Charles James: Beyond Fashion*. New York: The Metropolitan Museum of Art.

Kumar KG, Pramod (2015) 'Incognito: Photographs of Women across Princely India', in Poddar, Abhishek and Gaskell, Nathaniel (eds) *Maharanis: Women of Royal India*. Ahmedabad, India: Mapin Publishing in association with Tasveer, pp. 21–37.

La Femme Chic (Noël 1946), photograph, p. 42.

Längle, Elisabeth (2005) *Pierre Cardin: Fifty Years of Fashion and Design*. London: Thames & Hudson.

Legris, Michel (1966a) 'Les Laboratoires de la Mode', *Le Monde*, no. 6695, 23 July.

Legris, Michel (1966b) 'Les Laboratoires de la Mode', *Le Monde*, no. 6696, 24–25 July.

Les Modes (1912), no. 138, June, illustration, p. 15.

Les Modes (1912), no. 139, July, illustration, p. 9.

Les Modes (1912), no. 141, September, cover.

Lever, Stephanie, Trame, Ilaria and Wu, Jiaxuan (2021a) 'Interview with Antoine Poiret, Grandson of Paul and Denise Poiret, Paris, 30th March 2021', in Bucher, Antoine and Marco Pecorari (eds), *Alaïa and Poiret. Exploring Fashion Heritage*. Paris: The New School Parsons Paris and the Fondation Azzedine Alaïa, pp. 43–48.

Lever, Stephanie, Trame, Ilaria and Wu, Jiaxuan (2021b) 'Interview with Charlotte Poiret, Granddaughter of Paul and Denise Poiret, Paris, 29th March 2021', in Bucher, Antoine and Pecorari, Marco (eds), *Alaïa and Poiret. Exploring Fashion Heritage*. Paris: The New School Parsons Paris and the Fondation Azzedine Alaïa, pp. 51–55.

Martin, Richard and Koda, Harold (1992) *Flair: Fashion Collected by Tina Chow*. New York: Rizzoli.

Martin, Richard and Koda, Harold (1994) *Orientalism: Visions of the East in Western Dress*. New York: Metropolitan Museum of Art; H. N. Abrams.

Mauriès, Patrick (2020) *Maison Lesage Haute Couture Embroidery*. London: Thames & Hudson.

McEvoy, Marian (1977) 'Gres Matter', *Women's Wear Daily*, 15 February, pp. 6–7.

McNeil, Peter (2008) 'Interview with Valerie Steele, director and chief curator of the Museum at the Fashion Institute of Technology', *ACNE PAPER*, 6, Summer, pp. 46–47.

Mears, Patrica (2007) *Madame Grès: Sphinx of Fashion*. New Haven and London: Yale University Press in association with the Fashion Institute of Technology New York.

Menkes, Suzy and Flaviano, Oliver (2019) *Yves Saint Laurent Haute Couture Catwalk: The Complete Haute Couture Collections 1962–2002*. London: Thames & Hudson.

Merceron, Dean with Alber Elbaz and Harold Koda (2007) *Lanvin*. New York: Rizzoli International Publications.

Milbank, Caroline Rennolds (2023) 'The Sari in Western High Fashion during the Twentieth Century', in Bowles, Hamish (ed.), *Indian Fashion: The Impact of Indian Dress and Textiles on the Fashionable Imagination*. New York: Rizzoli Electa, pp. 134–44.

Miller, Lesley Ellis (2007) *Balenciaga: 1895–1972: The Couturiers' Couturier*. London: V&A Publications.

Miller, Lesley Ellis (2017) *Balenciaga – Shaping Fashion*. London: V&A Publishing.

Million & Robert (1992) *La mode dans l'art; Garde-Robes 1860–1980; Accessoires, Dessins et Photos de Mode*. Auction catalogue. Auction expert Françoise Auguet.

Minault, Gail (1998) *Secluded Scholars: Women's Education and Muslim Social Reform in Colonial India*. Delhi: Oxford University Press.

Mode Pratique (1936), 11 January, cover.

Monti, Gabriele (2021) 'Zurich, 1970. The Exhibition Balenciaga: Ein Meister der Haute Couture', *Fashion Theory*, vol. 25, no. 4, pp. 513–39.

Morais, Richard (1991) *Pierre Cardin: The Man Who Became a Label*. London: Bantam.

Musée de la mode et du textile (2002) *Sixties: mode d'emploi: collections du Musée de la mode et du textile*. Paris: Musée de la mode et du textile.

Musée du peigne et de la plasturgie (1998) Catalogue of the exhibition *Une vision plastique: Paco Rabanne: rencontre de la plasturgie et de la Haute Couture*. Oyonnax: Musée du peigne et de la plasturgie.

Musée Historique des Tissus Lyon (1985) *Hommage à Balenciaga*. Lyon: Herscher.

New York Times (1967), 1 August, illustration, p. 26.

New York Times (1975), 10 October, photograph, p. 42.

L'Officiel de la Couture et de la Mode de Paris (1936), no. 183, November, illustration, p. 28.

L'Officiel de la Couture et de la Mode de Paris (1954), no. 383–384, March, photograph, p. 258.

L'Officiel de la Couture et de la Mode de Paris (1967), no. 545–546, September, p. 110 (illustration), p. 368.

L'Officiel de la Couture et de la Mode de Paris (1968), no. 557–558, September, advertisement, n.p.

L'Officiel de la Couture et de la Mode de Paris (1969), no. 563–564, March, pp. 188–89, 256, 286, 328, cover, advertisement.

'Paco Rabanne' (1967) News report. Office national de radiodiffusion télévision française (ONRTF), produced by Alain de Sedouy, André Harris, 31 January.

Palais Galliera Paris (1986) *Paul Poiret et Nicole Groult: maîtres de la mode art déco*. Exhibition catalogue. Paris: Palais Galliera.

Palais Galliera Paris (2015) *Jeanne Lanvin*, Exhibition catalogue. Paris: Palais Galliera.

Paris Match (1954), February–March, photograph, n.p.

Paul Poiret: King of Fashion (1976). New York: Design Laboratory at Fashion Institute of Technology.

Pavitt, Jane (2008) *Fear and Fashion in the Cold War*. London: V&A Publishing.

Périer, Jean-Marie (1998) *Mes années 60*. Paris: Filipacchi.

PIASA (2005) *La Création en Liberté: Univers de Paul et Denise Poiret 1905–1928*. Auction catalogue, 2 vols. Auction expert Françoise Auguet.

Picardie, Justine (2023) *Coco Chanel: The Legend and the Life*. London: Harper Collins Publishers.

Plaire – Numéro De Luxe (1945), no. 4-5-6, illustration, n.p.

Poddar, Abhishek, and Gaskell, Nathaniel (eds) (2015) *Maharanis: Women of Royal India*. Ahmedabad, India: Mapin Publishing in association with Tasveer.

Poiret, Paul (1931) *My First Fifty Years*. Translated by Stephen Haden Guest. London: Victor Gollancz.

Polle, Emmanuelle (2013) *Jean Patou: Une vie sur mesure*. Paris: Flammarion.

Pritchard, Jane (ed.) (2010) *Diaghilev and the Golden Age of the Ballets Russes 1909–1929*. London: V&A Publishing.

Radioscopie (1974) Interview between Denise Boulet-Poiret and Jacques Chancel, 26 February. INA.

Rahman, Farhana (2019) 'Purdah', in *Encyclopedia of Women in World Religions: Faith and Culture across History: Indigenous Religions to Spirituality*. London: Bloomsbury Publishing, pp. 89–91.

Rawsthorn, Alice (1996). *Yves Saint Laurent: A Biography*. New York: Doubleday.

Rester Jeune (1938), Summer, cover.

Rittenhouse, Anne (1913) 'Prophet of Simplicity', *Vogue*, American edition, 1 November, pp. 42–43.

Romano, Alexis (2011) 'Exhibition Review: Saint Laurent Rive Gauche: la révolution de la mode', *Textile History*, 42(2), pp. 268–71.

Romano, Alexis (2012) '*Elle* and the Development of *Stylisme* in 1960s Paris', *Costume*, vol. 46, no. 1, pp. 75–91.

Romano, Alexis (2022) *Prêt-à-Porter, Paris and Women: A Cultural Study of French Readymade Fashion, 1945–68*. New York and London: Bloomsbury.

Rousso, Henry (ed.) (2000) 'La mode des années soixante', *Bulletin de l'IHTP*, no. 76, November.

Rovine, Victoria L. (2009) 'Colonialism's Clothing: Africa, France, and the Deployment of Fashion', *Design Issues*, vol. 25, no. 3, pp. 44–61.

Russell, Mary (1968) 'Ungaro', *Women's Wear Daily*, 9 July, pp. 1, 12.

Saillard, Olivier (2011) *Madame Grès, La Couture à L'Oeuvre*. Paris: Paris Musées.

Saillard, Olivier (2020) *Alaïa and Balenciaga: Sculptors of Shape*. Paris: Fondation Azzedine Alaïa.

Salazar, Ligaya (2011) *Yohji Yamamoto*. London: V&A Publishing.

Salvy, Claude (1966) *Le Monde et la mode*. Paris: Hachette.

Samson, Alexandre and Madsen, Anders Christian (2023) *Givenchy Catwalk: The Complete Collections*. London: Thames & Hudson.

Savignon, Jéromine with Blisthène, Bernard, Chenoune, Farid and Müller, Florence (2010) *Yves Saint Laurent*. New York: Petit Palais/Abrams.

Schoeser, Mary (2007) *Silk*. New Haven and London: Yale University Press.

Scottish Arts Council (1975) *A Scottish Arts Council Exhibition with the support of the Victoria and Albert Museum*. London: H.M. Stationery Office.

Schweizerisches National Museum (2010) *Soie Pirate Geschichte der Firma Abraham*, 2 vols. Zurich: Scheidegger & Spiess.

Singer, Juliette (2023) 'Poiret le Magnifique', in Paris-Musées (ed.), *Le Paris de la Modernité 1905–1925*. Paris: Éditions Paris Musées and Flammarion, pp. 105–06.

Steele, Valerie (1988) *Paris Fashion: A Cultural History*. New York: Oxford University Press.

Thévenon, Patrick (1965) 'Le couturier qui a pensé aux femmes d'aujourd'hui', *Candide*, 15 August, n.p.

Troy, Nancy (2003) *Couture Culture: A Study in Modern Art and Fashion*. Cambridge, MA: MIT Press.

Troy, Nancy and Tartsinis, Ann Marguerite (2023) *Mondrian's Dress: Yves Saint Laurent, Piet Mondrian and Pop Art*. Cambridge, MA and London: MIT Press.

Union centrale des arts décoratifs – musée de la mode et du textile (1999) *Garde-robes Intimités dévoilées, de Cléo de Mérode à … *. Paris: Union centrale des arts décoratifs, Musée de la mode et du textile.

Veillon, Dominique and Ruffat, Michèle (eds) (2007) *La mode des sixties: l'entrée dans la modernité*. Paris: Autrement.

Video of Maison Bruyère fashion show (1934). University of South Carolina, Moving Image Research Collections, ref. Fox Movietone News Story 24–44, https://digital.tcl.sc.edu/digital/collection/MVTN/id/6758/rec/16.

Vijayakrishnan, Shilpa (2015) 'Behind the Veil, in Front of the Lens', in Poddar, Abhishek and Gaskell, Nathaniel (eds), *Maharanis: Women of Royal India*. Ahmedabad, India: Mapin Publishing in association with Tasveer, pp. 60–74.

Vincent-Ricard, Françoise (1983). *Raison et passion. Langages de société: la mode, 1940–1990*. Paris: Textile/Art/Language.

Vogue (1923), French edition, April, illustration, p. 11.

Vogue (1936), American edition, 1 December, illustration, p. 84.

Vogue (1938), American edition, 15 September, photograph, p. 58.

Vogue (1939), French edition, 'Paris, rendez-vous de la Beauté', July, photograph, p. 27.

Vogue (1947), American edition, 15 October, photograph, p. 137.

Vogue (1948), American edition, 1 March, photograph, p. 215.

Vogue (1948), French edition, April, photographs, pp. 53, 100.

Vogue (1948), French edition, September, photograph, p. 29.

Vogue (1963), American edition, 'The Givenchy Idea', 15 April, pp. 64–65.

Vogue (1967), American edition, 15 March, photograph, p. 66.

Vogue (1967), American edition, 15 April, photograph, p. 72.

Vreeland, D. (1968), 'Vogue's Eye View: Fashion to Stimulate the World: The Inventive Savoir Vivre of Paris', *Vogue*, American edition, 15 September, pp. 116–17.

Weiner, Susan (2001) *Enfants Terribles: Youth & Femininity in the Mass Media in France, 1945–1968*. Baltimore, MD: Johns Hopkins University.

White, Palmer (1973) *Poiret*. London: Studio Vista.

White, Palmer (1986) *Elsa Schiaparelli: Empress of Paris Fashion*. New York: Rizzoli.

White, Palmer (1994) *Haute Couture Embroidery: The Art of Lesage*. Berkeley, CA: Lacis Publications.

Wilcox, Claire (2014) 'The Aura of Glamour: Couture Fashion', in Brown, Susanna (ed.), *HORST Photographer of Style*. London: V&A Publishing, pp. 62–75.

Wollen, Peter (1988) 'Fashion/Orientalism/The Body', *New Formations*, no. 1, pp. 5–33.

Wollen, Peter (1993) *Raiding the Icebox: Reflections on Twentieth Century Culture*. Bloomington: Indiana University Press.

Women's Wear Daily (1921), 25 November, illustration, pp. 3, 36.

Women's Wear Daily (1935), 8 March, photograph, p. 1.

Yohannan, Kohle and Nolf, Nancy (1998) *Claire McCardell: Redefining Modernism*. New York: Harry N. Abrams.

Contributors

Misha Anikst is an award-winning, Russian-born designer based in London. He heads Anikst Design, an internationally recognised graphic design studio that has worked with galleries and other prominent institutions as well as private clients. He has experience in architecture and stage design as well as the graphic arts, but has for most of his career primarily focused on book design.

Betül Başaran is Professor of History and the Coordinator of the Women, Gender, and Sexuality Studies Program at St Mary's College of Maryland. She specialises in the history of the Ottoman Empire and is particularly interested in women's history. For her most recent book, which focuses on the life and work of Princess Niloufer, she has conducted extensive archival research in Türkiye, the United Kingdom and India.

Judith Clark is Professor of Fashion and Museology at University of the Arts, London, and a curator and fashion exhibition-maker based in London. She is a visiting Professor at IUAV in Venice, and Associate Fellow at City and Guilds of London Art School. Clark set up the first experimental gallery of fashion in 1997–2002 in Notting Hill and has collaborated with museums, galleries and design archives worldwide including the Victoria and Albert Museum, the Barbican Art Gallery and the Palais de Tokyo in Paris. Clark currently runs a multi-disciplinary studio dedicated to practice-based research.

William DeGregorio is Associate Curator at The Costume Institute, Metropolitan Museum of Art, where he oversees 18th- and 19th-century fashion. Most recently he co-authored *The Percival D. Griffiths Collection: English Needlework 1600–1740* (Yale: 2023). He has contributed to numerous exhibitions and publications, including *Elegance in an Age of Crisis: Fashions of the 1930s* (FIT, 2014); *Salvaging the Past: Georges Hoentschel and French Decorative Arts from The Metropolitan Museum of Art* (MMA, 2013); and *Arnold Scaasi: American Couturier* MFA Boston, 2010).

Waleria Dorogova is an independent art historian, curator, and a specialist in the work of Sonia Delaunay. She completed her doctorate at the University of Bonn in 2022, where she wrote the first-ever history of the couture house Boué Sœurs (to be published in 2025). In 2022, she organised the exhibition *Maison Sonia Delaunay* at Kunstmuseen Krefeld. In 2024, she co-curated *Sonia Delaunay: Living Art* at Bard Graduate Center in New York City.

Caroline Evans is a fashion historian and Professor Emerita at Central Saint Martins (University of the Arts London). Her books include *Women and Fashion* (1989), *Fashion at the Edge* (2003), *The Mechanical Smile* (2013) and *Time in Fashion* (2020). She has contributed to many publications, lectured widely at international design schools and universities, and has been a consultant on several fashion exhibitions, including at the Victoria and Albert Museum, London, the Museum of London, MoMu, Antwerp, and the Palais Galliera Paris. She has played a key role in the development of the discipline of fashion history and theory.

Mary Galloway is a writer and actor from London. For Francesca Galloway she has worked as a copywriter and editor on numerous projects, occasionally researching and contributing to catalogues including *Women at the Mughal Court: Perception and Reality*, as well as working on the couture collection. She studied English Literature at Cambridge and trained as an actor at Guildhall.

Sarah Glenn ACR is a fashion and textile conservator. Through her company, Atelier Nine Conservation Ltd, she has been involved in a wide variety of projects throughout the UK and abroad. Her work on major national and international exhibitions includes *Sargent and Fashion* (Tate Galleries, 2024); *Fashion City* (Museum of London, 2023); *Fashioned from Nature* (V&A, 2018); *Alexander McQueen: Savage Beauty* (V&A, 2015); *Italian Fashion* (V&A, 2014); and *Yohji Yamamoto* (V&A, 2010). Sarah is a member of the Clothworkers' Company.

Katrina Lawson Johnston was given her first camera (an analogue Nikon FM2) at the age of sixteen, and has never been without a camera since. Much of her 'personal' work addresses how photography serves as a form of memory. She says: 'A moment or person from the past can be injected into the present through the act of halting time in the shutter.' Her clients include Manolo Blahnik, Jimmy Choo and Stella McCartney Kids, and her commercial work has been published in *Condé Nast Traveller*, *HTSI* and *Cabana*.

Mei Mei Rado is Assistant Professor of Textiles, Dress, and Decorative Arts at Bard Graduate Center. Previously she was Associate Curator of Costume and Textiles at Los Angeles County Museum of Art, and held various curatorial and research positions at the Metropolitan Museum of Art, the Palace Museum (Beijing), and Institut national d'histoire de l'art (Paris). Her research focuses on Chinese and French textiles and dress from the 18th to the early 20th century. Her forthcoming book *The Empire's New Cloth: Cross-Cultural Textiles at the Qing Court* will be published by Yale University Press in 2025.

Christine Ramphal is an independent art consultant with a special focus on textiles and 20th-century fashion. Her first foray into the world of haute couture and prêt-à-porter was when she worked for the Swiss textile firm Abraham in Zurich. She was involved in *Giorgio Armani – A Retrospective* at London's Royal Academy of Arts and the Triennale di Milano, and worked for Christie's London Costume & Textiles department. She is a long-time collaborator of Francesca Galloway.

Alexis Romano is a scholar whose work spans fashion, design history and visual culture, with a focus on women's history, photography and the everyday, subjective aspects of dress. She teaches Fashion Studies at Parsons School of Design, The New School, and holds fellowships from Wesleyan University (2024–25) and the Costume Institute, Metropolitan Museum of Art (2020–21). She is the author of *Prêt-à-Porter, Paris and Women: A Cultural Study of French Readymade Fashion, 1945–68* (Bloomsbury, 2022).

Image credits

An Eye for Couture
A Collector's Exploration of 20th Century Fashion

© Prestel Verlag, Munich · London · New York, 2024
A member of Penguin Random House Verlagsgruppe GmbH
Neumarkter Strasse 28 · 81673 Munich

© for the texts by Judith Clark, Caroline Evans, Mei Mei Rado, Betül Başaran, Alexis Romano, Christine Ramphal, Waleria Dorogova

© for the collection photographs Katrina Lawson Johnston

Cover: Detail of Jacques Fath cocktail dress, c. 1955 (no. 64)
Frontispiece: Detail of silk gazar from Cristóbal Balenciaga evening dress, 1961 (no. 69)

Library of Congress Control Number is available; a CIP catalogue record for this book is available from the British Library.

The publisher expressly reserves the right to exploit the copyrighted content of this work for the purposes of text and data mining in accordance with Section 44b of the German Copyright Act (UrhG), based on the European Digital Single Market Directive. Any unauthorised use is an infringement of copyright and is hereby prohibited.

Produced in the United Kingdom by Hali Publications Ltd.,
6 Sylvester Path, London E8 1EN
www.hali-publications.com

Every effort has been made to trace the copyright holders and obtain permission for the images included in this book. If any image has been included without the correct permissions, we apologise and will make the necessary corrections in future editions upon being informed.

Editor and project director
Christine Ramphal

Photographer
Katrina Lawson Johnston
assisted by George House and Oliver Goodrich

Set designer
Sarah Parker Creative
assisted by Ella Thumin

Fashion & textile conservator
Sarah Glenn

Photoshoot producer
Mary Galloway

Book designer
Misha Anikst

Research and cataloguing
William DeGregorio and Christine Ramphal

Contributors
Judith Clark
Caroline Evans
Mei Mei Rado
Betül Başaran
Alexis Romano
William DeGregorio
Christine Ramphal
Waleria Dorogova

Penguin Random House Verlagsgruppe FSC® N001967

Printed and bound in Italy by Graphicom, Vicenza
Printed on 170gsm Perigord paper from a sustainable source

ISBN 978-3-7913-7763-6

www.prestel.com

FSC
www.fsc.org
MIX
Paper | Supporting responsible forestry
FSC® C013123